6/94

This book was donated
to honor
the birthday of

Cært Voorhees '92

by

Sara & Dayton Voorhees

2-25-94

DATE

LATIN AMERICAN ARTISTS OF THE TWENTIETH CENTURY

LATIN AMERICAN ARTISTS

Distributed by Harry N. Abrams, Inc., New York

OF THE TWENTIETH CENTURY

Edited by Waldo Rasmussen

with Fatima Bercht and Elizabeth Ferrer

THE MUSEUM OF MODERN ART, NEW YORK

Published on the occasion of the exhibition
Latin American Artists of the Twentieth Century,
organized by Waldo Rasmussen, Director, International
Program, The Museum of Modern Art, New York,
June 6–September 7, 1993

This exhibition is made possible by grants from
Mr. and Mrs. Gustavo Cisneros; Banco Mercantil (Venezuela);
Mr. and Mrs. Eugenio Mendoza; Agnes Gund; The
Rockefeller Foundation; Mrs. Amalia Lacroze de Fortabat;
Mr. and Mrs. David Rockefeller; the National Endowment for
the Arts; The International Council of The Museum of
Modern Art; Consejo Nacional de la Cultura y Galería de
Arte Nacional, Venezuela; and WXTV-Channel 41/Univision
Television Group, Inc.

The exhibition was commissioned by the Comisaría de la
Ciudad de Sevilla para 1992 and organized by The Museum
of Modern Art under the auspices of its International Council.

Produced by the Department of Publications
The Museum of Modern Art, New York
Osa Brown, Director of Publications
Project editor: Harriet Schoenholz Bee
Editors: Christopher Lyon, Susan Weiley,
Jessica Altholz, and Barbara Einzig
Designed by Phillip Unetic, Lawrenceville, N.J.
Production by Vicki Drake
Composition by U.S. Lithograph, typographers, New York, N.Y.
Printed by Litho Specialties, Inc., St. Paul, Minn.
Bound by Midwest Editions, Inc., Minneapolis, Minn.

Published by The Museum of Modern Art
11 West 53 Street, New York, New York 10019

Clothbound edition distributed in the United States and Canada by
Harry N. Abrams, Inc., A Times Mirror Company

Clothbound edition distributed outside the United States and
Canada by Thames and Hudson, Ltd., London

Cover: Tarsila do Amaral. *Urutu*. 1928. Oil on canvas, 24 x 28⅜" (60 x 72 cm). Collection
Gilberto Chateaubriand, Rio de Janeiro

Honorary Advisory Committee

Patricia Phelps de Cisneros, *Chairman*

Alfredo Boulton

Gilberto Chateaubriand

Barbara D. Duncan

Natasha Gelman

Jorge Helft

María Luisa and Eugenio Mendoza

José E. Mindlin

Beatrice and Julio Mario Santo Domingo

Elizabeth Straus

Advisors to the Exhibition

Aracy Amaral

Rita Eder

Paulo Herkenhoff

Ariel Jimenez

Angel Kalenberg

Susana Torruella Leval

Llilian Llanes

Samuel Paz

Sylvia Pandolfi

Eduardo Serrano

CONTENTS

FOREWORD

This volume, published on the occasion of the exhibition *Latin American Artists of the Twentieth Century*, not only represents and amplifies this extraordinarily comprehensive survey of the modern art of Latin America but also recalls the Museum's long involvement with this vast and culturally diverse region. The Museum of Modern Art was the first institution to collect systematically the modern art of Latin America, and an exhibition mounted just fifty years ago, *The Latin-American Collection of The Museum of Modern Art*, gave the public its first view of an already remarkable depth in the Museum's holdings in this area.

Organized under the auspices of the Museum's International Council, this exhibition is also a reminder of the Council members' generous commitment to the organization of traveling exhibitions that for three decades have benefited viewers throughout Latin America, as well as Europe and Asia. Indeed, earlier versions of this exhibition itself have been seen in Spain, where it was commissioned by the City of Seville as part of its Columbus quincentennial celebration, and in Paris and Cologne. We thank Alejandro Rojas-Marcos y de la Viesca, Mayor of the City of Seville, and the Comisaría de la Ciudad de Sevilla para 1992 for their invitation and support, which initiated this project.

An undertaking of this magnitude could not have proceeded without the extraordinary generosity and cooperation of many individuals and institutions. Foremost among them are the members of The International Council of the Museum. Their active interest and involvement, shared by the Council's president, Jeanne C. Thayer, have been essential to its realization. We also warmly thank for her unwavering support Patricia Phelps de Cisneros, Chairman of the exhibition's Honorary Advisory Committee, who generously and effectively led sponsorship solicitation for the exhibition and its publications. The assistance of David Rockefeller, chairman of the Board of Trustees of The Museum of Modern Art, who has long been an advocate of Latin American art, was most helpful in obtaining loans of works important to the exhibition. We are grateful to many other individuals who facilitated loans of art works from abroad, and our thanks to them and to institutional and private lenders to the exhibition are more specifically expressed elsewhere in this volume.

Many individuals on the staff of the Museum have contributed to this exhibition. Particular gratitude and admiration are due the exhibition's director, Waldo Rasmussen, who has also directed the International Program since 1969. He first traveled to Latin America in 1957, accompanying the United States representation to the São Paulo Bienal, and his thorough acquaintance with the art of Latin America and deep commitment to furthering appreciation of its quality and importance are the fundamental elements of this project. Marion Kocot, Senior Program Associate, the International Program, has superbly coordinated all aspects of the exhibition, assisted by Gabriela Mizes.

The unprecedented scope of *Latin American Artists of the Twentieth Century* has been made possible by the generosity of many contributors, including Mr. and Mrs. Gustavo Cisneros, Banco Mercantil of Venezuela, Mr. and Mrs. Eugenio Mendoza, Agnes Gund (president of The Museum of Modern Art), The Rockefeller Foundation, Mrs. Amalia Lacroze de Fortabat, Mr. and Mrs. David Rockefeller, the Consejo Nacional de la Cultura y Galería de Arte Nacional, Venezuela, and WXTV-Channel 41/Univision Television Group, Inc. For their assistance, we are immensely grateful. In addition, grants from the National Endowment for the Arts and the Museum's International Council continue their deeply appreciated record of support for the Museum's exhibitions and programs. Finally, we express our very warm gratitude to the artists and lenders whose participation made this undertaking possible.

Richard E. Oldenburg
Director, The Museum of Modern Art

INTRODUCTION
TO AN
EXHIBITION

■

Waldo Rasmussen

This volume of essays by scholars and critics is published on the occasion of the exhibition *Latin American Artists of the Twentieth Century* at The Museum of Modern Art, New York. The book is intended to introduce the vast and complex field represented by the exhibition, elucidating some of the circumstances in which the works of more than four generations of Latin American artists have been created. The essays have been selected to provide both a synoptic view of principal lines of development and in-depth research on lesser-known areas or on individual artists generally unfamiliar to the public outside Latin America.

For a North American curator, selecting work for a broad survey of modern Latin American art is a delicate undertaking, especially in the aftermath of the quincentennial commemorations—celebratory, critical, or mournful—of the European discovery of the new world.[1] Thus, it is particularly important that curatorial and institutional positions are made explicit at the outset. The Canadian critic Bruce Ferguson has suggested that exhibitions are a form of language spoken by art museums to an audience, but that in order for this communication to be reciprocal, questions regarding an exhibition's aims, its "hopes and desires," the audience to which it is directed, and the intentions of the exhibition's curator should be articulated. Ferguson has noted that it is especially useful to ask whether an exhibition "admits to its own necessary contradictions and multiplicities."[2] It is the aim of this essay to stimulate dialogue through a discussion of the origin and purpose of the exhibition *Latin American Artists of the Twentieth Century*. A twofold narrative—both institutional history and autobiography—is required by this approach. Having evolved from personal experiences that extend back some thirty years, this project intersects with The Museum of Modern Art's longer history of some sixty years of involvement with Latin American art, a history that shapes the present exhibition and, I hope, one that may in turn be illuminated by it.

The Museum of Modern Art was the first institution outside Latin America to exhibit and collect the art of that region. In 1931, only two years after its founding, the Museum presented an exhibition of Diego Rivera's work that was attended by nearly 57,000 visitors, a record-breaking number.[3] This was the second one-person show held at the Museum (the first was of the work of Henri Matisse), and only its fourteenth exhibition. Rivera was, in many respects, a logical choice; he was among the most famous and influential artists in the world in the early 1930s, and in 1928 he had met Alfred H. Barr, Jr., soon to become the Museum's first director, while both were visiting the Soviet Union. Abby Aldrich Rockefeller (Mrs. John D. Rockefeller, Jr.), one of the three founding patrons of the Museum, was a great admirer of Rivera's work and provided a grant that enabled the Museum to invite the artist to paint seven fresco panels especially for the exhibition.[4] Only one of these, *El agrarista Zapata* [*Agrarian Leader Zapata*] of 1931 (plate 171), entered the Museum's collection; it was purchased in 1940 through the Abby Aldrich Rockefeller Fund. In 1933 an exhibition of ancient art from Latin America, *American Sources of Modern Art (Aztec, Mayan, Incan)*, was the first in a series of ethnological shows held at the Museum. *Art in Our Time*, the exhibition inaugurating the Museum's new building in 1939, included works by Rivera, José Clemente Orozco, David Alfaro Siqueiros, and Cândido Portinari.[5] Latin American exhibitions at the Museum in 1940 included *Portinari of Brazil*, a one-person show of

works by the Brazilian social-realist painter and muralist,[6] and *Twenty Centuries of Mexican Art*, an early "blockbuster," which filled the entire Museum with material ranging from pre-Columbian sculpture and colonial paintings to works by contemporary artists, with folk art shown in a "Mexican market" in the Museum's garden.[7] In 1944 *Modern Cuban Painters* was shown at the Museum and afterward seen in twelve cities in the United States.[8] The Museum's Department of Circulating Exhibitions, begun in 1933 under the direction of Elodie Courter, sent Latin American exhibitions throughout the United States during this period, beginning with *Three Mexican Artists* (Rivera, Orozco, and Siqueiros) in 1938 and 1939. Between 1938 and 1946 twelve Latin American exhibitions were circulated.

The Museum's permanent collection of Latin American art was begun in 1935 with the gift of Orozco's *The Subway* of 1928, donated by Abby Aldrich Rockefeller, who gave the Museum many of its first Latin American works. In 1942 the Museum's Inter-American Fund was initiated with the gift of a large sum from an anonymous donor, given expressly for the purchase of Latin American works of art. In search of acquisitions, Barr traveled to Mexico and Cuba with Edgar J. Kaufmann, Jr., and Lincoln Kirstein went to South America. Their success can be measured by the fact that when the Museum's Latin American collection was shown in its entirety a year later, for the first and only time, it had grown from just over seventy works to nearly three hundred. *The Latin-American Collection of The Museum of Modern Art* was also sent on tour in the United States accompanied by a catalogue with a text by Kirstein and an introduction by Barr.[9]

Abby Aldrich Rockefeller's interest in the Museum's Latin American exhibitions and collection was shared by her son Nelson A. Rockefeller. He became a trustee of the Museum in 1932 and served as the Museum's president from 1939 until 1941, when he resigned to work full-time as President Franklin D. Roosevelt's Coordinator of the Office of Inter-American Affairs. (Later he would hold the office of Assistant Secretary of State for Latin American Affairs.) The Rockefeller family's commitment to Latin American art and culture, which helped encourage the Museum's activities in that area, coincided not only with their business interests in Latin American countries (Standard Oil of New Jersey's operations in Venezuela and Mexico, for example) but also with the official United States wartime "Good Neighbor" policy, which Nelson Rockefeller had a hand in elaborating through his government appointment. The policy was intended in large part to influence Latin American countries toward the Allies rather than toward the Axis powers.

Among the projects undertaken by the Inter-American Affairs office were exhibitions of American art sent to Latin America and reciprocal shows of Latin American art circulated in the United States. The organization of a number of these exhibitions was contracted to The Museum of Modern Art. The most ambitious was a 1941 survey of contemporary American painting organized by The Brooklyn Museum, The Metropolitan Museum of Art, The Museum of Modern Art, the Whitney Museum of American Art, and the American Museum of Natural History. Serving as secretary of the exhibition and accompanying it on its Latin American tour was Stanton Loomis Catlin, at the beginning of a career that has spanned over fifty years, during which he has made important contributions to the study of the history of Latin American art. *Brazil Builds: Architecture New and Old, 1652–1942*, organized by The Museum of Modern Art, the American Institute of Architects, and the Office of Inter-American Affairs, was shown at the Museum in 1943.[10] Afterward it was presented in Mexico City and then circulated for three years in the United States. Special editions of the show were sent to Rio de Janeiro and London.

Nelson Rockefeller was assisted in the activities of the Inter-American Affairs office by René d'Harnoncourt, who would serve as director of The Museum of Modern Art from 1949 to 1968. D'Harnoncourt has a special importance in this narrative, with regard both to the Museum's relations with Latin America and to my own personal and professional history. Born in Vienna in 1901, he painted and drew in his youth, collected old-master prints, and organized the first exhibitions in his home town of Graz of prints by Pablo Picasso and Matisse. Trained as an industrial chemist, d'Harnoncourt emigrated to Mexico in 1925 but found no employment in his profession. He employed his skills as a draftsman to support himself and then became a dealer in pre-Columbian artifacts and Mexican folk art. During the 1920s and 1930s he organized traveling exhibitions of indigenous and folk art for the Mexican government and became friends with the Mexican muralists and other leading artists. In 1927 he arranged in Mexico City the first important showing of paintings by Rivera, Orozco, and Rufino Tamayo. In 1930 he organized a large exhibition of Mexican colonial, folk, and modern art that was shown at The Metropolitan Museum of Art in New York and later circulated in the United States. In 1937 he joined the newly organized Indian Arts and Crafts Board in the United States and in 1941 directed the exhibition *Indian Art of the United States* for The Museum of Modern Art, where it was a tremendous success, establishing d'Harnoncourt as a master of installation design.[11]

In 1944, at the instigation of Nelson Rockefeller, d'Harnoncourt joined the staff of the Museum as a vice president whose responsibilities included foreign activities. He arrived during a period of uncertainty and change in the Museum. The year before, Alfred Barr had been removed abruptly from his position as director, though he refused to sever his connection with the Museum and was given a research position in the library. For a time, management of the Museum was handled by a committee of trustees and subsequently by a coordination committee of trustees and staff, of which d'Harnoncourt was named chairman. Three years after coming to the Museum, d'Harnoncourt restored to Barr full curatorial status as director of Museum Collections, a newly formed position with responsibility for the permanent holdings of all the curatorial departments, the individual departments retaining jurisdiction over exhibitions. He held this position from 1946 until his retirement in 1967.

During the more than twenty years of partnership between these two men, vastly different in background and temperament, the Museum entered a new phase of growth, greatly expanding its collection, exhibition space, staff, and the scope of its programs. As the Museum's founding director, Barr had established its multidepartmental concept. It became the first museum in the world to collect and exhibit all of the visual arts of our time—not only painting and sculpture but also film, photography, prints, drawings, architecture, and design. Believing that art has no national barriers, he had defined the Museum as an international institution. Barr brought European modern art to the United States when the country was still artistically

isolated; educating the public about international modern art was a cause he embraced with almost evangelical fervor.

While Barr concentrated on building and refining the collection, d'Harnoncourt extended the Museum's scope internationally. In 1938 it had sent an exhibition abroad for the first time. *Three Centuries of American Art*, which included folk art as well as selections representing all the other types of art collected or exhibited by the Museum, was shown at the Musée du Jeu de Paume in Paris. In general, photographic works, architecture and design, and films were well received, but the French deprecated the works by American painters and sculptors—including such artists as Alexander Calder, Charles Demuth, Edward Hopper, and Georgia O'Keeffe—as provincial and derivative. By the 1950s American painting and sculpture had entered a new phase. Partly in response to this, d'Harnoncourt established a new Museum department in 1952, the International Program, with the principal aim of making modern art in general and recent American art in particular better known to the world. The program was underwritten by the Rockefeller Brothers Fund with an initial five-year grant and was also supported by The International Council of The Museum of Modern Art, an organization of art patrons from all over the world that was begun in 1953 with Blanchette Rockefeller (Mrs. John D. Rockefeller 3rd) as its first president. The International Program was an outgrowth of the Museum's Department of Circulating Exhibitions, but its operations reflected as well the experiences d'Harnoncourt and the Museum had gained when working with the Inter-American Affairs office.

Porter McCray, who had worked with Nelson Rockefeller and d'Harnoncourt at the Inter-American Affairs office, was the International Program's first director. Trained as an architect, McCray had directed the Museum's Department of Circulating Exhibitions alternately with Elodie Courter and had traveled around the world in various capacities for the government. D'Harnoncourt and McCray became my mentors and friends when I joined the staff of the Museum; their broad vision still influences the International Program.

The Museum of Modern Art's policy of sending exhibitions to cities that lacked significant collections of modern art was of prime importance in setting the course my life was to take. Having lived in the state of Washington as a child, I was fourteen years old when my family moved to Portland, Oregon, in 1942. Until then I had never seen an art museum nor had I any introduction to modern art. Among the first exhibitions I saw at the Portland Art Museum were ones sent by The Museum of Modern Art, which included works by Picasso, Joan Miró, and Paul Klee that soon converted me to modernism. Experiencing such shows throughout my life has made me aware of what a profound effect exhibitions can have on the receptive viewer. This is especially true for artists, many of whom have recorded how their own art has been affected by their seeing an exhibition that had special meaning for them.

Mexican muralism had influenced me even earlier than European modernist painting. The Mexican painters were very popular in the United States during the Depression, and the social realism they practiced became a leading art movement in this country, particularly outside New York. Numerous local projects, such as post office murals, were sponsored by the Federal Art Project as part of President Roosevelt's New Deal. In my high school library, I read about the Mexican Mural Movement, and at that time it defined modernism for

me, well before I learned about modernist styles like Cubism. The Pacific Northwest had its own regional school of art, centered around Mark Tobey and Morris Graves. The very first exhibition of contemporary art I remember was a Tobey show at the Portland Art Museum in 1945. This Northwest Coast school was strongly connected to Asian art as well as to the modern tradition.

Portland in the 1940s—a small city with an art movement on the periphery of mainstream modernism, one in which social realism was still influential—offers parallels to many Latin American cities during that same period. Likewise, my working-class background and Scottish and American Indian ancestry, which placed me outside the dominant culture of the Eastern establishment I was later to join, undoubtedly encouraged me to identify with the peripheral situation of many Latin American artists.

During my college years I became interested in the possibility of a museum career and took studio courses in painting at the school of the Portland Art Museum in order to learn something of the problems of making art. Reading Clement Greenberg's articles in *Partisan Review* was also a major influence, but the critical experience for me was of a show of contemporary American painting circulated by The Museum of Modern Art in 1950, with work by Jackson Pollock, Arshile Gorky, Willem de Kooning, and Mark Rothko—artists whose paintings I had seen only in reproductions. Abstract Expressionism was the art of our time that affected me most deeply then, and it has continued to do so.

In 1952 I joined the staff of the Portland Art Museum, and for the next two years I was trained in the museum profession by working in the registrar's department, being responsible for the care and recording of works of art. During this period I met the sculptor David Smith, who came to Portland to serve on the jury of a regional exhibition. He brought with him a selection of his drawings, which I was assigned to install in the museum—probably the first museum show of Smith's drawings. He was my first contact with the New York art world and remained a friend until his death in 1965.

I moved to New York in 1954 to study at the Institute of Fine Arts of New York University; soon after arriving I was hired by Porter McCray and joined the staff of The Museum of Modern Art's International Program. At that time it was circulating in Europe a major exhibition of American art, *Modern Art in the United States: Selections from the Collection of The Museum of Modern Art*. It was in many ways a successor to the 1938 exhibition of American art sent to Paris, once again representing all of the Museum's curatorial departments. On this occasion, however, American paintings and sculpture, especially Abstract Expressionist works, were received with much greater enthusiasm. During the remainder of the 1950s the International Program focused on sending recent American art abroad.

In New York in the 1950s there was an entire gallery in The Museum of Modern Art devoted to works by Latin American artists, chiefly the Mexicans Rivera, Orozco, Siqueiros, and Tamayo. This was a feature of the "permanent" installation of the collection until the building was remodeled in 1964. Works by Matta were always on view in the galleries devoted to Surrealism, and Wifredo Lam's *La Jungla* [*The Jungle*] of 1943 (plate 102) was given a prominent position in the Museum's lobby by Alfred Barr, a hanging of arguable merit that has persisted to the present day. Latin American exhibitions of note in the 1950s included *Ancient Arts of the Andes*,

directed by René d'Harnoncourt in 1954,[12] *Latin American Architecture since 1945* in 1955,[13] and the 1957 retrospective of Matta's work, which was the first exhibition at the Museum organized by William Rubin,[14] who later became director of the Department of Painting and Sculpture. In 1961 *Orozco: Studies for the Murals at Dartmouth College* was shown at the Museum and afterward circulated in the United States and Scandinavia.

During its first decade the International Program assumed responsibility for sending exhibitions representing the United States to major international festivals, including the Venice Biennale and the São Paulo Bienal, there being no government agency charged with this function. Unlike the venerable Venice Biennale, which was begun in 1895, the São Paulo Bienal was a recent addition to the art-festival circuit, established as a means of acquainting the Brazilian public with international developments in modern art, as well as providing Brazilian and other Latin American artists with an exhibition forum. At the urging of Nelson Rockefeller, before the International Program was established, the Museum organized the exhibition representing the United States at the first Bienal in 1951, a presentation of 124 works by fifty-eight artists, selected by a committee drawn from The Museum of Modern Art, The Metropolitan Museum of Art, the Whitney Museum of American Art, The Brooklyn Museum, and the Philadelphia Museum of Art. For the second Bienal in 1953, the Museum sent Picasso's *Guernica* of 1937 (then on long-term loan to the Museum from the artist) to a special exhibition honoring the artist; and a large exhibition of works by Alexander Calder, organized by René d'Harnoncourt, which received great acclaim. With the aid of a subsidy from the International Program, the San Francisco Museum of Art sent an exhibition of the work of West Coast artists to the third Bienal in 1955.

I first traveled to Latin America accompanying the United States representation prepared for the fourth Bienal in 1957, the exhibition *Jackson Pollock: 1912–1956*, which had just closed at the Museum. Along with the Pollock retrospective was a group show of the work of five painters (James Brooks, Philip Guston, Grace Hartigan, Franz Kline, and Larry Rivers) and three sculptors (David Hare, Ibram Lassaw, and Seymour Lipton). I supervised the assembly, packing, and shipment of the exhibitions and assisted Porter McCray with their installation. Barr was the United States Commissioner for the Bienal and also served on its international jury, which gave a special citation to the Pollock exhibition.

The fourth Bienal featured works by a number of emerging Latin American artists including Frans Krajcberg (who received first prize for a painting by a Brazilian artist) and artists working in various styles of geometric abstraction—among them Lygia Clark, Hélio Oiticica, Sérgio Camargo, Edgar Negret, Alejandro Otero, and Eduardo Ramírez Villamizar, who are included in the present exhibition and book. I must admit, however, that at the time I was too absorbed by Abstract Expressionism to respond very strongly to their work, which today I greatly admire. More important to me was the experience of Brazil itself, to which I felt an immediate connection, and my first exposure to the international art world. In retrospect, the most positive aspect of the Bienal as an art event for Brazilians may have been juxtaposing exhibitions of work by established artists (including a group show of Bauhaus artists and shows of works by Marc Chagall, Paul Delvaux, René Magritte, Ben Nicholson, and Egon Schiele) alongside works representing contemporary developments in a wide range of styles. The Bienal provided an unparalleled opportunity for Latin American artists to show their work in an international context. The fly in the ointment, however, was a system of awarding prizes that created a false sense of nationalist competition, which I feel was very damaging to the artists.

The next project for the International Program in which I was engaged was a major exhibition devoted to Abstract Expressionism in America. *The New American Painting* was organized at the request of the museum directors Willem Sandberg of the Stedelijk Museum in Amsterdam, Robert Giron of the Palais des Beaux-Arts in Brussels, and Arnold Rüdlinger of the Kunsthalle in Basel. The exhibition was directed by Dorothy C. Miller, curator of Museum Collections, with the help of the poet Frank O'Hara, who was on the staff of the Museum until his death in 1966. I assisted with the show's organization and its installation in Basel, where the exhibition, which was shown jointly with the Pollock retrospective, had its inaugural presentation in 1958. The response to *The New American Painting* was extraordinary. European critics acknowledged that the United States had produced a new kind of painting, signaling the graduation of American art from a provincial role to a position of central importance in the modern movement. For the first time in our history, American artists had invented a plastic language capable of altering the course of art; its influence spread internationally. During the following years, a series of one-person exhibitions of work by Abstract Expressionist artists—Kline, Rothko, Robert Motherwell, Smith, de Kooning, Helen Frankenthaler, and Barnett Newman—was circulated by the International Program in Europe. It was deeply satisfying to be associated with those exhibitions and to play an active role in gaining respect for the achievements of the American Abstract Expressionists. It is my great hope that the present exhibition and book will make a similar contribution to the understanding and acceptance of work by Latin American artists.

———

In 1962 the International Program changed direction. After a decade of organizing the official United States representations to international festivals, including those of São Paulo, Venice, Tokyo, and New Delhi, The Museum of Modern Art announced that it would no longer undertake that role and encouraged the government to assume responsibility for it. The Museum gave its International Program an expanded charge, sending circulating exhibitions on wider itineraries. In this elaboration of earlier Museum policies Latin America was a particular priority, as a part of the world still lacking major public collections of modern art. Therefore, funds were raised specifically for exhibitions to circulate in Latin America, and prominent Latin Americans were invited to join The International Council. Following the resignation of Porter McCray, and with the counsel and encouragement of René d'Harnoncourt and The International Council's president, Elizabeth Bliss Parkinson (now Mrs. Henry Ives Cobb), I began to direct the International Program.

Abstract Drawings and Watercolors U.S.A. was the first of more than forty exhibitions in many fields of modern art, architecture, photography, and film that have since been circulated by the International Program in Latin America. It was selected by the art historian and critic Dore Ashton and represented Abstract Expressionism

with works by Pollock, de Kooning, Gorky, Kline, and Motherwell; geometric abstraction in works by Burgoyne Diller, Fritz Glarner, and Ludwig Sander; and the younger neo-Dada generation with pieces by Jasper Johns and Robert Rauschenberg. Besides introducing recent developments, this exhibition's tour to twelve cities in 1962 and 1963 established what were to become long-term working relationships with museums and cultural institutions throughout Latin America. Other milestone exhibitions in the series included *The School of Paris: Paintings from the Florene May Schoenborn and Samuel A. Marx Collection*, shown first at the Museum and in 1966 at the Museo de Arte Moderno in Mexico City, where it was installed by René d'Harnoncourt. It included forty-five paintings by fourteen artists, among them six by Matisse, fourteen by Picasso, six by Georges Braque, and others by Giorgio de Chirico, Juan Gris, Fernand Léger, Joan Miró, Amedeo Modigliani, and Chaim Soutine. In 1968 *From Cézanne to Miró* presented a range of painting by European masters from the late nineteenth century to 1940, lent by seven museums and twenty private collectors in the United States. Its tour to Buenos Aires, Santiago, and Caracas established attendance records and made it possible for many in those cities to see original works by modern masters for the first time. In 1971 and 1972 *Surrealism*, drawn from the Museum's collection, traveled to six countries, including a showing in Santiago at the invitation of President Salvador Allende. One-person exhibitions circulated in Latin America have included selections of paintings by Josef Albers (1964–65) and Hans Hofmann (1964); sculpture by Jacques Lipchitz (1964) and Alexander Calder (1970–71); and prints and drawings by Gorky, Miró, Motherwell, and Picasso. *Latin American Prints from The Museum of Modern Art* toured ten cities in 1974 and 1975. Major exhibitions during the 1980s included *Four Modern Masters: De Chirico, Ernst, Magritte, and Miró* in 1981 and *Contrasts of Form: Geometric Abstraction, 1910–1980* in 1986, which presented works drawn from the collections of the Solomon R. Guggenheim Museum and The Museum of Modern Art, including ones by the Latin American artists Marcelo Bonevardi, Negret, Rivera, and Jesús Rafael Soto. Both exhibitions were circulated to Buenos Aires, São Paulo, and Caracas.

As I traveled to a number of countries with the Museum's exhibitions in the 1960s, I was able to meet many of the artists in those countries and view their work, and I was profoundly affected by the powerful art created during that period. In Venezuela the kinetic art of Alejandro Otero, Carlos Cruz-Diez, and Jesús Rafael Soto was gaining widespread acceptance. Their work was championed by Miguel Arroyo, who built the collection of the Museo de Bellas Artes in Caracas with great daring and taste, acquiring, for instance, Jacobo Borges's *Ha comenzado el espectáculo* [*The Show Has Begun*] in 1964 (plate 30), the year it was painted, as well as a great collection of the works of Armando Reverón. Arroyo was also the first museum director in Latin America to begin to acquire a wide range of art from Latin American countries other than his own. Among the many exhibitions I saw during Arroyo's tenure, the installation of Gego's *Reticuláreas* in 1969 was especially magical.

Another innovative museum director during this period was Marta Traba, who directed Bogotá's Museo de Arte Moderno when it was located in small galleries in the Universidad Nacional. An ardent feminist and a brilliant critic, Traba encouraged an entire generation of gifted young artists, including Beatriz González, whose enamel portrait of Simón Bolívar was the first in a series of ironic tributes to national heroes, and Ana Mercedes Hoyos, then beginning a series of geometric abstractions, a series whose later works appeared to dissolve into pure light. The Colombian Fernando Botero, living in New York throughout the 1960s, had already sold his *Mona Lisa, a los doce años* [*Mona Lisa, Age Twelve*] of 1959 (plate 32) to The Museum of Modern Art. His success, in spite of his independence from international influences, was an inspiration to artists even younger than he.

In Buenos Aires during the 1960s the Instituto Torcuato Di Tella was one of the most provocative and stimulating avant-garde centers of music, dance, theater, and the visual arts anywhere in the world. It was under the direction of Jorge Romero Brest, a former director of the Museo Nacional de Bellas Artes and a great teacher and influential critic. He was also an international figure in the arts, frequently serving on art commissions and juries around the world. It was at the Instituto in 1964 that I first encountered the Nueva Figuración group of artists—Jorge de la Vega, Luis Felipe Noé, Ernesto Deira, and Rómulo Macció—and felt immediate sympathy for their work, related as it was to my own predilection for contemporary expressionist painting. Other artists reacting against the dominant tradition of Argentine geometric abstraction during this period included Marta Minujín, with her early environments and Happenings, and those practicing local variants of Pop art (Delia Cancel, Juan Stoppani, and Susana Salgado).

New approaches to Conceptual art were formulated by artists in several countries, notably Hélio Oiticica and Lygia Clark in Brazil and Víctor Grippo in Argentina. Other prominent Conceptual artists came to the United States during the 1960s; Liliana Porter and Luis Camnitzer are two of particular importance to me. Many of the aforementioned artists created affecting political statements during the most repressive periods of military dictatorship in their countries.

A contemporary and close friend of René d'Harnoncourt's since his early days in Mexico was Fernando Gamboa, who directed the Mexican government's international exhibitions for many years. During the 1970s he was director of the Museo de Arte Moderno in Mexico City, where he presented several shows from the International Program to supplement his own exhibitions of Mexican art. The critic Mário Pedrosa was a crucial figure in the development of art in Brazil; he served as Secretary General for the 1961 São Paulo Bienal, to which the International Program had sent exhibitions of the work of Motherwell, Reuben Nakian, and Leonard Baskin.

In 1966 Alfred Barr traveled to the Bienal in Córdoba, Argentina, and selected a group of works by Latin American artists exhibited there that were later acquired by The Museum of Modern Art. These acquisitions included works by Jorge Eielson of Peru, Rodolfo Mishaan of Guatemala, and Eduardo Mac Entyre, Rogelio Polesello, and César Paternosto of Argentina. In 1967 the exhibition *Latin American Art: 1931–1966* presented these and other works from the Museum's collection.

In the 1970s and 1980s, Latin American artists continued to be featured occasionally in exhibitions at The Museum of Modern Art. *Information*, the first important exhibition of Conceptual art, organized by Kynaston McShine in 1970, was one of the very few international surveys of its time to include artists from outside Europe and the United States.[15] Among the Latin American artists represented

were Hélio Oiticica, with an installation, Cildo Meireles, the New York Graphic Workshop (Luis Camnitzer, Liliana Porter, and José Guillermo Castillo), and Marta Minujín. In 1971 *The Artist as Adversary: Works from the Museum Collection* included Orozco's fresco *Dive Bomber and Tank* of 1940 (plate 140), which had not been on view for many years, as well as works by Botero, Marisol, Rivera, Antonio Ruiz, and Siqueiros, and a print section featuring the popular graphics by the Mexican satirist José Guadalupe Posada and those of the Taller de Gráfica Popular (People's Graphic Workshop) of Mexico City from the 1930s and 1940s. The Projects series of exhibitions by contemporary artists, begun in 1971, has included installations by Luis F. Benedit (1972), Porter (1973), Rafael Ferrer (1974), Meireles (1990), Guillermo Kuitca (1991), and Felix Gonzales-Torres (1992). A Happening by Minujín, titled *Kinappening*, took place in the Museum's sculpture garden in 1974. *Mexican Art: Selections from The Museum of Modern Art* was shown in 1978. The Department of Photography mounted shows of works by the Mexican master Manuel Alvarez Bravo in 1956 and 1971, and in 1979 the Projects series included *Martín Chambí and Edward Ranney*, in which photographs of social life in Cuzco during the 1920s and 1930s by the Peruvian Chambí were shown with the American Ranney's photographs of Inca monuments and the Peruvian landscape. The Department of Architecture and Design organized *The Architecture of Luis Barragán*, an exhibition of work by the brilliant Mexican architect, in 1976,[16] and *Roberto Burle Marx: The Unnatural Art of the Garden*, featuring the work of the Brazilian landscape architect, in 1991.[17] Deborah Wye, curator in the Department of Prints and Illustrated Books, organized *Committed to Print: Social and Political Themes in Recent American Printed Art* (1988), which presented political art by both Latin Americans working in the United States and American Latino artists, including Rupert García, Luis Cruz Azaceta, Camnitzer, Juan Sánchez, Marisol, Josely Carvalho, Alfredo Jaar, and Luis Jimenez.[18] In 1991 *Art of the Forties*, an interdepartmental show drawn from the Museum's collection, exhibited Orozco's *Dive Bomber and Tank* after a twenty-year absence from public view and temporarily moved Lam's *Jungle* from the lobby to the exhibition galleries.[19] Works by Frida Kahlo, Matta, Siqueiros, Tamayo, and Joaquín Torres-García were also included.

It is important to record these events, but if we consider that Latin American artists have been included in only fourteen exhibitions at the Museum during the past twenty years, it is clear that interest in Latin American art has not exactly been flourishing recently, nor has the situation been appreciably different in other major museums in this country and Europe. It was this relative indifference to Latin American art that first led me to develop a project for a major exhibition of this art, which I hoped might help redress the situation. Having been strongly influenced by Stanton Catlin's *Art of Latin America since Independence*,[20] held in 1966 at the Yale University Art Gallery in New Haven, I envisioned an exhibition that would represent a still wider range of the visual arts in Latin America of the nineteenth and twentieth centuries, including photography as well as painting and sculpture. Feeling that Europe might be more receptive than the United States to such an exhibition, I proposed it in 1976 to John Drummond, then director of the Edinburgh International Festival, and he accepted it with enthusiasm for a showing in 1981. But after

more than two years of preparation, numerous difficulties made it necessary to cancel the project.[21]

After so long a period of neglect by cultural institutions in the United States and Europe, Latin American art has been examined in retrospectives of works by individual artists and the subject of several survey exhibitions during the past few years. The present exhibition is perhaps the most ambitious of the latter efforts, as it represents the work of more than ninety artists with over three hundred examples, beginning in 1914 with the first generation of Latin American modernists and extending to contemporary artists, including Latino artists working in the United States today.

In organizing the exhibition I have sought to present a broad view of the many complex strands in the work of Latin American artists, stressing an international perspective by grouping the works chronologically rather than by nationality. It is important to counter the strong tendencies toward nationalist interpretation. I do not assume that Latin American artists share a common identity that can be defined easily or that separates them from other Western artists, and I have therefore avoided concepts—such as those that stress the exotic, folkloric, surrealist, or political—that reduce the complexity of the artists' contributions. Instead, I have attempted to explore the intensely rich body of work by Latin American artists as inclusively and openly as possible.

The survey format was selected for the exhibition and publication because I felt it could best provide a broad historical view of the context in which the work of Latin American artists has developed. The very scope of the survey format implies certain limitations and dangers, especially, in Guy Brett's words, "the inevitable oversimplification and homogenization of another reality."[22] Despite my affinity for the work of Latin American artists, the selection remains an outsider's mapping of a vast area, with the strengths and weaknesses that implies. I have attempted to counter some of the limitations of the survey form by representing many of the artists with several works or large-scale examples. Nevertheless, a number of important figures in the history of Latin American art could not be included. An important aim of this exhibition and the publication that accompanies it is to stimulate further study and research in this field, especially scholarly studies of neglected individual artists and specific periods and movements in Latin American art.

In many ways I have conceived of the exhibition in relation to The Museum of Modern Art's collection—not only to place works from it in the overall context provided by this survey, but in a sense to provide a kind of ideal collection by featuring major artists of earlier generations who are not and, in many cases, can never be represented in the Museum's collection. This is not to point a finger at what Barr called, with reference to collecting, "the sins of omission," which he felt were much more serious than "the sins of commission" because they could not be rectified; rather, it is with the hope that this exhibition and publication will generate new interest at The Museum of Modern Art and elsewhere in collecting and researching Latin American art.

As noted above, during the 1950s Latin American works from the collection, primarily those by Mexican artists, were shown in a separate gallery. I am far from advocating a return to this arrangement. I hope that in the future more works by Latin American artists

will be incorporated within the international context of the Museum's collection, so that Torres-García, for example, may be presented as part of the Constructivist tradition in which he was an important innovator, and that Mexican works of the 1930s and 1940s may be shown together with their North American counterparts. Similarly, I hope that Latin American artists will increasingly find open to them inclusion in major international exhibitions and publications. My deepest dream is for Latin American artists to join more fully the world community of artists on the terms of equality and dignity they deserve.

Notes

1. Earlier versions of *Latin American Artists of the Twentieth Century* were shown in Seville, Paris, and Cologne in 1992–93. The first of these showings was commissioned by the city of Seville as part of its Columbus quincentennial celebration. See *Artistas latinoamericanos del siglo XX / Latin American Artists of the Twentieth Century*, essay by Edward J. Sullivan (Seville: Comisaría de la Ciudad de Sevilla para 1992, 1992); *Art d'Amerique Latine 1911–1968* (Paris: Musée National d'Art Moderne, Centre Georges Pompidou, 1992); *Amériques Latines: Art contemporain* (Paris: Hôtel des Arts, 1992); and Marc Scheps, ed., *Lateinamerikanische Kunst im 20. Jahrhundert* (Munich: Prestel-Verlag, 1993).

2. Bruce Ferguson, "Dialogues in the Western Hemisphere: Language, Discourse, and Culture" (Paper delivered at the conference "Artistic and Cultural Identity in Latin America," the Memorial da America Latina, São Paulo, September 22–25, 1991).

3. See *Diego Rivera*, introduction by Frances Flynn Paine, notes by Jere Abbott (New York: The Museum of Modern Art and W. W. Norton, 1931); Hayden Herrera, *Frida: A Biography of Frida Kahlo* (New York: Harper & Row, 1983), p. 131; and *Diego Rivera: A Retrospective* (New York: W. W. Norton; Detroit: Detroit Institute of Arts, 1986), p. 79.

4. Rivera's history with members of the Rockefeller family continued when in 1932 he was commissioned to paint a mural for the lobby of the RCA building at Rockefeller Center, then under construction. Painted the next year, *Man at the Crossroads Looking with Hope and High Vision to the Choosing of a New and Better Future* commented explicitly on the evils of capitalism and the benefits of socialism and included a portrait of Lenin. When Nelson A. Rockefeller asked that the portrait be removed, Rivera refused and scandal ensued when he was dismissed from the project. The mural was covered, and in 1934 it was destroyed. Rivera re-created the composition on a wall at the Palacio de Bellas Artes in Mexico City. See *Diego Rivera: A Retrospective*, pp. 85–89.

5. See *Art in Our Time* (New York: The Museum of Modern Art, 1939).

6. See *Portinari of Brazil* (New York: The Museum of Modern Art, 1940).

7. See *Twenty Centuries of Mexican Art* (New York: The Museum of Modern Art, 1940).

8. See "Modern Cuban Painters," *Museum of Modern Art Bulletin* 11, no. 5 (April 1944), pp. 1–14.

9. Lincoln Kirstein, *The Latin-American Collection of The Museum of Modern Art* (New York: The Museum of Modern Art, 1943).

10. See *Brazil Builds: Architecture New and Old, 1652–1942* (New York: The Museum of Modern Art, 1943).

11. See Frederic H. Douglas and René d'Harnoncourt, *Indian Art of the United States* (New York: The Museum of Modern Art, 1941).

12. See Wendell C. Bennett, *Ancient Arts of the Andes*, introduction by René d'Harnoncourt (New York: The Museum of Modern Art, 1954).

13. See Henry-Russell Hitchcock, *Latin American Architecture since 1945* (New York: The Museum of Modern Art, 1955).

14. See William Rubin, *Matta* (New York: The Museum of Modern Art, 1957).

15. See Kynaston McShine, ed., *Information* (New York: The Museum of Modern Art, 1970). Kynaston McShine is now senior curator in the Department of Painting and Sculpture.

16. See Emilio Ambasz, *The Architecture of Luis Barragán* (New York: The Museum of Modern Art, 1976).

17. See William Howard Adams, *Roberto Burle Marx: The Unnatural Art of the Garden* (New York: The Museum of Modern Art, 1991).

18. See Deborah Wye, *Committed to Print: Social and Political Themes in Recent American Printed Art* (New York: The Museum of Modern Art, 1988).

19. See *Art of the Forties*, essay by Guy Davenport, introduction by Riva Castleman (New York: The Museum of Modern Art, 1991).

20. See Stanton Catlin and Terence Grieder, *Art of Latin America since Independence* (New Haven: Yale University Press, 1966).

21. Essays by Latin American art historians had been commissioned for a planned accompanying publication, and much hard work had been done, when there arose difficulties in fund-raising and in obtaining the cooperation of several Latin American governments. In addition, a proposed European tour, following the Edinburgh showing, had been accepted by only one institution, the Kunsthalle in Düsseldorf. The essays were eventually published in Damián Bayón, ed., *Arte moderna en América Latina* (Madrid: Taurus Ediciones, 1985).

22. Guy Brett, "Preface: Assembly," in his *Transcontinental: Nine Latin American Artists* (London and New York: Verso, 1990), p. 5.

Notes on the Birth of Modernity in Latin American Art

Edward J. Sullivan

Modernity in early twentieth-century Latin American art was not simply the result of the activities of isolated individuals. In many ways it sprang from a zeitgeist, or collective sensibility, which compelled writers, artists, and other intellectuals to look for ways to reinvigorate and, in a certain sense, reinvent their cultures. The need for renewal propelled many Latin American artists to go to Europe, mainly Paris, to immerse themselves in avant-garde circles. These artists returned to their native countries with different ideas about how to initiate what many undoubtedly hoped would be a large-scale cultural revivification. In certain countries the spirit of modernism took on a substantially more literary than visual cast, as was the case in 1920s Peru, where poetry emerged as the most innovative artistic medium.[1]

In considering the birth of a modern spirit in the art of Latin America we must take into account numerous special circumstances, as well as the varied and widespread phenomena, that distinguish this art from its counterparts in Europe or North America. Although the early manifestations of a modernist temper in Latin American art are related to the artistic phenomena in Europe that engendered them, the uses and purposes of the forms of expression developed in Europe were sometimes radically changed by Latin American artists, who responded individually to different sets of cultural, political, social, and even geographic and demographic realities in the various nations in which they lived. This essay examines these manifestations in some of the countries and cities in Latin America where intellectual or ideological circumstances made their development not only possible but, in many cases, inevitable. Such broad descriptions as attempted here necessarily have their pitfalls; not every country or city can be treated equally, and discussions of significant individuals must, in some cases, stand as paradigms for other protagonists of the early development of modern art in Latin America.

There is, of course, no single mode of vision or unified pictorial style that describes all the artists under consideration. Modernism was, rather, an attitude or a state of mind that manifested itself in a highly eclectic fashion in a variety of urban centers throughout Latin America. Thus we can categorize such diverse painters as Pedro Figari, Tarsila do Amaral, Abraham Angel, Armando Reverón, and Alberto da Veiga Guignard as representatives of the modernist spirit in art. Modernism did not occur everywhere at the same time, and in many cities a renewal of the artistic spirit and a rejection of prevailing academicism did not happen until substantially later in the century (as was the case, for example, in Bogotá or Quito). In the 1920s and 1930s modernism was a manifestation of the adoption by Latin American artists of what was most representative of a dynamic attitude toward contemporary life. This is not to say that tradition was rejected out of hand, although at first glance there might appear to have been an overriding dichotomy between the artists of modernity and the academics. Many of the artists who participated in the so-called modernist revolution had received thorough academic training in their home countries and, often, abroad as well. While their work usually represents a departure from academic tendencies, some of the artists (like Diego Rivera) reincorporated various elements of classical academicism into their mature art for purposes of irony—or to create glosses on certain aspects of tradition. Virtually all the artists who are credited with initiating modernism in Latin America had studied for periods of time in Europe. While most of them had gone

to Paris, others studied in Spain, Germany, or elsewhere. Italian art, especially Futurism, was also instrumental in the rise of Latin American modernism. In fact, the word *futurism* itself took on emblematic significance in certain countries, such as Brazil, where artists tended to use it to describe a wider variety of phenomena than their counterparts in Europe.

A broad investigation of the rise of modernity in Latin America might well begin with the most basic questions: How, when, and why did the idea of modernism come to each of the individual countries? In many nations the stage had been set several decades prior to the 1920s for the importation and adaptation of ideas from abroad. Indeed, these processes of cultural transferral maintained a pattern of artistic dependence that had been established during Latin America's colonial past and had survived independence.

The art of Mexico during the 1920s and 1930s is a particularly complex example in regard to modernist sensibility versus local identity. The art of the Mexican school, which has long dominated most writing on the subject, and the so-called Mexican Mural Movement did depend for its effectiveness upon the viewer recognizing and decoding symbols of national identity, which in many cases referred to the recently concluded Revolution. Yet the question of the origins of Mexican modernism is even more problematic than this; in any discussion of Mexican art of the 1920s and later, a great number of other factors must be taken into account. In 1976 Jorge Alberto Manrique defined a series of countercurrents in the art of Mexico that had been highly influential in the development of the avant-garde in that country.[2] Manrique stressed the significance of those artists who had aligned themselves with the Estridentista movement as well as those associated with the literary figures who formed the group known as Los Contemporáneos. Less politically motivated than the muralists, painters like Gabriel Fernández Ledesma, Manuel Rodríguez Lozano, and Agustín Lazo were important for their development of other modes of vision in Mexican art of the early twentieth century. More recently, Karen Cordero Reiman has pointed out other artistic strategies, including the Escuelas de Pintura al Aire Libre (Open-Air Schools of Painting), the Método Best Maugard (Best Maugard Method), as well as the Estridentistas, that contributed to the beginnings of Mexican modernism.[3]

In Mexico the "opening up" of the country during the presidency of Porfirio Díaz (a period that lasted from 1876 to 1911 and is known as the *porfiriato*) had been an important factor in the introduction of a wide variety of aesthetic phenomena from abroad. The Mexican Revolution of 1910–20 created a cultural imperative for change, although the renovation of the panorama of Mexican visual and literary arts had been a continuing process since the turn of the century. In Brazil and other countries in South America (such as Venezuela) the presence of foreign artists associated with European avant-garde movements further inspired the Latin American artists to investigate current phenomena abroad.

At the beginning of the twentieth century the academic tradition was still very much in place throughout Latin America, and there was disenchantment with the modes and ideals of art taught in official schools. Academies had been founded in various centers during the colonial period; Mexico's Academia de San Carlos, founded in 1785, was the first.[4] In the academies and private art schools of Rio de Janeiro, Buenos Aires, Havana, Lima, and elsewhere, European

artists were often employed as teachers and directors. Many of them promoted styles based on latter-day versions of what had been current in Europe a generation before. Neoclassicism gained a strong foothold and lingered as a viable option for Latin American painters and sculptors well into the last years of the nineteenth century. Mexican artists are perhaps the best-known practitioners of this tradition. The early neoclassical works by the sculptor and architect Manuel Tolsá and by Rafael Ximeno y Planes, a Spanish painter active in Mexico, set standards that were followed by many until the early years of the Revolution. During the long *porfiriato*, neoclassical modes were appropriated by artists and utilized for pre-Hispanic subject matter to create an art in which feelings of nationalism were as strong as the sentimentality of the images. Painters like José Obregón, Leandro Izaguirre, and Félix Parra painted scenes of the heroism of Aztecs and other historical figures, which anticipated the re-creations of Mexican history by some of the muralists in the 1920s and 1930s. The academic painters, however, must also be understood as spokesmen for the specific political agendas of the *porfiriato*.[5]

The many political upheavals of nineteenth-century Latin America produced fewer examples of ideologically motivated or "socially conscious" art than might have been expected. Although there were certainly some notable exceptions, such as the Uruguayan Juan Manuel Blanes's painting *Paraguay* of about 1880 (Museo Nacional de Artes Visuales, Montevideo), a symbolic portrayal of that country's decimation during the war of 1864–70, painting itself was supported by the upper classes, who were not interested in being reminded of the more difficult aspects of life. Realism of the type practiced by European artists of the late nineteenth century, which included scenes of labor or social unrest, was virtually unknown in Latin America. Social consciousness in Latin American art of the present century has taken a variety of forms. Certain painters who may be cited as socially committed artists belonged to a group known as *indigenistas*. They evidenced throughout Latin America a desire to portray the past and present of indigenous societies and political organizations. Indigenism fell into several classifications, ranging all the way from serious concern for the economic hardships and political inequalities from which native populations suffered to catering to the tourist trade with folkloric and picturesque images. Indigenism also included artists from countries such as Mexico, where—in subject and in style—it was connected with sentiments of nationalism. Among the painters whose representations of native groups are the most convincing are Camilo Egas of Ecuador and the Peruvian painter José Sabogal, whose woodcut *India Huanca* of 1930 (figure 1) is a good illustration of this movement. Although the thematic repertories of these artists stretched far beyond the limitations of indigenism, their depictions of the native peoples of their respective countries are among their most successful works.

Many of the late-nineteenth-century Latin American painters who cultivated a European manner also found ways to create their own highly personal, if not exactly indigenistic, variations on European themes. Examples might include Juan Manuel Blanes, who spent many years in Italy and painted genre scenes of gauchos, and the Argentine Eduardo Sívori, a student of Jean-Paul Laurens and Pierre Puvis de Chavannes. The Brazilian artist José Ferraz de Almeida Júnior had begun his artistic training in Rio de Janeiro, but from 1878 to 1882 he attended the Ecole des Beaux-Arts in Paris, where he

studied with Alexandre Cabanel and assumed much of the academic spirit of his teacher's work.

On the whole, Latin American artists of the late nineteenth century were drawn to conservative modes of art, regardless of where they had studied. The more avant-garde European movements found little resonance in Latin America before 1900. Impressionism and related styles enjoyed popularity with some collectors (there were, for instance, major examples of the work of the Spanish plein air painter Joaquín Sorolla in Buenos Aires, Havana, and other cities). Latin American masters who painted in this manner were, nevertheless, relatively few. Among the exceptions were the Colombian Andrés de Santa María, who had worked with Claude Monet, and the Puerto Rican artist Francisco Oller. The latter had studied in France, meeting Gustave Courbet and Paul Cézanne; spent an extensive period of time in Spain, where he is often credited with introducing the tenets of French Impressionism; and finally returned to his native country, where he executed many Puerto Rican landscapes in a manner reminiscent of Camille Pissarro. In Venezuela, Armando Reverón painted his early works in a style derived in part from Impressionism but soon moved on to develop a highly personal artistic vocabulary. In Mexico certain painters, like the youthful Gerardo Murillo (known as Dr. Atl), as well as Alfredo Ramos Martínez and members of the Open-Air Schools of Painting, produced some pictures that demonstrate affinities with Impressionism; but their flirtations with this style were brief. Perhaps the only Mexican artist who remained faithful to the techniques of Impressionism was Joaquín Clausell, whose essays in plein air painting were begun only in the late 1920s and represented a somewhat retrograde consideration of Impressionism's achievements.

Latin America in the late nineteenth and early twentieth centuries had not witnessed an "organic" growth of the avant-garde, as had Europe. The often strident realism of Courbet, the radical departures of Edouard Manet, and the formal experimentation of Cézanne had no parallels in Latin American art. There was little of what could be called a prologue to the development of modernism in the visual arts of Latin America—with the possible exception of Mexico, where the birth of modernity and the rupture with past traditions had a particularly noticeable impact in other countries.

The modernist revolution in Latin American art was preceded by a series of dramatic changes in literature. In the last decade of the nineteenth century and in the early part of the twentieth there was a radical shift in the writing produced in many nations. Poets, novelists, and playwrights felt constrained by the traditional modes of language and literary form in Spanish letters. One of the leading protagonists in this movement was the Nicaraguan poet Rubén Darío, a peripatetic figure who had lived in Santiago, Buenos Aires, Madrid, and Paris. His prose and verse reached a large public throughout South America and had a huge impact on writers in the region, who avidly read his books *Azul* (1888) and *Prosas profanas* (1896). Many of Darío's contemporaries, such as the Cuban José Martí and the Colombian José Asunción Silva, had also carried out literary experiments of their own and contributed to what the scholar Jean Franco termed "a rebellion against a literary heritage, the invention of new forms of expression."[6] Many of the poems and novels that resulted from this period of literary florescence include experiments with vocabulary and syntax as well as with expressive forms.

There are many important parallels between the literature and avant-garde visual art that developed in Latin America in the 1920s and 1930s. Many artists were in direct contact with writers, and their cooperative efforts served to sharpen the definition of Latin American modernity. Art criticism assumed a much greater position in the fashioning of tastes and ideas, especially in the promotion and dissemination of knowledge of artists' works. Notable among these relationships was that between Jorge Luis Borges and Xul Solar of Argentina or between Oswald and Mário de Andrade and Tarsila do Amaral of Brazil. Writers and painters often worked in symbiotic union, at times collaborating with one another. In many cases the artists themselves were the authors of manifestos, proclamations, and other written definitions of their goals and philosophies. In 1921 David Alfaro Siqueiros, then living in Barcelona (a city that had become an important center for avant-garde activity in post–World War I Europe), published a magazine which he named *Vida americana*. Although only one number appeared, it contained the artist's important and well-known tract "Tres llamamientos de orientación actual a los pintores y escultores de la nueva generación americana" ("Three Appeals for a Modern Direction to the New Generation of American Painters and Sculptors").[7] In it, as in other similar writings, the example of the Italian Futurist Filippo Tommaso Marinetti was patent. In his tract Siqueiros exhorted artists to turn their backs on decadent forms of visual expression, namely Symbolism and Impressionism. He urged his fellow Latin American painters and sculptors to reconsider past traditions without falling into the trap of the folkloric, the picturesque, or the archaizing. Siqueiros was aware of the regenerative power that African art had for European modernism and implied parallels with the art of ancient America as a source of spiritual (although not strictly formal) renewal in Latin America.[8] Siqueiros demanded "universality" in art: "Let us throw off the theories based upon the relativity of a national art. Let us universalize so that our true racial and local physiognomies will inevitably appear in our work!"[9]

In 1921 the dogmatic orthodoxy of the older Siqueiros was still many years in the future. The "Three Appeals for a Modern Direction" possesses certain parallels with the later writings of the artist's younger contemporary Rufino Tamayo, who, in a number of his texts on art, called for a universal expression in painting and other forms of art.[10] Siqueiros's tract also expresses sentiments not unlike those of the Guatemalan-born artist Carlos Mérida, who had, after his return to Mexico from France in 1919, called for the development of a truly American spirit in a series of articles published in *El universal ilustrado*. Throughout his long life Mérida produced many writings on his own art and the art of others. And perhaps there is no Latin American more prolific in terms of theoretical writing than Joaquín Torres-García, whose texts, written both in Europe and after his return to his native Uruguay, advance similar universalist and "Americanist" ideals, and epitomize the theoretical and literary discourse inextricably bound up with the development of Latin American modernism.

The enormous proliferation of magazines, newspapers, and other journals dedicated to art and culture, as well as the continual appearance of pamphlets, broadsides, and other ephemera dealing with issues of modernity and the avant-garde is another important aspect of this new phase of visual expression in Latin America. Some of these publications were of brief duration, while others lasted longer

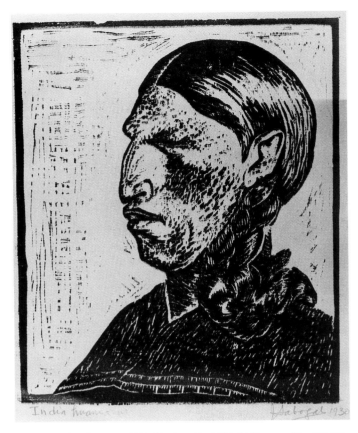

1. José Sabogal. *India Huanca*. 1930. Woodcut, 13 x 10½". Art Museum of the Americas, OAS, Washington, D.C.

and had more impact on their audiences. In Argentina several reviews advanced the tenets of modernity as it developed both at home and abroad. *Martín Fierro* is perhaps the best known. The principal writer for this magazine was Jorge Luis Borges, who had returned to Buenos Aires in 1921 after spending many years in Europe. From its founding in 1924, *Martín Fierro* launched numerous attacks on the conservative arbiters of taste and culture in the country. As Jean Franco noted, "Its writers made fun of the older generation, and satirized the establishment mercilessly, as if determined to shatter forever the old image of Argentina."[11] Similar sentiments were expressed in many other Latin American reviews. Among the most significant were the Brazilian magazine *Klaxon*, founded in 1922; the *Revista de antropofagia*, begun in São Paulo in 1928; and *Amauta*, started in Lima in 1926. The texts published in these journals placed a strong emphasis on concepts of the future, and the dynamism and energy of urban life. As was the case in Europe, modernity in art was a celebration of modern urban existence. The Italian Futurists' use of the city as a metaphor for the urgency and vibrancy of contemporary life was emulated by many Latin American artists and writers at this time.

—

Readers of histories of Mexican art have often received a highly simplified view of Mexican painting of the early twentieth century. In this stereotypical version of the events, the Mexican school and the protagonists of the Mexican Mural Movement triumph over reactionary aesthetic forces headed by Porfirian traditionalists. The modernist discourses established in Mexico by Rivera and others after 1921 had, however, been prefigured by numerous events since the turn of the century. Some understanding of these historical and philosophical underpinnings is needed to fully grasp the nature of modernity in Mexico, if not all of Latin America. In addition, as has been already noted, many other phenomena occurred during the years of the ascendancy of what would become known as the Mexican school.

Positivism was one of the underlying tenets of the *porfiriato*. Ideas of the inevitability and desirability of progress, coupled with a didactic sense of historical progression, lent themselves to the establishment of a realist mode represented by artists such as Joaquín Ramírez and Leandro Izaguirre, heirs to a classicizing manner that was used to underline specific nationalist political philosophies. Positivism was antithetical to the growth of an avant-garde sensibility and was inevitably challenged in many quarters. Rubén Darío's call for a fashioning of literary sensibilities was taken up in Mexico in the pages of the *Revista moderna*, which was founded by the poet Jesús E. Valenzuela in 1903. Although essentially eclectic in its approach, this journal has often been referred to as the organ of Mexican Symbolism in the first decade of the century. The sensibility promoted by the *Revista moderna* became known as *modernismo*, a term used throughout Spanish-speaking Latin America to define a visual style and a literary movement, which should not be confused with the English use of the term *modernism*. Mexican *modernismo* incorporated elements of Art Nouveau, Symbolism, Impressionism, and naturalism, as well as medieval and Asian art, and has important parallels with an analogous artistic movement in Spain. Some of the key figures in the *modernismo* movement were associated with the *Revista moderna*. Most outstanding among them was one of the magazine's principal illustrators, Julio Ruelas, perhaps Mexico's best-known Symbolist.[12] His painting and prolific graphic work share many affinities with the art of Europeans such as Max Klinger, Arnold Böcklin, and Félicien Rops (whom Ruelas may have met during a 1904 study trip to Europe). His art is redolent of a type of decadent sexuality found in the novels of Joris-Karl Huysmans and in the prints of Aubrey Beardsley. Beardsley's illustrations also had an influence on other graphic artists in Mexico, such as Roberto Montenegro, whose drawings and prints express a similar, barely suppressed erotic tension.

Montenegro was a significant member of the group associated with an antipositivist stance in art in the early years of the twentieth century. Like Ruelas, Jorge Enciso, and others, he incorporated aspects of Art Nouveau into his early work in Mexico and in Europe, where he was sent on a grant given to him by the governor of the state of Veracruz in 1907, the same year Diego Rivera left for Spain. The style of Montenegro's prints published in Paris and his first murals painted in Mallorca displays his interest in the art of Beardsley, Rops, and Alphonse Mucha, among others. Returning to Mexico in 1920, he executed a curious stained-glass window in the former Colegio Máximo de San Pedro y San Pablo in Mexico City. The window's subject, what Olivier Debroise has called an exoticist view of "typical" Mexico, reflects the growing interest of Montenegro and other artists in Mexican themes.[13] Debroise also stressed the eclectic nature of the art of Montenegro, who later incorporated into his work many vanguard elements as they appeared in Mexican art over the next forty years.[14]

Another artist who responded to the growing interest in *modernismo* was Saturnino Herrán. A product of the academy and the

teachings of the Catalan Antonio Fabrés, Herrán was one of the major exponents of what has been termed a "fervent nationalistic revival" in Mexican art in the opening years of the twentieth century—well before the members of the Mexican school began to employ indigenous people and other local types to express their *mexicanidad*.[15] Like many of his contemporaries, Herrán combined an enthusiasm for formal strategies based on the tenets of Art Nouveau (during the first and second decades of the century he was in close contact with Spanish modernist painters) with an interest in his Mexican heritage. Unlike Izaguirre, Obregón, and others who painted scenes of Indian history in a neoclassical style derived from that of Jacques-Louis David, Herrán displayed a less ideologically charged and more Symbolist approach to elements drawn from the national past. His most famous achievement in this vein is a series of preparatory drawings for a never-realized mural for the Teatro Nacional in Mexico City (now the Palacio de Bellas Artes), collectively titled *Our Gods*, of 1914–18. These ambitious drawings represent Indians and Spaniards in adoration of the Aztec deity Coatlicue, who is conflated with a crucified Christ, as in the study for the central figure, *Coatlicue Transformed* (figure 2). Herrán was also associated with a group of younger artists and writers who published articles promoting Symbol-

2. Saturnino Herrán. *Coatlicue Transformed*. 1918. Crayon and watercolor on paper, 39⅜ x 31½". CNCA-INBA, Museo de Arte Moderno, Mexico City

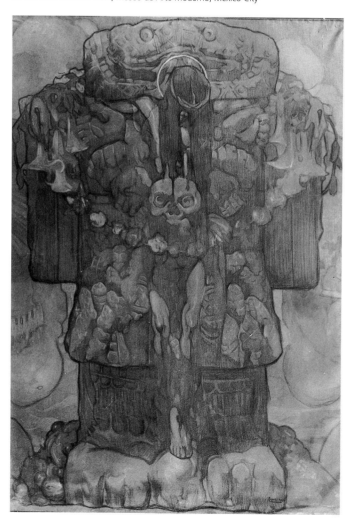

ism in the review *Savia moderna*, one of the several highly influential magazines of its time that called for a renewal of the arts and an establishment of the *modernismo* style in avant-garde Mexican circles. Many of Herrán's best-known works are scenes of an everyday type in which the artist tended to fuse reality with symbol. Color and line are the predominant carriers of mood in these paintings, where a single hue might be used to impart an emotional tone to the picture. Unconventional viewpoints and the use of curvilinear forms (derived in part from the artist's interest in *japonisme*) also relate his work to similar paintings executed by the young Diego Rivera, then living in Europe.

Much attention has been paid in the literature on modern Mexican art to the development of Rivera's career. His enormous importance in the history of Mexican painting, especially during the 1920s and 1930s, caused his artistic persona to assume virtually mythic proportions in his own time. This was due in part to the romantic aura he created about himself and the political and artistic controversies in which he became involved. Trained in an academic environment in Mexico City, he was sent to Europe in 1907, through a grant from the government of Veracruz, and began a long odyssey in various parts of the continent, absorbing many of the elements of both traditional and vanguard art. There are a number of key monuments of Rivera's early years, painted in a modernist idiom, and it is important to consider him within the context of European modernism. Although Rivera returned to Mexico for a brief stay in 1910, he remained abroad until 1921. His initial studies in Spain with Eduardo Chicharro y Agüera, his association with Ignacio Zuloaga, and his visits to the Museo del Prado in Madrid and the religious monuments of Toledo were critical for his incorporation of both incipient modernism and old-master techniques into his art. His later travels to northern Europe, his study trip to Italy, and, most important, his lengthy residence in Paris resulted in an eclectic body of work that showed the influences of realism, Impressionism, Symbolism, and Cubism. Late in his European career, he turned his artistic vision to a consideration of the accomplishments of Pierre-Auguste Renoir, Cézanne, and, finally, the art of the Byzantine and Renaissance periods.[16]

The year 1910 was a decisive one for Mexican art as well as politics. To celebrate one hundred years of independence, several ambitious exhibitions were organized in Mexico City under the aegis of Porfirio Díaz, who also wished to celebrate the accomplishments of his long presidency.[17] At the same time, Rivera's first one-person show was held at the Academia de San Carlos.[18] Highly praised in the press, it showed the work of an artist still in an early stage of his development. Nocturnal scenes of Bruges recalled paintings by the Belgian Symbolist Fernand Khnopff; images of Paris demonstrated Rivera's understanding of the work of Monet and some of the other Impressionists. The young Rivera also had gleaned ideas from the images of labor popularized by Courbet and his successors. Among the most successful works in this exhibition was *The Picador* of 1909 (Fundación Dolores Olmedo Patiño, Mexico City), and Spanish iconography persisted in Rivera's work after his return to Europe.[19] Under the influence of several fellow painters, Rivera began to look closely at the art of El Greco. The Mexican artist Angel Zárraga, with whom Rivera maintained close contact, had executed several compositions based directly on pictures by El Greco in the Prado. Zárraga,

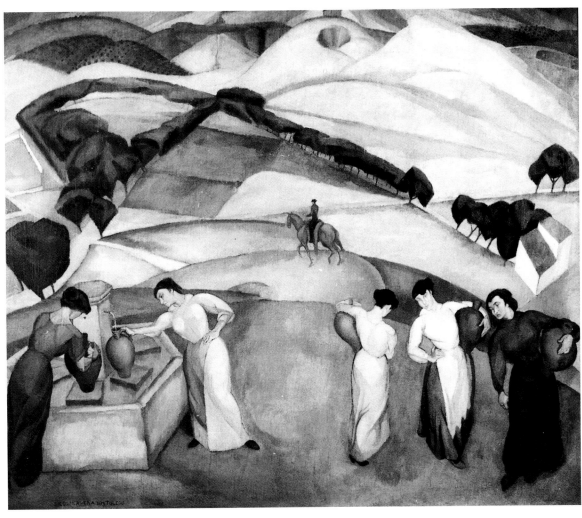

3. Diego Rivera. *At the Fountain near Toledo*. 1913. Oil on canvas, 65⅜" x 6' 8⅜". Fundación Dolores Olmedo Patiño, Mexico City

Zuloaga, Rivera, and his common-law wife, the artist Angelina Beloff, rented a house together in Toledo in 1907. Rivera returned there in 1912, while he was living in Paris, and Toledo became the setting for many of his best-known paintings of 1912 and 1913, transitional works in which the young artist's incipient Cubism is evident.

At the Fountain near Toledo of 1913 (figure 3) is an important document of the various forms of modernism with which Rivera was experimenting at this time. While the background landscape bears witness to his emerging interest in Cubism, what comes most readily to mind when viewing this painting is the art of Cézanne. Rivera once stated: "I came to Europe as a disciple of Cézanne, whom I had long considered the greatest of the modern masters."[20] For more than ten years he investigated and experimented, assimilating Cézanne's style and techniques in a variety of ways. Although Rivera's most "Cézannesque" phase did not occur until about 1918, in *At the Fountain near Toledo* he was obviously paying homage to the great French master's landscapes, such as his scenes of Mont Sainte-Victoire. Rivera's sturdily constructed figures in the foreground of this work evoke Cézanne's bulky bathers.

In the fall of 1912, Rivera and Beloff moved into a studio on the rue du Départ in the Montparnasse district of Paris, which was to be their home for seven years. The decision to move into this building was a momentous one, as it offered Rivera immediate access to his neighbors Piet Mondrian and the lesser-known, Dutch Cubist Lodewijk Schelfhout. The spatial experimentation in which these two artists were engaged in their own work at about this time is reflected in the division of the landscape in *At the Fountain near Toledo*.[21]

Rivera exhibited in the 1913 Salon d'Automne in Paris. He had already established close friendships with Fernand Léger, Robert Delaunay, and Marc Chagall, but it was not until the following year that he made the acquaintance of Pablo Picasso. By this time Rivera had entered his Cubist phase, which lasted until 1917. He produced over two hundred paintings in both the Analytic and Synthetic Cubist modes, principally still lifes, cityscapes, and portraits. In many cases they represent a unique contribution to the history of this critical early modernist style. He also painted his fellow artists. Rivera felt a certain affinity with members of the foreign artists colony in Paris, and he depicted a number of them during the terrifying years of World War I. Many of Rivera's French colleagues were at the front or had left Paris for safer havens outside the country. The foreigners who remained in the city (some of whom were suspect for their supposed enemy sympathies) were thrown into greater proximity, friendship, and mutual support.[22] In 1915 Rivera painted a portrait of the Spanish writer and literary critic Ramón Gómez de la Serna. The previous year he had

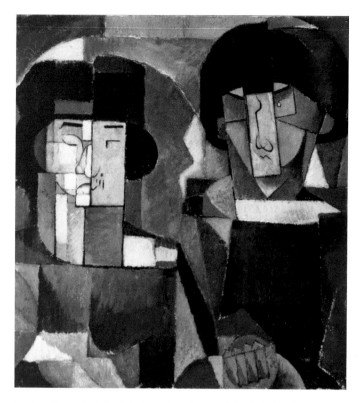

4. Diego Rivera. *Portrait of Messieurs Kawashima and Foujita.* 1914. Oil on canvas, 31½ x 29⅝". Private collection

depicted the sculptor Jacques Lipchitz, who had come to Paris from Lithuania in 1909 (plate 165). A slightly earlier painting, *Portrait of the Sculptor Oscar Miestchaninoff* of 1913 (Collection Gobierno del Estado de Veracruz), depicts the Russian artist, whose success and wealth led Kenneth E. Silver to describe him as a *"grand seigneur* in Parisian artistic circles, especially among the Jews of Montparnasse."[23]

Among Rivera's most interesting portraits executed during his Cubist years is the 1914 *Portrait of Messieurs Kawashima and Foujita* (figure 4). This impressive canvas, painted in rich reds, oranges, deep greens, and blues, depicts two Japanese painters famous in Paris in their day for wearing traditional clothing from their native country.[24] Considered to be lost until recently, the painting is an important document of Rivera's life during this period.[25] At the time he was working on this portrait, Rivera had his first meeting with Picasso, of which he wrote:

The talented Chilean painter, Ortes de Zárate, came to my apartment early one morning. "Picasso sent me to tell you that if you don't go to see him, he's coming to see you."

I accepted the invitation with pleasure and gratitude and immediately accompanied Zárate to Picasso's, together with my friends the Japanese painters, Foujita and Kawashima, who were posing for a canvas I was then doing. This was a portrait showing two heads close to one another. . . . Typical of my work of this period, it owed not a little to Mondrian, a good friend and neighbor, with whom I had been exchanging ideas and artistic experiences.

Dressed in costumes used for the portrait, my Japanese models looked picturesque and amusing. Both wore long toga-like

robes and sandals. Their hair was cut in bangs over their foreheads and encircled with colored ribbons.[26]

By 1915 Rivera and Picasso were perhaps at their closest in terms of style. That year was a critical one for Rivera; a somewhat lively, brighter, even decorative aesthetic entered his work. Rivera's greatest picture of 1915 is the monumental *Paisaje zapatista—El guerrillero* [*Zapatista Landscape—The Guerrilla*] (plate 167), an evocation of the Mexican revolutionary hero Emiliano Zapata (actually inspired by a photograph of Zapata taken by Augustín Víctor Casasola). When Rivera painted this picture, Picasso was at work on *Man Leaning on a Table* of 1916 (Private collection, Switzerland), which, in its initial stages, was remarkably similar to Rivera's composition. In the *Zapatista Landscape* there are, naturally, many references to Mexico itself: a mountainous setting, a large sombrero, a serape. Rivera was evidently very pleased with this picture, which he referred to as "my Mexican trophy."[27] Such popular Mexican elements (as well as some of the lively colors that may also be considered Mexican) appear in a number of still lifes from the same time and are perhaps indicative of the artist's desire to reassert his national identity (which grew even stronger in the years following his return to Mexico in 1921). *Table on a Café Terrace*, also of 1915 (The Metropolitan Museum of Art, New York), is certainly not as overtly "Mexican" as the *Zapatista Landscape*, but a local touch is recognizable in the inscription *"Benito Jua"*—a reference to the independence leader and president Benito Juárez—on the label of a Mexican cigar box in the upper right of the picture. This painting is also close to Picasso's still-life compositions of the same year in its wide variety of trompe l'oeil textures. It also displays evidence of Rivera's fondness for neopointillist stippling effects, which he shared with Picasso.

In 1916 Rivera renounced the decorative "rococo" aspects of some of his works for a more somber and architecturally solid conception (especially in the still lifes). Paintings like *Composition: Still Life with a Green House* (figure 5) demonstrate this new, austere classical style. In such works Rivera moved closer to the sensibility of Juan Gris, whose 1916 *Still Life with a Newspaper* (The Phillips Collection, Washington, D.C.) shows a comparable gravity. Some of Rivera's paintings of this year evince his interest in science and metaphysics, passions he would discuss with other painters who were involved in a search for greater purity in their Cubist-related work. The artists with whom Rivera maintained close relationships at this time included Jean Metzinger, Gino Severini, and André Lhote, an artist whose teachings were crucial for several early Latin American modernists (especially the Brazilian painter Tarsila do Amaral).

Rivera's last few years in Europe present a complex picture of aesthetic dialogue with the work of various artists, both living and dead. In 1917 and 1918 many of his paintings and drawings were done in the manner of Cézanne. Shortly thereafter the sensuality of Pierre-Auguste Renoir captured his imagination, and he made several important paintings of bathers in which the voluptuous plenitude of that artist's late works is recalled. In February 1920 Rivera went to Italy, where for seventeen months he saturated himself in the study of Etruscan, Byzantine, and Renaissance paintings and mosaics. Returning to Mexico in June 1921, he incorporated many of the lessons learned in Italy into his earliest fresco compositions, such as *The Creation* of 1922–23, a mural for the Anfiteatro Bolívar of the

Escuela Nacional Preparatoria, as well as into the paintings of the fresco cycle he began at the Escuela Nacional de Agricultura in Chapingo in 1924. The 1920s, however, represented a decade during which Rivera gradually left the effects of his European experience behind and committed himself to the expression of social messages.[28]

During Rivera's residence in Europe, important events had been taking place in Mexico. In 1903 Gerardo Murillo (who later changed his name to Dr. Atl—*atl* being the Nahuatl name for water—as a gesture of reaffirmation of his Mexican identity) had returned to Mexico from Europe and become associated with the revival of national values in art. In 1910 he helped organize an exhibition of independent Mexican artists not included in the government-sponsored centennial show, and planned to open a center dedicated to the painting of murals on public buildings (a scheme that was not realized owing to the hostilities of the Mexican Revolution). Dr. Atl was particularly instrumental in specific areas of art education and reform in Mexico during the years of the Revolution. The famous strike at the Academia Nacional de Artes Plásticas in 1911 closed the institution when students (including José Clemente Orozco) protested against the outmoded theories and methods promoted by the school's director, Antonio Rivas Mercado. Ultimately, Alfredo Ramos Martínez was appointed director of the newly formed Escuela Nacional de Bellas Artes, which replaced the Academia.

5. Diego Rivera. *Composition: Still Life with a Green House*. 1916. Oil on canvas, 24 x 18⅛". Stedelijk Museum, Amsterdam

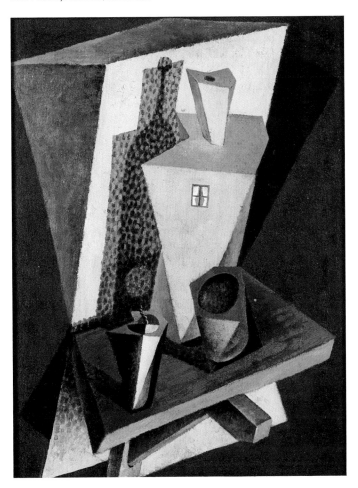

Martínez had spent fourteen years in Europe. He, along with Dr. Atl (who succeeded him as director in 1914), fostered among the students an interest in direct contact with nature, which resulted, in 1913, in the founding of the Open-Air Schools of Painting, the first of which was set up at Santa Anita Ixtapalapa on the outskirts of Mexico City and given the name "Barbizón." While the Impressionist and Post-Impressionist styles promoted by these schools did not completely satisfy the need for a radically new artistic vision in Mexico, they were, nonetheless, important influences on a number of artists who would later participate in the muralist and other vanguard movements. Included among those who had trained at various Open-Air Schools of Painting were Fernando Leal, Gabriel Fernández Ledesma, Fermín Revueltas, and the young Siqueiros.[29]

Throughout his life as a teacher and painter Dr. Atl promoted Mexico itself as prime subject matter for artists. Dr. Atl's own landscape paintings are often vast scenes that share certain spiritual affinities with the panoramic wall paintings of Rivera, Orozco, Siqueiros, and others. After 1921 Dr. Atl encouraged the efforts of muralists (Siqueiros, Rivera, Leal, and others) who had been invited to decorate the walls of public buildings by José Vasconcelos, the first Minister of Public Education under the government of Alvaro Obregón. Vasconcelos also inspired the formation, in 1922, of the Sindicato de Obreros, Técnicos, Pintores y Escultores de México (Union of Technical Workers, Painters, and Sculptors of Mexico)— one of the first attempts to organize artists for political purposes and create an image of the artist as worker in the service of the people, a concept that was, at least theoretically, at the heart of the early Mexican Mural Movement.

Another important chapter in the history of the avant-garde movement in Mexico was the development, in the years prior to 1920, of the Best Maugard Method of drawing, conceived by Adolfo Best Maugard as a standardized form of art education for children. Employing simplified means, based in part on pre-Hispanic design elements combined with those found in both colonial and popular art, Best Maugard proposed to create a truly national artistic expression. There are many links between this philosophical policy and the promotion of "spiritually pure" art based on similar sources, which was being carried out in Russia at approximately the same time. Karen Cordero Reiman states that Best Maugard came to know the work of the Russian "neo-primitives" (such as Vasily Kandinsky) during a trip to Europe between 1912 and 1914.[30] At the 1913 Salon d'Automne in Paris, he visited an exhibition of Russian folk art and work by those painters who were influenced by popular paintings and toys. The Best Maugard Method, described in handbooks distributed in public schools (and abroad in translation) became both popular and successful, and might be seen as one of many manifestations of the enlightened educational policies developed by Vasconcelos.

Rivera's return to his native country was one of the events that marked the beginning of a heroic age for Mexican art. The Mexican Mural Movement was the creation of Rivera, the two other artists of *los tres grandes*, José Clemente Orozco and David Alfaro Siqueiros, as well as numerous other important (if somewhat lesser-known) figures like Jean Charlot, Fernando Leal, Ramón Alva de la Canal, and Fermín Revueltas. The promotion of muralism by Vasconcelos, who provided the walls on which the artists created their images, was a crucial element in the development of this movement, which was to

have strong repercussions abroad (especially in the United States in the 1930s). While Rivera's first murals showed an aggregate of influences from the Byzantine and Italian Renaissance traditions, his new style was most perfectly manifested in the frescoes he painted beginning around 1923. Rivera's work of the 1920s and 1930s represents the high point of his career. During this time he became a revered (and often disputed) master in his own country, and his reputation abroad grew enormously, especially in the United States, where he executed several large fresco commissions. Rivera's repudiation of his earlier Cubist work suggests that its formal concerns were inappropriate to the postrevolutionary fervor that he (now a member of the Communist Party) and his fellow Mexicans were feeling. In his murals for the Secretaría de Educación Pública in Mexico City of 1923–28 (titled collectively *Political Vision of the Mexican People*) he began to develop the socially concerned iconography that would form an integral part of his work for the rest of his life. In a number of his murals Rivera tended to depict a utopian view of postrevolutionary Mexican society. The social reform and progress shown in many of these scenes did not always conform to the chaotic political situation of Mexico in the 1920s.

The 1924 easel painting *Woman Grinding Maize* (Museo de Arte Moderno, Mexico City) is an excellent example of Rivera's treatment of the dignity of the working classes of Mexico. With the exception of his mural depictions of warfare and the oppression of Indians at the hands of the Spaniards, Rivera rarely, if ever, showed the proletariat suffering. *Woman Grinding Maize* displays the artist's interest in the same type of classical form (composed of rounded contours and solid figures) that was being cultivated in Europe by artists like Picasso. Rivera's subjects, however, were drawn from the daily Mexican life he observed around him. There is often a great lyricism in these depictions of quotidian activities. *Día de flores* [*Flower Day*] of 1925 (plate 168) is one of many paintings in which the calla lily is employed as the principal motif. The solemnity of the presentation and the impressive plasticity of the forms remind us immediately of the artist's great reverence for the pre-Hispanic sculpture and painting that he had begun to study seriously upon his return to Mexico. Calla lilies are often used in a funerary context in Mexico, yet their profusion and pleasing odor mitigate the sadness of the events with which they are associated. A later painting using the calla-lily motif, *Fiesta de flores, día de Santa Anita* [*Flower Festival: Feast of Santa Anita*] of 1931 (plate 169), recalls the Good Friday traditions on the Canal of Santa Anita, which Rivera depicted on the walls of the second floor of the Secretaría de Educación Pública in Mexico City.

In his canvases Rivera often repeated pictorial elements that he had first developed in his frescoes. *El agrarista Zapata* [*Agrarian Leader Zapata*], a portable fresco painting Rivera created for his 1931 retrospective at The Museum of Modern Art, New York—now in the Museum's collection (plate 171)—portrays the revolutionary hero standing next to a white horse. It recapitulates a section of the 1930–31 mural *History of the State of Morelos: Conquest and Revolution*, at the Palacio de Cortés in Cuernavaca. This historicizing political allegory is reminiscent of his most ambitious fresco cycle, painted intermittently from 1929 through the 1940s at the Palacio Nacional in Mexico City, illustrating the history of the Mexican people.

A more straightforward approach to political commentary was taken by José Clemente Orozco. Among his earliest works was a

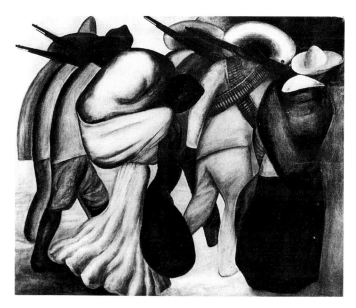

6. José Clemente Orozco. *Camp Followers*. 1926. Oil on canvas, 32 x 38". CNCA-INBA, Museo de Arte Moderno, Mexico City

series of drawings (c. 1910–13) set in brothels. Their scathing directness relates them to the grotesqueries of the art of George Grosz and other German Expressionists. Many of Orozco's paintings, drawings, and prints also display his indebtedness to the great Mexican master of turn-of-the-century satire, José Guadalupe Posada, whose broadsides with social commentary (often in the form of *calaveras*, or animated skeletons) were important sources of inspiration for many other artists of the Mexican school.

Orozco worked with Rivera, Siqueiros, Charlot, Revueltas, and others on the murals at the Escuela Nacional Preparatoria between 1923 and 1926. Although his earliest mural there, titled *Maternity*, reworks Italian Renaissance elements, the scenes he painted later at the same site represent the work of a mature artist who had found his own style. *Camp Followers* of 1926 (figure 6) is a canvas that, like many others, repeats a subject already developed in fresco (in this case one of the scenes from the Preparatoria murals). In this picture, soldiers are accompanied by their female companions. All are bent over, with their backs to the viewer, their bodies speaking eloquently of the exhaustion and futility of warfare. The heroic moments as well as the everyday events of the Mexican Revolution provided the subjects for Orozco's art long after the events themselves were over. *Barricada* [*Barricade*] (plate 138) and the famous scene of *Zapatistas* (plate 139), both of 1931, rely on the use of strong diagonal lines and dramatic earth colors to make their messages palpable. Orozco had also illustrated the 1929 edition of one of the greatest novels of the Mexican Revolution, *Los de abajo* (*The Underdogs*) of 1915 by Mariano Azuela, with drawings whose simplicity and directness embody much of the power of his ambitious paintings.

During World War II Orozco's art experienced many transformations. The expressive content in his paintings and prints became even more concentrated. This is especially true in series of works with religious subjects, such as *The Resurrection of Lazarus* of 1943 (Museo de Arte Moderno, Mexico City). While only nominally Christian, these often highly pessimistic scenes reveal a sense of longing for a return to humane order in a universe gone mad. In the last several

years of his life the artist reached the height of what could be called his expressive intensity. *Dismembered* of 1948 (figure 7) repeats a subject treated by Théodore Géricault in his studies of arms and legs but invests it with new meaning. While Orozco's art never entered the realm of the purely abstract, his 1948 *Metaphysical Landscape* (Instituto Cultural Cabañas, Guadalajara) shows that he shared many spiritual affinities with certain Abstract Expressionist painters of metaphysically charged canvases, such as Mark Rothko, Clyfford Still, and Barnett Newman.

The historian of Mexican muralism Antonio Rodríguez has noted several aspects of David Alfaro Siqueiros's art that differentiate him from other members of the Mexican Mural Movement. These include his political militancy and active participation in revolutionary struggles, his interest in developing his thought along theoretical lines, and his desire to support technical and stylistic innovations in his own art as well as that of others.[31] There are an aggressiveness and a tenacity in the paintings of Siqueiros that surpass those of virtually all of his contemporaries. The assertive determination to make his ideas understood in the clearest possible way often militates against the use of narrative in his art. The figures in his murals and easel paintings are transformed into unusually powerful iconic symbols. Siqueiros rarely depicted the history of his nation in the panoramic ways of which both Rivera and, to a lesser extent, Orozco were fond. The central theme in much of Siqueiros's oeuvre is the

7. José Clemente Orozco. *Dismembered*. 1948. Piroxilyn on masonite, 63 x 48". Instituto Nacional de Bellas Artes, Mexico City

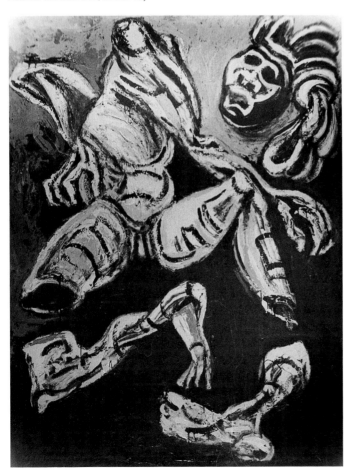

oppression of the Mexican lower classes. *Víctima proletaria* [*Proletarian Victim*] of 1933 (plate 196) is a terrifyingly graphic example of his direct approach to subject matter. The nude woman's flesh is tightly bound by thick ropes that bite into her skin causing it to fissure and bleed. In what is perhaps Siqueiros's most famous picture, *Eco de un grito* [*Echo of a Scream*] of 1937 (plate 198), universal destruction, desolation, torment, abandonment, and hopelessness are personified by the wailing baby whose enlarged head floats above a field of rubble. Siqueiros was inspired to create this commemoration of ruin and devastation by his experiences fighting with the Republican forces in the Spanish Civil War. There are no clues that are specific to either time or place, yet this image (like Picasso's grand antiwar statement *Guernica*, painted the same year) clearly encapsulates the cataclysmic terror of bloody conflict.

Siqueiros's incorporation of motifs or stylistic elements drawn from the indigenous traditions of Mexico was the most indirect of *los tres grandes*.[32] Nonetheless, he obviously admired the volumetric solidity of pre-Hispanic art and, in pictures like *Head* of 1930 (figure 8) and the 1931 *Zapata* (Hirshhorn Museum and Sculpture Garden, Smithsonian Institution, Washington, D.C.), an almost masklike density and emotional impenetrability of the features is apparent. In certain works Siqueiros actually incorporated real pre-Hispanic elements. In fact, *Etnografía* [*Ethnography*] of 1939 (plate 199) was first titled *The Mask*. This potent image has been described by the art historian Lowery Sims: "The apparition of an Indian peasant reincarnated as an Olmec deity effects a psychological and emotional empowerment of this disenfranchised segment of the Mexican population, one of the enduring artistic and political goals of the Mexican Revolution."[33]

Siqueiros was an artist whose message is communicated not only through potent images but also by his use of nervous, rapid lines and especially through the increasingly textured surfaces that characterized his painting as his career progressed. The boldness of Siqueiros's paintings was an important influence on many younger artists—both in and out of Mexico—who became important in the avant-garde movements of the 1940s and 1950s. In April 1936 Siqueiros founded the Experimental Workshop on West Fourteenth Street in Manhattan. The Workshop aimed to "be a laboratory for experimentation in modern art techniques [and to] create art for the people."[34] Among its pupils were Jackson Pollock and his brother Sanford McCoy. Siqueiros had a profound effect on Pollock's work of the 1930s. According to one contemporary, "[Thomas Hart] Benton taught Pollock about the ideals of beauty; these Mexicans taught him that art could be 'ugly.'"[35] The dark, surging, amorphous spaces in *Suicidio colectivo* [*Collective Suicide*] of 1936 (plate 197) seem to anticipate the spirit of American Abstract Expressionism that emerged in the following decade. In this painting, form and content engage in an equal struggle for visual power.

While in the United States, Siqueiros participated in as many manifestations of radical political philosophy as he had in Mexico. His later frescoes became even more imbued with anticapitalist ideology. The 1939 *Portrait of the Bourgeoisie*, for the walls of the Sindicato Mexicano de Electricistas, and the 1957–66 painting *From Porfirism to the Revolution*, for the Museo Nacional de Historia (both in Mexico City), are among the most compelling statements of this socially committed force in modern Mexican art.

Orozco had said that the year 1922 found the table set for the

beginnings of muralism.[36] From the first great series of murals done in that and the following years in the Escuela Nacional Preparatoria through the later phases of mural painting, this mode of art making came to represent in the minds of many the major accomplishment of Mexican modernism. Nonetheless, the history of twentieth-century Mexican art has included not only those artists who conformed to the most widely recognized movements, but also renegade figures, or countercurrent artists working either in solitude or in unofficial styles. The modernism of the 1920s and 1930s was not comprised solely of *los tres grandes* but was enriched by many artists who had consciously rejected the propagandistic monumentality of the muralists and had greater affinities with other forms of vanguard visual expression. For example, the expressionist Francisco Goitia, who had spent eight years in Italy and Spain before returning to Mexico in 1912, executed a body of work in his native state of Zacatecas that emphasizes the most horrific aspects of the Revolution. His use of graphic detail to illustrate pain and suffering reveals his interest in the late work of Francisco Goya. The hauntingly nightmarish atmosphere of *The Witch* of 1916 (Museo Francisco Goitia, Zacatecas) recalls the imagery of artists such as James Ensor, Edvard Munch, and Alfred Kubin. Goitia's masterpiece, *Father Jesus* of 1926–27 (figure 9), is a melancholic painting of mourning Indian women that has been referred to as "a Mexican pietà."[37]

Among the most significant events of the early 1920s were preparations for a large exhibition of Mexican folk art, which was eventually seen in Los Angeles, Siqueiros's tract "Three Appeals for a Modern Direction," Carlos Mérida's call for a completely "American" art, and the wide-scale diffusion of the Best Maugard Method of drawing. The writings of the Estridentista group also appeared at this time. In December 1921 their credo was made known through "Actual no. 1, hoja de vanguardia, comprimido estridentista," a text written by the poet Manuel Maples Arce that was published as a poster and affixed to walls in the Mexican capital. The Estridentistas, led by Maples Arce and Germán List Arzubide, glorified the city and the concept of simultaneity. While Estridentista writing and visual art were indebted to Italian Futurism,[38] the group also introduced a note of what Cordero Reiman called "primitivism" into their modernist practices.[39] This is an aspect of their art that may be seen in woodcuts by artists associated with the group. Further manifestos of the Estridentistas were published in *Puebla* (January 1923) and *Zacatecas* (July 1925), representing a fairly unusual early instance of vanguard activity outside Mexico City.

Agustín Lazo, another non–Mexican school artist, was promoted by the literary group known as Los Contemporáneos, who were harshly criticized by the muralists for their so-called decadence as well as for championing imported values. Lazo's art has various points in common with that of both Max Ernst and Giorgio de Chirico. Jorge Alberto Manrique has also cited the exquisitely small paintings of Antonio M. Ruiz as opposite in spirit to the grandiloquence of the muralists and thus able to express a playful sense of humor, a quality usually lacking in the frescoes by *los tres grandes* and others.[40] Other painters of the countercurrent might include Juan O'Gorman, Alfonso Michel, and even Frida Kahlo, who appropriated many *mexicanista* elements in her art for her own highly personal, subversive purposes. The notion that the Mexican school enjoyed absolute hegemony has tended to obscure some of the more

subtle complexities of the history of painting (and to a lesser degree, sculpture) in that country. Already in the 1920s many of the values espoused by the Mexican school—both plastic and philosophical—were coming under attack. Even a superficial examination of the work of the muralists themselves reveals a high degree of diversity in their approaches to the narrative problems they addressed. While Rivera did indeed continue to paint "typical" scenes on the walls of the Secretaría de Educación Pública and images of Mexican history in the Palacio Nacional, he turned his attention to science and industry in his 1932–33 murals at The Detroit Institute of Arts.

Among the vast panorama of vanguard tendencies in Mexico in the late 1920s and 1930s was the introduction by Rufino Tamayo of a sensibility influenced by the work of Picasso. As early as 1926 there was a reliance on certain formal conventions inspired by the Spanish painter—with whose art Tamayo became more intimately familiar in New York. As Olivier Debroise has pointed out, the 1930s also witnessed the absorption on the part of artists such as Jesús Guerrero Galván, Carlos Orozco Romero, and Alfredo Zalce of some of the neoclassical aspects of the painting of Picasso and others in Paris.[41]

—

In Brazil modernity in art was initiated in São Paulo. Unlike the city as we know it today, with its pollution and relentless urban sprawl, São Paulo in the early twentieth century was a place with seemingly

8. David Alfaro Siqueiros. *Head*. 1930. Oil on board, 21⅛ x 16⅞". Museum of Art, Rhode Island School of Design, Providence. Nancy Sayles Day Collection of Latin American Art

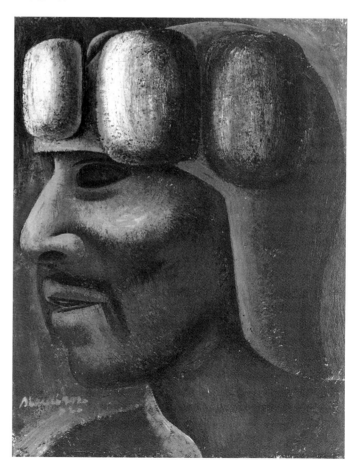

unlimited possibilities in virtually every realm, from the economic to the cultural. For many years São Paulo remained a fairly small town; it did not become a large metropolitan center until the last decades of the nineteenth century, when the population began to grow prodigiously. In 1900 there were 240,000 inhabitants; by 1920 the number had increased to half a million. São Paulo also became the venue for Brazil's most progressive cultural events.

While Rio de Janeiro continued to generate significant works of art, there was more of an emphasis in that city on a conservative tradition. The Academia Imperial de Belas Artes had been founded there in 1826 (changing its name to the Escola Nacional de Belas Artes in 1890). This institution continued to set the guidelines for art making in the rest of Brazil for many decades. Later, similar official schools were opened in the provinces, among them the academies of Bahia (1877), Porto Alegre (1908), and Belém (1918). In São Paulo such an institution was not opened until 1925, long after the modernist fervor had begun there. São Paulo also had a higher proportion of recent European immigrants, and the intellectual climate was ripe for the acceptance of avant-garde forms of expression in painting, sculpture, architecture, music, dance, and literature. The multiplicity of areas in which the phenomenon known as *modernidade* came into being was underscored by the interdisciplinary nature of the famous *Semana de arte moderna*, the week-long event that has been cited as the starting point for the true flowering of modernity in Brazil, held in February 1922.[42] The *Semana* has been characterized as representing "essentially an attitude of rupture and provocation, a confrontation to Brazilian cultural stagnation."[43] The original concept for this diverse, multidisciplinary event most likely began with Emiliano di Cavalcanti, who described it in his autobiography as a "week of literary and artistic scandals meant to put the spurs into the belly of the São Paulo bourgeoisie."[44] Central to the conception of the *Semana* was the notion that a cross section of the arts would be represented. There were poetry readings, concerts, and dance performances. The art exhibition included mainly examples by São Paulo artists. Among those who sent the most outstanding works were Anita Malfatti, Victor Brecheret, Vicente do Rego Monteiro, and di Cavalcanti. Only theatrical performances and films were absent from this week-long event that caused great controversy in the press.[45] There had been, however, several exhibitions held previously that had set the stage for the radical innovations introduced by the *Semana*. The first was an exhibition of paintings and prints by the Lithuanian-born artist Lasar Segall held in 1913; the second was an exhibition of the work of Malfatti held in 1917.

Of these two phenomena, the shock caused by the work of Malfatti (a native of São Paulo) galvanized more strongly critical opinion regarding modernist art because it pointed out the barriers that the members of the avant-garde faced in their struggle to renew the character of aesthetic expression in Brazil. Malfatti, like virtually every Brazilian modernist, had studied abroad. In 1910 she had traveled to Berlin to take classes at the Imperial Academy of Fine Arts there, and later studied with Lovis Corinth. While in Germany she became familiar with the art of Edvard Munch, Vincent van Gogh, Paul Gauguin, and Ferdinand Hodler, all of which became influential in the development of her art. At the end of 1914 she left for New York, enrolling at the Art Students League and later at the Independent School of Art, where she studied with Homer Boss. At the Independent School

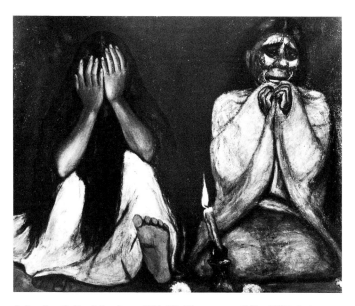

9. Francisco Goitia. *Father Jesus*. 1926–27. Oil on canvas, 31½ x 39⅜". CNCA-INBA, Museo Nacional de Arte, Mexico City

of Art, an institution that stressed an interdisciplinary approach, she was introduced to many participants in the budding avant-garde in Manhattan. Malfatti became friendly with several cultural figures, including Marcel Duchamp, Isadora Duncan, and Léon Bakst. She was quickly inspired by what she saw in New York, a city that had only recently welcomed modern art with its famous Armory Show of 1913. The paintings included in her 1917 São Paulo exhibition represented a highly personal distillation of many of the elements of Cubism, Futurism, and Expressionism to which she had been introduced abroad. Among the most impressive paintings in the exhibition were portraits or half-length studies of men and women. *The Fool* of 1915–16 (figure 10) shows a woman wearing a bright yellow blouse, sitting in a chair at the right side of the canvas, against a background of blue, green, and red tones divided in a quasi-Cubist manner. The handling of the face and body, as well as the use of strong color as a major force in the presentation of a disturbed mood, in this and other works, links Malfatti to the sensibility of the German Expressionists, especially Franz Marc.

Although her exhibition excited many visitors, it drew vituperative criticism from the influential critic Monteiro Lobato, who condemned what he viewed as the excesses of the work.[46] Oswald de Andrade responded in the press, defending Malfatti's work, but the predominantly negative reception and a lack of support adversely affected the development of her art. It is often stated that Malfatti's greatest contribution to *modernidade* in Brazil was the example she set for younger painters to expand beyond the academic modes that had been so deeply entrenched in Brazilian art for many years. The art she showed at the 1917 exhibition represented the high point of her career, but Malfatti continued to exhibit and took part in the *Semana de arte moderna*. Her later work, however, became more conservative.

Malfatti was very important in the birth of modernity in Brazil as a transmitter of the modernist vocabulary she had absorbed in Europe and the United States. Unlike some of the other key figures of the Brazilian avant-garde (like Tarsila do Amaral and Vicente do Rego

Monteiro) she had fewer direct links to Paris. In a similar fashion, Lasar Segall was instrumental in introducing receptive audiences in Brazil to the avant-garde innovations taking place in Central and Eastern Europe. Although Segall had come to the attention of the São Paulo public as early as 1913, he did not become an integral component of the art scene in that city until 1923. His childhood—spent in the Jewish quarter of Vilna—remained a constant and lifelong subject of his paintings, drawings, and prints. His earliest experiences as an art student in Berlin between 1907 and 1909 were crucial for his development, but it was his move in 1910 to Dresden that was perhaps most important for his initial success. Although many of his early works had been done in an Impressionist mode, he was soon associated with the members of the Expressionist group known as Die Brücke (The Bridge). He exhibited at the Galerie Gurlitt in Dresden, where he won several prizes, and in 1919 he helped to found the Gruppe 1919 der Dresdner Sezession with Otto Dix, Conrad Felixmüller, and other artists.

Segall's paintings between 1910 and the early 1920s have a generally somber palette and portray troubled figures in often claustrophobic interiors. In many works of this period the artist exaggerated the heads of the figures, simplifying their features in a way that suggests his study of African tribal art. Segall's visit to Brazil in late 1912 may have been "premature" in terms of its influence on his work, as the critic Mário de Andrade implied,[47] yet it may also have stimulated him to look more carefully at non-Western art when he returned to Europe. The 1919 painting *Os eternos caminhantes* [*The Eternal Wanderers*] (plate 185) recalls Segall's childhood, but its style can easily be associated with the expressionistic intensity of artists like Karl Schmidt-Rottluff and Ernst Ludwig Kirchner. In this painting the figures, composed of distorted geometric forms, stand in an indeterminate setting; its elements are compartmentalized in a way reminiscent of Cubism.

Segall returned to Brazil (where he became a naturalized citizen) in 1923. In the mid-1920s he became fascinated by the variety of types he observed in Mangue, Rio de Janeiro's red-light district.[48] The prostitutes and their customers became the subjects of an extraordinary series of paintings and prints executed during the late 1920s. In these works Segall does not display prurience or colonialist voyeurism. The Mangue series is testimony to a humanistic empathy with the members of the working class he depicts, as in *Woman and Sailor* of 1929 (Collection Gilberto Chateaubriand, Rio de Janeiro) and *Figura feminina reclinada* [*Reclining Woman*] of 1930 (plate 186).

Segall continued to have close links to Germany and exhibited in various German cities until 1937, when his work—considered "degenerate" by the Nazis—could no longer be shown there.[49] His art of this period is redolent of the misery of Europe's economic situation of the late 1920s and 1930s and the continued threat posed by the rise of Fascism. He also combed his childhood memories, recalling the pogroms against the Jewish population of Eastern Europe and the consequent waves of emigration. This led him to create a series of images that occupied him throughout much of his later career. His drypoint etchings of immigrants and studies of this theme in other mediums eventually led Segall to create one of his masterpieces, *Navio de emigrantes* [*Ship of Emigrants*] of 1939–41 (plate 191). This poignant rendition of seemingly hundreds of forlorn individuals in an inadequate small boat is a statement of universal

10. Anita Malfatti. *The Fool*. 1915–16. Oil on canvas, 24 x 19⅞". Museu de Arte Contemporânea da Universidade de São Paulo

suffering. We can consider it in art-historical terms as a continuation of the romantic subject of the storm-tossed ship as metaphor for the vicissitudes of human existence. While it reprises many of Segall's early (and more specific) themes of human affliction, it takes on monumental and affecting connotations by means of its grand scope and the contemporary events that it reflects.

Segall also played an important role in the development of São Paulo's art organizations. In 1932 he was a founder of the influential artists' association known as Sociedade Pró-Arte Moderna (SPAM). This group, which had a fairly short but significant life (November 1932–December 1934), included among its members many of the earliest adherents to the modernist aesthetic in São Paulo. SPAM's central idea was to serve as a link between artists, intellectuals, collectors, patrons, and the public as a whole and to create a propitious public environment for vanguard art in Brazil. The members of SPAM held two significant exhibitions. The first (April–June 1933) included paintings by members of the School of Paris from São Paulo collections (among them, that of Tarsila do Amaral) as well as works by locally active artists such as Malfatti, Segall, Brecheret, John Graz, Regina Graz, Hugo Adami, and Rossi Osir. The second show, organized in November 1933, was comprised solely of works by Brazilians, including di Cavalcanti, Ismael Nery, Cândido Portinari, and Alberto da Veiga Guignard. Even more memorable were the two carnival balls organized by the group. Although originally conceived as fund-raising projects for SPAM, they resulted in what today would be called Happenings or "performances" and included elaborate sets

and costumes designed by Segall.[50] It should be noted that the same year SPAM was organized another artists' organization, both more professional and more political, was founded. Clube dos Artistas Modernos (CAM) was initiated by the architect and artist Flávio de Carvalho to serve as an antidote to what was considered the bourgeois elitism of SPAM.

The art historian Aracy Amaral has stated the following regarding the introduction of modernism into Brazil: "Modernism had an enormous impact. It consisted of a re-elaboration of a formal language under the influence of models imported from Paris, beginning with the Cubist revolution; at the same time, through its influence, native Brazil became itself a source of inspiration and reaffirmation."[51] As Amaral explained, Brazilian modernists to the present day have "Brazilianized" what they have observed in the work of foreign artists, making it distinctly their own. It is the originality and acumen with which these transformations are effected that constitutes the creativity of this art. Far from being a Eurocentric analysis of the nature of Brazilian modernism, Amaral's evaluation considers what is foreign in the work of Brazilian artists but concentrates on the way in which it is recast to reflect the political, social, and aesthetic realities of an individual Latin American nation.

Like most of the creators of modernism in Brazil and elsewhere, Tarsila do Amaral emerged from an academic background, having first studied with Pedro Alexandrino in São Paulo in 1916.[52] In Paris from 1920 to 1922, she took classes with the conservative painter Emile Renard and others at the Académie Julian. She must have been disappointed to have just missed the portentous events of the São Paulo *Semana de arte moderna*.

Amaral's second trip to Paris, which she undertook in late 1922, followed by Oswald de Andrade, who later became her husband, marked the beginning of fundamental changes in her aesthetic approach. The impact of the Impressionists and Post-Impressionists, such as Cézanne and van Gogh, as well as that of the Fauves can be sensed in certain of her works from 1921 and 1922. In 1923, however, Amaral painted *A Negra* [*The Black Woman*] (plate 2). In this image, a woman of African descent is depicted with exaggerated anatomical features. She seems to stand out in high relief against a background composed of two key elements: a structured geometrical system of color bands and a stylized banana leaf. Amaral had seen and quickly understood the tenets of Cubism and was evidently anxious to assimilate them in her art. Yet at the same time, she was tenacious in giving this pictorial mode her own private stamp, making of it a truly Brazilian product of her imagination. Amaral had made many friends in the avant-garde circles of Paris. She studied with André Lhote[53] and also became friendly with the somewhat less doctrinaire master Fernand Léger, whose studio she visited frequently. Léger was to be a major figure in the definition of Amaral's aesthetic.

Amaral's interest in the culture and art of her own country, however, was strengthened by her stay in Paris at a moment when the primitive and the exotic were of much interest to the members of that city's intelligentsia. Their fascination with non-Western cultures (often approached from a naive and colonialist point of view) was pervasive. Amaral herself became a focal point for other artists, poets, and novelists who gravitated to her, seeing in her both the embodiment of sophistication and, inevitably, a representative of what the Europeans considered "aboriginal" society.[54]

Amaral arrived home from Paris in December 1923, soon followed by Oswald de Andrade and the poet Blaise Cendrars, who, fascinated by the prospect of observing this faraway country in the company of his friends, accompanied them to the Carnival celebrations in Rio de Janeiro and to the numerous baroque towns of the state of Minas Gerais during Holy Week.[55] The trip to Minas was particularly inspiring for the artist. As late as 1939 she wrote about the impression that Mariana, Tiradentes, Congonhas do Campo, Sabará, and other small colonial towns, as well as the city of Ouro Preto, had made on her at the time, stressing the importance to her of this "return to simplicity."[56] Amaral, Andrade, and Cendrars spent most of their time in São João del Rei, where Amaral enlarged her repertoire of Brazilian subjects, which thereafter would be some of the most characteristic elements of her art.

These trips fired the enthusiasm of Amaral and Andrade for what they saw as the quintessential qualities of Brazil. Their journeys to these less developed parts of the country also inspired Andrade to write his famous "Pau-Brasil Poetry Manifesto," published in March 1924, in which he lauded national customs and traditions. Here Andrade wrote, "The Carnival in Rio is the religious outpouring of our race. Pau-Brasil. Wagner yields to the samba schools of Botafogo. Barbaric, but ours. Rich ethnic mix. Richness of vegetation. Minerals. Casserole of vatapá. Gold and dance."[57] The manifesto, named for brazilwood, the nation's first export product in the colonial period, called for the formation of a true indigenous spirit in literature. It also paralleled the directions that Amaral's art had recently taken.

Amaral's work between 1924 and 1927 (often referred to as her Pau-Brasil period) is marked by a combination of continued experimentation with Cubist-related form and Brazilian subject matter. At times her themes are derived from the pulsating rhythms of the cities. In *E.F.C.B. (Estrada de Ferro Central do Brasil)* [*E.F.C.B (Central Railway of Brazil)*] of 1924 (plate 4), railroad cars, trestles, signs, telephone poles, houses, a church, and palm trees form Brazilian analogues to the urban iconography of Léger in Paris, and even that of the North American Precisionists Charles Demuth, Charles Sheeler, and others working at the same time. In numerous other works of the Pau-Brasil period, the farm of her childhood and the effulgent flora and fauna of Brazil are depicted.

An oneiric quality informs Amaral's paintings of the late 1920s such as *Abaporú* of 1928 (plate 3) and *Antropofagia* of 1929 (plate 5). The monstrous nature of the beings in these paintings parallels Oswald de Andrade's "Anthropophagite Manifesto" of 1928, another statement of the autonomy of Brazilian culture, thought, and life.[58]

A series of events in the early 1930s rapidly transformed the power structure of Brazilian politics. In October 1930 a revolt against the federal government erupted in the southern state of Rio Grande do Sul. The economic health of the country soon deteriorated, spurred on in large part by a collapse in the price of coffee on the international market. The newly established dictatorial regime of Getúlio Vargas created a climate of political and economic instability that affected Amaral, who, as a landowner, depended on the income generated by farming and cattle ranching. Her marriage had also grown untenable. Separated from Andrade in 1929, she decided to travel in 1931 to the Soviet Union with Osório César, a Socialist physician who was interested in art produced by the insane. She visited Moscow and Leningrad and had an exhibition of her work at the

11. Vicente do Rego Monteiro. *The Swimmers*. 1924. Oil on canvas, 31½ x 35½".
Collection Gilberto Chateaubriand, Rio de Janeiro

Museum of Modern Western Art in Moscow in June of 1931. Aracy Amaral cites numerous references to the artist's fascination with Russia. Many of Tarsila do Amaral's paintings done after 1933 demonstrate her new interest in social themes and may even hint at an attraction toward Soviet social-realist painting.

During the 1940s Amaral executed a number of images inspired by the religious spirit of the Brazilian working classes. After her 1951 retrospective at the Museu de Arte Moderna in São Paulo, she began to reexamine the work of her Pau-Brasil period, to recreate some of her earlier compositions, and to produce new paintings with the iconography and pictorial syntax of her "classic" mode. This neo-Pau-Brasil phase lasted until the artist's death and generated paintings that evoke a semblance of the power of her earlier masterworks; these pictures merely reflect the extraordinary imagination that made Amaral's artistic personality crucial in the development of South American modernism.

Although Amaral's European sojourns were comparatively brief, those of other Brazilians were substantially longer. Such is the case with the European experience of Vicente do Rego Monteiro. This artist is somewhat less well known outside Brazil than Tarsila do Amaral, but his work embodies, in many ways, the cosmopolitan and international components that were characteristic of Brazilian modernism as it emerged in the 1920s and 1930s. The words of the art historian Walter Zanini express the diversity of stimuli that affected the art of Rego Monteiro: "The ingredients of Monteiro's culture derived from Cubism, from Léger, from the forms found in the Amazon region, to his specific observations of the immobility and frontality of ancient sculpture . . . all of which produced for him an absolutely *sui generis* situation within the School of Paris."[59]

Rego Monteiro initially studied in Paris from 1911 to 1914, then returned in 1922 and remained until 1930. A man of wide-ranging interests, he was first drawn to sculpture. He was impressed by the work of Auguste Rodin, Emile-Antoine Bourdelle, and the

Catalan artist Pau Gargallo (who sculpted a portrait of Rego Monteiro). Because of this early exposure to three-dimensional art, a rich plastic sensibility is never absent from his paintings. Rego Monteiro's second love was dance, and in 1918 he created a series of drawings inspired by the performances of Anna Pavlova. When asked to name the sources of his artistic canon, he often replied with such diverse names as Piero della Francesca, Georges-Pierre Seurat, Georges Braque, Juan Gris, and the Portuguese Gothic master Nuno Goncalves.[60] The angularities, solidity, and smooth, tubular surfaces seen in many of his paintings also remind us of his affinities with the art of Léger and, at the same time, situate him well within the ornamental aesthetic of Art Deco, with which he is inextricably associated.

Rego Monteiro was also a significant figure in the promotion of modern art in Brazil. He had taken part in the *Semana de arte moderna* in 1922, and in 1930, after one of his long sojourns in Europe, he organized the first large-scale exhibition of the paintings of the members of the School of Paris.

Works such as *Adoração dos Reis Magos* [*Adoration of the Magi*] of 1925 (plate 159) embody many of the characteristics of his art as a whole. At first glance, it appears more like a relief than a painting, and displays the sense of solidity, frontality, and hieratic representation that he admired in antique sculpture, especially that of the ancient Near East. Rego Monteiro often depicted religious themes in his art, as did Amaral. One of the more curious aspects of his thematic repertory was his attraction to sports. During the 1920s and 1930s he produced numerous images of tennis players, swimmers, and young men and women engaged in other athletic contests, creating pictures like *The Swimmers* of 1924 (figure 11), for example. Depictions of sports in Latin American art are not unknown in the twentieth century; both Antonio Berni of Argentina and Antonio M. Ruiz of Mexico painted scenes of cyclists. Perhaps the artist closest to Rego Monteiro, however, is the Mexican painter Angel Zárraga, who, in the 1920s, created a well-known series of pictures of soccer players and other athletes such as *Game of Football* of about 1925 (figure 12). The modernist simplicity of these canvases and the energetic activities depicted recall Robert Delaunay's dynamic 1916 image of football players, *Football: The Cardiff Team* (The Museum of Modern Art, New York).

When Amaral, Andrade, and Cendrars made their trip to Minas Gerais during Holy Week of 1924, they traveled to the colonial heartland of Brazil. Since early colonial times, Minas had been one of the wealthiest areas in the nation, with its abundance of gold, minerals, and other natural resources. Its art-historical legacy was equally rich. The ecclesiastical and private patrons of Minas, especially those in the capital of Ouro Preto, had commissioned churches, chapels, municipal buildings, and private homes that expressed the grandiosity and theatricality of the Brazilian baroque. Virtually every town possessed outstanding examples of baroque splendors created by the great sculptor and architect Antônio Francisco Lisboa, called "Aleijadinho," and his school. By the 1920s, however, it was difficult to reach Minas because of poor roads and infrequent train service, and it had become a half-forgotten part of the nation. Unique religious customs, such as Holy Week processions, and popular art forms survived from the eighteenth century, and it was these manifestations of Brazilian tradition that the modernists came to explore.

Alberto da Veiga Guignard spent much of his later life in the

state of Minas after he had, like so many of his contemporaries, received academic training in Europe. He returned to Brazil in 1929 and, before settling in Minas Gerais in 1944, worked in Rio de Janeiro and elsewhere, creating landscapes, still lifes, and a particularly compelling series of portraits. The style of *Léa e Maura*, painted in 1940 (plate 75), is evidence of Guignard's interest in naïve painting, an attraction undoubtedly encouraged by his study of Italian trecento art, which can display a similar directness of expression. Popular portraiture by untrained or anonymous artists often displays a certain stiffness and concentration on decorative form in clothing or other accessories. This type of art has served as a significant source for painters in various parts of Latin America in the twentieth century, especially during the period under discussion here, in which a general reevaluation of the importance of folk art was taking place in several countries. The work of the Mexican artists Abraham Angel and Frida Kahlo also benefited from their study of naive painting.

Guignard's first years in Minas Gerais provided him with great personal happiness, to judge from letters he wrote to his friends, as well as a new repertory of themes for his art. The critic Frederico Morais has equated the new sense of light and the almost mystical quality that appears in Guignard's paintings with the transformation in Paul Klee's art upon his discovery of Kairuouan, Tunisia.[61] This analogy is well taken; Guignard and Klee, both interested in the work of untutored artists, were introduced to essentially exotic, nonurban environments that deeply touched their sensibilities. The

12. Angel Zárraga. *Game of Football*. c. 1925. Oil on canvas, 39⅜ x 31½". Private collection

first site where Guignard painted in his newfound home was the small town of Sabará, eighteen kilometers from Belo Horizonte. He continued to depict this village throughout the 1950s, as in the 1952 *Paisagem de Sabará* [*Landscape of Sabará*] (plate 76). In all paintings of the countryside and towns of Minas, including his many depictions of Ouro Preto, Guignard created a magical aura by applying his paint thinly and setting the houses and other buildings in deep recesses of space. Everything appears as if at a great distance. This device has the effect of creating an almost impenetrable barrier between the spectator and the setting depicted. The towns and villages of Minas Gerais thus take on a quasi-magical presence and an aura of the faraway, which is analogous to the position of this state in the Brazilian consciousness as a paradigm for a long-lost Golden Age.

While he worked outside the modernist mainstream, Guignard was an important component in the development of modernism in Brazil. His refined manipulation of the sources he found in popular art partakes of a spirit of sophisticated *brasilidade* similar to that which served as the basis of much of the work of Tarsila do Amaral. Guignard also taught for many years in Rio de Janeiro and Belo Horizonte, where he started his own school. The students who benefited from his pedagogical emphasis on individual freedom included Lygia Clark, Amílcar de Castro, and Mary Vieira.

The work of Cícero Dias may also be considered in the company of those Brazilian modernists who attempted to evoke the appearance of popular art in their work. Dias was active in Rio de Janeiro but, after 1937, spent much time in Europe. His delicate landscapes recall the linear perspectives of Guignard. This intuitive perspective, as well as certain elements of fantasy in the art of Dias evidence his interest in Marc Chagall. In other works, such as his depictions of the female nude, a sensitivity to erotic qualities and an interest in decorative patterning are testimonies to the artist's enthusiasm for the paintings of Henri Matisse.

Another Brazilian modernist pioneer, Ismael Nery, also combined eroticism and a sense of oneiric fantasy. Nery traveled to Paris in 1920 and studied at the Académie Julian. He progressed through several modernist styles in his work, from a late Symbolism in his youth to a Cubist-inflected Art Deco idiom. In 1927 Nery returned to France and met Chagall. He was the first to introduce Surrealism—in the form of his own personal variant of the style—to Brazil.

Two other major figures in the development of Brazilian modernism, Emiliano di Cavalcanti and Cândido Portinari, focused on the social reality of their country. Di Cavalcanti, a native of Rio de Janeiro, had been one of the principal initiators of the *Semana de arte moderna*. Although many of his early works were done in a Symbolist mode (such as his 1918 illustrations for the magazine *Panóplia*, inspired by the work of Aubrey Beardsley), his later paintings are more direct evocations of the life of the various social classes and racial groups in the nation. The 1925 *Samba* (plate 43) can be related to the work of many artists of the 1920s in Europe and South and North America who were interested in classicism. The 1930 painting *Cinco moças de Guaratinguetá* [*Five Girls of Guaratinguetá*] (plate 44), on the other hand, is reminiscent of those representations of the Mangue district of Rio that had also been depicted by Segall. Qualities of caricature link this painting to Segall's art as well as to that of the German *Neue Sachlichkeit* (New Objectivity) artists of the 1920s, who had commented so scathingly on the society of the Weimar

Republic. Di Cavalcanti himself once stated that behind his seemingly optimistic renditions of the various strata of Brazilian society there was much that hinted at defeat and disintegration.[62]

Cândido Portinari declared: "I decided to paint the Brazilian reality, naked and crude as it is."[63] Although few of his paintings could actually be said to suggest the sense of despair or degradation evoked in di Cavalcanti and abundantly present in the work of Siqueiros, Portinari (especially in the socially concerned pictures of the 1930s) elicits a sympathy for the plight of the individuals who inhabit his scenes. A number of works depict life in the *favelas*, shantytowns built by the disenfranchised peasants who, fleeing the waves of drought that plagued Brazil in the 1930s and 1940s, came to the cities to seek a more economically solid life. The nobility of the working classes is present in the painting titled *O Mestiço* [*The Mestizo*] of 1934 (plate 152), in which a handsome, muscular young man confronts the viewer directly. Portinari's most famous canvas is *Café* [*Coffee*] of 1935 (plate 153), in which the artist refers to the principal crop of his home state. The difficult nature of the workers' labor is clear, yet there is little or no hint of despair. This painting received Second Honorable Mention in the 1935 Carnegie International Exhibition of Paintings in Pittsburgh, bringing the artist wide attention. Portinari concentrated his subsequent efforts on murals, many of which were painted in the United States, such as his frescoes for the Brazilian Pavilion at the 1939 World's Fair in New York, the Library of Congress in Washington, D.C., and the headquarters of the United Nations in New York.

——

In Argentina and Uruguay, Buenos Aires and Montevideo witnessed the principal manifestations of the new spirit in art. Both cities (especially the former) experienced profound changes in the early twentieth century. Between 1905 and 1910 more than one million immigrants—mostly from Spain and Italy—entered Argentina, the vast majority of them settling in Buenos Aires. Neither Argentina nor Uruguay had substantial indigenous populations; what few native peoples there were had long since been massacred by the colonizers, and the cultural outlook of these countries was principally European. The artists of the avant-garde gravitated to European capitals to keep abreast of events, and soon the major styles that had surfaced in Paris and elsewhere were appropriated by painters and sculptors from Argentina and Uruguay.

Emilio Pettoruti was one of the most significant Argentine masters to adopt the Cubist idiom. He had spent the years 1913 to 1924 in Europe. He trained both in Florence and in Paris, where he was particularly impressed not only with Picasso but with the work of the Purists and that of Juan Gris. A painting such as *"Lacerba"* (*Studio*) of 1915 (Private collection) clearly demonstrates his affinities with artists such as Lhote and Gris. His return to Buenos Aires in 1924 was marked by an important and much-debated exhibition (at Salón Witcomb) of his Cubist images as well as others that showed the influence of the Italian Futurists. These pictures incorporate many of the devices of his European colleagues, but also, as art historian Susan Verdi Webster has recently pointed out, they feature numerous references to local customs.[64] This is particularly true in his depictions of tango-band musicians.

While the 1928 *Harlequin* (figure 13) refers to the traditional *commedia dell'arte*, it can also be interpreted as referring to the musicians in the popular tango bands of the day, and specifically the player of the *bandoneón*, or small accordion, the instrument most closely associated with tango. Tango music has been understood by many writers (including Jorge Luis Borges) as expressing the most trenchant sentiments of the soul of the inhabitants of the Río de la Plata region.

Xul Solar, a singular case in the history of Latin American modernism, was, like Pettoruti and Borges, a member of the important Martín Fierro group. In September 1980 Borges gave a lecture at the Fundación San Telmo in Buenos Aires in which he spoke of his memories of his friend.[65] Borges described him as a genius, referring to the inventiveness of his art, his intellectualized plays on the meanings of words, and his creation of new languages with ingenious syntactical rules. Xul Solar called these languages *neocriollo* (based on Spanish, English, Portuguese, and German) and *panlengua*.

Xul Solar, a name the artist adopted around 1916–17 (his given name was Oscar Agustín Alejandro Schulz Solari), left Argentina for Hong Kong in 1912. He never reached Asia but remained in Europe (England, Italy, and France) until 1924. The range of art and artists with whom he came into contact at that time and whose work he assimilated was enormous. His earliest paintings, small watercolors, bear a certain relationship to the Symbolism of the Dutch artist Jan Toorop and other late practitioners of the Art Nouveau style. After 1918 geometric Constructivism became his chief means of portraying the landscapes of his imagined world. Xul Solar sometimes painted these places inhabited by strange hybrid creatures, while at other times, views of pure architectural structures dominate the compositions.

Those critics who have written about Xul Solar's work have invariably mentioned his shared affinities with Robert Delaunay, František Kupka, Vasily Kandinsky, Kasimir Malevich, Joan Miró, and others, all of whom could be loosely classified, in certain respects, as spiritual painters. Each had experienced the impact of some of the mystical writers of the early twentieth century like Annie Besant and Helena P. Blavatsky.[66] Paul Klee is another artist with whom Xul Solar was fascinated. It is not clear if the two ever met, but the irony, humor, and delicacy of their styles, and what could be described as nihilistic tendencies that they seem to have had in common, suggest strong spiritual links between them. Despite affinities with the artists mentioned above, as well as others, such as the Dadaist Kurt Schwitters, Marc Chagall, George Grosz, and some of the Italian Futurists, Xul Solar's contribution is a unique one which becomes even more distinctive when seen against the conservative background of the art scene in Buenos Aires until the 1920s. The influential critic Alberto Chiabra Acosta, known as "Atalaya," remarked, "Xul . . . is the genius of the house"; and Borges stated, "I always considered him my teacher."[67]

Xul Solar's visual imagination continued to develop and grow more intricate and enigmatic. A painting such as *Mundo* [*World*] of 1925 (plate 230) might serve as a paradigm of the complexities of his sensibility. In the 1930s he began to evoke the strange architecture of desolate landscapes. In *Bri, país y gente* [*Bri, Country and People*] of 1933 (plate 232) eccentric creatures walk along paths between large zigguratlike buildings. Xul Solar's art, while incorporating certain formal devices he learned in Europe, allows the spectator a clear view

13. Emilio Pettoruti. *Harlequin*. 1928. Oil on canvas, 44⅞ x 27½". Private collection

through the artist's eyes into one of the most original worlds of fantasy and inventiveness ever evoked by an artist in Latin America. In spite of the affinities with European modernists cited above, it can be said that Xul Solar was an isolated figure in the history of modernism in Latin America. His inventive and idiosyncratic visual language found little resonance in the art of his contemporaries.

The same could be said for the Uruguayan Pedro Figari, another important figure in the history of modernism of the Río de la Plata region. Figari, like Paul Gauguin (with whom he is sometimes associated in terms of style and subject matter), became a full-time artist after making a career as a respected lawyer and public defender. He was also a well-known writer on issues such as public welfare, aesthetics, and education. Yet all the while he continued his childhood interest in drawing and painting. In 1921, at the age of sixty, he dedicated himself completely to painting. He moved with his son Juan Carlos to Buenos Aires, where he remained for four years, and then he went to Paris for nine years. Figari had already established his thematic concerns in canvases executed before 1921.[68]

Almost all of his later work was done on small pieces of cardboard, the size and texture of which give his paintings a feeling of intimacy. One of Figari's favorite subjects was the daily life of the black men and women of Uruguay (many of whom were former slaves from Brazil), including their social gatherings known as *candombes*, the title of a 1921 painting by Figari, in which dancing and singing played a dominant role (plate 63). Figari also depicted the life of the gauchos on the vast pampas of the Río de la Plata region. Although dealing with a subject that had also concerned the nineteenth-century genre painter Blanes, Figari re-created the life of the gauchos in his own unique style, which can be seen in *Pampa* (plate 64). Figari's works feature the use of flat colors and frontal representation, and show little interest in perspective or depth. Some of the gaucho scenes take place in a moonlit landscape and include the *ombú* tree, characteristic of the Río de la Plata plains. Figari often relied on the suggestive power of strong color (especially reds and blues) to carry the mood of his scenes. The curvilinear aspect of both figures and landscape elements is also a significant feature of his art.

Many of his paintings have been related to the works of the French so-called Intimist painters Edouard Vuillard and Pierre Bonnard and there are indeed certain points of contact between them. The turn-of-the-century Catalan artist Hermen Anglada-Camarasa was also an early stylistic influence for Figari.[69] Virtually all social classes of the Río de la Plata region became subjects of Figari's compelling works. *Baile criollo* [*Creole Dance*] of about 1925 (plate 62), for example, portrays a scene of a more European entertainment. In certain other works the pretensions of the well-to-do bourgeois classes are gently satirized. Damián Bayón pointed out an important fact regarding Figari's work when he stated that the Uruguayan painter "inspired other South American artists to recapture the essential elements of their culture without falling into a facile folkloristic or tourist-oriented art."[70] The art of Figari, while expressing universal values, is rooted in his native region. The gauchos, participants in the *candombes*, and other social types of the Río de la Plata area predominate among his subjects.

José Cúneo, a less well-known representative of Uruguayan modernism, on the other hand, took a much more transcendental approach to his subjects. Cúneo had a highly eclectic development in Europe. Something of a peripatetic figure throughout his life, he never tired of traveling and looking at new sources of inspiration for his art. One of the artists who appears to have been most influential for his early style was Anglada-Camarasa, with whom he studied in Paris as a young man. Anglada-Camarasa is known for his highly expressive art, which has stylistic links to Art Nouveau. His brushstroke is particularly thick, an element that obviously impressed Cúneo, who retained it as a feature of his own art.

While some of Cúneo's mature works are abstract,[71] the best-known pictures of this master depict a single theme—the moonlit landscape. These paintings, which have been likened by Angel Kalenberg to the eerie, expressive, and haunting landscapes of the North American Symbolist Albert Pinkham Ryder and the Expressionist Chaim Soutine,[72] rarely depict any recognizable place. In virtually all of them a huge moon hangs over a low horizon. Clouds seem to swirl around the scene; the landscape elements (such as trees) and the small houses or other structures are thrown off balance by the intensity of the moon's brilliance and dwarfed by its overwhelming

size. The generative power of the cosmos is evoked, and the viewer stands in awe of nature. The magnitude of Cúneo's skies and moons is analogous in its impact to the measureless spaces of the pampas, which Figari often conjured in his paintings.

Of all the Uruguayan modernists, Rafael Pérez Barradas was the artist most closely in touch with the latest trends of the European avant-garde. Although he had studied extensively in Italy, Barradas's career developed almost entirely in Barcelona and Madrid.[73] He was an integral part of the avant-garde circles in both cities and often bridged the gap between the visual artists and the innovators of the literary world. Barradas was closely associated with the *ultraísta* movement, which had developed in Spain around 1919 as an antidote to the literary sentimentalism of fin-de-siècle letters. Among the members of the *ultraísta* circle were the poets Jorge Luis Borges, Gerardo Diego, Eugenio Montes, and Guillermo de Torre. Evocations of simultaneity, fusion of time and space, as well as a synthesis of various psychological states of being were among the things that the *ultraístas* attempted to achieve in their poems and other literary works. Analogous sentiments were evoked in the paintings of Barradas. The pulsating life of city streets, the speed of automobiles, the indications and information given by advertising on billboards and shop windows were all a part of the artist's compositions. To suggest activity and velocity Barradas called his paintings "vibrations"; this was related to the feeling for motion of the Italian Futurists whom Barradas had met in Italy. Barradas's works are close in form and especially in color to the images of Gino Severini.

Barradas also used many of the techniques of Cubism in his paintings. *Vibracionist* of 1917 (Private collection), for example, includes fragments of words ("*VERMOU*") in its depiction of a café scene. Collagelike representations of sheet music also connect it to techniques used by Picasso, Braque, and others. *Verbena de Atocha* [*Atocha Festival*] of 1919 (plate 13), an evocation of a popular street fair in Madrid, suggests the noise and animation of a large crowd literally tumbling over itself. The simultaneity of the movement brings this work close to the sensibility of Barradas's Italian contemporaries.

Barradas had met Joaquín Torres-García in 1916 or 1917. Their common Uruguayan heritage connected them but, more important, they both shared a similar aesthetic outlook.[74] Both men were deeply concerned with the concept of modernity in art in its widest possible connotations. The art forms developed by these key figures in the history of twentieth-century South American painting represented not just a change in the aesthetic outlook of their region but a true renewal and, in a sense, a cleansing of the outmoded methods of expression that had been the norm for many decades. Upon his return to Montevideo in 1928 at the end of his short life, Barradas, like Pettoruti and Torres-García several years later, became an important conduit for the passage of new ideas and revolutionary forms of art to the Río de la Plata region. The next several decades witnessed the flowering of the careers of numerous artists who based their work on the Constructivist aesthetic that had been adumbrated in Argentina and Uruguay by Barradas, Pettoruti, and Torres-García.

The rise of modernity in Venezuela was somewhat less dramatic than in Argentina, Uruguay, or even Brazil and Mexico. Until the 1920s the country's economy was principally agrarian. The two dictators whose presidencies lasted from 1899 to 1935, Cipriano Castro and Juan Vicente Gómez, were hostile to intellectuals. The

Academia de Bellas Artes in Caracas flourished during this time, but it promoted a strictly academic standard in painting and sculpture. Even as late as the first decade of this century students were not allowed to study from the nude model.[75] In 1912 there was a student strike at the academy resulting in the founding of the Círculo de Bellas Artes, which organized an important series of exhibitions (the first was held in 1913) in which at least some aspects of the avant-garde were in evidence. The Círculo, however, was closed by the police in 1917. Before it was shut down, two foreign artists—Samys Mützner from Romania and Nicolas Ferdinandov from Russia—became associated with the organization and served as links between artistic developments in Caracas and certain aspects of modern art in Europe. Mützner and Ferdinandov both promoted a style of painting linked to that of the Fauves. Their art awoke in certain Venezuelan painters a new sensitivity to color. By far the most important figure to respond to their stimuli was Armando Reverón.[76] Reverón had studied at the academy and in 1911 was given a scholarship to travel abroad. He spent most of his time in Barcelona and Madrid, returning to Caracas to a somewhat more progressive atmosphere, owing to the presence of the two foreign painters cited above, as well as that of the Franco-Venezuelan artist Emilio Boggio.

The work of Reverón has often been associated with French Impressionism. Yet his light-saturated landscape paintings have much more to do with the artist's own visionary experiences and personal approach to natural phenomena than with any lessons he may have learned from his contact with Parisian artists. After several years of working in a Symbolist-related mode, this singular master developed an approach to landscape painting that often took him to the brink of pure abstraction. His thinly painted canvases (especially those done after 1925, the year in which he initiated his "white period") seem to breathe the heat-saturated air of his surroundings in the then-isolated seaside village of Macuto. The 1926 painting *Luz tras mi enramada* [*Light Through My Arbor*] (plate 162) does not suggest a specific place but possesses a dreamlike quality; scintillating luminosity creates an almost painfully shimmering effect. Very few tones except the whites and blues are perceptible in this painting or in many related works. Reverón seemed to want to dematerialize the content of his pictures, making them quasi-sacred ruminations on nature. In his intense spirituality Reverón is not unlike many other artists of his day, both in Latin America and abroad, who responded to the need for "the spiritual in art," as Kandinsky put it. Regarding the spirituality of Reverón, it is enlightening to understand something of his working methods. His friend José Nucete Sardi wrote: "Reverón prepares the atmosphere before starting to work. . . . He goes outside to warm up his sight, driving it to ecstasy in the bright colors of the sunlit landscape around him. . . . He works almost nude to prevent the colors of his clothes coming between his work and his eyes."[77] While Reverón was undoubtedly eccentric, his work is serious and calculated. Although landscape painting (first in white and later in sepia tones) dominated his efforts, the human figure makes occasional appearances, especially in the mid-1930s and then again in the last years of his life. Among his most fascinating later paintings are those in which the artist included the female form, partially nude and usually in groupings of several figures. Although his companion and model Juanita Ríos posed for many of these images, Reverón also employed large rag dolls that he had created and around which he fashioned

an entire world, an isolated existence in his own seashore solitude. *Self-Portrait with Dolls* of 1949 (Fundación Galería de Arte Nacional, Caracas) shows Juanita posed to the artist's right, in profile, with feathers in her hair (as the artist often depicted her), while on his other side, one of his dolls peers out at the viewer.

Reverón has become a cultural icon in Venezuela. For several generations younger artists have looked to his work as a model of artistic freedom. One of the country's most distinguished contemporary painters, Jacobo Borges, met and admired Reverón as a young man. Although Borges's paintings are entirely different in temperament from those of this reclusive master of Macuto, in their intensity and the fervor of their expressive force, they nonetheless reflect the aims and accomplishments of Reverón's art.

—

While the birth of modernism in the early twentieth century constituted a break with the past, a radical alternative to received artistic tradition, modernism in Latin America was by no means a monolithic entity. The pluralistic nature of Latin American culture is reflected in the wide variety of paths that the rise of modernity took in individual nations. Latin American modernism constituted a struggle for the establishment of a contemporary vocabulary that could represent the plurality of nations. It was, at the same time, a strong assertion of a renewed self-awareness on the part of individual artists. In Mexico, for example, certain manifestations of the modern spirit were intimately linked to the revolutionary movements of the second decade of the century, while other avant-garde artists rejected anything that had to do with representations of the everyday life of that country. A number of Brazilian artists followed European lines somewhat more closely than many of their colleagues in other Latin American nations. The works of Tarsila do Amaral, for instance, can be connected in a precise way to some of the painters with whom she was associated in Europe (Lhote and Léger). In many instances, traditional subjects were adapted by the Latin American modernists with new vocabularies derived from an international avant-garde sensibility. The work of

Pedro Figari is a case in point. The lives of the gauchos, mulattos, and urban and rural whites were depicted, and sometimes satirized, in a highly personal style, which might superficially recall European Expressionist modes but is, in essence, a completely personal contribution to the development of the modern spirit in Figari's country. Some of the most interesting modernist painters in Latin America were idiosyncratic and often somewhat isolated figures, developing repertories of visual forms that often did not have strong resonances or consequences for other painters of their time. The work of Xul Solar might represent an example. Other modernists, such as Joaquín Torres-García, had an enormous impact not only within the confines of their native countries but throughout Latin America as a whole.

For the most part, however, the artists discussed here initially grappled with stylistic options and philosophical strategies that were initiated in countries outside their own. The early years of the twentieth century witnessed a new symbiosis between Latin America and the rest of the Western world. The eyes of Latin America were trained both on Europe and on itself. A satisfactory détente was sought between the revolutionary images of the avant-garde Europeans and the desire on the part of Latin American artists to develop a visual language that would express the cultural and psychological realities of a new, promising century. The many solutions to this conundrum could be grouped together under the rubric *modernismo*. These answers were arrived at by artists who were able and willing to take the creative pulse of their own nations, as well as that of neighboring countries, and who could also evaluate the solutions of the European vanguard. Perhaps more than a style, mode of vision, or a set of philosophical or political circumstances, modernism in Latin America was a state of mind—a utopian belief in the power of experimentation and openness. It was, in a sense, an acceptance of what a still-young century had to offer. The inception of a new sensibility required a definitive break with the old one. Once that was effected, there was no turning back, and the way was cleared in Latin America for the multiple permutations of modernism that were to follow.

Notes

I would like to thank the following individuals for their help and useful suggestions: Miriam Basilio, Fatima Bercht, Tadeu Chiarelli, Elizabeth Ferrer, Marion Kocot, Ivo Mesquita, Waldo Rasmussen, and Joseph R. Wolin.

1. Mirko Lauer, "Máquinas y palabras: La sonrisa internacional hacia 1927," in Ana María de Moraes Belluzzo, ed., *Modernidade: Vanguardas artísticas na América Latina* (São Paulo: Memorial, UNESP, 1990), p. 46.

2. Jorge Alberto Manrique, "El proceso de las artes, 1910–1970," in *Historia general de México*, vol. 4 (Mexico City: El Colegio de México, 1976).

3. Karen Cordero Reiman, "Ensueños artísticos: Tres estrategias plásticas para configurar la modernidad en México, 1920–1930," in Olivier Debroise and Graciela de Reyes Retama, eds., *Modernidad y modernización en el arte mexicano, 1920–1960* (Mexico City: Museo Nacional de Arte, 1991), pp. 53–65.

4. There is, unfortunately, no synoptic study of academic art in Latin America. One of the nations whose nineteenth-century art is best documented is Mexico. For the history of the Academia de San Carlos and the development of the academic mode in Mexico, see Jean Charlot, *Mexican Art and the Academy of San Carlos 1785–1915* (Austin: University of Texas Press, 1962); Justino Fernández, *El arte del siglo XIX en México* (Mexico City: Universidad Nacional Autónoma de México, 1983); and Fausto Ramírez, *La plástica del siglo de la Independencia* (Mexico City: Fondo Editorial de la Plástica Mexicana, 1985). See also the essay by Fausto Ramírez, "The Nineteenth Century," in Dore Ashton et al., *Mexico: Splendors of Thirty Centuries* (New York: The Metropolitan Museum of Art; Boston: Bulfinch Press, 1990), pp. 499–509. The essay by Edward Lucie-Smith, "A Background to Latin American Art" in Holliday T. Day and Hollister Sturges, eds., *Art of the Fantastic: Latin America, 1920–1987* (Indianapolis: Indianapolis Museum of Art, 1987), pp. 15–35, contains some information on the academic tradition.

5. Analogous sentiments were expressed through the sculpture of the time. Miguel Noreña, a disciple of Manuel Vilar, perhaps Mexico's best-known neoclassical sculptor, created several well-known monuments along the Paseo de la Reforma in Mexico City. For a further discussion of the political ramifications of the late manifestations of neoclassicism in Mexican art, see Daniel Schávelzon, ed., *La polémica del arte nacional en México, 1850–1910* (Mexico City: Fondo de Cultura Económica, 1988), pp. 197–298.

6. Jean Franco, *The Modern Culture of Latin America: Society and the Artist*, rev. ed. (Harmondsworth: Penguin Books, 1970), p. 26.

7. David Alfaro Siqueiros, "Tres llamamientos de orientación actual a los pintores y escultores de la nueva generación," *Vida americana* (May 1921); reprinted in Belluzzo, *Modernidade*, pp. 240–42.

8. See Francisco Reyes Palma, "Vanguardia: Año cero," in Debroise and Reyes Retama, *Modernidad y modernización*, p. 44.

9. Ibid. [author's trans.]

10. See Raquel Tibol, ed., *Textos de Rufino Tamayo* (Mexico: Universidad Nacional Autónoma de México, 1987).

11. Franco, *Modern Culture of Latin America*, p. 107.

12. José Juan Tablada called Ruelas the inaugurator of the modern era in Mexican painting. See his *Historia del arte en México* (Mexico City: Nacional Editora Aguilas, 1917).

13. Olivier Debroise, *Figuras en el trópico: Plástica mexicana, 1920–1940*, 2d ed. (Barcelona: Ediciones Océano, 1984), p. 37.

14. Ibid.

15. See Ramón Favela, in Ashton, *Mexico: Splendors of Thirty Centuries*, p. 576.

16. The most complete study of the early career of Diego Rivera is Ramón Favela, *Diego Rivera: El joven e inquieto Diego María Rivera (1907–1910)* (Mexico City: Editorial Secuencia, 1991). Favela is currently preparing a catalogue raisonné of the art of Rivera.

17. For the history of art at this period, see *1910: El arte en un año decisivo* (Mexico City: Museo Nacional de Arte, 1991).

18. For a full account of this exhibition see Favela, *Diego Rivera: El joven e inquieto*, pp. 132–38.

19. Rivera returned to Spain in January 1911, shortly after the close of the exhibition.

20. Diego Rivera with Gladys March, *My Art, My Life* (1960; reprint ed., New York: Dover, 1990), p. 40.

21. Ramón Favela, *Diego Rivera: The Cubist Years* (Phoenix: Phoenix Art Museum, 1984), p. 47. Favela's study of Rivera's Cubist period remains the standard work on the subject.

22. The quarrels between artists for both aesthetic and political reasons during the tense days of World War I in Paris have been charted in Kenneth E. Silver, *Esprit de Corps: The Art of the Parisian Avant-Garde and the First World War, 1914–1925* (Princeton: Princeton University Press, 1989). See Chapter 4, "Internecine Warfare," especially p. 166, where a quarrel between Rivera and the publisher Pierre Reverdy is described.

23. See Kenneth E. Silver, "Jewish Artists in Paris, 1905–1945," in Kenneth E. Silver and Romy Golan, *The Circle of Montparnasse: Jewish Artists in Paris 1905–1945* (New York: Universe Books, 1985), p. 32. On Rivera in Paris, see Olivier Debroise, *Diego de Montparnasse* (Mexico City: Fondo de Cultura Económica, 1979).

24. Tsuguharu Foujita became a well-known member of the School of Paris, remaining in Europe for many years. Much less is known of Kawashima.

25. This painting was last exhibited in Amsterdam, shortly after it was painted. Since then it had been cited as a work whose whereabouts were unknown until it appeared in an auction catalogue in 1992 with a brief essay on the picture by Ramón Favela. See *Latin American Paintings, Drawings, Sculpture and Prints* (New York: Sotheby's, May 19, 1992).

26. Rivera, *My Art, My Life*, pp. 59–60.

27. Rivera referred to *Zapatista Landscape* in this way in a letter to his friend Martín Luis Guzmán. See Favela, *Diego Rivera: The Cubist Years*, p. I07.

28. It is important, nonetheless, to understand the later development of Rivera's oeuvre not in terms of a rejection of the things he had learned in Europe, but as a transformation of them. The Cubist grid, for example, by no means disappeared from his work; it served as a frame on which to place his multifigured fresco compositions (such as those in the Palacio Nacional, Mexico City). The classicizing trends that became important in art in Paris and elsewhere after World War I made a strong impact upon the artist, and the ample-figured inhabitants of his paintings should be related to a similar classically derived mode of vision pursued by Picasso and others in the 1920s and 1930s.

29. For a discussion of the history of the Open-Air Schools of Painting, see Raquel Tibol, "Las escuelas al aire libre en el desarrollo cultural de México," in *Homenaje al movimiento de escuelas de pintura al aire libre* (Mexico City: Museo del Palacio Nacional de Bellas Artes, Instituto Nacional de Bellas Artes, 1981); and Laura González Matute, *Escuelas de pintura al aire libre y centros populares de pintura* (Mexico City: Instituto Nacional de Bellas Artes, 1987).

30. Cordero Reiman, "Ensueños artísticos," p. 59.

31. Antonio Rodríguez, "Siqueiros: Teórico e innovador," in Mario de Micheli, *Siqueiros*, trans. Ruth Solís (New York: Harry N. Abrams; Mexico City: Secretaría de Educación Pública, 1985), p. 17.

32. For details of the Siqueiros and Rivera debates, see Laurance P. Hurlburt, *The Mexican Muralists in the United States* (Albuquerque: University of New Mexico Press, 1989), p. 221.

33. See Ashton, *Mexico: Splendors of Thirty Centuries*, p. 645.

34. Hurlburt, *Mexican Muralists*, p. 222.

35. Peter Busa, quoted in B. H. Friedman, *Jackson Pollock: Energy Made Visible* (New York: McGraw Hill, 1974), p. 29.

36. José Clemente Orozco, *Autobiografía*, rev. ed. (Mexico City: Ediciones Era, 1970), p. 59.

37. Hayden Herrera, in Ashton, *Mexico: Splendors of Thirty Centuries*, pp. 570–71.

38. "Actual no.1, hoja de vanguardia, comprimido estridentista," by Maples Arce included Marinetti's famous phrase, "A moving automobile is more beautiful than the Victory of Samothrace." See Belluzzo, *Modernidade*, p. 244.

39. See Cordero Reiman, "Ensueños artísticos," p. 64.

40. Jorge Alberto Manrique, "Otras caras del arte mexicano," in Debroise and Reyes Retama, *Modernidad y modernización*, p. 137.

41. Debroise, "Introducción," in ibid., p. 24.

42. For a history of the *Semana de arte moderna* see Aracy A. Amaral, *Artes plasticas na semana de 22* (São Paulo: Editôra Perspectiva, 1970). See also the rev. ed.: *Arts in the Week of '22* (São Paulo: Câmara Brasileira do Livro, 1992). Many of the aspects of the rise of modernism in Brazil and other nations of Latin America are treated in Belluzzo, *Modernidade*.

43. Walter Zanini, ed., *História geral da arte no Brasil* (São Paulo: Instituto Walther Moreira Salles, 1983), vol. 2, p. 533.

44. Emiliano di Cavalcanti, *Viagem da minha vida* (Rio de Janeiro: Civilização Brasileira, 1955), pp. 114–15; also quoted in ibid.

45. On January 29, 1922, the newspaper *Correio Paulistano* published the following description of the *Semana de arte moderna*: "Various intellectuals from São Paulo and Rio have resolved, thanks to the initiative of the writer Graça Aranha, to organize a week of modern art to give to their public a perfect demonstration of the most up-to-the-minute achievements in sculpture, painting, architecture and literature. . . .

"The Teatro Municipal will be open during the week of 11 to 18 February for the installation of a curious and important exhibition in which our best modern artists will participate.

"The programs will include the following names:

"Music—Villa Lobos, Guiomar Novaes, Paulina D'Ambrósio, Ernani Braga, Alfredo Gomes, Frutuoso, Lucília Villa-Lobos

"Literature—Mário de Andrade, Ronald de Carvalho, Alvaro Moreyra, Elysio de Carvalho, Oswald de Andrade, Menotti del Picchia, Renato Almeida, Luiz Aranha, Ribeiro Cuoto, Deabreu, Agenor Barbosa, Rodrigues de Almeida, Afonso Schmidt, Sérgio Milliet, Guilherme de Almeida, Plínio Salgado

"Sculpture—Victor Brecheret, Hildegardo, Leão Velloso, Haarberg

"Painting—Anita Malfatti, Di Cavalcanti, Ferrignac, Zina Aita, Martins Ribeiro, Oswald Gueld, Regina Graz, John Graz, Castello and others

"Architecture—A. Moya and Georg Przyrembel

"The literary and musical parts will be divided into three presentations and will count upon the prestige of Graça Aranha who will give the inaugural lecture for the week of modern art."—Quoted in Amaral, *Artes plásticas*, p. 130.

46. This text, published in *O estado de S. Paulo* (December 20, 1917), was originally titled "A propósito da exposição Malfatti." In 1919 it was reprinted in *Idéias de Jeca Tatú* (São Paulo: Brasiliense, 1946), a compilation of Lobato's short pieces, with the title "Paranóia ou mistificação" ("Paranoia or Mystification"). The article may also be found in Aracy Amaral, ed., *Modernidade: Art brésilien du 20e siècle* (Paris: Musée d'Art Moderne de la Ville de Paris, 1987), pp. 62–64. This catalogue contains numerous other documentary sources fundamental to an understanding of modernism in Brazil. See also Mário de Andrade, *O movimiento modernista* (Rio de Janeiro: Casa do Estudante do Brasil, 1942); Mário da Silva Brito, *História do modernismo brasileiro* (Rio de Janeiro: Editôra Civilização Brasileira, 1964); and Zanini, *História geral da arte no Brasil*, vol. 2, pp. 513–19. For further information on Monteiro Lobato, see Domingo Tadeu Chiarelli, "The 'Jeca' versus Picasso: Nationalism as Modernity in Monteiro Lobato's Art Criticism," *Brazilian Art Research Yearbook I* (May 1992), pp. 11–16.

47. Mário de Andrade, quoted by Frederico Morais, "O Rio de Segall," in *Lasar Segall e o Rio de Janeiro* (Rio de Janeiro: Museu de Arte Moderna, 1991), p. 29.

48. Ibid.

49. Segall's work was included in the Nazi-organized exhibition *Entartete Kunst* (*Degenerate Art*), which opened in Munich in 1937 and traveled to many cities in Germany and Austria. See Stephanie Baron, ed., *Degenerate Art: The Fate of the Avant-Garde in Nazi Germany* (Los Angeles: Los Angeles County Museum of Art, 1991), pp. 350–51.

50. See Belluzzo, *Modernidade*, p. 103, for a photograph of these sets. Some of them still survive and were restored and exhibited at the São Paulo Bienal of 1991.

51. Aracy A. Amaral, "L'art et l'artiste brésilien: Un problème d'identité et d'affirmation culturelle," in Belluzzo, *Modernidade*, p. 36.

52. The standard study of Tarsila do Amaral is Aracy A. Amaral, *Tarsila: Sua obra e seu tempo* (São Paulo: Editôra Perspectiva, 1975), 2 vols. with a catalogue raisonné. See also, rev. ed. in one vol. (São Paulo: Tenenge, 1986).

53. An artist dubbed by Robert Rosenblum, "the official academician of Cubism." See his *Cubism and Twentieth-Century Art* (New York: Harry N. Abrams, 1976), p. 182.

54. Tarsila do Amaral was very much in contact with the high society of Paris. According to Aracy Amaral she often gave lavish dinner parties (serving Brazilian food) and dressed in clothes designed by the most famous couturiers of her day, such as Paul Poiret.

55. For a description of this journey, see Amaral, *Tarsila* (1986), pp. 102–7.

56. Ibid., p. 102.

57. This manifesto is published in English in Dawn Ades, ed., *Art in Latin America: The Modern Era, 1820–1980* (New Haven: Yale University Press; London: Hayward Gallery, 1989), pp. 310–11.

58. Ibid., pp. 312–13.

59. Walter Zanini, *Vicente do Rego Monteiro (1899–1970)* (São Paulo: Museu de Arte Contemporânea da Universidade de São Paulo, 1971), n.p.

60. Zanini, *Vicente do Rego Monteiro*. In addition, Rego Monteiro, like other Brazilian artists of his day, was intensely interested in the traditions of his native country. In 1923 he executed the illustrations for an edition of *Légendes, croyances et talismanes des indiens de l'amazonie*, edited by P. L. Ducharte (Paris: Tolmer, 1923).

61. Frederico Morais, *Guignard* (São Paulo: Edição Centro de Artes Novo Mundo, 1974), p. 71.

62. Leopoldo Castedo, *Historia del arte iberoamericano* (Madrid: Alianza Editorial, 1988), p. 306.

63. Quoted in Sarah Lemmon, "Cândido Portinari: The Protest Period," *Latin American Art* 3, no. 1 (Winter 1991), p. 32.

64. See Susan Verdi Webster, "Emilio Pettoruti: Musicians and Harlequins," *Latin American Art* 3, no. 1 (Winter 1991), pp. 18–22.

65. Jorge Luis Borges, "Recuerdos de mi amigo Xul Solar," *Fundación San Telmo: Comunicaciones* 3 (November 1990).

66. Maurice Tuchman, "Hidden Meanings in Abstract Art," in Maurice Tuchman, ed., *The Spiritual in Art: Abstract Painting, 1890–1985* (Los Angeles: Los Angeles County Museum of Art, 1986), p. 37.

67. See Mario H. Gradowczyk, "Xul Solar: An Approximation," in *Alejandro Xul Solar* (New York: Rachel Adler Gallery, 1991), n.p.

68. Marianne Manley, *Intimate Recollections of the Río de la Plata: Paintings by Pedro Figari* (New York: Center for Inter-American Relations, 1986), p. 18. For the most recent information on Figari, see the text for the catalogue *Pedro Figari: 1861–1938* (Paris: Paris-Musées and Union Latine, 1992).

69. Ibid., p. 17.

70. Damián Bayón, *Historia del arte hispanoamericano*, vol. 3. *Siglos XIX y XX* (Madrid: Alhambra, 1988), p. 301.

71. Cúneo signed his abstract works with the name "Perinetti," which is the second part of his last name and his mother's surname. See Raquel Pereda, *José Cúneo: Retrato de un artista* (Montevideo: Edición Galería Latina, 1988), p. 163; and Alice Haber, "La lección del maistro," in her *Cúneo Perinetti* (Montevideo: Galería Latina, 1990), n.p.

72. Angel Kalenberg, *Arte uruguayo y otros* (Montevideo: Edición Galeria Latina, 1990), p. 103. For a fully documented biography of Cúneo's life, see Pereda, *José Cúneo*.

73. The most complete monograph on Barradas is Raquel Pereda, *Barradas* (Montevideo: Edición Galería Latina, 1989).

74. See Joaquín Torres-García, "Rafael Barradas," in his *Universalismo constructivo* (1944; reprint ed., Madrid: Alianza Editorial, 1984), vol. 2, pp. 474–79.

75. See Hollister Sturges, "Armando Reverón 1889–1954," in Day and Sturges, *Art of the Fantastic*, p. 42. For the most recent information on Reverón, see Miguel G. Arroyo et al., *Armando Reverón (1889–1954): Exposición antológica* (Madrid: Museo Nacional Centro de Arte Reina Sofía, 1992).

76. Alfredo Boulton, *Reverón* (Caracas: Ediciones Macanao, 1979), pp. 94–95.

77. Quoted in Sturges, "Armando Reverón," p. 47.

ARMANDO REVERÓN

—

Rina Carvajal

The Venezuelan painter Armando Reverón was an isolated figure who worked apart from the avant-garde movements of his time. Nevertheless, he has long been regarded as a precursor of modernism in Latin America. Having decided in the early 1920s to live in the small coastal town of Macuto,[1] Reverón spent over thirty years in virtual solitude, patiently and laboriously consolidating an autonomous pictorial vision that gave new form and new significance to what he saw and experienced.

In his paintings the landscape, the burning incandescent light of the tropics, and the simple everyday things that surrounded him became extraordinary under the vital force of his gaze. The primitive hut that he built at Macuto became the center of his remote but expansive world, a reflection of his distinctive imagination. Reverón sought simplicity, renouncing urban life in order to establish his own creative space.

Until the beginning of the 1920s, however, Reverón had participated actively in the cultural life of Caracas, the Venezuelan capital. In 1908, at the age of nineteen, he entered the Academia de Bellas Artes, a rigid and retrogressive institution that fostered extremely conservative methods and techniques, still focusing its instruction on history painting and portraiture. Three years later he traveled to Europe, where he studied in Barcelona and Madrid between 1911 and 1915.

Reverón's Spanish teachers also followed the academic tradition and perpetuated a late nineteenth-century realist style not far removed from that practiced at the academy in Caracas. Although modern Spanish painters such as Ignacio Zuloaga and Joaquín Sorolla had a certain influence on Reverón's early oeuvre, it was Francisco Goya's extraordinary pictorial technique that left a more lasting impact. During his European sojourn Reverón also lived in France for a few months, but little is known of his French experience. He remained in Paris for a short time, painting and viewing the work of the Impressionists and Paul Cézanne in the museums.[2]

Upon his return to Caracas at the end of 1915, Reverón joined the artists of the Círculo de Bellas Artes. Formed three years earlier by musicians, intellectuals, and a dissident group of painters that opposed the academy, the Círculo's members sought to create a more open and stimulating cultural climate in the city. The group's painters expressed a new sensitivity toward the native landscape, working directly from nature and portraying the country's tropical scenery with fervor. Through their aims and achievements these artists began to establish a foundation for modernism in Venezuela.

The presence of three European artists living in Venezuela at this time—the Russian Nicolas Ferdinandov, the Romanian Samys Mützner, and the Franco-Venezuelan Emilio Boggio (the latter two late Impressionists)—had an important effect on Reverón's development as well as that of the other artists of the Círculo. The most important among them for Reverón was Ferdinandov, an illustrator trained in the Symbolist tradition of Alexandre Benois. His art and range of cultural knowledge as well as his contagious enthusiasm deeply affected the Círculo painters, especially Reverón. Upon his arrival in Venezuela, Ferdinandov had developed an obsessive passion for the sea; he painted its coasts and lived among its fishermen. The intense chromaticism of his work, with its nocturnal atmospheres and persistent use of blue, influenced some of Reverón's paintings of the 1920s. Ferdinandov became Reverón's friend and mentor, and played

a pivotal role in the course of his early artistic life, especially in encouraging him to leave the city and concentrate on his painting in Macuto.

Reverón's decision to withdraw from urban society was in many ways the clearest option open to him in conservative turn-of-the-century Venezuela. With a rural economy and a long history of *caudillo* (strong-man) regimes and civil wars, the nation offered a very provincial way of life, local and isolated, with limited possibilities for international exchange. His choice gave him the freedom to create a space of his own, closer to nature and apart from the constraints of an extremely traditional society.

When he moved permanently to Macuto, Reverón built a *rancho* (hut) from local materials, including palm fronds, tree trunks, branches, earth, stones from the sea, and burlap. He also fashioned his own rudimentary furniture and some of his canvases, brushes, and pigments. Slowly, over time, other objects also occupied the space of his refuge, as Reverón fabricated musical instruments and scores, masks, wings, a birdcage (figure 1), a telephone, and the dolls that, from the late 1930s, would serve as the sources for his female images.

During his years of seclusion on the coast, Reverón's painting, with its Symbolist overtones, blue hues, and mysterious, dreamlike atmosphere, opened the way to a late Impressionism, which he gradually neutralized, opposed, and transformed. Completely dedicated to his painting, the artist synthesized and constantly experimented;

stripping away his early sources, he created his own visual language.

Reverón discovered that the light of the tropics is so intense that it blinds, dissolving images in its own incandescence. Reverón sensed, translated, and gave visual form to this light for the first time. Light for him was no longer the mere representation of atmosphere. As expressed through the motif of the landscape it became the very substance of his painting.

From 1926 on, light modified the dimensions of all things in Reverón's work, its irradiation dissolving forms and colors. The blues of his early works became less evident, although they continued to appear sporadically until the mid-1930s.[3] Little by little, an ever more enveloping luminosity became itself the subject of the paintings. In *Luz tras mi enramada* [*Light Through My Arbor*] of 1926 (plate 162), the light filters through a screen of sticks, branches, and leaves, impregnating the space of the hut. The reverberation of light blurs shapes, which seem to tremble like incorporeal reflections. The subject of *Marina* of 1927 (figure 2), despite remnants of color, seems to fade into a watercolor evanescence of vague outlines.

Before beginning to paint, Reverón performed rituals and exercises. He often bound his waist tightly with a rope in order to separate his mind from his sexuality, ideas from body. He wrapped his brushes and paint tubes in rags so as not to touch metal while painting, and stuffed his ears with cotton, deliberately seeking silence, trying to eliminate all that was not the visual experience, the painting itself. He stood half naked, his feet bare to make direct contact with

1. Armando Reverón. *Birdcage*. n.d. Bamboo, feathers, string, metal, paper, cardboard, gouache, and pastel, 22⅛ x 47¼". Fundación Museo Armando Reverón, Macuto

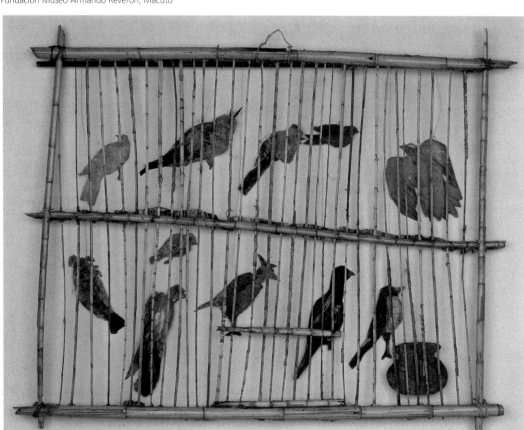

2. Armando Reverón. *Marina*. 1927. Oil on canvas, 18 x 21⅜". Fundación Galería de Arte Nacional, Caracas

3. Armando Reverón. *Rancho*. 1933. Oil and tempera on burlap, 17 x 18⅜". Collection Dr. Leopoldo José Briceno Iragorry, Caracas

the earth. With intense concentration and rapid gestures he moved rhythmically from one side of the canvas to the other.[4] Coupled with the isolation and asceticism of his daily existence, these exercises strengthened Reverón's efforts to focus completely on the creative experience.

In his search for pictorial simplicity, the artist progressively reduced and eliminated the pictorial elements in his paintings. From the mid-1920s until the early 1930s the colors slowly became diluted,

appearing almost without contrast in an intense chromatic atmosphere tending toward pure white. With great economy of means, he maximized the use and expressive value of his materials, while his energetic gestures created form with a few strokes. *El Arbol* [*The Tree*] of 1931 (plate 164) presents a landscape almost totally unencumbered by detail, reduced to its essence with abbreviated and simple strokes. A mere visual trace, submerged in the extreme luminosity of the painting, it reaches the limit of dissolution. Light—fulminating and direct—gives birth to and annihilates the image.

Reverón continued to paint landscapes until the mid-1940s. In these, as in his figurative works, the choice of materials was essential to his expression. His canvases remained unprimed or were prepared with textured grounds. He particularly preferred canvases of a very absorbent nature and with a visibly heavy weave, such as burlap or fabric made of agave fibers, using them as surface and color at the same time.[5] In *Paisaje en azul* [*Landscape in Blue*] of 1929 (plate 163), *The Beach* of about 1933 (Collection Alfredo Boulton, Caracas), and *Rancho* of 1933 (figure 3), shapes and vegetation emerge from the bare surface of the canvas or burlap. The swift strokes of the paintbrush define contour and color.

The very emptiness of the blank canvas functioned as the base from which form was structured. In *Woman's Face* of 1932 (Collection Patricia Phelps de Cisneros, Caracas) the features of a face emerge from the blank and silent space of the canvas with only sparse shadows and few brushstrokes. The image—immaterial, pure reflection within the intense brightness that envelops it—reveals the tension, the spectral pulse of the constant appearance and disappearance of form.

The artist painted figures throughout his career—portraits and nudes of Juanita Ríos, his lifelong companion,[6] and also images of local models, the dolls, and self-portraits. From the 1930s on, the female figure played a fundamental role in his production. The artist began to include in his compositions the rag dolls he made with Juanita. These dolls were enigmatic and complex elaborations of the artist's psyche that gradually took the place of living models. Lifesized, each with its own name, jewelry, and costume, the dolls merged with human models in Reverón's paintings until it became impossible to distinguish one from the other.

Reverón's work followed a relentless course of transformation and synthesis. After a process of chromatic reduction to a state of pure white he began reincorporating colors, yet his technique remained minimal and incisive. The bare surface of the canvas in *The Hammock (Against the Light)* of 1933 (figure 4) plays a major role in the overall configuration of the painting. As with a photographic negative, it reflects the effect of the intense light enveloping the scene by making shadows appear bright and the light areas dark. The evocative simplicity of Juanita's figure in the hammock, and that of her unidentified companion (a deliberate omission by Reverón of all that is not visually essential), suggests—from the intrinsic flatness of the plane itself—color, depth, and spatial relations.

Reverón painted not only light but climates, modes of experience. His later figure paintings belong to the introspective sphere of a world of desires, fantasies, and obsessions.[7] The veiled eroticism and distancing of *Maja* of about 1939 (figure 5) evoke a private, secret place of dreams from which the woman's figure seems to emerge. Reverón diffused the image, deliberately leaving it incomplete,

4. Armando Reverón. *The Hammock (Against the Light)*. 1933. Tempera and earth color on canvas, 46½ x 57½". Fundación Galería de Arte Nacional, Caracas

5. Armando Reverón. *Maja*. c. 1939. Oil on canvas, 41⅝ x 55⅝". Fundación Galería de Arte Nacional, Caracas

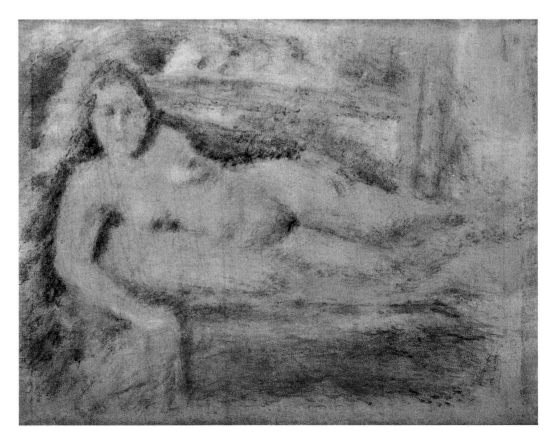

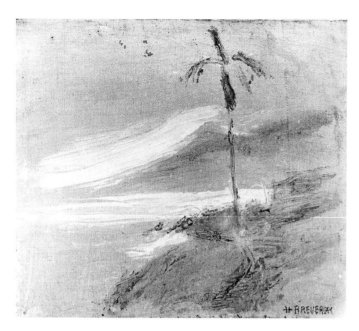

6. Armando Reverón. *Coconut Palm*. c. 1944. Oil and tempera on canvas, 19¾ x 23". Fundación Galería de Arte Nacional, Caracas

suspended in the plane. The monumental forms—constructed from subtle strokes that combine tempera, oil, and tenuous patches of color—appear to float weightlessly on the surface of the canvas.

In the 1940s Reverón painted figures, self-portraits, and images of the port of La Guaira, and summarized his experience of the landscape. The vigorous and concise strength of the line in *Coconut Palm* of about 1944 (figure 6), the economy of means, and the visual containment—consequence and continuation of his synthetic spirit—created a new dimension in its pictorial space. Depth is formed from a dialogue of planes, colors, and brushstrokes. With the simplest means—burnt sienna, ocher, the few dark strokes, the white of the sky and of the sea, each in its place—the extraordinary expressive power of the painting is conveyed.

In the final decade of his life, Reverón suffered two major mental crises and was confined to a sanatorium for short periods of time.[8] During these episodes he stopped painting but resumed once he had recuperated. His work became increasingly self-referential and introspective. He immersed himself completely in the private surroundings of the hut, in his world populated by dolls and objects, and by the phantoms of his imagination. From then until his death in 1954, Reverón rarely employed live models, preferring for his compositions the dolls he dressed and adorned.

Self-Portrait with Dolls and Beard of 1949 (figure 7) belongs to a series of self-portraits painted by the artist beginning in 1947.[9] In this picture, through the artifice of the mirror, the reality of his physi-

cal world and the fictional space of the dolls seem to fuse, leaving no discernible line between them.

Reverón's painting is that of an artist who chose fragments and limitations to conquer the infinity of vision. From the moment he decided to confine himself to the universe of his hut until his death, he returned again and again to the same themes, insisting on the landscape and the eternal feminine. His dwelling, the light, the sea he beheld each morning, and the dark sphere of his inner world constantly took on new dimensions and meanings.

By the time of his death in 1954, Reverón had developed a solid, coherent language of his own. Created from the particular reality of Venezuela and the boundaries of his own solitude, his language was so personal that it eluded the usual art-historical categories.

Although Reverón's artistic life spanned the modernist era, he was not directly concerned with the issues raised by modernism. It was his own individual work in the pursuit of a particular way of seeing that led him to modernity. His pictorial asceticism, his emphasis on the visual and on the flatness of the picture plane, his use of unconventional humble materials, and his subjective, unorthodox fusion of art and life are all part of the modernist tradition.[10]

With hardly any material resources, and from his own experience, Reverón created a universe. In the end, his was a search neither for the landscape, nor for the figure, nor for modernity—only for things visible.

7. Armando Reverón. *Self-Portrait with Dolls and Beard*. 1949. Carbon, pencil, chalk, and crayon on paper, mounted on cardboard, 25⅜ x 34½". Fundación Galería de Arte Nacional, Caracas

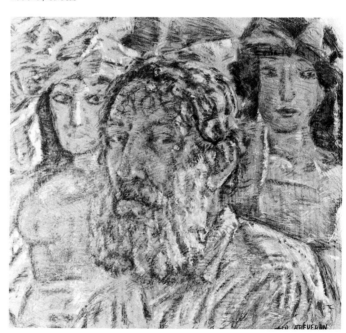

Notes

This essay was translated from the Spanish by M. Christina Lambert.

1. Various writers have disagreed on the exact date of Reverón's move to Macuto. Alfredo Boulton said it was 1920. See his *Reverón* (Caracas: Ediciones Macanao, 1979), pp. 97, 186. Juan Calzadilla wrote that Reverón did not move permanently to Macuto until 1921. See Juan Calzadilla and Wuilly Aranguren, eds., *Reverón: 18 testimonios* (Caracas: Lagoven and Galería de Arte Nacional, 1979), p. 7. Catalogues for exhibitions organized by the Fundación Galería de Arte Nacional in Caracas follow Calzadilla's dating. See the recent Miguel G. Arroyo et al., *Armando Reverón (1889–1954): Exposición antológica*. (Madrid: Museo Nacional Centro de Arte Reina Sofía, 1992), p. 182.

2. In notes relating to his European stay, drafted in his final years, Reverón stated that he "much admired the painters Degas, Martin, Sisley, Cézanne" and that he "spent long hours studying the masterpieces in the Louvre and Luxembourg museums." See Boulton, *Reverón*, p. 189.

3. To date, most of the research on Reverón's work follows, in a more or less precise manner, the chronology established by Boulton, who, in his various publications, divided the artist's production into three chromatic periods: Blue (c. 1915–24), White (1925–36), and Sepia (1936–49). Although it has been an important reference for the organization and general comprehension of the artist's work, this periodization has limitations and presents more than a few problems.

 Several issues complicate the actual and relative dating of Reverón's paintings. His emphasis on certain colors results from his engagement in expressive and technical research, and thus distinctions between one predominating hue and another in a given work are often not clearly definable. He did not adhere strictly to a progressive utilization of color schemes in his painting, often reemploying color schemes from an earlier period and using a number of different color schemes during the same period. In addition, as Boulton himself pointed out, it is known that the artist signed and dated many of his works at the time he sold them, even if they had been painted months or even years earlier. Thus Boulton's sequence of chromatic periods can be misleading. The task of assembling Reverón's oeuvre for a comprehensive comparison and a more tenable relative dating has yet to be undertaken.

4. The various exercises performed by Reverón prior to painting have been described by several authors. See Boulton, *Reverón*, pp. 100, 117; Juan Liscano, "Tras la experiencia de Armando Reverón," in Raúl Díaz Legórburu, ed., *Armando Reverón: 10 ensayos* (Caracas: Concejo Municipal del Distrito Federal, 1975), p. 46; José Nucete Sardi, "Armando Reverón, un Gauguin moderno," in Calzadilla and Aranguren, *18 testimonios*, p. 17.

5. For an excellent study of Reverón's materials and their expressive use, see the 1979 essay by Miguel G. Arroyo C., "El puro mirar de Reverón," in Roldán Esteva Grillet, ed., *Arte, educación y museologia: Estudios y polémicas, 1948–1988* (Caracas: Biblioteca de la Academia Nacional de la Historia, 1989), pp. 87–95.

6. A woman of humble origins, Juanita Ríos lived with Reverón from 1918 until his death. In most of the literature on Reverón, she is called, simply, Juanita. Her surname is the subject of some confusion. Boulton and most other sources agree on Ríos. Boulton, however, also paraphrases Reverón himself, who, in an autobiographical note, referred to her as "Juanita Mota." See Boulton, *Reverón*, p. 189.

7. The paintings of figures belong to a universe completely different from the one of his landscapes. They seem connected with a psychological side of Reverón, linked with obscure aspects of his own obsessions and complex relationships with women. They are more expressionistic in character, and after the 1930s the majority of them suggested interior, rather than outdoor, spaces.

8. The first of Reverón's mental crises occurred in 1945 and lasted three months. The second one, in 1953, lasted almost a year. They both led to his hospitalization in the sanatorium San Jorge in Caracas, under the care of the psychiatrist J. M. Báez Finol. The artist died at the sanatorium of a cerebral embolism on September 18, 1954.

 There has been much discussion about Reverón's mental illness, its sources, and its possible effect on the artist's production. The few rather general medical essays published on the subject were written by Báez Finol and another psychiatrist, Moisés Feldman, and consist of hypothetical diagnoses drawn in retrospect. They mention that Reverón experienced two major psychotic crises during his life. Báez Finol traced their possible origins to either encephalitis, which he may have developed as a consequence of typhoid fever contracted when he was a child, or perhaps his unstable family history. See the account of a 1955 conference by Báez Finol at the Galería de Arte Nacional in *Armando Reverón: Colección María Josefa Báez Loreto* (Caracas: Ediciones Galería de Arte Nacional, 1981), pp. 4–12. Later on, Báez Finol retracted his diagnosis of encephalitis. See *Presencia y luz de Armando Reverón: Exposición iconográfica documental en el centenario de su nacimiento* (Caracas: Ediciones Galería de Arte Nacional, 1989), p. 37. Feldman never treated Reverón and wrote his essays more than twenty years after his death. Feldman generally agreed with Báez Finol's diagnosis. He also suggested that Reverón's way of life, while the result of his search for a solitary space in which to pursue his artistic vision, could also be viewed as his own therapeutic response to an intuitive need to create an environment conducive to the preservation of his mental stability. See "Reverón y sus muñecas," *Imágen* (1987), p. 38; "Aspectos Psicopatológicos de Reverón," in Legórburu, *10 ensayos*, pp. 155–63, and, in the same volume, "Armando Reverón y sus muñecas," p. 38.

 In the absence of clinical studies, efforts to establish a relationship between Reverón's mental condition and his work remain speculative.

9. While Reverón painted self-portraits throughout his career, twenty of the thirty-one known self-portraits were produced between 1947 and 1951, and the majority of these depict the artist with dolls. See Rafael Romero, "Autorretrato 1944," in *Presencia y luz de Armando Reverón*, p. 93.

10. Modernism was a break with the methods and techniques of artistic practice as much as a radical rupture in the nature of representation. Reverón was modern particularly in his attitude and commitment to his medium. Painting for him was, above all, a purely visual experience.

XUL SOLAR: WORLD-MAKER

—

Daniel E. Nelson

The Argentine artist Xul Solar, born Oscar Agustín Alejandro Schulz Solari in 1887, played a crucial role in the Argentine avant-garde of the 1920s. His work evolved from a synthesis of European avant-garde styles into a unique artistic expression specifically suited to the cosmopolitan environment of Buenos Aires. During the course of his life, Xul Solar created a number of inter-related verbal and visual languages expressing both his identity as an Argentine/Latin American artist and a utopian desire for universal brotherhood.

Xul Solar was born in San Fernando, Buenos Aires province, to a German father and an Italian mother. Very little is known of his early life. He attended a normal school in Buenos Aires and briefly studied architecture before obtaining a municipal job[1] and dedicating himself to the study of languages, literature, art history, religion, astrology, music, theater, and philosophy.[2] Absorbed by his studies of comparative religion, he left Argentina in 1912 seeking spiritual enlightenment in the Far East, but he disembarked in Europe instead and began a twelve-year tour of the Continent.[3] In Europe he assimilated the literary and plastic languages of Symbolism, Cubism, Futurism, Expressionism, and Constructivism; synthesized a verbal and visual language of his own invention; and began to construct images of his own spiritual universe in watercolor, his medium of choice.

In Paris in 1914 Xul Solar began painting watercolors reflecting his interest in theosophy. The Theosophical Society, founded in 1875 by Helena P. Blavatsky and Henry Steel Olcott, combined Eastern and Western mysticism in order to give the individual direct access to spiritual reality outside of organized religion. Theosophy exerted a significant influence on European modernism, amply documented in the exhibition *The Spiritual in Art: Abstract Painting 1890–1985*.[4] Xul Solar found in it a theoretical framework for the spiritual content of his art. By the time he moved to Florence, in 1916, his fellow Argentine vanguardist Emilio Pettoruti, favorably impressed by the technique and hermetic content of his early watercolors,[5] found him already "full of artistic, linguistic, philosophic, religious, and esoteric preoccupations."[6] His change of name that same year also manifested his interest in theosophy: *xul* is an anagram of *lux*, Latin for *light*, while in Spanish *solar* is an adjective referring to the sun, so his name may be translated "Solar Light." Blavatsky herself defined theosophy as "the pure colorless sunlight of eternal truth."[7] Xul Solar's new name reflected the ethereal nature of his personality, too, which Pettoruti characterized as "that of a being who rises above himself, all light and all spirit."[8]

In one of his earliest watercolors, *Man-Tree* of 1916 (figure 1), Xul Solar emphasized the themes of light and spirituality by combining a self-portrait with an image of a flaming tree. A masklike image of the artist's head and a flame appear on either side of the fifth branch of a seven-branched tree. In theosophical thought each universal cycle consists of seven phases, which are in turn composed of seven stages of human evolution.[9] *Man-Tree* symbolizes humanity's present position in the fifth stage of the fourth phase. According to Blavatsky, the human personality is also divided into seven aspects of increasing spirituality: Physical Body, Vital Principle (Prâna), Astral Body, Animal Soul, Human Soul, Spiritual Soul (Buddhi), and Spirit (Atman).[10] The Buddhi retains the individuality of the soul, as it remains constant through multiple incarnations. Blavatsky also characterized the Buddhi as a tree or vine, with the Animal Soul—which

changes with each incarnation—symbolized by an individual branch.[11] In this watercolor Xul Solar represents his Buddhi as the tree and places his Animal Soul on the fifth branch, which echoes humanity's present evolutionary state and the esoteric principle that "things are above as they are below."[12]

Xul Solar's most accomplished metaphor for his search for enlightenment is the watercolor *Trunks* of 1919 (figure 2). In his use of geometric shapes to represent figures, flattening of imagery, and dynamic composition, he reveals his knowledge of Cubism and Futurism. In the lower right corner appear a crescent moon and two serpents, one lying flat on the earth while the other lifts his head above ground. Between two stick figures, a stylized gray bird soars in an orange sky toward the sun. Both bird and serpent are archetypes of spiritual transcendence in many cultures,[13] while the trunks themselves are stylized male and female representations of the cosmic tree, seen before in *Man-Tree*.[14] These figures rise toward the sun as they complete the zigzag motion from lower right to upper left initiated by the bird and serpents. The ascent into the sun typifies Xul Solar's realization of theosophy's search for spiritual transcendence of the material world.

Xul Solar's Italian period ended in 1920, when Pettoruti arranged the artist's first European exhibition, in Milan. Although it received excellent reviews, there were no sales because of the painter's steadfast refusal to part with his works. Soon afterward, Xul Solar moved to Munich, where he studied decorative arts in one of the local art schools and became acquainted with Paul Klee's work. He identified with certain elements of Klee's style, such as the arrows and broad bands of translucent color. These motifs began to appear as compositional elements in Xul Solar's watercolors in 1921.[15] During this period, perhaps in reaction to the unstable conditions in the Weimar Republic, or perhaps because he was homesick, he started to think of returning to Argentina. As a result, he started incorporating Latin American elements into his work, such as the Argentine flag in *I Miss My Fatherland* of 1922 (Galería Rubbers, Buenos Aires) and the pre-Columbian motifs in *Nana-Watzin* of 1923 (plate 227), which suggest that he was consciously working toward constructing his identity as a Latin American artist so as to transcend his own European immigrant heritage.

Hence, *Nana-Watzin* is an example of Xul Solar's integration of pre-Columbian language and mythology into his work as a means of establishing his own cultural identity. This watercolor is reminiscent of Klee in its iridescent palette and geometric approach to biomorphic forms. The central figure, Nana-Watzin, leaps into the heart of the fire as arrowlike flames rise toward the sun. According to Aztec cosmology, from which Xul Solar drew, the sun of the present era was born when the syphilitic god Nanauatzin, a manifestation of the dog-headed sun-god Xolotl, leaped into a bonfire and reappeared as the sun.[16] The fire itself burns on a hearth dedicated to Tlazolteotl, an Aztec earth goddess associated with the moon,[17] as well as with "carnal sin, confession and penitence."[18] A soaring *quetzal* bird emphasizes the connection of Nana-Watzin with Quetzalcoatl, god of creation and purification.[19] To the left of Nana-Watzin, a combination of Spanish and Portuguese words reads "*renovación por fogo santo*" ("renovation by holy fire"), referring to the process of purification through fire. Above the flames appear the words "*flama pa[ra e]l sol*" ("flames toward the sun"), representing Nana-Watzin's

transcendence of his physical state. This idiosyncratic blend of Spanish, Portuguese, and the Aztec language Nahuatl is *neocriollo*, a language of Xul Solar's own invention through which he sought Latin American cultural unification.

When Xul Solar and Pettoruti returned to Argentina in July 1924, they both joined the Florida group, which along with Boedo was one of the two avant-garde movements active in Buenos Aires at that time. The avant-garde artists and writers of Florida, gathered around the influential art and literary review *Martín Fierro*,[20] opposed both the prevalent fin-de-siècle decadence of French Impressionism and Spanish-American modernism, as well as the program of the Boedo group, which rejected the formal innovations of Florida in favor of promoting social revolution. The *martinfierristas* aimed at the

1. Xul Solar. *Man-Tree*. 1916. Watercolor on paper, 11¾ x 7⅛". Fundación Pan Klub, Museo Xul Solar, Buenos Aires

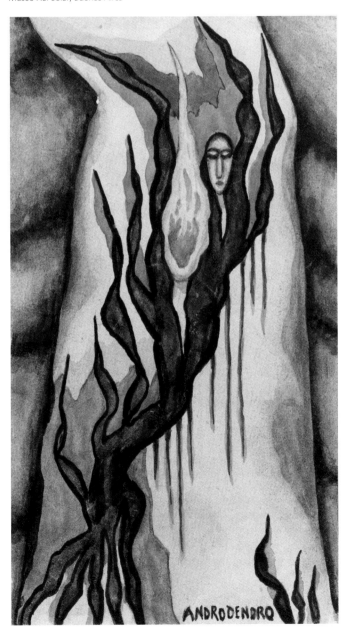

2. Xul Solar. *Trunks*. 1919. Watercolor on paper, 12⅜ x 18½". Collection Carol Lynn Blum de Lowenstein, Buenos Aires

3. Xul Solar. *Celestial Landscape (Flags)*. 1933. Watercolor on paper, mounted on cardboard, 15⅞ x 20⅝". Gradowczyk Collection, Buenos Aires

4. Xul Solar. *Panjogo*. c. 1940. Painted wood with metal hardware, dimensions variable. Fundación Pan Klub, Museo Xul Solar, Buenos Aires

complete renovation of Argentine arts and letters. Their ultimate goal was a selective adaptation of European modernism to meet the expressive needs of artists and writers functioning in the modern, but culturally conservative, environment of urban Buenos Aires in a way that would be relevant to their Latin American circumstances.

Although the Argentine *ultraísta*[21] Norah Borges (sister of Jorge Luis Borges) had already introduced European modernism to Buenos Aires through the woodcuts she published in the cultural reviews *Prisma* and *Proa* beginning in 1921, the Argentine public was still relatively unprepared for avant-garde art. Unsurprisingly, Pettoruti's first exhibition in Buenos Aires—at the Salón Witcomb in October 1924—provoked a riot,[22] in spite of Xul Solar's explanatory article "Pettoruti," which had appeared on the front page of *Martín Fierro* before the exhibition opened.[23] Xul Solar displayed his work with the other *martínfierristas* in numerous group exhibitions during the 1920s,[24] and in 1926 he participated with Pettoruti and Norah Borges in an exhibition organized in honor of the Italian Futurist poet Filippo Tommaso Marinetti's visit to Buenos Aires.[25] At the same time he also began a collaborative relationship with Jorge Luis Borges involving book illustration and linguistic investigation. In all these ways he played a leading role in the campaign to establish an Argentine modern style undertaken by the Martín Fierro group, even though his works, unlike those of Pettoruti, were virtually unknown outside the group.

During this period, while maintaining his international outlook and personal iconographic system, Xul Solar began to focus more on his identity as an Argentine/Latin American artist, and as a result his art underwent important changes. *Mundo* [*World*] of 1925 (plate 230) exemplifies this Americanist evolution in his art. In this small watercolor a winged dragon carrying a human figure and a multitude of flags flies from right to left above the ocean, weaving an undulating path among celestial bodies. At the bottom of the composition, two red fish signifying transcendence rise from the lower depths of the ocean, just as the serpents emerge from the earth in *Trunks*. Crowned by the symbols of Christianity, Judaism, and Islam, the winged dragon combines features of the serpent and bird as symbols of transcendence.[26] The flags of the Latin American nations adorn the dragon itself, while those of the colonial powers are relegated to the periphery. A humanoid figure with an arrow emerging from his forehead rides atop the dragon; the arrow points directly toward the sun, as does the spear he carries. This shaman figure wears an X-shaped sash and a large curved headdress, also marked with an X, which often functions as an abbreviated signature of the artist. In this case the X suggests that the shaman represents Xul Solar himself as a militant leader guiding Latin America toward cultural self-empowerment. In essence this work combines Xul Solar's program for a national modern style with his interest in spiritual enlightenment. The complex tension between national and universal values is the hallmark of his early Argentine work.

Beginning in the 1920s Xul Solar further developed *neocriollo* in a series of literary texts known as the *San signos*, which described visions he saw in trancelike meditations. In the early 1930s, with the collapse of the Argentine avant-garde as an organized movement, he withdrew into himself and began to translate these visions into painted form in a new style. Only two of the *San signos* have been published to date: "Apuntes de neocriollo" and "Poema." The

watercolor *Bri, país y gente* [*Bri, Country and People*] of 1933 (plate 232) is a visual representation of Bria, the "world of souls"[27] described in these writings. The image is dominated by a series of two-dimensional, screenlike skyscrapers that resemble "towers of cards" rising from a "great pit or bottomless valley."[28] On a V-shaped ramp "suspended in the night"[29] a procession leads a Chinese dragon along the descending path while four pilgrims climb the ascending path. "Stars, little suns, moons, tiny moons" hang suspended from the ceiling in the "deep solid black theo-night."[30] This watercolor, like *Celestial Landscape (Flags)* of 1933 (figure 3), depicts Xul Solar's mystical mental universe, a spirit-country in which the viewer joins the artist on a journey toward spiritual transcendence.

During the late 1930s and early 1940s Xul Solar painted relatively little and exhibited even less, as he pursued new interests.[31] His most ambitious project during this period was the creation of the monosyllabic, astrologically based language *panlengua*, composed of roots taken from many languages and aimed at creating the universal brotherhood advocated by theosophy. Each consonant represented an entire category of ideas, qualified by the vowels to produce words arranged in a positive/negative series.[32] Its "dictionary" was the astrological chess game Panjogo (pan-game), governed by base-twelve mathematics. The consonants were the game pieces and the vowels the 169 squares of the board (figure 4).[33]

In 1943 Xul Solar began to produce a series of somber temperas and black-and-white sketches depicting mountainous landscapes and fantastic cityscapes. Traversed by stairs and ladders and peopled with mystics and gurus, these works are reminiscent of the settings of short stories by Borges, especially "La biblioteca de Babel" ("The Library of Babel") of 1944[34] and "El inmortal" ("The Immortal") of 1949.[35] Overshadowed by the war years and the dictatorship of Juan Perón, paintings such as the tempera *Borders of San Monte* of 1944 (figure 5) provide a much darker vision of life than anything in Xul Solar's previous oeuvre.

During the 1950s Xul Solar designed a series of whimsical architectural projects intended for the Delta del Tigre area of the Río de la Plata, where he owned a small house. Other important works of this period, like *Mars-Saturn* of 1954 (figure 6), showed astrological, duodecimal versions of the Sefirot, or cabalistic Tree of Life. The Sefirot are the attributes of God arranged in a Tree of Life pattern linked by pathways corresponding to the letters of the Hebrew alphabet.[36] In this watercolor the artist interpreted the Sefirot as containing "all things in the cosmic order."[37] According to the artist, each attribute is represented by a planet, while the paths are associated with zodiacal signs and artistic movements in his "total aesthetic doctrine."[38]

Toward the end of the decade, Xul Solar began his last artistic project, a series of paintings titled Grafías (Ideograms) involving the translation of phrases in *panlengua* into a series of plastic scripts of his own invention whose diverse styles can be defined as geometric, block letter, cursive, vegetable, anthropomorphic, and mixed.[39] These works literally transform the contemplation of the painting into the reading of a text and make the spectator an active participant in the creation of meaning. Xul Solar produced at least three versions of the phrase "*Lu kene ten lu base nel nergie, sin nergie, lu kene no e kan*" in 1961, one geometric, another in block letters, and a third in cursive script. The title, *Knowledge Has Its Base in Energy, Without*

5. Xul Solar. *Borders of San Monte*. 1944. Tempera on paper, mounted on cardboard, 13¾ x 19⅝". Collection Juan Alejo Soldati, Buenos Aires

6. Xul Solar. *Mars-Saturn*. 1954. Ink and watercolor on paper, 14⅛ x 9⅜". Museo de Arte Moderno, Buenos Aires

7. Xul Solar. *Knowledge Has Its Base in Energy, Without Energy Knowledge Is Not Possible.* 1961. Tempera on paper, mounted on cardboard, 6⅜ x 12". Gradowczyk Collection, Buenos Aires

8. Xul Solar. *Knowledge Has Its Base in Energy, Without Energy Knowledge Is Not Possible, II.* 1961. Tempera on paper, mounted on cardboard, 6 x 11³⁄₁₆". Rachel Adler Gallery, New York

9. Xul Solar. *Knowledge Has Its Base in Energy, Without Energy Knowledge Is Not Possible, III.* 1961. Tempera on paper, mounted on cardboard, 5¾ x 12". Rachel Adler Gallery, New York

Energy Knowledge Is Not Possible, alludes to the theosophical theory of spiritual energy set forth in Annie Besant and Charles W. Leadbeater's *Thought Forms* (1905). The verticals and polygons of the first version (figure 7) recall Vasily Kandinsky's geometric abstractions of the early 1920s, while the second (figure 8), with its multicolored block letters and esoteric signs, suggests the work of Paul Klee. The third (figure 9) has a more curvilinear and diagonal motion, which is distinctively Xul Solar's own. A close comparison of the three works allows a keen reader/observer to "crack the code" and decipher the meaning of the phrase embedded in the paintings.

Taken as a whole, Xul Solar's oeuvre emphasizes communication in all its forms. Only an overarching communicative aim can explain his creation of multiple visual and verbal languages. *Neocriollo*, a vehicle of Latin American cultural unification, represents Xul Solar's definition of himself and his art in regional terms, while *pan-lengua*, a universal language, characterizes him in theosophical terms as a citizen of the world at large. Nonetheless, this conflict between regionalism and universality is only apparent because his ultimate, utopian goal was to move beyond national/regional barriers to unite all of humanity through the creation of a common language and culture. By viewing his paintings and reading his writings, it is possible to join this global community and experience, if only for a moment, his message of union with the cosmos on a metaphysical level. Unfortunately, his public was not always equal to the task. His pioneering efforts in the 1920s toward defining and establishing the Argentine avant-garde were known only to a small group. During the remainder of his life, his work was appreciated only by a reduced circle formed by his family, friends, and disciples. Not until after his death in 1963 did his contribution to Argentine art and literature reach a wider audience and begin to receive the attention it deserves.

Notes

1. J. M. Taverna Irigoyen, *Xul Solar* (Buenos Aires: Centro Editor de América Latina, 1980), p. 2. This work was mistakenly attributed by the publisher to Irigoyen; the author is Jorge López Anaya.

2. Osvaldo Svanascini, *Xul Solar* (Buenos Aires: Ediciones Culturales Argentinas, 1962), p. 33.

3. Mario H. Gradowczyk, *Alejandro Xul Solar: 1887–1963* (Buenos Aires: Galería Kramer and Ediciones Anzilotti, 1988), p. 67. The reasons for his change of destination remain unclear.

4. Maurice Tuchman, ed , *The Spiritual in Art: Abstract Painting, 1890–1985* (Los Angeles: Los Angeles County Museum of Art, 1986).

5. Emilio Pettoruti, *Un pintor ante el espejo* (Buenos Aires: Hachette, Solar, 1968), p. 101.

6. Ibid.

7. H. P. Blavatsky, *The Key to Theosophy: An Abridgement*, ed. Joy Mills (reprint ed., Wheaton, Ill.: Theosophical Publishing House, 1972), p. 33.

8. Pettoruti, *Un pintor*, p. 103.

9. Blavatsky, *Key to Theosophy*, p. 120.

10. Ibid., p. 56.

11. Ibid., pp. 114–15.

12. Maurice Tuchman, "Hidden Meanings in Abstract Art," in Tuchman, *The Spiritual in Art*, p. 28.

13. Joseph L. Henderson. "Ancient Myths and Modern Man," in Carl G. Jung, ed., *Man and His Symbols* (New York: Doubleday Anchor, 1964), pp. 151–54.

14. Titus Burckhardt, *Alchemy: Science of the Cosmos, Science of the Soul*, trans. William Stoddart; ed. Jacob Needleman (1960; reprint ed., Baltimore: Penguin, 1971), pp. 130–38.

15. Pettoruti, *Un pintor*, pp. 135–40.

16. Thomas A. Joyce, *Mexican Archaeology: An Introduction to the Archaeology of the Mexican and Mayan Civilizations of Pre-Spanish America* (1914; reprint ed., New York: Hacker, 1970), p. 51.

17. Ibid., p. 52.

18. Ibid., p. 44.

19. Ibid., pp. 46–48.

20. Pettoruti, *Un pintor*, pp. 171–85.

21. Norah and Jorge Luis Borges introduced *ultraismo*, a Spanish literary and artistic movement of the 1920s, to Buenos Aires after their return from Madrid in 1921. The Argentine *ultraistas* published the cultural reviews *Prisma* and *Proa*. They opposed the decadence of Spanish-American modernism and sought to reduce poetry to pure metaphor.

22. Pettoruti, *Un pintor*, pp. 186–87.

23. Ibid., interleaf, pp. 80–81.

24. Gradowczyk, *Alejandro Xul Solar*, p. 67.

25. Pettoruti, *Un pintor*, p. 212.

26. Henderson, "Ancient Myths," pp. 154–56.

27. Xul Solar, "Apuntes de neocriollo," *Azul: Revista de ciencias y letras* 11 (August 1931), p. 205.

28. Xul Solar, "Poema," *Revista Xul* 1 (October 1980), p. 21.

29. Xul Solar, "Apuntes de neocriollo," p. 202.

30. Xul Solar, "Poema," p. 22.

31. Gradowczyk, *Alejandro Xul Solar*, p. 15.

32. Svanascini, *Xul Solar*, pp. 8–9.

33. Ibid., p. 9.

34. Jorge Luis Borges, "The Library of Babel," in his *Ficciones*, ed. and trans. Anthony Kerrigan (London: Weidenfeld; New York: Grove, 1962).

35. Jorge Luis Borges, "The Immortal," in his *The Aleph and Other Stories, 1933–1969, Together with Commentaries and an Autobiographical Essay*, ed. and trans. Norman Thomas di Giovanni (New York: E. P. Dutton, 1970).

36. Tuchman, *The Spiritual in Art*, p. 372.

37. Svanascini, *Xul Solar*, p. 38.

38. Ibid.

39. Gradowczyk, *Alejandro Xul Solar*, p. 15.

TARSILA DO AMARAL

Fatima Bercht

The Brazilian painter Tarsila do Amaral, along with other pioneers of modernism in the Americas, began her career as a painter in the academies of her homeland and Europe. But it was the progressive elements in the intellectual and artistic community of São Paulo that changed her course. Amaral's objective in her art—to develop a style that was simultaneously Brazilian and modern—led her to seek artistic training directly from the Parisian avant-garde and to learn a modernist language through which her unique poetic sensibility could be expressed. Although her career spanned five decades, it was a small group of radically original paintings she created in the 1920s that was instrumental in the modernization of art and culture in her native country.

Amaral was born in 1886 and raised on a farm in the interior of the state of São Paulo, in southern Brazil. Her family were bourgeois landowners who provided her with a comfortable and privileged upbringing, which enabled her to pursue a career as an artist without financial concerns, at least until the beginning of the international economic depression in 1929. Her talent for the visual arts began to manifest itself when she was still an adolescent, yet she pursued formal artistic training seriously only after her first marriage had ended. In 1913 she moved to the city of São Paulo, then the second largest in Brazil. The city was the chief commercial center of the country, especially for the export of coffee, Brazil's most important crop. Industry was booming in São Paulo at this time, and new modes of production provided a new economic, philosophical, and social outlook; this provoked dissatisfaction with tradition and a desire for the new, and helped foster an incipient modernism in the city's cultural milieu.

In 1916 Amaral began formal training in São Paulo, taking three years of art classes with academic painters and sculptors.[1] In June 1920 she went to France, where she continued to study with academicians.[2] A measure of Amaral's persistence and success at this early stage of her career is the fact that one work, a picture of a woman titled *Figure* of 1922 (Collection João Marino, São Paulo), was accepted at the Salon de la Société des Artistes Françaises in Paris in 1922.[3]

While in Paris, Amaral was kept abreast of developments among the modernist artists and writers of the São Paulo avant-garde, which culminated in the interdisciplinary *Semana de arte moderna* in February 1922, a week-long sequence of poetry readings, concerts, and an art exhibition in the Teatro Municipal de São Paulo. Amaral's chief correspondent appears to have been Anita Malfatti, the pioneering Brazilian painter who worked in a style influenced by Fauvism and German Expressionism.[4] When Amaral returned to Brazil in June 1922, Malfatti introduced her to the modernist writers Oswald de Andrade, Mário de Andrade, and Paulo Menotti del Picchia, all of whom had been key figures in the organization of the *Semana*. Amaral had a studio built for herself, where the two painters and three writers often met and where they formed the Grupo dos Cinco. Until her return to Brazil and her discussions with the São Paulo modernists, Amaral really had had only minimal understanding of what modernism entailed.[5] For example, she had not cared for Malfatti's controversial 1917 exhibition in São Paulo; Malfatti worked in a highly expressionistic style, with very free use of color, for which the Brazilian art community was not prepared. Nor did she like the Cubism and Futurism at the Salon d'Automne in Paris

in 1920, although she was also no longer enthusiastic about the academic art exhibited there.[6] She also wrote of her disagreements with the book by the Italian Umberto Boccioni, *Pittura, scultura futuriste: Dinamismo plastico*, which she was reading, finding his invectives against traditional art and literature offensive.[7]

The regular meetings and discussions about modernism with the members of the Grupo dos Cinco and other participants in the São Paulo vanguard ultimately changed Amaral's ideas about art and were decisive in shaping her future direction. Malfatti's achievements with modernist visual language had an effect on Amaral that was discernible in the change that occurred in her paintings at this time, especially in liberating her use of color. On a theoretical level, the writers advocated the development of artistic means capable of addressing the modern urban experience of São Paulo and the diverse cultural reality of Brazil.[8] These ideas for a modernist and nationalist art must have affected Amaral at this time, but only surfaced in her art—and then forcefully—during the next year in France, to which she returned in December 1922.[9] Oswald de Andrade, who had fallen in love with her, followed in January 1923. For about three months, Amaral attended the school of André Lhote, a painter who taught a classicizing and rather conservative version of Cubism. "Cubism is the military service of the artist," she later stated. "To be strong, every artist should go through it."[10] Amaral and Andrade began to hold informal salons in their apartment-studio; they invited Brazilian artists and intellectuals living in Paris to meals where they could come in contact with their French counterparts. In May the couple met the poet Blaise Cendrars, with whom they quickly became friends. Cendrars introduced Amaral to Constantin Brancusi, Guillaume Apollinaire's widow Jacqueline Kolb, Jean Cocteau, and Fernand Léger.

During her stay in Paris, Amaral methodically pursued her goals as an artist with a strong sense of determination. Even her salons should be seen as an effort to create an atmosphere of intellectual challenge and exchange. From the academic Cubism of Lhote, Amaral went on to learn modernism from two major figures of the avant-garde who took students. In the fall she started attending classes at Léger's studio. She wrote home to her family: "Today I started with Léger. I went by his studio last Saturday and brought some of my recent works, the more modern ones. He though I was very advanced and liked some of them immensely. I went home very excited. I will see if I can also take some lessons with Gleizes, a very advanced artist. . . . With these lessons I will come back conscious of my art. I only listen to what suits me from the teachers. After these lessons, I don't intend to continue with teachers."[11] She did not stay with Léger long, although they remained friendly; she went on to study with Albert Gleizes for less than a month and a half.[12]

In fact, by the time she painted the groundbreaking image *A Negra* [*The Black Woman*] in 1923 (plate 2), Amaral had already abandoned the type of Cubism she had learned from Lhote, which in some pictures had become a kind of Cubist-inflected naturalism, in favor of a simplified and flattened treatment of space and form. *The Black Woman* depicts a nude woman sitting cross-legged. Her massive proportions and rounded volumes give her an almost sculptural monumentality that recalls the cylindrical, machined volumes of figures painted by Léger. However, *The Black Woman* was painted

before Amaral had actually met the French modernist; she later recounted that it was a painting that Léger particularly admired at their first meeting.[13]

Despite its formal correspondence to the standard figures of Parisian modernists, *The Black Woman* immediately asserts a difference by virtue of its subject. It depicts a black woman in a tropical setting, denoted by the stylized banana leaf seen over her right shoulder. The figure is made explicitly sexual by her exposed, pendulous breast and by the configuration of her exaggerated lips. This image also brings to mind the Afro-Brazilian wet nurses often employed by families of European descent throughout Brazil.[14] The breast and the crossed legs, however, precisely echo the features of an Afro-Brazilian religious sculpture of Yemanjá, a Yoruba deity. It is not known if Amaral ever saw a figure of this type, but on the formal evidence alone, it seems likely.[15] Regardless of its derivation, the iconic woman in Amaral's painting can easily be interpreted as an archetypal fertility figure.

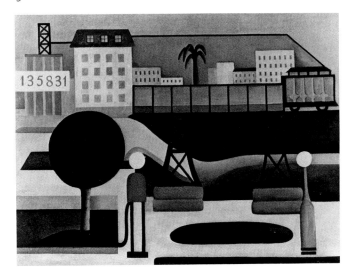

1. Tarsila do Amaral. *São Paulo (135831)*. 1924. Oil on canvas, 22⅞ x 36". Pinacoteca do Estado da Secretaria de Estado da Cultura de São Paulo

The association of primordial themes and the body of a black woman or man is a primitivist trope that runs throughout the history of modernism. The rage for all things *nègre* among the Parisian avant-garde in the 1920s encompassed everything from African sculpture to the dancing of the African-American Josephine Baker.[16] In 1923, the same year Amaral painted *The Black Woman*, Constantin Brancusi created *La Négresse* (Philadelphia Museum of Art), a smooth, white marble ovoid with topknot, devoid of distinguishing features save for a protruding pair of slightly off-center lips, which Amaral probably saw on her visit to the sculptor's studio.[17] Also that year, Léger was at work designing sets and costumes for the Ballets Suédois production of *La création du monde*, written by Cendrars.[18] This ballet depicted an "African" genesis in which African art forms were used to signify the primordial. One of Léger's drawings for the stage set even depicts a figure similar to *The Black Woman* in its slitted oval eyes, wide, blunt nose, oval mouth with emphasized lips, and, most tellingly, a single breast hanging over an arm crossing the chest.[19] Other primitivizing events of note during that year included

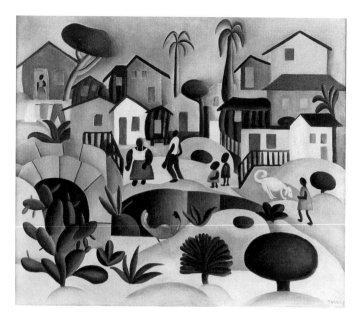

2. Tarsila do Amaral. *Hill of the Shantytown*. 1924. Oil on canvas, 25¼ x 29⅞". Collection João Estéfano, São Paulo

3. Tarsila do Amaral. *Carnival in Madureira*. 1924. Oil on canvas, 28⅞ x 24⅞". Private collection

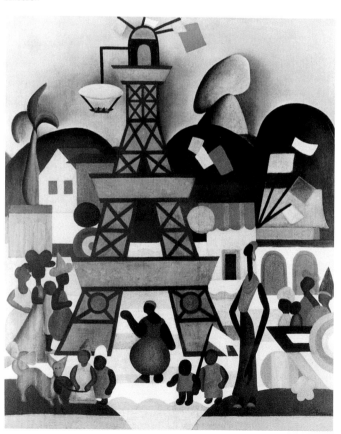

a retrospective of Paul Gauguin's work in April and May; an exhibition of *art nègre* at the end of the year, for which Lhote and Paul Poiret (Amaral's friend and couturier) lent works; and, in November, a Pedro Figari retrospective at the Galerie Druet, which included the Uruguayan painter's images of South American black life and customs, including *candombe* dances.

Like her contemporaries, Amaral was aware of African sculpture, but her use of Afro-Brazilian forms and bodies bore a different meaning than the primitivism of the Europeans. Upon his arrival in Paris, Andrade had presented a lecture at the Sorbonne, noting the "full modernity" of the "suggestive presence of the black drum and the chant of the Indian."[20] For Amaral and Andrade, the representation of Afro-Brazilian culture, however simplified or dimly understood, was part of their nationalist and modernizing agenda. Far from escapist exoticism, their reclamation of the African component of Brazilian society was an engagement with the modern reality of their country, elevating subjects formerly consigned to oblivion by the cultural elite to an emblematic expression of the nation.[21] Similar representations of Afro-Brazilian people and culture are found in the work of Emiliano di Cavalcanti, a friend of Amaral in Paris and one of the key instigators of the *Semana* in 1922. Vicente do Rego Monteiro, also in Paris in the 1920s, likewise explored indigenous Brazilian subjects and themes in his art.

Amaral returned to São Paulo in late December 1923, and Andrade followed shortly thereafter. She quickly established herself as a leading proponent of modern art in Brazil; her own paintings as well as her collection of European art caused a stir in that city's still conservative cultural circles.[22] In a newspaper interview published upon her arrival in Rio de Janeiro, while she was still en route to São Paulo, she stated her goals as an artist: "I intend to work, mainly. I am deeply Brazilian and I am going to study the taste and the art of our country people [*caipiras*]. I hope to learn with those who have not been corrupted by the academies. To be a Brazilian artist is not to paint only Brazilian landscapes and farmhands [*caboclos*]."[23]

Amaral was the only Brazilian-born artist included in the first exhibition of French modernist paintings that Blaise Cendrars, who had arrived in Brazil in February 1924, organized at the Conservatório Musical de São Paulo that June.[24] With Amaral, Andrade, and a group of friends, Cendrars made two major journeys to experience "authentic" Brazilian culture during his six-month stay in South America, the first to Rio de Janeiro to attend Carnival, the second through the state of Minas Gerais with its colonial towns and baroque churches. Cendrars's visit was significant, as Aracy Amaral has written, because his example affirmed the artistic directions of Oswald de Andrade and Tarsila do Amaral.[25] Their travels with the European poet set into motion their "rediscovery" of Brazil.

Amaral sketched on these sojourns, making schematic and notational records of the landscape, towns, buildings, animals, and people she saw, often from the window of the train. She also drew the signs of growing industrialization: trolleys, cranes, and the railroad itself, cutting through the countryside. During the succeeding months she returned to these sketches, drawing from them various elements that she synthesized in her painted compositions. *E.F.C.B. (Estrada de Ferro Central do Brasil)* [*E.F.C.B. (Central Railway of Brazil)*] of 1924 (plate 4), for example, depicts the area around the Brazilian Central Railway. Houses, a church, trees, telegraph poles,

railroad signs, cars, and tracks are assembled in series of overlapping planes indebted to Léger's Cubist space. Amaral created a flat and emblematic composition that embraces the coexistence of the industrial and the vernacular in the Brazilian landscape; the man-made geometries take over the natural terrain. *São Paulo (135831)* of 1924 (figure 1), *São Paulo (Gas)* of 1924 (Private collection, São Paulo), and *The Station* of 1925 (Collection Rubens Schahin, São Paulo) take a similar approach to space created by the overlapping of forms and constructions (including smokestacks) to refer to industrialized modern Brazil. But here, in distinctly urban settings, the architecture is not vernacular, and the landscape has been tamed to a bare minimum of vegetation. In all of these pictures, graphic communication—flags, signals, numbers, and letters—plays an important role. Amaral's celebrations of the industrialized city not only echo Léger's geometricization of the modern French landscape but also find parallels in Cendrars's contemporaneous poetry. "São Paulo," a poem of 1924 that was originally published with a drawing of a locomotive by Amaral, mentions "factories suburbs a nice little trolley/Electric wires" as well as a gas pump and railroad station.[26]

Other paintings of Amaral's from this period portray different aspects of an "authentic" Brazil. *Hill of the Shantytown* of 1924 (figure 2) and *Carnival in Madureira* of 1924 (figure 3), both composites of scenes Amaral sketched on the trip to Rio de Janeiro, portray a more purely vernacular side of Brazilian life while maintaining the artist's modernist style. The former depicts a patchwork of a hillside shantytown with bridges, stairs, a clothesline, and houses colorfully painted or of bare wood planks, while the latter is an image of popular leisure with an Eiffel Tower–like construction. In contrast to the more industrial pictures, figures of humans and animals inhabit these scenes and play an important role by providing a context for the architecture, here integrated into the landscape, as an expression of Afro-Brazilian vernacular culture. The scenes are presented without any sense of social criticism, such as that later found in works by Lasar Segall, Cândido Portinari, and Amaral herself in the 1930s. Amaral's palette of greens, blues, pinks, ochers, and iron reds reflects the hues she found in painted houses and secular and religious interiors. These color combinations were used by the artist not only for regional and vernacular scenes but in her depictions of Brazilian urban and industrial milieux as well. More than a pictorial choice, they signified a rejection of European pictorial values and an assertion of Brazilian identity.[27]

The Fair, II of 1924 (figure 4) shows a local outdoor marketplace with a variety of neatly heaped fruits and vegetables, rows of potted plants, and three small animals. Again Amaral chose a subject typical of Brazilian life, one that merges the urban and natural worlds. The artist focused here on the abundant diversity of Brazil's flora, emphasizing the order inherent in the mercantile arrangement of the natural products, itself a manifestation of vernacular culture.

Yet another "authentic" Brazilian scene is *Lagoa Santa* of 1925 (figure 5), which corresponds closely to a drawing made during the journey through Minas Gerais. Beyond a fence is seen a small rural town with a distinctive colonial church and houses. A banana tree bearing fruit and some pigs in a town plaza complete the scene. While depth is still compressed and flattened, this is one of Amaral's most naturalistic scenes of the 1920s and one of the least dependent on the example of Léger. The posts of the fence stand between the

4. Tarsila do Amaral. *The Fair, II*. 1924. Oil on canvas, 18⅛ x 21⅝". Collection Zitta Penteado Camargo, São Paulo

viewer and the town depicted beyond, and exhibit a strange, inanimate anthropomorphism, resembling human limbs, which Amaral later developed in the pictures of 1928 and after.

The themes of Amaral's paintings of the mid-1920s encompass a broad spectrum of twentieth-century Brazilian categories that read like a typology of the country: industrial, urban, vernacular, ethnic, regional, and rural. The majority of these images focus on manifestations of material culture—architecture, agriculture, urbanism, industry, commerce, and leisure—be they in cities or on the periphery. The industrialization of the cities and countryside, and the contemporary life of the Afro-Brazilian population, had not previously been addressed by "high" art. A modernist visual language tied the diverse elements of the artist's typology together, and this body of work formed an unprecedented, cohesive vision of modern Brazilian experience.

Amaral's paintings of 1924–27 have been grouped under the label Pau-Brasil, the name of a manifesto Oswald de Andrade wrote in 1924.[28] The "Pau-Brasil Poetry Manifesto" radicalized the programmatic concerns that had been present at the genesis of the São Paulo modernist movement and were apparent in Amaral's imagery. The exploration of cultural identity, references to the coexistence of industrial and preindustrial traditions, and even an interest in vernacular colors were shared by the poet and the painter:

Poetry exists in facts. The shacks of saffron and ochre among the greens of the hillside favelas, under cabraline blue, are aesthetic facts.

The Carnival in Rio is the religious outpouring of our race. Pau-Brasil. Wagner yields to the samba schools of Botafogo. Barbaric, but ours. Rich ethnic mix. Richness of vegetation. Minerals. Casserole of vatapá. Gold and dance.

We have a dual heritage—the jungle and the school. Our credulous mestizo race, then geometry, algebra and chemistry after the baby's bottle and herbal tea. "Go to sleep my baby or the bogeyman will get you," mixed with equations.

5. Tarsila do Amaral. *Lagoa Santa.* 1925. Oil on canvas, 19⅝ x 31⅞". Collection Julio Bogoricin Imóveis, São Paulo

A vision which is present in windmills, electric turbines, industry, factories, and the Stock Exchange, but which keeps one eye on the National Museum. Pau-Brasil.[29]

Andrade's manifesto also included a call to battle to establish the modernists' goals: "One lone battle—the battle for the way forward. Let us distinguish: Imported poetry. And Pau-Brasil Poetry, for export."[30]

Amaral's paintings of modern Brazil were exhibited in 1926 at the Galerie Percier in Paris. The fact that she had intended these images for an international audience from the start may be inferred from her statement in a 1923 letter to her family about her return to Brazil: "I intend to spend a lot of time on the farm as soon as I arrive, and hope on my return here [to Europe] to bring back a good deal of Brazilian subject matter."[31] She already knew that France's capital welcomed the expressions of foreign artists: "Everyone brings a contribution from his own country. That explains the success of Russian ballets, Japanese prints, and black music. Paris is fed up with Parisian art."[32] The Parisian critics responded well to her exhibition but, although acknowledging the sophistication and rigor of her modernist style, still characterized her paintings as "enchanting" and "exotic."[33] However, one writer, Maurice Raynal, noted that the exhibition marked a turning point in the history of the "artistic autonomy of Brazil."[34]

After returning from Paris in mid-1926 Amaral married Oswald de Andrade. They spent much of their time on her family's farm, and visited São Paulo occasionally. Amaral continued to paint but produced no major works during this period. A breakthrough occurred in 1928 when she finished a composition she later described as "a monstrous solitary figure, enormous feet, sitting on a green plain, the bent arm resting on a knee, the hand supporting the featherweight of the minuscule head. In front, a cactus exploding in an absurd flower."[35] She gave this painting to her husband as a birthday present on January 11. Andrade, much impressed, titled the work *Abaporú* (plate 3) from the words for "man who eats" in the Tupi-Guaraní Indian language.[36] For Andrade the image symbolized pri-

mordial man, rooted in the earth and cannibalistic, and inspired his "Anthropophagite Manifesto," employing the concept of anthropophagy, or cannibalism, as a metaphor for Brazil's ingestion, digestion, and metabolic transformation of imported European culture. The playful and nonsensical polemic sardonically called for a primitivist and nativist revolt against the status quo: "We want the Carahiba revolution. Bigger than the French Revolution. The unification of all successful rebellions led by man. Without us, Europe would not even have its meagre Declaration of the Rights of Man. The golden age proclaimed by America. The golden age and all the girls."[37] Andrade's manifesto poetically mixed a number of historical, political, ethnographic, and psychoanalytic references with mercurial juxtapositions that display a familiarity with some of the principles of French Surrealism, although he seems to suggest that surrealist qualities were indigenous to Brazil: "We already had communism. We already had surrealist language. The golden age. Catiti Catiti Imara Natiá Notiá Imara Ipejú."[38]

Surrealism likewise seems to have inflected Amaral's imagery. The proportional distortions of the figure in *Abaporú* recall the kinds of figural deformations found in Surrealist works by Pablo Picasso or Joan Miró, artists represented in Amaral's collection. The distortions of *Abaporú* are also plainly an escalation of those already found in Amaral's 1923 painting *The Black Woman*. *Abaporú* supersedes *The Black Woman* in the development of the role landscape plays within Amaral's works. While the artist has returned to the conception of the single, monumental, iconic figure, it has become inseparable from the natural setting. The iconography of the landscape has been refined to the essentials of a very anthropomorphic cactus, the green ground on which the figure rests, the clear blue sky, and the blazing sun/flower. The palette of the Pau-Brasil period is retained, but also rarefied to the bare minimum, in its blues, greens, yellows, and fleshy ochers.

The Lake of 1928 (Estanislau do Amaral Family Collection, São Paulo) and *Setting Sun* of 1929 (figure 6) resemble the Pau-Brasil paintings in their depiction of Brazil, but it is the world of nature, apparently untouched by humankind. Unlike those earlier works, the Brazilian landscape is here as much the product of the artist's imagination as it is a composite of observed elements. The vivid and intense colors, the stylized natural forms, the anthropomorphic vegetation, and the distinctive foreground groupings—a trio of flowers or seedpods in *The Lake* and five swimming *ariranhas* (Amazonian otters) in *Setting Sun*—establish a surreal, dreamlike atmosphere.

An entirely unnaturalistic, oneiric imagery pervades *Forest* of 1929 (figure 7) and *Urutu* of 1928 (plate 6).[39] A strange tree seems to protect a deposit of pink eggs at its base in *Forest*, eggs and tree seemingly the only vital elements in an otherwise desolate landscape. A semicircle of ambiguous tree trunks stand guard like menhirs on the emerald-green horizon. The communication of isolated verticals in a largely barren landscape recalls the work of Giorgio de Chirico, an artist admired by Amaral and by the Surrealists.[40] The title *Urutu* refers to a poisonous snake found in southern Brazil, which in the painting emerges from behind and under a large egg to coil around a scarlet spike, inexplicably stuck in a green field. Pictorial and thematic tensions abound between the egg, archetypal symbol of fertility, and the phallic red lance, and among the threatening point of the spike, the tensile and constricting strength of the serpent, and the brittle

fragility of the eggshell. While *Urutu* clearly belongs among the surreal landscapes of the late 1920s, the scale of the egg gives it a compositional authority that makes it the equivalent of the iconic figure in *Abaporú*, or even *The Black Woman*.

Amaral's paintings of the late 1920s may be said to parallel her Pau-Brasil period in their delineation of a Brazilian typology, but the later landscapes picture a natural, primordial land, a Brazil of the imagination. The artist's visual poetics correspond not only to Oswald de Andrade's anthropophagism but also to the literary inventions of Mário de Andrade's 1928 *Macunaíma*, the fantastic and comic narrative of a Brazilian Odysseus.[41] One critic has said of Mário de Andrade's use of imagination: "As a writer from a country with no great pre-Columbian civilization on which to found a national myth, and without even a national classical style and heritage, Andrade was forced to confront the themes of tribalism, totemism, sacrifice, cannibalism and magic. This was a world inaccessible to one born in sophisticated São Paulo other than by force of imagination,"[42] and, it might be added, by Andrade's dedication to researching Brazilian popular culture and folklore through his extensive travels.

In 1929 Amaral reprised and synthesized her two pivotal figural compositions, *The Black Woman* and *Abaporú*, in an act of virtual self-cannibalization, the painting *Antropofagia* (plate 5). This time she seems to have been directly inspired by Oswald de Andrade's ideas, as expressed in his manifesto, and by the anthropophagist movement it spawned, complete with a magazine, *Revista de antropofagia*, founded by Andrade, Raúl Bopp, and Antonio Machado. The pair of seated figures in *Antropofagia* overlap and merge, the breast of the one seen frontally hanging over the leg of the one in profile, which crosses the leg of the first. Both figures have lost their identities; similar in flesh tones, faceless, without hair or toenails, they form a kind of schematized Adam and Eve with only the vestigial attributes of banana leaf and cactus with attached solar flower to characterize their tropical Eden. Amaral has here restated

6. Tarsila do Amaral. *Setting Sun*. 1929. Oil on canvas, 21¼ x 31⅞". Collection Jean Boghici, Rio de Janeiro

the mythic themes of fertility and sexuality that originated in *The Black Woman* and were developed in the suggestive shapes and symbolic objects in the landscapes of 1928 and 1929. On the occasion of her first one-person exhibition in Brazil, in Rio de Janeiro in 1929, Oswald de Andrade proclaimed her the most important painter Brazil had produced and declared: "No one has penetrated as well as she did the wildness of our land, the barbarian which is each one of us, the true Brazilians who are eating with all possible ferocity the old culture of importation, the old unusable art, all the prejudices."[43]

Amaral's production between 1923 and 1927 had concentrated on a pair of nontraditional subjects: industrialized urban reality and the popular culture that included the manifestations of the lives of Afro-Brazilians and the *caipiras*. Implicit within this latter category of the vernacular, and forming a backdrop to it, is the legacy of the colonial past, which brought the melding of Portuguese, African, and indigenous traditions, a hybridization that shaped the Brazilian reality the artist depicted, from the colors and configurations of houses to religious architecture and popular festivals, from the manner of building a fence to the arrangement of fruits in the marketplace, from modes of dress to the racial makeup of the Brazilian people. All of these elements disappear from the group of images painted at the end of the 1920s, which no longer addresses these real subjects, but instead explores an imaginary conception of a primordial Brazil.

The self-referential synthesis of *Antropofagia* heralded the end of a remarkable creative cycle and the beginning of a long period in which Amaral's paintings lacked the poetic and idiosyncratic originality that had marked her images of the 1920s. Often during the remainder of her career, she readdressed themes or subjects from that decade of inventive achievement, which remains a milestone in the development of modern art in Latin America.

7. Tarsila do Amaral. *Forest*. 1929. Oil on canvas, 25¼ x 30". Museu de Arte Contemporânea da Universidade de São Paulo

Notes

I wish to thank Joseph R. Wolin for his assistance during the writing of this essay.

1. Among her teachers were the Swedish sculptor William Zadig, Alceste Mantovani, the German Georges Fischer Elpons, who was influenced by Impressionism, and Pedro Alexandrino, an important Brazilian academician.

2. Amaral enrolled in figure-drawing classes at the Académie Julian, and later studied with the painter Emile Renard, whose instruction in painting was somewhat less rigid than that at the academy. She also studied drawing with an artist named Oury.

3. This 1922 painting later came to be known as The Passport because it provided her official entrance to the French Salon. See Aracy A. Amaral, Tarsila: Sua obra e seu tempo (São Paulo: Tenenge, 1986), p. 36. The picture is reproduced on p. 29.

4. Amaral had met Malfatti in 1917 at the studio of Pedro Alexandrino. For accounts of the correspondence between the two artists, see Carlos Zilio, A querela do Brasil: A questão da identidade da arte brasileira: A obra de Tarsila, di Cavalcanti e Portinari, 1922–1945 (Rio de Janeiro: Edição Funarte, 1982), p. 44; and Amaral, Tarsila, p. 36. See Aracy A. Amaral, Arts in the Week of '22 (São Paulo: Câmara Brasileira do Livro, 1992).

5. See Amaral, Tarsila, pp. 30, 32; and Zilio, A querela, p. 44.

6. See her letter to Malfatti of October 26, 1920, quoted in Amaral, Tarsila, pp. 30, 32.

7. Ibid.

8. For an in-depth discussion of nationalism in Brazilian arts in the context of modernism, see José Augusto Avancini, "A pintura modernista e o problema da identidade cultural brasileira: Estudo comparativo da obra de Tarsila, di Cavalcanti e Rego Monteiro, 1911–33," Master's thesis, Universidade de São Paulo, 1982; see also Zilio, A querela, pp. 47–55.

9. Amaral, Tarsila, p. 68.

10. Interview in the newspaper Correio da manhã (Rio de Janeiro), December 25, 1923, p. 2; cited in Grandes artistas brasileiros: Tarsila (São Paulo: Art Editôra/Círculo do Livro, 1991), p. 13. Translations are by the author, unless otherwise noted.

11. Letter of September 29, 1923, quoted in Amaral, Tarsila, p. 83.

12. She later remembered having attended no more than three sessions with Léger. See Amaral, Tarsila, p. 84.

13. Ibid., p. 82, n. 47.

14. The figure's anatomy has also been discussed in the context of a story told by the artist. Amaral once recalled being told by her family's black maids of how slaves would lengthen their breasts by tying stones to their nipples. See Aracy Amaral, "Sôbre o desenho de Tarsila," in her Desenhos de Tarsila (São Paulo: Editôra Cultrix, 1971).

15. The Yemanjá (or Iemanjá) figure referred to is of painted wood from nineteenth-century Bahia and is now in the collection of Emanoel Araujo in São Paulo. See A mão afro-brasileira: Significado da contribução artistica e histórica (São Paulo: Tenenge, 1988), fig. 203, p. 188; and Bilderwelt Brasilien: Die europäische Erkundung eines "irdischen Paradieses" und die Kunst der brasilianischen moderne (Zurich: Kunsthaus, 1992; Bern: Benteli Verlag, 1992), p. 267. Ana Maria de M. Belluzzo has also suggested this connection between the Brazilian sculpture and The Black Woman. See her article, "The Modernist Conscience and the Great Return," New Observations 89 (May/June 1992), pp. 23–26. The author wishes to thank John Alan Farmer for bringing this article to her attention.

16. For a critical reading of traditional accounts of modernist primitivism see James Clifford, "Histories of the Tribal and the Modern," in his The Predicament of Culture: Twentieth-Century Ethnography, Literature, and Art (Cambridge, Mass.: Harvard University Press, 1988), pp. 189–214.

17. Zilio, A querela, p. 49. Amaral visited Brancusi in late May or early June 1923. See Amaral, Tarsila, p. 75.

18. Darius Milhaud composed the music and Jean Börlin developed the choreography. For a discussion of the ballet, see Bengt Häger, Ballets suedois (The Swedish Ballet) (New York: Harry N. Abrams, 1990), pp. 41–44; a reprint of an account of the dance by C. W. Beaumont is found on pp. 190–91. See also Laura Rosenstock, "Léger: 'The Creation of the World,'" in William Rubin, ed., "Primitivism" in 20th Century Art: Affinity of the Tribal and the Modern (New York: The Museum of Modern Art, 1984), vol. 2, pp. 474–84.

19. This drawing is reproduced in Häger, Ballets suedois, p. 68. The ballet premiered on October 25, 1923. Amaral's painting was probably completed in the summer of 1923, before her September 29 meeting with Léger. See Amaral, Tarsila, pp. 82–83, n. 47.

20. Oswald de Andrade, "L'Effort intellectuel du Brésil contemporain," Revue de l'Amérique Latine (July 1, 1923), pp. 197–207; cited in Amaral, Tarsila, pp. 75–76.

21. A discussion of these issues is found in Avancini, "A pintura modernista," pp. 10–16.

22. Amaral returned from Europe with a collection of art that included Robert Delaunay's 1911 image of the Eiffel Tower (Champ de Mars, La tour rouge, The Art Institute of Chicago) and works by Gleizes and Léger. She later acquired Brancusi's Prometheus of 1911 (Hirshhorn Museum and Sculpture Garden, Smithsonian Institution, Washington, D.C.), works by Lhote, Picasso, Modigliani, Miró, and Larionov, and two paintings by de Chirico. See Aracy A. Amaral, Tarsila: Sua obra e seu tempo (São Paulo: Editôra Perspectiva, 1975), vol. 1, pp. 287–89; and Amaral, Tarsila (1986), p. 100.

23. Interview in Correio da manhã (Rio de Janeiro), December 25, 1923, p. 2; reprinted in Amaral, Tarsila (1975), vol. 1, pp. 441–43; translated in Marcelo Guimarães da Silva Lima, "From Pau-Brasil to Antropofagia: The Paintings of Tarsila do Amaral," Ph.D. dissertation, University of New Mexico, Albuquerque, 1988, pp. 184–90.

24. The exhibition included Léger, Gleizes, Delaunay, Lhote, and Lasar Segall, a Jewish Lithuanian artist who had moved to Brazil in 1923. See Aracy A. Amaral, Blaise Cendrars no Brasil e os modernistas (São Paulo: Livraria Martins Editôra, 1970), pp. 106–9.

25. Ibid., p. 2.

26. "São Paulo" was first published in Feuilles de route (Paris: Au Sans Pareil, 1924), a book that was illustrated with Amaral's drawings, including an outline sketch of The Black Woman on the cover. See Blaise Cendrars, Complete Postcards from the Americas: Poems of Road and Sea, trans. with an introduction by Monique Chefdor (Berkeley, Los Angeles, and London: University of California Press, 1976), pp. 18–21, 114, 191.

27. Amaral wrote of her use of color: "I found in Minas the colors that I loved as a child. . . . Later I was taught that these were ugly and provincial. I followed the road of refined taste. . . . But later I took revenge on that oppression by using in my canvases pure blue, violet-pink, bright yellow, singing green, all more or less saturated according to the admixture of white." See Tarsila do Amaral, "Pau-Brasil e Antropofagia," in Revista anual do salão de maio (São Paulo, 1939); quoted in Amaral, Tarsila (1986), p. 104.
 The Concrete poet Haroldo de Campos wrote insightfully about the nationalistic aspect of Amaral's use of color. See his essay "Tarsila: Uma pintura estrutural," in Tarsila: 1918–1968 (Rio de Janeiro: Museu de Arte Moderna, 1969), pp. 35–36.

28. Pau-brasil is the name of a type of hardwood that was the first natural resource in Brazil systematically exploited by the Europeans in the sixteenth century.

29. Oswald de Andrade, "Manifesto da poesia pau-brasil," in Correio da Manhã (Rio de Janeiro) March 18, 1924; trans. in Dawn Ades, ed., Art in Latin America: The Modern Era, 1820–1980 (New Haven: Yale University Press; London: Hayward Gallery, 1989), pp. 310–11.

30. Ibid., p. 310.

31. Letter dated August 12, 1923, quoted in Amaral, Tarsila (1986), p. 81.

32. Letter to her parents of April 19, 1923, quoted in ibid., p. 71.

33. Ibid., pp. 172–77.

34. Maurice Raynal in L'Intransigeant (Paris), June 13, 1926; quoted in Amaral, Tarsila (1986), p. 177.

35. Amaral, "Pau-brasil e antropofagia"; quoted in ibid., p. 208.

36. See Tarsila do Amaral in Diário de São Paulo (March 28, 1943); paraphrased in ibid., p. 206.

37. Oswald de Andrade, "Manifesto antropófago," Revista de antropofagia (São Paulo), no. 1 (May 1928); translated in Ades, Art in Latin America, p. 312.

38. Ibid.

39. This painting was formerly known as O Ovo [The Egg].

40. Amaral and Andrade owned two de Chirico paintings; one, The Enigma of a Day (1914), is now in the Museu de Arte Contemporânea da Universidade de São Paulo.

41. For a translation, see Mário de Andrade, Macunaíma, trans. E. A. Goodland (New York: Random House; London: Quartet, 1984).

42. Gerald Martin, Journeys Through the Labyrinth: Latin American Fiction in the Twentieth Century (London and New York: Verso, 1989), p. 143.

43. Interview, "A propósito de sua exposição, um antropófago de S. Paulo assim nos falou," in O Paiz (Rio de Janeiro); quoted in Amaral, Tarsila (1986), p. 224.

OROZCO AND RIVERA: MEXICAN FRESCO PAINTING AND THE PARADOXES OF NATIONALISM

Max Kozloff

In Guadalajara, Mexico, at the end of a long commercial esplanade that leads east from the city's colonial center, there stands the Instituto Cultural Cabañas, a starkly beautiful, gray, neoclassical domed building, formerly the chapel of an orphanage (*hospicio*), which houses a fresco cycle by José Clemente Orozco. At the moment he completed it in 1939, the work, whose theme is nominally the history of Mexico, was recognized as the peak achievement of an already full and upsetting career.

The visitor enters the Instituto through the central portal of a barrel-vaulted space, as if into the middle of a transept. To the left and the right, decorated lunettes encased in a stone entablature gird the entire hall. They are surmounted by the curved ceiling, whose ribbed arc is divided into six large painted segments, opened upward at the center by frescoed spandrels and then niches above them circling beneath a great cupola. In that concave space, at the apex of the fresco program, strides a figure with whom Orozco often identified himself: a man on fire, a man who brings fire (figure 1).

Seen from a worm's-eye view, this figure dangles with a wizardlike illusionism, as if actually in our space, totally defying the hemispherical surface on which it is painted. In that lofty cauldron, and in the colors of the flanking images, which warm during the early afternoon—grays and oranges, then cerulean blues and sap greens—Orozco's artistic forebears reveal themselves. They are Tintoretto, El Greco (whom the Mexican actually depicts on the north wall), Goya, and Daumier. To take in the whole vault is a dizzying exercise in rotating and craning one's head, for the top of each panel is adjacent to the bottom of the next. Meanwhile, at floor level, the black wrought-iron bannister that protects the lower frescoes emulates a kind of overscaled barbed wire, a presence whose repelling function ties in with the admonishing character of Orozco's art.

This viewing discomfort parallels the disquiet of the painting's historical epoch as it rustles through the artist's very strokes. The fact that Europeans were about to be convulsed in their second great fratricide of the century in 1939 bedeviled consciousness on both sides of the Atlantic. Lázaro Cárdenas (president, 1934–40) had explicitly opened Mexico to defeated Republican émigrés from the Spanish Civil War, and he welcomed the fugitive Russian revolutionary Leon Trotsky, whom no other country would accept. Aside from Orozco, the two other founders of the Mexican Mural Movement were deeply political. David Alfaro Siqueiros, a Stalinist, had fought on the side of the Republicans. Diego Rivera was an expelled member of the Mexican Communist Party who had sheltered Trotsky, later to be the target of an assassination attempt led by Siqueiros himself in 1940. Meanwhile, native fascist goons staged riots and did free-lance murders, like that of the British consul Geoffrey Firmin at the end of Malcolm Lowry's novel *Under the Volcano*. Without doubt Mexico was being injected with ideological toxins from across the sea that added to its own malaise, for which there were as yet no known antidotes.

The painters had been schooled by their country's extremely confusing Revolution, in which they intermittently participated, with conflicting results. As early as 1911 Orozco had worked as a caricaturist for a newspaper opposed to the Revolution in its first, liberal bourgeois phase under the leadership of Francisco Madero; and in 1915 he drew for a radical paper aligned with the forces of Venustiano Carranza against the army of the famous guerrilla chief Pancho

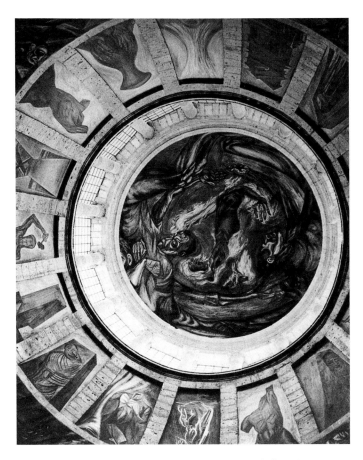

1. José Clemente Orozco. *Man of Fire*. 1938–39. Fresco. Detail of cupola at Instituto Cultural Cabañas, Guadalajara

Villa, once thought to be a partisan of agrarian reform. But, as Europe clouded over, Orozco could not fail to see that the long record of Mexico's internal violence—in a panorama that extended backward in time to before the Spanish Conquest—was to be exceeded by an international cataclysm. Just as his own indigenous style owed a debt to modern art—he was affected by German Expressionism—so the struggles of his homeland were linked to the sanguinary impetus of Europe. If nothing else, Orozco's work in Guadalajara reflects on the kinship between destructive behavior in the New and the Old Worlds. The fifty-two-panel ensemble at the Instituto Cultural Cabañas was, in fact, the last of his three projects in the city, having been preceded by two others that address comparable themes, those at the Palacio de Gobierno and the Universidad de Guadalajara, both begun in 1937. It would therefore be fair to say that this city, the capital of the state of Jalisco, is also a citadel of Orozco's art. And, more precisely, it is the place in which to view the major artistic aftershock of Picasso's *Guernica* of 1937: Orozco's pictorial accusation of atrocities, conceived in an undeveloped country, on a much vaster scale if still in allegorical terms, and transformed by an artist of even more specifically nationalist consciousness.

Orozco's retrospective overview of the history of his country was, from the first, intended to be combined with a most up-to-date insight into contemporary menace, unfolding as he painted. Among other things, this unsettled the temporal index of a fresco cycle that depicted crosses and swords but also barbed wire and dynamos. There was no attempt to provide a narrative and, therefore, historical

accountability in what is an affective and symbolic evocation of the Mexican past. Rather, Orozco examined his feelings about that past and brought them to a point of almost feverish ambivalence as he dwelt on the most traumatic of all Mexican memories, the Spanish Conquest.

For example, Hernán Cortés, the Spanish conqueror and patriarch of Indian doom, is seen from below as a combination of Saint George and a literally heartless RoboCop (figure 2). His sword tip rests at the crotch of a prostrate, diminutive, brown-skinned figure, the offal of conquest. Looking up, viewers are positioned to identify with the victims of an irresistible (and as Orozco has it), highly mechanized, twentieth-century power. (By contrast, in a bas-relief of 1549 carved into the plateresque entrance of the Palacio Montejo at Mérida, a conquistador quite heroically tramples upon an Indian slave.) But it is not simply from a physical vantage point that Orozco drew a moral. He reinforced it in other panels by a kinesthetic appeal that empathizes with Indian terror in his depiction of the horse as a metallic, indestructible machine of war or as a two-headed monster of apocalypse.

Here is a metaphor through which the artist wanted to make his own viewers see what their ancestors saw—but in contemporary terms. The true nightmare of the Cabañas cycle is demonstrated by

2. José Clemente Orozco. *Cortés Triumphant*. 1938–39. Fresco. Detail of ceiling at Instituto Cultural Cabañas, Guadalajara

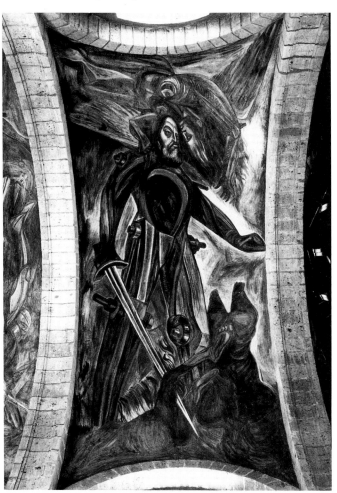

its capacity to shift nominally historical impulses and states of affairs into a present mode, as alarmingly as flesh mutates into metal. In the ground-level lunettes, the master-slave dichotomy is reflected, or anticipated, as a demagogue-masses relationship. It would not have been difficult for the first viewers at Cabañas to recall the roars at Nuremberg or the May Day parades at Moscow. We cannot determine if reference to them is background noise or the ultimate rationale of the whole project. But we can be certain that social relationships have been usurped by the most naked power relationships, symbolized by the whip and the barbed wire. In such passages as these ground-level lunettes, coercion from above has replaced any civic accord in a community. The ornamental treatment of crowds on the march, punctuated by blank banners (as if waiting for write-in slogans), shows abasement—not the height of any genuine human solidarity. As for Guadalajara itself, the spaces of the city are elsewhere revealed in Cabañas as tableaux much like Giorgio de Chirico's *pittura metafisica*—that is, as hallucinatory and desolate urbanscapes, with the communal life somehow pumped out of them. What remains is only a collection of coffinlike roofs, a caricature of the government palace, whose façade is awash in pompous baroque scrolls, and some church towers that relate a little bit to the surrounding town, as the banners do to the crowd—except that they are lonelier.

The Catholic Church is a key agent in Orozco's view of Mexican history, and its influence is a kind of shade that darkens much of his verdict on modern history as well. Though he is pictorially inventive in such details as the cross that functions as a surrogate sword, the painter's judgment of the Conquest as a theocratic juggernaut is unexceptional. It would have had much official support in an anticlerical Mexico that in the previous decade had undergone the Cristeros warfare, a widespread, fanatical, murderous peasant revolt, egged on by disempowered priests and just as savagely repressed by the government. In the murals at the Instituto Cultural Cabañas, the Franciscans often appear as another class of (robed) warrior before whom the Indian is necessarily abject and supine. And in the ceiling, in his portrait of a gigantic King Philip II of Spain, embracing his blood-stained cross with ostentatious piety, Orozco has given us an awesome and overbearing emblem of total autocracy wedded to holy faith (figure 3). Nowhere in Counter-Reformation art, which originally provided a model for this "saintly" image—certainly not in El Greco—would the kiss of a cross have been transformed into the creases of a sneer as it is here. In Cárdenas's Mexico, it was easy to associate the Church's political history with the repressions of an old regime. The reactionary clergy supported the dictatorships of Porfirio Díaz (1877–1911) and Victoriano Huerta (1913–14), while in Spain at that very moment it was in triumphant alliance with Francisco Franco.

Just the same, the partnership of Church and fascism was a theme not altogether in tune with the undeniable good works of the orphanage's founder, Bishop Cabañas, nor with certain aspects of Orozco's temperament as a man and artist. He clearly acknowledged that the missionaries succored the Indians, while the bishop distributed what bread was available to the poor. Earlier in his career, in 1926, at the Escuela Nacional Preparatoria, the painter had shown a great humanitarian priest of the Conquest, Bartolomé de Las Casas, in the embrace of a starved Indian, an image that, with its Christian brotherly love, depicts the antithesis of King Philip's righteousness. Orozco holds on to the distinction between what Christian faith does

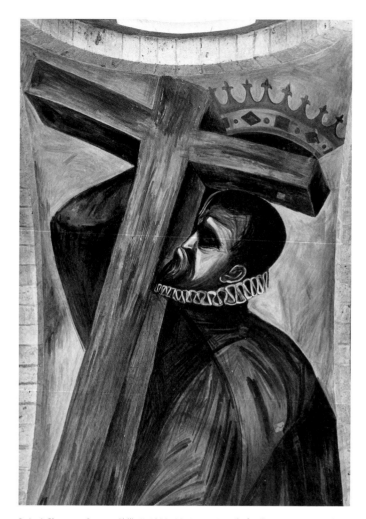

3. José Clemente Orozco. *Philip II*. 1938–39. Fresco. Detail of ceiling at Instituto Cultural Cabañas, Guadalajara

to extend itself to others and the cruel deeds often masked by profession of that faith. In any event, he makes this point not at all with the bland aim to provide an equitable sampling of a historical record but in order to treat religion itself with the seriousness it deserves as a basic drive of human life.

Perhaps that is why for Orozco religion was sometimes in accord with, but also existed on another plane from, the dogmas and cant he spontaneously condemned. Orozco evidently strove to work on that plane himself by creating an artistic form in which living flesh seems to be consumed in a turmoil of unrest and aspiration that is not material. His long strokes highlight inchoate dark masses with a flickering rhythm, much like the stoking of a fire—all contagious hot impulse and no body. (At the same time, paradoxically, the way he often worked on plaster, wet on wet, contributed more substance—or at least opacity—to fresco paint than it normally has.) Though he was very likely not even a believer, his art seems imbued with a kind of spiritual motility. Within the vectoring of such an impulse, which far outdistances any political ideology—though of course it has political impact—he discerned a continuum of values in which pathos and indictment are vitalized. Characteristically, this vitalism was directed by the artist back against religious ritual itself, not least to that of the

Aztecs, whose faith fell before that of the Catholic Church he elsewhere scourges. In 1929 he wrote: "Many of my murals . . . are a real glorification of the indigenous race, a noble reference to its virtues, its sufferings and its heroism; I have never dressed [the aborigine] as a scarecrow, a *charro* or a *china poblana* or as a personage of a pornographic or political revue. I have never made fun of his folklore or of his customs, and always . . . I attacked those who exploit, cheat or degrade him."[1]

These remarks accurately reflect Orozco's position ten years before he completed the Cabañas cycle. In two other panels near the entrance, however, he did not hesitate to show the Indians as drunken savages uttering gibberish at arcane rites or performing unspeakable human sacrifices. At this point, he joined in another kind of argument about Mexico's Indian heritage, and on a different ground from the more idealistic didacticism of his early career.

Thus Orozco ceased to be, if he ever in fact was, a spokesman for an indigenist ethic. The individual Indians that appear in his work are scruffy, or spavined, but above all are anonymous victims. The crowds that they or their poor descendants form are generic, whereas the Spaniards have a virtually iconic status. One hardly feels the painter's regard for the Indians so much as his wrath at those who incarnate the inhuman principle that destroys them. (This attitude bears comparison to Goya's in the etching series Disasters of War.) From a psychological viewpoint, these antagonists are characterized only just enough and no more in order to show the implacable force of the one and the desperation of the other. But the very process in which Orozco *weighs* these scenes of the great conflict that led to the birth of modern Mexico speaks of the true conceptual detachment behind his vehement handling of paint.

To be sure, a preliminary gouache for the figure of Cortés depicts him as a knightly savior and therefore reveals something of a conventional *parti pris* before it was drenched by the vitriol of Orozco's artistic imagination. We know, too, that he took pride in a family pedigree that was assumed to trace back to the Spanish conquerors of Nueva Galicia (now the state of Jalisco). Yet, when he was

4. José Clemente Orozco. *Victims of the Revolution: Il Fusilado.* 1940. Fresco. Detail of wall at Biblioteca Gabino Ortíz, Jiquilpán

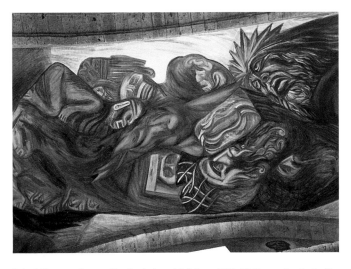

5. José Clemente Orozco. *The Confusion of Religions.* 1938–39. Fresco. Detail of ceiling at Instituto Cultural Cabañas, Guadalajara

pigeonholed as either Hispanist or indigenist, he reacted with an outraged neutrality. By 1942 he spoke out in his memoirs against all racial sectarianism: "Like victims of amnesia we haven't found out who we are. We go on classifying ourselves as Indians, Creoles, and mestizos, following blood lines only, as if we were discussing race horses."[2] If genealogical politics, which he hated, so often ruled discussion, Orozco very characteristically reversed gears and deindividuated his figures.

From the first, at the Escuela Nacional Preparatoria, the blocked-out, strongly sculpted presence of the Orozco personage indicated that this one—a *campesino*, say—represented the many other like-minded members of his class in his cause. When historical characters appeared, they were supposed to symbolize the whole of their people, as does the nude La Malinche, Cortés's Indian interpreter and, in this case as well, the conqueror's mate. That was in the early 1920s. In the 1940s, especially in his frescoes at the Biblioteca Gabino Ortíz in Jiquilpán, in the state of Michoacán, all singularity is pressed out of dying or dead peasant figures. They even cease to be corporeal, for they live only as incisive black calligraphy that chafes the white walls of a one-time chapel (figure 4).

The fact that his subjects were people, losing their freedom and their lives, took precedence over the fact that they belonged to this tribe or that community. In his (historically justified) view, it is, in fact, their chauvinist recognition of their differences that incites their mutual oppression. Absolute "otherness," as we would say now, was denied by the artist, but his art aimed to show that the perception of it, in the past and the present, is dehumanizing. When Orozco commented, again in his memoirs, that the Spanish, upon their discovery of the New World, were as much a mixture of different ethnic and racial stocks as the Indians, and that Mexico was the society into which both sides poured everything that ensued between them later, he spoke against racial pride and nationalistic consciousness. He was no friend of those memories that enfranchised the selfhood of minorities. From the vantage point of the debate on these issues that rages today, he would perhaps be looked upon as a monoculturalist rather than a multiculturalist. But in his time he understood himself to be a "uniculturalist," one who assessed the way differences

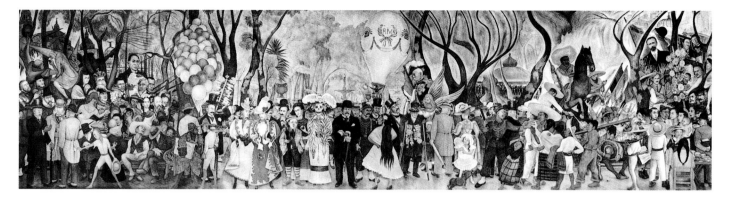

6. Diego Rivera. *Dream of a Sunday Afternoon in the Alameda Park*. 1947–48. Fresco, approximately 16 x 45'. Originally, Hotel del Prado, Mexico City, presently installed in Museo del Mural de Diego Rivera, Alameda Park, Mexico City

Below: 7. Diego Rivera. *Dream of a Sunday Afternoon in the Alameda Park*. 1947–48. Fresco. Detail

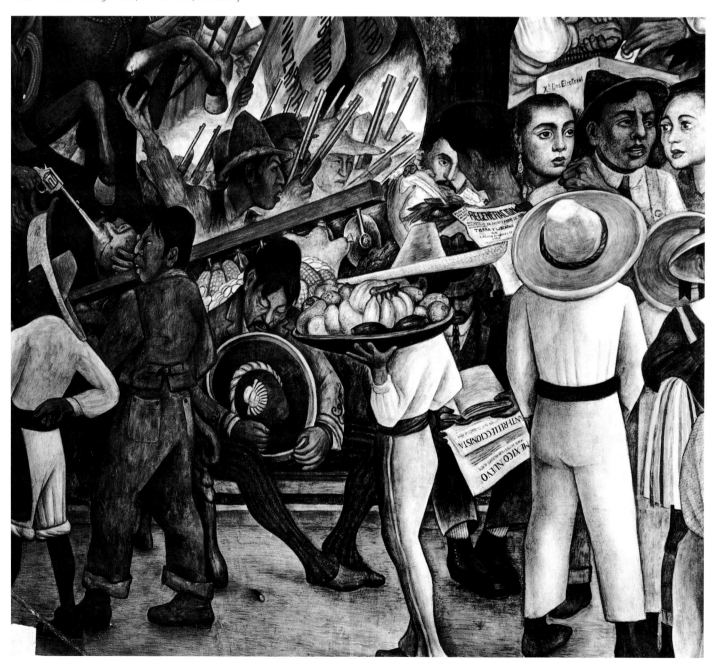

contributed to the overall outlook of a people. Still, though they had a common, heterogeneous legacy, he didn't assume that any one part of it was automatically assimilable—or was even legible—to any one group at any one moment.

One of the most curious and illuminating panels at the Instituto Cultural Cabañas, in this regard, is the one called *The Confusion of Religions* (figure 5). In it, Huitzilopochtli, the Aztec god of war, rubs noses with the Toltec Chacmool, or rain god, along with Jehovah and Christ crowned with thorns: all of them subsisting pell-mell in some obscure, reddish glutinate of mixed deities. As for Quetzalcoatl— the white god worshiped by the Toltecs, the one who invented all the great Mesoamerican arts of medicine, astronomy, and others, and who prohibited human sacrifice—he had been a major persona in Orozco's mural *The Expulsion of Quetzalcoatl* of 1932–34 (Baker Library, Dartmouth College). But in the Cabañas cycle he is represented as only one of many heads, almost appalled at the company he is obliged to keep. In the fertility of this confusion, the artist extended the theme of *Guernica*—the historic violence of the present fused with memories of cruel myth—into the spectrum of world religious beliefs. At the same time, Orozco's totemic vision inspired the deliberately more garbled and grotesque subjects shortly thereafter in the art of Jackson Pollock.

At home, though, the Cabañas frescoes could have provided little cheer to all those Mexicans who brought ideological grudges to bear on an exposition of their country's past. The otherwise laudatory Marxist art historian Antonio Rodríguez lamented the fact that Orozco "paints idealists as demagogues" and that his work is permeated by a "lack of respect for the masses."[3] And even Rivera was to refer to Orozco as the "only reactionary genius" in the history of art.[4] For ordinary *mestizo* viewers, of course, the spectacle of the Conquest is the panorama of their defeat, as it reveals their ancestors trampled by a foreign people whose language they now speak. No wonder Orozco could complain of the "amnesia" of the Mexicans and of their search even now for their identity, the roots of their genesis—a magnificent vision of which he handed down to them, ironically encased within the vaults of an orphanage.

——

In 1948, with the full tide of his life almost behind him and in the maturity of his art, Diego Rivera completed a fresco for the Hotel del Prado, in Mexico City. The locale was the back foyer of a swank, late Art Deco hotel just opened to cater to gringo tourists descending on Mexico in the affluent postwar years. By this time, Rivera's work was itself a tourist attraction. His frescoes in the capital's Secretaría de Educación Pública (1923–28) and the Palacio Nacional (1929–51) figured on every tour guide's list. The fact that he was renowned as a government-sponsored painter made him a commercial asset to his private patrons. For this worldly occasion, his second hotel job, Rivera chose to treat his habitual theme, the history of Mexico, but now from an autobiographical viewpoint. The seasoned painter looked backward across his own experience and that of his country in the twentieth century—backward, also, through his art, to the time when he was a fat ten-year-old boy, in 1896 during the era of Porfirio Díaz. Not only did he depict himself at that moment of childhood, but he wanted to reconstitute the freshness of childhood sensation in a public statement that is also explicitly personal.

No doubt the hotel's floodlit presentation of Rivera's giant frieze (it is roughly sixteen feet high by forty-five feet long) in a darkened room was a bit theatrical. But it suited the work's expressive tone, which, to be sure, was not so much dramatic as intensely lyrical and dreamlike. Today, that mural, *Dream of a Sunday Afternoon in the Alameda Park* (figures 6 and 7), is housed in its own museum after being miraculously spared in the 1985 earthquake which destroyed the Hotel del Prado as well as many other buildings around Alameda Park. In this painting Rivera imagines the park, just across the street from the hotel and always crowded on Sunday, as populated by the ghosts of the Mexican past, known and unknown. Though the moment of depiction is firmly established as the end of the last century, the characters presented date all the way from the 1550s through the boy's own time, to his future wives and children, and their world in the present. Everyone congregates invitingly in one long, bumptious horizontal throng that is massed up to the height of the picture at extreme left and right. This assemblage includes notorious outlaws, prelates, revolutionaries, and dictators, all rubbing elbows with each other. While there is some street action in the foreground—petty thievery, an argument, a shooting even—most of the characters seem out for a stroll or about to pose. The denser groups are already up on their unseen bleachers. Rivera's whole metaphor is that of a group portrait, the people there not yet attentively readying themselves for the ambulatory photographer, a child-adult who is also their poet laureate.

The narrative and genre aspects of this pageant are elided into its essential qualities of display. Somehow the park is transformed into a market of physiognomies and manners, certainly, but also of things to buy and eat. With its intense yellows, russets, straw browns, lavenders, viridian greens, pinks, and peach tones, there is no better word to describe Rivera's palette than succulent. It is as if it had just rained before the sun burst forth, and every hue brought out a maximum moist ripeness in the objects to be seen. They must have beckoned hotel clients with a vision of the lusciousness that awaited them during their stay in Mexico. But more than that, they evoke a moment of primary contact with the sensate world, remembered in its fondest glow. Ever since Rivera returned to Mexico in 1921, after his apprenticeship in Spain, his early success as a Cubist in Paris, and his studies of Italian Renaissance art, he successively rehearsed his first euphoric response as a mature artist to the chroma of his native land.

The late-nineteenth-century avant-garde was also among those traditions with which Rivera's art had set up a dialogue— particularly the example of Paul Gauguin. Most significantly, the Mexican adapted to his own purposes the colorism of the French painter, which had come to full flower in discovery of an exotic place. In Gauguin's art Tahiti is assumed to be innocent of the decadence and corruption that had afflicted Europe. The purity and saturation of Gauguin's palette were signs of an enchantment Rivera visualized even—and most remarkably—when he dealt with abuses in Mexico's history. How musical, for instance, is the rhyming of the Inquisitor's cat-o'-nine-tails, flaying open his victim's back, with the delicate tree branches nearby. So, the artist looked upon Mexican civilization with all the excitement of an outsider whose senses are alerted to new possibilities of spectacle, while he also retained the native's proprietary insights of knowledge and critique.

As for other precedents, it is strange that scholarship has

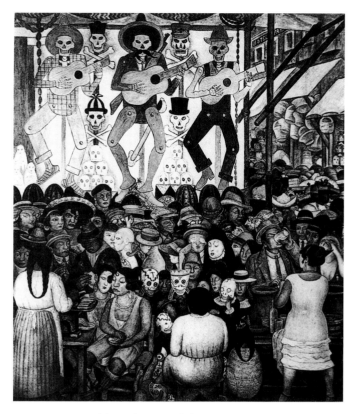

8. Diego Rivera. *Day of the Dead: Street Festival*. 1923–24. Fresco. Detail of south wall, Court of the Fiestas, Secretaría de Educación Pública, Mexico City

apparently not linked the del Prado fresco with a painting completed the same year Rivera was born: Georges-Pierre Seurat's *A Sunday on the Island of La Grande Jatte* of 1884–86 (The Art Institute of Chicago). Both are magnified summaries of the contemporary bourgeoisie at weekend leisure, and both deploy caricatural treatment of silhouetted figures within an elysian field. More than a hint of Seurat's scientific rationalism is followed through in the evident symmetry of Rivera's processional frieze. (Among his many sidelines, Rivera was an amateur student of medical history and botany, who incorporated his research into his work.) And in the upward flaring of the tree trunks, emanating above the isometric crowd, there is an echo of Charles Henry's theory of the psychological equivalent of forms, which animated the classicism of the Neo-Impressionists.

Layered even deeper into the hotel painting are surely allusions to Gustave Courbet, whose *Interior of My Studio, A Real Allegory Summing Up Seven Years of My Life as an Artist* of 1854–55 and *A Burial at Ornans* of 1850 (both in the Musée d'Orsay, Paris) can be viewed as exemplary forerunners of this Mexican promenade In the first work Courbet memorialized his life in art, portraying as real subjects friends who were the subjects of previous works, and who now, as he sits before his easel, are presumed to take their ease or gather around him as if in an apotheosis of his own creativity. Rivera was of that egotistical line. At the California School of the Arts (now the San Francisco Art Institute) in 1931, for example, he showed himself with great posterior, on the scaffold, painting the fresco we see. This emphasis on their own process of construction advertises the painters' claims of honest realism, which are not fulfilled because the range in iconographical time had to be impossibly compressed in

the one moment of presentation. The fresco for the Hotel del Prado shares with Courbet's *Interior of My Studio* the sense of the artist contemplating his world as he depicts himself within it, and offering absent or dead figures as miraculous new presences. Hence the contradictory aims, which indeed combine into a "real allegory," or a painted dream. Rather than depict a bohemian milieu, however, Rivera conflated nothing less than the history of Mexico with his private life, in an effort to show that they were intermingled and that he was involved.

In Courbet's other work, *A Burial at Ornans*, the artist represents a dour country funeral, including peasants, at his hometown, the place where he was born and brought up. It strikes a note of unmistakable nostalgia within a pastoral setting. For his part, Rivera at the del Prado, not for the first time in his career, projected *campesinos* into the metropolitan fabric. Whether in nineteenth-century France or more particularly in early twentieth-century Mexico, the peasantry was looked upon as an unappeased and dangerous underclass by city dwellers. In the land of Emiliano Zapata, it had terrorized the countryside and waged war on central governments, which promised but did little to effect vital land reform. One memorable episode of *Dream of a Sunday Afternoon in the Alameda Park* offers us a Mayan-looking peasant family being given the bum's rush by a gendarme while a top-hatted bourgeois smirks (all this under the equestrian figure of Zapata himself). Though a public park, Alameda was clearly an open territory from which "undesirables" could be tacitly ejected.

Courbet's paintings signaled a dissident political consciousness in their mammoth scale, for his life-sized figures demonstrated that artists or peasants could actually star within the mode of epic history painting previously reserved for dynastic rulers or legendary heroes. "Low" subjects, up to then thought worthy of only genre treatment, now entered a larger stage, whose representational power endowed them with a threatening stature in the view of bourgeois publics. We have only to look at James Ensor's sardonic *Christ's Entry into Brussels in 1889*, painted in 1888 (J. Paul Getty Museum, Malibu), and Giuseppe Pellizza da Volpedo's idealistic *The Fourth Estate* of 1901 (Civica Galleria d'Arte Moderna, Milan) to see how that warning was followed in great march pictures on a line from which the del Prado fresco descends.

Rivera, who had participated in the Cubist revolution in art before and during World War I, addressed his work to the *social* revolution when he was called home to work for the Alvaro Obregón regime in the early 1920s. The decisive moment came when he was commissioned to paint the patio walls and stairways of the Secretaría de Educación Pública in Mexico City. There the cosmopolitan modernist changed flags to that of a Marxist nationalist, without thought of any contradiction in those new terms. That the building itself was the headquarters of a new federal program of education made his work there emblematic not only of a government's propaganda concern to unify its people, through a celebration of their diverse tradition of folklore, but of the artist's desire to ennoble an imported theory of class struggle. Since the one theme had no necessary tie with the other, Rivera's work has a quality of special pleading about it, with a cast of ingenious new heroes and stock villains. So, for example, in a section titled *Corrido of the Proletarian Revolution* (1928) he shows his red-shirted wife, Frida Kahlo, distributing arms

to Mexican workers, who unite with mounted *campesinos* under a Communist banner to fight some undetermined status quo. These were historical absurdities, not only as they referred to Mexican conditions but as they implied any base in Soviet reality, of which he had had firsthand acquaintance during a long visit to Russia recently concluded. The imagination of the secretariat frescoes has something quite grand and perversely wishful about it, for they suppose an alliance between proletarians and farmers whose interests were actually divergent. As for the Mexican governments that Rivera served, they manipulated the labor unions and the peasant associations with such assurance that social progress was so embryonic as not even to deserve the name incomplete.

Here, then, was another kind of painted dream. The Marxist hope that it extended to the downtrodden paralleled, in its way, the Catholic faith of the sixteenth-century priest Las Casas, a spiritual support as long as it was recognized as the one true religion in which everyone was handed assigned parts. But Rivera had aesthetic goals as well as political reasons for orchestrating this visual program. He had taken upon himself the task of forging an authentically national art whose very qualities would have revolutionary import for the world. Additionally, he wanted to idealize the suffering multitudes by showing at once their vulnerability and their militancy. This could only lead to a stasis, a kind of energetic equilibrium, which was, in point of fact, the *formal* ideal of his program.

The viewer must look far and wide in the art of this painter of history to discover the heat, as compared with a prevailing charade of action. On the contrary, it could be argued that Rivera was an organizer of monumental still life, informed by a moral reckoning of opposed principles in tension with each other. Just as health is profiled by the recurrence of sickness, so civic harmony is contrasted by reiterated historical violence. Cortés is opposed by the last Aztec leader Cuauhtémoc, the Archduke Maximilian of Austria (emperor of Mexico, 1864–67) by Benito Juárez, Porfirio Díaz by Francisco Madero; and then, by a great leap intended to comprehend them all, Marxism contends with imperialism and Nazism. Orozco wanted to impress on his viewers an equation between the extemporaneous quality of his handling and the urgency of his representation. By contrast, Rivera's dainty and caressive strokes, always locked in by firm outlines, act as a distancing factor in a concept that presumes to answer to a truth higher than that of an individual's zeal.

In his most official ensemble at the Palacio Nacional, the seat of the old viceroys of Mexico, Rivera especially bore down upon his viewers the thought that this firmament was preordained. At the same time, its "celestial" and its "infernal" echelons are equally decorative, although his skills as a caricaturist lend them great variety. The eye is at a loss when it contacts the fatiguing democracy of his effects. Instead of Orozco's great crescendos, there is a comparably relentless leveling in Rivera. The viewer has to take it in, part by accreted part, as in the Spanish copies of pre-Columbian Mexican codices he studied. For his works in the United States, he developed a series of compositional brackets, typically scaffolding or girders, while in his homeland his constructive approach was more unbuttoned and seemingly casual. Yet each calls for a kind of distracted browsing around larger episode and smaller incident, without main guidelines. The attention is pivoted and ricochets where it chances upon dispersed details. Just when curiosity seems depleted, it is replenished

by some new invention in an apparently inexhaustible series of lively observations. Though initially dominant in effect, an omnivorous piquancy settles into a tone of decided sweetness. Rivera's anthologies of historical potentates, crowded cheek by jowl into the most shallow spaces, have something almost Asiatic about them. Still, though they are lost in vast assemblages, each character in them is thought through, has an integrity, not only as a type but as a person.

This is particularly evident in one of the less polemical panels at the Secretaría de Educación Pública, *Day of the Dead: Street Festival* (figure 8). With its masks, its jiggling cutouts of skeletons clothed in mariachi costumes, and its sugared skulls, the fresco does qualify very well as a folkloric essay on a famous national celebration. But it works even better as a sardonic street scene. Pimps and other sharpies hobnob together with office workers, country hicks, and señoritas, all observed with a flair and grotesquerie worthy of Ensor. Rivera is there too, a smiling face in the crowd, as if he were Alfred Hitchcock making a subtle cameo appearance in his own movie. Yet his presence also has a rhetorical function, since it coincides with his view of himself as a kind of everyman in touch with the collective sentiments of his people. Speaking of himself in the third person, Rivera claimed in 1925: "He [was] a unit identical with the thousands

9. Diego Rivera. *Dream of a Sunday Afternoon in the Alameda Park*. 1947–48. Fresco. Detail

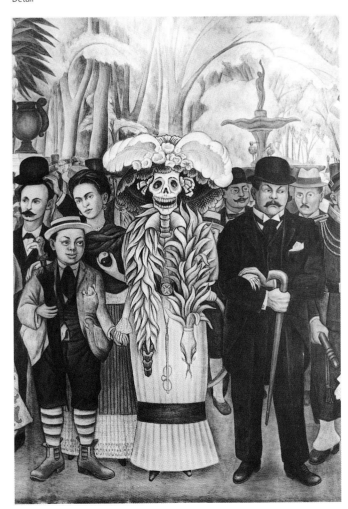

of Mexican workers. The artist did not have to pretend any spiritual or philosophical posture, nor much less take a political stand, but simply listen to his own deepest feelings—it was that of his fellows."[5] In order to interpret this statement, we should not assume a personal modesty on the artist's part, but rather, a rhetorical inflation of the Mexican proletariat, a class to which this workaholic assumed he had the honor to belong.

Such was the background for the *Dream of a Sunday Afternoon in the Alameda Park* in the Hotel del Prado. By now we can see that it is tied to his radical politics of the 1920s and 1930s, much as the gaily colored balloons are tethered by the vendor in the park. Everyone is depicted as having his or her feet on the ground, but treated as if incipiently buoyant. (The central balloon in the composition is their logo.) This is no less true of the boy with the goitrous, all-seeing eyes and the frog in his pocket, for whom the proceedings are ingested as phenomena rather than record. The artist's wife Frida Kahlo embraces the child's back, while he himself holds the bony claw of his mother for the occasion, the lady figure of death, *la muerte Catrina*, as she was called, arm in arm on her left with her most devoted illustrator, the turn-of-the-century engraver José Guadalupe Posada, Rivera's father in the dream (figure 9). Rivera imagined himself to have the most formidable parents, whom he associated with his artistic beginnings. For Posada had been the producer of popular image and broadside metal engravings that had first inspired him, while the Catrina had been Posada's most arresting contribution to the death cult in the Mexican imagination.

In many of his other works, past and future, Rivera had been at pains to suggest the role played by a biological and geological foundation in the rise of cultures. Here, in a hotel where most of his viewers lived briefly and left, he alluded to his own genesis in a marvelous social vignette, almost center stage. While the skeleton would have been stereotypically understood as a comment on human vanity, she allows more significant readings—to the artist's ultimate purpose. Catrina's *belle-époque* stole is the plumed serpent, the Quetzalcoatl of Toltec legend and the symbol of Mexico, now pictured as a limp insignia that adorns a death's head. So the world of the fresco is an entirely secular world, foreign to pagan spirits—but also to Christian ones. On a placard in the mural there had originally been written—and then removed under Catholic pressure—"God Does Not Exist," a remark of a nineteenth-century scholar who advocated the separation of church and state. In the end, there is no consolation of an afterlife in the material radiance of the Alameda Park mural, that microcosm of a culture and its remembrance. We take from it a pleasure as light as chiffon in a human parade whose members pass briefly in view within the infinitude of time.

—

From the frequently asocial standpoint of modernism, Orozco sometimes gets a respectful nod, but Rivera is snubbed because he located the ideal of freedom *within* a community, not outside it. But the modernist impulse has abated just as the communist system has withered. And this is not to speak of our new, global political reality: rampant nationalism asserting itself ever more fiercely against minorities, now that central power blocs are either weakened or removed. The Mexican painters were deeply involved with, or freely evoked, like circumstances earlier in the century. All this reinvigorates the presence of their art today, and brings it from where it was into closer range with our own dilemmas.

Given our present cultural wars, North American viewers must be startled by conditions in Mexican society that allowed such deeply antagonistic artists as Rivera and Orozco to be sponsored by the authoritarian state. It was all very well for Orozco to conceive connivers, embezzlers, and absconders frolicking while a sluttish justice sleeps, but it was quite another thing for him to execute such a vision on the walls of the Suprema Corte de Justicia, in 1941! For him the more official the setting, the more of an opportunity he had to give conspicuous offense. In the United States no such curmudgeonly tradition exists in public art. Here, to be sure, parties in power may often renege on their promises, but they never presume to radical activism as does Mexico's ruling political party, the Partido Revolucionario Institucional. This has allowed a curious, longstanding trade-off between government and intellectuals, well described by the journalist Alan Riding: "Academics, writers, painters . . . inherit the right . . . to participate in politics . . . to sit in judgment on the regime, even to denounce the system. The government in turn promotes their reputations, finances their cultural activities and tolerates their political dissidence, preferring the price of appeasing or coopting intellectuals to the perils of ignoring or alienating them."[6] Riding goes on to say: "Intellectuals, recognizing the centralized nature of power in Mexico, consider it more useful to influence the government than public opinion."[7] But who was to calculate the impression repeatedly brought home upon the undifferentiated visitors to the ministries, hotels, schools, churches, and libraries where Mexican fresco painting belabored the ruling classes or pointed to atrocious injustice? And who would deny that some large sense of their destiny was conveyed to people by the way the works themselves were absorbed into the visual culture?

José Vasconcelos, Obregón's Minister of Education, started it all in 1921 by commissioning Rivera, Orozco, plus many others, in the first concerted—and still most prestigious—government program in Latin America to feature painting on public walls. Furthermore, he toured his artists through the country's states in order to afford them an intimate knowledge of regional folk styles. Significantly, at that moment, the government's first priority was to put down local factions and warlords in many of those states. This veteran politico was also a dreamy philosopher who believed that when the arts flower in total freedom, society will have reached its highest state. "It was therefore his bad luck," wrote the artist and chronicler of the Mexican Mural Movement, Jean Charlot, "that the group of artists he took to pasture were mostly tired of artistic license and eager to rehabilitate didactic painting."[8] Though they were suspect in high circles, and ferociously protested by influential Catholic and right-wing groups, the painters were thereafter set in their course as the most visible representatives of a national school.

In their inevitable competition with each other, Orozco enjoyed all the advantages of the detractor over the apparent homilies of Rivera the eulogizer. In 1934 the Mexican intellectual Samuel Ramos wrote: "The most striking aspect of Mexican character . . . is distrust. This attitude underlies all contact with men and things. It is present whether or not there is motivation for it. . . . It is almost his primordial sense of life. . . . It is like an a priori form of his oversensitivity. . . . It embraces all that exists and happens."[9] Orozco would seem to have

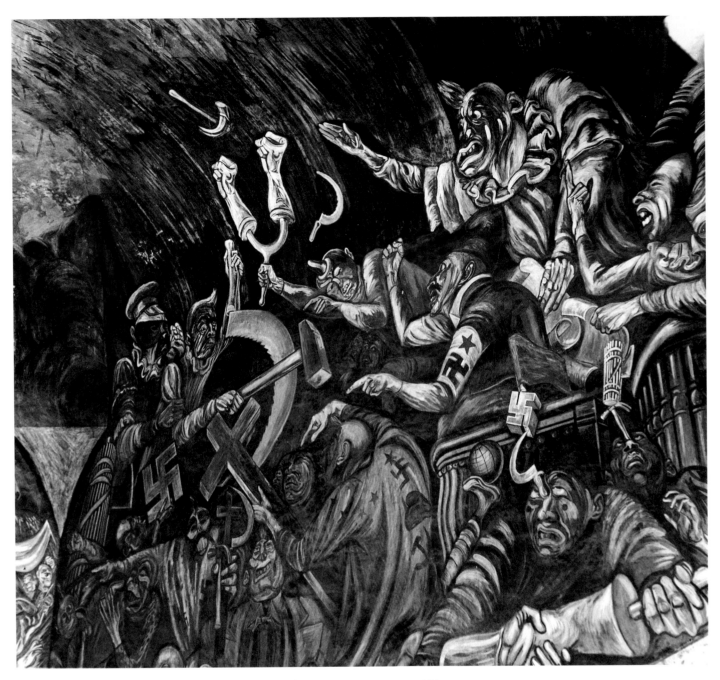

10. José Clemente Orozco. *Carnival of Ideologies*. 1937–39. Fresco. Detail of mural, Palacio de Gobierno, Guadalajara

inherited this downbeat trait, which was fed by the shams of public policy and its critics. If Ramos is any guide, then surely Orozco's *Carnival of Ideologies* at the Palacio de Gobierno at Guadalajara is the supreme expression of this world view (figure 10). This congress of swine is treated less kindly than those in the panel called *The Confusion of Religions* at the Instituto Cultural Cabañas. The beliefs that led to World War II, on *all* sides, are incarnated by pop-eyed or cross-eyed mountebanks, hailing or flailing the air, pledging, accusing, wringing their puppet hands in vile clownery. But this was simply a concentrated instance within a panoramic skepticism.

Whereas Orozco did not hesitate to depict the fond communist conjunction of the proletariat and the army as an alliance of

morons and brutes, Rivera represented workers and soldiers joined together in a noble fraternity of the future. Orozco had nothing but contempt for the potential of mass action, for it is energized by thousands of dupes led by bleating mouths (in a mural in Jiquilpán). In contrast, Rivera could think only of the paradisiacal solidarity of the people, induced by correct doctrine. We have seen what Orozco expressed about the Indian past; Rivera, on the other hand, glowed with ethnocentric pride at the magnificence of the Indians' civilization, though he did not overlook their cruelty (Palacio Nacional). Still, it was not so much in their values as in their belief systems that these two painters disagreed throughout their careers.

The Lear-like rages that Orozco developed at Guadalajara were

the product of a disappointed idealist who had too much intelligence and pride to become a nihilist. Everything is fined down in this art to the one enduring moment of extremity, narrated by a monologist accompanied by the groans of the ruined and the wretched. But where Orozco expounded on the varieties of human self-extinction, Rivera discoursed on the perhaps un-Mexican hope of the possibilities of the future, with a giant chorus as a silent partner to back him up. For him, vision builds on a politics of communion and of social accord within the mosaic of peoples. His art is filled with encounters between unlike creatures who conflict with, but also learn from, each other. This sociality throws into maximum relief the alienation of Orozco, in whose world no conciliation existed and no quarter was ever given. True enough, Rivera made no provision for the unsightly poor in his pictorial zone, but his work is also capable of making important distinctions relevant to Mexico that were not of concern to Orozco.

In the fabled, dioramic spaces of Rivera, the countryside is certainly given its due, but it is the city that magnetizes him. It spawns every possible petty crime and decadence. It overflows with bigots, gluttons, profiteers, thieves, clowns, and whores. It is also the political headquarters of repression. Yet Rivera had an instinctual need to enjoy himself; he worked in that city, he utterly depended on its urban culture, which he described with a serene, yet gargantuan zest. Where it was shown as the place of desolation by Orozco, Rivera portrayed the city as the crucible of understanding for our species. More than that, it is the stage where women come into their own, fully as active, industrious, and comradely as men, while appetizing in their sex. Rivera's art, for all its great mobs, is remarkably quiet—a hush is sustained throughout, as in a *tableau vivant*—but it is wonderfully scented. Orozco, on his side, rarely represented women at all except very occasionally as whores signifying the debasement of human affairs. There is no room in his art for any feminine principle that might mitigate the fatality of his ideas or introduce a spirit of generosity or caring. In his autobiography, he never even mentioned his wife nor that he had a family. Studying his art, we almost hear an avalanche of sound, but since the skin has been removed from the sinews of his figures, there is no corresponding stimulus for the sense of touch. Orozco's bodies, said Octavio Paz, "are ignorant of the caress: they are bodies of executioners and of victims."[10]

Rivera seems to us a weirdly composite artistic personality, revivalist in style, classicist in mood, and yet revolutionary in temperament. His political credos were evidently just as synthesized. In touch with anarchist ideas before World War I, he subscribed to Marxist Leninism after it, and then became a full-fledged Trotskyite. The very aged Rivera who, for reasons best known to himself, craved entrance into Stalin's good graces and the rigid Mexican Communist Party, would have shocked the younger, firebrand Rivera, who had scorned them. Certainly things in Mexican society had a very obvious and problematic habit of winding up charged with a very different content from the way they had begun. By expropriating and nationalizing the oil industry, for instance, in a move that antagonized United States interests, President Cárdenas officially prohibited any strikes in a development he upheld as faithful to the Revolution. And in the 1930s Vasconcelos evolved into a conservative Catholic and pro-Franco zealot, a believer in the supremacy of the Hispanic legacy. It

was perhaps to discredit such a position that Rivera showed Cortés as a hunchbacked degenerate at the Palacio Nacional. These examples point up the really dramatic shifts of political experience in Mexico, to whose ambiguities people often tended to respond by major reversals in their thinking. In Rivera's case it was not his personal deviations from any line, "progressive" or "antiprogressive" as it may be, which makes a difference for us. What we note, rather, is the way he repeatedly returned through mingled interests to the same point of highly sensuous response to Mexican life and history. In the end, his good intentions, though serious, had to make do or stand aside for his irrepressible appetites.

Ultimately, Orozco joined with Rivera, though far more tortuously, in reverting to the central predicament of both their oeuvres: the question of individual freedom—and what the social contract should be—in an oppressive society. Although a documentarian, Rivera was not as realistic as his colleague in assessing society as it existed. It would be fair to say that Orozco struggled with the issue of the relation of freedom to social malignance, and with a sense of self-destruction in human psychology, throughout his career. Without question, his most forceful treatment of the theme is in the staircase fresco of the Palacio de Gobierno at Guadalajara.

Approaching the work up the stairs from an entrance in the court, the viewer at first sees only the lower portion of the painting on the back wall, a gray, writhing mass of combatant figures, prickling with bayonets, those in the foreground already dead, while the scene shows them in their fall. Death is the product of the overall action. A bit farther in the ascent, there come into view heavy, toppling red banners whose color is enhanced by the molten hue of a fiery stake held in the fist of an enormous black-garbed figure, who thrusts it above the viewer's head at the landing. Higher and back toward the court at the mezzanine, the full subject is revealed, the renegade priest and Creole revolutionary of 1810, Miguel Hidalgo, whose ferocious, possessed, uncanny face looms across the vaulted ceiling and whose presence weighs down as if to crush and scorch the unsuspecting viewer (figure 11). Here Orozco summoned up the Wars of Independence (1810–21) as the historical challenge to the Conquest, shown at Cabañas. It is one of the most spectacular *coups de théâtre* in the painting of our century. But what is Orozco actually telling us about revolutionary action?

Outstanding among conspirators who wanted to see a Creole junta replace the Spanish colonial government, Hidalgo had status among the poorest Indians, whose dialects he spoke. His radical manifesto included the abolition of Indian tribute and slavery and a return of all lands rightly belonging to Indian communities. But his leadership was swamped by uncontrolled Indian hordes eventually defeated in a bloodbath after they themselves had committed great atrocities. As Orozco saw him, Hidalgo is partly a mastodon of revenge and partly Christ Pantokrator. The visionary hero presides in a kind of Last Judgment that raises the most disturbing questions. For he seems at the same time to unleash, to chastise, and to sponsor— perhaps even to incarnate—the malevolence beneath him. Though he is established in the hall of Mexican patriotism, Hidalgo is a false god, a terrifying figure whose doctrine was libertarian.

Hidalgo's spirit is that to which all attempts to better the human condition must answer. Orozco could not have portrayed it so convincingly if he had not also succumbed to it. As if to acknowl-

edge his own demon in his own pantheon, Orozco depicted at Cabañas the man of fire. The painter had declared himself a foe of all fixed ideas, which led humankind into bondage and self-destruction. But Orozco recognized that this judgment, reiterated throughout his life, was itself an *idée fixe*, and he knew himself to be its hostage. That is why Prometheus (already the hero of his fresco at Pomona College, Claremont, California, of 1930) serves as the artist's alter ego, and burns even as he lords it over Orozco's cosmos.

Thus in these works a kind of existential crisis informs the paradoxes of nationalism. The glorious travails of Mexico are mythologized as symbolic of our common fate. In a society so inexperienced in liberal values, intellectual freedom is a dream that turns to ashes, even though it is the only goal worth living for. Nowhere was it written that the pictorial arts in Mexico should have taken such a turn. It had been energized by two driven men, schooled in caricature, both vividly flawed and gifted by the environment they knew so well. About one of them, Jean Charlot wrote: "Young Rivera, penniless and lusty, sat fourteen hours a day up on a plank, brush in hand, face to the wall like any scolded schoolboy. Old Rivera, toothless, famous, and wealthy, sat brush in hand, fourteen hours a day, on a kitchen chair hoisted on four planks, his back still turned on the objective world."[11]

But we should like to think that what took form on that wall was a loving memory of that world, its sensations and its dreams. About Orozco, Paz said simply and eloquently that "he was the prisoner of himself."[12] Both artists reflected upon their reality by returning with monomaniacal force to a few points in order to get deeper into them. Even as this entailed severe restraints or bitter knowledge, it formed their best hope of involvement in the Mexico of their day. Considering their art, we have to ask, finally: How different is that day from ours?

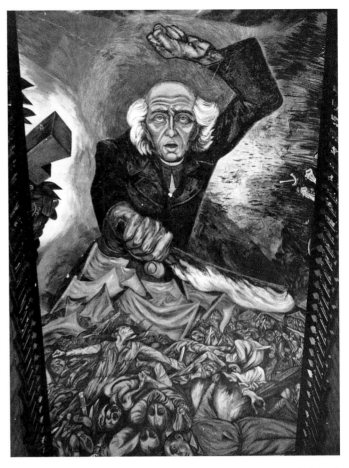

11. José Clemente Orozco. *Father Miguel Hidalgo*. 1937–39. Fresco. Detail of mural, Palacio de Gobierno, Guadalajara

Notes

1. José Clemente Orozco, in Carlos Pellicer, ed., *Mural Painting of the Mexican Revolution, 1921–1960* (Mexico City: Fondo Editorial de la Plástica Mexicana, 1960), p. 179. Originally published in "Una Corrección," *Mexican Folkways* 5 (January–March 1929), p. 9.

2. José Clemente Orozco, *An Autobiography*, trans. Robert Stephenson (Austin: University of Texas Press, 1962), p. 104.

3. Antonio Rodríguez, *A History of Mexican Mural Painting*, trans. Marina Corby (New York: G. P. Putnam's Sons, 1969), pp. 350–51.

4. Ibid., p. 350.

5. Diego Rivera, "Los frescos de la Secretaría de Educación," in Rodríguez, *History of Mexican Mural Painting*. Originally published in *El Arquitecto* (September 1925), p. 17.

6. Alan Riding, *Distant Neighbors: A Portrait of the Mexicans* (New York: Alfred A. Knopf, 1985), p. 17.

7. Ibid., p. 295.

8. Jean Charlot, *The Mexican Mural Renaissance, 1920–1925* (New Haven and London: Yale University Press, 1963), p. 295.

9. Samuel Ramos, *Profile of Man and Culture in Mexico*, trans. Peter G. Earle (Austin: University of Texas Press, 1962), p. 64.

10. Octavio Paz, "Social Realism: The Murals of Rivera, Orozco and Siqueiros," *Arts Canada* 232/233 (December 1979–January 1980), p. 64.

11. Charlot, *Mexican Mural Renaissance*, p. 317.

12. Paz, "Social Realism," p. 59.

JOAQUÍN TORRES-GARCÍA AND THE TRADITION OF CONSTRUCTIVE ART

———

Florencia Bazzano Nelson

Constructive art in Latin America is an avant-garde enterprise of vast proportions, which began in the 1930s with the pioneering work of Joaquín Torres-García. Born in Uruguay in 1874, he left at the age of seventeen for Europe, where he developed his art and aesthetic theories in tandem with the avant-garde movements in Barcelona and Paris. He returned permanently to Uruguay in 1934 with a vanguardist project to develop a "universal" constructive art rooted in the Americas.

What Torres-García called Constructive Universalism rested on two principles: the universalist notion that an artistic tradition has existed since remote times that expresses essential truths through geometrically determined archetypes, and the classical idea that the work of art is a ground where opposing cosmic forces can be combined harmoniously. On these principles Torres-García elaborated a monumental but coherent metaphysical and aesthetic system. His beliefs were so firm and his message so timely that his avant-garde Americanist project influenced several generations of artists.

This essay first analyzes the origins and aims of Torres-García's Constructive Universalism. A comparison between the artistic theories and practices of the European avant-garde movements Torres-García encountered and his own developing theory and practice is followed by a general discussion of the metaphysical and aesthetic system that he elaborated throughout his life. This shows how Torres-García, by synthesizing elements taken from classicism, Cubism, Neo-Plasticism, and Surrealism, as well as pre-Columbian art, formulated through his work, and later in his writings, a universalist system, which differentiated his art from other European Constructivist tendencies. This process was completed in Uruguay during the 1930s and 1940s.

A second objective is to explore how Torres-García's system influenced artistic discourse in Latin America. After his return to Uruguay, Torres-García established two arts-and-crafts schools in Montevideo, one in 1935 and another in 1943. Through these institutions, where an intensive pedagogical activity was maintained, he launched an avant-garde project that inspired not only the young Uruguayans who participated in his workshops but also several generations of abstract artists in Uruguay, Argentina, Brazil, Peru, Venezuela, Ecuador, and even the United States. Although Torres-García's message was heard throughout the continent, it was more completely assimilated in Uruguay and Argentina. For this reason, Torres-García's complex legacy is represented here by a discussion of the works of two artists from the Río de la Plata region: Gonzalo Fonseca, who in his youth was a student of Torres-García, and César Paternosto, who belongs to the generation that came of age in the 1960s.

———

Torres-García's development of an aesthetic theory began with his formulation in Barcelona of a Mediterranean classicism. Torres-García and his family traveled to Spain from his native Uruguay in 1891. The next year he began studying art in two Barcelona academies while becoming acquainted with the Catalonian art world. In 1893 he joined the Cercle Artístic Sant Lluc, an association for Catholic artists, where he was greatly inspired by two sermons, "The Infinite and the Limit of Art" and "Artistic Language," by the group's religious counselor, Dr. Josep Torras i Bages, in 1896–97.[1] Soon after,

he began to spend much of his time reading "thick volumes of philosophy and also others of literature: Kant, Schopenhauer, Hegel, Goethe, on the one hand, and on the other, Homer, Sophocles, Aeschylus, Plato, Horace, Epictetus."[2]

As a result of this reading, Torres-García began to formulate his distinctive approach to art. In 1901 he wrote an article opposing the extreme individualism and romanticism of Catalonian modernism, arguing in favor of a classic art that expresses "the eternal in every thing and every act."[3] By 1906 several young artists and writers who shared some of Torres-García's views on classicism formed a group called the Noucentistes. They agreed in affirming, as the means to further develop a Catalonian cultural identity, a return to Mediterranean classicism.[4] One of the best examples of Torres-García's Mediterranean classical style is the unfinished cycle of frescoes he painted from 1912 to 1918 for the Saló de Sant Jordi, in the Palau de la Generalitat in Barcelona. Although Torres-García already had an established reputation as an artist—he had worked for Antoni Gaudí and painted other frescoes in Barcelona—his work was controversial enough to eventually cost him the commission.

The second panel in the cycle was titled *The Family* (c. 1913–15).[5] In the foreground of this Mediterranean pastoral scene, a mother nurses her baby while a man with work tools watches over them. On the left, an old man holds a toddler in front of him. Behind them, two men plough a field in a hilly landscape. Below, to the left of a door, a woman holds a basket of fruit, and on the right, a man holds a shovel. Torres-García's classicism appears in several ways: the idealization of the scenery, the poses of the figures, and their garments—or lack thereof. Also, the allegorical images were meant to represent timeless, and therefore classical, truths: the cycle of life, the nurturing mother as a symbol of nature, a connection to the land, and a traditional assigning of roles according to gender. Formally, Torres-García showed a preference for solidly structured compositions, earthy colors, and a primitivizing figurative style, and he was attacked by many who were not yet ready for such a vanguard look.[6]

The last of the cycle's frescoes that Torres-García completed attests to a significant change of direction in his art that was taking place in 1916.[7] In the lunette of the upper part, he depicted three allegorical figures in classical dress: a woman working at a mechanical loom, a woman standing beside a tall construction crane, and a man sitting in front of an airplane. In the square panel below, the theme of industry is elaborated with images of workers and businessmen in the foreground, a crane and a train in the middle plane, and factory buildings in the background. In these panels Torres-García attempted to reconcile the opposing forces of the classical tradition and the modern mechanized world. The classicizing of the allegorical figures conveys the notion that certain values are permanent, existing like Platonic Forms, above the particularities of history. On the other hand, references to the cotton textile industry, the backbone of the Catalonian economy; the forces of progress represented by the airplane, train, and factories; and the implied disharmony between labor and management; are specific elements connected with Barcelona's historical context.[8] The shift from archaic to modern seen in this fresco marks a transition in Torres-García's work from Noucentisme to a new style, Vibracionismo (Vibrationism).

Since the beginning of World War I, several artists in exile, including the Uruguayan Rafael Pérez Barradas, Robert Delaunay,

Sonia Delaunay-Terk, Albert Gleizes, and Francis Picabia had been in Barcelona. Their stay had been preceded and accompanied by a series of exhibitions of modern art.[9] The main influence on Torres-García's art during the war years was his friend Barradas, who introduced him to the ideas of the Futurists he had met in Italy.[10] When he arrived in Barcelona in 1914, Barradas was working in the futurist style he called Vibracionismo.

Together with Barradas, Torres-García discovered the other pole of his metaphysical system: the "vibrant" aspects of urban life, which he began to represent in works such as *Barcelona Street* of 1917 (Collection J. B. Cendrós, Barcelona) and an untitled drawing of June 1917 (figure 1). In these works Torres-García focused on the fast-paced activity of urban life, juxtaposing fragmented images of electric signs, people walking, cars, and factories. The dynamic rhythm of both artworks clearly reveals many points of coincidence with the futurist tendencies and avant-garde aesthetics brought to Barcelona by Barradas and other artists in exile, which liberated

1. Joaquín Torres-García. Untitled. 1917. Reproduced in *Un enemic del poble*, no. 3 (June 1917). Biblioteca dels Museus d'Art, Barcelona

Torres-García from the burden of figuration. At the same time, he continued to ground his compositions in solid structures and increasingly organized the visual fragments along vertical and horizontal axes. His Vibrationism would find its best expression in one of the most frenzied places in the world, New York City, during the 1920s.

After the termination of his commission for the Saló de Sant Jordi, the closing of the experimental art school Mont d'Or, where he had been teaching since 1907, and the loss of the toy-manufacturing business he had established, Torres-García became disenchanted with Catalonia and emigrated to New York in 1920, intending to resume toy production on a larger scale. However, Torres-García was unable to establish himself as a self-supporting artist or adapt to the United States, which he considered very civilized and orderly, but too mechanized and materialistic.[11] He remained until 1922, when he returned with his family to Europe, settling in Italy. There his objective was to manufacture his toys and sell them in New York. That venture did not work either, and, after a brief period in the south of France, Torres-García moved to Paris in 1926.

Although he was already fifty-two years old when he arrived in the French capital, he considered it the place where he reached artistic maturity and produced some of his best works.[12] In his confrontation with the avant-garde movements in Paris during the late 1920s, he established the aesthetic and theoretical foundations of Constructive Universalism. It was a monumental synthesis of the concrete value of form in Cubism, of the purified concept of structure in Neo-Plasticism, and of the intuitive and archetypal bent of Surrealism.[13] The harmonious combination of these terms in a Constructivist language was the basis of his modern classicism.

In 1926 Torres-García was already using Cubism to attain a synthesis between the artistic vitality he had achieved during his Vibrationist period and the Platonic and Pythagorean view of the world as a manifestation of eternal truths, which had informed his thought during his classical period in Barcelona. He considered Cubism a liberating force in modernism because it ended "the tradition of the Renaissance, which consisted in the imitation of the *appearance*; because Cubism goes *to the real*; what is substantial in things and not apparent."[14] For this reason, he considered the two most important aspects of Cubism to be its revolutionary affirmation of the concrete value of form, independent of its representational function, and its emphasis on geometry, which gave the work of art an ordering principle. However, he objected to the fact that this ordering was done intuitively, without a numerical basis, and that Cubism retained indications of volume and specific shapes of represented objects, suggesting a third dimension.[15] Torres-García concluded that Cubism could not be a completely universal art, although he conceded that it had achieved "the fundamental principles of classicism, and the strictest sense of plastic art ruled its production." Thereby, "Cubism, almost without thinking, re-established the ancient canon."[16]

Already in Italy he had begun a series of works, such as *Guitarra* of 1924 (The Museum of Modern Art, New York), which showed his interest in Cubism as a way of achieving more abstract and geometric means of expression. Vaguely reminiscent of Pablo Picasso's sheet metal and wire *Guitar* of 1912–13 (The Museum of Modern Art, New York), Torres-García's small sculpture is constructed of a wood whose roughness suggests an ancient object. The choice of material also might be connected with the modular wood toys he designed. As with his toys, he reduced the configuration of a guitar to a few simple geometric shapes. *Forms on White Ground*, another sculpture of 1924 (Fundació Museu d'Art Contemporani, Barcelona), is perhaps his earliest completely abstract work. As with Cubism, he considered pure abstraction a necessary step in the liberation of the artist from naturalism, but he found it lacking in intuitive qualities and therefore unsatisfactory.[17]

In Paris Torres-García continued to search for an improved synthesis of universal elements and became concerned with the primitivizing aspects of Cubism. His interest in the "primitive," to employ the term Torres-García used, was twofold. On the one hand, he saw it as a strategy for departing from naturalism, and on the other, he recognized in it—or projected onto it—universal and spiritual aspects. Early in the twentieth century many Parisian modernists appropriated features of nonnaturalistic African tribal art in ways that reflected their formal preoccupations rather than the inherent concerns of African art itself.[18] For Torres-García African tribal art, like

pre-Columbian art, exemplified another way of "returning to the origins," not by rejecting Western civilization in favor of a supposedly unspoiled state, or a lost golden age, but as a way of revealing the kind of universal truths or "memories of the soul" that he sought through his preoccupation with classicism.[19] Thus, Torres-García appropriated nonnaturalistic African tribal art and gave it a place in the genealogy he established of what he called the great tradition of constructive art. This identification of African with constructive art was predicated on his perception of certain similarities between his creative processes and those of primitive peoples: "[When] the so-called savage interprets form . . . that form lives in his soul, because he knows it intuitively, directly; and when he creates something that responds to the spirit of the form (his work, a fetish), he refrains from copying the reality from which it originated [and] because what he sees is not there anymore, he resorts to geometry [*la geometría*] to shape his work. With it he joins the universal in nature to the universal in reason, and that is the geometric [*lo geométrico*]."[20] Torres-García insisted that only a "metaphysical" affinity with primitive art is acceptable and asserted that artists "must be primitive[s] in the twentieth century. Without fearing new forms, which will deal with geometry, planes, abstract values, . . . the great ships, the chimneys of factories, the street traffic."[21]

However, in spite of his advice, he often used masklike images and, later on, pre-Columbian motifs in his painting and sculpture. For instance, his oil painting *Mask* of 1928 (figure 2) is a schematic representation of a mask—employing flatness, geometric simplification, and earthy colors—that recalls Picasso's style of 1907–08 and Juan Gris's work of the 1920s.[22] *Mask* also represents a further step in Torres-García's search for universal images. He purified the image of naturalistic residues by using Cubism as a filter that privileged certain primitivistic formal simplifications.

In 1928, the same year that Torres-García painted *Mask*, he met Theo van Doesburg (and Piet Mondrian in 1929) and began to evaluate the plastic and theoretical possibilities of Neo-Plasticism for his universalist project. He was attracted to the structural clarity of this style, but he felt that it had been achieved at the expense not only of nature, but of almost all formal elements, and so it was still an incomplete solution.[23] He considered Neo-Plasticism "somewhat dead in its cold abstraction, lacking greatness . . . [and] failing to transcend the aesthetic plane."[24] Mondrian and van Doesburg to a degree achieved balance in their work by opposing formal elements. However, Torres-García believed that Mondrian's equilibrium produced neutrality, not harmony.[25] Torres-García concluded that Neo-Plasticism was a dead end, overly scientific and lacking the necessary spiritual qualities to become universal.[26]

The bias in Torres-García's interpretation of Neo-Plasticism reveals a deeper prejudice against what he called the materialism of the North. In fact, Mondrian was deeply involved with spiritual matters. According to the art historian Carel Blotkamp, in Neo-Plasticism Mondrian expressed "the unity that was the final destination of all beings, the unity that would resolve harmoniously all antitheses between male and female, static and dynamic, spirit and matter."[27] Torres-García's frequent refusal to recognize the underlying concern with the spiritual that characterized Neo-Plasticism and much of European modern art may have been a result of his friendship and correspondence with José Enrique Rodó, a famous Uruguayan writer,

who, in the influential book *Ariel* (1900), criticized the materialism of Anglo-Saxon culture in the United States.[28] Following Rodó, Torres-García frequently lamented that the countries of the North, including those of Europe, imposed on the world material values that gave predominance to scientific and commercial interests.[29] Thus, Torres-García was unable to see in the well-ordered façade of Neo-Plasticism anything but a confirmation of his antimaterialist bias.

During this period of exploration, Torres-García attempted to synthesize Cubism, Neo-Plasticism, and Surrealism in order to create what he called a "complete art."[30] *Pintura constructiva (El sótano)* [*Constructive Painting (The Cellar)*] of 1929 (plate 211) and *Physical*, also 1929 (Collection Maurice Biederman, New York), show two stages of this synthesis. In *Constructive Painting (The Cellar)* Torres-García structured his composition with the golden section, which he began to use in 1929, following either the example of van Doesburg or of Torres-García's friend the Spanish painter Luis Fernández, a Freemason knowledgeable in esoteric matters.[31] A series of ordinary objects, reduced like his *Mask* to a few schematic lines, stands in front of an open window, through which we see a cityscape. Every line in the painting and every dissociated plane of color is oriented according to the underlying compositional structure, an arrangement that was not new in Torres-García's art, having precedents in the

2. Joaquín Torres-García. *Mask*. 1928. Oil on cardboard, 20 x 14½". Collection Torres-García Family

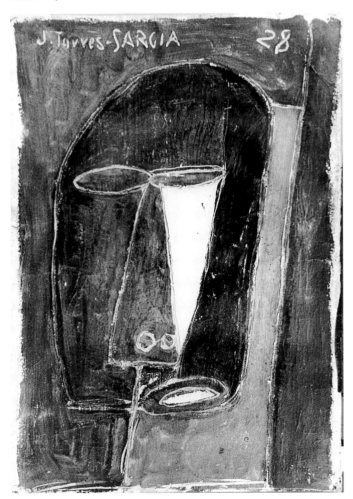

frontality of his classic murals as well as in the orthogonality of many of his Vibrationist paintings. Here, however, the influence of Neo-Plasticism is felt in his tendency to reify the orthogonal structure, making of it an independent sign.

The preeminence of the orthogonal structure is even more evident in *Physical*, one of his first Constructive Universalist compositions. In this painting all formal elements are grounded on and interlocked with the grid structure. The areas of color are independent of the represented objects and subordinated to the grid. The objects depicted, which are placed within the niches created by the intersecting axes, have been reduced to summary graphic figures: man, woman, horse cart; machine, classical temple; number five, fish. They are symbols of the physical world to which the title refers, schematic representations of essences.

The symbolic quality of Torres-García's Constructive Universalism is one of its most notable features. The use of symbols became an essential aspect of his system, and it is the most important point of difference between his work and that of other Constructivists. His symbols are self-referential graphic ideas that do not represent anything but themselves because the idea is completely identified with the form.[32] Torres-García's symbols are, by his own reckoning, comparable to Platonic Forms because they are "*materializations of the universal spirit*,"[33] which, having the magical virtue of translating spiritual states, awake analogous emotions in the soul[34] and "make the spirit present."[35] He also believed that his symbols expressed the vast world of the unconscious, a conviction that indicates the often overlooked connection of his work with Surrealism.[36]

Although Torres-García was one of the moving forces behind the formation in 1930 of the group Cercle et Carré, which brought together Constructivists in order to oppose the Surrealists, he found in the Surrealist exploration of the unconscious essential elements for his own project. Torres-García's interest in the unconscious began around 1917, when he realized that certain states of consciousness allowed him to comprehend things that were not accessible to him in an ordinary state,[37] and he recognized that the process of creation originated for him in the activity of the unconscious.[38]

Other references for Torres-García's symbols were Jungian archetypes, primordial images that, as Carl Jung theorized, have existed since remote times and do not have fixed meanings. Although Jung was never mentioned by Torres-García, who rarely acknowledged his sources in his extensive writings, it is not surprising to find in his work many connections with Jungian concepts.[39] Archetypes, which Jung based on Plato's Forms, connect the individual not only with the unconscious but also, through the notion of the collective unconscious, with timeless cultural traditions.[40] Thus, the theory of a cross-cultural and spiritually powerful archetype is analogous to Torres-García's concept of a universal tradition of constructive art that is perpetuated by the magical power of its symbols.

In works like *Constructive Painting*, of about 1931 (The Museum of Modern Art, New York), *Constructivo de la elíptica* [*Elliptical Constructive Painting*] of 1932 (plate 215), and *Universal Composition: Elements of Nature* of 1932 (Private collection, New York), Torres-García introduced into the structural grid symbols that may be considered archetypal: their meanings are not precise and they have appeared in the art of many cultures. Sun and stars, man and woman, fish and leaf, ship and building, are symbolic representations

of essential qualities of the spiritual, human, natural, and material levels of the universe. Torres-García's treatment of colors also shows great variety, from the solid blocks of red, ocher, and blue of *Elliptical Constructive Painting* to the expressionistic brushwork in browns, grays, and blues of *Universal Composition: Elements of Nature*. In the orthogonal configuration of the structure, based on the golden section, and in the geometric representation of the symbols, Torres-García found a way of harmoniously synthesizing their universal and modern aspects.

Surrealism also affected Torres-García's relationship with adherents of other Constructivist movements.[41] Torres-García could only agree partially with their aim of consolidating "a common front against 'the tyranny of the individual' in art" because he still deemed the unconscious necessary in the "constructive" process.[42] Torres-García also disagreed with their opposition to all art of the past, a stance proposed by Naum Gabo and Antoine Pevsner in the "Realistic Manifesto" of 1920, and with their emphasis on logical reasoning based on scientific facts, and their call for standardization and utilitarianism.[43] Thus, Constructive Universalism differed greatly from its European counterparts because Torres-García defined and understood constructivism not only in terms of the avant-garde but also as continuing a tradition of universal art that privileged metaphysical concerns above all others.

How Torres-García fits into the modernist avant-garde project is a complex question. If we define modernism as a centralized enterprise of successive avant-gardes that propose original solutions as they reject the art of the past, then Torres-García was a modernist. Because he saw modernism in terms of opposition between center and periphery, he considered Paris the center of modern culture, while outside it he saw "nothing, only vulgarity and ignorance."[44] When his artistic project shifted to Montevideo in 1934, he realized the need for a new center, and he wrote: *Our North Is the South. For us there must not be a North, except in opposition to our South.*"[45] As a modernist, Torres-García was intransigent about his ideals and firmly believed that his solutions were new, original, and superior to all others. Like most vanguardists, he emphasized formal innovation. If, as Juan Fló has noted, Torres-García's interest in extra-artistic concerns places him at odds with modernism, this points not to a lack of modernity in Torres-García but is rather a sign that critics who see his attitude as antimodern still subscribe to the reductive view of modernism proposed by Clement Greenberg.[46] Perhaps Torres-García had a stronger sense of tradition than other European artists of his time, but his theoretical and artistic practice was firmly based on avant-garde assumptions, and his vanguardism became a fundamental principle of his Americanist project.

Constructive Universalism as Theory

Torres-García's formulation of his aesthetic theories almost always followed what he intuitively discovered in the practice of art. Considered as a whole, his extensive writings function as a justification for the choices he made along the path toward Constructive Universalism. Furthermore, in his publications he not only established a solid ground for an aesthetic system but also developed a metaphysical foundation that provided him, and later his students and followers, with a cohesive rationale for his artistic practice.

"If we are asked, what is Constructive art?," Torres-García once wrote, "we can give a categorical answer: it is the art that, founded on universal concepts, can achieve a true construction in which everything is included."[47] The need for an extension of an aesthetic system into a philosophical one comes from the artist's firm belief that the role of constructive art is not simply utilitarian, much less scientific, but instead eminently metaphysical. He thought that art provides a visual record of the transcendental and harmonious relationship between the individual and the universe. In fact, Torres-García found an intrinsic identity between both realms. To explain his belief that the universe and the individual—which he called the Abstract Man, a general notion rather than a reference to a particular person—are structured in similar ways, he wrote, "The Abstract Man is the Cosmos (totality), module of Creation in its unity. Everything is there, in each man, microcosm."[48]

According to Torres-García, the universe is divided into inanimate, animate, and metaphysical realms. On the metaphysical level, "*the beginning of everything*" is unity, which he often associated with similar notions, such as God, logos, and universal harmony.[49] Unity presupposes duality and multiplicity, because it results from the harmonious opposition between the male principle, whose attributes are linked to the spirit, abstraction, reason, intelligence, and classicism, and the female principle, which embodies concrete reality, intuition, emotion, and romanticism.[50]

Torres-García's dualism, which is illustrated in a series of drawings he produced around 1930 (figure 3), was based on the Pythagorean notion that the "ultimate principles were limit and the unlimited, equated with good and bad, respectively."[51] From the eternal struggle between these opposites, Torres-García believed, life and movement spring forth, creating the multiplicity of the universe. He also used Pythagorean numerical and geometrical metaphors to explain the notion of multiplicity: "We represent reason (the idea) with the one, . . . its activity, or manifestation, with the number two (desire for existence, for being, already soul), and with the number three, the organized and materialized. Thus we have a perfect triangle. These three terms would correspond to the three levels in the nature of things: one, reason, law, geometry, abstraction—two, desire for action, will, emotion, and soul—and three, the material, the concrete, the definitive realization. . . . Those components, abstract, emotional, and material world, are what form each human being."[52] Thus, the tripartite makeup of the individual parallels the very structure of the universe and reflects the complete ordering of creation.[53] For this reason, Torres-García considered the individual to be "the archetype of Creation, figure and symbol of the universe," which he denominated the "Man-Universe."[54]

Following Pythagoras, Torres-García found *harmonia* to be the key principle that makes cosmic unity possible, in spite of multiplicity, and provides a link between the human and the universal levels. For the Pythagoreans, he wrote, "Salvation is obtained by the acquiescence of the intelligence and the soul in the HARMONIC laws that rule the WORLD."[55] One of these laws is the golden section, which he also called the Golden Rule, a system of proportion with a well-established tradition in Western art.[56] The golden section is the division of a line or proportion of a geometrical figure so that the smaller dimension is to the greater as the greater is to the whole. It can be expressed in mathematical terms as a:b=b:(a+b).

3. Joaquín Torres-García. *Intellectual Plan (Symbols)*. c. 1930. Pencil on paper, 6 x 4".
Collection Torres-García Family

For Torres-García, the Golden Rule determined the relationship between cosmic dualities. Because the terms of the ratio defined by the golden section are unequal, one pole of opposites will always prevail over the other but will not completely eliminate it. He explained this concept as the "struggle between Universal Man and the [particular] individual; a struggle that, under other names, takes place between good and evil, . . . between Spirit and Matter . . . finally, between the larger and smaller parts of our [Golden] Rule, . . . *evil cannot be eliminated* and is an integral part of the Cosmic Totality."[57]

Harmony has ethical connotations as well because, in order to be in harmony with the cosmos, individuals need to achieve equilibrium within themselves. However, since reason and intelligence are just one pole of a duality, they are limited in their capacity to apprehend universal truths, which can only be grasped by relying on the soul and intuition as well.[58] Alluding to Platonic concepts, Torres-García stated that the individual is able to perceive essential truths by a "necessary dilation of the soul."[59] He further explained that the poet talks without thinking: "The painter and the sculptor: they remember; memory of the soul. Plato was right: . . . when we look inside, who do we hear? *We return*, we return to our origin."[60]

Artists who balance reason and soul, intelligence and intuition, are in universal harmony and thus are able to express in their own works the essential truths their souls remember. An artist has "to be in order to do," as Torres-García often said.[61]

Torres-García also drew on Plato's doctrine of Ideas or Forms, which proposed that beyond the physical world there is another world more real than ours, the nonphysical, nonspatial, nontemporal world of Forms.[62] These Forms, which we can know through our soul, are the causal source or essence of all the things that exist in our world, which is only a shadow of the perfect realm of Forms.[63] For instance, if something is beautiful, it is only because it is a reflection of the Form "beauty." Through this concept, Torres-García explained how art exists on a higher plane of reality: "Form has an *absolute value, in itself*; in itself and not in relation to any reality: *it is a plastic form*. And it is to [this form] that Plato alludes."[64] For Torres-García, as for Plato, returning to origins meant recognizing the ability of the soul to "recall" the Forms among which it lived before being born into the human realm.[65]

In his aesthetic theories, Torres-García also expressed his preference for a harmonious compromise between the formalism of pure abstraction and the vitality of modern life. In his search for a more permanent art, he rejected the emphasis on novelty and subversion of established truths characteristic of certain modernist movements, as well as naturalistic and subjective art. Instead, he favored, and claimed as his own antecedents, all artistic expressions in the tradition of art that are based on universal ordering principles.

Tradition was thus a fundamental element in Torres-García's art and theory because he legitimized his notion of universality by linking it to a tradition of art reaching back to the Neolithic period. He established a highly selective genealogy of modes of artistic expression that are geometrical and nonnaturalistic but that reveal essential qualities of reality through the use of schematic symbols or archetypal forms. As he defined it, this artistic tradition reflects a harmonious relationship between macrocosm and microcosm, while at the same time privileging metaphysical concerns above utilitarian or scientific ones. Torres-García stated: "Constructive art is . . . the art of Humanity, . . . a true Tradition. It is the great geometric art of Egypt and Greece; of Byzantium and of the cathedrals; of Aztecs, Incas, and Oceanics. Art that is founded on rhythm, which is number, and that will always have unity as its base: a classical art of all times."[66]

Classicism, as understood by Torres-García, was a not a reference to Greek and Roman art or later revivals. For him, classical art follows the principles of frontality; orthogonality; dynamic relationship of planes and volumes; unity achieved through equilibrium; and geometric, schematic, nonrealistic figuration.[67] All art that follows these rules is classical, and Constructive Universalism was for Torres-García the culmination of the tradition of classical art.

Torres-García's Modernist Project in the Americas

In 1932 Torres-García's financial situation became critical once again. The market crash of 1929 and ensuing Depression paralyzed the art market in Paris. Searching for a more stable environment, he returned to Spain and remained in Madrid until 1934. When both his finances and the Spanish political situation deteriorated, he finally decided to return to his native country. He settled with his family in Montevideo

ESCUELA DEL SUR

PUBLICACION DEL TALLER

TORRES - GARCIA

MONTEVIDEO - URUGUAY

4. Cover of *Escuela del sur* (Montevideo: El Taller Torres-García, 1958) with 1943 drawing by Joaquín Torres-García

and, with his first lectures, began to formulate an avant-garde project of lasting consequence.

Torres-García's Americanist project had two aims. First, he wanted to introduce avant-garde art and theory to Uruguay. He had found there a completely modernized society but one lacking an understanding of modern art. Second, he wished to re-center his artistic and theoretical production on the South American continent. To achieve both objectives, he proposed to develop in Uruguay an art movement based on his universalist synthesis and the constructive example of pre-Columbian art. "Indo-American" art for Torres-García represented both a confirmation of his universalist theories and a path toward a unified Latin American visual culture.[68]

A few months after his arrival, he found a group of enthusiastic artists and intellectuals who shared his objectives. In 1935 they became the Asociación de Arte Constructivo (AAC), which counted among its many members Torres-García's two sons, Augusto and Horacio, as well as Rosa Acle, Julián Alvarez, Amalia Nieto, and Alberto Ragni. The AAC had regular meetings, organized exhibitions, and produced publications, including a series of manifestos and the magazine *Círculo y cuadrado*, which was the second series of the

publication *Cercle et carré*. Torres-García lectured extensively and in 1935 published the book *Estructura* in order to present to his followers and the Uruguayan public a complete view of his metaphysical and aesthetic theories.[69] However, in spite of Torres-García's enthusiasm, his ideas were not well received. The public's lack of knowledge of modernism and his own resistance to compromise isolated him and the AAC from art critics and the general public. This rejection eventually influenced even the members of the AAC, who already had established careers and found it difficult to change their views.[70]

Among the most remarkable achievements of the AAC was its exploration of pre-Columbian art as a springboard for the unification of Latin American art. For Torres-García, this interest had begun in Europe during the early 1930s, at the time that he was establishing the theoretical basis for Constructive Universalism. He began to introduce, in paintings such as *Symmetrical Composition in Red and White* of 1932 (Collection Mr. and Mrs. Meredith J. Long, Houston), elements such as earthy colors, masklike figures, and geometric patterns taken from pre-Columbian art.[71] In its initial stages, this appropriation manifested his interest in the metaphysical qualities of the primitive; later, it also served to illustrate his belief in a universalist genealogy or tradition of constructive art.[72] Finally, drawing on pre-Columbian art became a way to differentiate his Latin American project from European modernism and affirmed the need for a new autochthonous culture.

Torres-García believed that the pre-Columbian Andean cultures had produced a truly original heritage held in common by all Americans. In his lectures on pre-Columbian art, published in 1939 as *Metafísica de la prehistoria indoamericana*, he explained that it was not his objective to depict native cultures or reproduce their works—he was diametrically opposed to the figuration of indigenism and nativism prevalent in the 1930s—but rather to adopt their creative principles, which had allowed them to formulate a symbolic and geometric artistic language that could be integrated with his own constructivism.[73] By consciously synthesizing European modern art and pre-Columbian references, the artists of the AAC effectively rooted their cultural identity in Latin America while continuing to work within modernism.

Indoamerica (Private collection), painted by Torres-García in 1938, illustrates some of the concepts the AAC was developing during those years.[74] Its schematic inverted map of South America is a reelaboration of an inverted map that he had published in *Círculo y cuadrado* in 1936, which was an invitation to artists to become culturally independent from Europe and make the South their objective. *Indoamerica* is also a symbolic guide to various native American cultures, including that of the nomadic inhabitants of the pampas, which appear around the Uruguayan flag, and the Incas, mentioned by name and also symbolized by a sun, a mask, and a pot inside a pyramidal shape. The flatness and schematic quality of the design affirm its modernity, while the archetypal images and pre-Columbian references connect it not only to a Latin American heritage but also to the universal tradition of constructive art defined by Torres-García. The motif of the inverted map was repeated and reused by Torres-García during the 1940s and by his followers after his death (figure 4).

The AAC's synthesis of modernism and tradition is also manifested in Torres-García's *Cosmic Monument*, installed in Monte-

5. Joaquín Torres-García. *Cosmic Monument*. 1936–38. Cast concrete. Parque José Enrique Rodó, Montevideo

video's Parque José Enrique Rodó in 1938 (figure 5). Its stone shape recalls the Gate of the Sun in Tiah'uanaco.[75] Symbols from diverse sources are organized around the central archetypal image of the sun, signifying for Torres-García the universality of the solar theme that was the basis of theogonies in Tiahuanaco and Inca cultures, and in many others. Torres-García had written of the sun's mystical connotations in *Père soleil*, a small book he published in Paris in 1931, and the pre-Columbian solar theme frequently appeared in the work of the AAC members, symbolizing for them "unity in life and in the work of art."[76]

In 1940 the AAC was dissolved as an art workshop. In spite of his disillusionment, Torres-García continued to lecture, and by 1943 a group of young and enthusiastic followers had succeeded in convincing him to organize a new art school, which was called the Taller Torres-García (TTG). Among its members were Elsa Andrada, Julio Alpuy, Gonzalo Fonseca, José Gurvich, Francisco Matto, and Augusto and Horacio Torres. After Torres-García died in 1949, the TTG continued to function, led by his former students, until 1962. Its many achievements include the series of twenty-seven constructive murals in the hospital Colonia Saint Bois in Montevideo, the publication of the periodical *Removedor* from 1944 to 1961, and the establishment

in Uruguay of a school of arts and crafts. In their artistic production the members of the TTG did not differentiate between fine and applied art, and, always working within the Constructive Universalist system, explored many mediums, including architecture, stained glass, furniture, pottery, and mural painting, achieving such remarkable diversity and quality that their example is scarcely equaled in scope or influence in the modern art of the Americas.

The utopian character of the TTG appears in an unrealized project for an ideal community of artists, conceived by Francisco Matto in 1948. It consisted of a series of superimposed platforms on which artists could build their own studios. Bricks fired in a communal kiln were to be the building material, not only for the rooms but also for a series of totemic sculptures intended to decorate the complex.[77] The impulse behind the project was the TTG's search for a collective art that reflected the anonymous artistic traditions of the Middle Ages as well as the pre-Columbian world.

Although the members of the TTG were very interested in pre-Columbian art and traveled through the Andean region on study trips, they also were alert to the contemporary world around them. Torres-García had always believed that art should balance tradition and modernity by focusing on the archetypal and permanent qualities

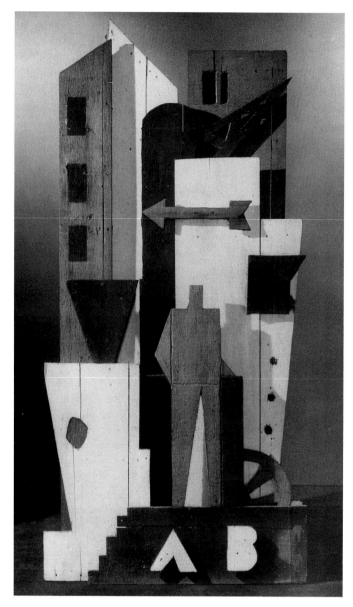

6. Julio Alpuy. *Construction with Red Man.* 1945. Painted wood, 6' 2" x 36" x 9⅛". Private collection, New York

of the contemporary world. In sculpture like Julio Alpuy's *Construction with Red Man* of 1945 (figure 6), we can see how Alpuy transformed a view of the port of Montevideo into a universal statement about the individual in the modern world by abstracting the scene's geometric and structural order and eliminating superficial details.

Since the 1940s, Torres-García's aesthetic and metaphysical theories have been disseminated throughout Latin America. In 1944 his book *Universalismo constructivo* was published in Buenos Aires. His first retrospective exhibition in that city and his friendship with the Uruguayans Rhod Rothfuss and Carmelo Arden Quin, two avant-garde artists working there, encouraged the introduction of abstraction in Argentina. This exhibition also influenced the early works of the Argentine Alfredo Hlito, a member of the Asociación Arte Concreto-Invención. Although Hlito did not know Torres-García personally, he identified with his Constructivist approach.[78] In 1959

Torres-García's art became better known through a retrospective exhibition at the São Paulo Bienal. His influence was even felt in the Andean regions by artists such as the Peruvian Fernando de Szyszlo and the Colombian Eduardo Ramírez Villamizar, who have acknowledged their debt to Torres-García's artistic and theoretical synthesis of abstraction and pre-Columbian references.[79] By the late 1970s, the connection between Torres-García's constructivism and later forms of abstraction had become so widespread that in *Geometría sensível,* a groundbreaking exhibition organized in 1978 at the Museu de Arte Moderna in Rio de Janeiro, more than twenty Latin American artists working with soft-edge geometric abstraction were, perhaps indiscriminately, characterized as followers of Torres-García.[80]

The Legacy of Torres-García

In recent years there has been a concerted effort to recognize the enormous influence of Torres-García's Americanist project. According to the art historian Mari Carmen Ramírez, "Torres-García's pioneering attempt to reposition the South American continent on the map of Western modern art has yielded a complex legacy that in many cases is far more conceptual or ideological than it is aesthetic or formal."[81] This legacy, which may be represented by the work of his fellow Uruguayan Gonzalo Fonseca and the Argentine César Paternosto, presents both positive and negative aspects.

On the positive side, Torres-García's artistic and theoretical legacy helped support, in the Río de la Plata region, an environment in which radical avant-garde explorations were possible, especially during the 1940s. Later on, many artists, including Paternosto, Alejandro Puente, Miguel Angel Ríos, Adolfo Nigro, and, more recently, Elizabeth Aro and Alejandro Corujeira, found in Torres-García legitimacy for their own Latin Americanist concerns through an artistic discourse that privileged his appropriation of pre-Columbian art over other fundamental features of his artistic practice. On the negative side, Torres-García's overwhelming influence has sometimes been too strong to allow some of his followers to develop individual styles. Gonzalo Fonseca, Augusto and Horacio Torres, Francisco Matto, Julio Alpuy, and José Gurvich, to name a few important artists who were also members of the TTG, achieved artistic individuality only after struggling for years with Torres-García's legacy. Fonseca was almost forty years old when he began to break away from the influence of his teacher.

Gonzalo Fonseca, a native of Montevideo, was a member of the TTG from its beginning in 1943. As a child he traveled with his family through Europe, where he was so impressed by the museums and archaeological sites that he later learned stone carving, studied architecture for a couple of years, and finally joined the TTG. His interest in the ancient and primitive, which was complemented by Torres-García's universalist theories, took him and other members of the TTG to Peru and Bolivia in 1945 to study pre-Columbian art. His artistic production during those years followed the guidelines of the TTG. For instance, in *Mural* of 1945 (Collection Mr. and Mrs. Eduardo Irisarri, Montevideo) Fonseca combined the structuring principles of Constructive Universalism with references to modern Montevideo by using block letters and numbers, as well as schematic symbols.

In 1950, a year after Torres-García's death, Fonseca returned to Europe. Continuing his interest in ancient cultures, he later worked

for the English archaeologist Lancaster Harding in Syria. He also traveled to Italy, Egypt, Sudan, Lebanon, Turkey, and Greece, and, after a brief period in Montevideo, he moved to New York in 1958. Since 1970 he has alternated between New York and Carrara, Italy, where he produces his larger sculptures.

In New York Fonseca began to redefine his art as a synthesis of Torres-García's aesthetic ideas and his own cultural experiences. Fonseca shared his former teacher's view that Constructive Universalism was the continuation of an ancient artistic tradition. At the same time, however, as Ramírez has pointed out, Fonseca broke away from the TTG by liberating "the pictographic symbol from the grid-structure of the constructive idiom into a three-dimensional life of its own."[82] His gradual rejection of the principle of frontality was significant. For Torres-García, the ability of his symbols to express magical and spiritual power was predicated on their frontality and geometric configuration, as well as their arrangement within the "cosmic" space of the structure. The fact that he supported his artistic practice with an extensive theoretical discourse did not diminish the spiritual power of his works. Fonseca, on the other hand, taps into the mythical aspects of the constructive tradition through a double strategy: absolute theoretical silence and the use of fragmented references to past cultures. Fonseca has always declined to speak about his work.[83] He prefers that the weight of history and the past, which has permeated his sculptures since the 1960s, speak for itself. Thus the mystery of his enigmatic and fragmented dwellings is protected from being dissected, while Fonseca opens the work through its own indetermination, inviting viewers to complete the work using their own imaginations.

In the 1960s Fonseca created a transitional series of relief sculptures in which he strove to find a freer expression than that of the rigidly determined Constructive Universalist approach. However, what Fonseca lost in universality and clarity he gained through playful configurations and suggestive titles, which appeal to the viewer at an intuitive level. Some of these reliefs allude to themes of death and sacrifice, which refer in an indirect way to his need for freedom from the influence of Torres-García. For instance, *Orphic Paraphernalia* of 1962 (Collection the artist) refers to the lyre-playing Orpheus, who rejected the cult of Dionysus in order to worship Helios, the sun, through human sacrifice. As punishment, Dionysus ordered Orpheus's death. In this relief are fetishes, strings, and a sunlike shape, suggesting aspects of the myth of Orpheus, specifically, perhaps, an expression of the desire for freedom from the universalizing cult of the sun, which was such a strong thematic constant in the work of the AAC and the TTG.

In *For the Geometrician's Grave, Vol. II* of 1973 (figure 7) and *Large Columbarium* of 1976 (Collection Germán Jiménez, Caracas) Fonseca dealt again with the theme of death. The first of these two reliefs is a stone book, which can be opened to reveal movable pieces that, if removed from their small niches, reveal further secrets. An approximately orthogonal ordering reflects Torres-García's sense of structure, but the muteness of Fonseca's open book and the artist's enigmatic selection of the fragments resist a comprehensive interpretation. The grave of the geometrician, perhaps the grave of geometry itself, has a transitional and indeterminate identity, between a tomb and a dwelling, between the revelation of geometry and the mystery of the irrational, between life and death.

7. Gonzalo Fonseca. *For the Geometrician's Grave, Vol. II*. 1973. Tennessee pink marble, 12 x 24 x 5". Collection the artist

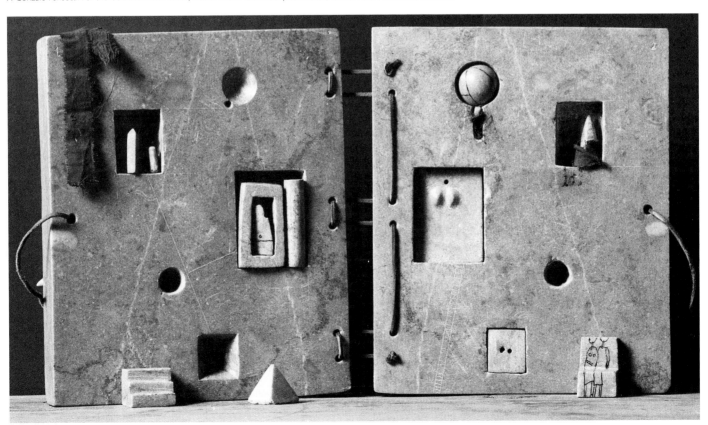

The "columbarium" of the second relief's title is a structure with recesses in the walls in which the ashes of the dead are placed. (*Columbarium* is Latin for dovecote.) Formally, the orthogonal emphasis of this modular wood relief refers to Fonseca's years in the TTG. The title suggests that the interstices of Torres-García's grid have become the niches of a tomb in which the ashes of defunct archetypal symbols may be placed. If so, this work might be considered a metaphor of death and rebirth in Fonseca's evolution as an artist.

During the 1970s Fonseca began to work with fully three-dimensional pieces, while continuing to employ references to the past and sacrificial rituals. In *Solar Barge* of 1974 (Private collection, Colombia) and *Islip* of 1987 (plate 68), two boat-shaped limestone sculptures, he used the form of the barge as a reference to the many symbolic representations of ships in Torres-García's paintings and murals. While Torres-García regarded the ship as a symbol of the modern world, it represents for Fonseca a regressive journey, another archetypal metaphor of the search for universal truth that is given mythical form by the death and resurrection of Osiris and the voyages of Odysseus. In *Estela con baetylos* [*Stele with Baetyl*] of 1987 (plate 66) Fonseca again refers to an ancient rite. Baetyl, from the ancient Greek, signifies a roughly shaped stone of uncertain origin that is worshiped as a divine manifestation. In *Stele with Baetyl*, it is not clear which stone is the divine one: the rock placed on top, one of the fetishlike rocks hanging from the side of the sculpture, or the stele itself. However, the vertical configuration of the sculpture, reminiscent of the Greek *omphalos*, a white stone in the Temple of Apollo at Delphi that was supposed to mark the midpoint of the earth's surface, supports an interpretation of the stele itself as the baetyl. Fonseca thus alludes to ritual and the divine qualities of stone, an element "which, since ancient times, . . . has been considered the most intimate structure and fundament of the very universe, having had, in different cultures, references charged with meaning."[84]

In his sculptures Fonseca loosely maintains Torres-García's grid structure as an organizing principle but treats materials in a primitivizing way. His symbols acquire a magical connotation, although not through geometry, as Torres-García had proposed, but rather via the ancient myths of sacrifice, death, and rebirth to which Fonseca alludes. Thus, the ancient past suggested by his sculptures is transformed into a metaphysical realm through the use of "irrational" elements—fetishes and divine stones, niches and ladders—which can only be explained in terms of another dimension, where things work differently than in our own. Fonseca's silence and indeterminacy keep all interpretations open.

In the early 1980s César Paternosto became involved with Torres-García's legacy as a result of his own artistic and scholarly interest in pre-Columbian art. In the geometry that underlies Inca art and architecture, Paternosto found a vehicle for his own metaphysical and cultural concerns. Although, as an Argentine artist living in New York, he was removed from the Andean world culturally, racially, and geographically, Paternosto consciously connected his artistic production with the pre-Columbian past as a way of expressing his Latin American cultural identity. Like many other Latin American artists, Paternosto found in Torres-García's art and writings on pre-Columbian art "theoretical guidance and legitimation of . . . aesthetic and ideological concerns."[85]

During the early 1960s Paternosto's work shared in the

8. César Paternosto. *Painting*. 1961–62. Mixed mediums on masonite, 19½ x 28½". Collection the artist, New York

abstract tendencies then current in Argentina, where he was a member of the informalist Grupo SI. In several works of those years, such as *Painting* of 1961–62 (figure 8), he rejected the purely abstract treatment of color and thick-textured surfaces of informalism by introducing figurative symbols evocative of native American motifs found on the pottery of northern Argentina.[86] He abandoned this style, however, and by 1963 his works had become more geometric, while retaining a certain expressionist quality that links his art to the soft-edge Geometria Sensível movement. From 1965 to 1967, Paternosto worked on a series of paintings, including *Duino* of 1966 (The Museum of Modern Art, New York), partly inspired by the postpainterly abstractions of Barnett Newman, Frank Stella, and Kenneth Noland. In these works he combined shaped canvases with brightly colored surfaces, painted in oil.

When Paternosto moved to New York in 1967, he began to work in an increasingly minimal and radical mode. In a 1969 series titled Oblique Vision he rejected painting's traditional mode of presentation and of being viewed by placing color only on the sides of his deep, unframed stretchers. There he painted rectangular bands and squares of color, leaving the front of these paintings blank but enclosed by the faint aura that the colored sides reflected onto the supporting wall surfaces. In the early 1970s his multipanel works began to be organized along horizontal and vertical lines, and they included some touches of color along the edges of the frontal plane, taking Piet Mondrian's idea of the decentralization of the picture plane to a new limit. However, feeling he had exhausted the possibilities of a minimalism devoid of meaning, he was soon compelled to reevaluate his artistic objectives.

Paternosto began the complex process of redefining his work ten years after his arrival in the United States. As an Argentine living in New York, he shared with other Latin American artists in that city not only the experience of marginality but also certain cultural elements that gave him a perspective on the southern continent that reached beyond his own national culture.[87] In 1977 he also became interested in Inca art and made several research trips to Bolivia and Peru, which culminated in the publication in 1989 of *Piedra abstracta* (*Abstract Stone*), a scholarly book on Inca abstract sculpture. Paternosto included in this text a discussion of the influence of pre-

Columbian art on the work of several modern artists, among them Torres-García, whom he "rediscovered" in the early 1980s while researching his book.[88] Paternosto identified with Torres-García's preference for a geometrically structured symbolic system and revalidated his call for a Latin American art based on autochthonous traditions and developed from values independent of those imposed from outside the continent.

When Paternosto arrived in Peru for the first time, he was, in his own words, "'ready to see' the abstract, 'constructivist' sculptural work of the Incas . . . which finally provided a cultural identification to my concerns as an abstractionist."[89] Not surprisingly, he soon began to introduce textures, colors, and patterns that are often found in Inca textiles and stonework into paintings such as *Trilce II* of 1980 (plate 149), *T'oqapu* of 1982 (figure 9), and *Portal No. 7* of 1990 (Collection the artist). *Trilce II*, whose title comes from a book of poems by the Peruvian poet César Vallejo, reflects, through its austere geometry, textured surfaces, and monochrome earth tone, the lasting impression that the Temple of the Sun in Ollantaytambo had on the artist.[90] Although this painting combines the simplicity of Frank Stella's pinstripe paintings with the subtlety of Ad Reinhardt's works, it goes beyond their concerns in painting to affirm the metaphysical connotations of geometry and Paternosto's cultural self-definition as a Latin American.

In *T'oqapu* Paternosto explored his growing interest, during the early 1980s, in ancient Peruvian textiles, which he found to be intimately related to Inca architecture through what he called the "tec-

9. César Paternosto. *T'oqapu*. 1982. Synthetic polymer paint on canvas; four panels bolted together, overall: 66 x 66". Collection the artist, New York

tonic principle," which excludes a biomorphic or organic artistic approach in favor of a geometric interpretation of form determined by weaving—a geometric impulse he also found to be characteristic of Inca stonework.[91] According to the artist, "the non-illusionistic, planar angularity, as well as the modular and symmetric repetitions observable in most Andean iconography, [are] overwhelmingly determined by the textile medium."[92] Paternosto also linked the seminal role that he believes textiles play in Incan art to the semiotic potential of *tocapus*, geometric designs in certain Inca textiles that seem to have functioned as a linguistic code.[93] In *T'oqapu*, Paternosto alludes, through an intricate geometric design based on a structural rhythm of repetition and variation, to the linguistic possibilities of the *tocapu*.

Recently Paternosto has worked on a series of paintings on cutout supports, titled either Façades or Portals, which reflect the experiences of the Argentine avant-gardes of the 1940s and his own shaped canvases of the 1960s. In these pieces, the artist shifts from specific geometric references to a more general reading of archetypal forms. For instance, *Portal No. 7* is connected with symbolic configurations found in Tiahuanaco and Ollantaytambo, while *Façade No. 1: Saqqara* of 1991 (Collection the artist) refers to ancient Egypt. In these gatelike objects Paternosto alludes to "the metaphor of the 'passage,' of the transition from profane space to sacred space," an idea of spiritual transcendence present in numerous cultures and also found in Torres-García's works.[94]

Through his exploration and use of the different geometric systems operating in Inca art, Paternosto affirms his belief in a constructivist tradition that existed in pre-Hispanic Andean cultures and whose relevance for Latin American art can be more significant than traditions originating in European cultures. This revalidation of the autochthonous constructivism of the Incas provides a path for Paternosto between his own work and a historical cultural heritage he considers common to the southern continent. In establishing this bridge with the past, Paternosto not only affirms his cultural identity but also renews Torres-García's call for the establishment of an alternative artistic tradition firmly based on Latin America.

▬

For Torres-García, Constructive Universalism was not just an episode in the history of modernism in Europe and Latin America but the continuation of an ancient utopian quest for universal values. He expanded the field of modern art and emphasized the continuing presence of classical paradigms with metaphysical and ethical connotations. By drawing attention to pre-Columbian art, he broadened the definition of the constructivist tradition and Americanized his modernist project. The most lasting aspect of Torres-García's legacy in Latin America has been his call for an art of universal values rooted in the Americas. His message has been heard since the 1930s by several generations of artists throughout the continent. Among many others, Gonzalo Fonseca and César Paternosto have helped revitalize the complex heritage of Torres-García, which continues to inspire young Latin American artists to define and claim their rightful place in twentieth-century art.

Notes

I am grateful to Daniel E. Nelson, César Paternosto, Nancy Deffebach, and Fatima Bercht for their insightful comments and invaluable help in the preparation of this essay.

1. Enric Jardí, *Torres-García*, trans. Kenneth Lyons (1973; reprint ed., Boston: New York Graphic Society, n.d.), p. 10.

2. Joaquín Torres-García, *Historia de mi vida* (Montevideo: Talleres Gráficos Sur, 1939), p. 70. Translations from this source are my own.

3. Joaquín Torres-García, in *Pel i ploma* (1901), pp. 34–35; cited in A. Cirici Pellicer, *El arte modernista catalán* (Barcelona: Aymá, 1951), p. 414. My translation.

4. Francesc Fontbona, "The Art of Noucentisme," in *Homage to Barcelona: The City and Its Art, 1888–1936* (London: Hayward Gallery, 1985), p. 170. Torres-García dealt with the issue of classicism in several publications during those years, including his books *Notes sobre art* (Gerona, 1913), *Diàlegs* (Tarrasa, 1915), *Un ensayo de clasicismo: La orientación conveniente al arte de los países del mediodía* (Tarrasa, 1916), and *L'art en relació amb l'home etern i l'home que passa* (Barcelona, 1919).

5. Reproduced in Jardí, *Torres-García*, p. 50. This fresco is also known as *La edad de oro de la humanidad* (*The Golden Age of Humanity*).

6. Ibid., p. 77. For a detailed account of the controversy surrounding Torres-García's frescoes at the Saló Sant Jordi, see Torres-García, *Historia*, pp. 158–60, 174–78, 236–40.

7. Reproduced in Jardí, *Torres-García*, p. 53.

8. Joan Connelly Ullman, *The Tragic Week: A Study of Anticlericalism in Spain, 1875–1912* (Cambridge: Harvard University Press, 1968), p. 66.

9. For an account of Barcelona's cultural context during World War I, see Christopher Green, "The Foreign Avant-Garde in Barcelona, 1912–1922," in *Homage to Barcelona*, pp. 183–84.

10. Joaquín Torres-García, *Universalismo constructivo*. 2 vols. (Buenos Aires: Editorial Poseidón, 1944), pp. 552–53. Translations from this source are my own.

11. Torres-García, *Historia*, pp. 189, 217–18.

12. Torres-García, *Universalismo*, p. 253; Torres-García, *Historia*, p. 249.

13. Torres-García, *Universalismo*, p. 238.

14. Ibid., p. 461. Emphasis here, and in subsequent quotations from this and other sources, is in the original.

15. Ibid., pp. 112, 461, 574; Joaquín Torres-García, *Estructura* (Montevideo: Biblioteca Alfar, 1935), p. 104. Translations from this source are my own.

16. Torres-García, *Universalismo*, p. 456.

17. Ibid., pp. 574–75.

18. James Clifford, "Histories of the Tribal and the Modern," in his *The Predicament of Culture: Twentieth-Century Ethnography, Literature, and Art* (Cambridge: Harvard University Press, 1988), pp. 190–91.

19. Torres-García, *Universalismo*, p. 373. The concepts of transmigration and memory of the soul are discussed in Plato's dialogue *Phaedo*.

20. Ibid., pp. 68–69.

21. Ibid., p. 60.

22. For instance, compare Torres-García's *Mask* with Pablo Picasso's *Woman's Head*, 1908, reproduced in William Rubin, ed., *"Primitivism" in 20th Century Art: Affinity of the Tribal and the Modern* (New York: The Museum of Modern Art, 1984), vol. 1, p. 291.

23. Torres-García, *Universalismo*, p. 112.

24. Ibid., p. 278.

25. Ibid., p. 474.

26. Ibid., p. 278; Torres-García, *Historia*, p. 262.

27. Carel Blotkamp, "Annunciation of the New Mysticism: Dutch Symbolism and Early Abstraction," in Maurice Tuchman, ed., *The Spiritual in Art: Abstract Painting, 1890–1985* (Los Angeles: Los Angeles County Museum of Art, 1986), p. 103.

28. Torres-García, *Historia*, p. 271. The correspondence must have taken place from 1912 or 1913 until 1917, when Rodó died .

29. Torres-García, *Universalismo*, p. 79. Torres-García also must have been influenced in his view of Europe as "materialistic" by the rise of Fascism during the 1920s and 1930s.

30. Ibid., pp. 369–70.

31. Margit Rowell, "Order and Symbol: The European and American Sources of Torres-García's Constructivism," in Cecilia Buzio de Torres et al., *Torres-García: Grid-Pattern-Sign, Paris-Montevideo, 1924–1944* (London: Hayward Gallery, 1985), p. 12.

32. Torres-García, *Universalismo*, p. 98.

33. Ibid., p. 179.

34. Ibid., pp. 101, 178.

35. Torres-García, *Estructura*, p. 45.

36. Torres-García, *Universalismo*, p. 99.

37. Torres-García, *Estructura*, p. 93.

38. Torres-García, *Universalismo*, pp. 122–23.

39. See ibid., p. 99; and Mario H. Gradowczyk, *Joaquín Torres-García* (Buenos Aires: Ediciones de Arte Gaglianone, 1985), p. 52.

40. R. W. Coan, "Archetypes," in Raymond Corsini, ed., *Encyclopedia of Psychology* (New York: John Wiley, 1984), pp. 86–87.

41. Juan Fló, *Torres-García en (y desde) Montevideo* (Montevideo: Arca, 1991), pp. 15–17.

42. Stephen Bann, "Introduction: Constructivism and Constructive Art in the Twentieth Century," in Stephen Bann, ed., *The Tradition of Constructivism* (New York: Viking Press, 1974), p. xxv.

43. Naum Gabo and Antoine Pevsner, "Realistic Manifesto" (1920), in Bann, *Tradition of Constructivism*, pp. 3–11.

44. Torres-García, *Universalismo*, p. 253.

45. Ibid., p. 213.

46. Mari Carmen Ramírez, "Re-positioning the South: The Legacy of El Taller Torres-García in Contemporary Latin American Art," in Mari Carmen Ramírez, ed., *El Taller Torres-García: The School of the South and Its Legacy* (Austin: University of Texas Press, 1992), p. 257.

47. Torres-García, *Universalismo*, p. 342.

48. Torres-García, *Estructura*, p. 29. Although not a particularly sexist person—he encouraged his students equally—Torres used sexist language; this is perhaps a reflection of his times.

49. Torres-García, *Universalismo*, p. 361.

50. Ibid., pp. 362, 708; see also Joaquín Torres-García, "Querer construir," in Jorge Schwartz, ed., *Las vanguardias latinoamericanas: Textos programáticos y críticos*, trans. Estela dos Santos (Madrid: Cátedra, 1991), p. 399 [essay originally published as "Vouloire construire," *Cercle et carré* 1 (March 1930)].

51. W. K. C. Guthrie, "Pythagoras and Pythagoreanism," in Paul Edwards, ed., *The Encyclopedia of Philosophy* (New York: Macmillan, Free Press; London: Collier-Macmillan, 1967), p. 38.

52. Torres-García, *Estructura*, p. 2.

53. Torres-García, *Universalismo*, p. 69.

54. Ibid., pp. 159–60.

55. Torres-García, *Père soleil* (Paris, 1931; reprint ed., Montevideo: Fundación Torres-García, 1974), n.p. My translation.

56. Torres-García, *Estructura*, p. 17.

57. Torres-García, *Universalismo*, pp. 588–89.

58. Ibid.

59. Ibid., p. 57.

60. Ibid., p. 373.

61. Ibid., pp. 64–66.

62. W. T. Jones, *The Classical Mind: A History of Western Philosophy*, 2d ed. (New York: Harcourt Brace & World, 1969), vol. 1, p. 123. The theory of Forms is discussed in Plato's dialogues *Symposium*, *Phaedo*, *Republic*, *Sophist*, and *Parmenides*.

63. Ibid., p. 128.

64. Torres-García, *Universalismo*, p. 846.

65. J. N. Findlay, *Plato and Platonism: An Introduction* (New York: Times Books, 1978), pp. 87–88.

66. Torres-García, *Universalismo*, p. 343.

67. Ibid., p. 166.

68. For a detailed account of Torres-García's 1934–49 period, the activities of his two art schools, the Asociación de Arte Constructivo and the Taller Torres-García, as well as the legacy of his art and theory in Latin America, see Ramírez, *El Taller Torres-García*.

69. Cecilia Buzio de Torres, "The School of the South: The Asociación de Arte Constructivo, 1934–1942," in Ramírez, *El Taller Torres-García,* pp. 12–13.

70. Buzio de Torres, "The School of the South," pp. 20–22.

71. For an account of Torres-García's pre-Columbian sources, see Rowell, "Order and Symbol," pp. 13–20.

72. Joaquín Torres-García, *Metafísica de la prehistoria indoamericana* (Montevideo: Asociación de Arte Constructivo, 1939), p. 3.

73. Buzio de Torres, "The School of the South," p. 15.

74. In 1941 Torres-García painted another version of this work on animal hide; it is reproduced in Rowell, "Order and Symbol," p. 91.

75. Buzio de Torres, "The School of the South," p. 16.

76. Ibid.

77. Ibid., p. 128.

78. Ramírez, "Re-positioning the South," p. 254.

79. Fernando de Szyszlo, "The Paths of Tradition: Latin American Abstraction," lecture given at the Archer M. Huntington Art Gallery, The University of Texas at Austin, December 1989; *Eduardo Ramírez Villamizar: Escultura* (Mexico City: Museo Rufino Tamayo, 1987), n.p.; cited in Ramírez, "Re-positioning the South," p. 254.

80. Roberto Pontual et al., *América Latina: Geometria sensível* (Rio de Janeiro: Jornal do Brasil/GBM, 1978).

81. Ramírez, "Re-positioning the South," p. 253.

82. Ibid., p. 262.

83. Gonzalo Fonseca, telephone interview with the author, April 1991.

84. César Paternosto, *Piedra abstracta: La escultura Inca: Una visión contemporánea* (Buenos Aires and Mexico City: Fondo de Cultura Económica, 1989), pp. 180–81.

85. Ramírez, "Re-positioning the South," p. 253.

86. Saúl Yurkievich, "César Paternosto retorna en sus obras a la figuración geométrica," *El Día* (November 20, 1964), cited in Fermín Fèvre et al., *César Paternosto: Obras 1961/1987* (Buenos Aires: Fundación San Telmo, 1987), n.p.

87. César Paternosto, written interview with the author, December 1985.

88. César Paternosto, telephone interview with the author, July 1992.

89. César Paternosto, "My Work: An Autobiographical Sketch," unpublished essay, 1990–91, p. 1.

90. Ibid., p. 3.

91. César Paternosto, "Torres-García and the Hemispheric Sources of Abstraction," lecture presented at the Hirshhorn Museum and Sculpture Garden, Smithsonian Institution, Washington, D.C., 1992.

92. Ibid.

93. Ibid.

94. César Paternosto, letter to the author, January 1991. My translation.

ABSTRACT CONSTRUCTIVIST TRENDS IN ARGENTINA, BRAZIL, VENEZUELA, AND COLOMBIA

■

Aracy Amaral

In postwar Latin America, Constructivism, Concrete art, neo-Concretism, kinetic art, and other forms of geometric abstraction emerged in regions that were receptive to a modern art linked with advanced European trends. These movements flourished primarily in the urban centers of Argentina, Uruguay, Brazil, and Venezuela, countries that lacked strong national pictorial traditions or substantial pre-Columbian influence on their cultures.

A further reason for the rise of geometric abstraction in South America may have been related to a desire to create some order out of the complex and problematic contradictions of progressive artistic milieux in the underdeveloped countries under discussion, as suggested by the critic Frederico Morais.[1] Cosmopolitan artists who traveled to Europe and interacted with vanguard artists there were crucial to the development of Constructivist art in Argentina, Brazil, Venezuela, and Colombia. Another formative event was the career of Joaquín Torres-García, a Uruguayan whose education and professional life were European and who returned to his native country in 1934 after an absence of forty-three years. He came to dominate Uruguayan cultural circles by attracting a school of prolific disciples. His symbolism and Constructive Universalism were permeated by a desire to create an "American" art with pre-Hispanic Andean roots that were actually fairly alien to his own gaucho culture. Torres-García's Americanist enterprise was, however, based on the most advanced European abstract movements—Constructivism and Neo-Plasticism—and it was as a link to those movements that he influenced the developments under discussion here. What was important to the vanguard in Buenos Aires in the 1940s, according to the Argentine Concretist Alfredo Hlito, was Torres-García's Constructivist painting and not the theory contained in his texts.[2]

■

In Argentina a significant Latin American abstract movement first emerged as early as the second decade of this century, when the painter Emilio Pettoruti created abstract works derived in large part from Italian Futurism. Somewhat later, his militant adherence to the lessons of Cubism positioned him as a pioneer of that style in South America. Other cosmopolitan artists who worked in Argentina in subsequent decades include the highly original Xul Solar, as well as Juan Del Prete, who, upon returning to Buenos Aires from Paris in 1933, held an exhibition of abstract paintings and collages. The sculptors Antonio Sibellino and Pablo Curatella Manes were also early practitioners of abstraction in the period before World War II.

In the mid-1940s there occurred a number of events that would have a lasting impact on the course of abstract art in Argentina. A group of artists published a single issue of the magazine *Arturo* in the summer of 1944, which heralded new developments in Argentine abstract-geometric and Constructivist movements. The magazine featured a cover by Tomás Maldonado, designed in the style of automatic writing or informal abstraction (figure 1), and illustrations and vignettes by him, Rhod Rothfuss, Lidy Prati Maldonado, Marie Hélène Vieira da Silva, Augusto Torres, Vasily Kandinsky, Piet Mondrian, and Torres-García. The influence of other theoretical artists of the period on the Argentine vanguard is evident in *Arturo*, which was devoted as much to poetry as to the plastic arts. Its contributors defended their principles with manifestos and critical writing. In contrast to the style of Maldonado's cover, the first text in the

magazine proclaimed *"INVENTION contra AUTOMATISMO."* An essay by the artist Carmelo Arden Quin called for an art of pure creation: "Neither expression (primitivism); nor representation (realism); nor symbolism (decadence). INVENTION."[3] The poet Edgar Bayley also emphasized invention: "The image-invention is the interpreter of the unknown, it habituates man to freedom."[4] Demanding a new art for a new age, Bayley also exalted the "new" for its own sake.

The Argentine avant-garde wasted no time in acting upon its newly articulated intentions. In the same year as the appearance of *Arturo*, Gyula Kosice created his groundbreaking polished wood sculpture *Röyi* (plate 94) out of three manipulable elements pegged to each other and to five other components with a craftsman's skill; also in 1944 he made another movable, untitled sculpture in bronze (plate 95). Instead of a conventional sculpture of mass, *Röyi* is an assemblage of changeable linear (and virtual curvilinear) vectors in space, and invites the participation of the spectator. During the following year Arden Quin executed *Coplanal* (plate 10), a wall-mounted relief with movable components in wood painted with lacquer. *Coplanal* subverts the notion of the conventional pictorial support, replacing the rectangular canvas or panel with a virtual square formed by four abstract elements forming its corners. These elements, each a singular composition in which the circle is an integral motif, are joined by the black band that articulates the sides of the implied square. In 1945 Kosice, Arden Quin, and others also organized two exhibitions of art and performance. The first, at the house of Dr. Enrique Pichon-Rivière in Buenos Aires in October, was titled in French *Artconcret invention*; the second, at the home of the photographer Grete Stern, who had studied at the Bauhaus with Peter Hans,[5] was held in December and announced in Spanish as *El movimiento de arte concreto-invención*. Maldonado, his wife Lidy Prati, and a number of other Concrete artists did not participate in these exhibitions, having already broken conceptually with the group led by Arden Quin and Kosice.

A dynamic succession of events followed. Maldonado and his group formed the Asociación Arte Concreto-Invención. Prati, Hlito, Manuel Espinosa, Enio Iommi and his brother Claudio Girola, Raúl Lozza, Oscar Núñez, Primaldo Mónaco, Jorge Souza, Alberto Molenberg, and others were among the original members. Later additions to the group included Juan Melé, Virgilio Villalba, and Gregorio Vardánega. The first exhibition of the association, held at the Salón Peuser in Buenos Aires in March 1946, was accompanied by the "Inventionist Manifesto," in which can be found, in addition to formalism, a utopian pragmatism. It makes an impassioned plea for the role of the artist in society: "A poem or a painting must not justify inaction but, on the contrary, must help man act within his society. . . . Art must serve the world's new sense of communion."[6] Fighting for a "collective art" and the exaltation of the optical above "elite art" or art depicting "insignificant intimate dramas," the manifesto ends with the phrase: "Don't Search or Find: Invent."[7] And Maldonado himself, in a text in the inaugural issue of *Revista arte concreto-invención* (August 1946), summarized the international history of Concretist precursors and ideas, and followed this with an account of what his group was achieving. "We understood from the beginning," he wrote, "that the greatest deficiencies of nonrepresentational art had their origin in their failure to achieve either a new composition or the final elimination of the illusory. We therefore began by breaking the

traditional form of the canvas (Rothfuss, Maldonado, Arden Quin, Prati, Espinosa, and later Hlito, Mónaco, and Souza)."[8] The irregularly shaped compositions of these artists, while not entirely without precedent, represented a fresh formulation of pictorial boundaries as well as a newfound sense of inventive freedom.

In August 1946 another group of Concrete artists in Buenos Aires, all of whom had participated in the two 1945 exhibitions, launched the Grupo Madí with an exhibition at the Instituto Francés

1. Tomás Maldonado. Cover of *Arturo* magazine. 1944. Private collection, New York

de Estudios Superiores. Accounts of the origin of the name of the group, which included Arden Quin, Kosice, Rothfuss, Diyi Laañ, and Martín Blaszko, among others, are contradictory. The critic Córdova Iturburu wrote: "There are those who suppose that the word Madí is the acronym of the *Movimiento Arte de Invención*. It appears not to be thus. The founder of the movement, *Gyula Kosice*, attests that the word Madí signifies nothing and that it was invented by him to denominate a tendency that needed to be characterized in a new and expressive manner."[9] Kosice himself later recalled that Madí was a contraction of "Madrid."[10] Arden Quin, however, stated that the word came from an anagram of his own name (Car<u>M</u>elo <u>ArD</u>en Qu<u>I</u>n),[11] while Jorge Eduardo Bosch noted that the designation was derived from the first syllables of the two words *materialismo dialéctico* (dialectical materialism).[12]

The "Madí Manifesto" of 1946, written by Kosice, asserted that Madí art could be identified by the "absolute values" of "presence, movable dynamic arrangement, development of the theme itself, lucidity and plurality," and that these values were to be expressed by the formal characteristics of Madí drawing ("an arrangement of dots and lines on a surface"), painting ("color and two-dimensionality . . . irregular frame, flat surface"), and sculpture ("no color . . . articulated, rotating, changing movement").[13] Reference was made as well to Madí architecture, music, poetry, theater, fiction, and dance.[14] The innovative and interdisciplinary approach of the Madí movement, alternating "fantasy, inventiveness and creative playing," helped make it, as Nelly Perazzo has written, "a completely peculiar phenomenon."[15]

In the case of Madí painting, an early handbill of the group proclaimed: "*In articulating planes of color*, strictly proportioned and combined, Madí projects Painting beyond the old formula that encompassed the supposed planarity of neoplasticism, nonobjectivism, constructivism, and other schools of concrete art in general."[16] Despite such claims, the initial achievements of the artists of the Grupo Madí paralleled those of the Asociación Arte Concreto-Invención. All the Argentine Concretists had a common point of origin in *Arturo*, and certain innovations that the Madí movement claimed as its own were actually utilized by both groups. The break with the conventional orthogonal frame, for example, cited as an invention of the Grupo Madí,[17] was pioneered by Rothfuss as early as 1944[18] and taken up by Arden Quin the next year, but is also seen in the coeval work of Prati, Lozza, and Espinosa.

The early Concretist groups in Argentina soon splintered, spawning offshoots with competing, yet closely related, views. In 1947 Arden Quin and Blaszko broke with Kosice and the Grupo Madí. After holding a "Matinée Madiste" on April 4, 1948, Arden Quin left for Paris, where he started a parallel Madí movement that gained a certain international renown. In Buenos Aires, Kosice founded the magazine *Arte Madí universal*; his branch of the Grupo Madí came to be known as the Madinemsor movement. Also in 1947, Raúl Lozza, his two brothers, and Alberto Molenberg split from the Asociación Arte Concreto-Invención and began a movement they called Perceptismo, which, like the other Argentine abstract movements, also had a theoretical arm, expressed first in Abraham Haber's 1948 book *Raúl Lozza y el perceptismo* and later in *Perceptismo*, their magazine.[19] The first exhibition of the "perceptists," accompanied by their manifesto, was held in 1949 at the Van Riel Galería de Arte. Believing that abstract artists had not yet succeeded in eliminating representation from their works, specifically the representation of space, Lozza postulated the colored field as a determinative ground on which the planar elements of his compositions could be set. Color, form, and surface area were, for the artist, codependent on a conception expressed in the invented word *cualimetría*, which combines the idea of quality with that of quantity. Haber, the apologist of Perceptismo, wrote that Lozza was responsible for "the separation of the color form in real space and the discovery of a relation between the quality and the extension of the form and the luminous value of the color that permits the construction of a structural unity whose essential characteristic is the coplanar disposition and its integration with the plane provided by the wall."[20] The combination of the desired nonrepresentational planarity and the use of the colored field

2. Gyula Kosice. *Madí Neon, No. 3*. 1946. Wood, neon, and wire, 22 x 16⅛". Musée de Grenoble, France

implies the coincidence of the field with the wall and points in the direction of mural painting.[21] While the format of Lozza's *Painting No. 285* of 1951 (Galerie von Bartha, Basel)—cutout elements in relief on a square panel—resembles that of a conventional painting, the artist insisted on the identification of the colored field as "a piece of the wall" and thus defined the fundamental difference of Perceptismo from conventional art.[22]

The various factions of the Buenos Aires avant-garde did come together for exhibitions. In late October 1947, the exhibition *Arte nuevo* was held at the Salón Kraft in Buenos Aires. *Arte nuevo* included independent abstract artists (Del Prete) as well as members of the Asociación Arte Concreto-Invención (Espinosa, Girola, Maldonado, Mónaco, Prati, Souza, Vardánega, Villalba, etc.), the Perceptismo movement (Molenberg), and the Grupo Madí (Arden Quin, Blaszko). Kosice and the Madinemsor artists do not seem to have participated in the exhibition, although they do appear in the catalogue.[23] Tomás Maldonado, Salvador Presta, and other artists distributed pamphlets that clamored for passersby on Florida Street in Buenos Aires to take notice of the new trends then being introduced to Argentina, with the slogan: "Take sides, citizen—modern art in Argentina exists, see it at the Kraft salon."[24] The different groups were also invited to participate in the *Salon des réalités nouvelles* at the Palais des Beaux-Arts in Paris in the summer of 1948. Only the room devoted to the Grupo

Madí, however, caught the attention of the French critics. Michel Ragon, for example, recalled "our astonishment and our amusement when we saw this first Madí exhibition in Paris," with its transformable reliefs, articulated paintings, and paintings without frames.[25]

In September 1948 another significant exhibition, the *Salón nuevas realidades, arte abstracto, concreto, no figurativo* was held at the Van Riel Galería de Arte in Buenos Aires, again bringing together artists from all sectors—the Asociación Arte Concreto-Invención, members of both factions of the Grupo Madí, and independents—and demonstrating the vigor of Argentine abstract art. This exhibition also manifested a desire for the integration of art with architecture by presenting photographs of the work of Argentine and foreign architects.[26] One of these, the Italian Ernesto Rogers, then editor of the magazine *Domus*, was invited by the Escuela de Arquitectura de Tucumán to give a lecture in Buenos Aires on "The Position of Concrete Art."[27] Rogers was fundamental in altering the path Tomás Maldonado was to follow; he recommended Maldonado to Max Bill when the artist went to Europe at the end of 1948, where he met Richard Paul Lohse, Georges Vantongerloo, and Friedrich Vordemberge-Gildewart, among other artists. Shortly after Maldonado's departure for Europe, the Asociación Arte Concreto-Invención dissolved.

The continual development and refinement of competing aesthetic theories divided the various factions among Argentina's Concretists in the latter half of the 1940s, but it also sparked their common and prolific production of artistic innovations in both format and materials. In the search for an objective, nonrepresentational art of forms that would be valid in and of themselves, and compositions that would remain faithful to the works' two-dimensional surfaces, painters not only broke with the rectangular frame but also began to work with materials that lent themselves to these ends. While some artists, such as Maldonado and Hlito, continued to work with traditional paint on canvas, Arden Quin, Rothfuss, and Juan Bay used enamel, Prati made use of oil on laminate, and Diyi Laañ, Kosice's wife, dispensed with the idea of the support almost entirely, exhibiting painted and irregular frames. Arden Quin and Kosice created sculptures of carved and polished wood, while Enio Iommi's spatial and linear constructions made use of diverse materials, both traditional and industrial. His sculptures, starting from a base of wood, marble, or aluminum, define and perforate space with careful attention to the properties of the materials utilized. The rigid vertical of the plexiglass plane of his *Construction in Space* of 1946 (Galerie von Bartha, Basel), for example, is broken by the penetration of the angled metal element, cantilevered obliquely but with a horizontal arm parallel to the sculpture's wooden base. Aggressiveness and rationality dominate this work, as opposed to the gestural graphic linearity of Iommi's sculptures of the years immediately following. Kosice created his first neon sculptures in 1946 (figure 2), anticipating later American developments, like Dan Flavin's fluorescent constructions, by more than fifteen years. In 1957 Kosice created his first hydraulic sculptures.

It is the originality and singularity of the Argentine Concretist vanguard's principles that led Salvador Presta to emphasize a contemporaneity between it and the developments occurring at the time in Europe, making the artists of the Argentine movements not followers but agents of continuity. For example, in 1946, the same year

that saw the first exhibitions and manifestos of both the Asociación Arte Concreto-Invención and the Grupo Madí, Lucio Fontana, in Buenos Aires, launched his "White Manifesto," the germ of Spatialism, an intuitive movement that arose in Italy parallel to the rise of the ideas and events of Concretism in Argentina.

At the behest of the critic Aldo Pellegrini, Maldonado, Girola, Hlito, Iommi, and Prati joined with four independent semiabstract artists (José Antonio Fernández-Muro, Sarah Grilo, Miguel Ocampo, and Hans Aebi) to form the Artistas Modernos de la Argentina in 1952. The group exhibited at the Viau Galería de Arte in Buenos Aires that year. In 1953 they held an exhibition at the Museu de Arte Moderna in Rio de Janeiro and another at the Stedelijk Museum in Amsterdam. In 1954 Maldonado again left Argentina, at Bill's invitation, to become a professor at the Hochschule für Gestaltung in Ulm, where he would later serve as director.[28]

The Argentine Concretist movements of the 1940s created an atmosphere in that country that nurtured a generation of artists who were also able to make their contribution in abstract-geometric idioms. Luis Tomasello and Martha Boto, for instance, had already participated in *Arte nuevo* by the end of the 1940s. "Generative

3. Antonio Maluf. *First Bienal São Paulo Brasil*. 1951. Lithographic poster, 36 x 25". Fundação Bienal de São Paulo

art"[29] was practiced by Miguel Angel Vidal and Eduardo Mac Entyre, who, in the words of Salvador Presta, "aggregate, continue, and vivify, so to speak, the evolutionary march of concretism," and who, by making dynamic the planar lines, points, and circles of the Concretists, "GENERATE movement."[30] Other abstract-geometric artists of the succeeding generation include Ary Brizzi, Carlos Silva, Rogelio Polesello, Alejandro Puente, and César Paternosto. Several of them moved permanently to Paris or spent substantial portions of their careers working there. Julio Le Parc settled in the French capital in 1958; that same year he produced *Moiré Effect*, a kinetic work that anticipated his later participatory and environmental experiments, which employed a great range of optical and dynamic effects.

It is difficult to establish precisely some of the relationships among the various Concretists, especially in terms of accurately delineating the chronology of developments of these Argentine abstract artists. Raúl Lozza, the founder of Perceptismo, however, stated quite clearly that it was Arden Quin who brought a spirit of inquiry to Argentina in the early 1940s, and that it was he who had the idea for *Arturo*.[31] Nevertheless, the characteristics of the Argentine vanguard of the 1940s that are clearly observable, namely continual artistic and conceptual innovation, accompanied by constant internal conflict, would also manifest themselves among Brazilian Concretists in the 1950s.

Brazil: From Concretist Production to Neo-Concretist Expression

Early manifestations of abstraction in Brazil include two abstract-geometric architectural decorations for residences in São Paulo: a ceiling painted by Lasar Segall of about 1926 and a panel by John Graz of about 1930. In 1939 the Brazilian architect Jacob Ruchti exhibited rigorous Constructivist compositions, *Linear Construction* and *Spaces*, in the third Salão de Maio in São Paulo. Works by European and North American artists like Josef Albers, Alexander Calder, Jean Hélion, Eileen Holding, Hans Erni, Alberto Magnelli, Jean Xceron, and Werner Drewes in that same exhibition also pointed in the direction of geometric abstraction.

In postwar Brazil, particularly in the 1950s, the rapid development of industrial centers like São Paulo, the administration of President Juscelino Kubitschek, which brought the automotive industry that attracted new foreign capital to the country, and the building and inauguration in 1960 of the capital city Brasília represented what might be called the apogee and final years of the Brazilian "modern" period. It was also in this atmosphere of social and cultural development that museums and the São Paulo Bienal, which together formed the crucial infrastructure for the country's continued exposure to international exhibitions, were founded. The Museu de Arte de São Paulo was founded in 1947, and 1948 saw the opening of the Museu de Arte Moderna in São Paulo and the Museu de Arte Moderna in Rio de Janeiro.[32] The French critic Léon Degand, who was the first director of the Museu de Arte Moderna, São Paulo, organized the inaugural exhibition in 1949, *Do figurativismo ao abstracionismo*.[33] This was a significant show of European art that stimulated young artists such as Waldemar Cordeiro and Luís Sacilotto, who were still influenced by expressionism, to venture into abstraction, in their case by investigating Neo-Plasticism. Other Brazilian artists at the end of the 1940s, such as the informal abstractionist Antonio Bandeira, and Cícero Dias, who was creating chromatic

4. Luís Sacilotto. *Concretion 5629*. 1956. Enamel on aluminum, 23⅝ x 31½". Museu de Arte Contemporânea da Universidade de São Paulo

5. Waldemar Cordeiro. *Visible Idea*. 1957. Paint and primer on plywood, 39⅜ x 39⅜". Pinacoteca do Estado da Secretaria de Estado da Cultura de São Paulo

abstractions, owed their abstract leanings to their residencies in Paris, where they had been exposed to the influence of modern movements. Also important was the Max Bill exhibition at the Museu de Arte de São Paulo in 1950.[34] Shortly afterward, artists Alexandre Wollner and Geraldo de Barros left Brazil to study with Bill at the Hochschule für Gestaltung in Ulm. Returning later to São Paulo, they dedicated themselves to graphic and industrial design, while continuing to pursue their involvement with Concrete painting.

The first São Paulo Bienal in 1951 also featured Bill's work, which won the Bienal's international grand prize for sculpture, as well as that of a group of Swiss Concrete artists, including Leo Leuppi,

Sophie Taeuber-Arp, and Richard Paul Lohse. The Bienal provided a decisive impetus to a group of young artists in São Paulo. The Italian-born artist Waldemar Cordeiro, who was to become this group's leader, exhibited abstract-geometric works in the Bienal. Cordeiro had contacts among a number of Concrete artists in Buenos Aires, including Maldonado and Arden Quin, and ties with São Paulo architects. The Bienal's poster, designed by Antonio Maluf (figure 3), was also abstract-geometric in style. Other Brazilian abstract artists in the first Bienal included Ivan Serpa and Abraham Palatnik; the latter exhibited *Cinecromático* of 1950–51 (present whereabouts unknown), a machine that generated an abstract configuration with light, color, and movement, anticipating later developments in kinetic art in Latin America.[35] The first São Paulo Bienal sparked a radical modification in the arts in Brazil by exposing local artists to international modernism. The second São Paulo Bienal, held in 1953, included major works borrowed from foreign collections. Pablo Picasso's *Guernica* and works by Oskar Kokoschka, Paul Delvaux, Piet Mondrian, Henry Moore, and various Cubists were brought to Brazil at this time.

Another formative event for the Brazilian vanguard was a series of six lectures at the Museu de Arte de São Paulo by the Argentine critic and historian Jorge Romero Brest in 1948, the same year that Ernesto Rogers had gone to speak about art and architecture in Argentina. Romero Brest's lectures, one of which positioned architecture as the primary art of the era, were of fundamental importance for the future Concretists of Brazil, where architecture and design had been closely linked to Concrete trends since their emergence.

Like their Argentine counterparts, Brazilian geometric abstractionists organized movements to address artistic and theoretical issues. In 1952 São Paulo artists formed the group Ruptura under the dogmatic leadership of Cordeiro, who also wrote its manifesto. This was the first formal association of Concretists in Brazil and counted among its adherents Geraldo de Barros, Luís Sacilotto, Lothar Charoux, Kazmer Féjer, Leopold Haar, Anatol Wladyslaw, and Mauricio Nogueira Lima. The "Ruptura Manifesto" belittled the role of expression and subjectivity in art, in favor of the objectivity of "artistic intuition endowed with clear and intelligent principles and grand possibilities for practical development."[36] At the same time, "hedonistic nonfiguration, the product of gratuitous taste, which seeks the mere excitation of pleasure and displeasure,"[37] was rejected by Cordeiro as out of date.

The rigid theories of the São Paulo Concretists were based on a respect for the two-dimensionality of the support, often of industrial materials (such as particle board or aluminum), and prescribed the use of enamel instead of traditional oil, highly polished surfaces, modularity, the play between real and virtual space, and the supremacy of rationality over expression. Sacilotto's *Concretion 5629* of 1956 (figure 4), a work in enamel on aluminum, for example, is based on the modular unit of an equilateral triangle, arranged unremittingly in eight rows of alternating positive/negative or black/white, that creates an optically intense composition. In Cordeiro's *Visible Idea* of 1957 (figure 5) two groups of bent lines—red above, black below—spiral in a rhythmic succession that creates both chromatic and compositional dynamics out of a rationalistic conception.

Other artists in São Paulo who shared affinities with the Ruptura group include Judith Lauand, Alexandre Wollner, and Her-

6. Hermelindo Fiaminghi. *Alternate, No. 1*. 1957. Enamel on board, 23⅝ x 31½". Pinacoteca do Estado da Secretaria de Estado da Cultura de São Paulo

melindo Fiaminghi. Fiaminghi's graphic design, inspired by the benday dot, developed along Concrete lines before he knew of the existence of such a movement. His association with Cordeiro dated only from 1955, and in 1959 he severed those ties. His primary contact with artists was through the Polish-born Leopold Haar, who also worked as a graphic artist and display designer. Fiaminghi's *Alternate, No. 1* of 1957 (figure 6) is, like Sacilotto's *Concretion 5629*, a painting in enamel on an industrial support in which the composition of modular elements creates an optical effect.

The São Paulo Concretist movement was multidisciplinary, much like the modernism of the 1920s, and encompassed painting, poetry, advertising, graphic arts, landscaping, and music.[38] In 1952, the same year the Ruptura group was formed, Haroldo de Campos, his brother Augusto de Campos, and Décio Pignatari, the three greatest poets of Brazilian Concretism, began publishing the magazine *Noigandres*.[39] The integration of the arts was a tangible presence in the 1950s, stimulated by modern architecture and by the desire for a social art for a new era. In another journal of the time, Waldemar Cordeiro wrote: "We believe with Gramsci that culture only comes into being historically when it creates a unity of thought among the 'simple' and the artists and intellectuals. And in fact it is only through this symbiosis with the simple that art cleanses itself of would-be intellectual elements and those of subjective nature to become life."[40] This echoes Raúl Lozza, who, when writing of the aims of his "perceptist" movement, claimed "to bring the plastic arts closer to man and reintegrate them into their true social function, the architectonic surface."[41] The utopian aspect of abstract art was also supported by the art critic Mário Pedrosa, who, along with the poet José Ribamar Ferreira Gullar, became the leading theoretician and fomenter of geometric abstraction in Brazil.[42]

During the 1950s Rio de Janeiro also became a center for vanguard art. In 1952 a group of Concrete artists, including Ivan Serpa, Abraham Palatnik, Aluísio Carvão, Lygia Clark, Lygia Pape, and Hélio Oiticica, formed the Grupo Frente, which held its first exhibition in 1954.[43] The first *Exposição nacional de arte abstrata* was held in 1953 at the Hotel Quitandinha in the nearby town of Petrópolis, and an exhibition of work by Argentine Concretists was presented that year at the Museu de Arte Moderna in Rio de Janeiro. Max Bill gave lectures in 1953 in both São Paulo and Rio de Janeiro.

The initial contact between the Concrete poets of Brazil's two major cities occurred only in 1955, between Augusto de Campos from São Paulo and Ferreira Gullar, his counterpart in Rio de Janeiro. After a brief period of contact and exchange between artists from both cities, conflict among various figures provoked dissension between the two groups and within the Concretist movement. Disagreements among the artists were already apparent at the time of the first *Exposição nacional de arte concreta*, a presentation of both art and poetry, held at the Museu de Arte Moderna in São Paulo, in December 1956 and at the Museu de Arte Moderna in Rio de Janeiro the following month. The São Paulo artists denounced the work of the Rio de Janeiro group because, according to a later account, they claimed it demonstrated "the preponderance of experience over theory, the comprehension of the work as expression and not as product, which compromises its objectivity and concreteness, and . . . the negative consequences of these theoretical equivocations in the more free use of color. According to this critical view, the group from Rio had not yet understood the principles of Concretism, and the fact of working with geometric forms was not sufficient for them to be integrated into the Concrete movement."[44]

Breaking with the poets of the São Paulo group, Ferreira Gullar wrote the "Neo-Concrete Manifesto," the first in a series of texts he wrote in the Rio de Janeiro newspaper *Jornal do Brasil* about an evolving movement among artists in that city, which he termed neo-Concrete.[45] In opposition to Concretism, the neo-Concretists totally rejected the idea of "serial form and purely optical effects" in favor of organic form.[46] The neo-Concrete artists presented themselves as an experimental group that valued above all the "generative moment of the work, which makes of theory a lesser urge, determined rather than determining."[47] They opened themselves to expressivity and subjectivity, which, as the critic Fernando Cocchiarale wrote, leads to the sensorial by transcending the rational.[48] Neo-Concretism also implied, according to Ferreira Gullar, "a descent to the same source of experience, where the work of the artist will burst forth impregnated with that emotive, existential nonthetic sense. The neo-Concretists reaffirm the creative possibilities of the artist, independent of science and of ideologies."[49] This was the great leap of the Rio de Janeiro group that led them toward the experimentation of the 1960s.

Neo-Concrete poetry, open to all kinds of sensorial experimentation, did not remain restricted to the space of the book page or to the possible optical and phonetic games arising out of the wordplay in which poets take such delight. The neo-Concrete poets used, by 1959, words combined with visual and tactile effects, such as color and paper, and created "book-poems" to be unfolded by the spectator. Ferreira Gullar, like Oiticica and Clark in the visual arts, took poetry to its extreme when he created the *Buried Poem*, a subterranean, neon-illuminated cubic room, six and one-half feet per side,

excavated in the backyard of Oiticica's house in Rio de Janeiro. In the center of the room the viewer found a small red cube; underneath that was a smaller green cube, and beneath it, a white cube. This last was solid, resting on the ground, and on its face was written the single word of an impossible imperative: "*Rejuvenesça*" (Rejuvenate).[50] Thus, as a Concrete poet and major theoretician of the neo-Concrete movement in Brazil, Ferreira Gullar was able to create works that combine a plastic-spatial conception with a verbal, poetic inspiration.

Neo-Concrete art was characterized by the participation of the viewer, by the use of ephemeral materials, and by sensory, as opposed to merely intellectual, pleasures, despite its abstract-geometric origins, as in the work of Oiticica and Clark. At the same time, its constructive-conceptual tenor was to have an effect on several subsequent generations of Brazilian artists. The neo-Concretist group included, in addition to Ferreira Gullar, Clark, Oiticica, Carvão, Pape, Willys de Castro, Hércules Barsotti, Franz Weissmann, and the sculptor Amílcar de Castro, who designed the layouts for Ferreira Gullar's *Jornal do Brasil* articles. Castro's chosen means of expression was iron, the material that is the greatest natural resource of his native state, Minas Gerais. Folding and cutting geometric iron plates of various thicknesses with an intuitive gestural energy, as in an untitled work of about 1958 (figure 7), Castro, with what Ferreira Gullar called "an uncontainable force,"[51] raised his sculptures off the ground poetically, in a manner far from the rigid principles of the São Paulo Concretists. Lygia Pape progressed in her art from Concrete xylography to three-dimensional works. In 1958 she created *Concretist Ballet* with Reinaldo Jardim, and her *Book of Creation* of 1959 is a veritable plastic poem.

7. Amílcar de Castro. Untitled. c. 1958. Iron, 32⅜ x 62 x 47⅝". Museu de Arte Moderna, Rio de Janeiro

A number of other Brazilian artists, among them such veterans as Alfredo Volpi and Milton Dacosta, and even artists like Mira Schendel and Sérgio Camargo were sensitive to the Constructivist wave. In Paris in the 1960s, Camargo adopted white, light, and shadow as the basic principles of his sculptures, composed of cylindrical modules that were made first of painted wood and later of marble. Schendel, a quiet experimenter, realized a singular and solitary career, but her work achieved full recognition only in the 1980s. Also of interest is the solitary course of Arthur Luíz Piza, who for many years was dedicated to engraving, and later created monochromatic reliefs on cardboard. Sérvulo Esmeraldo was also interested in kinetic experiments in his works of the 1970s in Paris known as Excitables, which used magnetic elements. Innumerable artists were drawn to the Concrete experience; even a painter like Rubem Valentim, whose themes were linked to Afro-Brazilian rituals, was affected by Constructivism—symbolic, in his case. This attraction did not prove to be permanent for most Brazilian artists; it seemed to mark a period of rigorous experimentation followed by a return to figuration or informal abstraction.

Venezuela: Kinetic Art

In spite of many differences, the circumstances surrounding the rise of Constructivist tendencies in Venezuela had much in common with those in Brazil. In both countries there were neither compelling pictorial traditions nor significant material remains of indigenous cultures; both countries, on the Atlantic coast, were open to new ideas from Europe in the mid-1940s. In Venezuela, according to Roberto Guevara, the end of World War II and the subsequent oil boom brought the country "abruptly . . . into a new social and economic dynamic, which implied . . . the possibility of a new degree of creative responses at all levels."[52]

A number of events in the postwar period helped to build up the momentum that transformed Venezuela's artistic landscape. Conflicts within the Escuela de Artes Plásticas in Caracas spawned a group of rebellious students in 1945. A number of them exhibited together and for a short time formed an alternative group known as the Barraca de Maripérez, after the neighborhood of their studio, but soon left for Mexico City and Paris.[53] In 1948 the Taller Libre de Arte (Free Art Workshop) was founded with the goal of creating controversy, debating new ideas, and abandoning the prevailing Caracas landscape school. Among those taking part in early discussions at the Workshop were the Cuban critic José Gómez Sicre, the Cuban writer Alejo Carpentier, who was exiled in Venezuela, and the French critic Gaston Diehl. In 1950 Diehl brought such exhibitions as De Manet a nuestros días to Caracas, playing the role of an informed exponent of European art in Venezuela, much as Léon Degand had in São Paulo.[54] Influential exhibitions of Latin American art were also organized in this period, contributing to the dynamic that began to open Venezuelan cultural circles to the outside world. In 1948 the Asociación Arte Concreto-Invención from Argentina exhibited at the Workshop, undoubtedly having an effect on the younger Venezuelan artists, and in 1955 an exhibition by Wifredo Lam was held at the Museo de Bellas Artes.

The young artist Alejandro Otero had left for Paris on a grant in 1945, in a specific quest to make his pictorial language up-to-date and more universal, paying special attention to the work of Cézanne and Picasso. In the French capital he produced a series of still lifes called Coffeepots from 1946 to 1949; in the latter year the Coffeepots were shown in Caracas at the Museo de Bellas Artes and at the Taller Libre de Arte. The tentative abstraction of these paintings sparked a widespread public debate in conservative Venezuelan art circles. In 1950 Otero and a group of Venezuelan artists and writers in Paris, having been branded "dissidents" by Diehl, published five issues of a periodical, Revista los disidentes, which attacked the cultural and artistic conservatism of their native country.[55]

The true Constructivist revolution, however, began in Venezuela in the 1950s when the young, restive artists began to return from their trips abroad. A catalyst of that revolution was the design by the architect Carlos Raúl Villanueva for the Ciudad Universitaria in Caracas. This project proposed and implemented integration among the arts, and created a unique atmosphere on the South American continent by placing works by recognized masters of contemporary art—such as Fernand Léger, Alexander Calder (with his gigantic work for the ceiling of the university's main auditorium), Henri Laurens, Victor Vasarely, Antoine Pevsner, Jean (Hans) Arp, and Lam—beside those of local artists Otero, Jesús Rafael Soto, and Francisco Narváez.[56]

During the 1950s the triad of Venezuelan kinetic Constructivists—Otero, Soto, and Carlos Cruz-Diez—developed distinctive abstract vocabularies and began to achieve public recognition for their pictorial investigations. For instance, in 1952 Otero was included in the Primera muestra internacional de arte abstracto at the Galería Cuatro Muros in Caracas. By 1955 Soto was elaborating his optical-kinetic reliefs and participated in the exhibition Le Mouvement at the Galerie Denise René in Paris alongside Calder, Marcel Duchamp, Vasarely, Jean Tinguely, Robert Jacobsen, and Yaacov Agam. In 1958 Otero showed his Colorritmos in the annual salon at the Museo de Bellas Artes in Caracas and won the National Prize for Painting. Although he had been carrying out abstract-chromatic experiments since 1954, in 1959 Cruz-Diez produced the first of his Fisicromías, working with modules on a white surface and making use of shadow and virtual form as plastic elements. Fisicromías refers to one of the aspects of opticality addressed by these works, that of "physical color." By 1969 kineticism had found public affirmation in Venezuela with the exhibition El arte cinético y sus orígenes, at the Ateneo in Caracas.[57]

Constructivist kineticism may have become an accepted and acclaimed style in Venezuela because it seemed to fulfill the desire for contemporaneity in art far beyond that offered by more established modernist movements.[58] The vertical black bars and colored forms of Otero's Colorritmos may be seen as successors to Mondrian's Neo-Plastic grids; they differed in effecting totally dynamic surfaces. As described by critic José Balza, Otero's lines established "an open directional rhythm as regarded both the sides and the extremities of the panels. The colors play between the lines creating dimensional and spatial counterpoint, whose departure is the vibration of the parallels and the colors."[59]

Cruz-Diez arrived at a more radical chromatic kineticism through movement of the viewer in front of his Fisicromías. In these reliefs, constructed of painted slats attached to panels, "the structure is conceived in a manner that allows different results of vision not only in the translation but also in the perpendicular movement," according to the artist. "The additive process, the construction and

8. Jesús Rafael Soto. *Guggenheim Penetrable*. 1974. Steel and nylon tubing, 36 x 26 x 26'. Installation view, Solomon R. Guggenheim Museum, New York

destruction of planes becomes more or less complex as the spectator passes in front of the object."[60]

Soto developed his work by utilizing repetition, the final result being an intense optical whole that affects the spectator's perception. In the late 1950s he began his Vibrations series, with attached objects seemingly oscillating against backgrounds of visually active, closely spaced lines; he then went on to the Penetrables in the late 1960s, works of hanging linear elements that may be physically entered by the viewer. The thirty-six-foot-high *Guggenheim Penetrable* (figure 8) was made in 1974 of thin nylon tubing hung from a steel frame. The 1970 *Sonorous Penetrable* (Museo de Arte Moderno Jesús Soto, Ciudad Bolívar), of suspended metal pipes that knock together sonorously when moved by the participating viewer, reflects Soto's background as a musician, which may also be detected in the visual rhythms of his wall-bound works; their poetic interference in real space with three-dimensional elements is simultaneously delicate and imposing.

In the late 1960s Otero also began to realize kinetic works by conjoining the resources of technological materials to wind, light, and to the movement of the viewer in front of his monumental sculptures, such as *Solar Wing* of 1975 (Centro de Administración Distrital, Bogotá), *Solar Delta* of 1977 (National Air and Space Museum, Smithsonian Institution, Washington, D.C.), and *Solar Tower* of 1987 (Guri Dam, Venezuela).

Monumental kinetic and optical works, such as Otero's or the many public projects by Cruz-Diez, which also include installations at Guri Dam, came to represent the official face of Venezuelan art in commissions both within the country and abroad. Beginning with the Ciudad Universitaria of Caracas, as the critic Roberto Guevara noted, the dialogue between Venezuelan artists and the urban environment achieved unprecedented prominence in Latin America (second only to the Mexican Mural Movement).[61] This dialogue had the obvious intent of designing a new and technologically advanced art for a society that wanted to keep pace with developments in European and North American art. The transformation of Venezuelan kineticism from aesthetic experiment into "official art" did not pass uncriticized. Marta Traba, the outstanding Argentine critic of the century, who lived in Venezuela for several years, stated: "The Venezuelan ruling class has sought to offer a purely progressive image of their country."[62] She went on to claim that, "Kineticism ceased to be an interesting experiment from a given period of the modern world; it came to illustrate the ambitions of the upper bourgeoisie and the 'progressive' rulers."[63] Traba also inveighed against the indifference suffered in the 1960s and 1970s by artists in Venezuela who, because they were not kineticists, were not accorded the value they deserved by collectors and by cultural institutions.

Gego, for example, who arrived in Venezuela in 1939 as an architect from the Universität Stuttgart, has had much less influence than the "big three" Venezuelan kineticists. Traba wrote that Gego "thinks like an architect, solves problems like an engineer, and designs like an artist."[64] She constructed environments (or environmental art, which later, following artistic fashion, came to be called "installations") that poetically and creatively take control of physical space. Two of these works—*Reticulárea* of 1969 (figure 9), exhibited in New York at the Center for Inter-American Relations, and *Jets*, shown at the Betty Parsons Gallery, New York, in 1971—are veritable weavings of delicate modular enameled wires, loosely joined by con-

9. Gego. *Reticulárea*. 1969. Wire, dimensions variable. Installation view, Fundación Museo de Bellas Artes, Caracas, 1970

necting rings that allow them some freedom of movement. Like Soto, Gego took pure abstraction as her point of departure, but she was less concerned with the physically active participation of the spectator in what may be termed her "impenetrables." These are webs elaborated at the limit of rationality, which the observer comprehends only by means of visual and emotional sensitivity.

Colombia: An Individual Context

The emergence of abstract art in Colombia in the second half of the 1940s was related to a wider cultural phenomenon in the country among, according to Alvaro Medina, "all the intellectuals and artists who fought to catch up with the times, some with profundity and seriousness, others with impressive swiftness."[65] An intellectual penchant for Constructivism is evinced by the 1946 statement of the critic and poet Jorge Gaitán Durán on Colombian muralism, which he found "imbued, as is logical, with the Mexican mural, which to my way of thinking is merely a stage along the way to the great collectivist mural, abstract, architectonic, and static."[66] Nevertheless, unlike Argentina, Brazil, and Venezuela, Colombia did not develop artistic movements or groups defined by manifestos, conflicting approaches, and dissension, but, rather, an art consisting of a series of individual artistic investigations related to the departures of Colombian artists for Europe or the United States.

In 1948, influenced by the School of Paris, Marco Ospina began creating abstract paintings with flat areas of color. Soon thereafter, Edgar Negret and Eduardo Ramírez Villamizar, who would become Colombia's best-known Constructivist sculptors, began their own experiments with an abstract vocabulary. In 1944 Negret had met the Spanish sculptor Jorge de Oteiza, who introduced him to the work of Henry Moore and other contemporary artists. By 1949 Negret was living in New York and, while still creating linear steel sculptures like *Bird in a Cage* (Collection the artist) and *Vase with a Flower* (figure 10), which remain representational in a manner reminiscent of Alexander Calder's work, he also produced *Angel* (Collection César Tulio Delgado, Cali), a ceramic sculpture that, although still alluding to the figure, was conceived more abstractly.

Negret's residence in Europe from 1951 to 1955 was of crucial importance to his further development. In Paris he met Constantin Brancusi, Alberto Giacometti, Jean Tinguely, Wifredo Lam, Ellsworth Kelly, Jack Youngerman, Soto, and Otero. At the same time, he began to exhibit regularly in the United States. While living in Spain in 1953 and 1954, Negret was fascinated by the logic underlying the apparent caprice in the architecture of Antoni Gaudí, as well as by its repetition of simple formal elements comprising complex constructions in space. Negret was also keenly interested in the technique and materials of wrought-iron works made by the artisans of Mallorca, and he created his first sculptures in welded and painted iron there.[67] In about 1953 he started to use principles of modular composition in his work, and in 1955, after returning to New York, he began to work with thin sheets of aluminum, joining them together with plainly visible screws and nuts, a visual indication of his inspiration in clockwork. The resulting sculptures of 1955 to 1965, the Aparatos Mágicos (Magic Apparatuses), were machines without functions constructed with a technological rigor that imparted a sense of purity of facture and detachment. In the Magic Apparatuses, however, and

10. Edgar Negret. *Vase with a Flower.* 1949. Steel, 12⅜ x 8¼ x 9½". Casa Museo Negret, Popayán, Colombia

throughout Negret's later work, there is an apparent contradiction between the Constructivist and the baroque, the latter persisting in a poetic reference to a modern "solomonic column"[68] and in the richness and dense containment of Negret's delimited forms, closed or half open under rigid control, incapable of being manipulated, fixed by the artist. Natural forms or configurations of almost organic movement are logically conceived in Negret's sculpture. A final application of matte industrial paint effects the machinelike quality of these aggressive, authoritative "animals" of painted iron. Noting that Negret revealed the beauty inherent in machines, the critic Germán Arciniegas stated that with the Magic Apparatuses the sculptor dismantled the vocabulary of mechanics to replace it with a "training ground for musicians, poets, and workers—not proletarians—in the so-called fine arts."[69] The result, according to Arciniegas, is that "Negret's sculpture is functional. It lends itself to aesthetic enjoyment as much as do machines to mechanical tasks."[70] At the same time, Roberto Guevara wrote, an "internal sense of vertebration also facilitates the sculptures' attainment of urban or architectonic feeling."[71] By the 1960s Negret had already introduced many sculptural features that appeared in his work in later decades. Among these, Guevara stated, were "the color subdued preferably to the monochrome, the sheets arched and adapted to serial forms or in continuous sequence, the bodies screwed together, the unfolding of the concept as a structure that suggests expansion and flexibility but preserves its quiet and definitive vigor."[72]

Ramírez Villamizar's first Constructivist works were made in Paris in the early 1950s. By the latter half of that decade he was

11. Eduardo Ramírez Villamizar. *16 Towers.* 1972. Concrete, 23' high. Parque Nacional, Bogotá

painting flat colored forms in compositions dominated by the orthogonal, both depicted and implied. In 1958 Ramírez Villamizar merged his pictorial speculations with architectural space in the first of his large mural reliefs, the *Golden Relief* at the Banco de Bogotá. Critics have remarked on the "extensive musicalness"[73] of these murals, which mark the artist's transition from abstract painting to sculpture. In these works the artist organized space in such a way that a strong linear structure is softened by rounded corners, making a bold but not harsh equilibrium. The reliefs were also the beginning of Ramírez Villamizar's explorations of the potential for poetic creation on an architectonic and urban scale, explorations culminating in the monumental *16 Towers* (figure 11), which the artist gave to the city of Bogotá. Standing on a hill in the Parque Nacional overlooking the city, the twenty-three-foot-high concrete pylons and the negative spaces at their interstices generate a visual play of form, light, and shadow. Since the early 1960s Ramírez Villamizar utilized a great range of materials—from plastics, aluminum, and iron to concrete and wood—to produce his personal brand of "sensitive geometry."[74] The tilted verticals in his sculptures of the 1970s and 1980s create obliquely moving rhythms, alternating planar forms that continue to impose themselves into urban and architectural spaces.

Several slightly younger Colombian artists, including Omar

Rayo, Carlos Rojas, Fanny Sanin, Antonio Grass, and John Castles, have similarly persisted in creating abstraction, despite the continued predominance of an influential figurative tradition in their country. In the late 1960s and early 1970s, Rojas produced Constructivist sculptures that incorporated space into their rectilinear structures. Like Negret he articulated the joints in some of his painted iron pieces, leaving the screws and nuts exposed, but Rojas's works remain static and solemn. In the mid-1970s the artist began a series of paintings inspired by the striped textiles woven by Colombian artisans. Rojas's delicate and musical chromatic modulations represent an encounter between refined erudition—his sensitivity to color and the reflexive gesture—and an identification with the popular. In a number of these canvases, known collectively as the America series, the horizontal stripes of color, muted and elegant, are spaced irregularly, insinuating multiple images of visionary horizon lines. In some paintings the subtle chromatic weave appears in a play of transparency. The critic Juan Acha referred to Rojas's color as "very current for the type of art termed cultured and very old for artisanry, [taking] painting beyond forms and composition and [expressing] the individual and the collective of the artist."[75] In all of Rojas's work, from the sculpture of iron rods and drawings for monuments to paintings, a hieratic quality seems to hint at a search for quietude, for silence, or for religion.[76]

Constructivism also emerged in other Latin American nations in the second half of the century. In Chile two movements comprising abstract-Constructivist artists arose: the group Rectángulo, led by Ramón Vergara, in 1955 and, ten years later, Forma y Espacio. This latter group, complete with manifesto, proposed, as did the São Paulo Concretists, integration among the arts as well as the integration of art with life, and rejected "all individualistic and capricious expression."[77] In Mexico, a nation that did possess a vast pre-Columbian heritage and strong artistic traditions, a Concretist movement emerged even later. Not until 1976 could an exhibition such as *El geometrismo mexicano: Un movimiento actual*[78] be organized despite the presence of artists like Carlos Mérida and the German-born Mathias Goeritz, who, with the architect Luis Barragán, had created in 1957 the extraordinary sculptural-architectonic monument *Towers of Satellite City* in Mexico City (figure 12). In Ecuador abstraction emerged in the mid-1950s with Araceli Gilbert and Manuel Rendón. But it was only with the internationalist painters Estuardo Maldonado, who works with color on stainless steel, and Luis Molinari—both belonging to the generation of the 1960s—that abstract constructivism would coalesce in this Andean country.[79]

Cultural circles in Europe and North America have remained largely indifferent to Constructivist movements in Latin America, as well as to its many other artistic developments. Michel Ragon wrote of this problem in his discussion of Kosice's work: "After all, Kosice doesn't live in Paris. Buenos Aires is far away, so let's pretend he doesn't exist."[80] The same idea was expressed by Otto Hahn, who noted that it was not easy for a Latin American artist "to make an impression when one lives 10,000 kilometers from an artistic center like Paris or New York."[81] Something similar was noted by the American critic James R. Mellow in writing on the work of Negret, whom he considered one of the most notable of contemporary sculptors: "It seems to be the fate of Latin-American and South-American artists that while their work has been frequently shown and respectfully received in the United States, the artists have seldom achieved the kind of spectacular reputations that were a feature of the American art scene—at least during the sixties."[82]

The same could be applied to other Constructivists, such as the Brazilians Clark, Oiticica, Schendel, and Castro. Indifference to their work in Europe and the United States was alleviated only by the pioneering and insightful interest demonstrated by Guy Brett, beginning in the 1960s. It is beyond question that conventional North American and European artistic circles began to notice artists below the equator only when a certain openness within the international artistic milieu coincided with an affirmation of the validity of these artists by a highly respected critic like Brett. This recognition, or lack of it, however, has not been a determining factor in the dynamic of artistic development in the postcolonial societies of Latin America.

Constructivist artists in Latin America labored under the shared conviction that their enterprise was a utopian one. "The constructive project," Frederico Morais wrote, "is fundamentally optimistic and Utopian. The constructive artist believes in art as an effective means for the transformation of society, and it is his desire to construct a new reality even, if possible, on the social and political levels. . . . Constructive art goes beyond aesthetic and endows itself with an

ethical and even political dimension."[83] It is telling that the sculptor Ramírez Villamizar has spoken of his abstract painting of the 1950s, a bloody period in Colombia's history, as a reaction against the violent in art: "I reacted against the violence of Expressionism, showing its contrary. The contrary of violence is construction, order, civilization."[84]

Latin America has always been a terrain mined with social contradictions. When Marta Traba criticized the "illusory technological level supposedly attained by Venezuela,"[85] embodied in the works of its officially sanctioned Constructivist kineticists, she referred to the contrast between the projection of an ordered "progressiveness" posed by Constructivist trends and the contradictory reality of social, economic, and political conditions in the country at that time. Yet despite the problematic nature of Constructivist art, reflecting the cultural complexities in which it takes root, the utopia of egalitarian developmentalism, like a mirage in the desert, continues to beckon to Latin America.

12. Mathias Goeritz and Luis Barragán. *Towers of Satellite City*. 1957. Painted concrete, 100, 120, 130, 150, and 165' high. Queretaro Highway, Mexico City

Notes

This essay was translated from the Portuguese by Clifford E. Landers.

1. See Frederico Morais, "A vocação construtiva da arte latino-americana (mas o caos permanece)," in Roberto Pontual et al., *América Latina: Geometria sensível* (Rio de Janeiro: Edições Jornal do Brasil/GBM, 1978), pp. 13–29. A version of this essay, "Vocação construtiva (mas o caos permanece)," was published in Frederico Morais, *Artes plásticas na América Latina: Do transe ao transitório* (Rio de Janeiro: Editôra Civilização Brasileira, 1979), pp. 78–91.

2. Alfredo Hlito, in a statement to the author, Buenos Aires, May 12, 1992.

3. Carmelo Arden Quin, in *Arturo* 1 (Summer 1944), n.p.

4. Edgar Bayley, in *Arturo* 1 (Summer 1944), n.p.

5. Gyula Kosice, in a statement to the author, Buenos Aires, May 13, 1992.

6. Edgar Bayley et al., "Manifiesto Invencionista" (March 1946), reprinted in *Revista arte concreto-invención* 1 (August 1946), p. 8. Translated in Dawn Ades, ed., *Art in Latin America: The Modern Era, 1820–1980* (New Haven: Yale University Press; London: Hayward Gallery, 1989), p. 331.

7. Bayley, "Manifiesto," p. 8.

8. Tomás Maldonado, "Lo abstracto y lo concreto en el arte moderno," *Revista arte concreto-invención* 1 (August 1946), p. 7.

9. Córdova Iturburu, *80 años de pintura argentina: Del pre-impresionismo a la novísima figuración* (Buenos Aires: Ediciones Librería La Ciudad, 1978), p. 157, n. 5.

10. Gyula Kosice, quoted by Jorge López Anaya, "Gyula Kosice, la memoria y el proyecto," in Rafael Squirru, Gyula Kosice, and Jorge López Anaya, *Kosice: Obras 1944/1990* (Buenos Aires: Museo Nacional de Bellas Artes, 1991), p. 12.

11. See Salvador Presta, *Arte argentino actual* (Buenos Aires: Editorial Lacio, 1960), p. 56.

12. Ibid.

13. Gyula Kosice, "Manifiesto Madí" (1946), translated in Ades, *Art in Latin America*, p. 330.

14. Ibid.

15. Nelly Perazzo, *El arte concreto en la Argentina en la década del 40* (Buenos Aires: Ediciones de Arte Gaglianone, 1983), p. 63. In addition to its Argentine members, the Grupo Madí attracted participants from other countries. The Romanian-born Sandu Darié, for instance, maintained a correspondence with the Argentines from his adopted Cuba; and Masami Kuni, a Korean, developed geometrical choreography for the Madí circle, comprising movements that were created without the necessity of recourse to music, with rhythm imparted by the body, and which sought a purity of language in their continuity.

16. "La pintura Madí," handbill of June 1946, reproduced in Gyula Kosice, *Arte Madí* (Buenos Aires: Ediciones de Arte Gaglianone, 1982), p. 42.

17. See an untitled handbill of June 1946, reproduced in Kosice, *Arte Madí,* p. 43.

18. In 1944 Rothfuss had theorized the evolution of the "cutout" frame with his article "El marco: Un problema de plástica actual" in *Arturo* 1 (Summer 1944), n.p., translated in Ades, *Art in Latin America*, pp. 329–30.

19. Abraham Haber, *Raúl Lozza y el perceptismo: La evolución de la pintura concreta* (Buenos Aires: Diálogo, 1948). The magazine *Perceptismo*, subtitled *Teórico y polémico*, began publication in Buenos Aires in October 1950 and lasted for seven issues, until July 1953. See Perazzo, *El arte concreto en la Argentina*, pp. 115–18.

20. Abraham Haber, "Juicios de Abraham Haber," in *Raúl Lozza: Cuarenta años en el arte concreto (sesenta con la pintura)* (Buenos Aires: Fundación San Telmo, 1985), p. 1.

21. Haber wrote in ibid.: "The painting of Lozza is, above all, mural painting."

22. Raúl Lozza, in a statement to the author, Buenos Aires, May 14, 1992.

23. See Perazzo, *El arte concreto en la Argentina*, p. 93.

24. See Presta, *Arte argentino actual*, p. 60.

25. Michel Ragon, "Kosice: Un précurseur méconnu et le mouvement MADI/Kosice: The Poorly-Known Precursor and the MADI Movement," *Cimaise* 17, nos. 95–96 (January–April 1970), pp. 30–45.

26. The Concretists' interest in architecture is also manifested by the later career of Gyula Kosice. His conception of *la ciudad hidroespacial* (the hydrospatial city), for instance, was theorized in the 1972 manifesto of the same name that called for utopian dwellings for humankind, suspended in space, or, in the words of Pierre Cabanne, "aerial cities, in a world in which space and time, light and water are conjoined with the fantastic and the poetic"; quoted in Rafael Squirru, *Kosice* (Buenos Aires: Ediciones de Arte Gaglianone, 1990), p. 191. Squirru noted that "When the Madí Manifesto, in 1946, spoke of a mobile architecture which could be moved around in space, a skeptical smile crowned those desires" [see Squirru in *Clarín* (1976); cited and trans. in Squirru, *Kosice*, p. 6]. Today, however, technology and human achievements have come so far that the architectural accomplishments of a group like SITE are a natural occurrence of our time. Kosice's postulations are thus perceived as one of the valid modernist utopias of this century, for, as Vasarely wrote, "It is through water and *movement*, of which Kosice is part, that the new plastic thought will be present in the physical extensions of the world, in the infinite prolongations of universal consciousness." See Victor Vasarely (1961), quoted in Squirru, *Kosice*, p. 183. For Kosice's manifesto, see Gyula Kosice, *La ciudad hidroespacial* (Buenos Aires: Ediciones Anzilotti, 1972); reprinted and translated in Squirru, *Kosice*, pp. 116–22.

27. Rogers's lecture was published in the inaugural issue of the magazine *Ciclo*, which appeared in 1948. In the same issue was a review of the *Salón nuevas realidades* by Edgar Bayley. *Ciclo* was edited by Aldo Pellegrino, Enrique Pichon-Rivière, and Elías Eiterberg, with input and graphic design by Maldonado, and later Hlito. See Perazzo, *El arte concreto en la Argentina*, pp. 96–97.

28. Maldonado would write a monograph on Bill. See his *Max Bill* (Buenos Aires: Editorial Nueva Visión, 1955).

29. The name was coined by the critic Ignacio Pirovano. See Presta, *Arte argentino actual*, p. 89; and Nelly Perazzo, "Constructivism and Geometric Abstraction," in Luis Cancel et al., *The Latin American Spirit: Art and Artists in the United States, 1920–1970* (New York: The Bronx Museum of the Arts and Harry N. Abrams, 1988), p. 132.

30. Presta, *Arte argentino actual*, p. 89.

31. Raúl Lozza, in a statement to the author, Buenos Aires, May 14, 1992.

32. These Brazilian museums are the result of the initiative of three determined individuals. The Museu de Arte de São Paulo was founded by Assis Chateaubriand, the Museu de Arte Moderna de São Paulo by Francisco Matarazzo Sobrinho, and the Museu de Arte Moderna do Rio de Janeiro by Paulo Bittencourt.

33. The art of two North Americans was also included in this exhibition, that of Patrick Henry Bruce, apparently brought by Degand, and Alexander Calder, the latter with five works borrowed from São Paulo collections. See *Do figurativismo ao abstracionismo* (São Paulo: Museu de Arte Moderna de São Paulo, 1949). A larger representation of artists from the United States had been planned but canceled because of various difficulties. The art was selected by Marcel Duchamp and Sidney Janis through Leo Castelli, and was organized in four sections: "American Painters," "The American Pioneers," "Various Painters," and "New Sculptors." See Aracy Amaral, "A história de uma coleção/The History of a Collection," in *Museu de Arte Contemporânea da Universidade de São Paulo: Perfil de um Acervo* (São Paulo: TECHINT, 1988), pp. 19–20.

34. As a result of seeing Bill's work, two young artists, Almir Mavignier and Mary Vieira, would go to Europe, where they still live today. Mavignier moved to Hamburg, where he has become fully immersed in the German cultural milieu; Vieira settled in Basel.

35. The members of the election committee of the first São Paulo Bienal did not accept Palatnik's *Cinecromático* because they did not consider it to be art and, at the same time, because it did not fit into the conventional categories of painting, sculpture, drawing, and printmaking. Mário Pedrosa, however, and the artist Almir Mavignier were able to arrange a special projection of the work for the public in the auditorium of the Museu de Arte Moderna de São Paulo in Sete de Abril Street. Upon the opening of the Bienal, there was an empty space designated for one of the foreign delegations whose works had not arrived in time; it was suggested that Palatnik exhibit his work in their place. According to correspondence sent to the artist at this time, the international jury of the Bienal, not knowing of the absence of any reference to Palatnik's work in the catalogue (or of his refusal by the selection committee), recommended that it be mentioned as an important contribution to modern art and that it deserved a place in the collection of the Museu de Arte Moderna de São Paulo. In the second Bienal of 1953–54, Palatnik was represented in the catalogue in the category of painting, with an installation of abstract chromatic projections (Palatnik, in a statement to the author, November 29, 1992).

36. Waldemar Cordeiro, "Manifiesto Ruptura" (São Paulo, 1952), reprinted in Aracy Amaral, ed., *Projeto construtivo brasileiro na arte (1950–1962)* (Rio de Janeiro: Museu de Arte Moderna do Rio de Janeiro; São Paulo: Pinacoteca do Estado da Secretaria de Estado da Cultura, 1977), p. 69.

37. Ibid.

38. Concrete music would emerge from the contact of the Concretist poets of São Paulo with Gilberto Mendes, who was already interested in "urban folklore," as well as with Willy Corrêa de Oliveira and Rogério Duprat. Corrêa de Oliveira took his inspiration from advertisements, television programs, newscasts, etc. According to Mendes, two com-

posers—Duprat and Damiano Cozzella—went so far as to concede at the end of the 1950s that the "artistic" was finished. What should matter from then on, they asserted, was mass communications media and their new language. See Gilberto Mendes, "A música," in Afonso Avila, ed., *O Modernismo* (São Paulo: Editôra Perspectiva, 1975); partially reprinted as "Música e poesia concreta," in Amaral, *Projeto*, pp. 341–43.

39. Interestingly, Brazilian Concretism is often celebrated as a movement advanced by the poets, with the visual arts serving as "illustration." This is an approach that does not correspond to historical reality.

40. Waldemar Cordeiro, "O Objeto," *Revista AD–arquitetura e decoração* (São Paulo), December 1956.

41. Raúl Lozza, "El arte y el hombre," in *Perceptismo* (Buenos Aires) 1 (October 1950), p. 2.

42. Both Pedrosa and Ferreira Gullar were from Rio de Janeiro. Pedrosa began his advocacy of the Brazilian avant-garde in the late 1940s, defending his thesis "Teoria da afetividade da forma" ("Theory of Affectivity of Form"), influenced by Gestalt theory, at the Faculdade Nacional de Arquitetura in Rio de Janeiro in 1948.

43. Anna Bella Geiger, in a statement to the author, November 29, 1992.

44. Fernando Cocchiarale and Anna Bella Geiger, *Abstracionismo geométrico e informal: A vanguarda brasileira nos annos 50* (Rio de Janeiro: FUNARTE, 1987), p. 18.

45. See José Ribamar Ferreira Gullar, "Manifiesto Neoconcreto," *Jornal do Brasil* (Rio de Janeiro) (March 22, 1959); reprinted in Amaral, *Projeto*, pp. 80–84; translated in Ades, *Art in Latin America*, pp. 335–37.

46. José Ribamar Ferreira Gullar, "Da arte concreta à arte neoconcreta," *Jornal do Brasil* (Rio de Janeiro) (July 18, 1959); reprinted in Amaral, *Projeto*, p. 112.

47. Cocchiarale and Geiger, *Abstractionismo geométrico e informal*, pp. 19–21.

48. Ibid.

49. Ferreira Gullar, "Da arte concreta à arte neoconcreta," p. 112.

50. José Ribamar Ferreira Gullar, in a statement to the author, November 27, 1992.

51. José Ribamar Ferreira Gullar, "Sobre a escultura" (1960); reprinted in Alberto Tassinari, ed., *Amílcar de Castro* (São Paulo: Editôra Tangente, 1991), pp. 156–57.

52. Roberto Guevara, "Artes visuales en Venezuela, 1950–1980," in Damián Bayón, ed., *Arte moderno en América Latina* (Madrid: Taurus, 1985), p. 211.

53. See the *Diccionario biográfico de las artes plásticas en Venezuela: Siglos XIX y XX* (Caracas: Instituto Nacional de Cultura y Bellas Artes, 1973), p. 286. The group included Pedro León Zapata, Sergio González, Celso Pérez, Enrique Sardá, Raúl Infante, Luis Guevara Moreno, and Perán Erminy.

54. See Bélgica Rodríguez, *La pintura abstracta en Venezuela: 1945–1965* (Caracas: Editorial Gerencia de Relaciones Públicas Maraven, 1980), p. 19.

55. A few Venezuelan artists were interested in advanced European styles before actually leaving their own country. Luis Guevara Moreno, for example, had been drawn to the Neo-Plasticist work of Mondrian before he left Venezuela in 1949. In addition to Otero and Guevara Moreno, the founders of the group Los Disidentes comprised Pascual Navarro, Mateo Manaure, Carlos González Bogen, Narciso Debourg, Perán Erminy, Rubén Núñez, Dora Hersen, Aimée Battistini, and J. R. Guillén Pérez. Later adherents included Armando Barrios, the film director César Enríquez, the poet Rafael Zapata, Miguel Arroyo, the painter Oswaldo Vigas, Alirio Oramas, and Régulo Pérez. The final issue of the magazine also noted the affiliation of Genaro Moreno and Omar Carreño.

56. Other young Venezuelan artists who contributed to the Ciudad Universitaria project included Victor Valera, Omar Carreño, Mateo Manaure, Armando Barrios, Oswaldo Vigas, Pascual Navarro, and Curlos González Bogen. See Guevara, "Artes visuales en Venezuela," p. 212.

57. This was just after, as Bélgica Rodríguez noted, a second great exodus of Venezuelan artists for Paris. See Rodríguez, *La pintura abstracta en Venezuela*, p. 91.

58. The idea is Guevara's. See Guevara, "Artes visuales en Venezuela," p. 211.

59. José Balza, *Alejandro Otero* (Milan: Olivetti, 1977), p. 66.

60. Carlos Cruz-Diez, in *Fisicromías* (Caracas: Museo de Bellas Artes, 1960), n.p.

61. Guevara, "Artes visuales en Venezuela," p. 202.

62. Marta Traba, *Mirar en Caracas* (Caracas: Monte Avila Editores, 1974), p. 124.

63. Ibid., p. 127.

64. Ibid., p. 53.

65. Alvaro Medina, *Procesos del arte en Colombia* (Bogotá: Biblioteca Básica Colombiana, 1978), p. 362.

66. Jorge Gaitán Durán, "El VII Salón de Pintura," *El Tiempo* (October 20, 1946), quoted in Medina, *Procesos*, p. 362.

67. *Negret—última década 1980–90/Regreso al padre Inca* (Caracas: 1990).

68. See Marc Berkowitz et al., *Edgar Negret* (San Juan: Museo de Bellas Artes, Instituto de Cultura Puertorriqueña, 1974).

69. Germán Arciniegas, "Aparatos mágicos," in *Negret: Aparatos mágicos* (Caracas: Museo de Bellas Artes, 1962), n.p.

70. Ibid.

71. Roberto Guevara, "La articulación creadora," in *Edgar Negret* (Caracas: Sala Mendoza, 1979); cited in José María Salvador, *Edgar Negret: De la máquina al mito, 1957–1991* (Monterrey: Museo de Monterrey; Mexico City: Museo Rufino Tamayo, 1991), p. 97.

72. Ibid.

73. Frederico Morais, "Utopía y forma en Ramírez Villamizar," in *Ramírez Villamizar* (Museo de Arte Moderno de Bogotá, 1984), p. 51. See also pp. 32–33 and the section titled "Murales: Del oro al blanco: La musicalidad del silencio," pp. 36–38. Walter Engel, an Austrian critic who made his home in Colombia, had earlier compared Ramírez Villamizar's reliefs to musical rhythms.

74. "Sensitive geometry" refers to the "geometría sensível" postulated as a pan–Latin American mode of abstraction, not aligned with a more rigid and mathematically inspired Concretism, like that practiced by artists in São Paulo in the 1950s. See Pontual, *América Latina: Geometria sensível*, the catalogue for an exhibition held at the Museu de Arte Moderna do Rio de Janeiro in 1978. Other practitioners of "sensitive geometry" in this exhibition included Otero, Volpi, Amílcar de Castro, Antonio Dias, Carlos Rojas, Negret, Jacques Bedel, Soto, Schendel, Omar Rayo, Valentim, Vicente Rojo, and Nelson Ramos.

75. Juan Acha, *Carlos Rojas/Edgar Negret* (Mexico City: Galería Juan Martín, 1978), n.p.

76. See Rafael Vega and Carolina Ponce de León, in José Hernán Aguilar et al., *Carlos Rojas: Una constante creativa* (Bogotá: Museo de Arte Moderno, 1990).

77. See Gaspar Galasz and Milan Ivelic, *La pintura en Chile désde la colonia hasta 1981* (Valparaíso: Universidad Católica de Valparaíso, 1981), p. 260. Participating in the Rectángulo group's exhibition at the Círculo de Periodistas de Santiago in 1956 were Gustavo Poblete, Waldo Vila, Matilde Pérez, Elsa Bolívar, and James Smith. Forma y Espacio included the early members of Rectángulo as well as Adolfo Berchenko, Miguel Cosgrove, Gabriela Chellew, Kurt Herdan, Robinson Mora, Ernesto Muñoz, Francisco Pérez, Carmen Piemonte, and Claudio Roman.

78. See Jorge Alberto Manrique et al., *El geometrismo mexicano* (Mexico City: Universidad Nacional Autónoma de México, Instituto de Investigaciones Estéticas, 1977).

79. See Jacqueline Barnitz, *Abstract Currents in Ecuadorian Art (Araceli, Maldonado, Molinari, Rendón, Tábara, Villacis)* (New York: Center for Inter-American Relations, 1977).

80. Ragon, "Kosice: Un précurseur méconnu," p. 30.

81. Otto Hahn, "Kosice entre Calder et Tinguely, *L'Express* 1223 (December 16–22, 1974), p. 23.

82. James R. Mellow, "Edgar Negret: Sculpture for the Space Age," *The New York Times* (February 13, 1972), p. D23.

83. Morais, "Utopía y forma en Ramírez Villamizar," p. 30.

84. Ramírez Villamizar, in an interview with María Isabel Mejía Marulanda, 1976, quoted in Morais, "Utopía y forma en Ramírez Villamizar."

85. Traba, *Mirar en Caracas*, p. 128.

LYGIA CLARK
AND
HÉLIO OITICICA

—

Guy Brett

In most of the recent museum surveys of Latin American art, the Brazilian artists Hélio Oiticica and Lygia Clark have been represented by a small selection of their early work—productions which are most easily recognized as art objects in the conventional sense and fit with least trouble into the framework of such exhibitions. Audiences will therefore almost certainly have missed the greatness of these two artists and thinkers.

On the one hand, they are likely to miss the universality of Clark's and Oiticica's work when it appears under the banner "Latin American," despite the deep roots that both artists had in the reality and culture of modern Brazil and their defense of what is popular and particular in it. Labels function in distinct ways. The modernity of Mondrian or of Malevich is not seen as restricted by one artist's Dutchness or the other's Russianness, but the modernity of Latin Americans is still qualified by Europeans and North Americans. They are seen as not quite equal participants in what Eugenio Dittborn has called "an international of the transits and networks of hybridization between local tradition and modern utopia."[1]

Audiences may also miss this work's experimental, innovatory nature. Toward the end of her life, Lygia Clark doubted if she should be called an artist. She preferred a word like *researcher*. (A description of what she was actually doing in those last years will make it clear why the distinction was significant and not pedantic or precious.) I would like to respect the openness and accessibility of the work of Oiticica and Clark—for they themselves often did things in the spirit of play and fun—but not to be the agent of its assimilation to categories they did not agree with.

—

Why, first of all, write about these two artists together? Both were founding members of the neo-Concrete group in Rio de Janeiro in 1959 (Clark was then thirty-nine, Oiticica twenty-two). When the group broke up, the two did not share a common platform again, and they developed separately, but they remained close friends and admirers of one another's work, which has come to seem profoundly complementary. The best description of the artistic relationship between them is Clark's: "Hélio and I are like a glove. He is the outside of the glove, very much linked to the exterior world. I am the inside. And the two of us exist from the moment there is a hand which puts on the glove."[2]

The oeuvres of both Clark and Oiticica are fascinating from the first work to the last. The work of each artist's earlier period, when they were responding to the influence of the European pioneers of the avant-garde, perhaps especially Mondrian, has extraordinary clarity and decisiveness. It is never "in the shadow of," or merely the addition of local color to an international language. Each artist's work arose from an independent understanding of the inner development of that avant-garde (influenced, no doubt, by the high theoretical level of Brazilian commentaries of the period around 1960 by Mário Pedrosa, Ferreira Gullar, and others) and a determination to carry it forward. Although Oiticica has referred to the shared "constructive will"[3] that characterized Brazilian culture in the 1950s and 1960s— an expression of the optimistic modernity which accompanied the modern architecture movement and the building of Brasília, the Concrete poetry movement, the early São Paulo Bienals, the beginnings of Cinema Novo, and so on—the mainly Rio-based neo-Concrete

grouping distinguished themselves polemically from the mainly São Paulo–based Concretist and Constructivist groupings on at least two counts. First, they criticized, as naive and somewhat colonialist, a mimetic application to Brazilian conditions of the principles of Concrete art, which had been channeled to Brazil mainly through the agency of the Swiss artist Max Bill; second, the neo-Concretists criticized an overly rational conception of abstract "structure." They believed works of art should be like living organisms.

"I began with geometry, but I was looking for an organic space where one could enter the painting," Clark said later.[4] Such is the intuition behind her wonderful sequence of early works, where an organic space does appear within geometric abstraction at its most classically pure and rigorously precise. It can be felt, first, in the leaking out of an interior, empty/full, dark void beyond the edges of the pictorial rectangle, as in the Unities of 1958, which include *Egg* (Collection David Medalla, New York); then by the discovery of an interior space within the plane, as in the Cocoons of the same year; and then in the hinged metal sculptures called Bichos (Animals) of 1960–63 (plate 46), where, for the first time, the rational schema of geometry, the pulse of life and nature, and the active body of the spectator meet in a three-part exchange. The Animals are still free-standing pieces of sculpture, but in the case of the rubber Grubs of 1964, in propositions like *Going* of 1964, and in the 1966 works *Air and Stone* (figure 1) and *Breathe with Me* (an expandable rubber tube to make the sound of breathing in one's own ear), the object comes into its full existence only through the direct act of each spectator and has no meaning without it.

A similar impulse lies behind Oiticica's development, which is marked by his Metaesquemas of 1958; Spatial Reliefs of 1959 (plate 137); Nuclei of 1960; the early versions of his series of Penetrables, beginning in 1960; the Bólides, from 1964 on; and the Parangolé, beginning in 1965—a development in which color played the major role (in contrast to Clark, for whom it was of secondary importance). Oiticica wanted to go beyond color juxtapositions and contrasts to discover the "primal state," the "nuclear" energy of color, which "creates its own structure."[5]

Either through an understanding—profoundly influenced by their own history and environment—of artists like Mondrian and Malevich, or a synthesis and concretization of their own experience aided by the examples of Neo-Plasticism and Suprematism (whichever way around one likes to put it), Clark and Oiticica thus arrived at an original position in art. For Oiticica, the inner meaning behind Mondrian's formal innovations was an emancipation in terms of life and living. He interpreted Malevich's seminal painting *Suprematist Composition: White on White* of 1918 (The Museum of Modern Art, New York), in a highly unusual way, as "a necessary state in which the 'plastic arts' divest themselves of their privileges and WHITEN THEMSELVES INTO SKIN/BODY/AIR." He went on: "The drive towards absolute plasticity and suprematism are drives [*sic*] towards life, and they lead us to take our BODY (to discover it) as [life's] first probe."[6]

Life, skin, body, air: the position they took becomes both provocative and playful if Oiticica's and Clark's elastic Moebius loop, *Dialogue of Hands* of 1966 (figure 2) (the one proposition they produced jointly), is compared with Max Bill's version of the Moebius loop, *Endless Ribbon* of 1935–53 (Musée National d'Art Moderne, Paris), which the Swiss artist produced as a ponderous granite monument.

1. Lygia Clark. *Air and Stone* (multiple). 1966. Inflated plastic bag and stone

2. Lygia Clark and Hélio Oiticica. *Dialogue of Hands* (multiple). 1966. Elastic Moebius band

Clark's anticipation, in her rubber Grubs, of such North American works as Robert Morris's soft hanging felt pieces (late 1960s), or Richard Serra's rubber *Rosa Esman's Piece* of 1967 (Collection Leo Castelli, New York)—and the relation of Oiticica's early Bólides to Robert Smithson's later Nonsite works—reorients the whole discussion of modern sculpture: one sees the Brazilian work as one phase in a different trajectory, where the main emphasis is placed on the body and the spectator's participation.

To mention this matter of the body in work by Brazilian and other Latin American artists is to broach an enormous subject. The attitude toward the body is clearly an integral part of the historical tensions between what broadly could be called Western culture and the indigenous Indian and transplanted African cultures as they have developed differently in different parts of Latin America since the Conquest. The metaphor coined by Brazilian intellectuals for the process of syncretism, *antropofagia* (cannibalism), suggests both the clash of different cultural values and the production of the new, literally by *incorporation*. The resonance of this idea is confirmed, for example, in Oiticica's insistence that, in the case of his Parangolé Capes, discussed below, the body does not merely become the work's "support," but that there is, or should be, a "total incorporation . . . of the body in the work and the work in the body."[7]

I think production of the new by incorporation is a key to the work of both Oiticica and Clark, although they usually did not discuss it in terms of cultural particularity but of "the universal development of art" and the philosophical and psychological dilemmas of being contemporary. For Clark in the period of the early reliefs and Unities, for example, the notion of the "death of the plane" had implications which were simultaneously corporeal, psychological, and philosophical: "Realizing that this [the plane] was our own poetics projected outside of ourselves, we understand at the same moment that we must re-integrate this poetics in ourselves, as an indivisible part of our person. It is equally this introjection which has exploded the rectangle of the painting."[8]

For Clark, this reincorporation spelt the end of the myths of both God and the artist, which she saw as projections of our spirituality and our creativity outside ourselves. Therefore, when "participation art" and "body art" later made their appearance in Europe and the Americas, Clark distinguished her approach both from tendencies like the work of the Groupe de Recherche d'Art Visuel in Paris, with their rather mechanical stimulus-response games for the public, and from those artists who more or less replaced the art object with their own bodies as a spectacle. To "re-integrate [our] poetics in ourselves, as an indivisible part of our person" meant returning to the sensuous body all our constructs: from our separating out of the five senses, to our notion of "the other," to our language, communication, architecture, and environment as a whole.

—

If these concerns are what broadly unite Clark and Oiticica, it is time now to turn to their differences, to what corresponds, in Clark's metaphor, to the "outside" and "inside" of the glove. Both artists wrote superbly about their work. Both pursued a broadly similar strategy: a dual strategy, elemental at the level of the senses—the body, the earth—and highly sophisticated in concepts. What, recalling Clark's words, linked Oiticica with the external world?

3. Hélio Oiticica. Nildo of Mangueira with *Parangolé Cape 13 ("I Am Possessed")*. 1966. Plastic, gauze, straw, cloth, and other materials

As he progressively freed his painting from the iconic tradition, Oiticica sought to transform the fixed, flat, passive surface, "on" which things are represented, into a live element. Combining this with his search for the inner, "nuclear" energy of color, he instituted in the early 1960s three generic "orders," which provided the structural basis of his work for the rest of his life. These were brilliant conceptualizations, whose many ramifications are hard to sum up briefly: Bólides ("fireballs" or "flaming meteors" in Portuguese), which began as boxes and glass containers holding color as a glowing mass of pigment; Penetrables, cabins or labyrinths whose recesses one entered and explored with all one's senses; and Parangolé, a word denoting a state of mind, which was usually materialized in the form of capes and other body coverings to be worn, unfolded, danced in. In a sense, each of these "orders" belonged to a larger order of "container," because each implied setting apart a portion of the universal flux, ranging from the small-scale ("within hand's reach") to the architectural and environmental. And each could cross easily from being a deliberately constructed object, often of delicious beauty, to a simple designation, an appropriation. Because it was a cosmic metaphor, he could use the Bólide, for example, to give a new energy to the most local, unnoticed things: the can of burning oil used at night in Rio de Janeiro as an improvised road light, which became a sign of the

transience of life; a builder's barrow of stones; a wire basket of eggs.

The Parangolé Cape (perhaps Oiticica's most original invention) is simultaneously a Concretist structure; a painting in which "support" and "act" are fused; a poetic recycling of many everyday, and often worthless, elements; an abstraction of Rio de Janeiro's *favelas* (shantytowns), whose reality the artist knew firsthand; the emanation of a person (the Capes were often inspired by particular friends); a "sensuality tester,"[9] as Oiticica once called it; and a means of public utterance (figure 3). But even such an expanded definition fails to convey the way he described Parangolé, not in terms of an object, but as a search for "situations to be lived," and as "proposals for behavior."[10]

When considering Oiticica's span of work, "situations to be lived" is an evocative phrase. Personal experience always fed Oiticica's concepts, and vice versa. In his unconventional career, he avoided the art market, finding other means of supporting himself, and realized his work through countless collaborations and friendships. His legacy is a complex archive, meticulously ordered by himself, consisting of objects, plans, maquettes, texts, notebooks, letters, diaries, films, photos, slides, and audio tapes. Words and writing play as great a role in this legacy as the making of physical objects. In fact, as his life progressed, each activity invested the other with meaning in increasingly dense ways.

For the sake of brevity, one path through Oiticica's work can be followed by tracing the development of his Bólides. It can be seen as a history of the transformation and reinterpretation of the nucleus, or energy center. First, there was a hedonistic period, around 1964, when Oiticica enjoyed the liberation of color and pigment from the rectangular painting; that period is represented by the Box Bólides, with their openings and compartments, and the Glass Bólides (figure 4), filled with pigment, earth or dust, and color-impregnated, flame-like gauzes. The fusion between the intellectual forming principle and

4. Hélio Oiticica. *Glass Bólide 4 Earth*. 1964. Glass, earth, and painted gauze

pleasure of the senses could be realized in many ways: one Bólide, *Olfactic* of 1967 (Projeto Hélio Oiticica, Rio de Janeiro), is a heavy bag of coffee beans whose aroma one snorts through a tube. In 1965 hedonism melted away in the solemn but loving boxes made as tributes to doomed outlaws of the Mangueira *favela*—to the desperate gesture of the individual revolt against impossible social conditions. The Bólide thus became a sort of tomb or shrine, yet its articulation was not religious or symbolic but corporeal and kinesthetic.

In its next phase the Bólide made its appearance as a bed, as in *Bed Bólide I* of 1968 (Projeto Hélio Oiticica, Rio de Janeiro), and in 1969 as rectangular enclosures of sand or straw in Area Bólides and as Nests. All were elements of Oiticica's "mind-settlement," *Eden*, first realized at London's Whitechapel Art Gallery in 1969, which he described as "an experimental 'campus,' . . . [a] mythical place for feelings, for acting, for making things and constructing one's own interior cosmos."[11] After its association with sensation and imagery, the Bólide here became a simple locus, a sympathetic void to be filled by an individual's reverie. It reflected Oiticica's idea that an artist's work should create a context in which people's own creativity can "catch fire," in a state of unrepressive leisure, which he called *crelazer* ("creleisure"). Instead of being a marketable commodity, the artist's work would be a kind of mother cell, which would reproduce itself endlessly and globally, allowing the input of every local cultural possibility. Because he gave the creative act more importance than the object, Oiticica also used the Bólide as a means of negation. In 1978, two years before he died, he made *To Return Earth unto Earth*, which he called a Counter-Bólide. It was part of an event he organized on the site of Rio's Cajú, a forlorn rubbish dump near the port, in what used to be the Portuguese imperial quarter. Rich, black earth was brought from another site and placed in a bottomless rectangular container. When it was removed, the earth remained on the ground. If the original Bólide had removed a portion of earth to the container, to make a connection between art discourse and the earth itself, the Counter-Bólide aimed to produce the same insight by the opposite action: opposite because in the meantime the art discourse had assimilated the original as an object, weakening its efficacy as an act.

—

It is illuminating to contrast the outward-turning Oiticica with the inward-turning Clark (though the effect is as much to link them as divide them). Each step in Clark's development seems to represent a move inward, away from the external, to articulate something as yet formless and incoherent in the psyche. And each of these moves was marked by changes not only in her work but in her notion of a context for it. In other words, she was continually seeking an audience through means as experimental as those she used when devising her "propositions." The metal Animals confront the gallery-goer as independent objects that can be manipulated. *Air and Stone*, *Breathe with Me*, and *Going* were propositions one set in motion oneself, and they had an intimate effect. In 1967 Clark made a series of Sensorial Hoods, incorporating eyepieces, ear coverings, and a small nose bag, which fuse optical sensations with sound and smell. (For a visual artist, Clark progressively deemphasized the visual sense to a remarkable extent.) At the same time, she began a series of "dialogues," sometimes in the form of suits, such as *The I and the You/Clothing-Body-Clothing* of 1967 (Estate of the artist, Rio de

5. Lygia Clark. *Mandala*, from the series Collective Body. 1969. Elastic bands linking people at their wrists or ankles

Janeiro), worn by a man and a woman, both blindfolded, who find by touch, in cavities in the other's suit, metaphorical suggestions of their own gender. Or one might, as in her 1969 *Mandala* (figure 5), put one's wrists and ankles into a web of elastic bands inhabited by several other people whose movements intimately affect one's own.

When Clark taught at the Sorbonne in the late 1960s, she was able to work regularly with the same group of people, and the interaction of the processes of initiation and feedback deepened. She began a series she called Body Nostalgia, aiming to rediscover "the erotic in the process of communication."[12] The work was "created by the gestures of the participants, each stretching a sheet of plastic, which, in turn, creates a cell which envelops one or another of the group. So it goes on. With each gesture a *living, biological architecture* is created, which melts away when the experience finishes."[13] After this Clark again moved away from externals—gestural, muscular, and motor relationships—to something more interior: experiences that were sometimes pleasurable and sometimes deeply disturbing to those taking part. The effect of participating in *Antropofagia* of 1973, in which blindfolded people sat in a circle eating fruit taken from pockets in the suit of another person, who was recumbent, was described as being "like entering each other's bodies."[14] The outpouring of cotton thread from the mouths of a group

of people onto the body of another person, again recumbent, in *Baba antropofágica* (literally, "cannibalistic slobber") of 1973, had the effect, Clark said, of an "exchange between people of their intimate psychology. . . . [It] is not a pleasant thing. . . . A person 'vomits' their life experience; . . . this vomit is going to be swallowed by the others."[15]

When Clark returned to Rio de Janeiro from Paris, her "audience" again changed, becoming individuals with whom she interacted one-on-one, not in public or institutional spaces but in her own studio; the context had changed from one of play and experiment to one of healing and therapy. She began to work as a psychotherapist, often taking on, even preferring to work with, people suffering from psychotic disturbances. In a sense, she had long been prepared for this transition, not only by her own experience of psychoanalysis as a patient, but also by her observations of how her sculptures affected people at a nonverbal or preverbal level, reawakening the body's memories, sometimes going back to the earliest years of life. In her therapy she would give to the "patient," in a sequence, devices from her repertoire of Relational Objects: heavy and light mattresses, air bags, shells, elastic, rough and smooth materials, combining these with her own touch, words, and sometimes her breath blown through a tube (figure 6). She kept detailed notes of each person's responses. It is impossible to discuss all the implications of her therapy in a brief essay (nor am I qualified to do it), but it is evident that the notion behind her earlier call for spectator participation—that the object does not have an identity of its own but is defined by its relationship to the subject's fantasy—took on an intense actuality during the therapy. For the patient, the objects often became, metaphorically, one aspect or another of the organs of adult bodies that he or she, long ago as an infant, had appropriated, contacted, and touched, "painful accidents that hit [the infant], pleasurably or not, in a process of symbolic metabolization that comes to constitute the ego."[16] In the eight years or so she carried out the therapy, Clark always noticed the best results with her most disturbed patients.

━━

Because Clark and Oiticica are both now dead, there is a tendency to consign their work to the past. But it seems to me that many questions arising from what they did have yet to be asked. In Brazil especially, their work is often discussed in terms of its applicability to established mediums, like sculpture and painting, with which they had decisively broken. It is complex work, which had its origins outside the "first world," outside the "cultures of plenty." This is apparent not only in its precarious materiality; its use of improvised, cheap, or rejected materials; its search for a context outside the art institutions and their rituals connected with social privilege; but also in the way it draws its strength from a dialectical experience of Brazil: its chaos and misery, but also its resilient popular art, lore, and knowledge.

There is no doubt that the work of Lygia Clark and Hélio Oiticica can be seen as an attempt to heal the body/mind split characteristic of Western culture since the Renaissance. In Clark's therapy, a "plastic" language, incorporating the visual with the tactile, auditory, and olfactory, enters an efficacious, medical, healing relationship with the body-mind. It cannot be said that Clark abandoned art to become a therapist, that she exchanged one métier and body of professional

knowledge for another, since she took her plastic discoveries with her into her work as a therapist. The question could be asked, as it can of every doctor or healer, Were Clark's results an outcome of her method (employing the Relational Objects and so on) or her personal qualities, her "soul force"? But this question rebounds into the realm of art: in Clark's (and Oiticica's) work, viewed as a participatory practice, expression lies not within the art object but in a relationship, a dialogue.

Both artists were perhaps less concerned with aesthetics than with a notion of liberation. Clark talked of her work as "a preparation for life," and Oiticica spoke of "life-acts" freed from all conditioning. There is, in fact, a striking resemblance between Oiticica's desire for an all-around fusion with the world, a "total body-

6. Lygia Clark. Individual therapy with Relational Objects. Rio de Janeiro, c. 1975–80

ambience communion,"[17] and the Hindu mystical ideal of liberation as "transcendence of duality, and the unity of 'I' and the phenomenal world."[18] In practice, however, they remained profoundly dialectical, or at least aware of impossible contradictions. Clark's propositions aim to realize an expansion of sensual awareness and the plenitude of the body through devices which appear to block and constrain it; Oiticica's Penetrables and Parangolé Capes are vehicles for pleasure and reverie but also, in a sense, containers or shrouds. It is hard to be definitive. In her therapy, Clark certainly had no absolute goals or final states but more modest and relative aims: "I think the important thing is to have a satisfactory life; it's enough. I'm convinced that anyone who thinks they can 'finish' another person forgets that people are and always will be 'unfinished' and will always be vulnerable to another crisis, provoked by the experience of new perceptions."[19]

Notes

1. "Una internacional de los tránsitos y las redes de hibridación entre lo tradicional local y la utopía moderna."—Eugenio Dittborn, letter to the author, July 1992.

2. Quoted in *Veja* (Rio de Janeiro), December 1986; cited in Guy Brett, "The Experimental Exercise of Liberty," in Guy Brett et al., *Hélio Oiticica* (Rotterdam: Witte de With, Center for Contemporary Art, 1992), p. 227.

3. Hélio Oiticica, "General Scheme of the New Objectivity" (1967), in Brett, *Hélio Oiticica*, p. 110.

4. Lygia Clark, quoted in *Veja* (Rio de Janeiro), December 1986.

5. Hélio Oiticica, diary entry, October 5, 1960, in Brett, *Hélio Oiticica*, p. 33.

6. Brett, "Experimental Exercise of Liberty," p. 227.

7. Ibid.

8. Lygia Clark, "Un mythe moderne: La mise en évidence de l'instant comme nostalgie du cosmos," *Rhobo* (Paris), no. 4 (1965), p. 18.

9. In a caption referring to a "poem-Bólide" in the form of a semitransparent body covering made in 1980, which Oiticica also described as a "warm-up for Carnival" and subtitled "Yours by Mine."

10. Hélio Oiticica, "Subterranean Tropicalia Projects" (New York, 1971), in Brett, *Hélio Oiticica*, p. 143.

11. Hélio Oiticica, "Eden" (1969), in Brett, *Hélio Oiticica*, p. 12.

12. Lygia Clark, "L'Art, c'est le corps," *Preuves* (Paris), 1975, p. 18.

13. Lygia Clark, "L'Homme, structure vivante d'une architecture biologique et cellulaire," *Rhobo* (Paris), no. 5–6 (1969), p. 12.

14. Guy Brett, "Lygia Clark: The Borderline Between Art and Life," *Third Text* (London), no. 1 (Autumn 1987), p. 87.

15. Ibid.

16. Ibid., p. 91.

17. Brett, "Experimental Exercise of Liberty," p. 237.

18. Sudhir Kakar, *Shamans, Mystics and Doctors: A Psychological Inquiry into India and Its Healing Traditions* (Delhi: Oxford University Press, 1982), p. 153.

19. Lygia Clark, letter to the author, October 1983.

SURREALISM AND LATIN AMERICA

Dore Ashton

In his autobiography the Chilean poet Pablo Neruda told of his early successes—a literary prize at school, a bit of popularity for his new books, and attention for his notorious cape. These lent him "a small aura of respectability beyond artistic circles." But, he wrote, "In the twenties, cultural life in our countries depended exclusively on Europe, with a few rare and heroic exceptions. A cosmopolitan elite was active in each of our republics, and the writers who belonged to the ruling class lived in Paris. . . . In fact, as soon as I had the first little bit of youthful fame, people in the street started asking me: 'Well, what are you doing here? You must go to Paris.'"[1]

All during the 1920s the artists and poets of Latin America dreamed of Montparnasse and not a few of them managed to get there, most notably Argentines, Brazilians, Peruvians, and a few Mexicans. There they tended to band together even while drinking at La Coupole or Le Dôme, but a few penetrated the interior of the avant-garde and were on hand to enter the febrile life of the newly established circle of artistic rebels known as Surrealists. Guided by André Breton, Louis Aragon, and Philippe Soupault, the Surrealists had from the beginning declared their intention to establish a point of view of existence which would be supranational, open to the voices of anyone in the world who shared their passionate contempt for constricting structures—among them nationalism, the Church, imperialism, and above all, the stranglehold of Western rationalism. Both the breadth of their program and their exuberant public presence appealed to their Latin American recruits, many of whom had left provincial situations in full rebellion. From the French point of view these visitors from a continent they had long romanticized were privileged.

The Surrealists were faithful descendants of the first generation of modernists, among them the poet Guillaume Apollinaire and the painters Pablo Picasso, Henri Matisse, and Georges Braque, all of whom haunted the halls of the old ethnographic museum, the Trocadéro, and collected works of non-European cultures. This generation maintained an avid interest in the Americas, where, they imagined, ancient mythological mores lived on intact. When, for instance, three years after his first Surrealist manifesto (published in 1924), Breton showed the work of Yves Tanguy in the Galerie Surréaliste, Paris, he also showed artifacts from New Mexico and wrote an ecstatic introduction referring to old Mexico. He saw in his voracious mind's eye a Mexico of impenetrable forests with wild masses of lianas making giant corridors, and impossible butterflies that opened and closed on great staircases of stone.[2] This primeval Mexico would be the very Mexico Breton discovered, and held fast to, on his trip in 1938. It is not surprising, then, that the Latin American poets and artists who drifted into his circle were more than welcome. One of the first was the Peruvian poet and artist César Moro, who had arrived in Paris in 1925 and by 1927 was a regular at Surrealist meetings. Years later, in 1940, Moro would organize, together with the Austrian artist Wolfgang Paalen and Breton, the first international exhibition of Surrealism in Latin America, the *Exposición internacional del surrealismo* at the Galería de Arte Mexicano, Mexico City.

Because of the Old World's appetite for ancient, unspoiled places—a dream that had a history in Europe going back to at least the sixteenth century—the traffic with Latin America went two ways. Among the poet-explorers who shared the rebellious spirit of the Surrealists, and often drew on the same literary sources, was the

early modernist Blaise Cendrars, who in 1923 entertained the Brazilian poet Oswald de Andrade and his companion, the painter Tarsila do Amaral, in Paris, and then returned with them to Brazil in 1924. Cendrars's intense interest in local customs, artifacts, and rites inspired his young Brazilian friends in their exploration of that eternal Latin American problem: identity. Others who were lured to Latin America early in their careers include the poet Benjamin Péret, who spent two years in Brazil in 1929–30, and the artist Henri Michaux, who made a long sojourn in Ecuador in 1928 and extended visits to Argentina and Uruguay in 1936. That same year, one of the purest exponents of Surrealist philosophy, the writer and actor Antonin Artaud, made his important trip to Mexico. All of these visits were significant to those Latin Americans who had, at a distance, heard about Surrealism and were already adopting at least some of its principles. In each country there was usually a small "cosmopolitan elite," as Neruda pointed out, that had followed with great attention all the avant-garde trends in art and poetry in Europe. Many of the favored sources of Breton and his friends both in art and in literature (Charles Baudelaire, Edgar Allan Poe, Arthur Rimbaud, the comte de Lautréamont, Max Klinger, Hieronymus Bosch, Paolo Uccello, and Charles Meryon, among others) were well known to these assiduous students of European tendencies. Moreover, there had been chance encounters of considerable consequence. For example, the Mexican artist and critic Agustín Lazo, who became an expert follower of Max Ernst and created Surrealist montages (figure 1) that were included in the 1940 Exposición internacional del surrealismo, had studied theater design in Paris from 1922 to 1925 in Charles Dullin's Atelier theater company. There he certainly crossed paths with Artaud, who from 1921 to 1923 not only designed costumes but played in many productions, among others Pedro Calderón's La vida es sueño.

As is well known, one of the principal tenets of Surrealism held that the dream is a prime source of authentic experience. Breton had stressed in his original manifesto that "Surrealism is based on the belief in the superior reality of certain forms of previously neglected associations, in the omnipotence of dream, in the disinterested play of thought."[3] The avowed purpose of the Surrealists was to bring reality and dream onto the same plane. It is not surprising, then, that Surrealist proclivities were congenial to many Latin American intellectuals. Throughout the history of Spanish letters, dreams have been of singular importance, ranging from Calderón's play with the marvelous line "La vida es sueño y los sueños sueños son" ("Life is just a dream, and dreams are nothing but dreams") to Francisco Gómez de Quevedo's poems, which the great Cuban writer José Lezama Lima said were all dreams of blackness and void, and which he compared to Francisco Goya's late work. Goya, who declared that the sleep of reason produced monsters, could not resist depicting his own nocturnal demons. He prefigures Picasso, who during several periods of his life was preoccupied with oneiric and sometimes black visions. When he wished to denounce Franco, the artist titled his series of scathing etchings Dream and Lie of Franco.

—

In the Surrealist enterprise between the wars, Paris was still the central post office, and André Breton the postmaster general. The adolescent poet Octavio Paz, for instance, chanced upon some pages of Breton's L'amour fou (published in 1937), a section of which had appeared in the Buenos Aires review Sur in 1936. According to Paz this excerpt, in which Breton described his climb to the summit of the volcanic Teides of Tenerife, "read at almost the same time as Blake's Marriage of Heaven and Hell, opened the doors of modern poetry to me."[4] Paz went on to become one of the great modern poets and one of the most eloquent commentators on Surrealism, particularly in Latin America. It was during the second phase of Surrealist activity in the 1930s that perceptible results occurred in the arts of Latin America. From the late 1920s until the outbreak of World War II, a great malaise overcame most artists and intellectuals in Europe, reflected in political quarrels and violent disagreements among the Surrealists and in the foreboding that darkened their lives once the Spanish Civil War broke out in 1936. This uneasiness spurred the efforts of the French Surrealists to reach out to the world. In 1932 Breton, who was guest editor of the Surrealist issue of the English-language art and literary review This Quarter, wrote: "It does not at

1. Agustín Lazo. Boat, Sailors, and Mannequin. n.d. Collage, 9⅞ x 12¾". Fundación Cultural Televisa, Mexico City

all appear to us impracticable to organize in the four corners of the earth a fairly extensive scheme of resistance and experiment. This plan . . . cannot be settled until there has been an interchange of the innermost desires of the live youth of all countries."[5]

Four years later Artaud, who had broken with Breton and his circle but had remained faithful to Surrealist principles, gave several important lectures at the University of Mexico. Here too he stressed the necessity of youthful exchange and pointed out that "French youth of today, who do not tolerate dead reason, are no longer content with ideologies. . . . In the eyes of youth it is reason which created the contemporary despair and the material anarchy of the world by separating the elements of a world which a real culture would bring together."[6] This lecture, "Man Against Destiny," was published in four installments in a widely read newspaper, El Nacional. Six months later the same paper printed a translation of Artaud's lecture "What I Came to Mexico to Do," in which he stated that he sought in Mexico a new idea of man, and he looked for it in "the ancient vital relations of man with nature that were established

2. Matta. Untitled. 1938. Crayon and pencil on paper, 19½ x 25½". Acquavella Modern Art, Reno

by the old Toltecs, the old Mayas—in short, all those races which down through the centuries created the grandeur of the Mexican soil."[7]

The fact is that in the staggered history of Surrealist influence in Latin America, both in painting and in poetry, there were numerous historical coincidences. The painters who had made it to Paris had been emboldened by experiments among the Surrealists with free association, which in its innermost depths was called "psychic automatism." Certain among them, from countries such as Peru and Mexico, where there were large Indian populations that preserved those vital relations of man with nature mentioned by Artaud, were incited by the increasingly keen interest in Paris in the study of tribal myths and mores. The growing desire to establish a Latin American identity distinct from that of both Europe and the United States was becoming urgent by the late 1920s. Harking back to José Martí's concept of *Nuestra América*—Martí's sophisticated, often bitter plea for liberation and distinction—many painters turned to popular life for thematic material at just about the time that Parisian Surrealism became a major force in European intellectual currents. Strange fusions occurred as the Surrealist idea of radical juxtapositions was mixed with specific allusions to local cultures, for example, in the paintings of Tarsila do Amaral in Brazil and of Amelia Peláez del Casal in Cuba. In 1928 Amaral's husband, Oswald de Andrade, published the "Anthropophagite Manifesto," an incendiary essay (still avidly discussed today) in which he exhorted fellow poets and painters to cannibalize European avant-garde ideas and use this nourishment to mine local sources of energy and themes—in Brazil's case its rich Indian and African heritage. Five years later the Cuban writer and musicologist Alejo Carpentier published *Ecue yambo o* while in exile in Paris. A novel based on a close observation of Afro-Cuban cult practices, it opened the argument that still plagues Latin Americans today, especially when they discuss Surrealist influences on Latin American arts. It was Carpentier who shaped the idea of Magic Realism and "the marvelous" in his voluminous writings, and who suggested that Latin America was innately endowed with extravagant imaginative resources. He himself was profoundly affected by Surre-

alist poetry, having lived in France from 1928 to 1939, and was far too intelligent to accept what he called abominable folkloric realism, or the local pieties of *criollistas* and *costumbristas*. But those resistant to the Surrealist infusion after World War II used Carpentier's writings to deny its influence, and in their need to declare a definite identity, fought under the banner of Latin American Magic Realism.

——

It was toward the end of the 1930s that Breton made common cause with the two most identifiable and gifted acolytes from Latin America: Matta (Roberto Sebastián Antonio Matta Echaurren) in 1936 and Wifredo Lam in 1939. The late 1930s witnessed a regrouping among the Surrealists, and several newcomers caught Breton's attention and would later work with him to establish Surrealism in the Americas, among them Paalen, and Gordon Onslow Ford from England.

If the word "influential" has any meaning at all, it covers the case of Matta who, well tutored in Surrealist principles, most particularly in psychic automatism, went on to develop a highly personal style that impressed friends such as Arshile Gorky and Robert Motherwell in North America. His works were reproduced in various avant-garde journals published in the New World in the 1940s. Matta was in every way a representative of the cosmopolitan elite that his fellow Chilean Neruda described. He had an excellent classical education under the Jesuits, and even before he left Chile in 1933 knew French and was *au courant* with advanced European poetry. Armed with an architecture degree, Matta worked on a free-lance basis as a draftsman for Le Corbusier during his first two years in Paris, leaving himself time enough to explore various circles there and elsewhere in Europe. He was uncannily successful in finding the personalities he knew would enrich his artistic experience. During a holiday visit to Spain in 1934, he met Rafael Alberti and Federico García Lorca at a time when both poets were deeply engaged in public activities that often earned them the pejorative label "surrealist." Lorca, having been closely involved with both the filmmaker Luis Buñuel and Salvador Dali, was always interested in Surrealist works, particularly in painting. As early as 1928 he had written "Sketch de la nueva pintura," in which he said: "The Surrealists begin to emerge, devoting themselves to the deepest throbbings of the soul. Now painting liberated by the disciplined abstractions of cubism . . . enters a mystic, uncontrolled period of supreme beauty."[8]

Probably it was through García Lorca that Matta met Dali, who in turn introduced the young architect to Breton. By this time, Matta had cast his avaricious eye on certain Surrealist paintings and had become acquainted with several enthusiasts, among them Onslow Ford, himself a recent convert. With Onslow Ford, Matta explored various alternatives to conventional science, including P. D. Ouspensky's *Tertium organum*, in which the Russian mystic declared that "each stone, each grain of sand, each planet has its *noumenon*, consisting of life and of psyche, binding them into certain wholes incomprehensible to us."[9] Matta's interest in fetching up imagery consistent with a visionary notion of the fourth dimension was immediately apparent in the small colored-pencil drawings he produced shortly before he met Breton. Although there are traces of Picasso's metamorphic drawings of the early 1930s, and certainly formal allusions to the baroque inventions of Max Ernst and André Masson, Matta brought something of his own to bear even in the early stages.

The wild, curvilinear forms, arrived at through the practice of automatism, underline his preoccupation with the creation of the world and reveal something of the apocalyptic Catholic vision instilled by his education in Chile. The 1938 colored-pencil drawings of sea, stars, stringy curvilinear forms, and nests of mineral and vegetable shapes indicate Matta's burgeoning philosophy (figure 2). He would soon call these works "psychological morphologies." When he began painting in 1938, at Onslow Ford's urging, he offered dark visions of heaven and earth in primary chaos, with pearly highlights and interstices of unearthly light. Breton was quick to see Matta's potential, and in an article written in 1939, "The Most Recent Tendencies in Surrealist Painting," he spoke of young Matta as an artist for whom "everything results from a desire to enrich the faculty of divination." He found in his work the use of all the elements of chance—one of Breton's original demands in the first manifesto—and "shimmering lights emanating from the mind and the body."[10] Breton noted above all that the recent recruits to the movement displayed a marked return to automatism, and he concluded that Matta, Paalen, Onslow Ford, and the Swiss artist Kurt Seligmann (all of whom would shortly be messengers to the New World) "share the same deep yearning to transcend the three-dimensional universe, as evident in the work of Matta (landscapes with several horizons) and Onslow Ford."[11]

No doubt Breton was charmed by the young Matta, who was as exhilarated by the work of the nineteenth-century visionary known as

4. Matta. *The Onyx of Electra*. 1944. Oil on canvas, 50⅛" x 6'. The Museum of Modern Art, New York. Anonymous Fund, 1979

the comte de Lautréamont as Breton was, and at his behest illustrated (as did Ernst, Masson, and Dali) one of the most extraordinary prose poems ever written, *Les chants de Maldoror*, finding there great cosmic themes and the clash of mythical worlds. Many of Matta's subsequent works echo the strange preoccupation of Lautréamont with the conjunctions of the three worlds—animal, vegetable, and mineral—and the great cosmic forces regulating them. By 1940 Matta had developed a palette of mineral colors, often deliberately blurred to suggest their trajectory through space and their transformation as they moved. Onslow Ford speaks of *Drawing for the Invasion of the Night* of 1940 (present whereabouts unknown) as a scene projected according to Matta's idea of psychological morphology: "Each personage, each object is extended in time and molded by the actions and interactions of the surroundings. . . . A personage becomes a flying machine and takes off; birds become hovering heavenly bodies. The earth is a transparent architectural construction that breathes."[12]

Matta was by that time ensconced in New York; one of the first of the Surrealist artists to arrive, he was certainly one of the most active proselytizers. It was he who brought the various Freudian parlor games of Parisian Surrealism to American artists such as William Baziotes, Robert Motherwell, David Hare, and Jackson Pollock; he who impressed Gorky with his linear, automatist drawings; and he who moved easily from circle to circle—the grand cosmopolitan who aspired to be one of the *grands transparents*, those alchemists of philosophy of whom Breton wrote. His work during the war years in New York was greatly admired for the way it fused inner and outer worlds; for the tectonic divisions of space put into the service of cosmic messages, as in the 1942 *Here, Sir Fire, Eat!* (figure 3), and still more graphically in *The Onyx of Electra* of 1944 (figure 4); and for his steadfast adherence to the Surrealist principle of salutary hallucination. As late as 1948 Matta was extolling history as the story of man's various hallucinations in an article titled "Hellucinations."[13] This tribute to Max Ernst declared that "the power to create hallucinations is the power to exalt existence" and defined an artist as "the man who has survived the labyrinth."

Breton's other Latin American star of the late 1930s, Wifredo Lam, came to him by quite another route. Older than Matta, Lam had made his first foray to Europe from his native Cuba in 1923, when he

3. Matta. *Here, Sir Fire, Eat!* 1942. Oil on canvas, 56⅛ x 44⅛". The Museum of Modern Art, New York. James Thrall Soby Bequest, 1979

headed for Madrid. There he discovered some of the Surrealist-designated precursors such as Hieronymus Bosch and Pieter Brueghel and met, among others, his countryman Alejo Carpentier precisely at the time he was taking a scholarly interest in the Afro-Cuban Santería cults. Carpentier stimulated Lam's interest in his own background, which included, through his godmother, exposure to Santería ceremonies. When the Spanish Civil War erupted, Lam fought on the Republican side. In late 1937 or early 1938, he was incapacitated and sent to a hospital, where he met the Spanish sculptor Manolo Hugué, a member of Picasso's band, who urged him to visit Picasso. It was to be a fateful moment. Picasso immediately responded to the Cuban of mixed African, Spanish, and Chinese descent who had already been influenced by Picasso's work. Lam not only reanimated Picasso's own long interest in African art, but perhaps even more importantly, he was a hero of the Spanish struggle. It was through Picasso that Lam had an exhibition at the Galerie Pierre in 1938—an exhibition that Picasso took uncommon pains to have others see, often accompanying friends himself, as was the case with Breton. By 1939 Lam was fully committed to Surrealism, and all through his life he reaffirmed the importance of his initial exposure. Recalling his early Parisian encounters, Lam told an interviewer: "André Breton in his first manifesto wanted to penetrate the essence of creation and stressed that the psychological behavior of man, acquired after birth, appeared clearly in his creative evolution. . . . Breton transmitted to me the poetic impulse: that of being more than ever independent in spirit. . . . There is a dualism between the thrusts of consciousness and those of the unconscious."[14]

Lam's incorporation into the Surrealist circle took place at a portentous moment. Shortly after, the exodus that would create a veritable diaspora of Surrealists commenced. Among the first to leave Europe were Yves Tanguy and the American Kay Sage, who arrived in New York in 1939 and were indefatigable in their efforts to bring their old comrades out of the threatening situation of the "Phony War" in France. By August 1940 Breton had become convinced that, as he wrote to Jacques Seligmann in New York, his place was there, where thanks to circumstance, "the greatest effervescence of ideas" could now take place.[15] In October 1940 Breton was installed in the Villa Air-Bel in Marseille, where the American emergency committee under Varian Fry had assembled a remarkable group, including old Surrealist comrades, such as Masson and Ernst, and new friends, among them Lam. Breton wrote *Fata Morgana* while awaiting his visa, and Lam illustrated it (figure 5). In March 1941 Lam embarked with Breton on what must have been one of the most remarkable sea voyages ever undertaken. Accompanying Lam and Breton, with wife and child, aboard the overflowing small freighter, were the famous Russian revolutionary Victor Serge and his son Vlady, and the innovative anthropologist Claude Lévi-Strauss. When they arrived in Martinique they were warmly welcomed by Aimé Césaire, whose poetry had appeared in Paris in the late 1930s, and whose interest in the lore of his own African traditions coincided with that of Lam. Breton, the old internationalist, was greatly inspired by the tropical experience and would later write prose poems about the island. His second encounter with the exotic cultures of the New World infused him with a new vision in which the magical practices he witnessed would become the source of fresh speculations concerning the role of myth in modern life. A few days after Lam and Breton landed in

5. Wifredo Lam. Illustration for *Fata Morgana*. Buenos Aires: Sur, 1942. Page 23.

Martinique, André Masson arrived, and after a few weeks, Masson and Breton left for New York on the same ship with Lam, who disembarked in Santo Domingo in order to take a ship home to Havana. This episode in Surrealist life would have considerable repercussions during the next few years.

When Lam first approached Breton, his work bore the imprint of what Picasso called his "exorcist" painting, *Les demoiselles d'Avignon* of 1907 (The Museum of Modern Art, New York). This could only have pleased Breton, who had been the first to understand the great importance of the painting and to write about it. The African masks that had so much attracted Picasso were smuggled into Lam's work, as were features from later Picasso works, such as the pin-headed creatures of the late 1920s, and the exaggerated limbs, especially hands and feet, of the early 1930s. These were augmented by clear references to Picasso's horses, often much affected by African animal masks. It was only after his return to Cuba that Lam managed to use both the Surrealist and the Cubist vocabularies in a way that proclaimed his original point of view. In direct contact now with intellectuals in Havana who were vigorously engaged in studying the music, rituals, and costumes of Afro-Cuban cults, Lam threw himself into finding the means to express the spirit of uprooted Africans who "brought their primitive culture, their magical religion with its mystical side in close correspondence with nature."[16] During the next few years Lam closely studied the character of native rituals. His Surrealist lessons were not difficult to assimilate to his rediscov-

ered native sources. In Afro-Cuban rites, as in the Brazilian *candomblé*, the drive is toward the ecstatic. The myriad gods, each with a separate function, are conjured through chanting and dance, and sometimes through the adepts' ability to go into a trance. Early Surrealist experiments with mediums, trances (one of the Surrealists most competent in inducing a trance in himself was the French poet Robert Desnos, who on a 1929 visit to Havana had witnessed ceremonies), and magic provided fertile ground for an already primed artist such as Lam. By 1942 he was crowding his paintings with luxuriant foliage—the ubiquitous sugar cane and bamboo of Cuba—out of which peered masked and costumed figures, half-animal, half-human, with occasional gourdlike shapes reminding viewers of the incantatory music of the ceremonies. There were titles naming Yoruba deities to emphasize the strangeness of these visions. By the time he had his first one-person show in New York, which Breton arranged at the prestigious Pierre Matisse Gallery in November 1942, Lam's passionate evocation of what his friend Aimé Césaire would later call "the primary terror and fervor" of the Caribbean was firmly established.[17]

—

In the diffusion of Surrealism in Latin America, Mexico must be seen as a special case. Although first Artaud, and then Breton, claimed Mexico as the ideal territory for the flowering of the Surrealist vision, many Mexicans were unwilling to become members of the Surrealist confraternity. Certain historical conditions had bolstered their resistance. Those with long memories could cite the nineteenth-century French invasion and the ill-fated reign of Maximilian. Others were wary of the oneiric, metaphysical diction the Surrealists favored, having participated as youths in the prolonged Revolution and guerrilla wars that preceded the government of Alvaro Obregón (1920–24), during which the revolutionary program of public education through murals got underway. Still others were deeply involved with the reforms of Lázaro Cárdenas, who established in 1934 a dynamic program of art for the masses that favored the formation of the collectives Liga de Escritores y Artistas Revolucionarios (LEAR) and Taller de Gráfica Popular (Workshop of Popular Graphic Art). Members of these idealistic and strongly politically oriented groups were not cordial to the exalted and distinctly esoteric ideas of their Surrealist visitors. Even though Artaud was enthusiastic about Mexican revolutionary social ambitions during his visit, and Breton was the guest of the revered muralist Diego Rivera, many rank-and-file artists were unmoved. Intervening were both nationalistic goals (the need to avoid foreign dominance, above all economically) and the vexing question of identity (which, during the same period, haunted their North American artistic colleagues). And finally, at least in certain radical milieux, the fact that Breton came to Mexico not only to explore its mythologies but also to meet Leon Trotsky was enough to arouse hostility among opposing groups of artists.

All the same, Breton's 1938 visit was crucial to the active life of Surrealism in Latin America. Shortly before he left for what was meant to be a lecture series in Mexico City, Breton inscribed for a Mexican friend his portrait by Picasso: "To the poets and artists of Mexico who have the privilege of expressing the place in the world where nature is most ardent, and of translating one of the highest historic efforts of man to achieve awareness and liberty, I address my fraternal salute and my joy in going to surprise, at its origin, the

secret of its genius."[18] Two months later Breton was en route to Mexico. Rivera met his boat in Veracruz on April 18 and installed him and his wife, Jacqueline Lamba, in his own house in San Angel. On May 9 the major newspaper *Excelsior* announced five lectures, but only one was offered since several factions promptly announced a boycott. In June Breton gave to the magazine *Universidad* a wide-ranging interview in which he spoke of the initiators of Surrealism among visual artists—Picasso, Marcel Duchamp, Giorgio de Chirico, and Vasily Kandinsky—and then said again that Mexico would become "the Surrealist place par excellence: transform the world, Marx said; change life, Rimbaud said: for us, Surrealists, these two watchwords form a unity."[19] After various junkets with Rivera, Frida Kahlo, and Trotsky to historic pre-Columbian sites, Breton began to gather his thoughts for the essay he would publish in *Minotaure* a year later. Mexico, he wrote, imperiously bids us to meditate on the goals of the activities of man, with its "pyramids made of several levels of stone corresponding to very distant cultures which are rediscovered and obscurely penetrated. . . . This power of conciliation of life and death is without doubt the principal allure of Mexico."[20] Since *Minotaure* was one of the most distinguished magazines in the world, read by artists everywhere, Breton's inspired memoir was extremely influential. Moreover, in all his statements about his Mexican sojourn Breton was at pains to speak of the importance of revolution and the originality of the arts of Mexico, which he pointedly attributed to its mixture of races.

Within a few months after publication of Breton's *Minotaure* article the Surrealist exodus began. Because of Mexico's extremely

6. Julio Ruelas. *Criticism (Self-Portrait)*. n.d. Etching, 9 x 6⅝". Instituto Nacional de Bellas Artes, Mexico City

EXPOSICION INTERNACIONAL
DEL SURREALISMO

MEXICO · 1940

7. Cover (with photograph by Manuel Alvarez Bravo) of catalogue for *Exposición internacional del surrealismo*. Mexico City: Galería de Arte Méxicano, 1940

liberal laws of refuge, so important during the Spanish Civil War, and because of their long-standing curiosity, many Surrealists headed for that country. By early 1940 Wolfgang Paalen and his wife, Alice Rahon, as well as the Peruvian painter and writer César Moro, were living in Mexico City, soon to be followed by the poet Benjamin Péret and his wife, the Catalan painter Remedios Varo, Onslow Ford and his wife (Jacqueline Johnson), and the British painter Leonora Carrington. Although Mexican critics are sharply divided in their opinion as to how much the presence of these foreign Surrealists affected Mexican artists, the very least that can be said is that they established an intellectual climate that in many cases modified the artistic styles of their hosts. There had always been a small but vocal minority of poets and painters who were open to European currents, and there had even been early precursors among Mexican painters. An early *modernista*, the Symbolist artist Julio Ruelas had been inspired by the same sources as the Surrealists, and his engravings at the turn of the

century (figure 6) show the influence of Félicien Rops, Arnold Böcklin, and Max Klinger, all of whom had greatly interested Surrealist poets and painters during the 1920s. In addition, some of the Mexican poets of the 1920s were familiar with *Les chants de Maldoror*, which, they did not fail to note, was written by a poet born and educated for his first thirteen years in Uruguay.

The influx of the unusually active refugees initiated many events, the most significant being the 1940 *Exposición internacional del surrealismo* (figure 7). Although by no means an exclusively Surrealist event—there was a separate section for "painters of Mexico" that included artist friends of the organizers, or artists whom Breton had met under Rivera's patronage—the message was that somehow Surrealism could rally practitioners of many styles. Proof of it was that Picasso, whom Breton had always said was beyond category, was one of the international exhibitors, together with Rivera and Kahlo (both of whom Breton had featured in *Mexique*, his 1939 exhibition in Paris, together with the photographer Manuel Alvarez Bravo and the satirical engraver José Guadalupe Posada). Unquestionably the organizers—Breton from Paris, and César Moro and Wolfgang Paalen in Mexico City—meant to throw a wide net. The atmosphere of excitement the Surrealists were always good at generating caught up many, and as Hayden Herrera notes, Frida Kahlo said in a letter that everyone in Mexico was becoming a Surrealist just to be included in the exhibition.[21] Kahlo herself, Herrera points out, despite her frequent disclaimers of Surrealist influence, produced the only large-scale canvases she ever made—*Las dos Fridas* [*The Two Fridas*] of 1939 (plate 90) and *The Wounded Table* of 1940 (figure 8)—and worked on them "with special urgency partly because she wanted them to be ready for the show."[22]

Certainly the Mexican section included artists far from Surrealist tendencies. There was the Guatemalan Carlos Mérida, who had come to Mexico in 1919, had been Rivera's assistant in 1921, and had evolved a quasi-abstract mode of painting influenced by his European encounters with such figures as Joan Miró and Picasso. Mérida's occasional sorties into a kind of folk humor, in which stylized, squat figures disport themselves against blue skies, could not easily be identified as Surrealist. Nor could the miniaturist Antonio M. Ruiz, whose whimsical paintings occasionally heightened by fantasy and caricature very much pleased Rivera. Then there was Agustín Lazo, whose earlier montages were certainly derived from Surrealism but whose paintings by 1940 were at most dreamlike—a quality that is not exclusive to Surrealism. Guillermo Meza, an artist of Indian origin who was interested in Mexican myths and legends, was working at the time he met the art dealer Inés Amor and Rivera (just before the Surrealist show) in a style that seems more related to that of Julio Ruelas than to contemporary Surrealism.

Nevertheless, the explicit presence of Surrealism in Mexico did have its effect. The work of María Izquierdo, whom Artaud had singled out to present in Paris, was reconsidered in the Surrealist light he had cast upon her; he found that her pure Tarascan origins peered through the hot reds of her paintings and that a mysterious world of magic naturalism, derived from ancient ruins, illuminated her work. He did note, however, that she had been somewhat contaminated by broad exposure to European art. Her paintings of the period after her visits to New York in 1930 and Paris in 1937 certainly attest to a strong interest in one of the princes of Surrealism, Giorgio de Chirico.

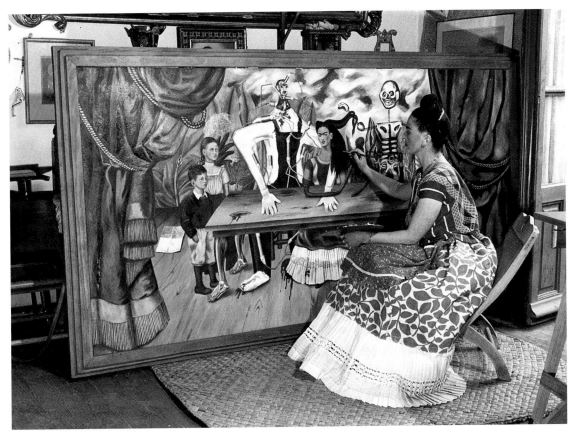

8. Frida Kahlo painting *The Wounded Table*. 1940. Oil on canvas, 47⅝" x 8' ½". Present whereabouts unknown

Her companion during the early 1930s, Rufino Tamayo, also gained from the general interest in Surrealism. Although Tamayo's work clearly derives from his specific interest in pre-Columbian art and modern folk traditions, it was injected during the early 1940s with a note of metaphysical terror and an undertone of violence that made it possible for Surrealist theorists to find affinities. Paul Westheim, the distinguished German refugee who had once been active in avant-garde circles in Europe, wrote that in Tamayo's work, "Death lurks in the background, casting a deep shade over every being and every event—the same way that in the Aztec concept of Coatlicue, known in Mexico through the monumental stone sculpture unearthed in Mexico City in 1790, the horrifying and sublime Earth Goddess, birth and death, and the beginning and end of all earthly beings are linked together."[23]

Coatlicue was an attraction for more than one Surrealist writer, and the name occurs frequently in Surrealist commentaries on Mexican art. As Lourdes Andrade has written:

One can see some of the concepts developed by Surrealism illustrated in the monstrous beauty of this Aztec goddess. Firstly, Coatlicue who wears "the serpent skirt" is a resounding example of the "convulsive beauty" that defines surrealist aesthetics. Moreover, Breton refers to "this power of reconciling life and death" as one of the country's major attractions. . . . Constructed in the same way as a surrealist collage, the goddess meets the specifications of the "internal model" that Breton developed. Moreover, the conjunction of the animal elements—jaguar, eagle, serpent—which symbolize

the gods, and human elements—her structure, her setting, the layout of her masses—gives rise to a merging of natural (reality) with supernatural (surreality) which fits in with Breton's thought.[24]

Shock and violence, often associated in the Surrealist mind with Eros, was best illustrated, certainly, in the work of Frida Kahlo, most particularly that of the early 1940s. The two paintings she presented in the 1940 exhibition, *The Two Fridas* and *The Wounded Table*, qualify at least in that respect. Trickling blood in both paintings and the visible signature of Death in *The Wounded Table* amply satisfied the demand created by the Surrealists—often in the name of black humor—for violent juxtaposition and a dialectic of life and death.

The changed locus of Surrealism during World War II offered the possibility of extending research begun long before and focused interests more concertedly toward anthropology and ethnology. Several of the Surrealist faithful in Mexico became deeply absorbed in the study of the pre-Columbian past. Benjamin Péret proved to be a serious researcher whose book of myths and legends of Native Americans appeared in New York in 1943 to wide acclaim. He was also an inspiring friend to several young artists, among them the Mexican painter Gunther Gerszo, whose earliest paintings were wholly Surrealist (figure 9). Wolfgang Paalen, the young protégé of Breton, was also swept up by the passion for knowledge of the peoples of distant horizons and began collecting pre-Columbian art in the early 1940s. He founded *Dyn*, an important journal that first appeared in April 1942. Although the magazine was published in French and English,

9. Gunther Gerszo. *Portrait of Benjamin Péret.* 1944. Oil on linen, 12 x 16". Collection the artist

thereby restricting its thrust into Mexican artistic life, it nonetheless rallied the small foreign Surrealist contingent as well as Manuel Alvarez Bravo, Carlos Mérida, Miguel Covarrubias, and a few other permanent residents who appeared in *Dyn's* pages together with Robert Motherwell, Anaïs Nin, and Matta, thereby extending the Surrealist international tradition. In the first issue Paalen declared his independence of Surrealism in an editorial translated by the young Motherwell, reproaching the Surrealists for their contempt for modern science and their Hegelianism. Together with Matta, Motherwell had spent some months in Mexico in 1941, and carried back strong impressions that he enthusiastically shared with Baziotes, Pollock, and others in New York. The most important publication of *Dyn* was probably the double issue called the *Amerindian*, for which Paalen invited Mexican scholars to write in depth, he himself bringing to their attention the work of the Northwest Coast Native Americans, particularly the Haida.

Even after the war period, Surrealist overtones lingered in Mexico. Cultural life had been considerably enriched by the widespread activities of the Surrealists, whose emphasis on local traditions was important to the new generation. It is true that long before Breton and his friends reveled in the brilliant colors used by peasant artisans, the spectacular landscapes, and the indigenous ability to sustain myth, there were serious Mexican artists well aware of these riches. The work of Frida Kahlo, for instance, was anchored in certain local traditions that she adapted for largely ideological reasons: the imaginative fantasies found on the walls of *pulquerias*;[25] the toys created for the Day of the Dead; the ex-votos with their often gruesome details; and the direct, naive style found in the work of nineteenth-century portraitists such as Hermenegildo Bustos, a provincial painter of rare talent who called himself an amateur. Much of the work by Kahlo and Rivera's friends, such as Antonio Ruiz, was also drawn from indigenous sources that, with the redoubled search for "Mexicanness" that began in the 1920s, were retrieved quite consciously. Still, the coming of the European Surrealists, with their inexhaustible wonder and their elaborate arguments, sparked in these Mexican artists a new sense of their own importance and an increasingly international

outlook. When the great Surrealist filmmaker Luis Buñuel arrived in 1947, the Mexicans were well primed to receive him, and his presence in Mexico City was of great importance to a new generation that was quick to see, even in the commercial films he undertook there, the Surrealist hand of the master.

Fortunately there was a superb writer, Octavio Paz, who emerged around 1950 as Mexico's most eloquent Surrealist voice and whose loyalties to certain Surrealist leitmotifs never flagged. In 1950 he revealed two important aspects of his meditations. In his profound study of Mexico, *The Labyrinth of Solitude*, he sought, as he said, to "recover the consciousness" of a Mexico "which is buried alive. . . . There is in Mexican men and women a universe of buried images, desires and impulses. I attempted a description . . . of the world of repressions, inhibitions, memories, appetites and dreams which Mexico has been and is."[26] This description strongly suggests the impact of Breton's preoccupations. That same year Paz published his oneiric poem "Mariposa de obsidiana" ("Obsidian Butterfly"), based partly on his study of Nahuatl poetry and pre-Columbian artifacts, and a year later *¿Aguila o sol? (Eagle or Sun?)*, a group of poems overtly based on the Indian heritage of Mexico and fueled by the Surrealist desire to bring dream and reality forward simultaneously in a language of startling contrasts.[27] It was also in 1950 that Paz published the initial study of one of Mexico's greatest and most puzzling early poets, the seventeenth-century nun Sor Juana Inés de la Cruz, which would later be the basis for a brilliant full-length study.[28] Certainly it was the Surrealist in Paz who was attracted to Sor Juana, who reflected the long Spanish preoccupation with the dream. Paz wrote, "Not even in sleep was she liberated," and quoted her, "'from this continuous movement of my imagination; rather it is wont to work more freely, less encumbered in my sleep . . . arguing and making verses that would fill a very large catalogue!'"[29] Paz insisted, "Dreaming is knowing," and spoke of Sor Juana's *Primero sueño (First Dream)* as "a poem about nocturnal astonishment."[30] He also stressed her unusual use of local dialects—the first in New World literature—and, from the Surrealists' point of view, stated that this predilection for languages and native dialects "does not so much reveal hypothetical divination of future nationalism as a lively consciousness of the universality of the empire: Indians, Creoles, mulattoes, and Spaniards form one whole."[31] Not only did Paz probe the distant, hidden sources of contemporary Mexican life, but he also wrote frequently on its quotidian artistic products. His art criticism appeared after 1950, not only in journals and newspapers but in his own poems, often addressed to the work of stellar Surrealist painters, including Matta and Miró. Together with a small circle of kindred spirits among writers, Paz created a receptive climate for the works of the new generation that drew upon Surrealist sources as well as others.

After 1950 Mexico was far more open to heterogeneous influences, but there were still artists, such as Francisco Toledo, who were touched by the Surrealist legacy. Toledo, who like Tamayo is of Zapotec origin, was a precocious independent. By the time he was twenty, he was in Paris, where he would remain for five years; there he studied for a period in Stanley William Hayter's engraving workshop. In Paris those invisible filiations of surprising international import played their role. Hayter was an early convert to the practical use of automatism to release images, and during the 1930s, together with such artists as Miró and Matta, he developed a distinctive

abstract style in prints that gave full rein to the prized Surrealist qualities of accident and free association. Toledo armed himself with a broad knowledge of modern European masters, among them Paul Klee, Kandinsky, and Marc Chagall, and to that added knowledge of his own artistic background, drawn from both the pre-Columbian and folk-art traditions of his native Oaxaca. Once back in Mexico he followed an independent course that is not orthodox Surrealist yet is informed by such Surrealist ideas as the natural metamorphosis of animals and humans. As the Mexican critic Salvador Elizondo has written, his works are the record of things and beings at a given moment, outside the laws of nature, and more like "instant dreams" than myths.[32]

—

"Our America," wrote the Cuban novelist and critic Edmundo Desnoes, "is a vast battleground . . . our Tower of Babel is filled with language or images."[33] On that battleground many aesthetic and philosophical conflicts have erupted, not the least of them inspired by Surrealism. The movement can be seen as part of the larger tradition of twentieth-century modernism, indebted as much to Picasso as to Duchamp. The search, for example, for the popular or vernacular expression of peoples was as important to Picasso, who used to go with the photographer Brassaï seeking arresting shop signs and graffiti, as it was to Breton. And of course it carried political implica-

tions whether in the Old World or the New. As part of the general modernist tradition, Surrealism functioned on many levels and was, from its practitioners' point of view, a revolutionary philosophy—a poetics of life rather than of style. Surrealist artists and writers were filled with fervor, and sought in their collective activities to convert the world. The evangelical aspect of Surrealism is epitomized in the activity of an artist such as Matta, whom the Argentine critic Saúl Yurkievich called "the itinerant one, the prolific one by antonomasia," whom some see as a painter of the grandiose and anguishing nature of South America but who is, in effect, an international painter who happens to have been born in Chile.[34] The same can be said of any number of Latin Americans after 1950, who, though well aware of their own heritage, felt free to draw upon any associations formed in imagination through their encounters with the entire world—whether drawn from the paradoxes of Duchamp, or the poetry of flight of the Chilean experimentalist Vincente Huidobro, or the international lexicons published by such art festivals as Documenta. Those who, like Hélio Oiticica and his heir, the young Brazilian Tunga, or the Cuban José Bedia, are drawn to the strong savor of the indigenous culture of their native countries nonetheless bring to their work a Western philosophic perspective introduced into Latin America by the Surrealists. The vast battlefield of aesthetics and political and stylistic ideologies that is Latin America has gained immeasurably from the active presence of the Surrealist internationalist confraternity.

Notes

1. Pablo Neruda, *Memoirs*, trans. Hardie St. Martin (New York: Farrar, Straus & Giroux, 1978), p. 64.

2. André Breton, "Preface,"*Yves Tanguy et objets d'Amérique* (Paris: Galerie Surréaliste, 1927).

3. André Breton, "Manifesto of Surrealism," in *Manifestoes of Surrealism*, trans. Richard Seaver and Helen R. Lane (Ann Arbor: University of Michigan Press, 1972), p. 26.

4. Octavio Paz, *On Poets and Others*, trans. Michael Schmidt (New York: Seaver Books, 1986), p. 72.

5. André Breton, "Surrealism: Yesterday, To-Day and To-Morrow," trans. E[dward] W. T[itus], *This Quarter* 5 (September 1932), p. 44.

6. Antonin Artaud, "Man against Destiny," in Susan Sontag, ed., *Antonin Artaud: Selected Writings*, trans. Helen Weaver (New York: Farrar, Straus & Giroux, 1976), pp. 358–59.

7. Antonin Artaud, "What I Came to Mexico to Do," in ibid., p. 372.

8. Cited in C. B. Morris, *Surrealism and Spain, 1920–1936* (Cambridge: Cambridge University Press, 1972), p. 50.

9. Cited in Susan M. Anderson, *Pursuit of the Marvelous: Stanley William Hayter, Charles Howard, Gordon Onslow Ford* (Laguna Beach: Laguna Art Museum, 1990), p. 38.

10. André Breton, "The Most Recent Tendencies in Surrealist Painting," in *Surrealism and Painting*, trans. Simon Watson Taylor (New York: Harper & Row, 1972), p. 146.

11. Ibid., p. 148.

12. Gordon Onslow Ford, *Creation* (Basel: Galerie Schreiner, 1978), p. 54.

13. Matta, "Hellucinations," in Max Ernst, *Beyond Painting and Other Writings by the Artist and His Friends* (New York: Wittenborn, Schultz, 1948), p. 194.

14. Wifredo Lam, quoted in Dore Ashton, ed., *Twentieth-Century Artists on Art* (New York: Pantheon Books, 1985), p. 118.

15. Quoted in *André Breton: La beauté convulsive* (Paris: Musée National d'Art Moderne, Centre Georges Pompidou, 1991), p. 346.

16. Lam, in Ashton, *Twentieth-Century Artists*, p. 117.

17. Aimé Césaire, "Wifredo Lam," *Cahiers d'Art* (1945–46), p. 357.

18. *André Breton: La beauté convulsive*, p. 237.

19. Ibid., p. 239.

20. André Breton, "Souvenir de Mexique," *Minotaure* 12/13 (May 1939), p. 32.

21. Hayden Herrera, *Frida: A Biography of Frida Kahlo* (New York: Harper & Row, 1983), p. 256.

22. Ibid.

23. Paul Westheim, "El arte de Tamayo: Una investigación estetica," *Artes de México* 4 (May–June 1956), p. 17.

24. Lourdes Andrade, "Love and Desillusion [sic]: The Relations Between Mexico and Surrealism," in *El surrealismo entre viejo y nuevo mundo* (Las Palmas de Gran Canaria: Centro Atlántico de Arte Moderno, 1989), p. 331.

25. *Pulquerías* are bars that serve pulque, a beverage made from fermented maguey.

26. Octavio Paz, quoted in the foreword to his *On Poets and Others*, trans. Michael Schmidt (New York: Seaver Books, 1986), pp. ix–x.

27. For an English translation of these poems, see *Obsidian Butterfly*, trans. Eliot Weinberger (Barcelona: Ediciones Polígrafa, 1983); and *Eagle or Sun?*, trans. Eliot Weinberger (New York: New Directions, 1976).

28. The English edition of this work is Octavio Paz, *Sor Juana or the Traps of Faith*, trans. Margaret Sayers Peden (Cambridge: The Belknap Press of Harvard University, 1988).

29. Octavio Paz, "Sor Juana Inés de la Cruz," in *The Siren and the Seashell, and Other Essays on Poets and Poetry*, trans. Lysander Kemp and Margaret Sayers Peden (Austin and London: University of Texas Press, 1975), p. 12.

30. Ibid., pp. 12–13.

31. Ibid., p. 9.

32. Salvador Elizondo, *Francisco Toledo Etchings: Aguafuertes* (New York: Martha Jackson Gallery, 1975), n.p.

33. Edmundo Desnoes, "La utilización social del objeto de arte," in Damián Bayón, ed., *América Latina en sus artes* (Paris: UNESCO, 1974), p. 189.

34. Saúl Yurkievich, "El arte de una sociedad en transformación," in Bayón, *América Latina*, p. 185.

MARÍA IZQUIERDO

Elizabeth Ferrer

María Izquierdo began her career as a painter in the late 1920s, a time when Mexican artists were reinvigorating the cultural life of their nation. Earlier that decade, in concert with the government, they had launched the Mexican Mural Movement, aimed at a broadly enhanced appreciation of historical and cultural legacies in the aftermath of the nation's Revolution. Despite the inclusionary ethic reflected in their far-reaching mandate—to work collectively, to recognize the value of indigenous culture, and to strive to create nothing less than a new order in Mexican society[1]—the muralists soon assumed a hegemonic role in Mexico's art world and excluded women almost entirely from their enterprise. Many women artists shared the muralists' commitment to social issues, to the exploration of popular culture, and to the formulation of a nationalistic mode of expression independent of the then-moribund academic traditions that had guided Mexican art in the preceding century. Yet they had few opportunities to participate in the large-scale public projects that were central to the initial phase of the Mexican school.[2] Like Frida Kahlo and Olga Costa,[3] María Izquierdo necessarily defined her position as an artist in response to the particular conditions she experienced as a female in a male-dominated culture, as a painter who lacked the public mural commissions that typically led to international prestige, and as an artist uninterested in social realism and propagandistic art. Working on the smaller, more intimate scale of easel painting, she avoided overtly political themes and concentrated instead on communicating individual concerns and psychological states. Because she was not a member of a movement with articulated goals, she developed idiosyncratically, creating a highly personal visual language.

Although Izquierdo has long been recognized as an important figure within twentieth-century Mexican art, she is not well known internationally, and in her own country the full significance of her oeuvre has been reassessed only recently.[4] Today she is respected for her artistic and social independence and for the authentic, emotional manner in which her work evokes Mexican traditions while reflecting an enthusiasm for trends in modern European art. Clearly ambitious and self-reliant, Izquierdo made rapid strides in developing her art with minimal formal training and limited exposure to original works of modern art. Once she committed herself to being a painter, she worked with a high degree of professionalism. As early as 1932 she was teaching art at the Departamento de Bellas Artes de la Secretaría de Educación in Mexico City. She continued in this position until 1937 and in the following year commenced a period of teaching at the Centro Productor de Artes Plásticas del Departamento de Bellas Artes. From early 1942 to mid-1943, she served as an art critic for the newspaper *Hoy*. Izquierdo was the first Mexican woman to have a one-person exhibition in New York, at The Art Center in 1930, and in the same year she exhibited in *Mexican Arts* at The Metropolitan Museum of Art. Thereafter, her work appeared with greater frequency in public institutions and private galleries in Mexico and to a lesser extent in the United States. She demonstrated a keen sense of social activism through her membership in the Liga de Escritores y Artistas Revolucionarios (LEAR), a leftist intellectual group, and through her organization of auctions in support of social and political causes. Consistently advocating the advancement of women, she spoke publicly and also organized an exhibition of posters with revolutionary themes by women artists.[5] Despite her achievements,

Izquierdo's career as an artist was not without struggle; even in 1945, when her career was well established, Diego Rivera and David Alfaro Siqueiros blocked a mural commission she had received by criticizing her lack of technical expertise.[6]

—

Izquierdo's early life was circumscribed by tradition. She was born in 1902 in the small town of San Juan de los Lagos in the state of Jalisco. Her father died in 1907; and because her mother worked she was cared for primarily by her grandparents and an aunt in an austere, middle-class household. At age fourteen she was married to an army colonel, eventually bearing three children. Her early years, despite their tedium and provinciality, had an important impact on her art. Based on memories of the traditions she knew as a child, Izquierdo's oeuvre abounds with still lifes, village scenes, portraits of peasant women, and images of small domestic altars. The annual fair held in San Juan—the most exciting event of the year—is reflected in her rich use of color and her numerous paintings of horses and the circus.

Izquierdo's life changed dramatically when she moved with her family to Mexico City in 1923. She became involved with the city's bohemian life, separated from her husband, and in 1928 seriously pursued her goal of becoming an artist by enrolling in the Escuela de Artes Plásticas (Academia de San Carlos). Before she left the school a year later, owing to dissatisfaction with its conservatism, she gained the attention of Diego Rivera, who was engaged in his brief tenure as the school's director. Rivera praised her work above all others during a 1929 exhibition of student work.[7] Thanks to Rivera, she had her first one-person exhibition later that year in Mexico City, at the Galería de Arte Moderno del Teatro Nacional. At this state-sponsored institution, which was then directed by Carlos Mérida and was later to become the Palacio de Bellas Artes, the work of other young artists, such as Rufino Tamayo, was often featured. Izquierdo had also met Tamayo while at the academy, where he was an instructor, and they soon moved in together, sharing a studio from 1929 to 1933. He had an undeniable formative influence on Izquierdo's career.[8] Young, but more worldly than she, he had a keen interest in modernism and had just spent more than a year in New York. Artistically, the two painters held several ideals in common. Each rejected academicism and embraced stylistic freedom. Both reflected a love for their culture in their work, but neither was drawn to the social realism common among the muralists. They essayed similar themes, concentrating on such subjects as still lifes and ordinary people. Tamayo augmented Izquierdo's practical skills, teaching her how to use watercolor, a medium she favored in the 1930s. Stylistically, she moved away from depicting figures in the stiffly wooden manner seen in *Portrait of Belem* of 1928 (figure 1), an ambitious early work. As her modeling and brushwork became more assured, Tamayo's volumetric realization of forms and expressive textures, displayed in works such as his *Woman in Grey* of 1931 (figure 2), found their way into Izquierdo's painting.

Tamayo's impact on Izquierdo's development should not obfuscate her innate strengths. She was a colorist par excellence, as is evident even in her earliest works. She also had an evocative manner of depicting objects, a quality that, while present in her early art, would not become fully manifest until the late 1930s, when she

painted numerous still lifes. In addition, many of the themes that subsequently characterized her work were present well before she met Tamayo. Finally, it appears that Tamayo's primitivist mode of simplifying forms, arrived at circuitously through his studies of pre-Columbian and modern art, was an approach that appealed to Izquierdo intuitively, as the intentionally naive style that she employed throughout her career demonstrates.

Izquierdo's introduction of new themes in her art in 1932 signaled her growing artistic maturity and independence, which she maintained throughout her involvement with Tamayo. Recalling some of her happiest childhood memories, she began depicting scenes of the circus. She also created a series of Nocturnes, mysterious allegorical compositions that feature nude women inhabiting cosmic spaces and crude landscapes littered with broken or fallen columns.[9] Although the two types of work initially appear to reflect contradictory impulses, in conjunction they suggest Izquierdo's complex outlook on life, which simultaneously encompassed joy and

1. María Izquierdo. *Portrait of Belem*. 1928. Oil on canvas, 59⅞ x 37". Collection Andrés Blaisten, Mexico City

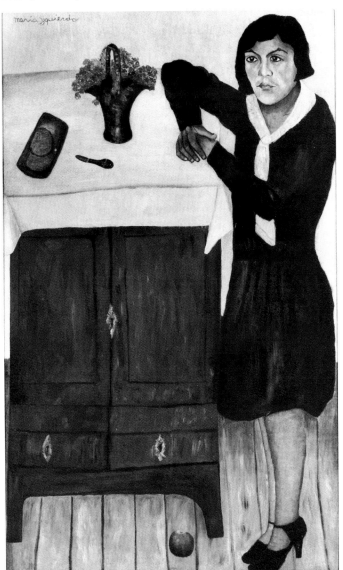

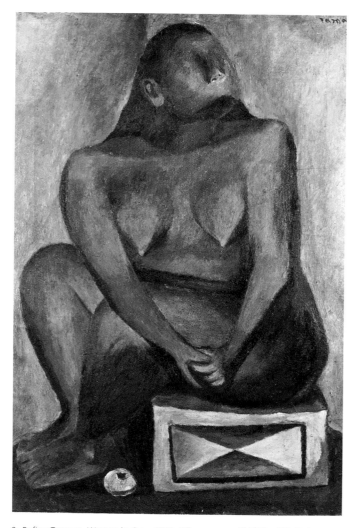

2. Rufino Tamayo. *Woman in Grey.* 1931. Oil on canvas, 7' 2½" x 64". CNCA-INBA, Museo de Arte Moderno, Mexico City

melancholy. For example, despite the humor and vibrant colors of the circus scenes, they are rarely celebratory; rather, they possess an insistent, brooding undercurrent. Because Izquierdo never portrayed an audience in these works, her performers carry out their activities in eerie isolation, oblivious to the world outside, underscoring the futility of their pursuits. In the allegories the figures maintain a despondent air, echoing the desolate, often broken quality of the environments they inhabit. Yet they also exhibit a stubborn will to survive. *Saturn* of 1936 (figure 3) depicts a group of struggling nude women pleading for freedom against an overwhelming natural force. Beyond revealing her own temperament in these series, Izquierdo was also responding to the fragile condition of civilization during the period in which she created these paintings. Together these works portray a world in retreat from reality (the Circus series) and humanity in a state of chaos, ungoverned by social structures (the Nocturnes).

In 1936 the French playwright and poet Antonin Artaud spent approximately eight months in Mexico, seeking psychic renewal and spiritual enlightenment. After seeing Izquierdo's work in Mexico City, he declared her a revelation: "All of the paintings of María Izquierdo are developed around this color of cold lava, in this shadow of a volcano. And that is what gives them their disquieting character, unique

among all the paintings of Mexico—they carry the spark of a world in formation."[10] It is unsurprising that Artaud was drawn to Izquierdo. Disdaining European society, he had come to Mexico in order to connect with a culture that believed in the supernatural and that maintained a holistic relationship with nature, or, as he later expressed it, "to make contact with the Red Earth."[11] Izquierdo's allegories of the 1930s not only have a magical quality, but they consistently depict humanity in confrontation with natural forces. Moreover, their landscapes are suffused with red, suggesting a raw, primal world. Artaud actively promoted Izquierdo's work, writing about it for the French and Mexican press.[12] After returning to Paris he arranged in 1937 for an exhibition of her recent gouaches at Galerie Van den Berg in Montparnasse. Most important, at a time when the muralists dominated the Mexican art world and Izquierdo's work continued to display Tamayo's influence, Artaud's support reinforced Izquierdo's confidence and her independent position, which was important for her development as a mature artist.

By the early 1940s Izquierdo had entered a new stage in her life. In 1938 she had begun a relationship with Raúl Uribe, a Chilean artist whom she married in 1944. She also began exploring other themes; in addition to a new series of circus scenes, she depicted Christian themes and executed many portraits, primarily of women. Izquierdo endowed the subjects of her portraits with a commanding presence. With their round heads, wide-set almond-shaped eyes, arched eyebrows, and full sensuous lips, they were cast, whether consciously or not, in her own image. Frequently Izquierdo depicted mothers holding infants and wearing simple shawls, thereby transforming archetypal Mexican women into madonnas, at once solidly connected with the earth and revealing transcendent qualities. This vision of Mexican spirituality extends to her several paintings of the Mater Dolorosa in the 1940s. In works such as *Altar of Sorrows* of 1943 (figure 4) Izquierdo explicitly expresses the fundamental spiritual nature of Mexico's popular culture, depicting the Virgin as a prominent and integral part of an arrangement of Mexican toys, fruit, the intricate paper cutouts known as *papeles picados*, and other common traditional objects.

3. María Izquierdo. *Saturn.* 1936. Watercolor on paper, 8¼ x 6⅝". Collection Andrés Blaisten, Mexico City

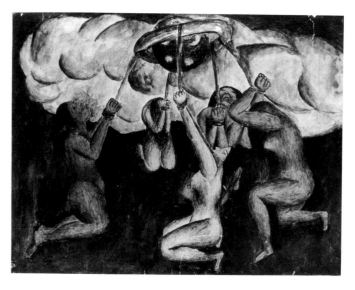

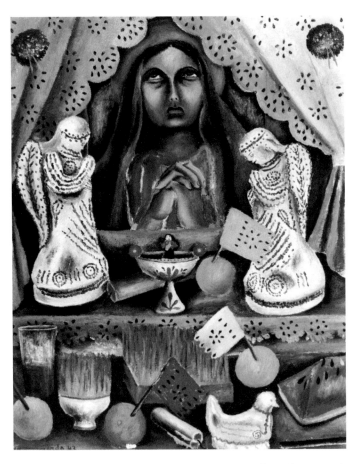

4. María Izquierdo. *Altar of Sorrows.* 1943. Oil on cardboard, 23¾ x 19⅝". Galería de Arte Méxicano, Mexico City

Izquierdo's naive mode of painting and her frequent portrayal of folkloric subject matter have caused many critics to overlook the sophisticated manner in which she could draw on European modernism, particularly in the 1940s and 1950s. Consistently, she incorporated this influence in a way that allowed her to express the concerns of her culture. In *Cupboard* of 1947 (Collection Françoise Reynaud de Vélez, Mexico City)—one of Izquierdo's numerous still lifes of this period—she depicted a series of objects arranged in a cupboard, exaggerating the perspective of the shelves to transform it into a deep architectural space. She also turned the cupboard's frame into a trompe l'oeil frame for the painting itself, playing games of scale and reality that juxtapose "real" objects, such as fruit or a painted ceramic bull, with objects of an uncertain status, such as a curiously diminutive wedge of watermelon displayed in one corner, or a small galloping horse in another. Izquierdo's composition is indebted to a genre popular in nineteenth-century Mexico: painted open cupboards (*alacenas*) displaying many objects, like miniature dioramas. However, the devices used in this painting reveal her engagement with the ideas of such Surrealist painters as Giorgio de Chirico and René Magritte. Borrowing elements from the European artists' styles, she endowed the objects in *Cupboard* with a sense of mystery, resonant with her childhood memories of traditional Mexico. This was a world that was being rapidly transformed by modernization, particularly in Mexico City, where Izquierdo lived.

Izquierdo exhibited a growing affinity with Surrealist tenden-

cies in the series of paintings she created from the 1940s until nearly the end of her life. In these works, such as *Living Nature* of 1946 (figure 5), still lifes merge with melancholic landscapes. In the picture's immediate foreground are ripe, sensuously modeled fruits and a conch shell; these objects appear disproportionately large because the landscape behind them is so deep, a quality heightened by the long wall receding into the distance on the right. The vista of empty space, completely devoid of humans, is reminiscent of the metaphysical landscapes of de Chirico and of the compositions of such Surrealists as Salvador Dali, Kay Sage, and Yves Tanguy.

For this series of works, Izquierdo began employing the term *naturaleza viva* (living nature), as opposed to *naturaleza muerta*, the Spanish for still life (literally, dead nature).[13] Yet these paintings are not simple celebrations of life. With their contrasts of vibrant tableaux and barren, somber landscapes, they express the dualities of life and death, joy and sorrow. The term *naturaleza viva*, however, does not contradict the content of these works but alludes to the manner in which inanimate objects are charged with meaning, cast as symbols of spirituality, the cycle of life and death, and psychological states of being. *Naturaleza viva* also has an ironic connotation, as these paintings appear to allude to society's spiritual bereavement at the time of their making, shortly after the conclusion of World War II.

▬

It is difficult to ascertain the degree to which Izquierdo was truly indebted to Surrealism. Some of its key tenets and pictorial themes— the use of chance and automatic drawing in creating art, the style of biomorphic abstraction, and the creation of seemingly hallucinatory imagery—are conspicuously absent from her work. Nevertheless, the cryptic still lifes and oneiric landscapes she created in the middle and later parts of her career have parallels in Surrealist concepts and, at the very least, share in the movement's spirit. Arising precisely during Izquierdo's formative years as an artist, Surrealism was likely an important stimulus to her work. Indeed, in its absence there would have been a much more limited artistic and philosophical context for

5. María Izquierdo. *Living Nature.* 1946. Oil on canvas, 17¾ x 21⅝". Collection Mrs. Alejandra R. de Yturbe, Miss Mariana Pérez Amor, Monterrey

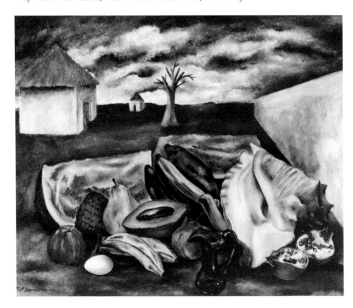

6. María Izquierdo. *Dream and Premonition*. 1947. Oil on canvas, 17¾ x 23½". Collection Ma. Esthela E. de Santos, Monterrey

the analysis and appreciation of her work, especially since her career coincided with the flourishing of the all-dominant Mexican school. Ultimately, the actual significance of Surrealism to Izquierdo is ambiguous; so-called surrealist qualities in her art can be ascribed with equal plausibility to her fertile imagination, as well as to such Mexican influences as pre-Columbian art, folk art, *retablos* (small narrative paintings, usually on tin, created as votive offerings), the *calaveras* of the turn-of-the-century engraver José Guadalupe Posada, and even those general aspects of everyday life in Mexico that had been so much a part of the artist's environment in childhood. Despite Artaud's involvement with Surrealism, Izquierdo's encounter with him was only incidental to her connection with the movement, for by the time of their meeting in 1936 Artaud had long broken with André Breton. In fact, her association with Artaud may have been a reason for her exclusion from the major Surrealist exhibition organized in part by Breton and presented in Mexico in 1940.[14] Moreover, despite the fact that many of the Surrealists who had fled Europe during the Spanish Civil War and World War II found refuge in Mexico, they had little interaction with the artistic community there, Izquierdo included.

In 1947 María Izquierdo painted *Dream and Premonition* (figure 6), a remarkable self-portrait. In it the artist is seen standing at the window of a building, holding her own severed head in her right hand. Tears from her truncated head become parts of a flower as they fall, along with bits of hair, into a trough below; longer strands of hair are entangled in the branches of trees that emerge inexplica-

bly out of another window. In the foreground are tree stumps and three small hills bearing crosses, an allusion to Calvary. Several decapitated figures are fleeing into the background, their heads hanging from branches above. Beyond a small number of self-portraits, Izquierdo's oeuvre contains few overtly autobiographical works. Here, however, she constructs a visionary image of her life as she uncannily prefigures her impending medical crises. Only months after completing this work she was to suffer the first of three strokes that left her paralyzed on her right side. While convalescing, Izquierdo trained herself to paint with her left hand, completing several canvases prior to her death in 1955. She returned to old themes—horses in the countryside, the circus, still lifes, and portraits, executed at times with a firm hand, in other instances in a crude style reminiscent of her earliest works but now indicative of physical limitations. Although some of these images have a plaintive quality, none conveys the feeling of hopelessness expressed in *Dream and Premonition*.

One unusual work, in fact, suggests that Izquierdo finally achieved a sense of redemption in her life, despite failing health and the dissolution of her marriage in 1953. *Toward Paradise* of 1954 (figure 7) depicts a blaze of fire set against an empty landscape; suspended in the sky above is a surreal interior inhabited by two figures, perhaps symbolizing her belief in the existence of an afterlife. In one image, then, Izquierdo created a hopeful symbol of life, death, and renewal, and ultimately a Promethean vision of spiritual purification through a fire born of red, primeval earth.

7. María Izquierdo. *Toward Paradise*. 1954. Oil on canvas, 35⅜ x 27½". Collection Mr. and Mrs. José Akle

Notes

1. "The Manifesto of the Union of Mexican Workers, Technicians, Painters, and Sculptors" is reprinted in Dawn Ades, ed., *Art in Latin America: The Modern Era, 1820–1980* (New Haven: Yale University Press; London: Hayward Gallery, 1989), pp. 323–24.

2. This is not to say that no women artists created murals in Mexico. The sisters Marion and Grace Greenwood from the United States helped to paint murals for the Mercado Abelardo Rodríguez, a public market in Mexico City, in 1935; Lucienne Bloch, also from the United States, assisted Diego Rivera with murals in Detroit and New York and went on to produce her own murals; and Aurora Reyes, a Mexican, painted a mural for the Centro Escolar Revolución in Coyoacán (now a part of Mexico City) in 1936. Needless to say, none of these women achieved the prominence of their male counterparts.

3. To the list of early modern women artists of Mexico who shared the working conditions under discussion, the photographer Lola Alvarez Bravo, born in 1907, should be added as a key figure of her generation.

4. Izquierdo was the subject of a major retrospective at the Centro Cultural Arte Contemporáneo, Mexico City, in 1988. The catalogue published on the occasion of this exhibition presents new research on the artist's life and work. See Lourdes Andrade et al., *Maria Izquierdo* (Mexico City: Centro Cultural Arte Contemporáneo, 1988).

5. Izquierdo directed the exhibition *Carteles revolucionarios de las pintoras del sector femenino de la sección de artes plásticas, Departamento de Bellas Artes* under the auspices of the Partido Nacional Revolucionario. It opened at the Dirección General de Educación del Estado in Guadalajara in May 1935 and then traveled throughout Mexico.

6. Izquierdo was commissioned to create a fresco of approximately 155 square meters on the themes of the arts and progress in Mexico City for the monumental stairway of the Palacio del Departamento del Distrito Federal. Very shortly before she was to begin work in February 1945, the project was temporarily halted by the building's engineer on the pretense that it presented unsafe working conditions. In October of that year, it was definitively canceled by a review committee that included Rivera and Siqueiros, which noted that she lacked the experience necessary for such an ambitious project. Although Izquierdo was offered an alternative project, she refused it and was embittered by the experience. To prove her ability to carry out the project denied her, she realized as portable frescoes two of the cartoons she had created in preparation for the mural. The cartoons and other studies have been preserved, primarily in the collection of the artist's daughter, Aurora Posadas Izquierdo de López. The entire incident was widely reported by the Mexican press. See Sylvia Navarrete, "María Izquierdo," in Andrade, *María Izquierdo*, pp. 92–93.

7. Margarita Nelken, who was a witness to the event, reports that Rivera, upon seeing Izquierdo's work in the exhibition, proclaimed: "Esto es lo único" (This is the only one). Other artists in the exhibition, some with more training than Izquierdo, were outraged by his judgment. See Olivier Debroise, "María Izquierdo," in Andrade, *María Izquierdo*, p. 28.

8. The issue of the degree to which Izquierdo influenced Tamayo also merits careful study but is outside the scope of this essay.

9. If, as has been suggested, the allegories symbolize the anguish she experienced as a result of her breakup with Tamayo in 1933, it should be noted that a despondent air marked her work well before the relationship's end. In few of her portraits from the late 1920s and early 1930s do any of her subjects smile or convey optimism. Instead, they gaze at the spectator with a solemn expectancy. In one nude of 1930, the seated female figure cradles her head in her arms as if undergoing some unbearable psychic pain.

10. "Toda la pintura de María Izquierdo se desarolla en este color de lava fría, en esta penumbran de volcán. Y esto es la lo que le da su carácter inquietante, único entre todas las pinturas de México: lleva el destello de un mundo de formación."—Antonin Artaud, "La pintura de María Izquierdo," *Revista de revistas* (Mexico City), August 23, 1936, n.p.

11. The quotation is from Helen Weaver's translation of Artaud's poem "La culture Indienne" in Susan Sontag, ed., *Antonin Artaud: Selected Writings* (New York: Farrar, Straus, & Giroux, 1976), p. 537.

12. Articles by Antonin Artaud on María Izquierdo include "Le Mexique et l'esprit primitif," *L'Amour de l'art* 8 (October 1937), reprinted in translation as "México y el espíritu primitivo," *El Universal* (Mexico City), March 13, 1938; "La pintura de María Izquierdo," *Revista de revistas* (Mexico City), August 23, 1936, n.p.; and "Mexico y el espíritu femenino: María Izquierdo," *Revista de la Universidad de México* 22/6 (February 1968), pp. 2, 4. For further information see Andrade, *María Izquierdo*, pp. 384–96.

13. In 1952 Frida Kahlo titled one of her still lifes *Naturaleza viva*. The still life was an important genre for Kahlo, too, in her later career, and it is unknown whether she borrowed this term from Izquierdo or arrived at it independently.

14. The other organizers of the exhibition, which included work by Mexican and European artists, were the painter Wolfgang Paalen and the Peruvian poet César Moro. The *Exposición internacional del surrealismo* was presented at the Galería de Arte Méxicano in Mexico City and was the major cultural event of the year.

New Figuration, Pop, and Assemblage in the 1960s and 1970s

Jacqueline Barnitz

By the middle of the twentieth century, abstraction had gained widespread currency in the painting and sculpture of South America. Arriving in Argentina in the 1920s and in Uruguay in the 1930s, it spread in the 1950s throughout Latin America. This was mainly a result of the first São Paulo Bienal in 1951, but it was also part of a more general trend away from social and political themes in art. Abstraction, however, proved unsatisfactory in meeting the particular expressive needs of some artists. They sought alternatives, one of which was a new figurative mode.[1] A revitalization of figurative art also took place in Europe and the United States in the latter half of the twentieth century, and the styles employed have come to be known by a number of names; here the term *neofiguration* will be used. Neofiguration arose in Mexico in the early 1950s as an antidote not so much to abstraction as to nationalistic art, and it appeared in South America in the late 1950s as a rejoinder to geometric and informalist abstraction. Assemblage and Pop soon followed in Latin America as natural outcomes of neofiguration.

To make a clear distinction between neofiguration, assemblage, and Pop proves difficult, since many artists used these forms interchangeably or together in the same work, as did the Argentine Antonio Berni. Furthermore, some artists referred to their installations as "Pop" even though they did not conform to what was meant by Pop in the United States. By the 1970s neofigurative artists had moved away from the use of expressive, sometimes fragmented images to more controlled, objective representations based on photographic or academic models. Given such indeterminacy in our terminology, this essay is organized along the lines of the major characteristics of each decade and each artistic career, rather than exclusively by style or country.

Among the major exponents of neofiguration in the 1960s were José Luis Cuevas in Mexico; Ernesto Deira, Rómulo Macció, Jorge de la Vega, and Luis Felipe Noé (who also created assemblages) in Argentina; and Jacobo Borges in Venezuela. Berni and Alberto Heredia (of Argentina) are also discussed within the framework of neofiguration in the 1960s, despite the fact that their art could just as well fall within the category of assemblage. Marisol is considered in the context of 1960s Latin American assemblage, although she worked exclusively in New York during this period. From the start, the Colombian painter Fernando Botero's type of neofiguration represented a departure from the expressionist configurations so dominant in the 1960s; we therefore situate our discussion of his work within the period of the 1970s. His fellow Colombian Santiago Cárdenas and the Argentine Antonio Seguí are dealt with similarly, for like Botero during this period they sought to eliminate all traces of the artist's hand. Only Cuevas continued to work in a fluid, expressive style through the 1970s.

In its initial phase, neofiguration can be understood in terms of its affiliations with the art of the CoBrA group[2] and with the paintings of Willem de Kooning, Jean Dubuffet, and Francis Bacon. Similarly, assemblage can be located in the context of its international counterparts. The Latin American perception of Pop art, however, requires some clarification. The use of objects taken from the realm of popular culture was common among Argentine artists in the 1960s, but the recontextualization of the objects in artworks radically complicated their meanings. The painter José Antonio Fernández-Muro, for instance, incorporated embossed impressions of manhole

covers, made furtively at night in the streets of New York, into mixed-medium paintings of flags. One example is his canvas *To the Great Argentine Nation* of 1964 (figure 1). A comparison with some of Jasper Johns's paintings of the mid-1950s immediately reveals that whereas Johns's Flags simply present the objects themselves, with little further contextual positioning, Fernández-Muro's paintings of flags are modified by the inclusion of extraneous elements. A manhole cover or a flag might individually be considered a Pop object, but an image of a flag that incorporates an image of a manhole cover no longer has the neutrality associated with Pop. A number of artists working in Buenos Aires in the 1960s, including Marta Minujín, Carlos Squirri, Dalila Puzzovio, Edgardo Giménez, Juan Stoppani, and Susana Salgado, considered themselves Pop artists. But few of them really used mundane, useful objects in their work, employing instead objects loaded with expressive associations. Puzzovio, Berni, and Heredia all incorporated discarded plaster casts, retrieved from local hospitals, in their work. A cast by its very nature eludes a neutral reading, for it refers to the history of its previous use. Similarly, Berni and Heredia used such detritus as bottle caps, rags, and broken dolls—the discards of consumerism.

Many of these "Pop" artists improvised, fashioning found materials into new things. In 1964 Minujín created ten-foot-high spiderlike creatures out of mattress ticking, while Berni made monsters that resembled prehistoric animals from various found materials. This is not to say that some Latin American artists did not approach Pop in a more dispassionate way. For a short period the Venezuelan Alejandro Otero incorporated store-bought objects—saws or shovels, very much in the spirit of Marcel Duchamp's Readymades—into his work, and Santiago Cárdenas approached the language of Pop in his representations of ordinary objects in his paintings of the 1970s. For most, however, Pop meant an art of objects propelled beyond their literal significance.

These unorthodoxies in Latin American Pop art were confirmed by the Argentine art critic Rafael Squirru, who in 1963 pointed out "one characteristic difference between the attitudes of these artists in North and South America. In Latin America there is an extra-aesthetic accent present in the form of social and political commentary. In the United States the accent is on the objects themselves, accepted as part of the artist's real world and to which he wishes to give the magic stamp of art."[3] South American artists thought of "Pop" in terms of the incorporation of locally familiar popular symbols, ranging from rock stars to religious images. Their conception of Pop art was tied to the notion of mass communication through the deployment of the object as accessible sign rather than as an end in itself. With these qualifications in mind, we can begin to explore the work of neofiguration, assemblage, and "Pop" artists active in Latin America during the 1960s and 1970s.

By the late 1950s a renewed figurative tendency among artists of the Western world was sufficiently widespread to prompt Peter Selz to organize the exhibition *New Images of Man* at The Museum of Modern Art, New York, in 1959.[4] Included were works by Karel Appel, Bacon, Leonard Baskin, Dubuffet, Leon Golub, de Kooning, and Rico Lebrun, and even four early 1950s works by Jackson Pollock, in which a residual human presence could be perceived. No Latin American

artists were included, although by that time Cuevas was already well known. A year later, in part as a response to this omission, Selden Rodman published his book *The Insiders*, in which he cited José Clemente Orozco and Cuevas among the "insiders" along with Grünewald, El Greco, Michelangelo, Francisco Goya, Bacon, Lebrun, and Baskin. Rodman believed that abstract art removed from all historical context was nonsense, and he defended and defined the insider as: "an artist who feels drawn to values outside himself strongly enough to examine them in his work."[5]

In the United States the figurative tendency was overshadowed by other art forms; it did not amount to a trend or movement until

1. José Antonio Fernández-Muro. *To the Great Argentine Nation*. 1964. Mixed mediums on canvas, 69⅛ x 57". Archer M. Huntington Art Gallery, The University of Texas at Austin. Gift of John and Barbara Duncan

much later, and artists working in this mode had to wait until the 1970s for recognition. De Kooning was thought of as an Abstract Expressionist rather than a figurative artist, although he was one of the models for Latin American neofiguration.[6] In Latin America neofiguration coexisted with abstraction but was also separate from it. What united Cuevas, Noé, Deira, de la Vega, Macció, and Borges was that, like the Abstract Expressionists, they were all nurtured on postwar existentialism, embodied in their art by distorted images of anguished, grimacing humanoids. Unlike de Kooning, they rejected total abstraction. Despite apparent similarities between these artists, their distillation of sources and their stated objectives differed considerably, as did the nature of their commitment to the human cause.

José Luis Cuevas and Nueva Presencia in Mexico

In the 1960s Mexican institutions began opening their doors to international art, and a new generation emerged, including Alberto Gironella, Cuevas, and the group of artists known as Nueva Presencia.[7] Gironella, as a member of Mexico City's cooperative Galería Prisse, gave Cuevas an exhibition there in 1953. Cuevas detested the nationalist position of the mural painters. He sought the "broad highways leading out to the rest of the world, rather than narrow trails connecting one adobe village with another."[8] By 1960 he had become much better known internationally, and several other artists in Mexico had taken up the banner of neofiguration.

Between 1961 and 1963 the Nueva Presencia group formed in Mexico City. Arnold Belkin and Francisco Icaza, who served as the group's spokesmen, were joined by other artists such as Francisco Corzas, Rafael Coronel, and the Colombian Leonél Góngora, all of whom subsequently established individual reputations. At first these artists were sympathetic to the muralist David Alfaro Siqueiros, who was at that time incarcerated for having spoken against the Mexican government. Belkin and Icaza even visited him in jail.[9] But soon they felt a generation gap. Siqueiros belonged to a romantic age of heroes and villains, while the new generation had no heroes and perceived the human species to be the victim not of old-fashioned villains but of intangible forces—such as war, violence, and spiritual isolation—over which it has no control.

Significant philosophical differences existed between Cuevas and the Nueva Presencia artists. Cuevas considered himself a mere observer of life around him, while the Nueva Presencia artists in their manifesto called for an "art which does not separate man as an individual from man as an integral part of society. No one, especially the artist, has the right to be indifferent to the social order."[10] Yet all of these artists shared a concern for addressing the problems of spiritual alienation and isolation. Inspired by the writings of Fyodor Dostoyevsky, Franz Kafka, and Albert Camus, they spoke against the "good taste" and elegance of the School of Paris and "art for art's sake." Some of their models, such as Goya and Orozco, were among the artists cited by Rodman in *The Insiders*. The group also shared with Cuevas a preference for graphic mediums as popular vehicles of mass communication, although, unlike him, some continued to paint in oil. Unlike artists in Argentina, whose models were primarily modern, Cuevas and the Nueva Presencia artists shared an interest in the art of the recent and more distant past. In addition to Goya, Orozco, and the satirical broadside printer Posada, they studied artists of the seventeenth century, particularly Velázquez and Rembrandt. Coronel, Gironella, and Cuevas borrowed from Velázquez. The nervous and fine lines of Rembrandt's etchings can be detected in the work of Cuevas and Góngora, and his self-portraits served as models for some of Corzas's, Góngora's, and Cuevas's male figures.

Cuevas and the Nueva Presencia artists differed in the degree of their reformist aspirations. The Nueva Presencia artists saw themselves as reformers, focusing on generic apocalyptic scenes that alluded, sometimes through biblical metaphors, to mass destruction and the ravages wrought by violence and war. Cuevas, on the other hand, was fascinated by death and decay. Posada's and Orozco's representations of monstrous, deformed creatures, degraded humanity, and prostitutes were of particular thematic interest to Cuevas, and he

2. José Luis Cuevas. *Cadaver*. 1953. Pen and ink and wash on paper. Private collection

based many of his pen-and-ink and his wash drawings on these subjects. He was motivated as an "observer, not as a reformer"[11] by his interest in a world populated by prostitutes, the insane, and humans in various stages of decomposition (figure 2).

Since early childhood Cuevas had preferred to work on paper, a fact he attributed to having been born over a paper mill.[12] In the middle of the 1950s, much of his work focused on inmates from an insane asylum, to which he had gained access through his brother, a psychiatrist. For Cuevas, these drawings, often in relatively heavy black lines, are "caricatures" of normal people (figure 3). He claimed that "in madmen, I encounter the personages I might know at any time in life."[13] These types became the basis for many of his later drawings, which by the 1960s had gained greater fluency, adopting the finer lines characteristic of Rembrandt's etchings. Their delicate veils of muted wash and watercolor often give the impression of a diaphanous, ambiguous space beyond the two-dimensionality of the picture.

Cuevas paid homage to his favorite painters and writers in numerous series of drawings. In 1973 he took Pablo Picasso's *Les demoiselles d'Avignon* of 1907 (The Museum of Modern Art, New York) as his point of departure for a series titled Homenaje a Picasso (Tribute to Picasso). Here he "corrected" Picasso's brothel and at the same time made reference to his later series of artists and models. Among works in Tribute to Picasso are *Autorretrato con las señoritas de Aviñón* [*Self-Portrait with the Young Ladies of Avignon*], *Autorretrato con modelos* [*Self-Portrait with Models*], and *Las verdaderas damas de Aviñón* [*The Real Ladies of Avignon*] (plates 49, 50, and 51). Here Cuevas rejects the formal conventions of Picasso's early Cubist distortions but celebrates the subject of prostitutes in a style resembling some of Picasso's preliminary sketches for his painting.

Cuevas's ladies do not stand or lie in the traditional odalisque pose but crouch, sit, stand, or strut, showing off their shapeless bodies and pendant breasts. The artist includes himself among his subjects. The seated figure in *The Real Ladies of Avignon* is a parody of Picasso's squatting foreground figure in *Les demoiselles*, but in Cuevas's version her legs are boldly spread apart. Two other rather emaciated naked figures in *Self-Portrait with Models* wear harlequin hats like those seen in Picasso's Blue-period paintings, perhaps a sign of approval of Picasso's earlier style.

In 1959, on the occasion of his participation in the fifth São Paulo Bienal, Cuevas traveled to Buenos Aires, exhibiting at the Galería Bonino and lecturing at Asociación Ver y Estimar, an arts center. Although this visit may have contributed to the rise of neofiguration in Argentina, the differences between Cuevas's sources and those of the Argentine artists are immediately apparent. The impact of Cuevas's work in Latin America was, in fact, more evident in the 1970s than it was in the 1960s.

Luis Felipe Noé, Jorge de la Vega, and Otra Figuración in Argentina

The single aspect the Argentine artists Noé, de la Vega, Deira, and Macció shared with Cuevas and the Nueva Presencia group was an antiaesthetic platform.[14] In 1965 Noé published a book titled *Antiestética*, in which he called for a break with "good taste" and rejected what he would later refer to as the "sacred mission of art that led to all mystifications."[15] He compared Coney Island (visited during a stay in New York), with "its fabulous world of games" and "all its monstrosity," to "the beauty of a woman."[16]

Whereas Cuevas thought of his drawings as personal extensions of himself and as observations of the human species, the four Argentine artists considered art making not as a reflection of the individual artist but as a historical and collective creative process. The

3. José Luis Cuevas. *Portrait from Life: Insane Person*. 1954. Pen and ink and wash on paper. Collection Jan Leff, Pennsylvania

artist, according to Noé, is merely an instrument of his history.[17] The Argentine representations of humans, in contrast to those of Cuevas, were symbols of the human species rather than generic types. They shared in the conviction that "the only way to adventure into art was by the adventure into man himself,"[18] and they sought to convey psychological rather than objective conditions. Like Cuevas and Borges, they perceived the world as a spectacle, but they considered themselves not observers of it but active participants.

From 1961 to 1963 the four artists found enough similarities in their outlook to share a studio in Buenos Aires and to form a group known as Otra Figuración after the name given to two of their earliest exhibitions.[19] The name derives from *art autre*, an appellation coined by the French critic Michel Tapié to denote an alternative to then-prevailing modes of expression.[20] The Argentine group corresponded chronologically to Nueva Presencia in Mexico, but there was little connection between them. The Otra Figuración artists exhibited as a group only a few times in the early 1960s, but they maintained a long-lasting friendship. During this period they all visited Europe, and between 1964 and 1967 they lived intermittently in the United States, where both de la Vega and Deira taught painting at Cornell University.

Otra Figuración paintings and collages of the 1960s feature brightly colored, CoBrA-like humanoid and animal forms. The main premise was a desire for complete freedom in painting. Jorge de la Vega wanted his work "to be natural, without limitations or formulas, improvised as life is."[21] Noé too wanted to escape all rules. In "Solemn Letter to Myself," published in the catalogue of his 1966 exhibition at the Galeria Bonino in New York, he wrote:

It is above all to understand chaos that we are living, because what we call chaos is nothing but that for which we lack a pattern of understanding. . . .

Here in the United States, as is manifest in Pop Art, the need for affirmation of the gregarious symbols is very urgent. It is a society which affirms itself. But in our country, as in the whole of South America, we are still at a stage previous to that of formulating our own way of life, as compared to the "American way of life," and thus we are left with that which precedes all order: chaos. Therefore, we must invest ourselves with it. . . .

Long live chaos, because it is the only thing which is alive![22]

Notwithstanding the similarities of their objectives, each artist formulated a personally identifiable style. While Noé's paintings allude to specific situations of urban life, de la Vega's refer to all time—past, present, and future. Although de la Vega stayed abreast of current events, he was not overtly political, and most of his paintings evoke psychological rather than external conditions. The phantomlike creatures in his paintings—composed of loose brushwork with pieced-together rags, rumpled bed sheets, coins, buttons, and broken pieces of tile—seem on the verge of floating upward or jumping like some nightmarish vision. *El día ilustrísimo* [*The Most Illustrious Day*] of 1964 (plate 54), for example, shows a crowd of faces—some painted, others made of collaged bits of tile—like positive and negative images in unstable configurations. In the same year de la Vega painted a series titled Anamorphic Conflict. "Anamorphic" denotes something made unrecognizable by distortion, unless viewed from a particular angle,

like the skull in Hans Holbein the Younger's *French Ambassadors* of 1533 (National Gallery, London). De la Vega thought of his distortions as analogous to what one sees in a trick mirror.[23]

Although Luis Felipe Noé's paintings also convey states of inner oppression, his emphasis is more on the external world. In *Closed for Witchcraft* of 1963 (figure 4), the lower section of the painting entraps the human species; furtive faces peer out of a gridlike structure. In the upper portion of the painting are images of a small crucifix and a crouching figure behind a large X. This symbol, which appears frequently in Latin American abstraction, blocks further entry into the space of the picture. Works such as this typify the Otra Figuración period through 1964. By 1965 changes had become evident in the work of all four artists.

Pop and Assemblage

Since the early 1960s Noé had made assemblages out of a combination of rags, canvas stretchers, and paint. Shortly before his return to Buenos Aires from New York in 1966, these works had grown in scale to become ramshackle constructions composed of hinged doors, reversed canvases, and painted images. One of them, exhibited at the Galería Bonino in New York in 1966, was so large that viewers could enter and climb into it, exemplifying a trend among Argentine artists in the mid-1960s toward creating environments that invited active participation.

A principal exponent of this mode was Marta Minujín, who was showing large-scale installations in New York and Buenos Aires galleries between 1964 and 1967. In Paris in 1963 she had declared the end of painting and staged a Happening in which she and her friends embarked upon a mass destruction of her previous work. Throughout the rest of the decade, she created environments and Happenings involving crowds of people rounded up from the streets or gathered in galleries. Defining herself as a Pop artist, she explained that Pop was "popular art, an art which the whole world can understand, happy art, fun art, comic art."[24] This definition fit *The Long Shot*, a large installation at the Bianchini Gallery in New York in 1966. A two-story plastic enclosure was covered by flashing neon lights and accompanied by sound effects. Inside were life-sized stuffed vinyl figures of rugby players and astronauts, live rabbits, and a seventeen-foot-long recumbent semblance of the actress Virna Lisi, ready to receive those who tobogganed from the upper level onto her stomach. Minujín continues to produce large-scale works requiring action on the part of the audience.

After Noé's 1966 Galería Bonino exhibition, he ended his affiliation with the gallery and stopped painting for almost ten years. New York's commercialism had apparently led him away from the salable object, and he turned to managing a bar in Buenos Aires that became a favorite meeting place for artists in the 1970s.[25] Following a short period when de la Vega's paintings appear to have been influenced by United States comic-strip Pop art, he too eventually played down his painting, opting for a career as a popular singer in Buenos Aires. Thus both artists acted out their gregarious instincts, coming into direct contact with the public in real-life parallels to Minujín's environments and Happenings. De la Vega's career was cut short when he died suddenly of a heart attack in 1971. Noé returned to painting in 1975.

The Paintings and Assemblages of Antonio Berni

Although the 1960s work of Berni conformed to the prevailing contemporary modes, his background differed from that of his younger colleagues, and his commitment to the human cause was more social than existential. The work is as continuous with his 1930s paintings of worker demonstrations and labor unions as it is reflective of modes current in the 1960s.

In 1933, when Siqueiros visited Argentina, Berni became acquainted with him, and they collaborated on a mural.[26] The economic depression of the 1930s caused widespread unemployment in Argentina, as it did elsewhere, and social concerns certainly preoccupied Berni as much as they did Siqueiros. However, public walls were not available in conservative Argentina, and alternatives had to be found. Siqueiros, who condemned easel painting as elitist, had wanted to launch a mural movement in Argentina but quarreled with Berni over this issue. Far from denouncing the merits of easel painting, Berni defended it as the only means possible in Argentina.

In 1934 he began a series of paintings that dramatized contemporary problems by adopting a social realism that was based on his own photographs of impoverished neighborhoods in Buenos Aires. The large scale of these paintings substituted for that of walls. *Desocupados,* o *Desocupación* [*Unemployed,* or *Unemployment*] of 1934 (plate 26) depicts sleeping men who range in age from a seated youth in the foreground to men in their sixties sprawled on the ground. This frontal composition of sharply defined life-sized figures places the viewer in a disturbing confrontation with the men, brutally conveying their sense of total uselessness and despair.

The rapid industrial growth of Buenos Aires in the late 1950s displaced thousands of poor workers into what became the *villas miserias*, or slums. Berni then revived the techniques of collage he had used in an earlier Surrealist phase, applying them to mural-scale works that combined "poor" materials—discarded and found objects affixed to wood or corrugated cardboard—in representations of these slum dwellers. He created two characters—Juanito Laguna, a boy from the slums (plate 27), and Ramona Montiel, a seamstress and prostitute—as the central figures in a nonsequential narrative that connected the works within a series. These characters were reiterations of the workers of the 1930s in contemporary guise.

Berni, like a number of his colleagues, felt strongly that art should have some humanist function, particularly that of communication by means of referents taken from popular art and from the media. In addition to Juanito and Ramona, generic symbols of the poor, he often utilized as subjects the popular myths and legends given currency in the news media. The assorted objects he used in his collages were the waste materials found in the slums: packing crate slats, tarred cloth, tops of empty oil drums, bottle tops, buttons, nuts and bolts, sheets of tin, straw, and household discards, as well as assorted objects found at flea markets. His wish for communication on a popular level was fulfilled in the 1970s, when certain tangos and *milongas* that were inspired by his paintings of Juanito Laguna were made into popular records and widely distributed.

Berni's representations of Juanito show the boy in diverse situations: going to the city in his Sunday best, learning to read, taking lunch to his father (a factory worker), helping his mother with her daily tasks, flying a kite, or playing amid the refuse of the slums that

4. Luis Felipe Noé. *Closed for Witchcraft*. 1963. Oil and collage on canvas, 6' 8¾" x 8' 3¾". Archer M. Huntington Art Gallery, The University of Texas at Austin. Archer M. Huntington Museum Fund

threaten to engulf him. In some double-layered compositions he appears trapped in his slum environment, while above is a world unattainable by him, represented, for example, by a billboard advertising a shiny new automobile, held by a beautiful young woman. Several works show an earthbound Juanito constrained by the slum, while astronauts in fanciful baroque spaceships pass overhead or salute him from afar.[27] Argentine artists, including Berni, were preoccupied with the atomic and space ages during the 1960s, as were neofigurative artists in Mexico. The Argentines, however, tended to represent these themes in threatening mythical metaphors. Thus the upper zones of Berni's assemblages do not always represent a region of unattainable dreams; they often depict apocalyptic disasters. In the large-scale seven-part collage *The World Promised to Juanito Laguna* of 1962 (Collection Elena Berni), two threatening mushroom clouds, painted in the festive colors of fireworks, rise ominously against a somber background. Their brightness contrasts with the drab slum environment in which Juanito and two girls stand in frightened anticipation.

The Assemblages of Alberto Heredia

Like Berni, Heredia expressed his humanist and political preoccupations by the use of "poor" materials, such as corrugated cardboard and plaster, and the incorporation of discarded objects. After producing geometric art in the 1950s, he took up a type of assemblage indebted to Surrealism, which combined humanoid forms with strange scaffoldings seemingly bandaged together.

Many of his works are made out of enclosures—boxes, wardrobes, kitchen cabinets, drawers. His *Cajas de camembert* [*Camembert Boxes*], made in Paris in 1963 (plate 77), contain curious conglomerates from the detritus of daily life, such as discarded rags, thread, and fragments of celluloid dolls, as well as human hair and animal bones. The spectator is invited to open the boxes to discover their unsettling contents.[28] The inspiration for these boxes probably derived from Salvador Dali's description of the genesis of his limp watches in *The Persistence of Memory* of 1931 (The Museum of

Modern Art, New York). Their purpose, according to Dali, was "to create the Camembert whose putrefaction brings forth the mushrooms of the mind."[29] Like Dali's gastronomic allusions, Heredia's title invites paradoxical associations with food. His boxes also function as metaphors for the unconscious. The Argentine critic Jorge López Anaya found in Heredia's work a "lucid compromise expressed through humor, irony, eroticism, ugliness, the monstrous, the diabolic . . . [they] function like little dreams—immediate experience, unmediated, denying all rational will."[30]

Heredia's boxes and other enclosures are designed to produce associations with life-and-death situations and with a sense of entrapment in oppressive habitats, "replete with useless objects that dominate" the lives of the humans who created them.[31] His series of towers and castles of 1964 and 1965 are composed of compartmentalized boxes filled with unidentifiable objects, evoking the unsettling archaeological remains of a bygone era. These works convey an obsessive sense of entrapment by external conditions beyond our control, recalling the themes of the neofigurative painters (such as Noé's "chaos"), now more personally stated.

Heredia's Los Amordazamientos [The Gaggings] of 1972–74 (plate 78) may be interpreted politically; these bandaged constructions, vaguely human, sport dentures with gags in them, referring to the fears and repression brought on by the military government of Argentina at its most oppressive, in the early 1970s. López Anaya referred to them as "mouths brutally censored."[32] Heredia's constructions function as agents of psychological associations, as did those of his Surrealist precursors, but they also evoke specific contemporary conditions. Their obvious political content and frequent allusion to unnecessary consumerism place them within the context of social discourse.

Jacobo Borges and Neofiguration in Venezuela

In the early 1960s the work of Jacobo Borges, like that of his compatriots Alirio Rodríguez and Humberto Jaimes Sánchez, followed the informalist direction of Cuevas and the Otra Figuración artists. Throughout the decade, however, Borges was far more committed to the exploration of social and political issues, and he sought to make his art a means of communication with a reformist goal.

Borges's professional career began in the 1950s, when Venezuela was under a military government. The prevailing school at the time was the geometric, optical, and kinetic one of Jesús Rafael Soto, Carlos Cruz-Diez, and Alejandro Otero, which Borges and others perceived as "official" art sanctioned by the government. Like his Argentine colleagues, Borges turned for visual models to the CoBrA artists, de Kooning, and, after 1972, Bacon, as well as to the Venezuelan impressionist landscape painter Armando Reverón. But he also admired masters of the past: James Ensor, Goya, Emil Nolde, Vincent van Gogh, Rembrandt, and Peter Paul Rubens.

Following his return to Caracas from a sojourn in Paris in the early 1950s, Borges began developing the expressionist style that culminated from 1963 to 1965 in some of his best-known works. At first his European experience led him to regard Venezuela as lacking in history and traditions. He defined Caracas as "a city without myths, separated from all historical continuity."[33] But he soon found that Caracas could serve as a base for his activist enterprise. Within a

year's time he painted Personajes de la coronación de Napoleón [Characters from Napoleon's Coronation] of 1963 (plate 31) and Ha comenzado el espectáculo [The Show Has Begun] of 1964 (plate 30).

Characters from Napoleon's Coronation is one of a large group of drawings and paintings by Borges on the subject of Napoleon. In this series, prelates, skeletons, and monstrous naked women are mixed to turn into a burlesque what was represented as a solemn event by Jacques-Louis David in his Coronation of Napoleon of 1805–07 (Musée du Louvre, Paris). Borges's paintings serve as a stage for the mockery of the pomposity of the ruling classes. In the words of Carter Ratcliff, Napoleon represents "an allegorical figure of the death that stalks individuals (and the idea of individuality) when the state attempts an unlimited extension of its power."[34] The Napoleon series has been interpreted as a protest against violence, corrupt oil interests, the Church, and the military, in a setting emphasizing stage effects. The nude is a prostitute and a metaphor for a "debased Venezuela."[35] Dore Ashton has traced the burlesque character of the figures in these works to Goya,[36] and Lawrence Alloway remarked on Borges's rhetorical use of fiesta imagery "to intensify disgust and anger at society and its agents."[37] This may be seen in The Show Has Begun, where the actors are prelates, military figures, a prostitute, and a skeleton. The death masks in the painting have been likened to those in Ensor's Christ's Entry into Brussels in 1889, painted in 1888 (J. Paul Getty Museum, Malibu). Like Cuevas, who also painted variety shows as allusions to human folly, Borges admired Posada and Orozco for their expressive caricatures, and he translated this affinity into his own versions of deformed and contorted figures.

By the mid-1960s Borges experienced a conflict between his desire for self-expression and his need for mass communication. In 1966 he abandoned painting for about five years and embarked on a collaborative production titled Image of Caracas, a multimedia event combining lights, props, and sound effects with projections of fractured and shifting film images. The environmental character of this work obliterated the space between art and audience. The actors were not professionals, but were selected from people on the street. The project had a social purpose; it was designed to make its participants, that is, the audience, aware of the inequities, cruelties, and hypocrisies of daily life. Although Borges's intentions were more activist than those of his Mexican or Argentine colleagues, he shared with the Argentine artists a desire for a collectivist and populist society.

By 1970, when Borges returned to drawing and painting, his work was less directly denunciatory and was no longer engaged in what Ratcliff would later characterize as an "impassioned expression of immediate feeling [that] would solve, or simply ignite and erase, the conflicts between art and politics."[38] Instead, he attained a more complex and premeditated treatment of the image, and some of the time shifts of film found their way into his work. Abandoning heavy impasto, he created the impression of large shifting spaces through a painstaking system of thin overlays and glazes that evoke shifts of memory. Over the years Borges had accumulated a large collection of photographic prints, and he began to use images from them as underpinnings for his work. Many of them were family photos of events of ritualistic character, such as betrothals or first communions, recreated in his work as fugitive images that appear alternately in positive or negative prints.

The Assemblages of Marisol

Borges's compatriot Marisol is more difficult to situate within the Latin American context, since her mature work dates exclusively to the time of her residence in the United States. Born in Paris of Venezuelan parents, she associated in New York with Philip Guston, Andy Warhol, Robert Indiana, and other artists from the United States, rather than with members of the Latin American community living in New York during the 1960s. Her success was due in large part to the sensual appeal her anthropomorphic constructions held, even for the uninitiated. She first exhibited at the Leo Castelli Gallery in the late 1950s, and from 1962 on showed regularly at the Stable, Sidney Janis, Dwan, and Fischbach galleries, all of which were known for their promotion of Pop art and New Realism.

Marisol attributed the decisive moment in her development to the chance discovery of a bag of hat forms during a visit to the East Hampton home of the artist Conrad Marca-Relli in 1960.[39] These large heads, recalling ex-votos, suggested the life-sized scale that she was to adopt for her sculpture. Establishing a downtown studio outfitted with carpentry tools, she began making boxlike bodies from cryptic numbered diagrams, to which she added heads sculpted from hat forms, plaster casts of her own face, and assorted accessories, such as handbags, hats, or skirts of real fabric.

In the early 1960s Marisol's subjects included family groups, figures with dogs, and stereotypes of North American middle-class

5. Marisol. *Women Leaning*. 1966–67. Wood and mixed mediums, 67" x 7' 2" x 41½". The Chicago Public Library Cultural Center

life and international society. *The Family* of 1962 (The Museum of Modern Art, New York) comprises freestanding and accessorized figures with plaster casts of the artist's own face. In 1967 she created a series based on famous figures, such as Andy Warhol, Bob Hope, and world leaders who were in the news at the time. Works representing the latter group, which included Charles de Gaulle, Francisco Franco, Lyndon Baines Johnson, and the queen of England, were exhibited at the Sidney Janis Gallery in 1967 under the title *Heads of State*. Marisol drew or stenciled images based on photos and magazine illustrations onto the wood surfaces of her sculptures. In *LBJ* of 1967 (plate 116), President Johnson's cubic head bears a flat image of his visage; on the sides of the block are Johnson's big ears. His left forearm stands out in relief from the boxlike form of his body and extends into a tray-shaped hand holding small effigies of Lady Bird Johnson and his two daughters. Through devices like these, Marisol poked fun at her subjects' public images as they were manipulated by the media.

From an aesthetic point of view, her sculptures do not necessarily depend on these comic details but can stand on their own formal merit. The works constitute an odd blend of Minimalist sculpture and Pop objects. In *Women Leaning* of 1966–67 (figure 5), four rhomboidal figures with minimal adornments (two handbags and the usual plaster casts of the artist's face) stand at an angle, their heads sectioned down the middle to align with the wall. According to the artist, the idea for this work came as a result of having seen a ladder standing against a wall. The fact remains that she is a great admirer of the Minimalist sculpture of Donald Judd, Tony Smith, and Robert Morris. She once remarked with regard to their work, "I wish I had thought of that," and noted that if she had removed the heads and ornaments from her own sculpture, she would have had Minimalist art.[40] But the fact that she did not do so made her work a clever synthesis of the prevailing art modes.

Fernando Botero's Neofiguration and Appropriations of Art History

Botero's subjects, like Marisol's, include family groups, heads of state, prelates, and middle-class couples, but also Latin American stereotypes: madonnas, houses of prostitution, military juntas, and opulent still lifes with exotic fruit. Botero admired Latin American colonial art as well as European art. He exploited all of art history, from the Middle Ages and the Italian quattrocento, through the Impressionists and Intimists (for example, Pierre Bonnard), to Picasso and Henri Matisse. His early style, however, owed its genesis to Cubism, as did the early work of his fellow Colombians Alejandro Obregón and Enrique Grau. Obregón subsequently opted for abstraction, and Grau chose a figurative form related to Botero's, with amplified human proportions but without Botero's distortions. What gives Botero's work its special stamp of contemporaneity is his total disregard for classical proportions, a characteristic he shared to some extent with de Kooning and Cuevas. Both Cuevas and Botero painted versions of Jan van Eyck's *Arnolfini Wedding Portrait* of 1434 (National Gallery, London); the deformations and asexuality in each of these paintings are characteristic of each artist's work.

Botero's style cannot be separated from the content of his works. Playing style against content, he often borrowed from the work of an earlier artist whose subject was relevant to his. For his

6. Fernando Botero. *War*. 1973. Oil on canvas, 6' 3 ⅛" x 9' 1 ⅞". Collection Mr. and Mrs. Carlos Haime, New York

paintings representing military juntas, for instance, he selected Jacques-Louis David's *Oath of the Horatii* of 1784 (Musée du Louvre, Paris) as an apt model, playing on David's theme of civic pride and duty to ridicule the military governments of his own time in Latin America.

Although a well-known and commercially successful artist today, Botero came of age against the grain. He has recounted in numerous interviews how, when he first moved to New York, he would go to the Cedar Bar (the Abstract Expressionists' favorite meeting place) and introduce himself to other artists as a figurative painter in the hope of becoming part of the New York art community, but would instead be snubbed for not conforming to the prevailing style. For a while he even experimented with expressionist brushwork, but he never felt comfortable with it.

In the late 1950s, he painted several works based on Leonardo da Vinci's *Mona Lisa* of 1503 (Musée du Louvre, Paris) and Velázquez's *Francisco Lezcano, el niño de Vallecas* of 1643–45 (Museo del Prado, Madrid). Dorothy C. Miller's 1961 selection of Botero's *Mona Lisa, a los doce años* [*Mona Lisa, Age Twelve*] of 1959 (plate 32) for the collection of The Museum of Modern Art, New York, put an end to the spell of invisibility he had been under. From then on, his reputation grew steadily and he began exhibiting regularly.

Both *Mona Lisa, Age Twelve* and *Après Velasquez (Niño de Vallecas)* [*After Velázquez (Boy of Vallecas)*] of 1960 (plate 33) were painted at a time when Botero was just emerging from his "expressionist" period, in which heavy brushwork was still apparent. The distortions of these two paintings, much more than those of Botero's later works, resemble the deformations in Cuevas's works of the 1950s. In the *Mona Lisa* the face is brutally compressed within the picture space so that it appears monumental, and in *After Velázquez (Boy of Vallecas)* the figure's anatomy is lost in an amorphous mass, in which one can barely recognize the details of Velázquez's original.

Botero's works of the 1960s display his fully developed style, in which he had eliminated all traces of brushwork, opting instead for smooth inflated shapes that negate all reference to textural variation. The textures of flesh, clothing, or fruit, the contrast between hard and soft substances, are not distinguished. A face has the same smooth surface as a trombone or a knife, and conveys no more emotion than its inanimate counterpart. Thus Botero opted for subjects

that lent themselves to the solution of some formal problem proposed by the model he chose to appropriate. He obeyed neither the rules of mimesis and classical proportion nor those governing abstraction or the prevailing forms of neofiguration.

His account of the genesis of his inflated forms is well known. In 1956 he was painting a mandolin and had placed a disproportionately small hole on its surface to indicate its opening. The resulting impression of a swollen instrument was so pleasing to him that he left it as it was and thereafter adopted the principle of this accidental occurrence as part of his style. Among his more recent explanations for this stylistic peculiarity is: "When I inflate things I enter a subconscious world rich in folk images. For me, rotundity in art is linked to pleasure. Basically, it's a matter of rationalizing natural impulses."[41]

As a means to these ends, Botero stretched his canvases only when they were almost finished. In this way he could further control the relationships between volume and space, obtaining a tautly compressed image curiously analogous to Claes Oldenburg's oversized soft objects. These proportions contribute to the appearance of distortion as well as to illogical scale shifts in Botero's paintings. A dog, for instance, may appear inexplicably large in comparison to its owner, or a woman in comparison to her male lover. Whether or not Botero employs anomalies of scale and other peculiarities in his pictures for purely pictorial reasons, as he often likes to claim, they invariably contribute a humorous note.

In his 1967 painting *La familia presidencial* [*The Presidential Family*] (plate 34), one finds an example of the use of scale shifts and the appropriation of an art-historical model to the subject of an exceptionally ordinary group of contemporary people. The figures and the background mountains blend together into a shallow tactile whole. Details such as the snake lurking on the ground, a smoking volcano in the distance, a dog at the feet of the priest, a fox stole on the arm of the First Lady, and the little girl clutching a toy airplane are clichés of what is expected of the commonplace tastes and character of a newly rich family. Moreover, the humor in this picture owes something to Botero's choice of Francisco Goya's *Family of Charles IV* of 1800 (Museo del Prado, Madrid) as a model. Like Goya, Botero appears in the background, painting the huge canvas. The result is a double parody, since Goya's group portrait of the royal family was itself most probably intended as a parody.

In *War* of 1973 (figure 6), a mountainous mass is made of dead humans from all walks of life, caught unexpectedly at the instant of the disaster. The painting parodies medieval allegories of greed, piety, and hypocrisy. Some figures lie in coffins, while others are piled on top of one another in a variety of obscene, Hieronymus Bosch–like poses amid flags declaring their patriotic cause. The serene, bloated faces and the impersonal quality of the scene make this composition easily interchangeable with Botero's still lifes, particularly his *Fruit Basket* of 1972 (Collection Mr. and Mrs. Carlos Haime, New York).

War is said to have been inspired by the Yom Kippur War between Israel and its Arab neighbors in 1973, and inevitably comparisons are made with Gabriel García Márquez's 1975 novel *Otoño del patriarca* (*Autumn of the Patriarch*), because of the common reference to the "senseless devastation that Colombia experienced during 'La Violencia.'"[42] But Botero is in no way a political artist and cannot be compared to Jacobo Borges in terms of commitment to a political cause. Botero utilizes such themes as points of departure for

the investigation of aesthetic problems, or in order to play on the subject and style of an earlier master, and not for the purposes of condemning political occurrences.

On the other hand, one should not dismiss Botero's ability to mine people's expectations of what Latin America is. His stereotypes of Latin American life are what his foreign public has come to expect. He once noted that Latin America is one of the few places left in the world where myths still exist.[43]

Santiago Cárdenas's Representations of Pop Art

Colombian neofiguration of the 1970s diverged in two main directions. On the one hand, there were politicized artists who worked primarily in the graphic mediums, and on the other, an essentially apolitical group employing various forms of academic figuration, with the nude as a favorite subject. What distinguishes Santiago Cárdenas from other neofigurative artists is that he rejected the old masters in favor of contemporary models. Moreover, most of his work is not so much figurative as representational, since he represented ordinary objects rather than the human figure in his paintings and drawings of the 1970s (he reintroduced the human figure after 1980).

Cárdenas grew up in the United States, where his father held a diplomatic post. At Yale University, where he received his M.F.A. degree in 1965, his instructors included Alex Katz, who was to become a major influence on Cárdenas's early style. He was happy to return in 1965 to the quieter ambience of Bogotá, where he could develop his work away from the distractions of the New York art world. The fact that after his return to Bogotá he taught painting in three of the city's universities[44] helps to explain the spread of realist figuration and variations of Pop art in Colombia in the 1970s, although Pop had already made prior incursions.

Cárdenas's subjects are manufactured household objects and clothing: chairs, umbrellas, ironing boards, a lone metal hanger, a plug and electric cord, a row of hanging neckties. They are isolated on a sheet of paper or a canvas, or sometimes as cutouts. He has also produced works depicting glass panes. In some of these the glass, set against a wall and aligned with the picture plane, intrudes into the otherwise pristine, minimal space of a shallow empty room; in others the reflection of the floor, seen in a mirror set at a slight angle against a wall, creates a sudden break in the horizontal order of the room.

7. Santiago Cárdenas. *Plug*. 1970. Oil on linen, 6' 9" x 13' 1 ½". Collection the artist

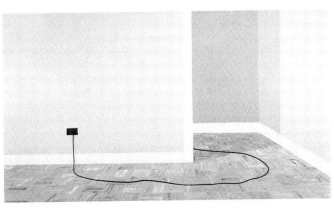

Cárdenas's reputation as a painter was secured when he was awarded a prize at the 1970 Medellín Bienal for his painting *Plug* of 1970 (figure 7), which represents a plug and electric cord as the sole contents of a room, leading off to a hidden space and provoking the viewer to speculate on the possible presence of a vacuum cleaner. Lawrence Alloway, who had been a member of the Bienal's jury, noted that Cárdenas's correlation of the canvas with identically sized objects reflects "his familiarity with the double-takes of Pop art."[45]

Clothing—vests, jackets, pants, or coats—is the subject of numerous life-sized charcoal drawings, rendered as realistically as possible. In themselves the drawings seem to have virtually no extraneous meaning. By the mid-1970s, however, Cárdenas expanded his repertory with blackboards, window shades, the side of a corrugated packing box, empty picture frames, and the back of a canvas with exposed stretchers, all of which were rendered illusionistically in oil or charcoal. *Pizarrón grande con repisa* [*Large Blackboard with Shelf*] of 1975 (plate 41), *Large Blackboard* of 1977 (Collection Charles and Eva Conkright, New York), and *Large Blackboard with Black Frame* of 1983 (Rachel Adler Gallery, New York), all oil paintings, belong to this series. In the words of the Colombian critic Eduardo Serrano, these works "allow a glimpse of imprecise mathematical or philosophical thoughts, vanished formulas, and the residue of lessons," even though "the paintings do not lend themselves to an extra-aesthetic hypothesis."[46] The artist himself perceived art as a means to trigger thought and explained that "those who look for trompe l'oeil effects in my paintings are usually off the track, because my intentions are not to trick or to play with the viewer. I use illusionism in order to create a 'presence,' just as nature does."[47]

While the play of correspondence between the flat object and the painting parallels the similar identification operative in the work of Jasper Johns, the clean sparseness of Cárdenas's pictures and his deliberate rejection of painterly texture resemble that of his teacher Katz. Cárdenas's particular erasure of all reference to the hand of the artist, coupled with the orderly arrangement of his subjects, obeys the rules of a silent geometry typical of the work of other contemporary Colombians, including Eduardo Ramírez Villamizar, Omar Rayo, and Carlos Rojas. Without actually painting abstract or geometric works as these artists do, Cárdenas creates a cool sense of order in his representations of common objects. In his hands the object becomes an icon.[48]

Antonio Seguí and Photographic Figuration in the 1970s

Both Cárdenas and Antonio Seguí used the medium of charcoal drawing as a major form of expression. They both also preserved the wholeness of the image, as compared to the fragmentation typical of the 1960s, and a sense of fact in contrast with the personally expressive modes of that decade. Like Borges, Seguí used the mechanical processes of photography but employed photographs only as a foundation. Although photorealism was known and was an option in Latin America, very few artists chose to take it up.[49] Neither Borges nor Seguí produced true photorealist works, although at times Seguí deceived the viewer into thinking that he had.

In the 1960s Seguí worked in a figurative mode related to that of the Otra Figuración artists with whom he had once associated, but he did not work directly with them. In the 1970s he abandoned this

form of painting in favor of large-scale drawing. He mined family and newspaper photographs as sources for his imagery without reproducing the mechanical character of the photograph; they were, rather, an aid to representational objectivity.

Seguí's choice of charcoal and pastel for finished works in the 1970s was not in itself unusual. His use of canvas rather than paper was. Both Cuevas and Cárdenas used paper, regardless of the scale of their drawings. Seguí, however, exploited the properties of the rough canvas surface by rubbing charcoal and pastel into it as a deterrent to the lure of color and the appeal of the brushstroke. Although he acknowledged the differences between painting and drawing, he felt that by using graphic mediums in this manner the image would be more immediate and make a far greater impact.[50] His use of photographic sources permitted him to distance himself from the work by eliminating the emotional involvement usually associated with the act of painting.

The first drawings of this period include a series of elephants done in 1973 on canvases measuring approximately six by six feet. Seguí situated them against backgrounds that range from lush jungle habitats to the more perplexing landscapes of the Argentine pampas. The elephants are usually shown from a low point of view, conveying a sense of their scale. The charcoal, rubbed into the textured canvas, mimics the roughness of their skin.[51]

The mere presence in such a setting of a creature alien to our Western environment introduces an element akin to Magic Realism. This special characteristic is what makes Seguí's later drawings, presented in the guise of photographic reportage, seem unsettling. In the mid-1970s the artist embarked on a series in which dogs appear, often in a rural setting, either as the central subject or as threatening agents amid other figures, like vicious guards of a doorway or an enclosed space. This latter device, which Seguí used many times, acts to hold the viewer's attention in the foreground of the picture, since further entry is associated conceptually with danger.

Beginning in 1976 one of Seguí's favorite strategies was the representation of interior or exterior spaces with a male figure, back to the viewer, staring at some distant point in a landscape partially invisible to the viewer, or in a room with a door slightly ajar, revealing little more than a mysterious dark space. These scenes create suspense, akin to looking at a frame from a murder-mystery film, or a moment frozen in time. The recurring figure of the man's back—as in the 1976 charcoal-and-pastel drawings on canvas *Contra el muro* [*Against the Wall*] (plate 192), *To Wait Seated* (Fundación Museo de Bellas Artes, Caracas), and *La distancia de la mirada* [*The Distance of the Gaze*] (plate 193)—is taken from René Magritte, an artist frequently quoted by Seguí. The latter used this figure to similar enigmatic ends; the viewer's attention is drawn to the same point in the distance of a landscape or a room as is that of this mysterious and elusive man. We are tempted to think the man is the artist himself. He reappears in Seguí's playful, crowded paintings of the 1980s as the peripatetic wanderer in urban settings evocative of Buenos Aires or of Paris, where Seguí has lived since 1963.

———

Although Latin American countries are in some ways more isolated from one another today than they were in the 1960s, artists maintain direct contact with other Western art centers through travel, exhibitions, and the news media. The emergence of neofiguration, assemblage, and Pop in Latin America was in great measure the result of a new emphasis on international communication in the 1960s, exemplified by the creation of several new international biennial exhibitions during those years. Yet far from paraphrasing foreign models, Latin American artists reflect entirely different and very specific frames of reference that are not readily transferable. If common concerns can be detected in their work of the 1960s, they are a lack of interest in the representation of objects as ends in themselves, and a desire to reach and appeal to a broad audience. Although in the 1970s some artists seemed to have lost the activism that motivated them in the 1960s, they found more covert and complex strategies for communicating their concerns.

Notes

1. *New figuration* and *neofiguration* have been used interchangeably since 1962 to denote a form of expressionist painting that includes the human figure. Although German Expressionism can be said to fit this definition, the term refers here to a particular outgrowth of abstraction/informalism that occurred in Spain, France, and Latin America in the 1950s. At first the term *neo-figuration* was hyphenated, but since the use of *neofiguration* as a single word is most common in recent scholarship, this term will be employed for the sake of simplicity throughout this essay. The history of the term is a complex one.

The term *new figuration* was first used by Michel Ragon in Paris in 1962. Prior to that, numerous other terms were applied to this type of expressionist figuration. In the United States it was identified by Peter Selz as an alternative to abstraction and became the subject of a Museum of Modern Art exhibition, *New Images of Man*, which he organized in New York in 1959. This was followed by *The Insiders* by Selden Rodman in 1960; see note 5. In Mexico, José Luis Cuevas was the first to work in this mode, but in the 1950s was seen by Rodman as Orozco's heir. Orozco's drawings from the period beginning in 1945 until his death in 1949 are satiric, expressionistic human images.

Only after 1959 did critics and artists search for appropriate terms to define the new figurative modes. The Nueva Presencia group of artists who emerged in Mexico between 1961 and 1963, headed by Arnold Belkin and Francisco Icaza, published five issues of a posterlike journal. This single page, folded six times, was titled *Nueva presencia*—literally, "New Presence." This term was selected after much deliberation. The term *Los Interioristas* was considered for a time; it was based on Rodman's book, which Belkin had read. Other terms used by the artists in *Nueva presencia* to define their art included *nuevo humanismo* (new humanism), *interiorismo, neohumanismo* (neohumanism), and *nuevo expresionismo* (new expressionism, defined as "figurative art of expressive content"). The illustrations in *Nueva presencia* included works by Rico Lebrun and Leonard Baskin, with whom the Mexican artists felt kinship. Lebrun had been to Mexico and had remained in contact with these artists, primarily as the result of Rodman's influence. The Nueva Presencia group first exhibited as "Los Interioristas" at the Cober Gallery in New York in 1961.

The Argentine group contemporary with Nueva Presencia—Otra Figuración—included Luis Felipe Noé, Ernesto Deira, Jorge de la Vega, and Rómulo Macció. Otra Figuración had also sought alternative terms before arriving at their appellation. In an unpublished manuscript (1989), Noé notes that prior to working with the group in 1960, he had proposed *new figuration, neo-expressionism, post-informalism,* and *new image of man* to denote their synthesis of figuration and abstraction. By 1961, critics were referring to the group as neofigurative, although this term was not officially adopted until the Pan-American Union exhibition in 1962. The group's eventual choice of Otra Figuración was a translation of *art autre* (other art), coined by French critic Michel Tapié, who had also invented the term *informalism* in 1952. Tapié saw in the new tendencies not "an anti-art . . . but a truly other art" and in the late 1950s organized an exhibition under that title. It included works by Karel Appel, Dubuffet, de Kooning, Jean Fautrier, Georges Mathieu, Jean-Paul Riopelle, Mark Tobey, and Wols (Aldo Pellegrini, *New Tendencies in Art*, trans. Robin Carson [New York: Crown Publishers, 1966], p. 66); the Spanish painter Antonio Saura, whose work bears a strong resemblance to that of Deira, also belonged to the *art autre* group (ibid., p. 111).

2. CoBrA is an acronym for Copenhagen, Brussels, and Amsterdam, the cities that were home to the artists who formed the group in 1948 (Karel Appel, Asger Jorn, Corneille, Pierre Alechinsky, Carel Henning Pederson, Jean Atlan, and others). These artists blended gestural painting with the inclusion of animal and human images; thus CoBrA refers also to the snake; see R. W. Oxenaar, *New Art Around the World* (New York: Harry N.

Abrams, 1966), pp. 182–202. A link between this group and the Argentine artists was forged by Aldo Pellegrini, a Surrealist poet who was also involved with his fellow Surrealist Edouard Jaguer's international *Phases* exhibitions. (In 1959 the *Phases* exhibition took place in Buenos Aires.)

3. Rafael Squirru, "Pop Art or the Art of Things," *Américas* 15, no. 7 (July 1963), p. 16.

4. See Peter Selz, *New Images of Man* (New York: The Museum of Modern Art, 1959).

5. Selden Rodman, *The Insiders: Rejection and Rediscovery of Man in the Arts of Our Time* (Baton Rouge: Louisiana State University Press, 1960), p. 4. Rodman's title was prompted by the English critic Colin Wilson's earlier book *The Outsider* (Boston: Houghton Mifflin, 1956), the apparent nihilism of which Rodman denounced. However, it should be noted that Wilson defended some of the same artists as did Rodman.

6. De Kooning was well known throughout Latin America by the late 1950s, although little documentation exists regarding specific contacts. His work was shown in the first São Paulo Bienal in 1951, but this was before he began the Women series, and is therefore irrelevant to the present discussion. According to Pellegrini (*New Tendencies*, p. 66), Michel Tapié included him in his first *art autre* exhibition, along with Appel, Jean-Paul Riopelle, Mark Tobey, and Wols; no date is given by Pellegrini. De Kooning was certainly known through The Museum of Modern Art's *New Images of Man* exhibition, in reproductions if not directly. Rodman also mentioned him throughout his book *The Insiders*, as well as in his *Conversations with Artists* (New York: Capricorn Books, 1961), which was known to the Mexicans.

7. See note 1.

8. José Luis Cuevas, *Cuevas por Cuevas* (Mexico City: Ediciones Era, 1965), p. 204. The receptivity to Cuevas's international outlook was reflected in a book published in 1965 by Marta Traba. Titled *Los cuatro monstruos cardinales* (Mexico City: Ediciones Era, 1965), the book addresses the art of Dubuffet, Bacon, de Kooning, and Cuevas.

9. Between 1960 and 1964 Siqueiros served four years of an eight-year sentence for "social dissolution." See Shifra M. Goldman, *Contemporary Mexican Painting in a Time of Change*, 3d ed. (Austin and London: University of Texas Press, 1981), pp. 37–38. He was accused of leftist activities in opposition to the policies of then president Adolfo López Mateos. See Hubert Herring, *A History of Latin America*, 3d ed. (New York: Alfred A. Knopf, 1968), p. 374.

10. From the Nueva Presencia manifesto published in *Nueva presencia* (Mexico City) 1 (August 1961); translated by Goldman, *Contemporary Mexican Painting*, p. 48.

11. Walter Brayman, "José Luis Cuevas," *Forum* (Kansas City Artists' Coalition, Summer 1981), p. 7.

12. See José Gómez-Sicre, "Introduction," in *José Luis Cuevas: Self-Portrait with Model* (New York: Rizzoli, 1983), p. 10. See also, in the same volume, Cuevas's letter on p. 20. Shifra M. Goldman, a reliable authority, cites the year of Cuevas's birth as 1933 rather than Cuevas's own record of 1934 (*Contemporary Mexican Painting*, p. 105).

13. Quoted by Francisco Icaza, "José Luis Cuevas pinta actualmente en el manicomio," *Mañana* (Mexico City), May 5, 1955, pp. 48–50.

14. See note 1, regarding the context of the term *Otra Figuración*.

15. Luis Felipe Noé, lecture delivered at the University of Texas, Austin, October 4, 1989, p. 15 of Spanish transcript.

16. Luis Felipe Noé, *Antiestética* (1965; reprint ed., Buenos Aires: Ediciones de la Flor, 1988), p. 30.

17. Ibid., p. 14.

18. Guillermo E. Magrassi, *De la Vega* (Buenos Aires: Centro Editor de América Latina, 1981), p. 4.

19. The first exhibition was at the Galería Peuser in 1961, the second at the Galería Bonino in 1962, both in Buenos Aires.

20. See Michel Tapié, *Un art autre: Où il s'agit de nouveaux dévidages du réel* (Paris: Gabriel-Giraud, 1952).

21. Quoted in Magrassi, *De la Vega*, p. 8.

22. Luis Felipe Noé, "Solemn Letter to Myself," *Luis Felipe Noé: Paintings* (New York: Galeria Bonino, 1966), n.p.

23. See Magrassi, *De la Vega*, p. 8.

24. Marta Minujin, quoted in interview with John King. See John King, *El Di Tella* (Buenos Aires: Ediciones de Arte Gaglianone, 1985), p. 244.

25. Noé has stated that after his 1966 exhibition, the owner of Galeria Bonino told him that the work was unsalable and difficult to store (Luis Felipe Noé, unpublished Spanish, manuscript, 1989, p. 22).

26. The mural was *Ejercicio plástico* (*Plastic Exercise*), painted with spray guns in the basement bar of the home of Natalio Botana in the town of Don Torcuato, on the outskirts of Buenos Aires. Besides Berni, other artists who collaborated on this mural included Juan Carlos Castagnino and Lino Enea Spilimbergo. For information about this mural, see Laurance P. Hurlburt, *The Mexican Muralists in the United States* (Albuquerque: University of New Mexico Press, 1989), p. 218.

27. Luis Felipe Noé has characterized the tendency of Argentine artists to see contemporary realities in mythological terms, referring to Argentina as "a society that has not yet been able to differentiate between technological revolution and Jules Verne." See his book *Una sociedad colonial avanzada* (Buenos Aires: Ediciones de la Flor, 1971), n.p.

28. Four of the Camembert Boxes are in the collection of the artist, and two are in the collection of Jorge and Marion Helft, Buenos Aires.

29. Salvador Dali, as told to André Parinaud, *The Unspeakable Confessions of Salvador Dali* (New York: William Morrow, 1976), p. 143.

30. Jorge López Anaya, *Alberto Heredia: Esculturas y dibujos, 1970/1984* (Buenos Aires: Fundación San Telmo, 1984), n.p.

31. Ibid.

32. Ibid.

33. Dore Ashton, "Jacobo Borges—Life and Work," in *Jacobo Borges* (Berlin: Staatliche Kunsthalle, 1987), p. 26.

34. Carter Ratcliff, "On the Paintings of Jacobo Borges," *60 obras de Jacobo Borges* (Monterrey, Mexico: Museo de Monterrey, 1987), p. 13.

35. See Holliday T. Day, "Jacobo Borges: 1931–," in Holliday T. Day and Hollister Sturges, eds., *Art of the Fantastic: Latin America, 1920–1987* (Indianapolis: Indianapolis Museum of Art, 1987), p. 153.

36. See Ashton, "Jacobo Borges," pp. 18, 22.

37. Lawrence Alloway, "Latin America and International Art," *Art in America* (June 1965), p. 72.

38. Ratcliff, "On the Paintings of Jacobo Borges," p. 17.

39. See Jacqueline Barnitz, "The Marisol Mask," *Artes Hispánicas* (Bloomington, Indiana) 1, no. 2 (Autumn 1967), p. 45.

40. Ibid., p. 47.

41. Quoted in Charlotte Aillaud, "Figures in a Tuscan Landscape: Artist Fernando Botero's Nineteenth-Century Farmhouse," *Architectural Digest* 42, no. 9 (September 1985), p. 134.

42. Cynthia Jaffee McCabe, *Fernando Botero* (Washington, D.C.: Smithsonian Institution Press, 1979), p. 97. "La Violencia" refers to a period of violence that occurred in Colombia between the mid-1940s and the early 1950s.

43. Fernando Botero, conversation with the author, New York, 1965.

44. Cárdenas taught at the Universidad de los Andes, the Universidad Jorge Tadeo Lozano, and the Universidad Nacional de Colombia.

45. Lawrence Alloway, *Realism and Latin American Painting: The 70s* (New York: Center for Inter-American Relations, 1980), p. 15.

46. Eduardo Serrano, *The Art of Santiago Cárdenas* (Miami: Frances Wolfson Art Gallery, Miami-Dade Community College, Wolfson Campus, 1983), n.p.

47. Santiago Cárdenas, quoted in ibid.

48. Rojas and Cárdenas exhibited together in a two-person show at the Center for Inter-American Relations (now the Americas Society) in New York in 1973. See *Carlos Rojas/Santiago Cárdenas* (New York: Center for Inter-American Relations, 1973).

49. A notable exception is Claudio Bravo.

50. See W. Kotte, "Interview with Antonio Seguí," in *Antonio Seguí, pinturas* (Caracas: Fundación Museo de Bellas Artes, 1978), n.p.

51. This series of drawings was exhibited in 1978 by the Galerie du Dragon in Paris, under the title *Elephants de la Pampa*. See *Segui: Peintures, dessins et reliefs* (Aix-en-Provence: Cloître Saint Louis, 1985), p. 106. Their present location is unknown.

The Theme of Crisis in Contemporary Latin American Art

Paulo Herkenhoff

In his essay "Crise do condicionamento artistico," the Brazilian critic Mário Pedrosa stated that a crisis in the communicative and social functions of art had catalyzed the emergence of a social and cultural phenomenon he described as postmodern.[1] Since the mid-1960s numerous artists from Latin America have addressed the theme of crisis. They include the Brazilians Frida Baranek, Waltercio Caldas, Antonio Dias, Frans Krajcberg, José Resende, and Tunga; the Colombians Miguel Angel Rojas and Bernardo Salcedo; and the Argentine Jacques Bedel.[2] Sculptors and painters of different generations, these artists do not belong to a single school, movement, or artistic tradition. Instead, they have engaged the theme of crisis through visual languages reflecting their individual histories of seeing, framed by the cultural traditions of their respective nations of origin. Because these languages also reflect the impact of the same philosophical discourses on artists in the United States and Europe, their mental itineraries are not restricted by geopolitical boundaries. Thus, their engagement with the theme of crisis gives credence to Tunga's assertion that "geopoliticizing is only a coarse approximation of what art represents for the human spirit."[3]

Many Brazilian artists who came to prominence in the 1960s were indelibly affected by a series of intertwined economic, political, and social crises that began to intensify after President Juscelino Kubitschek left office in 1961. Kubitschek's optimistic commitment to national progress through the process of modernization, symbolized by the construction of the new capital of Brasília, ultimately resulted in an enormous budget deficit which compounded Brazil's economic difficulties. When his successors attempted to resolve these difficulties by championing controversial reforms, conservative members of the military interpreted their efforts as a threat to capitalist interests. They consequently seized power in a 1964 coup supported by the United States government, establishing a military dictatorship that remained in control until 1985. Although the coup's leaders claimed that their seizure of power was justified by the severity of Brazil's economic problems, and that it would ultimately pave the way for the restoration of a healthy democracy, they consolidated their authority through increasingly repressive measures. These included depriving citizens of their political rights, censorship, and the imprisonment and torture of political dissidents, measures which became more severe during the late 1960s. Although the economy recovered briefly in the early 1970s, the military regime had dramatically altered the tenor of Brazilian life without providing any lasting answers to the problems at the root of the nation's social unrest.

It was within this historical context that an art of crisis emerged in Brazil. For many Brazilian artists, the abstract languages of Constructivism and informalism, which had dominated the visual arts since the early 1950s, had reached an aesthetic and social impasse by the end of the decade. In 1959 in Rio de Janeiro, a group of artists and writers disillusioned with Concretism, including Lygia Clark, Hélio Oiticica, Lygia Pape, Franz Weissmann, and Amílcar de Castro, signed the "Neo-Concrete Manifesto," written by Ferreira Gullar.[4] Inspired in part by the philosophies of Maurice Merleau-Ponty and Susanne Langer, the neo-Concretists advocated a new approach to perception, striving to instill the objectivity of Concrete art with a subjectivity verging on the poetic. At the same time, they sought to reintegrate art and life by forging a politicized alliance with a broad cross section of society. Their main strategy in this regard was

to transform the spectator from a passive observer into a subject in his or her own right, necessary for the plenary existence of the work.

Simultaneously, many artists influenced by informalist abstraction returned to the figure in an attempt to forge a new image of humanity that reflected the existential alienation afflicting postwar society. In 1961 *Otra figuración*, the first group exhibition of the Argentine artists Ernesto Deira, Rómulo Macció, Luis Felipe Noé, and Jorge de la Vega, who had collectively developed an expressionistic mode they called Nueva Figuración, was presented at the Galería Peuser in Buenos Aires. As Noé declared in the preface to the exhibition's catalogue, "*Otra figuración* is not figuration once again. The men of today have the same faces as those of yesterday, but, nevertheless, the image of the man of today is distinct from that of the man of yesterday. The man of today . . . is in a permanent existential relationship with his fellow men and with things. I consider this elemental relationship to be fundamental to *otra figuración*."[5] The new figuration espoused by these artists, who often added debrislike objects to their canvases, became known to many young Brazilians through an exhibition presented in 1963 at the Galería Bonino in Rio de Janeiro. Especially influenced were Antonio Dias, Rubens Gerchman, and Carlos Vergara.[6] Pop art, which was introduced into Brazil by the São Paulo Bienals of the 1960s, exerted a similar impact. Finally, in the political realm, the Cuban Revolution of 1959 inspired many Brazilian artists by offering the promise of a social utopia in the face of the ever-increasing threats to personal liberties posed by the repressive military regimes that had begun to seize power in Latin American countries in an alleged "defense" of freedom.

In the midst of this climate of combined political and artistic crisis, Dias emerged as an artist actively committed to exploring the ethical horizon of political transformation. After his most immediate artistic response to the military coup of 1964, a sculpture he created by shooting bullets into a mannequin, he produced a series of paintings incorporating stuffed objects evoking human viscera, affixed to supports on which skulls, bones, weapons, and other macabre images were painted in a style reminiscent of comic books. While the stuffed objects recall Claes Oldenburg's soft sculptures, as well as the collaged paintings of de la Vega's Bestiario series, such as *Indecision* of 1963 (Museu de Arte Moderna, Rio de Janeiro), they are perhaps most closely related to Clark's rubber Grubs of 1964, a series of soft, malleable, abstract sculptures intended for spectators to manipulate. Similarly, while the paintings' cartoonish images could recall the work of Pop artists from the United States, such as Roy Lichtenstein and Andy Warhol, they derive from a specifically Brazilian context. Instead of expressing the nature of consumption and communication in a postindustrial society of spectacle, Dias's repertory of bones, phalluses, weapons, flags, and dollar signs evoked a developing society which had not been saturated by media images and brand-name products. Perhaps more significant, it comprised an iconography that tested the limits of artistic freedom under a repressive dictatorship in which the threat of censorship, imprisonment, and torture had seriously compromised the right of free expression. These images reflect a society in which sex, politics, ideology, and capital constitute forces that compete in a violent struggle, a society in which the destructive drive of capitalism is signified by symbols that are fragmentary representations of power.

In such works as *Note on Unforeseen Death* of 1965 (figure 1),

which Oiticica considered the "turning point" with respect to the ethical status of the visual arts in Brazil in the 1960s, Dias explicitly criticized the violence unleashed by the implementation of the military dictatorship. Rendering images of torture and death in a banal graphic style reminiscent of comic books, he demythologized the glorified carnage that comic books often display and consequently unmasked the supposedly neutral mass media. Furthermore, by emphasizing the visual and tactile luxury of the stuffed objects affixed to the painting's lower quadrant, which evoke bloody viscera, he endowed this work with a multisensory appeal, reminiscent of the

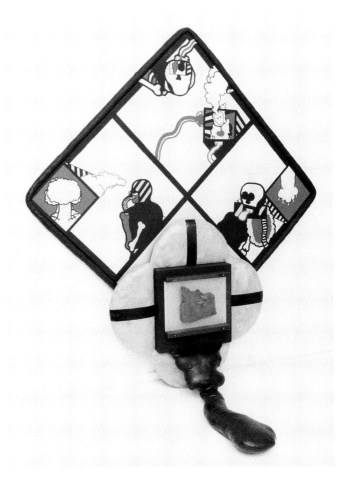

1. Antonio Dias. *Note on Unforeseen Death*. 1965. Synthetic polymer paint and vinyl on masonite and canvas, foam rubber, plastic, and wood, 6' 2⅞" x 69⅜" x 19⅝". Collection the artist

work of Marcel Duchamp, that signals a troubling eroticization of vision. Dias's symbols of the body become complicit with the eye's own carnality; as in the writings of Georges Bataille, the interdicted once again links itself with death through the process of vision. Never in Brazilian art had violence been so nakedly exposed as a crude state of beauty.

In 1968 Dias moved to Milan, where he abandoned the figurative mode he had been pursuing for the formal reductiveness of Conceptualism. His first works were monochromatic paintings inscribed with allusive words and phrases. Like "GOD" and "DOG," juxtaposed in *The Hardest Way* of 1970 (Private collection), these words were often yoked together like unreliable mirrors to reflect

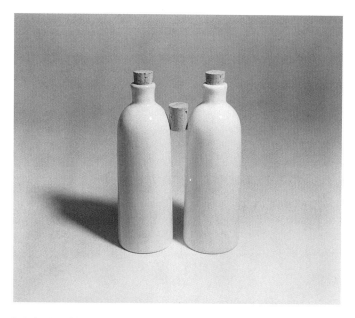

2. Waltercio Caldas. *Bottles with Cork*. 1983 (after a work of 1975). Two ceramic bottles and three corks, 9⅞" high. Collection Liba Knijnik, Pôrto Alegre, Brazil

previously hidden realities through harrowing yet irrefutable revelations. Though these works possess considerable sensual appeal in the refined purity of their graphic design, Dias's abandonment of images for language suggests that he increasingly desired to create politically committed art liberated from bourgeois aesthetic conventions.

He pursued this desire in a systematic manner in The Illustration of Art, a series of paintings and wall installations produced from 1972 to 1976, which follows an unrelenting regimen of reduction and repetition. *The Illustration of Art/Art Model* of 1973 (plate 55), comprises six black rectangular paintings displayed side by side; a square in the upper right corner of each, equal to one-sixth of the painting's surface, is left unpainted. *The Illustration of Art/Society Model* of 1973 (Private collection) comprises six paintings identical to the works just mentioned, plus a seventh painted entirely black. Dias has stated that the image of the rectangle with one corner missing evokes for him the floor plan of an art gallery, an association that encourages reflection on the process by which the relationship between art and society is defined through cultural institutions. When the two works are considered together, it may be inferred that the paintings constituting *Art Model* are a subset of those that make up *Society Model*, Dias thereby affirming that art is not autonomous from society, even within the rarefied aesthetic realm of the art gallery. He reaffirms this conviction by exploiting the convention of a painting as a rectangle, a convention that leads the spectator to perceive the unpainted area as a lack in each of the paintings that *Art Model* comprises, a lack which he defines as the social in *Society Model*.

In 1977 Dias traveled to Nepal, where he learned traditional techniques of paper production from local crafts people. Since that time his paintings and drawings have assumed a material richness not present in the works of his most rigorous Conceptual period; nevertheless, they reveal their link with those works through the persistent presence of images of rectangles with one corner missing. For example, in *Economy* of 1989 (plate 56), this symbol is poetically rendered in red and gold against a tactile gray background, as if its materiality

were a necessary condition of its reinvestment with new meaning. Symbols of power, such as phalluses and weapons, which Dias had used in his mixed-medium works of the 1960s, also re-emerged in this period in a newly materialized form. Thus, even in an opulent setting, there survives the artist's aim of articulating a critical symbolic language from the signs that saturate contemporary society.

Like Dias, Waltercio Caldas emerged as an artist during the most repressive years of Brazil's military dictatorship. Although the objects and sculptures he has created since the early 1970s lack an explicitly political content, they are not politically disengaged. They can be situated within a tradition inaugurated by artists like Marcel Duchamp, with his Readymades, and given a theoretical basis by critics like André Breton, whose essay "The Surrealist Situation of the Object" questioned the rationalistic models of perception developed during the Renaissance.[7] Moreover, Caldas formulated, through the extremely refined formal language of these works, an epistemology of perception in which the certainties of seeing are corroded, and he thereby engendered a politics of awareness in an era of rampant obscurantism.

In the first half of the 1970s Caldas designed a variety of disquieting objects, recalling both Duchamp's Rectified Readymades and Surrealist objects that disturb the complacency of the spectator's gaze. For example, *Center of Primitive Reason* of 1970 (Collection Gilberto Chateaubriand, Rio de Janeiro), is a box, bearing a plaque with its title, in which four spikes are aimed at the spectator, as if they were meant to impale his or her eyes. Similarly, in *Bottles with Cork* of 1983 (figure 2), object and eye interact as the spectator wonders when or if a cork, balanced between two ceramic bottles, will fall. The fact that this work (modeled on an earlier version of 1975) resembles a pair of binoculars suggests that Caldas's subject is the precariousness of perception itself. In the later *Einstein* of 1988 (plate 36), Caldas placed the black head of a pin in line with a black dot painted on a white ball. Pin and ball confront each other, as if the former is in danger of being dissolved into the black hole of the latter. By suggesting the possibilities that the spikes may impale, the cork may fall, and the pin may be dissolved, Caldas implies that perception is a troublingly uneasy process.

As he continued to design similar objects through the 1980s, Caldas simultaneously began to produce sculptures that express another kind of perceptual unease by stressing the qualities of emptiness, absence, silence, and lack. Reflecting the inspiration of Constantin Brancusi and Giorgio Morandi, these sculptures have a refined physical presence that positions them at the extreme limit of visibility. For example, *Curve I* of 1986 (Collection Ricard Takeshi Akagawa, São Paulo), a finely polished disk of black granite, is meant to be illuminated from above while the underside remains in darkness, so that its physical presence seems to be dissolved by the light it reflects. The artist has stated, "This object illustrates how I try for the same degree of absence and presence in each object. . . . It's as if the line were a comma in a sentence."[8] In *Spinoza* of 1986 (Collection the artist) Caldas constructed two surfaces not of matter but of air: one is defined by a vertical metal ring and the other by the two horizontal metal rods that flare from it. The sculpture subtly encourages the spectator to wonder whether it exists as a body or a space. Finally, in *Far* of 1986 (Collection the artist) Caldas utilized glass and thread to form a column of emptiness that dissolves the physical boundaries demar-

cating the work from the space surrounding it. In this sculpture, air becomes a skin that defines both the corporeality of the object and that space. In these seductively enigmatic works, the spectator cannot unequivocally discern the difference between materiality and immateriality. It is as if the propositions of Spinoza's *Ethics* were being addressed to a world in which the reciprocity between the object and its appearance has become exceedingly confused.

Such visual enigmas evoke Merleau-Ponty's philosophy of ambiguity as well as the phenomenology of Edmund Husserl. In this regard, it is useful to recall the former's assertion: "My body as stage director of my perception has shattered the illusion of a coinciding of my perception with the things themselves. Between them and me there are henceforth hidden powers, that whole vegetation of possible phantasms which it holds in check only in the fragile act of the look."[9] Caldas's sculptures require a kind of perception that can sense a realm lying beyond the physical one, for they seem to exist in a world that will not reduce itself to things seen. As the artist has said, "We are not required to believe entirely what we see, are we? There is doubt that belongs to clarity."[10] In these sculptures, perception establishes itself in the transitional zone between precision and ambiguity; seeing becomes a game of awareness. When confronting one of his works, the crucial question always seems to be, Where does the art begin in this art?

While Caldas has emphasized such qualities as immateriality, to encourage the spectator to become aware of the limitations of perception, his contemporary José Resende has instead stressed the materiality of his work. A dominant personality in the panorama of contemporary Brazilian art, Resende creates abstract sculpture by combining materials such as lead, copper, leather, paraffin, and felt, which he subjects to various physical processes (figure 3). With the

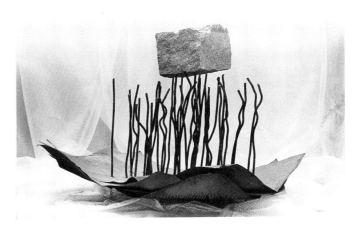

4. Frida Baranek. Untitled. 1988. Iron rods and plates, and stone, 36 x 47¼ x 39⅜". Collection John Arnstein, São Paulo

exception of his Cor-Ten steel sculptures, he does not previsualize his compositions. Instead, he allows the infiltrations, twistings, and movements of molten materials to determine the form of each work. His aim, he has stated, is to provide a poetic context for a set of actions and allow art to give a new dimension to the laws of nature by guiding nature's blind logic.

Resende's sculptures engage in a dialogue with nature. Although his use of elemental materials such as lead and copper has encouraged many critics to describe him as an alchemist, Resende has rejected this label: "I don't work with alchemy. I don't work with the symbolic representation of the elements. Perhaps it is the opposite of alchemy. Without being a physicist or a chemist, I would represent one more inversion of alchemy, in the order of art rather than science."[11] In contrast to the work of artists like Joseph Beuys, Resende's sculptures are not part of a process of symbolic articulation; they obey an inner destiny, determined by their materials' inherent qualities of plasticity, malleability, and resistance. These materials dynamically mold and structure themselves, in relation to one another, forming a kind of analogy of the self's search for its complement in the other. They diagram a model of social interaction determined by processes that reveal only partial identities.

Frida Baranek's fragile nests of rusted wire, stones, and steel sheets diagram an even more disturbing social model by exemplifying the aesthetic of precariousness that permeates contemporary Brazilian culture (figure 4). A generation younger than Caldas, Dias, and Resende, Baranek emerged in the early 1980s, after the collapse of the tyranny of painting in Brazil, together with the sculptors Jac Leirner, Ernesto Neto, and Waleska Soares. Although her work reveals the influence of Beuys, Eva Hesse, and Richard Serra, Baranek has been inspired equally by Brazilian artists such as Amílcar de Castro, Hélio Oiticica, Mira Schendel, Franz Weissmann, and especially Ivens Machado (figure 5). Like Machado, Baranek rejects a formalist approach and exploits the connotations of her materials. The social model of urban space that her sculptures suggest also reflects the influence of Machado.

Despite the rawness of their appearance, these works are replete with social implications. Baranek's materials seem to have been salvaged from ruins or demolition sites, giving the work a disturbingly urban character. Specifically, they evoke the *favelas,* or

3. José Resende. Untitled. 1991. Nylon, paraffin, and lead, 9' 10" x 59" x 16' 5". Collection the artist

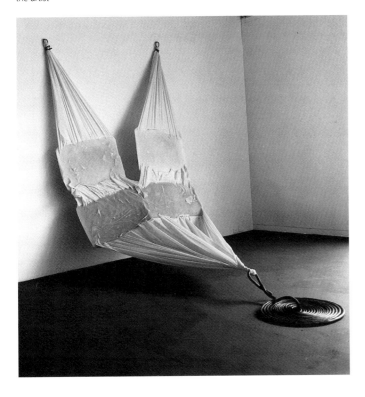

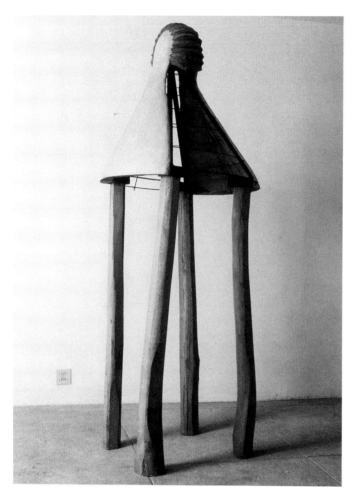

5. Ivens Machado. Untitled. 1985. Reinforced concrete and wood. 9' 2⅝" x 37⅜" x 37⅜". Collection the artist

shantytowns, that exist in virtually every major Brazilian city. The hovels in these *favelas* manage to stand in unstable equilibrium until they collapse each year with the coming of the summer rains. When Oiticica peremptorily affirmed, "of adversity we live," he underlined the ethical consciousness of the reality of risk that this phenomenon illustrates.[12] By positing her sculptures as fragments of this fragile social landscape, Baranek seems to suggest that their existence is conditioned by a certain degree of risk. Instead of the promise of eternity, their fate is to return to dust. In her art, as in the hillside shantytown, matter seems to disregard the law of gravity and to challenge any fantasy of certainty.

While Baranek's sculptures make the viewer aware of urban decay, Frans Krajcberg's drawings, reliefs, sculptures, and assemblages of the past two decades draw attention to the precarious condition of Brazil's rain forests, wetlands, and other natural regions. Krajcberg is a native of Poland who emerged within the context of European rather than Brazilian modernism. His family was killed during the Holocaust, and after the war he moved to Stuttgart, where he studied with Willi Baumeister. In 1948 he moved to Brazil, where he has lived in São Paulo and Rio de Janeiro, as well as more traditional communities in the states of Paraná, Minas Gerais, and Bahia. Krajcberg first experienced Brazil's natural environment after

moving to the southern state of Paraná in 1952, a time when massive deforestation was beginning to occur. He found in Paraná's semi-tropical forests an antidote to the moral despair that had plagued him since the end of World War II. As he has observed, "Nature gave me strength, gave me back the pleasure of feeling, thinking, and working. Of surviving. I walked through the forest and discovered an unknown world. I discovered life."[13] Although his first Brazilian works were monochromatic landscapes, it was paintings of ferns inspired by memories of Paraná that brought Krajcberg his initial success. After being honored as the best Brazilian painter in the São Paulo Bienal of 1957, he returned to Paris and then traveled to Ibiza, Spain, where he created his first earth and rock impressions, occasionally using natural materials he had brought from Brazil. These works recall the experiments with sand of both André Masson and Georges Braque, and in fact Krajcberg made two collaborative lithographs with Braque in 1960. He returned to his adopted homeland repeatedly during the 1960s and in 1964 established a studio in the central Brazilian state of Minas Gerais, where he created two-dimensional works from earth, roots, leaves, and other natural materials he collected from *mangues* (swamps) and *cerrados* (savannas); he also made sculptures of charred tree trunks scavenged from mining fields. In his search for new forms, Krajcberg recreated in these works the splendor of nature in visual rhythms of light and shadow. Yet he later described them as the products of his "naive and romantic phase."[14]

As he became more aware of the threats to Brazil's natural environment, Krajcberg began to think that his work of the 1950s and 1960s had been compromised by its purely aesthetic focus. Consequently, in the mid-1970s he attempted to transform his art into a weapon in defense of nature. A crucial step in this process was his 1978 voyage up the Rio Negro, the Amazon's greatest tributary, with the artist Sepp Baendereck and the critic Pierre Restany. Restany was inspired to write the "Manifesto of the Rio Negro," also known as the "Manifesto of Integral Naturalism," which expressed Krajcberg's vision of his art. Defining Amazonia as the last refuge of "integral nature" on the planet, Restany advocated the "integral naturalism" practiced by Krajcberg as a necessary response to the dematerialization of the art object initiated by Conceptual artists in the mid-1960s. For Restany this process of dematerialization was symptomatic of a crisis of legitimacy, which called into question the function of art in contemporary society. Integral naturalism promised a redemption of art by inaugurating a new era of pure sensibility. He wrote, "A context as exceptional as that of the Amazon gives rise to the idea of a return to original nature. Original nature must be exalted as a hygiene of perception and mental oxygen—an integral naturalism, gigantic catalyzer and accelerator of our faculties of feeling, thinking and acting."[15] Rebelling against the pollution of the senses, as well as that of the environment, this position is similar to the Brazilian writer Graça Aranha's conception of the jungle's role in the construction of the Brazilian modernist ethos.

The sculptures Krajcberg has created since the publication of the "Manifesto of the Rio Negro" powerfully reflect his determination to defend, with his art, Brazil's natural environment. Totems in a time of crisis, his works created from the charred remains of the rain forest are plaintive remnants of an ecological disaster of potentially catastrophic dimensions (figure 6). Like the phoenix, these fragments of tragedy are reanimated by Krajcberg, becoming hauntingly

lyrical works of art. In this way, he affirms his belief in the capacity of the individual to rebuild the world through the transcendental power of art.

In contrast to this optimistic vision, the work of Tunga is fraught with angst. Tunga emerged as an artist in the mid-1970s, and he is best known for the installations, sculpture, and drawings he has created since the early 1980s. These have included enormous tresses and braids made of wire, magnetized sheets and bins encrusted with iron filings and copper leaf, tori of various sizes, and paintings on silk. Images of intertwined snakes, lizards joined at the mouth or tail, Siamese twins who share the same hair, and circular tunnels from which there is no escape disturbingly animate the abstract forms he creates. In such works, Tunga uncovers a phantasmic dimension of art, politics, and psychoanalysis, a dimension that serves to undermine the rationalism that seemingly structures these discourses.

Like Lygia Clark, Tunga has been inspired by the expressive possibilities of topology, a branch of mathematics that deals with the properties of geometric configurations as they are subjected to various kinds of deformation. The topology of the Moebius strip, a spatial form in which the surfaces of interior and exterior meet on a continuum—as if obverse and reverse each contained the other—has held great appeal for the artist. He also has repeatedly employed the form of the torus, a doughnut-shaped surface that, like the Moebius strip, collapses the distinctions between interior and exterior. Although he has created many sculptures in this form, perhaps his most ambitious is *Economic Torus*, commissioned in 1983 by a

Brazilian insurance company whose logo features the image of Rio de Janeiro's Sugar Loaf Mountain. For this commission Tunga produced two tori. One was made of five hundred pounds of lead into which one-sixth of an ounce of gold was melted. The other consisted of a narrow band encircling Sugar Loaf Mountain, from whose summit one-sixth of an ounce of gold was sprinkled over the city. In this work, Tunga posed a fundamental question for an insurer, which also can be understood as a political allegory: is something valuable more secure if its location is known but it cannot be removed, or if it can be removed but its location is unknown? Posing this question without providing an answer, this work leaves the spectator in a state of unease.

Tunga further explored this state of unease in the sculptural installations that constitute his Lezarts, or Lizarts, series of the late 1980s, terms that are corruptions of the French *lézard* (lizard). He has suggested that the central metaphor for this series is an image of two lizards attempting to consume each other's heads to become one.[16] Just as the artist's use of the torus reveals the inadequacy of the terms interior and exterior, it likewise suggests how inadequate are the terms singularity and duality. Neither term can be applied to the double-lizard image, for it is, paradoxically, both and neither. Tunga's concept of relationality is exemplified by other images in the Lezarts series, such as intertwined serpents, gigantic braids of hair made of copper wire, and *The Capillary Siamese Twins* of 1989, two models joined by their hair (figure 7). These disturbing images are exhibited with texts that recount psychotically disjunctive narratives somewhat reminiscent of the stories of Edgar Allan Poe.

6. Frans Krajcberg. Untitled. 1992. Burnt wood with natural pigment, dimensions variable. Installation view, Museu de Arte Moderna, Rio de Janeiro, 1992

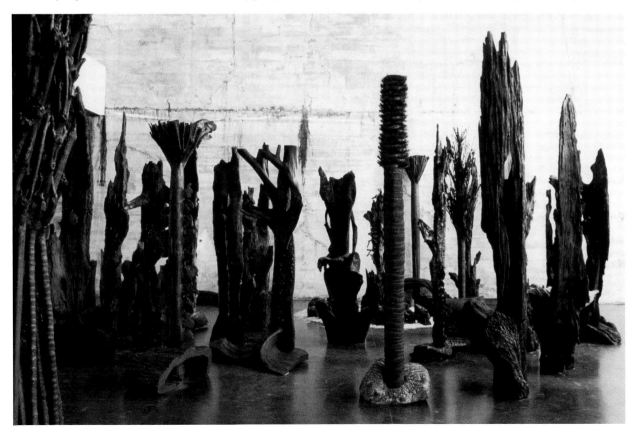

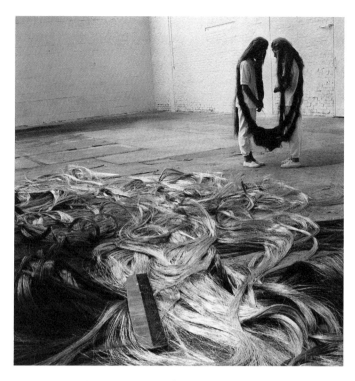

7. Tunga. *The Capillary Siamese Twins*. Performance, 1989. Shown with detail of *Lezarts II, Les Pendues*. 1989. Copper/iron plates and wire, and magnets, dimensions variable. Installation view, Kanaal Art Foundation, Kortrijk, Belgium, 1989

Tunga extended his uneasy interrogation of the concept of relationality directly into the psychic realm in what he called *Palindromo incesto* [*Palindrome Incest*] of 1992 (plate 221). He emphasized that the term should be regarded not as the title of a discrete work but as a concept that encompasses a series of works begun in 1990. One sculpture from this series, created in 1991, is composed of two large magnetic bins that attract copper and iron, respectively. This work depends on the concept of relationality rather than measure; it can consequently be presented differently each time it is installed. Like the Moebius strip, the torus, and the verbal palindrome, which can be read from beginning to end or end to beginning with no change in meaning, this work evokes a model of relationality in which binary opposition, one of the principles of Western rationalist thought, collapses. As Tunga has stated, he has tried here "to annul the terms of exterior and interior, of inconsequential and consequential."[17] Suggesting for him the very structure of the human mind, this work exemplifies what is at stake in his art: the restructuring of mental space.

In 1992 Tunga conceived an installation that built upon the conceptual foundation of *Palindrome Incest*. Using the same materials, he created different versions of this installation for each of three venues of the large exhibition of Latin American art of the twentieth century organized by the International Program of The Museum of Modern Art, New York.[18] The materials included three enormous "thimbles" of copper and iron, three similarly sized "needles" of copper and steel, three tori of copper and iron, and three bulbous thermometers. Like many of the artist's previous works, this installation comprised separate entities that formed a whole through the invisible force of magnetism, yet retained visibly distinct identities. It thus embodied the paradox of that which is one yet not one. His deploy-

ment of the elements in threes is of particular interest, since it recalls the Holy Trinity, the paradigmatic example of this paradox. Tunga has stated[19] that the installation is specifically related to Chapter Ten of Saint Augustine's *Confessions*, in which the early Christian theologian discusses his struggle to know God in spite of his senses: "Late have I loved you, beauty so old and so new: late have I loved you. And see, you were within and I was in the external world and sought you there, and in my unlovely state I plunged into those lovely created things which you made. You were with me, and I was not with you. The lovely things kept me far from you, though if they did not have their existence in you, they had no existence at all."[20] Augustine's description of his inability to recognize what was within him suggests the paradox that permeates Tunga's work.

——

As in Brazil, social and political unrest during the 1960s indelibly affected many emerging artists in Colombia, especially those who embraced Pop and Conceptual art. The founding of institutions like the Museo de Arte Moderno in Bogotá, begun in 1962, and the initiating of various national biennials later in the decade greatly expanded opportunities for young artists. Although Bogotá remained the artistic capital, cities such as Medellín, Cali, and Barranquilla were also very active. The art produced in these cities reflected the dominance of geometric abstraction and figuration. Artists such as Eduardo Ramírez Villamizar and Edgar Negret created work characterized by rigorous geometry, formal rationality, and the search for symbolic meaning. By contrast, artists such as Enrique Grau and Fernando Botero remained loyal to the figure, producing images that seemed to parallel the fantastic universe of the novelist Gabriel García Márquez.

Yet another group of Colombian artists utilized the formal languages of Pop and Conceptual art to create politicized work that responded to the violence unleashed as modernization began to transform traditional Colombian society. In this regard, it is useful to invoke the Argentine critic Marta Traba's concept of "closed" and "open" areas, which she explained in her influential book *Dos décadas vulnerables en las artes plásticas latinoamericanas, 1950–1970*.[21] Defining closed areas as those that maintain local cultural traditions and open areas as ones more permeable to transcultural influences, Traba described Colombia as a paradigmatic case of a closed area where two qualities of its traditional culture, eroticism and humor, have been a constant presence in its art. The work of Miguel Angel Rojas exemplifies the former, and that of Bernardo Salcedo shows the latter. The manner in which the work of each artist respectively displays these qualities reflects their view of art's function in a society plagued by violence.

Since the early 1970s Miguel Angel Rojas has created mixed-medium prints, photographs, and paintings, as well as installations, in which the theme of eroticism is part of a broader investigation of the violence entailed in the formation of social identity. Rojas's first major works were abstract geometric paintings derived from his study of mathematical perspective as an architecture student at the Pontificia Universidad Javeriana in Bogotá from 1964 to 1966. Although these works enjoyed critical success, Rojas soon became dissatisfied with the rigidity of geometric abstraction. As he stated in a 1989 interview, "I did not let myself get carried away with the success of the

work. I felt that this was not the path I was seeking. I broke with everything . . . and I drew until I managed to clarify the compulsion for eroticism as a subject."[22]

Explicitly confronting this compulsion, Rojas created in the early 1970s works addressing the concept of social identity: a series of photorealist drawings and prints in which he depicted cropped, erotic views of blue jeans, boots, and other articles of clothing regarded as fetishes. By the mid-1970s he had begun to approach art as a means of self-analysis. As he later declared, "I realized that I had to dig deep into myself and I looked upon art as a system for self-analysis. At that time I often went to the theater, the Faenza theater, for example, and this was the occult and intense aspect of my reality. There I found what was to connect me to my kind of truth."[23]

Inspired by his experiences at the Teatro Faenza, Rojas began a series of photographs in 1978. As the camera's voyeuristic eye became a virtual extension of his body, he secretly captured the clandestine sexual activities of the theater's patrons. In his photographs these activities are barely discernible because of the darkness of the images (figure 8). Nevertheless, voyeurism shades into clairvoyance by revealing glimpses of a phantasmic realm. For Rojas the obscurity of these photographs signals the impossibility of completely expressing the self through representation.

Rojas continued his investigations into this aspect of the formation of social identity two years later in a series of photographs titled Vía Láctea, for which he again secretly photographed furtive sexual encounters, this time through a small hole in a public rest room. Like the Teatro Faenza photographs, these images reveal a dark world in which voyeurism becomes a mode of access to the phantasmic dimension of sexuality. They suggest that beyond what is ordinarily visible lies a realm in which the production of identity is freed from the constraints of repression.

In the mid-1980s Rojas began a series of mixed-medium works which broadened his interrogation of the concept of social identity to include ethnicity. In these pieces, he explored the indigenous ancestry of his family and his nation, representing pre-Columbian figures through a vigorously expressive combination of drawing, painting, and photography. He described many of these works as *revelados parciales*, or "partially developed," photographic images ren-

8. Miguel Angel Rojas. *Three in the Orchestra, No. 3*. 1979. Gelatin-silver print. Collection the artist

dered almost unrecognizable by strokes of paint. With regard to these works, it is useful to consider the cultural critic Jean-François Lyotard's conception of "figural entreaty" in *Discourse, Figure*, which implies transgression of the distance inherent in representation and which strips bare phobias, repressions, and censures. In Rojas's works of this period, the images of the pre-Columbian figures are products of rendering that literally transgresses the boundaries that define the various mediums he employs, as if he were symbolically defying the interdictions of the Colombian patriarchy.

While Rojas has utilized eroticism to reveal the constraints imposed on the definition of identity in Colombia, Bernardo Salcedo has employed humor to pursue his critical agenda. Since the mid-1960s Salcedo has created collages and assemblages from found images and objects. Liberating them from their original functions, he invests them with new meanings, which expose in a humorous yet often disturbing manner the contradictions in the functionality that structures contemporary consumer society.

According to Jean Baudrillard, who addressed the concept of functionality in his seminal 1968 text *Le système des objets*, contemporary consumer society is distinguished by its "system of objects," the aggregate of commodities that proliferate in everyday life, as well as the concepts supporting their invention and marketing. The most central of these concepts is that of functionality. As Baudrillard observed, "'functional' by no means names that which is adapted to a purpose, but that which is adapted to an order or to a system: functionality is the faculty of being integrated with a whole. For the object, it is precisely the possibility of going beyond its function toward a second function, of becoming an element of play, of combination, of calculation in a universal system of signs."[24]

Since 1965 Salcedo has created several series of assemblages in the form of boxes, which give the appearance of having a function, and thus seem akin to Pop art, but in fact subvert functionality. Recalling the boxes produced from the 1930s to the 1950s by the Surrealists, and especially the Medici series of Joseph Cornell, these works are fabricated from heterogeneous machine parts, fragments of dolls, and other found objects. As Damián Bayón has written, their sense "is ambiguous, their signification aleatory like that of a mirror. That is to say: they reflect that which is put in front of them. An innocent will see the innocence of dolls; a fetishist will adore these girls dressed in bows and starched petticoats."[25] By mounting gears on them, elaborating their structures, and assembling disparate parts, Salcedo redesigned the objects he appropriated and invalidated the functions they originally served. Thus the spectator is led to recognize the extent to which he or she is constrained by the technological imperatives of contemporary consumer society. Salcedo thus affirmed, in Baudrillard's words, that "the everyday manner of using objects constitutes an almost authoritarian scheme of presumption of the world."[26]

In 1981 Salcedo exhibited thirty works from his series Personal Signs (plate 179). These works consist of found photographs of anonymous individuals, most of whom appear to be members of the bourgeoisie. Onto the faces of these individuals he affixed keys, compresses, shaving brushes, pieces of machinery, and other objects. In a statement published in the brochure accompanying the exhibition, Salcedo wrote, "This proves that one lives with his head filled with things, and that above all one must always remember people, who,

in general, are what is most quickly forgotten. Of course."[27] Reflecting his contention, Salcedo glued bullets on the faces of the anonymous men and women posing for a group portrait in *The Class of '42* of 1981 (Collection Rafael Santos Calderón, Bogotá). The bullets further obscure individual identities but allow the hidden realities of social and familial violence to emerge in a somber and mysterious rearticulation of meaning. Subverting the assumption that photography is a mirror of the world, Salcedo once again created a different logic for the mechanical, just as he had done in his boxes. His transformation of objects argues that art signifies not a cumulative process of cognizance but an experience in becoming.

—

The 1960s was a decade of turmoil in Argentina, as it was in Brazil and Colombia. In this period of political crisis, Jacques Bedel emerged as an artist. Reacting against the Nueva Figuración and Pop art movements of the first half of the decade, Bedel and other members of his artistic generation abandoned painting in their quest to redefine the nature of the art object. Although Bedel experimented with kinetic art during his studies with the Groupe d'Art Constructif et Mouvement in Paris in 1968, he developed his own distinctive style only after becoming a member of the Grupo de los Trece (Grupo CAYC), an association of progressive Argentine artists based at the Centro de Arte y Comunicación, an institution founded in Buenos Aires in 1968 by the critic Jorge Glusberg.

Although Bedel has created a variety of sculptural works, he is best known for the sculptural books he has produced since the mid-1970s. Unlike conventional books, these works, fabricated from polyester resin, are coated with liquid metals and artificially oxidized so that they appear to be ancient tomes recently unearthed. They are architectonic objects whose "pages" are inner worlds rendered three-dimensionally, thus transforming the two-dimensionality of an ordinary book's pages. In this respect, Bedel plays a phenomenological game of dimensions.

His earliest books open onto miniature landscapes—ruins of pre-Columbian cities, for example—in which human actions, adventures, and fantasies are not represented by the "space" of letters but by the "time" of materials. In contrast, his later books typically contain volumetric forms, and the raised figures of mathematical equations and symbolic languages. These latter works illustrate Bedel's conception of the book as the threshold of the doorway to knowledge. As he has observed, "My work is exclusively rational and thought out because it is important to me that there be intellectual work; it is a kind of homage to the intelligence that, for now, is human. . . . I am interested in the book as a symbol of our knowledge, as a vehicle of culture and of ideas. In order to discover its message, it must be opened, read; it is a kind of required dialogue. And when it is closed, that message remains hidden; it cannot be seen. The act of opening a book constitutes a revelation."[28]

Bedel's library offers intriguing parallels with the work of Jorge Luis Borges, who has inspired many Argentine artists.[29] In particular, a fascination with the concepts of infinity and eternity is evident in the work of both. Borges's story "La biblioteca de Babel" ("The Library of Babel") serves in this regard as a virtual vade mecum for Bedel's oeuvre. In this story Borges describes a universe in the form of a vast library containing a seemingly limitless number of books in which every possible orthographical combination, and therefore all knowledge, of both the past and the future, is recorded. Yet, because "for every sensible line of straightforward statement . . . leagues of senseless cacophonies, verbal jumbles and incoherences" abound, the answers to the universe's most impenetrable questions remain inaccessible.[30] As the narrator observes, this tragic irony has caused great despair: "Perhaps my old age and fearfulness deceive me, but I suspect that the human species—the unique species—is about to be extinguished, but the Library will endure: illuminated, solitary, infinite, perfectly motionless, equipped with precious volumes, useless, incorruptible, secret."[31]

The books in Bedel's library evoke a similarly troubling conception of the philosophical dimensions of infinity and eternity. In 1976 Bedel began a series which includes *Las ciudades de plata* [*The Silver Cities*] (plate 19), inspired by the Spanish conquistadors' search for the legendary silver cities that were supposed to exist in the Río de la Plata region of Argentina and Uruguay. The miniature ruins in these books confront the spectator with the silent pathos of a past that never existed. This series inspired Bedel to consider the question of knowledge in the context of eternity. As he observed in an interview published in 1985, "I made archaeological books, but then I began to think about an archaeology for the future. Seeing what might happen if one encountered a book with a decipherable message. At this time I am interested in thinking about the permanence of a message. I am thinking about the permanence of an idea which is in this case the book, an object symbolic of our culture and of our knowledge at this moment in history."[32]

He gave form to his thoughts on this subject in *Mankind's Memory, A-1, The Earth's Moon* of 1979 (plate 18), a stainless-steel book designed, as he has stated, "to be almost indestructible, made

9. Jacques Bedel. *Book of Sand*. 1984. Synthesized sand, polyester resin, and metal; closed: 7⅞ x 19¹¹⁄₁₆ x 27⁹⁄₁₆". Collection Jorge and Marion Helft, Argentina

to last an uncommonly long time, with a message that may be deciphered later on."[33] Conceived to be "read" long after our civilization has vanished, it is inscribed with images of both the near and far sides of the moon to reveal to future generations the level of human knowledge at this historical moment, a message of hope whose premise is the assumption of tragedy. But it is perhaps Bedel's *Book of Sand* of 1984 (figure 9), that most powerfully addresses the question of eternity. Evoking Borges's story of the same name, about a book whose text, to the narrator's horror, multiplies itself to infinity, Bedel's book is filled with sand.[34] Constantly remade every time it is opened, and in this sense endless, this book embodies the desire to decipher eternity.

Notes

This essay was translated from the Portuguese by Clifford E. Landers.

1. Mário Pedrosa, "Crise do condicionamento artístico" (1966), in Aracy Amaral, ed., *Mundo, homem, arte em crise* (São Paulo: Editôra Perspectiva, 1972), pp. 87–92. See also Pedrosa's "Mundo em crise, homem em crise, arte em crise" (1967), in ibid., pp. 215–20.

2. I discuss here only artists included in the exhibition *Latin American Artists of the Twentieth Century*, but many artists, of Latin American or other origin, have addressed the theme of crisis.

3. Tunga, in an interview with the author, 1991.

4. This manifesto is reprinted in Dawn Ades, ed., *Art in Latin America: The Modern Era, 1820–1980* (New Haven: Yale University Press; London: Hayward Gallery, 1989), pp. 335–37.

5. "Otra figuración no es otra vez figuración. Los hombres de hoy tienen los mismos rostros que los de ayer, y sin embargo, la imagen del hombre de hoy es distinta de la imagen del hombre de ayer. El hombre de hoy . . . [e]stá en permanente relación existencial con sus semejantes y las cosas. Ese elemento relación considero que es fundamental en una otra figuración."—Cited in *Deira, Macció, Noé, de la Vega: 1961 Nueva Figuración 1991* (Buenos Aires: Centro Cultural Recoleta, 1991), p. 35.

6. See Paulo Herkenhoff, *Nova Figuração: Rio/Buenos Aires* (Rio de Janeiro: Museu de Arte Moderna, 1987).

7. See André Breton, "Surrealist Situation of the Object" (1935), in Richard Seaver and Helen R. Lane, trans., *Manifestoes of Surrealism* (Ann Arbor: University of Michigan Press, 1972), pp. 255–78; and Breton, "Crise de l'objet" (1936), in *Qu'est-ce que la sculpture moderne?* (Paris: Musée National d'Art Moderne, Centre Georges Pompidou, 1986), pp. 366–68.

8. Cited in Geri Smith, "Waltercio Caldas: The Mental Carpenter of Rio," *Artnews* 90 (October 1991), p. 99.

9. Maurice Merleau-Ponty, *The Visible and the Invisible*, ed. Claude Lefort and trans. Alphonso Lingis (Evanston: Northwestern University Press, 1969), pp. 8–9.

10. "Não somos obrigados a acreditar inteiramente no que vemos, não é verdade? Há uma dúvida que pertence à clareza."—The artist's commentary on his work *Disco*, in *Manual da ciência popular* (Rio de Janeiro: Edição FUNARTE, 1982), n.p.

11. Interview with Mário César Carvalho, "José Resende quer fazer a público rir," *Folha de São Paulo* (November 30, 1991).

12. Hélio Oiticica, "General Scheme of the New Objectivity" (1967), in Guy Brett et al., *Hélio Oiticica* (Rotterdam: Witte de With Center for Contemporary Art, 1992), p. 120.

13. *Frans Krajcberg: Imagens do fogo* (Rio de Janeiro: Museu de Arte Moderna; Salvador: Museu de Arte Moderna da Bahia, 1992), p. 58.

14. Ibid., p. 59.

15. Ibid. The entire manifesto is reprinted on pp. 57–58.

16. Letter from the artist, n.d. [November 1992], Tunga file, Visual Arts Department, Americas Society, New York.

17. Cited in Paulo Herkenhoff and Geri Smith, "Latin American Art: Global Outreach," *Artnews* 90 (October 1991), p. 91.

18. The exhibition *Latin American Artists of the Twentieth Century* was shown in Seville, Paris, Cologne, and New York. While *Palindrome Incest* was not included in the Paris showing, it was seen in *Désordres* at the Galerie Nationale du Jeu de Paume, an exhibition that closed just before *Latin American Artists* opened in Paris.

19. Letter from the artist, n.d. [November 1992].

20. Saint Augustine, *Confessions*, trans. Henry Chadwick (Oxford: Oxford University Press, 1991), X. xxvii (38), p. 204.

21. Marta Traba, *Dos décadas vulnerables en las artes plásticas latinoamericanas, 1950–1970* (Mexico City: Siglo XXI Editores, 1973).

22. "Pero afortunadamente no me dejé llevar por esa buena acogida. Sentí que allí no estaba yo. Rompí con todo . . . , y dibujé hasta clarificar la compulsión erótica como tema."—Interview with Ivonne Pini, "Conversación con Miguel Angel Rojas," *Arte en Colombia* 40 (May 1989), p. 72 (English trans., p. 143).

23. "Entendí que debía hurgar en mis sótanos, y tomé el arte como sistema autoanalítico. Por aquellos días frequentaba esos teatros, el Faenza, por ejemplo, y esa actividad era lo más oculto e intenso de mi realidad. Allí encontré el asidero que me conectaría con mi verdad."—Ibid.

24. "'Fonctionnel' ne qualifie nullement ce qui est adapté à un but, mais ce qui est adapté à un ordre ou à un système: la fonctionnalité est la faculté de s'intégrer à un ensemble. Pour l'objet, c'est la possibilité de dépasser précisément sa 'fonction' vers une fonction seconde, de devenir élément de jeu, de combinaison, de calcul dans un système universel de signes."—Jean Baudrillard, *Le système des objets* (Paris: Éditions Gallimard, 1968), p. 89.

25. "Su sentido es ambiguo, su significación aleatoria como la de un espejo. Es decir: reflejan lo que se les ponga delante. Un inocente verá inocencia de muñecas; un fetichista adorará a esas niñas vestidas de lazos y enaguas almidonadas."—Damián Bayón, "Salcedo: Histoire d'O . . . antes o después?," in *Bernardo Salcedo* (Madrid: Galería Aele, 1976), n.p. [brochure].

26. "Le mode d'usage quotidien des objets constitue un schème presque autoritaire de présomption du monde."—Baudrillard, *Système des objets*, p. 81.

27. "Esto prueba que uno vive con la cabeza llena de cosas y encima de todo tiene que acordarse siempre de la gente que, por lo general, es lo que más rápido se olvida. Por supuesto."—Bernardo Salcedo, in *Bernardo Salcedo* (Bogotá: Galería Garcés Velásquez, 1981), n.p. [brochure].

28. "Mi obra es exclusivamente racional y pensada, porque me preocupa que haya un trabajo intelectual. . . . Me interesa el libro como símbolo de nuestro conocimiento, como un vehículo de cultura y de ideas. Para encontrarse con su mensaje hay que abrirlo, leerlo; es una especie de diálogo obligado. Y cuando se lo cierra, ese mensaje queda oculto, no se ve. El acto de abrir un libro constitye una revelación."—Jacques Bedel, "Jacques Bedel," artist information sheet (Buenos Aires: Ruth Benzacar Galería de Arte, 1991). For a more detailed interpretation of his work, see Miguel Briante's interview with the artist, "Jacques Bedel o la preparación de la eternidad," *El Porteño* 1 (June 1982), pp. 34–37.

29. Borges's fiction has played an exceptionally important role in the vitalization of the imaginary in the visual arts in Argentina. The writer's friendship with Xul Solar is described in Jorge Luis Borges, with the collaboration of María Kodama, *Atlas*, trans. Anthony Kerrigan (New York: E. P. Dutton, 1985), pp. 77–81. Another instance is Liliana Porter's incorporation of silkscreened images of Borges texts in her mixed-medium paintings. Finally, several critics have invoked the example of Borges in discussions of the paintings of Guillermo Kuitca, for example, Fabian Lebenglik, in Sonia Becce, *Guillermo David Kuitca: Obras, 1982–1988* (Buenos Aires: Julia Lublin Ediciones, 1989).

30. Jorge Luis Borges, "The Library of Babel," in his *Labyrinths: Selected Stories and Other Writings*, ed. Donald A. Yates and James E. Irby (New York: New Directions, 1964), p. 53. This story, first published in the collection *Ficciones* in 1944, is reprinted in Jorge Luis Borges, *Obras Completas* (Buenos Aires: Emecé Editores, 1974), pp. 465–71.

31. Ibid., p. 58.

32. "Yo había hecho libros arqueológicos, pero después empiezo a pensar una arqueología para el futuro. Ver qué pasa si uno encuentra un libro con un mensaje descifrable. En ese momento me interesa pensar en la permanencia del mensaje. Pienso en la permanencia de una idea que en este caso es el libro, que es el objeto simbólico de nuestra cultura, de nuestro conocimiento en este momento de la historia."—Interview with Mercedes Casanegra, "Jacques Bedel: Descifrar la eternidad," *Tiempo Argentino* (July 28, 1985), p. 4.

33. "Casi indestructible, hecho para durar una cantidad descomunal de tiempo, con un mensaje que pueda ser descifrado más adelante."—Ibid.

34. Jorge Luis Borges, "The Book of Sand," in *The Book of Sand*, trans. Norman Thomas di Giovanni (New York: E. P. Dutton, 1977).

DISPLACEMENT AND THE REINVENTION OF IDENTITY

Charles Merewether

T he cultural and social histories of Latin American nations remind us that the formation of identity—a theme addressed in the work of many artists in these countries—has developed through historical processes of displacement, dispossession, and fragmentation. Originating during the Conquest, when European colonizers appropriated the lands of indigenous communities and subsequently tried to eradicate native cultures, languages, and religions, these processes continued with the transatlantic slave trade that brought Africans to the Americas from the end of the sixteenth to the late nineteenth century. In the recent past, the impact of forced exile and migration of thousands due to military dictatorships and economic underdevelopment, and penetration of the region by global media technologies and the markets of international commerce, condition the way contours of identity are being drawn.

One of the most powerful responses to such processes in these countries has been the emergence of a contemporary art that dismantles or appropriates colonial and modernist language, whose forms and structures of support have shaped relations of discrimination and concepts of difference. In part, this essay concerns the ways contemporary art in Latin America constructs, through processes of contestation and reinvention, alternative languages that reflect contradictory experiences and also offer means of giving form to the identities of self and community.

Contemporary events force us to recognize the profound changes in the way identity and cultural difference are defined, not only for indigenous and African-American peoples but equally for persons of mixed ancestry, who constitute the vast majority of the middle-class populations living in Latin American cities. The very concept of identity, stripped of its appeal to notions of a homogeneous universalism, cultural organicism, or a pure cultural particularism, has become more distant and difficult to grasp, except as something imagined—a kind of mythic space that inhabits the historical memory of the present. For instance, the principles of nationhood and territorial sovereignty, on which nineteenth-century leaders such as Simón Bolívar based their struggles for independence and liberation from European governments, no longer serve as sufficient means of defining communities within these countries, unifying them, or responding to their needs. Rather, regimes characterized by authoritarian populism mobilize such concepts in order to maintain their legitimacy and power over the growing number of displaced and disenfranchised people. Appropriating the beliefs of popular religious cultures, these regimes transform or insert icons that embody the founding myths of the nation and promote cultural nationalism. These icons of political leaders, or saints and goddess figures—such as Che Guevara (Cuba), the Virgin of Guadalupe (Mexico), María Lionza (Venezuela), and Saint Jacques (Haiti)—imbued with supernatural or spiritual powers, are able to determine the course of history and therefore shape the identity of a people.[1]

For the urban middle classes in these countries, however, self-defining mythologies are found neither in the indigenous cultures of the Americas nor in the cultural heritage of Africa but rather through an exchange with the modern culture of the West. Such concepts as West and non-West, center and periphery, self and other, no longer serve as explanatory models in that exchange because the West's images and products have become icons inextricably woven into the fabric of Latin American culture. However, these icons are not simply

imposed but are always the subject of renegotiation and choice as the middle classes seek to define themselves through those images and products made available to them. For this reason, the idea of the border has in recent years assumed new meaning, both in real and symbolic terms. Borders have become sites where the processes of translating between cultures occur, and where discriminating representations of difference are located. They are places where modernism has played out its game of recognizing or disavowing other cultures, and so borders also are where the agents of aesthetic models of assimilation or exclusion can be exposed and where, through the reinvention of alternate cultural models, possibilities for the future can be forged. Processes of negotiation and exchange result in the formation of heterogeneous and hybrid identities as the individual sees his or her identity reflected by an image or figure on the border's other side, resulting in a doubling of images and figures against one another. Existing as neither one nor the other, neither outside nor in, these new identities belong to an "in-between" realm where the familiar and unfamiliar mix in a loose assemblage of contradictory energies, values, and modes of everyday life.

For many artists in Latin America during the 1970s and 1980s, institutions, language, and representation were critical agencies in the formation of identities and differences. These artists invented, appropriated, or assimilated cultural signs, codes, and models to create forms of representation that distinguish and define the self in relation to others. Identity is understood as a contested sphere, shaped by specific conditions such as the country, its economic and political conditions, and so on. In the work of artists as diverse as the Cuban José Bedia, the Cuban-American Ana Mendieta, the Puerto Rican–American Juan Sánchez, the Mexicans Julio Galán and Rocío Maldonado, the Brazilians Daniel Senise and Leda Catunda, and the Argentines Guillermo Kuitca, Liliana Porter, and Luis F. Benedit, histories of dispossession, fragmentation, and displacement become the unstable ground for the formation of identity in terms of gender, race, or cultural background. Appealing neither to concepts of cultural purity and origin nor to the autonomy of the individual subject, such work locates the human body and senses as the sites of historical inscription and acculturation. These artists explore the body as, on the one hand, the subject of (or a zone of mediation between) civilizing processes and technologies and, on the other hand, an embodiment of memory and the unconscious. Subjectivity and identity emerge from the transaction between these two realms, and across the border that divides them the artists' works replay that interchange in a vicarious game of self-imaging. The subject assumes its visible appearance and cultural significance out of the realm of memory and the unconscious, between language and the body, and by the relations between subjectivity and the technologies through which it is produced and circulated.[2]

For many artists who, by profession if not milieu, see in contemporary mass culture unlimited source material, notions of cultural patrimony and cultural change take on a new significance. Works by artists like Kuitca, Galán, Maldonado, and Senise show how the experience of that culture generates new fictions of individual subjectivity. Loosened from their signifying function, mass-culture images circulate, transformed into free-floating signs that, while bearing a residual trace of the past, are reinvested with an aura, taking on the character of ornament. The allure of these images is that they func-

tion like commodities, offering the promise of redemption for something of tangible value—perhaps even the redemption of the real. This aesthetic represents the phantasmagoric space of the new, symbolized by the modern and the West, or the past, transformed into a nostalgia for the recently outmoded or into mythic histories. The work of these artists suggests distinct but intersecting ways in which certain tendencies within the field of contemporary art in Latin America reaffirm art itself as distinct from other cultural objects.[3] Art reassumes a significance by internalizing and transforming contemporary conditions of displacement and fragmentation to create an aesthetic of difference.

The practices of such artists as Mendieta, Bedia, Sánchez, and Benedit, in comparison, demonstrate a critical engagement with the effects of historical change on the constitution of social and individual identities. Their work avoids assimilation, nostalgia, and parody as symbolic forms of resolution. Instead, their distinct ways of investing in the question of subjectivity and the pictorial are informed by the residual and emergent forms of everyday life in Latin America and the demand to recode hope for social transformation and renewal of individuals and the communities in which they define themselves. The promise of art lies in its ability to intervene critically in Latin America's violent history, to serve as an agent for symbolic liberation from disruption and loss. What makes this possible is the act of inscription, by which history is rewritten and art assumes the power of naming. Through strategies of quotation, appropriation, and contestation, these artists explore historical memory and the materiality of the everyday present as they produce in their work a flickering image of the future.

———

Remarking on whether or not a populist national literature existed in Italy, the Marxist intellectual Antonio Gramsci argued in 1934 that it did not because it lacked "an identity in the conception of the world held by 'writers' and 'the people'; this means that writers do not experience popular feelings as if they were their own, nor do they fulfil a 'national educational' function. In other words, they have never posed for themselves the problem of giving form to popular sentiments after having relived them and turned them into their own."[4]

For Caribbean artists like Mendieta, Bedia, and Sánchez, "giving form to popular sentiments after having relived them and turned them into their own" is a central concern because the very presentation of popular culture suggests within it the possibilities for social change. These artists work in an "in-between" space, the crossroads of history, a place of dispossession that embodies the historical experience of the Americas from the Conquest to the recent histories of émigrés, refugees, and exiles who have been displaced from their homelands.

In site-specific works and performances created from the early 1970s until her tragic and untimely death in 1985, the Cuban-American artist Ana Mendieta addressed the violent experience entailed by the social formation of identity through displacement. Drawing on her personal experience of exile from her native Cuba in 1961 at age thirteen, Mendieta's work also offers a general reflection on the collective identity of the colonial subject. Using the female body (initially her own) to configure woman and land as subjects of

conquest, Mendieta shifted the location of meaning and identity from the fixity of an image or place (the body represented, or the land) to the actual processes of inscription. Identity was posited as neither coherent nor given, and in such terms, the ephemeral, transient, and therefore unstable character of much of her work is central to understanding its significance.

Mendieta drew on Mexican and Afro-Cuban sources to explore the body as the ritual site of a history that encompasses the memory of the Catholic figure of the martyr, the servitude of the slave, or the state of exile of the runaway slave, or maroon. Her specific references to the Afro-Cuban religion of Santería are not claims to a lost identity, nor are they simply gestures toward her native land. Rather, she invoked Santería as she subjected the body to a process of symbolic healing and transformation, imbuing it with a vitality to embrace death and, ultimately, her ancestors. That process is a ritual of transition from one state to another.

In the Silueta series of outdoor "earth/body sculptures" that Mendieta created from about 1976 to 1982 (plates 124 and 125), the artist imprinted images of herself on earth, tree trunks, vegetation, and other natural materials she encountered near Iowa City, where she spent her adolescence and attended college, and around Oaxaca, Mexico, which she visited several times during the 1970s. She occasionally lined the silhouettes of her body with gunpowder and then set them aflame. For Mendieta, union with the earth through her art was of paramount importance. She stated in 1981: "Through my earth/body sculptures I become one with the earth. . . . I become an extension of nature and nature becomes an extension of my body. This obsessive act of reasserting my ties with the earth is really the reactivation of primeval beliefs . . . [in] an omnipresent female force, the after-image of being encompassed within the womb."[5]

Intimating disembodiment and loss, these works demonstrate Mendieta's ultimate refusal to affirm patriarchal and colonial modes of domination by embracing prepatriarchal, precolonial systems of belief. In another series, Fetishes, of 1977 she shaped sand and earth into figures of her own form lying flat and rigid, arms and legs pinned against the body. Mendieta traced arterial lines onto one work, and she pierced another with several upright sticks after setting it in a pool of water (figure 1). Through such symbols of sacrifice, she evoked both loss of contact and fertile union with the earth. Reexperiencing ritually the trauma of loss is a way of redeeming abandoned corporeality. For both artist and viewer such a ritual implies an intensity of experience that can transcend the loss.

In the series Tree of Life of 1976–77, Mendieta employed the body, understood in both literal and figurative terms, as a medium of exchange between herself and nature. In a work from this series, executed in Oaxaca, she laid a white cloth on the ground so that it seemed like a figure embracing a fallen tree trunk. With this act, woman was symbolically transformed as the artist transformed herself through her union with the earth. The cloth suggests a shroud or residue.[6] Using a trace of herself, she produced a double, which is always lacking, always without. Mendieta recognized that the colonized feminine body is always already a figure of discipline and submission, and only by assimilating displacement as an experience of irrevocable denial can identity be recovered.

In many of her works, Mendieta symbolically dissolved herself

1. Ana Mendieta. Untitled, from the Fetishes series. 1977. Earth/body work with sand, water, and sticks. Executed at Old Man's Creek, Iowa City, Iowa

to restore her relationship to nature. This attempt to overcome the experience of displacement from the earth is seen most poignantly in the only works she made in her homeland, the Rupestrian Sculptures of 1981. After her first visit to Cuba in 1980, Mendieta returned the following year to spend part of the summer in Jaruco, where she created this series by carving the outlines of female bodies onto rock formations and the walls of limestone caves (figure 2). Using the visual language of the extinct Taíno people of Cuba, Mendieta dedicated each work to fertility deities and to the rupestrian (rock) art of the island's first inhabitants. These works epitomize her concern with the experience of displacement. Caribbean artists and writers, like Mendieta, have repeatedly addressed the trauma of deterritorialization reflected in the histories of their violent ejection from their homelands and by the culture of colonial slavery.[7]

Like Mendieta, the Cuban artist José Bedia explores the violent dialectical tension between the deracination wrought by the colonizers and attempts by the colonized to reinscribe identity on their own terms. Since the early 1980s Bedia has been inspired by indigenous American cultures, specifically the Yanomamo of Venezuela and Brazil and the North American Lakota Sioux, as well as by the Kongo-based Afro-Cuban religion of Palo Mayombe, to create an art of dialogue and exchange. Through installations, paintings, and works on paper, Bedia reconfigures the disparate cultural realities that coexist in the Americas and dismantles syncretic identities to produce a series of mise-en-scènes in which new syncretisms reveal hidden or unofficial histories of displacement and dispossession. In installations specifically related to Cuba, such as Living on the Line of 1989 and Second Encounter Segundo Encuentro (plate 20), which consists of a wall drawing displayed with the paintings Isla jugando a la guerra [Island Playing at War] (plate 21) and Lucero viene alumbrando [Star

Comes to Light the Way] (plate 22), the latter three of 1992, Bedia represented indigenous Americans and African-Americans as subjects of history and agents of change.

By employing a recurring figure similar to the Everyman of medieval morality plays, Bedia produces an ongoing history of learning, confrontation, and exchange. The site of this history is the crossroads where, in traditional Afro-Cuban culture, the *orisha* (deity or spirit) called Eshu-Elegba resides, marking the border between the human and spirit world, life and death. For Bedia, the crossroads is the site of the passage of history between Cuba and the West. In the painting *Star Comes to Light the Way* Bedia portrays Lucero, the spirit figure of the night, who, like Eshu-Elegba, is a vigilante of the crossroads.[8] Lucero brings light in the form of a small, glowing boat that he holds aloft, which is named the *Buey Suelto*, literally "free bull." This name is associated with a branch of the religion Palo Mayombe, many of whose adherents live in Miami. Protected and illuminated by the spirit Lucero, the boat *Buey Suelto* bears the cosmogram *lucero mundo*, representing the crossroads and four points of the universe. Thus the boat symbolizes the search by these people for a place to live and practice their religion without persecution, and in so doing it recalls a history of intolerance in Cuba.

In the installation *Second Encounter Segundo Encuentro*, Bedia identifies the arrival of Columbus's vessels in the Americas with the presence of warships from the United States. He depicts the destruction of the ships by a spirit that springs from a ritual vessel known as a *prenda*, traditionally used by Afro-Cubans to hold charms and spirits.[9] As with *Living on the Line*, the installation format placed the spectator in a position between different forces, as if immersing him or her within the processes of history. Bedia connects colonial and contemporary history, the Spanish and latter-day North American conquistadors by using the symbol of a ship occupying the waters of the Caribbean and confronted by the spirits of Afro-Cuban culture. The critical point is not only to show that history repeats itself but to realign the relationship between history and the present. He invokes the warrior spirit to mediate this relationship and reimagine the future of Cuban culture.

2. Ana Mendieta. *Guanbancex and Guanaroca,* from the Rupestrian Sculptures series. 1981. Carved and painted rock wall in Jaruco, Cuba

Moving against official history, Bedia forges a correspondence with the beliefs and practices of Afro-Cuban religions. In doing so, he invests in the concept that the ancestral dead are not confined only to historical memory, but also occupy the land and the living. He seeks, therefore, not to produce a "primitivist" image of Cuban culture but to reclaim its religious beliefs as a form of contemporary memory. His work reaffirms the vital role Kongo religion has played in the history of the New World. For Bedia the purpose of image making is not only to invoke and embody the memories of popular or indigenous cultures repressed by colonial and modern states but also to relate personal and collective histories. As with Mendieta, his art reveals signs of a fragmented past in order to construct an image of a common destiny.

Similarly, Juan Sánchez is inspired by a sense of dispossession and the desire to reconstruct a history of the people of the Puerto Rican diaspora in anticolonialist terms. Addressing the right to nationhood of a suppressed Puerto Rican populace, he has, since the early 1970s, explored the ongoing involvement of the United States in the history of Puerto Rico and vice versa. Sánchez creates his mixed-medium works, which he calls Rican/Structions, by painting over photographs, newspaper clippings, and other appropriated mediums, thereby evoking the graffitied and poster-laden walls of the Puerto Rican neighborhoods in Brooklyn where he was raised. His techniques of tearing, cutting, and pasting images, and his juxtaposition of images from high and low cultures, symbolize the processes of historical recovery and restoration. In his work the image and its reproduction serve as emblems for the condition and possibility of change and independence for Puerto Ricans in their native land and in the continental United States.

In the Rican/Structions Sánchez recharged appropriated images of Puerto Rican people as icons of colonial oppression. His images are like memory houses, condensations of buried and fragmented histories, which can help to produce and secure individual, communal, and national identities. In *Mixed Statement* of 1984 (plate 180), the Puerto Rican flag eerily evokes the hoods of assassinated political activists and the shrouds of their corpses. In the triptych *Bleeding Reality: Así Estamos* of 1988 (plate 181), Sánchez reversed the colonialist attitude implied by an American Express advertisement that reads, "You've got Puerto Rico in the palm of your hand." He juxtaposed a pair of the advertisements, in the left-hand panel, with an image of hands afflicted with stigmata, in the right-hand one. He also depicted, in that panel, ideograms of the Taino, the indigenous Puerto Rican people exterminated by the Spanish during the Conquest. In this work Sánchez employed Catholic imagery to explore its residual power in the formation of identities in which the destiny of the self and society coincide. By overlaying symbols of Christ's sacrifice and martyrdom with images that evoke the heroism and violence that have characterized Puerto Rico's history, Sánchez identified the bleeding heart that fills the work's central panel with the "body" of the island of Puerto Rico.

The formation of both individual and national identities occurs when images of saints, the Holy Family, and other religious figures are linked with those of Puerto Rican nationalist heroes and leaders. With such works the artist creates emblems of liberation, both for individuals and communities. Moreover, by reusing and circulating such images, Sánchez endows them with a ritual function; they

accrue an iconic power by interweaving the present, past, and future. Precisely because of their power to be reproduced, and their sense of a past life, these images attain a kind of mythic status; they represent familial and social relations or serve as "living" testimony, embodying traces of a past that condenses moments around which identity is contested and named.

There is a poignancy in Sánchez's project of recovery. By traveling and forging new connections, his images accrue new meanings. To be sure, their presence depends on his act of appropriating and recontextualizing preexisting images in layered surfaces. However, rather than the production of seamless figures or hybrid identities, his work process is analogous to the generative dynamic of montage. By creating interdependence among disparate images and layering surfaces, he reflects the profoundly interdependent and layered nature of Puerto Rican/New York identities. Moreover, the *de*constructive nature of this work suggests that Puerto Rico can never be restored, only reinvented. Sánchez demonstrates that art can play a crucial role in the movement of national independence by reconstructing a language proper to its history. This process of reimagining means working through his people's suppressed heritage and colonial assimilation. His is a necessarily utopian quest to restore the past in order to create possibilities for the future.

——

What if the concept of cultural identity had no founding history to which one could appeal, no recourse to a point of origin, neither intensity nor interiority, but instead were an endless play of doubling, mirrors, and reflections? Such a scenario emerges as the West is recognized to have been implicated in the history of Latin America, and as it continues to be deeply involved in its future through channels of communication and mass culture. While one might perceive this involvement in terms of contamination, homogenization, and negation of difference, the interplay actually represents a field of constant negotiation and reinvention. The forms of modernism in Latin America are important precisely because they have worked to redeem physical reality against the individual and social experience of estrangement produced by modernization.

The return to pictorial figuration in the contemporary art of Latin America, especially in Mexico, Brazil, and Colombia since the mid-1980s, constitutes an attempt to restore a unified subject through a reenchantment of the spectator. The work transforms its subject into a spectacle of signs marking a narrative of desire seeking liberation from the sense of loss as an effect of fragmentation, indeterminacy, and ambiguity. This approach is taken by artists such as Galán, Maldonado, Senise, and their contemporary Ray Smith. They employ archival images, or ones culled from historical writings, including art history, to construct their paintings. Their images are mixed promiscuously to produce a spectacle in which the referent is disembodied and detached from its place and in which history is effaced. In the production and conferring of new identities, there is no agency. Rather, displacement, dispossession, and fragmentation are naturalized. The artist effects an aesthetic transmutation of history in which objects are given free play, unfolding across the surface, appealing to the pleasure of the gaze. Artifice becomes an empty ritual, yet it remains functional because pure surface serves as the ground on which subjectivity can now be reconstituted. The pictorial

stages a comeback by emphasizing the exhibition value of the work—that is, its display is an essential condition of its existence.

This account suggests that modern cultural identities consist of pure transmission and surfaces in which the self discovers the spectacle of desire being played out as "desire's endless traveling."[10] Objects become fetishes that form the patrimony of the artist's vicarious imaginings. This traveling is far from the kind of displacement seen in the work of Mendieta, Bedia, and Sánchez. Rather, in the work of Galán, Maldonado, and Senise, it is a movement of distraction, of endlessly traversing the surface of things. Depth is replaced by surface, interiority by ornament. As the German critical theorist Siegfried Kracauer wrote in developing a theory of "mass ornament": "Here, in pure exteriority, [the masses] encounter themselves: in the rapid succession of disconnected sensory stimuli they see revealed their own reality."[11] The mass ornament, for Kracauer, is not representational; rather, it is a configuration of icons and emblems that embodies nostalgia and melancholy, which mask the dislocations and discontinuities of the real.

In *My Parents One Day before They Knew I Would Be Born* of 1988 (Collection Francesco Pellizzi, New York) Julio Galán allegorized his birth through painting and collaging images drawn from various sources. In the work's center is placed an old canvas of a genre scene featuring a harlequin and a young woman in a wooded landscape with a stream in the background. The figures face one another, though Galán cut a hole in the canvas between them. The fictive space of this central image is extended into surrounding compartments, defined by black lines, in which there are scenes of trees, a pair of birds, and a woman's head. Other holes are cut into the canvas, fragmenting it and disrupting the symbolic narrative of origin. These holes represent absences, missing fragments of the story; they evoke a sense of anxiety in the very surface on which the narrative is played out, displacing the fictional coherence of the subject. By appropriating disparate images, binding them together so that they form a whole yet retain their identity as fragments, and by piercing the pictorial surface to emphasize its incompleteness and depletion, the artist's allegory of the self not only alludes to the creation of the individual subject but implicitly reflects the fabrication of modern Mexico as a postcolonial nation subject to the influence of the powerful transnational and local entities that control commerce and the mass media. Galán's work has an allegorical significance for a culture of reproduction, an aspect of it that suggests the importance of Andy Warhol for his work.

Galán paints an interior world in which fantasy and reality intermingle. Constantly eluding a fixed point, his paintings are replete with ellipses, interlaced circuits, and labyrinths of mirrors that produce identity as a series of surface effects and that extend the real into fantasy and memory and vice versa. Galán's narratives of high drama, nostalgia, and romance, embellished by a plethora of accessories, are the stuff of a fantasy that sustains the subject's identity. If his work evokes kitsch and melodrama, it is because artifice, display, and surface have come to represent the real. In these terms, his use of language and imagery culled from popular culture and the mass media—such as popular, sometimes vulgar sayings, double entendres, lines from Mexican ballads, and images from *telenovelas* or soap operas—recognizes how nostalgia and sentimentality inform subjectivity. The perceptual experience of Galán's painting points to a

process of fetishization. By immersing his subjects, which frequently include himself, in a field of accessories and ornaments, Galán often transforms his images into fetishes and his subjects into consciously parodistic objects of homoerotic desire. Such a method is, to paraphrase a passage quoted above, a process of endless substitutions, desire's ceaseless traveling among different images.

Galán's fetishization of objects and nostalgia for the past are clearly seen in *Tange, tange, tange* of 1988 (plate 69), which evokes a cargo of precious goods, a storehouse of memories, or characters from a children's storybook. Presenting an image that can be seen both as a tabletop and as a beach, Galán created a dazzling world, perhaps brought to shore by the ship seen in the distance, or washed up by the tide from distant lands. Across that decorative surface he spreads animals, a vase with flowers, and other objects, to create a scene that has the aura of a waking dream. We see the breath of a young boy at the bottom left transformed into the ocean above, animating the scene as though the image were a visualization of the discovery of the senses of touch, smell, sight, and taste; thus the painting symbolizes an awakening of desire and represents the thresholds or boundaries between self and culture. *Tange, tange, tange* demonstrates the essentially cosmetic nature of Galán's art, in which identity is a kind of mask. Rather than obscuring the real, layers of embellishment come to represent the truth of artifice, and visual spectacle becomes the surface across which difference and value are defined.

In Mexico the enthralling flicker of culture's transmission via the mass media has been matched only by the phantasmagoric power of the religious imagination. The power of religion and the mass media is to be found in the manner in which both intervene in the constitution of the self. Fascination with the image and the work of art lies in their appeal to the most intimate, even unconscious, desires. They act as both agents and objects, and their consumption offers the promise of fulfilling those desires. In the work of both Galán and Rocío Maldonado, the world of objects and the body is transformed into signs invested with the desires of the self. Art becomes a form of confessional. Yet, in a manner distinct from Galán's inexhaustible transformation of the objective world into sites of pleasure, Maldonado's imaging of the sensorial and erotic body turns on the idea of loss or the unconsummated object of desire.

Since the mid-1980s Maldonado has produced paintings in which the body of woman is represented by figures of the Virgin, angels, classical statues, young girls, and dolls. The centrality Maldonado gives to symbols of purity, beauty, and innocence emphasizes the body of woman as sacred and as an icon around which femininity itself is formed. The constitution of woman as a subject is founded on myths and idealizations. Woman becomes an icon by virtue of the boundary she marks and mediates between sacred and profane, between the symbolic and the real. Within the framework of Catholicism, in turn, the transposition of the image of woman through art redeems desire as an expression of yearning for the sacred. In her series of images dedicated to women mystics and saints, which includes the painting *Extasis de Santa Teresa II* [*Ecstasy of Saint Theresa, II*] of 1989 (plate 113), Maldonado drew directly on Gianlorenzo Bernini's baroque statue of the subject (1645–52) in the Cornaro Chapel of Santa Maria della Vittoria in Rome. Invoking the Catholic tradition of ecstatic feminine devotion, Maldonado presented ecstasy as the corporeal embodiment of the sacred and, alter-

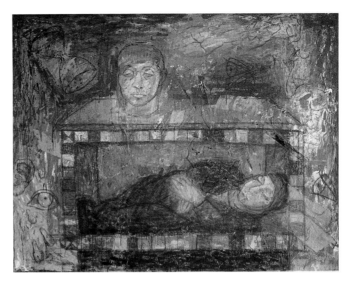

3. Rocío Maldonado. *Saint Monica*. 1990. Oil, synthetic polymer paint, and collage on canvas, 6' 3 ⅝" x 8' 3 ⅜". Private collection, Mexico

nately, the sublimation of female desire in response to the strictures of religious institutions or patriarchal societies.

In most of her paintings of the late 1980s, Maldonado disturbed the iconic power of her figures by surrounding them with fragments of male and female body parts, particularly eyes. Recalling the custom of *milagros* (miracles), used in popular Catholicism as metonymic representations of the ailing body, paintings such as *Saint Monica* of 1990 (figure 3), suggest a further exploration of the relation between woman and desire as it functions within the sacred. The floating eyes, ears, buttocks, and torsos around the figure of the saint symbolize both the appearance of the body cured of its illness and its fetishization as a function of the miraculous, through which desire for another can be sublimated. Like Galán, Maldonado underscores the relations between the act of painting, the body, and eroticism. Both artists visualize desire as a series of affective intensities that wash over and mark the body. Yet, whereas the body constitutes for Galán the surface on which the self and difference are defined, Maldonado forces the interiority of the body to speak, revealing how the identity of the subject is founded on sexual difference.

The appropriation and reelaboration of iconic forms is a recurring theme in the paintings of Daniel Senise. Sem título (*Sudario*) [Untitled (*Shroud*)] of 1989 (plate 195) implicitly refers to the legendary impression of Christ's face on Saint Veronica's veil, allegorically reflecting the techniques the artist employs to produce images on canvas. Senise's abstraction and manipulation of fragmented, partially seen objects displaces and supplants the objects themselves.

In his earlier work Senise portrayed a catalogue of banal objects at an inordinately large scale, forcing arbitrary fragmentations of their original form and distorting their significance. As the Brazilian critic Wilson Coutinho suggests, Senise's paintings of monumental and partial forms are like a "theater of mutilated sensations."[12] These works recall a statement by the French philosopher Jean Baudrillard: "It is not the passion (whether of objects or subjects) for substances that speaks in fetishism, it is the *passion for the code*, which, by governing both objects and subjects, and by subordinating them to itself, delivers them up to abstract manipulation."[13]

In *Shroud* and in *Ex-Voto* of 1990 (figure 4), Senise appropriated images with religious connotations, including nails, rope, stars, and rosary beads, and transformed them into autonomous, floating signs loosened from historical memory. The use of these forms from the past recalls the compositions of both Galán and Maldonado in that Senise, rather than locating the self within tradition, translates and gives tradition new life by calling upon it vicariously within the present. While the use of religious symbols and instruments of faith by Senise and a number of his contemporaries suggests the strength of the religious imagination in Latin America, it also bespeaks a loss of faith in religion and its governing institutions. These artists produce emblems and motifs that display the hidden relations between belief and the body. What is implied is a reading of the body as the site of discipline and suffering. The body becomes an affective surface that reflects an unfettered unconscious and a violent world that has produced a dependency on fetish objects, perversion, and self-censorship. The work of such artists creates a sensation of melancholy in the face of the subject's powerlessness.

In contrast to this scenario, the work of the Brazilian Leda Catunda playfully dismantles the anxieties of the modernist self. In her appropriation of everyday objects as both the support and the subject of her painting, Catunda produces an art that takes pleasure in mingling with the materials of daily life. Dispensing with grand narratives of origin or icons of faith, Catunda's art addresses the common thread that links the modern subject to the artisanal and industrial processes of contemporary life. Images and objects become emblems and signs invested with a power to transform values and shape identities of the self and others.

Catunda uses ready-made materials and objects, such as mattresses, clothing, quilts, towels, pillows, and beach umbrellas, with wit and gentle irony. This is apparent in *Alone in the Room* of 1985–86 (Stedelijk Museum, Amsterdam), in which a black umbrella and wig represent, respectively, a room and woman, or *Landscape with Lake* of 1984–85 (Private collection), which has a mattress as a support to signify a landscape and the site of the body's relaxation and pleasure. More critically, such work underscores the production of feminine subjectivity. Leisure and the body are the realms in which woman is allowed to define herself.

Catunda shares with Maldonado an interest in exploring these domains and the production of femininity, but, while Maldonado looks at the ambiguous fetishistic power of religious icons, Catunda locates the feminine in objects of everyday use. As in the work of artists such as the Chilean Juan Dávila or the Mexican Mónica Castillo, Catunda's collaging and stitching together of materials suggests the fabrication and artifice not only of the real but also of the feminine. By recognizing the artifice involved in its making, Catunda dismantles representation, revealing it as a series of surface effects.

By exposing the techniques she employs to fabricate her art—collage, assemblage, and sewing—Catunda undermines the sense of visual spectacle intrinsic to painting, especially to realist styles. Working against realism as the privileged site of identity, Catunda invokes Minimalism as the ground for reconstructing subjectivity. In her recent works, such as the series Blue Remnants of 1992 (figure 5) or Yellow Pillows of 1992, Catunda reduces the pictorial and anecdotal references while emphasizing texture, plasticity, scale, and volume. Her emphases on saturated, bright colors and on the forms and tex-

tures of materials result in images that stimulate the senses.[14] In her work, the visual delimits the sensual, visceral, and tactile materiality of the body and of everyday life. Yet, in stressing tactility and the sensorial, as well as the notion of pleasurable abandonment evident in her use of materials, Catunda eroticizes and gives gender to the Minimalist object. This stands in contrast to the ideological language of impersonality and apparent passivity (and hence the implicit patriarchal order, which disempowers the subject through prohibition and control) pursued by Minimalists in their embrace of technology and industrial materials. Unlike Galán, Maldonado, and Senise, Catunda neither naturalizes nor masks the separation between the personal and the social in a spectacle of reification or an appeal to the expressive self. Rather, by restoring to the spectator the possibility of sensorial exchange between the body and the material object, Catunda's work displaces the issue of representation for an aesthetic of the senses.

Like Mendieta and Sánchez, many contemporary Argentine artists address issues of exile and displacement. A crucial difference, however, distinguishes them. Whereas in the Caribbean, local knowledge of popular culture plays a central interpretive role in engaging with contemporary history, the specter of authenticity and origin, or, more precisely, their absence, haunts Argentine culture. Modern Argentina was founded in the wake of the displacement and disappearance of indigenous communities. The pampas, a vast, empty plain extending west and southwest from Buenos Aires to the lower terraces of the Andes, was occupied in the nineteenth century by émigrés who became known as gauchos and who worked the land like itinerant cowboys. While the gaucho asserted himself against inhospitable elements to forge a culture of survival, the urban Argentine aspired to a modern culture wherein everything was to be reinvented; at the same time, he or she wished to preserve roots in European culture.[15] Cultural production in the twentieth century has been seen by many intellectuals, writers, and artists as an act of artistic *reproduction* signalling their peripheral condition, whether it be geographical or economic. Art then represents a means of closing the distance between Argentina and Europe, of responding to the experience of a deferred reality and an emptying of history.

The power of images haunts artists as distinct from one another as Liliana Porter, Guillermo Kuitca, and Luis F. Benedit. In their work, subjectivity and individual identity can no longer be thought of in traditional European modernist terms. Rather, displacement and reproduction form the central and recurring agencies for the construction of the self, and the mediums and material supports employed by each artist play a vital role in the revision of this self. They engage with the concept of the copy as a palimpsest of subjectivity. Porter's trompe l'oeil figures, Kuitca's portrayals of apartment plans and maps, and Benedit's ecosystems and depictions of gaucho implements all attempt to retrace an original. Their images, therefore, are doubles, phantasms, and replicas that occupy unsettled spaces and repressed, discontinuous, and displaced positions. This impulse to employ and transform existing images is not a parodic subversion of the original but rather an attempt to discover a founding moment, to recognize a point of origin. For each of these artists, the material support of the work gives to the copy a dimension of the real sup-

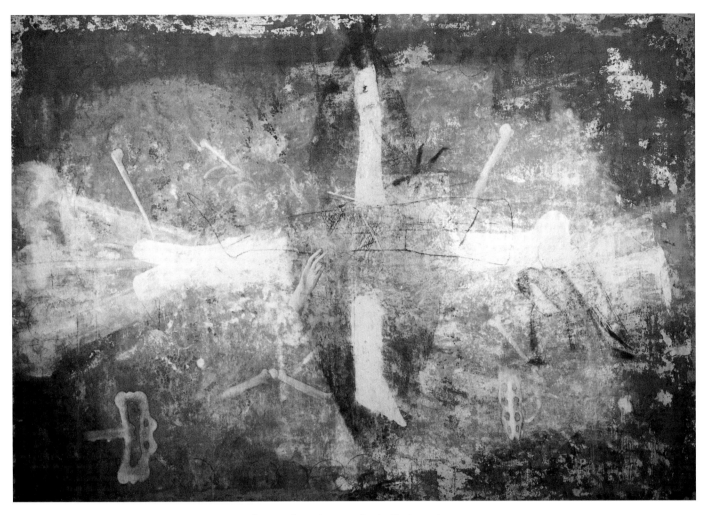

4. Daniel Senise. *Ex-Voto*. 1990. Mixed mediums on canvas, 7' 4¼" x 10' 7½". Collection Kjell Erick Killi-Olsen, Oslo

pressed or lacking in the referent or subject. Each is concerned with how identities can be created to mark out a space in substitution for that which has been the subject of repression. The faculty of the mimetic is reconceptualized by these artists as a critical means of disengaging from models that claim the authority of history. Art became, throughout the 1970s and early 1980s, a strategy of survival and memory in the face of a dictatorship that waged a "dirty war" of abduction, torture, or forced exile against its own people. Through censorship, exile, "disappearance" of the state's enemies, and the internalization of terror, art remained a defense against the loss of memory.

Since the early 1980s Guillermo Kuitca's work has resonated with an aspiration to imagine what is beyond imposed boundaries, delineations, and anonymous signs. His paintings of the early to mid-1980s represent beds, rooms, apartments, and maps. In a series titled The Sweet Sea of 1984–87 vast interior spaces are occupied by a few isolated figures who appear to be living under conditions of anxiety, uncertainty, and fear. In certain works from this series, such as *El mar dulce* [*The Sweet Sea*] of 1987 (plate 98), Kuitca incorporated a scene from Sergei Eisenstein's 1926 film *Battleship Potemkin*, the famous Odessa Steps sequence in which Cossacks massacre people of Odessa. Kuitca depicts the scene in which a baby carriage slips from a mother's hands, tumbling out of control down the steps and

violently throwing the infant onto the ground. By rendering this dramatic moment on what appears to be a monumental movie screen or mural on the rear wall of a stagelike space, Kuitca linked the interior scene to the violence of the child's tragic separation from its mother. By depicting an image of civil war and familial loss, he staged a double displacement, a personal and cultural trauma of separation from the maternal body. The relation of consummation to loss forms a movement around which identity is defined, a movement that in the end opens onto an endless expanse of nothingness.

Following this period, Kuitca painted plans of nondescript apartments, evoking a kind of non-place where no one is at home. Reminiscent of architectural models or blueprints, these images signify isolation and bounded spaces of confinement. They are sites in which the private realm is subject to surveillance, and where the physical and psychological conditions of life are reduced to quantifiable, controllable units. Nevertheless, they remain secret places of refuge and retreat, where desire can be most fully experienced. The floor plan is also a sign for the body, the site of its spent life. In *Corona de espinas* [*Crown of Thorns*] of 1990 (plate 100), the plan is reduced to an outline bristling with thorns, rendered on a metallic surface. Symbolizing the wounding, sacrifice, and death of the body of Christ, the thorns speak of a body exiled from its place of origin.

Kuitca's paintings also signify the body's wasting and expendi-

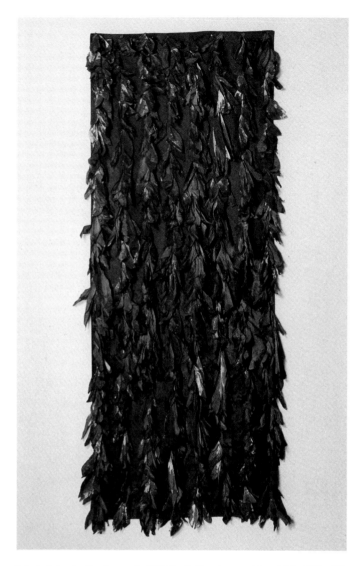

5. Leda Catunda. *Blue Remnants.* 1992. Synthetic polymer paint on fabric, 8' 5" x 40". Private collection

ture. In contrast to the work of Galán and Maldonado, the elements that signify expenditure and excess in Kuitca's painting ultimately have a visceral effect that sets them apart. He uses stains or drips to contaminate the purity of form of each apartment plan, thus compromising, as a model of surveillance and control, what is ultimately a symbol of the military dictatorships that have ruled Argentina intermittently since 1966, most recently from 1976 to 1983. This theme of contamination and extreme states is continued in another series of works in which Kuitca painted directly onto mattresses. In an untitled triptych of 1989 (Thomas Cohn–Arte Contemporânea, Rio de Janeiro), the mattress is both the support and the subject of the painting. The three second-hand mattresses in this work carry, like Christ's shroud, the memory, in the form of discharge and waste, of another's body. Kuitca paints maps on these mattresses, suggesting the space of daily experience and the dreams of journeys taken. The "bruises" and stains on the mattresses become signs of the subject's experience. The map is laid over this metaphorical body, which mediates between the self and the world. The spaces between the three parts of the triptych register both as distances to be traversed

and as the discontinuities between the self and the world. They signal a condition of rupture and violence. One falls between places, between bodies.

Kuitca's work addresses the relation between the corporeality of the body and its trace. The body's expenditures and issuings simultaneously repulse and fascinate because they signal a relation between death and the erotic. In effect, images of blood, semen, tears, and other bodily secretions in Kuitca's work flow powerfully across borders; they also signal the subject of desire—the absent figure implied by the object—to return to a condition of origin and to the maternal body of sustenance. The French theorist Julia Kristeva speaks of abjection as a narcissistic crisis, and the abject, the degraded person, as suffering the violence of mourning for an object that has already been lost.[16] These images are intensely symbolic of a life in which a commitment to intimacy and desire is always at risk, since these emotions are likely to be unfulfilled. As a result, Kuitca's subjects are haunted by a sense of abject loss and are depicted in a state of near depletion, moving toward anguish and death. They are breathless spaces, pared back to uncover the bare essentials, the bone, the crown of thorns, the wasted body. As a whole, Kuitca's images imagine and trace the lineaments of desire. A kind of irreality haunts his work: nothing more than trappings remains, the mundane mechanics and surfaces on which we build edifices, journeys, desires, and dreams of the self that are founded in the other.

The experience of fragmentation and the dispersal of identity also inform the work of Liliana Porter. Since arriving in New York from Argentina in 1964, Porter has addressed the relationship between her own and Argentina's history of displacement. Despite her distinctive subject matter and artistic approach, her work shares with that of Ana Mendieta a sense of frailty and transience. Both artists also have an interest in the relationship between the self and a process of investment in the image. However, rather than producing, as Mendieta did, an indexical image of the self to expose the splitting of the subject, Porter creates works which suggest the power of the simulacrum as a fictive domain to accommodate the displacement and ultimate deferral of the self.

Losing interest in conventional easel painting, Porter began to pursue printmaking in Mexico City's Universidad Iberoamericana in 1960. After moving to New York, she became increasingly involved in developing, along with Luis Camnitzer, a form of Conceptual art. Focusing on processes of reproduction and the concept of the copy as the subject of the work itself, Porter produced in her work an implicit critique of such notions as the commodification of the art object and modernism's cult of the original. In an art that conveys her delight and wit, with a sense of impending loss, Porter has since the 1960s created different readings of the real, which reveal the ambiguous power of appearance and illusion.

In the mixed-medium painting *The Simulacrum* of 1991 (plate 151), silkscreened images of the book covers of Jean Baudrillard's *Simulations* and Michel Foucault's *Ceci n'est pas une pipe* suggest a parallel critique of representation whereby the real is constructed by the illusory world of reproduction. Yet Porter juxtaposed with them silkscreened figures of Mickey Mouse, Donald Duck, Che Guevara, and a statue of a dancing lady, evoking an emblematic world where the fantasy of childhood turns on the command of the mirror images. The real is confounded by her reification of representational forms

whose status remains ambiguous. While such images inaugurate a fictive movement of recovery in the body of the simulacrum, there is a sense of pathos in these figures, generating a fantasy world whose destiny is at once banal and tragic. Rather than an image of utopia, Porter ironically suggests a "dystopia" where heroes are equated with cartoon characters, and both remain trapped in an impossible, illusory space.

A journey may lead to a point from which one can see the place of beginning, as if one's shadow were to be thrown back upon oneself. From this point, repetition is but an oblique reflection. This explains Porter's interest in Lewis Carroll's *Through the Looking-Glass* and the function of the mirror in revealing what is otherwise not present. In works such as *The Two Mirrors* of 1990 (Collection the artist), in which pages from Carroll's book are obliquely reflected in circular mirrors, the mirror offers a kind of impossible spatial simultaneity, capturing little more than the shadow of things. This form of displacement onto an absent subject undercuts the fictive craft of illusion, and yet it also disturbs the authority of the frame and the subject by privileging the copy, the reflection, and that which exists outside the frame. In an earlier work, *Triptych* of 1986 (plate 150), images—a loose thread, a broken vessel, miniature figures, open books, and pictures torn from a book—seem virtually incidental, uneasily occupying the space. The books in particular—Jorge Luis Borges's *Historia de la eternidad*; the Mexican Juan José Arreola's *Confabulario y varia invención*; a volume containing reproductions of Pablo Picasso's works; and a book of poetry written by the artist's father, when he was very young, under the pseudonym Julio Marsagot—hold great personal significance for the artist. Yet, they function as mere survivors of her life, partial and fragmentary, drifting out of context, and strewn like debris.[17] They resemble phantasms in the shadow of absence, on the periphery of the real. As disparate moments, elements in transition, forms and shards of things long forgotten or half-remembered, such fragments function as memory houses in which discontinuous histories and heterogeneous origins work to produce fictive unities and subjects. By virtue of their association with other images and objects, or through a placement within spaces, surfaces, and textures, the fragments gain a resonance, reflecting back in the light of other fragments as fields of intensities in the face of loss.

The paradox of this simultaneous experience of investment and divestment is captured in a quotation by Borges, a major influence for Porter, regarding "the imminence of a revelation that does not happen."[18] Images of an open book, the gestures and gazes of figures, objects, scraps of paper, and words evoke a separation and hence loss, yet there is also a poetics of the possible, of another life elsewhere. In a work like *Reconstruction with a Crying Girl, II* of 1988 (figure 6) the reassemblage of a dancing figure from torn pieces of paper seems to allow the figure to leave behind the fragmentary identity of her past. Understood in this way, it stands as an emblem for the artist herself, who, on her way to Paris in 1964, stopped in New York to visit the World's Fair and decided to stay, having to invent her life anew. Porter's work articulates what it might mean to live as a foreigner, an exile, a person displaced from a culture in which these experiences had already shaped those who came to occupy the land, as in Argentina. This is the specific condition and structure of feeling that informs and infuses her work.

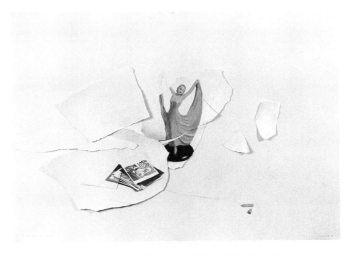

6. Liliana Porter. *Reconstruction with a Crying Girl, II*. 1988. Synthetic polymer paint, silkscreen, pencil, and collage on paper, 40 x 60". Collection Graciela Heymann, New York

Since the late 1960s the Argentine artist Luis F. Benedit has approached art as a way of reinventing Argentine history. His work represents an ongoing series of interventions that reflect the objects, instruments, and material systems that culture produces in order to construct for itself an identity. By combining aspects of Conceptual and Pop art he creates a kind of fictive anthropology of modern Argentine culture. In the early 1970s he produced a series of installations, or "living sculptures," that paralleled ethological studies of animal behavior by examining "mutations of instinctual responses as a result of an artificial imposition."[19] Installations like *Biotrón* of 1970 and *Fitotrón* of 1972, both labyrinthine in design, were controlled mini-ecosystems (artificial environments) of animals (bees, ants, fish, birds, lizards, turtles) and plants. In *Biotrón* the animals were presented with the option to escape into a natural environment, as opposed to remaining in their enclosures to survive through artificial means. The instinctual choice, more often than not, was to remain. The last installation in this series, *The Invisible Labyrinth* of 1973, was a gallery space converted into a labyrinth so that a visitor would automatically become a subject of the work. With such projects Benedit symbolically transformed Argentina into an archive and laboratory in order to study the role of environments and mechanisms of control in shaping action and cultural identities. People, his work seems to suggest, become unconsciously attached to attitudes and desires, rules and regulations, that have, in reality, no natural authority. In light of the subsequent history of dictatorship in Argentina, we are reminded of the Argentine writer Manuel Puig's admiring comment about Franz Kafka's interpretation of authoritarian systems of government operating both outside and inside the self: "What is he interested in? Cobwebs, the world of the unconscious, the system that somehow manipulates us, the bars we're not aware of but that are there and don't let us act freely."[20]

In 1987 and 1988 Benedit produced a series of collages, paintings, objects, and installations titled Journey of The Beagle based on Charles Darwin's drawings and account of his voyage to Tierra del Fuego from 1832 to 1834 (figure 7). A work of reconstruction, Benedit's series draws directly upon the records the English naturalist made during his journey and so becomes a memory of a memory.

7. Luis F. Benedit. *Delfin Fitz Roy,* from the series Journey of The Beagle. 1987. Watercolor on paper, oil on canvas and panel, and objects in epoxy resin, 11' 8" x 16' 8". Collection the artist

The historical irony of Darwin's voyage is that while it marked a historical moment of change, which led to the disappearance of an indigenous population and its culture, it was also the first scientific recording of the region. Darwin's encounter offers a mimetic trace of Argentine history. To understand Argentina before modernization necessitates passing through Darwin, retelling his history. Moreover, science displaces already existing cultural forms and forges a new cultural cartography. Repetition, as exercised by Benedit's work, performs a crucial function in disclosing a founding moment in modern Argentine identity that is part of a larger history of science and exploration carried out in the epoch of British imperialism.

More recently Benedit has turned his attention to the world of the gauchos in order to create a portrait of the ethical character of gaucho life and material culture. Benedit's method of approaching the subject corresponds to his approach to Darwin. While incorporating paintings, objects, and drawings into installations that suggest layers of representation, he drew directly on the drawings and watercolors of Florencio Molina Campos, an Argentine artist of the 1930s and 1940s who satirically celebrated the gaucho way of life.[21] For Benedit, Molina Campos represented the first real Argentine artist because his work was an attempt to portray an Argentine culture without direct recourse to a European model. Yet, in copying images by Molina Campos, Benedit subjected them to mock-Picassoesque reworking. Molina Campos's style, as a result, is separated from its subject, while Benedit's own rendering subjects a dominant style of European modernism to the style of Molina Campos. The effect is to produce a series of works that parody the role of style in the construction of its subject. Nothing is retrievable, except through a series of displacements and mediations.

The gauchos are folk heroes, fabled as men who imposed themselves on the harsh environment of the pampas and survived. In his work, Benedit looks at their material culture—ranches, tools, and other instruments that made their survival possible. In a series of watercolors, drawings, and objects—including such works as several versions of *Para F. M. C. (Calentando el horno)* [*For F. M. C. (Heating the Oven)*] of 1989 (plates 24 and 25), and *Boleadoras (A)* [*Bolas (A)*]

of 1990 (plate 23), the latter named after the weapons traditionally used by the gauchos to hunt rheas and wild horses—Benedit elevated the instruments he replicated from tools of trade to emblems of culture. Objects, such as *Mortar* of 1990 (figure 8), are filled with an expressive power whose source is the historical memory they embody. They therefore function as documents of a local cultural history. The very concept of cultural identity is shaped by instruments of the natural, physical, and social sciences, which form technologies of erasure, control, and survival. In this sense, the work reveals, on the one hand, that which is absent—indigenous communities—and, on the other, that which has been constructed out of mythic, although necessary, identities. Just as Benedit separates Molina Campos from his subject, the objects he portrays are transformed into dysfunctional aesthetic signs and cultural fetishes. They point to the continuous process of displacement and substitution which characterizes the history of Argentine culture.

As in Benedit's earlier work, the construction of a form of cultural landscape through the use of different material supports of art not only reconstructs the past but reelaborates the present. His artistic re-creations, like those of Kuitca and Porter, exhibit and dismantle the violence inherent in the mythic stories that sprang from colonization and continue to shape the contours of Argentine identity. Yet, by re-presenting these objects, the artist is able to suggest the dependence of the present on the mythic past.

━━

In contemporary art of Latin America, the subject is often defined not as a coherent cultural identity but as fractured, fragmented, decentered, and displaced. Art attains a sense of both anxiety and hope in its capacity to bear witness to history and the conditions of the present day, and therein to redeem the real. The body and the world of objects become central, as artists return to representations in order to reinscribe and account for the experience of the self and others. In so doing, they go beyond the modernist aesthetic that worked to colonize experience, and they thereby undo fictions of coherence and stability. The body, as their work continually demonstrates, can no longer be restored to its original primitive condition. Rather, art, becoming a register of local, repressed, and intimate histories, speaks palpably of impoverishment, underdevelopment, violation of human rights, and waves of exile, as well as the effects of modernization, the commodification of the imaginary, and institutional incursions into the arena of everyday life and the private sphere.

In the context of Latin America, as with minority cultures in the United States, the critical question remains that of agency. Who and what are the generating forces of social transformation? Is it to be resolved by dismantling dominant models or generating others? The early modernists of Latin America, particularly Tarsila do Amaral, Frida Kahlo, Wifredo Lam, José Clemente Orozco, and Joaquín Torres-García, transformed European modernism by developing pictorial languages relevant to the distinct and emergent intercultural identity of Latin America. In this manner they subverted the logic of neocolonial power and its discriminating modernist and hegemonic aesthetic.

Contemporary artists in Latin America can be distinguished by their interest in questioning, appropriating, and dismantling colonial and neocolonial cultural codes and models of dominance. A study of

these artists, among others in Latin America, reveals how they use and misappropriate European and North American cultures in order to overturn history and those cultures. They recognize identity as the subject of displacement, fragmentation, and dispossession. It is founded not only in the "in-between" and negotiated spaces of competing representations or processes of identification but in the conscious positioning of the individual in relation to difference. The issue is how to understand the social formation of the body—the realm of the senses, of memory and the unconscious, as well as vision and visuality—as social facts. Only then does the significance of artistic practice become clear, allowing artists to explore its discriminating power, its resistances, and its potentialities.

8. Luis F. Benedit. *Mortar*. 1990. Wood, acrylic, and corn; box open: 17 x 9 x 11 ½". Ruth Benzacar Galería de Arte, Buenos Aires

Notes

1. For a more specific discussion, see my essay "Return of the Dead," in *The Interrupted Life* (New York: New Museum of Contemporary Art, 1991), pp. 75–85.

2. The Mexican painter Frida Kahlo has been of special importance to Mendieta, Galán, Maldonado, Kuitca, the Chilean Juan Davila, and other members of this generation, because of the attention she paid to the body as the surface and site across which subjectivity can be violently inscribed. This inscription represents a movement across private and public spheres, encompassing both the individual and the collective subject, and between popular and high culture.

3. This distinction is made by Jean-François Lyotard in "Critical Reflections," *Artforum* 29 (April 1991), p. 93.

4. "Una identità di concezione del mondo tra 'scrittori' e 'popolo,' cioè i sentimenti popolari non sono vissuti come propri dagli scrittori, né gli scrittori hanno una funzione 'educatrice nazionale,' cioè non si sono posti e non si pongono il problema di elaborare i sentimenti popolari dopo averli rivissuti e fatti propri."—Antonio Gramsci, "Problemi della cultura nazionale italiana: 1. Letteratura popolare," *Quaderno 21, XVII* (1934–

35), reprinted in Valentino Gerratana, ed., *Quaderni del carcere* 3 (Turin: Giulio Einaure, 1975), p. 2114.

5. Cited in John Perreault, "Earth and Fire: Mendieta's Body of Work," in Petra Barreras del Rio and John Perreault, *Ana Mendieta: A Retrospective* (New York: New Museum of Contemporary Art, 1987), p. 10.

6. The idea of abandoning oneself to the earth is captured also by Mendieta's comments on a book on African culture, which she recorded in one of her unpublished notebooks: "The men from Kimberly go outside their village to seek their brides. When a man brings his new wife home, the woman brings with her a sack of earth from her homeland and every night she eats a little bit of that earth. The earth will help her make the transition between her homeland and her new home." That is, the earth itself is disinterred and deposited in the woman's body as a gesture of depatriation. Cited by Petra Barreras del Rio, "Ana Mendieta: A Historical Overview," in Barreras del Rio and Perreault, *Ana Mendieta*, p. 31.

7. See Gilles Deleuze and Félix Guattari, *Kafka: Toward a Minor Literature*, trans. Dana Polan (Minneapolis: University of Minnesota Press, 1986); and Nestor Garcia Canclini's study, *Culturas híbridas: Estrategias para entrar y salir de la modernidad* (Mexico City: Grijalbo, 1989).

8. Lucero is the *guerrero* (vigilante) for Sarabanda, god of iron and figure of the slave and railway worker, a figure of oppression and resistance.

9. The *prenda* is also called the *nkisi-kettle*. See Robert Farris Thompson, *Flash of the Spirit: African and Afro-American Art and Philosophy* (New York: Random House, 1983), p. 121.

10. Leo Bersani, *Baudelaire and Freud* (Berkeley: University of California Press, 1977), p. 98.

11. Siegfried Kracauer, *Das Ornament der Masse* (Frankfurt am Main: Suhrkamp, 1977), p. 315.

12. Wilson Coutinho, "Introduction," in *Daniel Senise*, catalogue produced for the 18th Bienal Internacional de São Paulo, 1985.

13. Jean Baudrillard, "Fetishism and Ideology: The Semiological Reduction," in his *For a Critique of the Political Economy of the Sign*, trans. Charles Levin (St. Louis: Telos Press, 1981), p. 92.

14. Catunda both appears and disappears as author of her work. In a catalogue for a one-person exhibition held at the Galería de Arte, São Paulo, in October 1990, a photograph of a sewing machine has been substituted for a portrait of the artist, the sewing machine thus becoming a witty metonym for the unrecognized labor and artistic work of women.

15. Most of the country's contemporary artists are first- or second-generation Argentines. Porter's grandparents came from Romania and Russia, Kuitca's from Russia, and Benedit's from Spain and the Basque region. The grandparents of the Argentine artists César Paternosto and Víctor Grippo were Italian.

16. See Julia Kristeva, *The Powers of Horror: An Essay on Abjection* (New York: Columbia University Press, 1982).

17. Letter from the artist, September 4, 1992, Liliana Porter file, Americas Society, Visual Arts Department, New York.

18. "Inminencia de una revelación, que no se produce."—Jorge Luis Borges, "La muralla y los libros" (1952), in his *Obras completas* (Buenos Aires: Emecé Editores, 1974), p. 635.

19. Alisa Tager, "Luis F. Benedit," in Sally Baker, ed., *Art of the Americas: The Argentine Project / Arte de las Américas: El proyecto argentino* (Hudson, New York: Baker and Co., 1992), pp. 85, 87.

20. Ronald Christ, "Interview with Manuel Puig," *Christopher Street* 3 (April 1979), p. 30.

21. According to Juan Carlos Ocampo, Walt Disney admired Molina Campos so much that he hired him to be an advisor on several films, but Molina Campos ultimately concluded that these films debased the image of the Argentine. However, according to Dave Smith, Archivist, Walt Disney Studios, Molina Campos never served as a consultant to Disney, though Disney did meet the artist on a trip to South America in the early 1940s, and Molina Campos subsequently visited Disney in California. There is, in any case, a telling resemblance between Molina Campos's drawings of the gaucho and those of the "bad guys" in Disney's animated films of the 1950s. See Juan Carlos Ocampo, "Introducción," in Angel Bonomini and Enrique Molina, *Florencio Molina Campos* (Buenos Aires: Asociación Amigos de las Artes Tradicionales, 1989), p. 8.

BLUEPRINT CIRCUITS: CONCEPTUAL ART AND POLITICS IN LATIN AMERICA

—

Mari Carmen Ramírez

Circuit \ . . . a course around a periphery . . . space enclosed within a circumference . . . a system for two-way communication.[1]

In 1972, taking stock of the status of Conceptual art in Western countries, the Spanish art historian Simón Marchán Fiz observed the beginnings of a tendency toward "ideological conceptualism" emerging in peripheral societies such as Argentina and Spain.[2] This version of Conceptual art came on the heels of the controversial propositions about the nature of art and artistic practice introduced in the mid-1960s by the North Americans Robert Barry, Mel Bochner, Douglas Huebler, Joseph Kosuth, Sol LeWitt, and Lawrence Weiner, as well as by the British group Art & Language. These artists investigated the nature of the art object as well as the institutional mechanisms that support it, and their results tended to deemphasize or eliminate the art object in favor of the process or ideas underlying it. North American Conceptual artists also questioned the role of museums and galleries in the promotion of art, its market status, and its relationship with the audience. Their exposure of the functions of art in both social and cultural circuits has significantly redefined contemporary artistic practice over the last thirty years.

For Marchán Fiz, the distinguishing feature of the Spanish and Argentine forms of Conceptualism was extending the North American critique of the institutions and practices of art to an analysis of political and social issues. At the time when he made these observations, the radical edge of North American Conceptual art's critique was obscured by the generalizing, reductive posture of Kosuth's "art-as-idea-as-idea."[3] In Kosuth's model the artwork as conceptual proposition is reduced to a tautological or self-reflexive statement. He insisted that art consists of nothing other than the artist's idea of it, and that art can claim no meaning outside itself. Marchán Fiz contrasted the rigidity of this self-referential, analytical model with the potential of "ideological conceptualism" to reveal political and social realities. For artists, he saw in this hybrid version of conceptualism the possibility of an exit from the tautological impasse which, in his view, had deadlocked the practice of Conceptual art by 1972.

In Latin America Marchán Fiz was referring specifically to the Argentine Grupo de los Trece, but the version of Conceptual art he described has flourished not only in Argentina but in Uruguay, Chile, and Brazil since the mid-1960s.[4] As with any movement originating in the periphery, the work of Latin American political-conceptual artists—in its relationship with the mainstream source—engages in a pattern of mutual influence and response. It is both grounded in and distant from the legacy of North American Conceptualism in that it represents a transformation of it and also anticipated in many ways the forms of ideological conceptualism developed in the late 1970s and 1980s by feminist and other politically engaged artists in North America and Europe.[5] To investigate the reasons for this complex interaction is to delve into the ways in which the peripheral situation and socio-historical dynamic of Latin America imprinted a new logic onto the most radical achievements of center-based Conceptual art.

Marchán Fiz's insight can illuminate the development of Conceptual art in Latin America. Two generations of political-conceptual artists are discussed in this essay: the first—exemplified by the Argentine Víctor Grippo, the Uruguayan Luis Camnitzer, the Brazilian Cildo Meireles, and the Chileans Eugenio Dittborn and Gonzalo Díaz—witnessed the emergence of Conceptual art and the political

upheavals of the 1960s in the United States and Latin America; the second group—which includes the Chilean Alfredo Jaar and the Brazilian Jac Leirner—emerged in the 1980s and experienced the demise and aftermath of the political dictatorships whose rise to power the previous generation had seen.[6] Taken as a whole, the work of both groups embodies a series of systematic inversions of important propositions of North American Conceptual art, "counter-propositions" that function as "exits" from the ideological impasse seen by Marchán Fiz.

Strategic Circuits: Unfolding Politics

In a recent interview with the critic Sean Cubitt, Eugenio Dittborn described the function of his Pinturas Aeropostales (Airmail Paintings) as a means of *traveling* "to negotiate the possibility of making visible the invisible: *the distance*." Traveling "*to negotiate a meaning*," he added, is the political element of his work; more precisely, it is "*the unfolding of that politics*."[7] A preoccupation with bridging distances, crossing borders, and violating limits is also evident in Alfredo Jaar's description of his photo-light-box installations as a body of production that deals with "the extraordinary, widening gap between Us and Them, that striking distance that is, after all, only a mental one."[8] Each of Jaar's installations features evidence of his travels to remote sites in order to research and document a theme. Understood conceptually, "traveling," in the work of Dittborn and Jaar, as in that of Camnitzer, Díaz, Grippo, Leirner, and Meireles, establishes an "inverted route" that reverses the cultural polarity of "South" and "North" that has persistently subordinated Latin America to Europe and North America.

The closing of the gap between "center" and "periphery," between "first" and "third" worlds—constructs that convey the disparities between highly industrialized and still-developing nations—has been at the heart of Latin American concerns since the colonial period. Geography and colonialism dictated a history based on cycles of journeys and displacements, circulation and exchange, between the metropolitan centers of Europe and the colonies of Latin America and the Caribbean. Forced into cultural and political subordination, the practices of art were locked in endless rounds of copy/repetition, adaptation/transformation, and resisting or confronting the dominant powers. With this background, the history of modern art in Latin America since the 1920s can be seen as a constant search to open a space for change amid the web of economic and cultural circuits that continues to determine the experience of artists in this region.[9]

The political-conceptual artists considered here are distinguished by their deliberate assumption of the peripheral condition as the starting point of their work. For instance, Dittborn's Airmail Paintings (plate 61) are emblems of the search to bridge the gap between the two worlds and also ironic vehicles to expose the precariousness of artistic practice in the periphery.[10] They consist of large sheets of brown wrapping paper or synthetic nonwoven fabric folded and then inserted into mailing envelopes (figures 1 and 2). Disguising a painting as a letter calls into question the relevance of the medium of painting, both in and for the nations on the periphery. At the same time, the works offer "a material option and artistic cunning" as means to break out of the isolation and confinement imposed by the periphery.[11] A number of artists have adopted similar strategies, utilizing their

1. Eugenio Dittborn. Twenty-four mailing envelopes, at the curb of a street in Santiago, each stack containing one Airmail Painting: *To Travel*, 1990–92; *The 6th History of the Human Face*, 1989–92; and *The 13th History of the Human Face*, 1992

2. Eugenio Dittborn unfolding *Airmail Painting Number 96: Liquid Ashes*. 1992. Paint, stitching, and photo-silkscreen on twelve panels of nonwoven fabric, dimensions variable. Installation in progress, Documenta 9, Kassel, 1992

peripheral condition as a tactic to exit outmoded circuits, whether artistic or ideological, that are marked by the legacy of colonialism.

Assuming the peripheral condition characterizes a generation of artists caught in the traumatic political and economic developments of the last thirty years in Latin America. Coming of age in the midst of the postwar development effort known as *desarrollismo*, which significantly reorganized the socioeconomic structures of major Latin American countries,[12] this group also lived through the promise of liberation from the political and economic stranglehold of the United States. Employing "dependency theory" to analyze their situation, they envisioned an emancipated role for Latin America in the "first world" order. Such optimism coincided with the shift of the art world's center from Paris to New York, reducing the distance—at least geographically—between that center and the Latin American periphery. The artistic environment of New York would play a pivotal role in the emergence of Conceptual and other experimental tendencies in Latin America by offering the large number of Latin American artists who arrived there in the 1960s freedom from the official conservatism of artistic institutions in their native countries.[13] It is important to note that unlike Brazil, where the early work of Hélio Oiticica and Lygia Clark had anticipated many experimental trends, Argentina, Chile, and Uruguay had little artistic experience to support the emergence of the radical practice of Conceptual art.[14] By contrast, the openly irreverent postures of such New York artists as Robert Rauschenberg, Jasper Johns, Jim Dine, Andy Warhol, and Robert Morris offered a context in which to engage openly in artistic experimentation. In general, the work of these North American artists offered a critique of formalism and a recovery of the iconoclastic legacy of Marcel Duchamp, both of which would strongly appeal to Latin American artists. Being in New York also placed in perspective both the social and artistic problems of Latin American countries.[15]

The generation that rode the optimism of the 1960s, however, experienced frustration of its hopes for Latin America. Between 1964 and 1976, six major countries in South America fell under military rule, including Brazil, Argentina, Chile, and Uruguay, where authoritarian regimes not only abolished the rights and privileges of democracy but also institutionalized torture, repression, and censorship.[16] The critic Nelly Richard has analyzed how the fall of Chile's president, Salvador Allende, in 1973, coupled with General Augusto Pinochet's seizure of power, shattered the existing framework of social and political experiences linked to democracy. This abrupt transformation of social structures brought about a "crisis of intelligibility," as Richard calls it. Subjected to strict rules of censorship, artists concerned with the production of art relevant to the country's recent history had no recourse but "to seek alternative ways to recover the meaning of that history, which had been replaced by the Grand History of the Victors."[17] Richard's description can be extended to countries like Argentina and Uruguay, which, until the mid-1960s, had known some degree of democracy.

All of the artists discussed here experienced authoritarianism, in its psychological and material forms, either as internal or external exiles.[18] Translating this experience artistically in a significant way could proceed only from giving new sense to the artist's role as an active intervener in political and ideological structures. Meireles, who produced art during the most repressive years of the Brazilian military regime, defined his practice early on as one of *inserção* (insertion) or

transgressão (transgression) of the real, whether the real is understood as an ideological representation or actual space.[19] On the other hand, Dittborn's Airmail Paintings originated in the pressing need to "salvage memory" in a social and political context that erased virtually every trace of it.[20] Grippo's concern with exploring the relations between art and science is based on his deliberate assumption of the role of artist as integrator and catalyst of experiences amid the fragmentation that characterizes life in marginal conditions.[21] For other artists, the dislocation that accompanied exile reinforced their commitment to a form of art based on ethical choice. For Camnitzer, "Every aesthetic act is an ethical act. . . . As soon as I do something in the universe, even if nothing else than a mark, I am exercising power."[22] Camnitzer's production has involved a long meditation on the "alienating myth of being an artist" in late capitalist society. This posture has led him to search for a form of art that can reveal the mechanisms of power in all their manifestations.[23] The belief that every aesthetic act or choice is a moral one also informs Jaar's commitment as an artist: "My dilemma as an artist is how to make art out of information that most of us would rather ignore. How do you actually make art when the world is in such a state?"[24] In Jaar's case, the sphere of his investigations extends beyond Latin America to call into question the hierarchies that separate the first and third worlds.

The renewal of artistic roles undertaken by these artists implied altering the function of art with respect to the crucial issue of Latin American identity. Authoritarianism and its aftermath—large foreign debt, inoperative economies, and marginalization from the dynamics of global politics and development—underlined the failure of the nationalist model that had operated in most countries since the 1920s. The new crisis led artists and intellectuals to investigate issues of representation and simultaneously to look for nonofficial models to articulate the identities of their places of origin. Many artists, feeling alienated from ineffective political structures, came to feel peripheral not only in relation to the first world but inside their own countries.[25] In this situation, identity could no longer be articulated with the emblems of the period of national consolidation. Likewise, an updated form of political and activist art had to disengage itself from the legacy of the Mexican Mural Movement, which had become not only an instrument of institutionalized power but a marketable stereotype of Latin American identity.

The dilemma confronting these artists was effectively expressed by the Brazilian artist Hélio Oiticica in the statement that accompanied his contribution to the exhibition *Information*, which was presented at The Museum of Modern Art, New York, in 1970. Oiticica declared: "i am not here representing brazil; or representing anythingelse: the ideas of representing-representation-etc. are over."[26] For Camnitzer, Díaz, Dittborn, Grippo, Jaar, Leirner, and Meireles Conceptual art provided the means to discover, in Dittborn's words, "another way of looking at ourselves, multiple, polytheistic, and *affordable*."[27] The appeal Conceptual art held for these artists rested on two factors: first, its equation of art with knowledge that transcends the aesthetic realm, which enabled them to explore problems and issues linked to concrete social and political situations; second, its critique of the traditional institutions and agents of art, which opened the way for an elaboration of a form of art suited to the political and economic precariousness of Latin America.[28] Instead of serving as vehicles to dissect the commodification of art under capi-

talism, the fundamental propositions of Conceptual art became elements of a strategy for exposing the limits of art and life under conditions of marginalization and, in some cases, repression. Hence, these artists developed a series of strategic inversions of the North American conceptual model, thereby determining the political character of their art.

Bargaining Circuits: Negotiating Meanings

If M. DUCHAMP intervened at the level of Art (logic of phenomena), . . . what is done today, on the contrary, tends to be closer to Culture than to Art, and that is necessarily a political interference. That is to say, if aesthetics grounds Art, politics grounds Culture.—Cildo Meireles[29]

In the work of most of the Conceptual artists under consideration, the aims of bridging distance to negotiate meaning evolved into a deliberate tactic of *insertion* into prevailing artistic and ideological circuits. This was done in order to expose mechanisms of repression and disrupt the status of Latin American identity as a commodity exchanged along the axis between center and periphery. The development of such a conceptual strategic language, however, eventually situated the work of these artists in a paradoxical relation to a fundamental principle of European and North American Conceptual art: the dematerialization of the discrete object of art and its replacement by a linguistic or analytical proposition. Latin American artists inverted this principle through a recovery of the object, in the form of the mass-produced Duchampian Readymade, which is the vehicle of their conceptual program.[30] Meireles's Coca-Cola bottles, bank notes, and leather boxes; Grippo's potatoes; Dittborn's found photographs and Airmail Paintings; Camnitzer's text/object combinations; Díaz's found objects and appropriated emblems of the advertising world; Jaar's light-boxes, mirrors, and frames; and Leirner's accumulations of "trash" provide us with curious twists of the Duchampian idea. Such objects are visual counterparts to the thought processes suggested by conceptual propositions. Following Duchamp, the artists were concerned not so much with the production of artistic objects but with the appropriation of already existing objects or forms as part of broad strategies of signification.[31]

The inversion of North American Conceptual art's analytic proposition can be attributed to these artists' explorations of the implications of Duchamp's legacy, which had already been investigated, with different results, by both Conceptual and Pop art. As Benjamin Buchloh has argued, with regard to analytic Conceptual art, the revival of the Readymade led to an analysis of the self-reflexive or self-referential qualities of the object. This analysis originated in a narrow reading of Duchamp's original intention; the significance of the Readymade was reduced to the act that created it: "It's art because I say so."[32] On the other hand, in the case of such Pop artists as Andy Warhol, appropriation of the idea of the Readymade led to the exaltation of marketable commodities, represented by the Coca-Cola bottle or Campbell's soup can, as icons of a market-driven culture.[33] Both approaches to the Readymade can be seen as grounded in a passive attitude toward the prevailing system, which this group of political-conceptual artists aimed to subvert. Thus, in the Latin American work, the ready-made object is always charged with meanings

related to its functions within a larger social circuit. That is the Latin American conceptual proposition. In most cases the infusion of broader meanings is achieved by removing the object from circulation, physically transforming it, and, in the case of Meireles, reintroducing it into an everyday circuit. Through such acts as silkscreening messages onto actual Coca-Cola bottles and bank notes (Meireles); sewing and stitching together large quantities of trash (Leirner); enlarging, cropping, and juxtaposing found photographs (Dittborn); or wrapping and staining commercial cardboard boxes with a red dye that simulates blood (Camnitzer), the artist reinscribes meaning into the commodity object. In this way, the ready-made, as these artists employ it, goes beyond Pop art's fetishization of the object, turning it into a conveyor of political meanings within a specific social context. Once transformed, the object is inserted into a proposition where it operates through the following linguistic mechanisms: explicit message, metaphor, and analogy.

Meireles's *Inserções em circuitos ideológicos: 1. Projeto Coca-Cola* [*Insertions into Ideological Circuits: 1. Coca-Cola Project*] of 1970 (plate 120) and *Insertions into Ideological Circuits: Bank Note Project (Who Killed Herzog?)*, of the same year (figure 3), are conceptual propositions based on the direct intervention or transgression of a circuit in order to relay information.[34] The works consisted, respectively, of removing Coca-Cola bottles and cruzeiro bills from circulation, inscribing political messages on them, and putting them back into circulation. In retrospect, these "projects" can be seen as having introduced several ideas that would be important for political-conceptual art, principally those of isolating a circuit, using a ready-made object to "package" a message, and designating the public at large as recipient of the message. In the early 1970s, during the most repressive years of the Brazilian military dictatorship, the strategy of insertion at the level of immediate reality deliberately aimed to transform the passive viewer into an active participant in the information circuit.[35]

3. Cildo Meireles. *Insertions into Ideological Circuits: Bank Note Project (Who Killed Herzog?)*. 1970. Rubber stamp and bank note. Collection the artist

While Warhol created serial, silkscreened representations of Coca-Cola bottles, Meireles printed anti-imperialist messages on real bottles, which he reintroduced into the bottle-deposit system of Brazil.

In contrast to Meireles's hybrid ready-mades, the works of Camnitzer, Dittborn, and Grippo convey political messages through the veiled mechanisms of metaphor and analogy. Their "deceptive" strategies are the kind developed by Conceptual artists operating in conditions where repression and censorship prevail.[36] Both mechanisms function to release information suppressed by the system: in metaphor, what is shown is equivalent to something that cannot be said, which thus remains ambiguous; analogy, on the other hand, sets up a framework for comparison of two formal systems, playing upon their correspondences to create a third system. Therefore, both depend on a "viewer-turned-accomplice" to decipher meanings. These artists extend Duchamp's Readymade into the equivalent of a fragment of reality. As such, it becomes a condensed site for the production of meaning. The significance of this proposition for political-conceptual art is that it allows the social referent to be conveyed in the very structure of the work.

Dittborn's "anti-paintings" are among the most complex instances of the metaphoric ready-made. Here it takes the form of found photographs of the faces of anonymous individuals, frequently mug shots, which the artist collects from old journals, diaries, police files, and newspapers. Dittborn's photographic gallery of the indigenous inhabitants of Tierra del Fuego, petty criminals, athletes, and beauty queens—who appear in many of his Airmail Paintings—may have been seen previously in a different context, perhaps by a large audience (figure 4). The value of such found photographs lies in their capacity to tap meanings already fixed in social memory; each photograph represents a lost identity, a repressed story whose meaning awaits unfolding by the viewer. The artist's tactic consists of transposing the identities of the photographed individuals from the past to the present, so as to exploit their signifying potential. He achieves this dislocation by detaching the image from its source through enlarging and cropping, and then by juxtaposing the images in series using a photo-silkscreen process. In this way the photograph is made contemporary with the viewer, turning him or her into an accomplice in the production of meaning. The act of viewing reveals subtle indicators of class, race, and social power, enabling recognition of what was regarded as anonymous; identity unfolds from this process.

Dittborn also manipulates the mechanical photograph by adding marks or objects, including handwritten texts, stains, feathers, and thread, as well as a child's (his daughter's) drawings.[37] Such methods call attention to the artificial nature of representational painting and turn the painting's surface into a complex field of signs, which act as vehicles for the metaphoric content of the work. The effectiveness of these elements depends on ambiguity, on evoking several levels of meaning. At one level they stand for forgotten citizens thrown into captivity, misfits whose lost histories are disinterred by Dittborn through the act of representing them. In the context of Chile's military dictatorship, these anonymous images can be taken as a metaphor for that nation's thousands of *desaparecidos*, persons regarded as political opponents of the regime who were "disappeared" and presumably killed by its security forces. Such an artwork becomes a "search for [an] entombed memory," in the words of Richard, and a catalyst for the living.[38]

A similar metaphoric process is at work in Camnitzer's *Leftovers*, 1970 (plate 38), a piece consisting of eighty tightly stacked standard, mass-produced boxes. Reworking Andy Warhol's Brillo boxes of 1964, Camnitzer wrapped his boxes with gauze, stained with a red dye that resembles blood, and stenciled each with the word "LEFT-OVER" and a Roman numeral. The meaning of these elements is open to interpretation: they may allude to intervention by the United States in Latin American affairs, shipments of arms intended to repress liberation movements, containers for dismembered bodies, dangerous waste shipped from the first to the third world, and so on.[39] All of these interpretations coalesce around the work's function as a metaphor for the network of oppression that articulates relations between the first and third worlds.

Metaphor operates differently in Jac Leirner's work.[40] Here the tactic of insertion is played back upon itself. It effects a circular movement through the recycling of trash, including empty cigarette packs, devalued bank notes, used shopping bags, and waste paper. Though these materials may have originated in some form of economic or symbolic exchange, they were out of circulation, so Leirner retrieved them, hoarding them over long periods of time. Then she set out to transform them through flattening, sewing and stitching, punching holes through them, or, in some cases, tearing them apart.[41] In *Pul-*

4. Eugenio Dittborn. *To Clothe.* 1986–87. Photo-silkscreen on paper. Archer M. Huntington Art Gallery, University of Texas, Austin

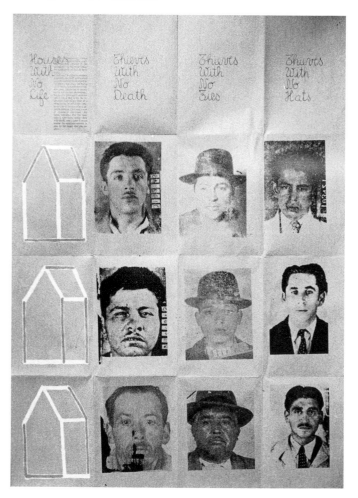

5. Jac Leirner. *The One Hundreds: Eroticism and Pornography.* 1986. Bank notes with anonymous graffiti and buckram, 23⅜ x 23⅜". Collection Luiz Buarque de Hollanda, Rio de Janeiro

mão [Lung] of 1987 (plate 108), the foil paper, cellophane tabs, and cellophane wrappers of twelve hundred packages of cigarettes smoked by Leirner during a three-year period were torn apart, turned into sculptural objects, and juxtaposed with such items as X-ray photographs of the artist's lungs. In Brazil these X-rays carry with them strong social connotations, since every citizen must present them in order to be considered for a job. Leirner's use of such socially charged icons situates the reading of the work in a "public" space. Thus the series emerges as a visual indictment of the tobacco industry.

Recycling produces an objective intervention in the system, an actual presence. The individual objects that constitute that presence represent not only themselves but are assembled by Leirner in structures that convey an additional level of meaning. For example, The One Hundreds of 1985–87 (figure 5) is a series of sculptures fabricated from seventy thousand one-hundred-cruzeiro notes, which had lost much of their value because of inflation, sewn together in quilt-like forms or shaped into lines and circles (plate 107). This process of assemblage positions the notes within a continuous, syntagmatic chain of meaning; the resultant languagelike structure is both a new *corpo*, or bodily presence, and an embodiment of new values. By creating an artwork out of devalued currency, the artist, ironically, "commodified currency itself and reinvested it with [artistic] value."[42] Undertaken in a period of deep economic crisis, characterized by the pressures of a large foreign debt and increasingly inequitable conditions for many sectors of Brazilian society, Leirner's assemblages are a powerful metaphor for a consumer-oriented society caught in the devaluation of its social and moral standards.

In Víctor Grippo's art analogy replaces metaphor to convey meanings related to contemporary social conditions. His art functions through the introduction of ordinary objects of everyday use and

consumption (such as a table or a potato) into analogical propositions that explore relations between art and science.[43] Despite their modest status, these objects are linked to social systems that endow them with meaning. *Table* of 1978 (figure 6), for instance, is an old table with a text written on its surface and on the bottom of its single drawer. The table leads us to consider the many symbolic functions and class or occupational referents of a common object within a social structure; it is a place to eat, think, do homework, make bread, fix clocks, write poems, and so on. As sites for the evocation of human activity, such reference-charged objects can be seen as means to blur the line between art and life.

For another work Grippo used potatoes, transforming them under conditions that resemble those of scientific experiments. In the conceptual program the potato's effectiveness depends on the network of cultural references it evokes. The potato produces energy by a chemical process that is also intrinsic to man, whose body converts energy into consciousness. The potato is indigenous to South America; transported to Europe, it significantly altered the eating habits of Old World societies.[44] In each case the potato stands for change, for transformation of internal and external structures. This function is further revealed in the Analogies series of the 1970s, in which potatoes are connected in order to demonstrate their capacity to produce energy. For *Analogía I [Analogy I]* of 1971 (plate 73), Grippo embedded copper and zinc electrodes in forty potatoes and connected them to an electric voltmeter. In other instances he employed electricity to effect metamorphoses in the vegetable. In each case, an analogical relation is established between the alterations effected in or by the vegetable and the process of transformation of human consciousness.

When used as an element within a larger structure of meaning, the ready-made allowed artists to extend the analysis of the audience, which had been undertaken by Conceptual artists within the sphere of the institution of art in the first world, to the vernacular, public matrix in which the object circulates in Latin America. Many of these artists' tactics originated in popular traditions. For instance, the idea of isolating circuits developed by Meireles finds a source in the chain-letter networks still operating in most Latin American

6. Víctor Grippo. *Table.* 1978. Ink on wood table and plexiglass, 21 x 39 x 30¾". Collection Ricardo Martin-Crosa

countries, whereby anonymous individuals pass on devotional religious promises.[45] Dittborn's Airmail Paintings recall the broadsides called *pliegos sueltos* (folded sheets) that were sold on the streets to be read aloud in the cities and countryside of Latin America in the mid-nineteenth century.[46] The rudimentary utensils used by Grippo in some works refer to the working-class immigrant culture of Argentina. In other examples, a reference to popular culture is implied by the ready-made because it has circulated extensively among large numbers of people before the artist appropriated it. Leirner's recycled objects bear the traces of their circulation in the graffitilike inscriptions, tears, or marks from being handled, which the artist accepts as part of the work.[47] In such works the communicative potential of the ready-made, as a reservoir of signifiers important to a specific community, is fully exploited.

—

As has been suggested, the capacity of the ready-made to convey political concerns in ways that are not literal or illustrative was extended in the work of Camnitzer, Díaz, Jaar, and Meireles to the installation format. For these artists, setting up an installation reversed the process of insertion described above. In an installation, objects are taken out of circulation and concentrated in a given space. The act of positioning objects, which is the essence of installation work, is an opportunity to alter the conventions of a given space in order to transform it into a cultural matrix where meanings are decoded and given new forms. Here space does not exist autonomously; it is the result of a conceptual proposition, or program, set up by the artist. The installation thus becomes a space of confrontation and negotiation of meaning. In the work of these artists, the confrontation is never intimidating; instead, a game-playing strategy informs the propositions, inviting the participation of the viewer.

Investigation of the abstract characteristics of a given space, by means of verbal propositions, was a fundamental strategy of North American Conceptual artists probing the conventions of art. The approach of Camnitzer, Díaz, Jaar, and Meireles, however, has been to regard the installation space as an object-filled proposition whose meanings refer beyond the space itself. This inversion of the abstract notion of space can be seen in Meireles's *Physical Art: Cords/30 km of Extended String* of 1969 (Collection Luiz Buarque, Rio de Janeiro), a Duchampian leather box in the form of a map of the state of Rio de Janeiro and a bundle of string thirty kilometers long, which had been stretched along the state's coast. While the North American or European Conceptual artist might restrict reference to the immediate object (as the title would lead one to expect), Meireles's work encourages the viewer to reflect on the arbitrariness of cartographic boundaries.

The conception of space as a matrix for "objectified" thought is exemplified best by Gonzalo Díaz's installations.[48] Exhibiting a complex use of the ready-made, these consist of three-dimensional objects, such as balusters, canopies, and toy horses, and paintings of appropriated images. The images derive mainly from such sources as labels and advertisements for consumer products; Díaz photographs, crops, and silkscreens them onto the support.[49] He then situates them in a space so that they will interact with three-dimensional objects. In this work the ready-made plays a double role: it synthesizes in three-dimensional form the various metaphoric levels (per-

7. Gonzalo Díaz. *Testing Bench/Frame*. 1986–89. Mixed-medium installation, dimensions variable. Archer M. Huntington Art Gallery, University of Texas, Austin

sonal, social, national) of the work, and it emphasizes the recycled aspect of the objects Díaz employs.

For the viewer, Díaz's installations are an active field; the challenge to "play" must first be accepted, and the viewer then proceeds to decipher the relations between objects and images.[50] An example of Díaz's "objectified space" is provided by *Testing Bench/Frame* of 1986–89 (figure 7), an installation grounded in the artist's experience of Pinochet's dictatorship in Chile. The central piece of the work is a bench for modeling and inspecting balusters. It also incorporates a neon light, a canopy, and two rectangular open boxes on the floor, one for casting and one for drying the balusters. The balusters are from a neoclassical building, whose style is associated with the birth of the Chilean republic and its political institutions. As a consumer laboratory tests commercial items, the state apparatus tests its citizens, represented here by the posts that support the balustrade's handrail. The ensemble is complemented by two paintings that serve as backdrops to the installation. In the paintings, images of the Chilean landscape, with symbols of national industries, are juxtaposed with full-length images of two women whose lives exemplify Chile's recent history. The modeling/testing bench, the assembly line incorporating it and the casting and drying boxes, and the pictorial elements all represent limits, boundaries, confinement. As described by the artist, the entire ensemble is intended to convey the "Chilean cartography of pain,"[51] and it thus relates to the central theme of

Díaz's work: "the occupation of the Chilean territory and its conceptualization as a 'cultural landscape.'"[52]

For Camnitzer, Jaar, and Meireles, the installation depends on activating the subject/object relationship in a given space by creating a sensorial environment where the viewer is systematically tested by perceptual mechanisms. Meireles's *To Be Curved with the Eyes* of 1970, a signature multiple work intended by the artist to be included in all his exhibitions, objectifies the subject/object interaction. The work, which reflects his interest in physics and geometry, is a box, containing two bars, on which is written "two iron bars, equal and curved." Meireles is thereby suggesting a relationship between vision and physical force, which should lead the viewer to carry out the action implicit in the title. Virtual Spaces: Corners, a 1967–68 series of forty-four projects that represents an early exploration of viewer interaction with an installation, was based on investigations of perception and virtuality. It consisted of a Euclidean model of space (three planes) transferred to a simulated house corner.

Meireles further developed these investigations by incorporating auditory impressions and tactile sensations into the installation. In *Eureka/Blindhotland* of 1970–75 (figure 8), he introduced sound as a supplement to the visual experience. The installation consisted of two hundred rubber balls strewn on the floor. Once inside, the viewer found that even though the balls looked exactly the same, each was different in weight. An antique scale in the middle of the space could be used to confirm the weight of a ball. Nine tape recordings of dropped balls hitting the floor were heard, reinforcing the differences in weight among the balls and establishing sound as an alternative to the tactile experience of the work. Meireles's exploitation of visual and perceptual ambiguity was forcefully realized in *Through* of 1983–89, one of his most ambitious installations. *Through* consisted of a series of ready-made barriers in the form of fences (trellis, picket,

9. Cildo Meireles. *Through*. 1983–89. Mixed-medium installation, dimensions variable. Installation view, Kanaal Art Foundation, Kortrijk, Belgium, 1989

cyclone), prison bars, mirrors, glass, windows, even curtains, arranged in rectangles around a monumental ball of cellophane, and over eight tons of broken glass (figure 9). The piece played on dichotomies: open/closed, exposed/covered, and so on.[53] These oppositions confronted the viewer at every turn, encouraging reflection on the notion of transgressing limits, whether visual or conceptual.

Luis Camnitzer's installations extend his investigations of both visual and conceptual displacements operating in the relations among objects, images, and language. He first achieved the inversion, described above, of Conceptual art's investigation of the abstract characteristics of a given space in early works such as *Massacre of Puerto Montt* of 1969, where he treated space as a reference-charged field. This installation was one of three done in the late 1960s that consisted of words on strips of white tape pasted on the floor. In this work, he achieved a "re-semanticization" of space through a strategic use of the words on tape, which "reenacted" the event to which the title alludes: the 1969 killing of peasants who occupied unworked land in the village of Puerto Montt, Chile, during the presidency of Eduardo Frei. Words indicated portholes, the soldiers manning them, and the arms used in the operation. By following a series of dotted lines painted on the floor, the viewer was able to recreate the trajectory of the bullets. *The Archaeology of a Spell* of 1979, represents a further step in this process. It combined handwritten texts, images, and objects to produce complex relationships: the texts reiterated the images, while the latter evocatively expanded the texts.

The formal key that allowed Camnitzer to extend his explorations of displacement to a form of political art, using installation as a medium, was the notion of the conceptual matrix, which he terms "the argument." The argument reflects an underlying narrative that provided the internal logic for the arrangements of texts and objects. While implicitly present, the argument was never completely revealed, allowing the viewer to compose his or her own. Camnitzer's installations thus became semantic, connotative fields where the artist's function was reduced to "designing the rules of the game," that is, to constructing the conditions for the presentation of the argument, which in turn would allow the viewer to produce the piece.[54]

8. Cildo Meireles. *Eureka/Blindhotland*. 1970–75. Two hundred black rubber balls of different weights, wood, felt, nylon netting, eight plates for newspaper insertions, and sound track of balls falling on floor, dimensions variable. Installation view, Museu de Arte Moderna, Rio de Janeiro, 1975

10. Luis Camnitzer. *Torture*. 1986–87. Mixed-medium installation, dimensions variable. Installation view, Venice Biennale, 1988

Torture of 1986–87 (figure 10), an installation presented at the 1988 Venice Biennale, articulated space using a format with "stations" recalling the Stations of the Cross in a Catholic church: a sequence of combinations of texts and objects placed against the wall, surrounding a central area made up of artificial grass, newspapers, and printed images. The entire space evoked a prisoner's cell and a narrative into which the viewer was drawn. It concerned a tortured prisoner who imagines he is free and then realizes his actual situation; the viewer experienced it within a "hopscotch" framework that allowed for multiple interpretations of the implied narrative, among them the conclusion that confinement is itself a form of torture. As in an earlier series of color photo-etchings titled From the Uruguayan Torture (1983–84), this work's montage of images, objects, and texts employed perceptual dislocations to evoke for a viewer the experience of imprisonment; banal ready-made objects conveyed the quotidian aspects of torture. Some examples, juxtaposed with texts, are a board with an image of the sky printed over it ("He had to create his own window"); a dish with resin ("He organized things as he saw them"); a ceramic pitcher with bricks inside ("He learned how to believe"); and finally, the omnipresent eye ("He lived imprisoned by the echo of his stare"). The viewer comes to realize the kind of torture that has taken place by "reading" in the gap, or fissure, between what is conveyed by the texts and by the objects or images. The ambiguity of the argument allows for a number of interpretations.[55]

Alfredo Jaar achieves an impressive synthesis of manipulated perception and the game-playing strategy we have seen Díaz and Camnitzer employ. In Jaar's work, space, viewer, and image are enmeshed in a structural relationship through the interplay of light-boxes, frames, and mirrors. Illuminated photographs are used as ideograms. They function as vehicles of social perception through which Jaar displaces subjects from remote locales, inserting them into the exhibition space. Through strategies of visual displacement, carried out largely through the use of mirrors and frames, Jaar addresses the inadequacy of the viewer's perception and also his or her position in the mental and spatial divisions that separate "us" from "them." Enlarged, cropped, and illuminated, the photographs are used by Jaar to map the relationship between subjects and viewers in the context of his installations. *(Un)Framed* of 1987–91 (Collection the artist), for instance, presents a large-scale photographic image of seven miners from Serra Pelada, a North Brazilian mining enclave. The miners seem to engage the viewer's gaze directly. Seven tall frames holding mirrors and sheets of glass arbitrarily obscure sections of the image and, as the viewer moves past them, also momentarily reflect the viewer's image. The effect is to enmesh the viewer in what Jaar has called "'an infernal triangle' . . . [where] we watch ourselves watching them watch us."[56]

Jaar's approach to the installation format ultimately involves the orchestration of a mise-en-scène through the manipulation of space and objects, using techniques and vocabulary akin to those of cinematic editing. Here, as in Meireles's installations, the spectator is confronted by the fact that there is no single "correct" point from which to look at or experience the work. After the initial self-conscious encounter, the viewer must deliberately choose how to see it. Untitled (*Water*) of 1990 (Collection the artist), a piece that deals with Vietnamese refugees ("boat people") in Hong Kong, consists of five double-sided light-boxes with pictures of water on one side and the boat people on the other. The images on the backs of the light-boxes are seen only in a row of twenty-five mirrors suspended on the wall behind the boxes. As the spectator moves past the piece, the images also appear to move, as in the cinema.

The installations of Camnitzer, Díaz, Jaar, and Meireles turn public space, whether institutional or commercial, into a matrix of signifiers, which illuminates the border between art and politics.

There is a gamelike aspect of the work in that each artist establishes a system of rules that invites participation by the viewer, who is led to transgress limits while acting out relations between victim and exploiter, self and other. By establishing a mise-en-scène and manipulating perceptual mechanisms, these installations displace the viewer mentally, encouraging new forms of awareness that destabilize previous understandings.

Exiting Circuits: "Recycled Contexts"

In tautology, there is a double murder: one kills rationality because it resists one; one kills language because it betrays one. . . . Now any refusal of language is a death. Tautology creates a dead, a motionless world.—Roland Barthes[57]

The political logic of the Latin American version of Conceptual art described thus far rests on two factors. On the one hand, it posits the recovery of the object and its insertion into a conceptual proposition or a physical space. This trait can be interpreted as anachronous to the extent that it runs counter to the general trend of mainstream Conceptual art, which moved toward the abolition of the art object. The constant presence of the object in the work of the artists discussed suggests that the reasons for the difference have to do with the demands of the Latin American context. The grounding of artistic languages in extra-artistic concerns has indeed been a constant of the avant-garde in Latin America since the 1920s. It was not only an intrinsic part of the process of tearing apart or recycling forms transmitted from cultural and political centers but a logical step in the act of constructing a tradition with the copy as its starting point. On the other hand, Benjamin Buchloh has suggested that the obsession with "facticity" of North American Conceptual art practices can derive only from the concept of an "administered society" typical of "late" capitalism.[58] The absence in Latin America of the social conditions supporting an administered society makes it an unsuitable model, perhaps even antithetical to a Latin American context. The elaboration of a Conceptual art practice aimed at exposing Latin American political and social realities thus involved a series of inversions of the mainstream model of Conceptual art. Along with the examples already discussed, the differences between the two can be summarized by the following oppositions:

Latin American	North American
contextualization	self-reflexivity
referentiality	tautology
activism	passivity
mediation	immediacy.

One could argue that if Duchamp's propositions found a fertile ground in Latin America, it was because a refusal to abandon the specificity and communicative potential of the aesthetic object was deeply embedded in the modern art tradition initiated by the Mexican Mural Movement and later embraced by the group of political-conceptual artists. However, Duchamp's radical subversion of art as institution, implicit in the provocative creation of the Readymade, is reenacted in these artists' works as an ironic tactic aimed at exposing a precarious activity: that of artistic practice in the frequently inoper-

ative conditions of Latin America. Therefore, utilizing the ready-made as a "package to communicate ideas,"[59] as Camnitzer has called it, ultimately points to an underlying concern with "devaluation," the loss of the object's symbolic value as a result of an economic or ideological process of exchange (as opposed to the North American artists' preoccupation with the process of commodification). Thus, the acts of "reinsertion" carried out by these artists are intended to reinvest objects with social meaning. The ready-made, then, becomes an instrument for the artists' critical intervention in the real, a stratagem by which patterns of understanding may be altered, or a site established for reinvesting reality with meaning. The ready-made also turns into a vehicle by which aesthetic activity may be integrated with all the systems of reference used in everyday life.[60]

Such a reintegration could proceed only from rejecting the idea that the sphere of art is autonomous, thereby recovering the ethical dimension of artistic practice. The ultimate aim of this form of art can be seen as the elaboration of a system of signs, symbols, and actions through which the artist can intervene in what Jaar has called "the process of production and reproduction of meaning and consciousness."[61] Unlike previous models of Latin American political art that relied on the content of the art's "message," the politics of this art requires "unfolding": deconstructing linguistic and visual codes, subverting meanings, and activating space in order to impress on the viewer the effects of the mechanisms of power and ideology. By presenting the work itself as a space (whether physical or metaphoric), this art recovers the notion of the audience. That is to say, it regains for the artist the possibility of engaging in active communication through the artistic object or installation. In these circumstances, the viewer, as a socially constituted recipient, becomes an integral part of the conceptual proposition of the artist.

For these artists the act of replacing tautology with meaning is grounded in the larger project of exiting exhausted political and ideological circuits through the revitalizing of contexts—artistic, geographic, economic—in which they practice their art. This project, in turn, reveals a complex understanding of the realities of Latin America in relation to those of the first world. The deep goal of the work lies in the way it manages "to place in crisis the history of its own culture without forgoing a commitment to that same culture."[62] No longer confined, however, to national boundaries, or split between national and international forces, center and periphery, first and third worlds, it exposes the relations among these constructs, their interdependence. To achieve this aim requires an active negotiation of meaning between them. The Latin American "inverted" model of Conceptual art thus reveals a practice which not only is inscribed in a different framework of development but responds to the misalignment of global politics. Through its capacity to blend central and peripheral sources in the structure and function of a work, it challenges the authority of the "center" as originator of artistic forms.

The practice of a revisionist Conceptual art, seen in the work of this select group of Latin American artists, represents the recovery of an emancipatory project. At a time when the "logic" of "late" capitalism has annihilated the goals of the historic avant-garde, and when most forms of contemporary art have run up the blind alley of self-referentiality, the range and possibilities of such an enterprise should not be overlooked in the United States, where the original propositions of Conceptual art were born.

Notes

1. *Webster's Third New International Dictionary* (Springfield, Mass.: G. & C. Merriam Company, 1981), p. 408.

2. Simón Marchán Fiz, *Del arte objetual al arte de concepto: Las artes plásticas desde 1960* (1972; reprint ed., Madrid: Ediciones Akal, 1988), pp. 268–71. This book provides one of the first comprehensive discussions to appear in Spanish of the Conceptual art movements in Europe and North America.

3. A number of authors in recent years have criticized the apolitical reductiveness of Conceptual art, both in its original versions and in recent revivals. For instance, Hal Foster, in *Recodings: Art, Spectacle, Cultural Politics* (Seattle: Bay Press, 1985), p. 103, has noted that the practices of Conceptual artists that focus on general assumptions governing the institution of art in "late" capitalism are compromised by "present[ing] the exhibitional limits of art as socially indiscriminate and sexually indifferent." Benjamin Buchloh has offered a detailed analysis and critique of those practices in "Conceptual Art, 1962–1969: From the Aesthetics of Administration to the Critique of Institutions," *October* 55 (Winter 1990), pp. 105–43. Other recent critics who have commented on these issues include Robert C. Morgan, The Situation of Conceptual Art," *Arts* 63 (February 1989), pp. 40–43. Of the artists being considered in the present essay, Alfredo Jaar has offered the most cogent critique of this aspect of Conceptual art practice in the following statement: "Conceptual art's greatest failure was definitely its provincialism, . . . in the sense that Tzvetan Todorov has used the term, . . . a failure to recognize that many provinces and capitals do exist. . . . All the dominant assumptions about art were challenged, but this was done practically behind closed doors, in an extraordinary [*sic*] exclusive fashion, almost in an arrogant way, and blind to a number of political events that transformed the world. For the conceptualists, obviously, life was elsewhere." Alfredo Jaar, "Alfredo Jaar," *Flash Art International* 143 (November/December 1988), p. 117.

4. Marchán Fiz, *Del arte objetual al arte de concepto*, pp. 269–70. The Grupo de los Trece was constituted in Buenos Aires in 1971 following a visit by the Polish director Jerzy Grotowski. The group was based at the Centro de Arte y Comunicación (CAYC), directed by Jorge Glusberg, and included the artists Jacques Bedel, Luis F. Benedit, Gregorio Dujovny, Carlos Ginzburg, Víctor Grippo, Vicente Marotta, Jorge González Mir, Luis Pazos, Juan Carlos Romero, and Horacio Zabala. For a summary of the history and objectives of the group, and illustrations of works by its members, see "El Grupo de los Trece," in Gabriel Levinas, ed., *Arte argentino contemporáneo* (Madrid: Editorial Ameris, 1979), pp. 197–201.

5. A glance at the catalogues that accompanied two of the most influential surveys of Conceptual art ever mounted, *Live in Your Head: When Attitudes Become Form, Concepts—Processes—Situations—Information* (Bern: Kunsthalle Bern, 1969), and Kynaston L. McShine, ed., *Information* (New York: The Museum of Modern Art, 1970), reveals an almost complete absence of political concerns, though these would emerge later in the work of Marcel Broodthaers, Daniel Buren, and Hans Haacke, and in that of feminist artists. Even then, excepting the later work of Haacke, Barbara Kruger, Louise Lawler, and Martha Rosler, political or ideological issues were limited to critiques of the institutions of art and rarely addressed politics.

6. Other important artists who contributed to the consolidation of this form of art in Latin America include, in Brazil, Anna Bella Geiger, Rubens Gerchman, Mario Ishikawa, and Regina Vater; in Argentina, León Ferrari and the group Tucumán Arde; in Uruguay, Clemente Padín and Nelbia Romero; in Chile, Virginia Errazuriz, Carlos Leppe, Catalina Parra, and the CADA group, which included Juan Castillo, Lotty Rosenfeld, and others; and in Colombia, Antonio Caro. Also important were Felipe Ehrenberg and the numerous artistic collaboratives of the 1970s in Mexico. See Jorge Glusberg, *Arte en la Argentina: Del pop-art a la nueva imagen* (Buenos Aires: Ediciones de Arte Gaglianone, 1985); Nelly Richard, "Margins and Institutions: Art in Chile Since 1973," *Art and Text* 21 (May–July 1986), pp. 17–114; Aracy Amaral, *A preocupação social na arte brasileira, 1930–1970* (São Paulo: Nobel, 1984); Walter Zanini, *Circunambulatio* (São Paulo: Museu de Arte Contemporânea da Universidade de São Paulo, 1973); *6 jovem arte contemporânea* (São Paulo: Museu de Arte Contemporânea da Universidade de São Paulo, 1972); *8 jovem arte contemporânea* (São Paulo: Museu de Arte Contemporânea da Universidade de São Paulo, 1974); Shifra M. Goldman, "Elite Artists and Audiences: Can They Mix? The Mexican Front of Cultural Workers," *Studies in Latin American Popular Culture* 4 (1985), pp. 139–54; *De los grupos los individuos: Artistas plásticos de los grupos metropolitanos* (Mexico City: Museo de Arte Carrillo Gil, 1985).

7. Sean Cubitt and Eugenio Dittborn, "An Airmail Interview," in Guy Brett and Sean Cubitt, *Camino Way: The Airmail Paintings of Eugenio Dittborn* (Santiago: Eugenio Dittborn, 1991), p. 28.

8. Alfredo Jaar, "La géographie ça sert, d'abord, à faire la guerre (Geography=War)," *Contemporánea* 2 (June 1989), inside cover.

9. This point is argued by Charles Merewether in "The Migration of Images: Inscriptions of Land and Body in Latin America," in *America: Bride of the Sun* (Antwerp: Koninklijk Museum voor Schone Kunsten, 1992), pp. 197–222.

10. Dittborn has explained, "Como todo trabajo de arte que quiere dar cuenta de la periferia en la que se produce y circula, mi obra se ha propuesto asumir creativamente el irrecuperable atraso, así como la multiestratificación de esta periferia (As with any work of art that wants to take into account the periphery in which it is produced and circulated, my work has proposed to creatively assume the irreparable backwardness as well as the multiple stratifications of this periphery)."—*Chile vive* (Madrid: Círculo de Bellas Artes, 1987), p. 282.

11. Cubitt and Dittborn, "Airmail Interview," p. 28. Between 1984 and 1991 Dittborn produced and circulated approximately ninety Airmail Paintings to more than thirty destinations around the world.

12. See Néstor García Canclini, *Culturas híbridas: Estrategias para entrar y salir de la modernidad* (Mexico City: Editorial Grijalbo, 1989), pp. 65–93.

13. Of the artists considered in this essay, Camnitzer has lived in the New York area continuously since 1964, and Meireles resided in New York in 1970 and 1971. Reflecting on why he moved there, Camnitzer has stated, "New York seemed fascinating: the center of the empire. The measuring stick for success was set by the empire and not in the colonies." —Cited in Carla Stellweg, "'Magnet—New York': Conceptual, Performance, Environmental, and Installation Art by Latin American Artists in New York," in Luis Cancel et al., *The Latin American Spirit: Art and Artists in the United States, 1920–1970* (New York: Bronx Museum of the Arts and Harry N. Abrams, 1988), p. 285. For an overview of other Latin American Conceptual artists active in New York during this period, see Stellweg, "'Magnet—New York,'" pp. 284–311; and Jacqueline Barnitz, Florencia Bazzano Nelson, and Janis Bergman Carton, *Latin American Artists in New York since 1970* (Austin: Archer M. Huntington Art Gallery, University of Texas, 1987), pp. 13–19.

14. For details see Jacqueline Barnitz, "Conceptual Art and Latin America: A Natural Alliance," in *Encounters/Displacements: Luis Camnitzer, Alfredo Jaar, Cildo Meireles* (Austin: Archer M. Huntington Art Gallery, University of Texas, 1992), pp. 35–48.

15. Several Latin American artists in New York created experimental work under the auspices of the New York Graphic Workshop, which was established by Camnitzer, Liliana Porter, and José Guillermo Castillo in 1964 and was dissolved in 1970 (author's telephone interview with Luis Camnitzer, September 24, 1992). The workshop was founded on a form of political activism that rejected the commodity status of art, seeking instead to make it accessible to a mass audience through prints. The workshop launched the idea of serial graphics in which a single element could be assembled in many ways, a concept described by the acronym FANDSO (Free Assemblage, Nonfunctional, Disposable, Serial Object). See Luis Camnitzer, *Art in Editions: New Approaches* (New York: Pratt Center for Contemporary Printmaking and New York University, 1968). Shifra M. Goldman has analyzed the activities of the N.Y.G.W. in "Presencias y ausencias: Liliana Porter en Nueva York, 1964–1974," in *Liliana Porter: Obra gráfica, 1964–1990* (San Juan: Instituto de Cultura Puertorriqueña, 1991), pp. 1–22.

16. The constitutional government of Brazil was overthrown by a military coup in 1964, and the nation was subsequently ruled by military dictators until 1985; Uruguay was ruled by a de facto military dictatorship from 1973 to 1985; Argentina experienced a succession of military governments after the coup of 1966; and Chile was governed from 1973 until 1989 by the dictator General Augusto Pinochet. Peru was under military rule from 1968 to 1980, Bolivia from 1971 to 1982, and Ecuador from 1972 to 1980. See Beverly Adams, "The Subject of Torture: The Art of Camnitzer, Nuñez, Parra, and Romero," Master's thesis, University of Texas, Austin, 1992, pp. 21–38.

17. Richard, "Margins and Institutions," p. 17.

18. Camnitzer was in New York when Uruguay's democratic government fell in 1973. Even though he did not return, the event indelibly marked his life and experience in the United States. Dittborn and Díaz remained in Chile throughout the military regime of Pinochet. Jaar lived through the fall of Allende and left Chile for New York in 1982; Meireles remained in Brazil for the duration of the military dictatorship, with the exception of the two years he spent in New York; Grippo lived through the black years in Argentina; Leirner has lived through the return of democracy to Brazil and the subsequent period of deep economic and social crisis.

19. "Insertion" does not exactly translate the word *inserção*. In Brazilian usage it refers to the act of introducing or fitting something into a reduced space or into a new system so as to alter its rules. Likewise, *transgressão* has a sense somewhat different than "transgression." It refers to the act of breaking established rules and patterns in order to introduce new values. See statements by Meireles in Ronaldo Brito and Eudoro Augusto Macieira de Sousa, *Cildo Meireles* (Rio de Janeiro: Edição FUNARTE, 1981), p. 24.

Although the military dictatorship was established in Brazil in 1964, freedom of expression was further stifled in 1968 by the establishment of censorship that affected all the arts. It was during this time that Meireles executed the works discussed in this essay.

20. Dittborn, in *Chile vive*, p. 282.

21. Grippo has stated: "El artista debiera tomar, como punto de partida, una intención ética y de progreso verdadero, transformándose en integrador de múltiples experiencias (en oposición a la continua fragmentación a que nos somete nuestra sociedad), para contribuir a la concepción de un hombre más completo (An artist should take as his point of departure an ethical and truly progressive intention, transforming himself into an integrator of multiple experiences [in opposition to the continual fragmentation to which we are subjected by our society], in order to contribute to the conception of a more complete man)." See Jorge Glusberg, *Víctor Grippo* (Buenos Aires: Centro de Arte y Comunicación, 1980), n.p.

22. He continues: "That may give my work a political aura, . . . political in the sense of wanting to change society." See "A veces es una locura quedarse; a veces es una locura irse: Un reportaje de Carla Stellweg a Luis Camnitzer," *Arte en Colombia* 13 (October 1980), pp. 50–55; cited by Mari Carmen Ramírez, "Moral Imperatives: Politics as Art in Luis Camnitzer," in Luis Camnitzer, Gerardo Mosquera, and Mari Carmen Ramírez, *Luis Camnitzer: Retrospective Exhibition, 1966–1990* (New York: Lehman College Art Gallery, 1991), p. 5.

23. See Camnitzer's articles "Access to the Mainstream" and "Wonderbread and Spanglish Art," reprinted in ibid., pp. 41–47. The theme of exile is also the subject of the artist's essay "Screaming in a Room Full of Jello," presented at the Mountain Lake Symposium in 1990.

24. Jaar, "Alfredo Jaar," p. 117.

25. This point has been made by the Chilean critic Adriana Valdés in "From Another Periphery: 17 Air Mail Paintings," in her *Eugenio Dittborn* (Melbourne: George Paton Gallery, 1985), p. 6.

26. Hélio Oiticica, in McShine, *Information*, p. 103. The implications of Oiticica's position for most of the artists under consideration are the subject of Guy Brett, *Transcontinental: Nine Latin American Artists* (London and New York: Verso; Birmingham: Ikon Gallery; Manchester: Cornerhouse, 1990).

27. Cubitt and Dittborn, "Airmail Interview," p. 29.

28. The theme of art and torture in the work of Camnitzer, Dittborn, and other artists from South America has been analyzed by Beverly Adams in "The Subject of Torture" and by Charles Merewether in "El arte de la violencia: Un asunto de representación en el arte contemporáneo," *Art Nexus* 2 (October 1991), pp. 92–96, and 3 (January 1992), pp. 132–35.

29. "Se a interferência de M. DUCHAMP foi ao nível da Arte (lógica do fenômeno), . . . uma vez que o que se faz hoje tende a estar mais próximo da cultura do que da Arte, é necessariamente uma inteferência política. Porque se a estética fundamenta a Arte, é a Política que fundamenta a Cultura."—Cildo Meireles, "Arte-Cultura," *Malasartes* 1 (September/October/November 1975), p. 15.

30. Conceptual artists do, of course, utilize objects in their work: photographs, video and audio tapes, drawings, maps, and diagrams, which function as "documents" that record the conceptual proposal.

31. Camnitzer, for instance, referred to form itself as being important only insofar as it could serve the purposes of content, and Meireles spoke of his attempts to develop a language of *inserção* rather than "style." See Luis Camnitzer, "Chronology," in Camnitzer, Mosquera, and Ramírez, *Camnitzer: Retrospective*, p. 52; and Meireles, in Brito and Macieira de Sousa, *Cildo Meireles*, p. 24.

32. Buchloh, "Conceptual Art 1962–1969," pp. 124–27.

33. For analysis of the relationship of Meireles, Leirner, and other Brazilian artists to Warhol, see Paulo Herkenhoff, "Arte e money," *Revista galena* 24 (October 1989), pp. 60–67.

34. Vladimir Herzog was a well-known socialist journalist arrested and killed while in the custody of the Brazilian army. Public outrage over the crime and the military's efforts to hide the truth marked the beginning of effective opposition to the military in Brazil.

35. See statements by the artist in Brito and Macieira de Sousa, *Cildo Meireles*, p. 24.

36. On the Chilean artists' use of metaphor to contest censorship, see Richard, "Margins and Institutions," pp. 23–33.

37. See Ronald Kay, "N. N.: Autopsia (4 rudimentos teóricos para una visualidad marginal)," in *E. Dittborn* (Buenos Aires: Centro de Arte y Comunicación, 1979), n.p.

38. See Richard, "Margins and Institutions," pp. 31–32, 38–41.

39. Camnitzer has referred to the political significance of the work as "something about the possible interference of the United States in countries which presumably were independent. The invasion of Cambodia seemed a good moment to remind people of Latin American history." The boxes were first exhibited at the Paula Cooper Gallery in 1971. On the gallery walls Camnitzer drew closets with partly open doors and shelves labeled with nomenclature intended to suggest weaponry supplied by the U.S. for repression of liberation movements. Facsimile letter to Beverly Adams, May 7, 1990, Archer M. Huntington Art Gallery Archives, University of Texas, Austin.

40. See Mário Cesar Carvalho's interview with the artist, "Jac leva cinzeiros furtados à Documenta," *Folha de São Paulo* (January 19, 1992), p. 5.

41. For a description of Leirner's process of assembling her works, see Michael Corris, "Não exotico," *Artforum* 30 (December 1991), pp. 89–92.

42. David Elliott, "Art and Spit," in his *Jac Leirner* (Oxford: Museum of Modern Art, 1991), n.p.

43. For a detailed discussion of Grippo's work, see Glusberg, *Víctor Grippo*; Glusberg, *Arte en la Argentina*, pp. 167–76; Brett, *Transcontinental*, pp. 81–87; and Ricardo Martín Crosa, "Víctor Grippo," in Sally Baker, ed., *Art of the Americas: The Argentine Project / Arte de las Américas: El proyecto argentino* (Hudson, New York: Baker and Co., 1992), pp. 59–79.

44. For more on the meaning of the potato in Grippo's work, see Glusberg, *Víctor Grippo*.

45. See statements by the artist in Brito and Macieira de Sousa, *Cildo Meireles*, p. 24.

46. Merewether, "Migration of Images," p. 202.

47. In The One Hundreds, Leirner sorted the bills according to the subject matter of the graffiti: love, sex, religion, politics, children's marks. She then proceeded to construct pieces on each of these themes.

48. The phrase *espacio objetualizado* has been used by the Chilean critic Justo Pastor Mellado in *Gonzalo Díaz: La declinación de los planos, instalación* (Santiago: Ediciones de la Cortina de Humo, 1991).

49. For an analysis of Díaz's early work with deconstructive techniques of painting, see Gaspar Galasz and Milan Ivelić, *Chile: Arte actual* (Valparaíso: Ediciones Universitarias de Valparaíso and Universidad Católica de Valparaíso, 1988), pp. 310–17.

50. Mellado, *Gonzalo Díaz*, n.p.

51. Gonzalo Díaz, unpublished text, Archer M. Huntington Art Gallery Archives, University of Texas, Austin.

52. Gonzalo Díaz, unpublished text for *Banco/Marco de prueba*, Archer M. Huntington Art Gallery Archives, University of Texas, Austin.

53. See Catherine David, "Da adversidade vivemos," in Guy Brett et al., *Tunga "Lezarts"/ Cildo Meireles "Through"* (Kortrijk, Belgium: Kanaal Art Foundation, 1989), n.p.

54. Luis Camnitzer, interview with the author, Great Neck, New York, September 1990. The philosophical distinctions between Camnitzer's conceptualism and that of the Wittgenstein-inspired school have been analyzed in Gerardo Mosquera, "El conceptualismo de Luis Camnitzer," *Casa de las Américas* 139 (July–August 1983), pp. 148–52.

55. Implicit references to other artists, in the form of appropriated images and motifs, such as René Magritte's clouds, Duchamp's pipe, etc., suggest a reading of the work in terms of the artist as master game player. See Ramírez, "Moral Imperatives," pp. 12–13.

56. Alice Yang, *1+1+1: Works by Alfredo Jaar* (New York: The New Museum of Contemporary Art, 1992), n.p.

57. Roland Barthes, *Mythologies*, trans. Annette Lavers (New York: Hill and Wang, 1972), pp. 152–53.

58. Buchloh, "Conceptual Art, 1962–1969," pp. 128–29.

59. Luis Camnitzer, "Contemporary Colonial Art," paper presented at the Annual International Congress of the Latin American Studies Association, Washington, D.C., 1970. Meireles also used the term *package* to refer to his conceptual propositions with readymades.

60. See Camnitzer, "Chronology," p. 53.

61. Jaar, "Alfredo Jaar," p. 117.

62. Merewether, "Migration of Images," p. 202.

Plates

—

In the captions, titles are first given in their original language, followed by an English translation enclosed in brackets. Several titles have no translation; for some the original language is English. Dimensions are given in feet and inches and in centimeters, height before width; for some works a third dimension, depth, is also given.

1

CARLOS ALMARAZ

Crash in Pthalo Green
1984
Oil on canvas, 48" x 6' (122 x 183 cm)
Los Angeles County Museum of Art

2
TARSILA DO AMARAL
A Negra [*The Black Woman*]
1923
Oil on canvas, 40 x 32" (100 x 81.3 cm)
Museu de Arte Contemporânea da Universidade
de São Paulo

3
TARSILA DO AMARAL
Abaporú
1928
Oil on canvas, 34 x 29³/₈" (85 x 73 cm)
Collection Maria Anna and Raul de Souza
Dantas Forbes, São Paulo

4
TARSILA DO AMARAL
E.F.C.B. (Estrada de Ferro Central do Brasil)
[*E.F.C.B. (Central Railway of Brazil)*]
1924
Oil on canvas, 55⁷/₈ x 50" (142 x 127 cm)
Museu de Arte Contemporânea da Universidade
de São Paulo

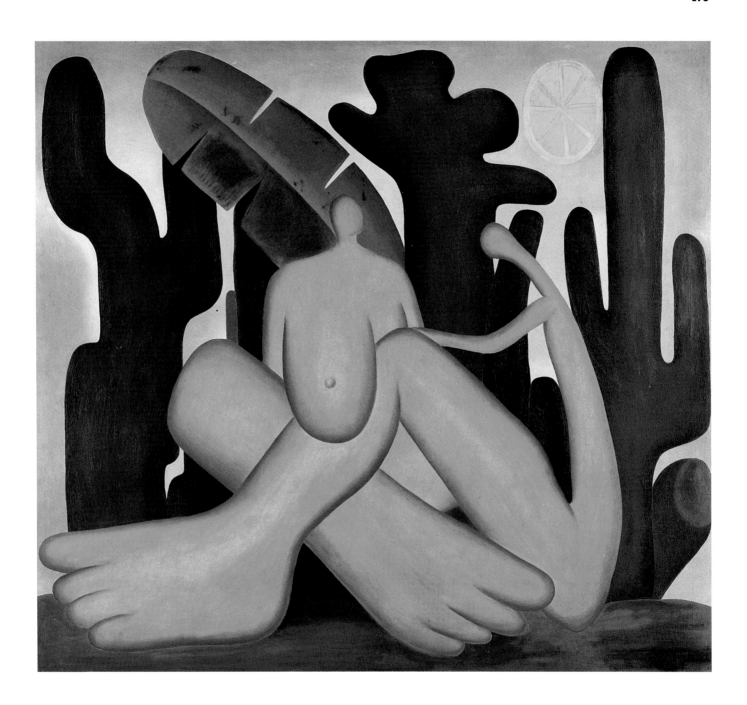

5
Tarsila do Amaral
Antropofagia
1929
Oil on canvas, 49⁵/₈ x 55⁷/₈" (126 x 142 cm)
Private collection

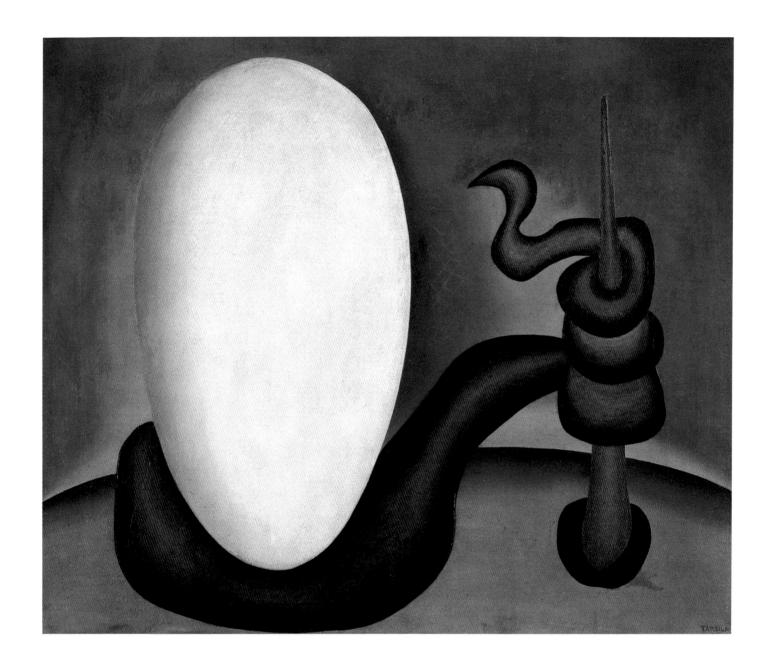

6
TARSILA DO AMARAL
Urutu
1928
Oil on canvas, 24 x 28³/₈" (60 x 72 cm)
Collection Gilberto Chateaubriand,
Rio de Janeiro

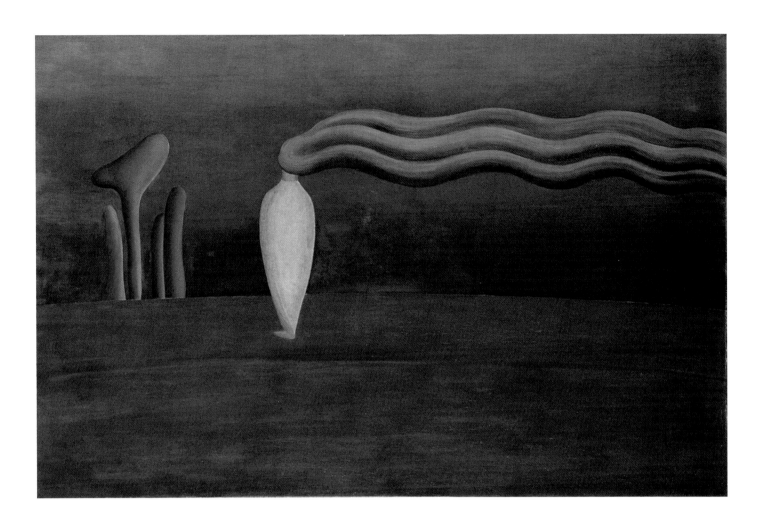

7
TARSILA DO AMARAL
Composição [Composition]
1930
Oil on canvas, 33¹/₄ x 51⁵/₈" (83 x 129 cm)
Collection Ricard Takeshi Akagawa, São Paulo

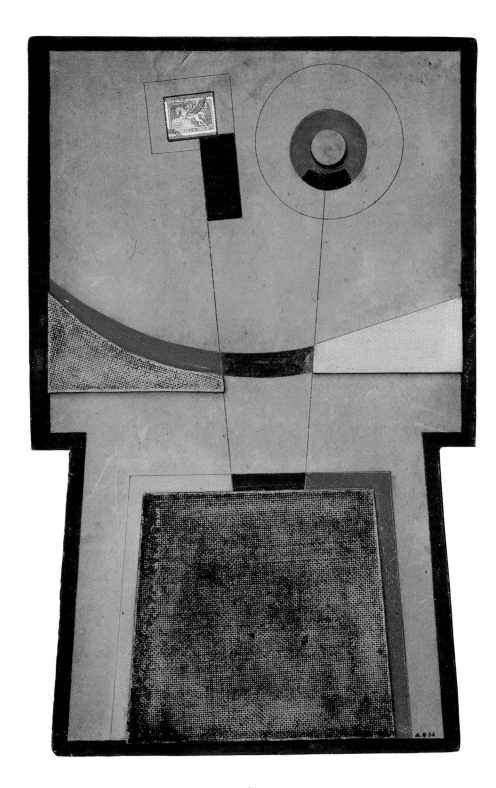

8
CARMELO ARDEN QUIN

Dada
1936
Oil and collage on cardboard,
20 x 12⁵/₈" (50 x 32 cm)
Collection Alexandre de la Salle, Saint Paul, France

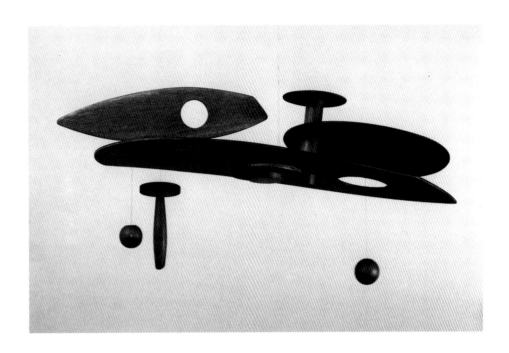

9
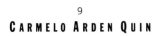
C A R M E L O A R D E N Q U I N

Astral Buenos Aires
1946
Wood, 22$^7/_8$ x 10$^5/_8$" (58 x 27 cm)
Private collection

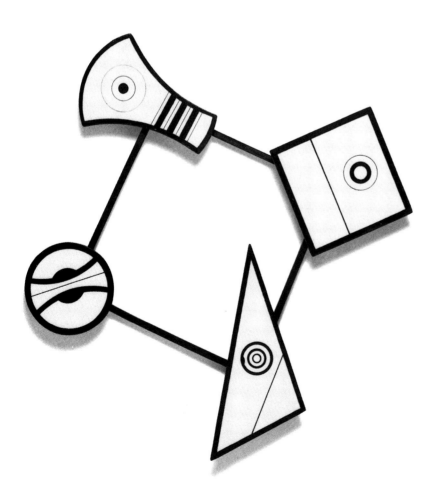

10
C A R M E L O A R D E N Q U I N

Coplanal
1945
Lacquer on wood with movable elements,
24 x 24" (60 x 60 cm)
Collection M. von Bartha, Basel

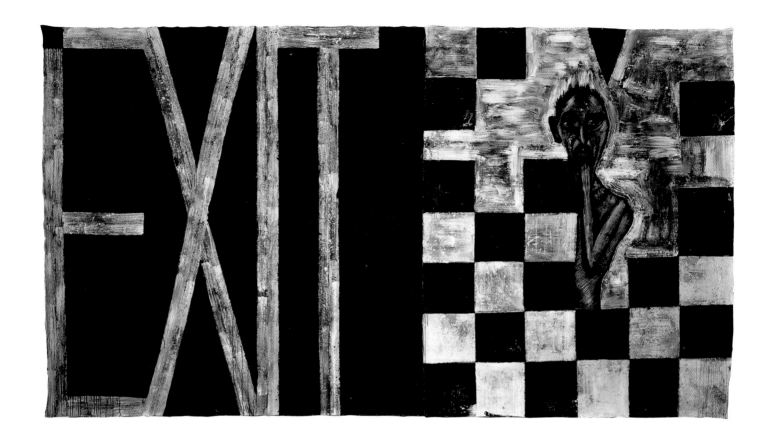

11
LUIS CRUZ AZACETA

No Exit
1987–88
Synthetic polymer paint on canvas; two panels,
overall: 10' 1$^1/_2$" x 19' (308.6 x 579.1 cm)
Frumkin/Adams Gallery, New York

12
FRIDA BARANEK
Unclassified
1992
Stainless steel, aluminum, and fiberglass;
approximately: 13' 2" x 14' x 12' (401.3 x 426.7 x 365.7 cm)
Collection the artist

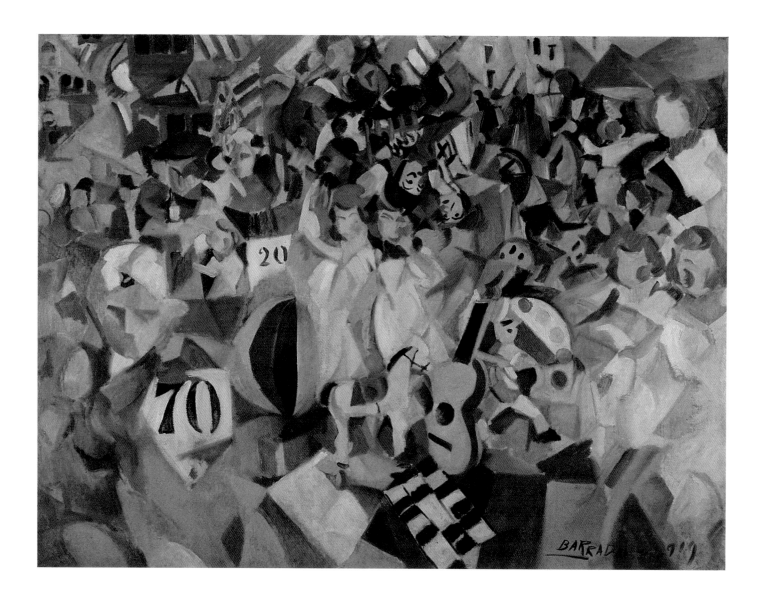

13

RAFAEL PÉREZ BARRADAS

Verbena de Atocha [*Atocha Festival*]
1919
Oil on canvas, 33¹/₄ x 44³/₄" (83 x 113.5 cm)
Private collection

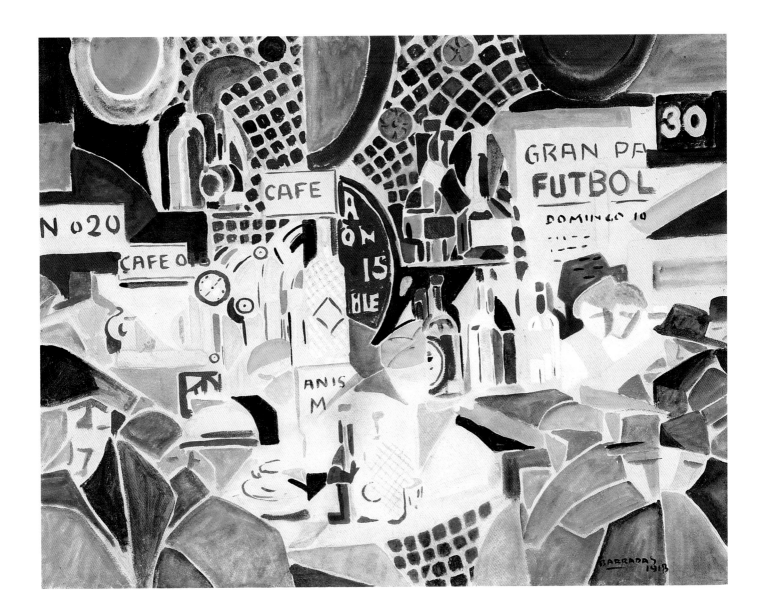

14
RAFAEL PÉREZ BARRADAS

Kiosko de Canaletas [*Canaletas Newsstand*]
1918
Watercolor and gouache on paper,
18⁵/₈ x 24¹/₄" (47.2 x 61.6 cm)
Collection Mr. Eduardo F. Costantini and
Mrs. María Teresa de Costantini, Buenos Aires

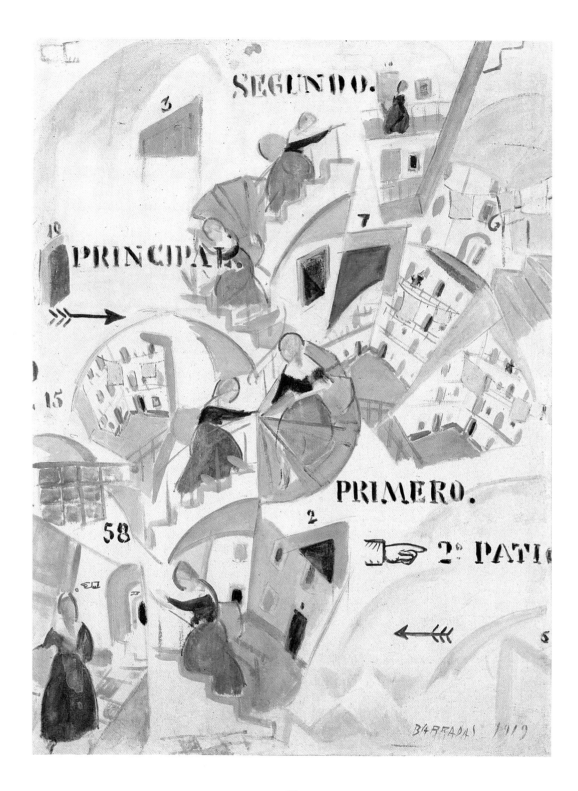

15
Rafael Pérez Barradas
Casa de apartamentos [*Apartment House*]
1919
Oil on canvas, 31 x 23" (79 x 59 cm)
Museo Nacional de Artes Visuales, Montevideo

16
JUAN BAY
Sin título [Untitled]
c. 1950
Oil on wood, 16³/₄ x 11¹/₂" (42.5 x 29.2 cm)
Rachel Adler Gallery, New York

17
JUAN BAY
Composición [*Composition*]
1950
Oil on cut wood, 18⁵/₈ x 15" (47.2 x 38 cm)
Private collection

18
JACQUES BEDEL
Mankind's Memory, A-1, The Earth's Moon
1979
Stainless steel; closed: 28 x 20 x 8" (70 x 50 x 20 cm),
open: 28 x 30 x 16" (70 x 76.2 x 40.6 cm)
Ruth Benzacar Galería de Arte, Buenos Aires

19
JACQUES BEDEL
Las ciudades de plata [*The Silver Cities*]
1976
Electrolytic aluminum; closed: 8 x 20¹/₄ x 28¹/₄" (20 x 50.5 x 70.5 cm),
open: 8 x 48 x 28¹/₄" (20 x 122 x 70.5 cm)
Ruth Benzacar Galería de Arte, Buenos Aires

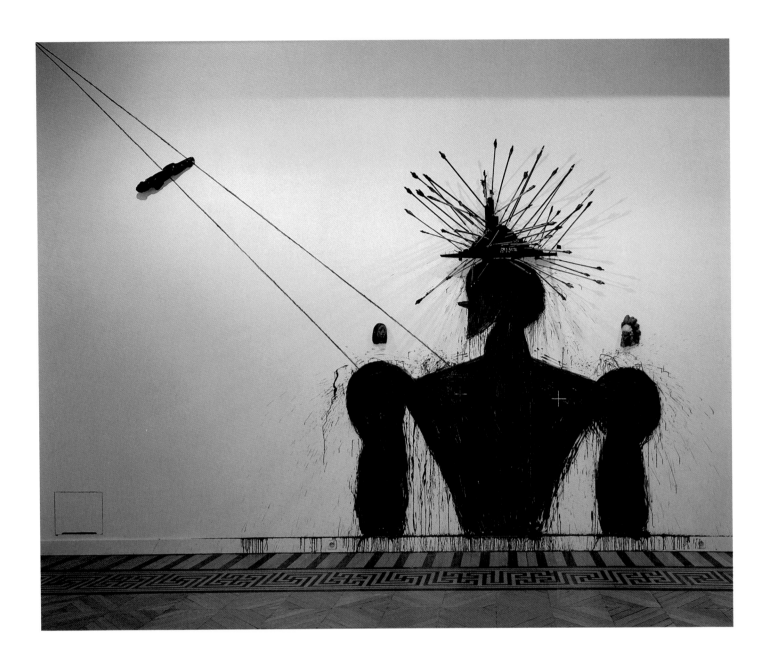

20
JOSÉ BEDIA

Second Encounter Segundo Encuentro
1992
Synthetic polymer paint on wall, found objects,
and carved wood; installation variable
Collection the artist
Installation view, Hôtel des Arts, Paris

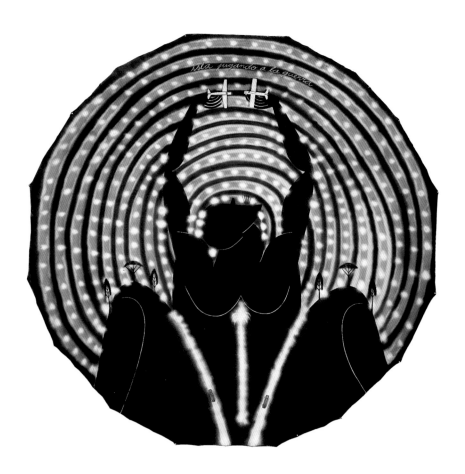

21
JOSÉ BEDIA
Isla jugando a la guerra [*Island Playing at War*]
1992
Synthetic polymer paint on canvas and found
objects, 9' x 9' 3$^{1}/_{2}$" (274.3 x 283.2 cm)
Frumkin/Adams Gallery, New York,
and Ninart Centro de Cultura, Mexico

22
JOSÉ BEDIA
Lucero viene alumbrando
[*Star Comes to Light the Way*]
1992
Synthetic polymer paint on canvas and found objects,
9' 1$^{1}/_{2}$" x 9' 4" (278.1 x 284.5 cm)
Collection Rosa and Carlos de la Cruz

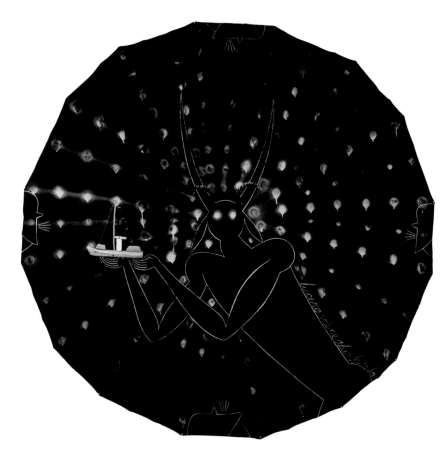

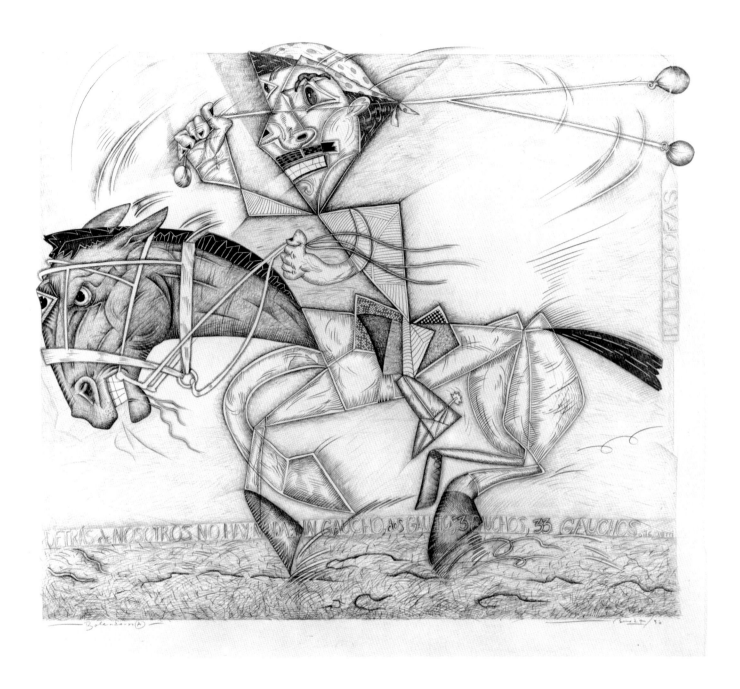

23
LUIS F. BENEDIT

Boleadoras (A) [*Bolas (A)*]
1990
Pencil on paper, 55$\frac{1}{8}$ x 62$\frac{7}{8}$" (140 x 159.7 cm)
Ruth Benzacar Galería de Arte, Buenos Aires

24
LUIS F. BENEDIT
Para F. M. C. (Calentando el horno) no. 3
[For F. M. C. (Heating the Oven), No. 3]
1989
Watercolor on paper, 40 x 55" (100 x 139.7 cm)
Collection the artist and John Good Gallery, New York

25
LUIS F. BENEDIT
Para F. M. C. (Calentando el horno) no. 4
[*For F. M. C. (Heating the Oven), No. 4*]
1989
Watercolor on paper, 39 x 55³/4" (99 x 141.6 cm)
Collection Mrs. María Marta Zavalía, Buenos Aires

26
ANTONIO BERNI

Desocupados, o *Desocupación*
[*Unemployed,* or *Unemployment*]
1934
Tempera on burlap,
7' 1⁷/₈" x 9' 10¹/₈" (218 x 300 cm)
Collection Elena Berni

27
ANTONIO BERNI
Retrato de Juanito Laguna [*Portrait of Juanito Laguna*]
1961
Collage on wood, 57 x 41³/₈" (145 x 105 cm)
Collection Nelly and Guido Di Tella, Buenos Aires

28
MARTÍN BLASZKO
Columna Madí [*Madí Column*]
1947
Painted wood, 30" (75 cm) high
Galerie von Bartha, Basel

29
MARTÍN BLASZKO
El gran ritmo [*The Great Rhythm*]
1949
Oil on composition board, 36⅝ x 17" (93 x 43 cm)
Galerie von Bartha, Basel

30
JACOBO BORGES
Ha comenzado el espectáculo [*The Show Has Begun*]
1964
Oil on canvas, 71" x 8' 10¹/₂" (180.3 x 270.4 cm)
Fundación Galería de Arte Nacional, Caracas

31
JACOBO BORGES
Personajes de la coronación de Napoleón
[*Characters from Napoleon's Coronation*]
1963
Mixed mediums on canvas,
47^1/$_4$" x 6' 8^3/$_4$" (120 x 205 cm)
Museo de Arte Contemporáneo de Caracas Sofía Imber

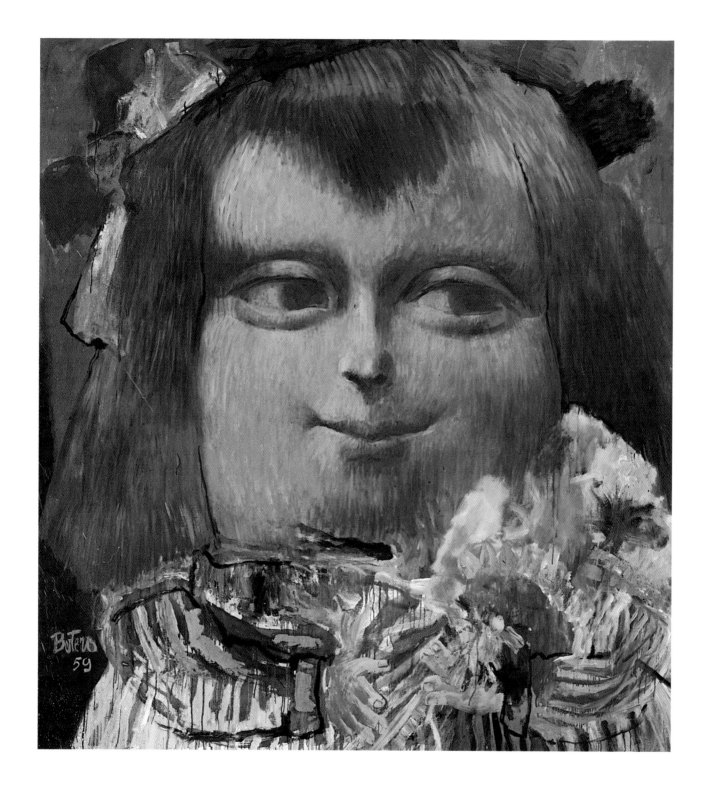

32
FERNANDO BOTERO
Mona Lisa, a los doce años [*Mona Lisa, Age Twelve*]
1959
Oil and tempera on canvas,
6' 11$\frac{1}{8}$" x 6' 5" (211 x 195.5 cm)
The Museum of Modern Art, New York.
Inter-American Fund, 1961

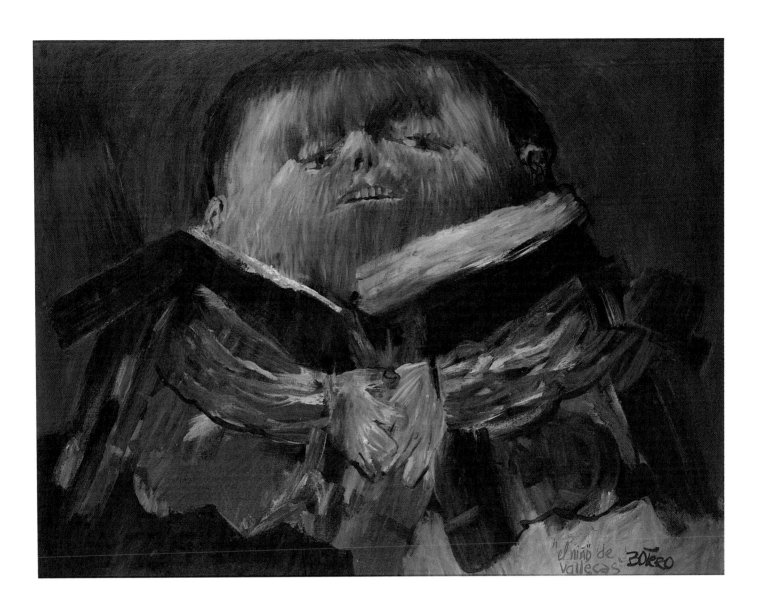

33

FERNANDO BOTERO

Après Velasquez (Niño de Vallecas)
[*After Velázquez (Boy of Vallecas)*]
1960
Oil on canvas, 46³/₈ x 51⁵/₈" (116 x 129 cm)
Collection the artist

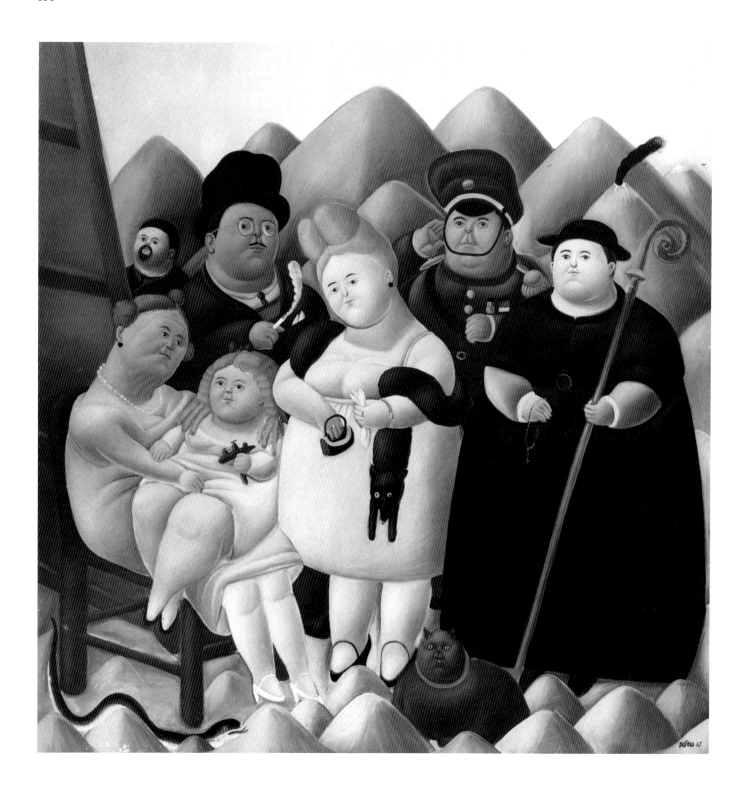

34

FERNANDO BOTERO

La familia presidencial [*The Presidential Family*]
1967
Oil on canvas,
6' 8 1/8" x 6' 5 1/4" (203.5 x 196.2 cm)
The Museum of Modern Art, New York.
Gift of Warren D. Benedek, 1967

35
WALTERCIO CALDAS
Sem título [Untitled]
1982
Iron, 6 x 28" (15 x 70 cm)
Collection Maria Camargo, São Paulo

36
WALTERCIO CALDAS

Einstein
1988
Wood, metal, and billiard ball, 12 x 20" (30 x 50 cm)
Collection Jorge and Marion Helft, Argentina

37
SÉRGIO CAMARGO

No. 1
1963
Painted wood, 40 x 40" (100 x 100 cm)
Fonds National d'Art Contemporain, Ministère
de l'Education Nationale et de la Culture, Paris

38
LUIS CAMNITZER
Leftovers
1970
80 cardboard boxes covered with gauze, paint, and acrylic,
6' 8" x 10' 7" x 8" (203.2 x 322.6 x 20 cm)
Yeshiva University Museum, New York

39
LUIS CAMNITZER

Objects Were Covered by Their Own Image
1971–86
Mixed mediums (wood table, book, pencil, paper, and bronze title),
30 x 20 x 10" (75 x 50 x 25 cm)
Collection the artist

40
AGUSTÍN CÁRDENAS

Chevalier de la nuit [*Rider of the Night*]
1959
Burnt wood and iron, 9' 10¹/₈" (300 cm) high
Collection Amélie Glissant, Paris

41
SANTIAGO CÁRDENAS
Pizarrón grande con repisa [Large Blackboard with Shelf]
1975
Oil on canvas, 50$^{1}/_{2}$" x 7' 10$^{1}/_{2}$" (128.4 x 240.1 cm)
The Museum of Modern Art, New York.
Mrs. John C. Duncan Fund, 1976

42
LEDA CATUNDA
Lago japonês [*Japanese Lake*]
1986
Mixed mediums, 47$^{1}/_{4}$" x 6' 6$^{3}/_{4}$" (120 x 200 cm)
Galeria Luisa Strina, São Paulo

43
E M I L I A N O D I C A V A L C A N T I
Samba
1925
Oil on canvas, 70 x 61⁵/₈" (175 x 154 cm)
Collection Jean Boghici, Rio de Janeiro

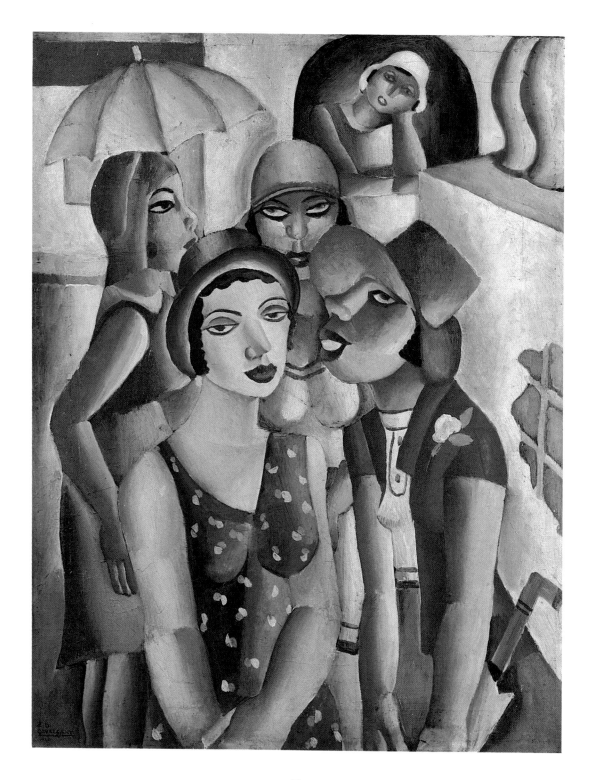

44

EMILIANO DI CAVALCANTI

Cinco moças de Guaratinguetá [*Five Girls of Guaratinguetá*]
1930
Oil on canvas, 36$^{1}/_{4}$ x 28" (92 x 70 cm)
Museu de Arte de São Paulo Assis Chateaubriand

45
LYGIA CLARK
Plano em superfícies moduladas no. 2
[*Plane with Modulated Surfaces, No. 2*]
1956
Industrial paint on Celotex, wood, and Nulac,
36 x 30" (90.1 x 75 cm)
Museu de Arte Contemporânea da Universidade de São Paulo

46
LYGIA CLARK

Bicho [*Machine Animal*]
1962
Aluminum, 22 x 26" (55 x 65 cm)
Collection Adolpho Leirner, São Paulo

47
CARLOS CRUZ-DIEZ
Physichromie, 48
1961
Cardboard and synthetic polymer paint on
wood, 24 x 24" (60 x 60 cm)
Collection the artist

48
CARLOS CRUZ-DIEZ
Physichromie, 506
1970
Synthetic polymer paint on polyvinyl chloride
pasted on strips of wood and plexiglass,
70⁷/₈ x 70⁷/₈" (180 x 180 cm)
Musée National d'Art Moderne,
Centre Georges Pompidou, Paris

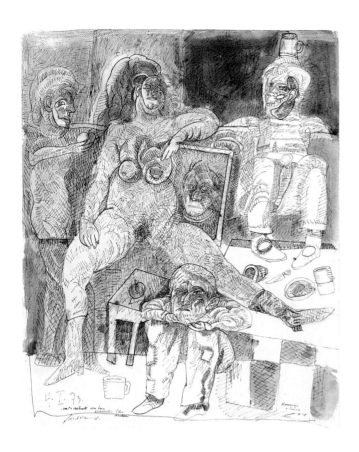

49
JOSÉ LUIS CUEVAS
Autorretrato con las señoritas de Aviñón
de la serie Homenaje a Picasso
[*Self-Portrait with the Young Ladies of Avignon*,
from the series Tribute to Picasso]
1973
Pen and ink and wash on paper,
$6^3/_8$ x $5^1/_4$" (16 x 13 cm)
Art Museum of the Americas,
OAS, Washington, D.C.

50
JOSÉ LUIS CUEVAS
Autorretrato con modelos
de la serie Homenaje a Picasso
[*Self-Portrait with Models*,
from the series Tribute to Picasso]
1973
Pen and ink and wash on paper,
$5^1/_4$ x $6^3/_8$" (13 x 16 cm)
Art Museum of the Americas,
OAS, Washington, D.C.

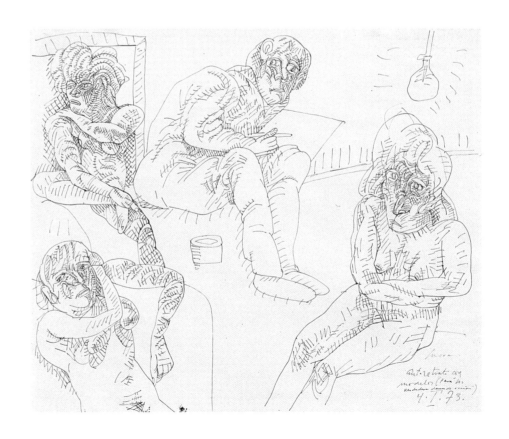

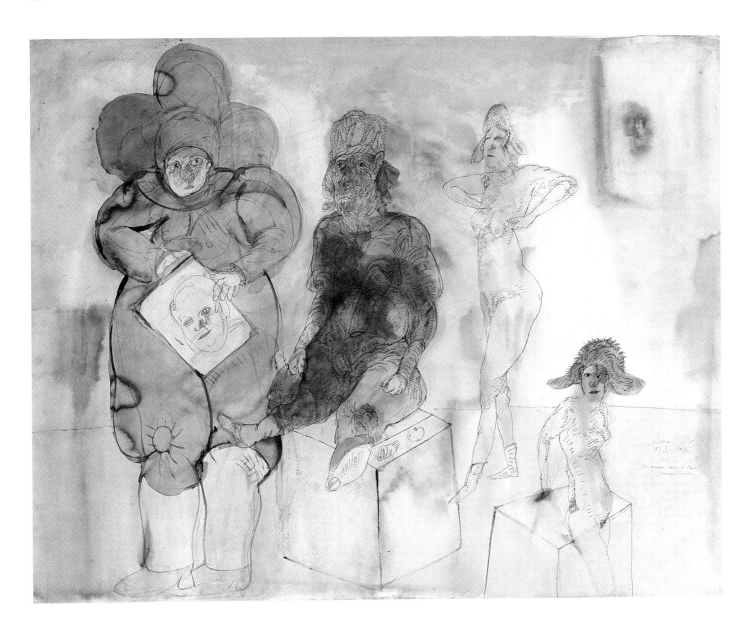

51
JOSÉ LUIS CUEVAS

Las verdaderas damas de Aviñón de la serie Homenaje a Picasso
[*The Real Ladies of Avignon*, from the series Tribute to Picasso]
1973
Pen and ink and wash on paper,
30 x 36" (75 x 90 cm)
Art Museum of the Americas, OAS, Washington, D.C.

52
JOSÉ CÚNEO
Ranchos del barranco [*Ranches in the Ravine*]
n.d.
Oil on wood, 57$^1/2$ x 38$^1/4$" (146 x 97 cm)
Museo Nacional de Artes Visuales, Montevideo

53

JORGE DE LA VEGA

Historia de los vampiros [*Story of the Vampires*]
1963
Oil and assemblage on canvas,
64 x 51$\frac{1}{4}$" (162.6 x 130.2 cm)
Museum of Art, Rhode Island School of Design, Providence.
Nancy Sayles Day Collection of Latin American Art

54
JORGE DE LA VEGA
El día ilustrísimo [*The Most Illustrious Day*]
1964
Mixed mediums on canvas,
8' 2¹/₄" x 6' 6¹/₂" (249.6 x 199.4 cm)
Collection Marta and Ramón de la Vega

55
ANTONIO DIAS
The Illustration of Art/Art Model
1973
Synthetic polymer paint on canvas; six elements,
each: 24 x 36" (60 x 90 cm)
Collection the artist

56
ANTONIO DIAS

Economy
1989
Graphite and synthetic polymer paint on canvas,
6' 2³/₄" x 8' 10¹/₄" (190 x 270 cm)
Collection the artist

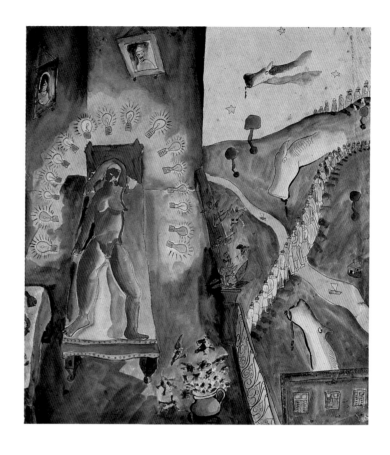

57
CÍCERO DIAS

Sonho da prostituta [*Prostitute's Dream*]
1930
Watercolor on paper, 22 x 20" (55 x 50 cm)
Collection Gilberto Chateaubriand,
Rio de Janeiro

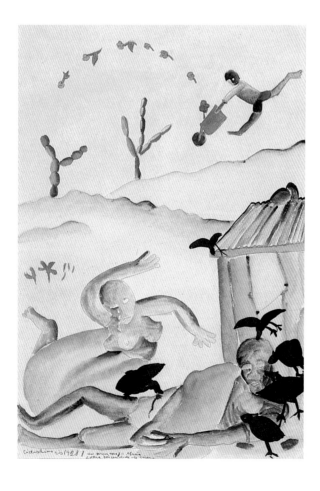

58
CÍCERO DIAS

Morte [*Death*]
1928
Pencil and gouache on paper,
19 x 13¹/₈" (48.2 x 33.2 cm)
Instituto de Estudos Brasileiros da Universidade
de São Paulo. Mário de Andrade Collection

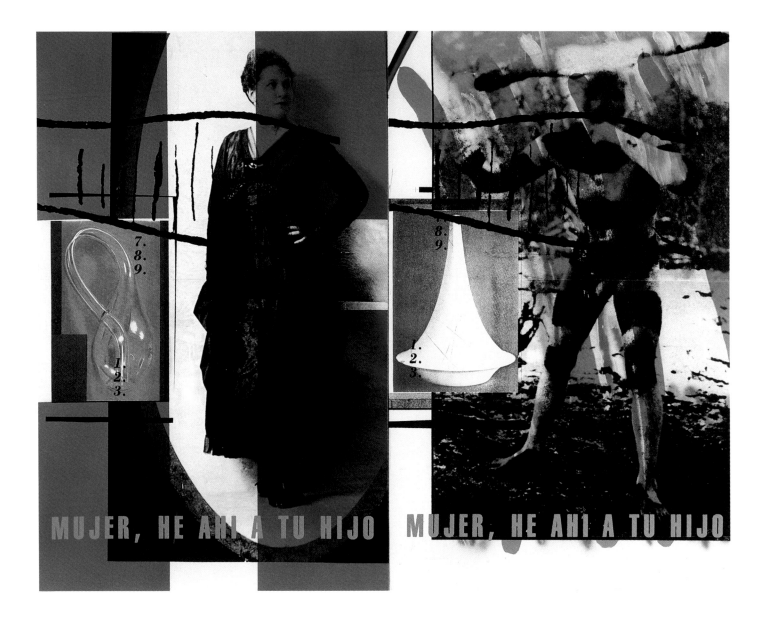

59

GONZALO DÍAZ

Tratado del entendimiento humano
[*Treatise on Human Understanding*]
1992
Mixed mediums (drawing, serigraph, offset,
tracing, and paint) on canvas; two of six panels,
both: 8' 2¹/₂" x 10' 8" (250 x 320 cm)
Collection the artist

60
GONZALO DÍAZ

Tratado del entendimiento humano
[*Treatise on Human Understanding*]
1992
Mixed mediums (drawing, serigraph, offset,
tracing, and paint) on canvas; two of six panels,
both: 8' 2^1/$_2$" x 9' 5^1/$_2$" (250 x 290 cm)
Collection the artist

61

EUGENIO DITTBORN

Pintura aeropostal número 91:
La XI Historia del rostro (500 años)
[Airmail Painting Number 91:
The 11th History of the Human Face (500 Years)]
1991
Paint, stitching, and photo-silkscreen on seven pieces
of nonwoven fabric; overall: 13' 10 3/8" x 18' 8" (420 x 560 cm)
Collection the artist

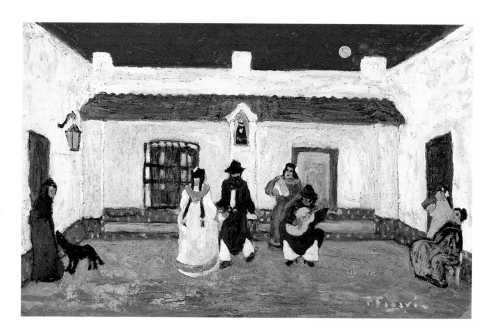

62

PEDRO FIGARI

Baile criollo [Creole Dance]
1925 (?)
Oil on cardboard, 20¹/₂ x 32" (52.1 x 81.3 cm)
The Museum of Modern Art, New York. Gift of
the Honorable and Mrs. Robert Woods Bliss, 1943

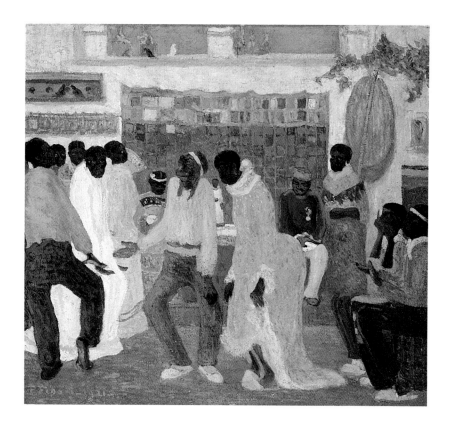

63

PEDRO FIGARI

Candombe
1921
Oil on canvas, 20³/₈ x 28" (51 x 70 cm)
Private collection

64
PEDRO FIGARI
Pampa
n.d.
Oil on cardboard, 29¹/₄ x 41³/₈" (74 x 105 cm)
Museo Nacional de Bellas Artes, Buenos Aires

65
PEDRO FIGARI
Pericón [*Quadrille*]
n.d.
Oil on cardboard, 28 x 40" (70 x 100 cm)
Museo Nacional de Bellas Artes, Buenos Aires

66
GONZALO FONSECA
Estela con baetylos [*Stele with Baetyl*]
1987
Spanish travertine,
70⁷/₈ x 59¹/₈ x 15³/₄" (180 x 150 x 40 cm)
Galería Durban/César Segnini

67
GONZALO FONSECA

Katabasis Ship
1963
Wood, 40" x 8' x 8" (100 x 244 x 20 cm)
Private collection

68
GONZALO FONSECA

Islip
1987
Limestone, wood, string, and sand,
13¼ x 30½ x 14¼" (33.7 x 77.5 x 36.2 cm)
Solomon R. Guggenheim Museum, New York.
Bequest of Henry Berg in gratitude to
Thomas M. Messer

69
JULIO GALÁN

Tange, tange, tange
1988 (inscribed 1991)
Oil on canvas, 63³/₄" x 6' 6" (161.9 x 198.1 cm)
Collection Francesco Pellizzi

70
JULIO GALÁN
Sí y no [*Yes and No*]
1990
Synthetic polymer paint, glass, aluminum pins,
and paper on canvas with leather belts;
diptych, overall approximately: 10 x 17' (304.8 x 516.2 cm)
Private collection

71
GEGO
Esfera [*Sphere*]
1959
Welded brass and steel, painted, 22" (55.7 cm) diameter;
on three points, 8⅝ x 7½ x 7⅛" (21.8 x 19 x 18 cm)
The Museum of Modern Art, New York.
Inter-American Fund, 1960

72
VÍCTOR GRIPPO

Analogía IV [Analogy IV]
1972
Mixed mediums (wood table; linen and velvet
tablecloth; acrylic potatoes, plate, knife, and fork;
porcelain plate; metal knife and fork; and potatoes),
30 x 37$^{1}/_{4}$ x 23" (75 x 94.5 x 59 cm)
Collection Jorge and Marion Helft, Argentina

73
VÍCTOR GRIPPO

Analogía I [Analogy I]
1971
Mixed mediums (potatoes, wire, electrodes,
voltmeter, and computer-printed text)
on wood mount,
19 x 61$^{1}/_{4}$ x 4" (48.2 x 153 x 10 cm)
Museo Nacional de Bellas Artes, Buenos Aires

74
VÍCTOR GRIPPO
Analogía I [*Analogy I*]
1976
Mixed mediums (potatoes, wire, electrodes, voltmeter,
computer-printed text, and wood); dimensions variable
Collection the artist
Installation view, Estación de Plaza de Armas, Seville, 1992

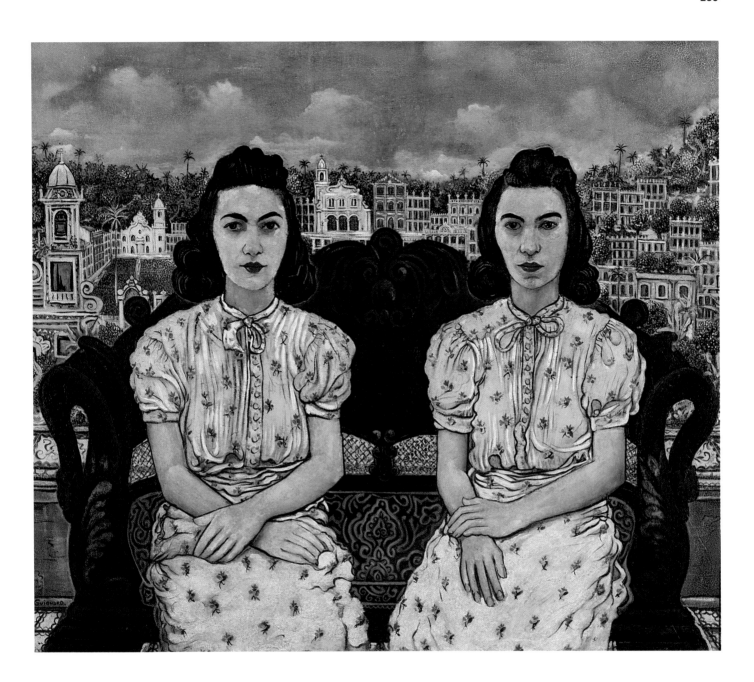

75
ALBERTO DA VEIGA GUIGNARD
Léa e Maura
1940
Oil on canvas, 43¹/₄ x 51¹/₄" (110 x 130 cm)
Museu Nacional de Belas Artes, Rio de Janeiro

76

ALBERTO DA VEIGA GUIGNARD

Paisagem de Sabará [Landscape of Sabará]
1952
Oil on wood, 20 x 24" (50 x 60 cm)
Museu Nacional de Belas Artes, Rio de Janeiro

77
ALBERTO HEREDIA
Cajas de camembert [*Camembert Boxes*]
1963
Assemblage; open, each approximately:
12⁵/₈ x 13³/₄ x 2³/₄" (32 x 35 x 6 cm)
Collection Jorge and Marion Helft, Argentina

78
ALBERTO HEREDIA

Los Amordazamientos [*The Gaggings*]
1972–74
Mixed mediums; five sculptures, height of each:
14⁵/₈" (37 cm), 20¹/₂" (52 cm), 22" (55 cm),
18¹/₂" (47 cm), and 18¹/₈" (46 cm)
Museo Nacional de Bellas Artes, Buenos Aires

79
ALFREDO HLITO
Curvas y series rectas [*Curves and Straight Lines Series*]
1948
Oil on canvas, 28 x 28" (70 x 70 cm)
Barry Friedman Ltd., New York

80
ALFREDO HLITO
Reabsorción del rombo
[Reabsorption of the Rhombus]
1953
Oil on canvas, 20 x 20" (50 x 50 cm)
Private collection, Basel

81
ENIO IOMMI
Direcciones opuestas [Opposite Directions]
1945
Painted iron, 35³/₄ x 28 x 40" (89 x 70 x 100 cm)
Private collection

82
ENIO IOMMI
Continuidad lineal [*Linear Continuity*]
n.d.
Steel, 42$\frac{1}{8}$ x 35" (107 x 89 cm)
Museo Nacional de Bellas Artes, Buenos Aires

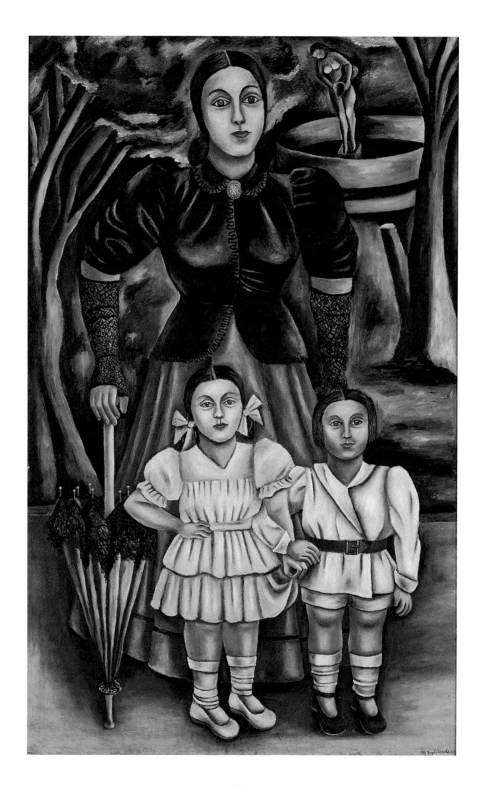

83
MARÍA IZQUIERDO

Mi tía, un amiguito y yo [*My Aunt, a Little Friend, and I*]
1942
Oil on canvas, 54³/₈ x 34¹/₄" (138 x 87 cm)
Private collection

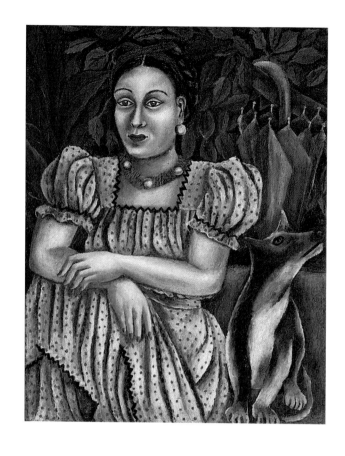

84
MARÍA IZQUIERDO
Autorretrato [Self-Portrait]
1947
Oil on canvas, 36¹/₄ x 28³/₄" (92 x 73 cm)
Collection Club de Industriales, A.C.

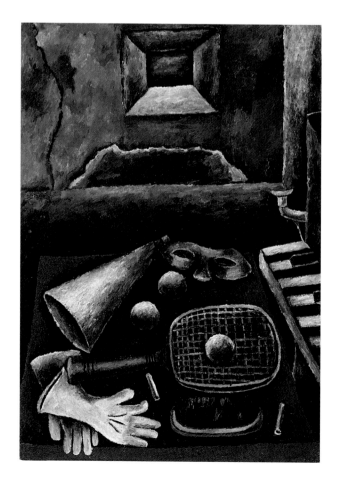

85
MARÍA IZQUIERDO
La Raqueta [The Racquet]
1938
Oil on canvas, 28 x 20" (70 x 50 cm)
Collection Andrés Blaisten, Mexico City

86
ALFREDO JAAR

Das Pergamon-Projekt/Eine Asthetik zum Widerstand
[*The Pergamum Project/An Aesthetic of Resistance*]
1992–93
Neon and photographs; dimensions variable
Collection the artist
Installation view, Staatliche Museen zu Berlin,
Pergamonmuseum

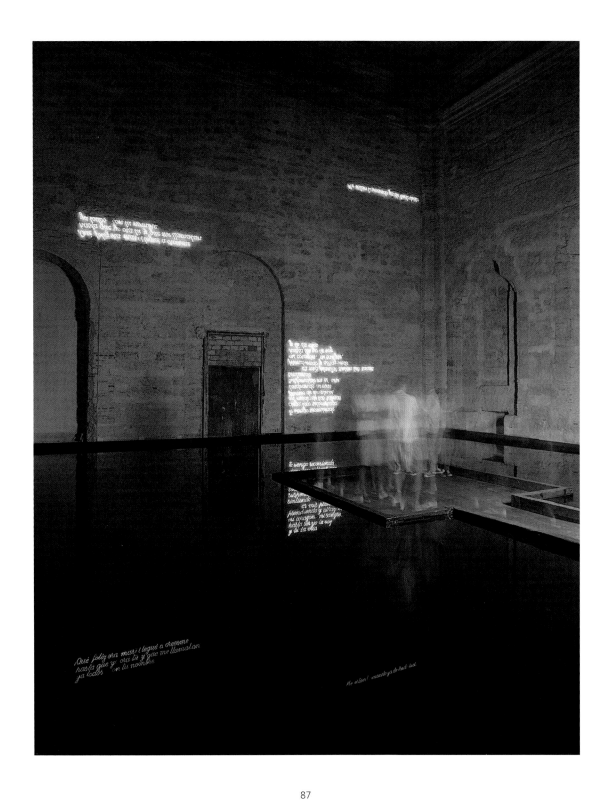

87
ALFREDO JAAR
Rafael, Manuel y los otros [*Rafael, Manuel, and the Others*]
1992
Neon, water, and sound; dimensions variable
Collection the artist
Installation view, Torre de la Santa Cruz, Cádiz

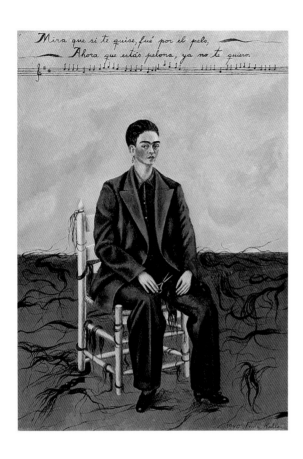

88
FRIDA KAHLO
Autorretrato con el pelo cortado
[*Self-Portrait with Cropped Hair*]
1940
Oil on canvas, 15³/₄ x 11" (40 x 27.9 cm)
The Museum of Modern Art, New York.
Gift of Edgar Kaufmann, Jr., 1943

89
FRIDA KAHLO
El suicidio de Dorothy Hale
[*The Suicide of Dorothy Hale*]
1938–39
Oil on masonite, 20 x 16" (50 x 40.6 cm)
Phoenix Art Museum. Gift of an anonymous donor

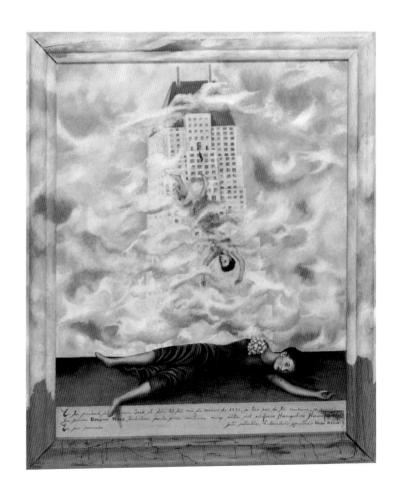

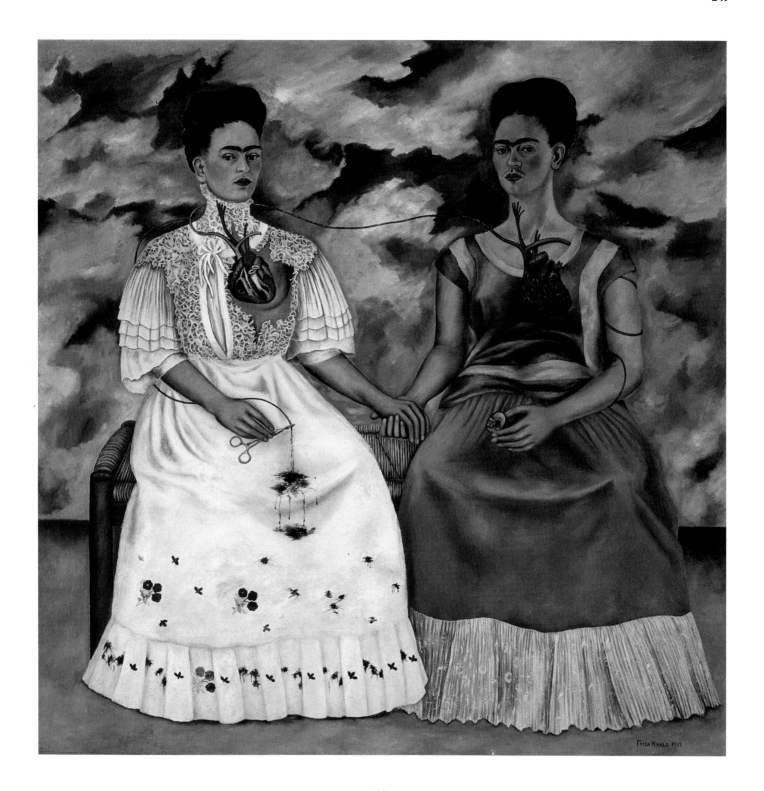

90
FRIDA KAHLO
Las dos Fridas [*The Two Fridas*]
1939
Oil on canvas, 68³/₈ x 68¹/₈" (173.5 x 173 cm)
CNCA-INBA, Museo de Arte Moderno, Mexico City

91
FRIDA KAHLO
Autorretrato con Bonito
[*Self-Portrait with Bonito*]
1941
Oil on masonite, 20⅝ x 17" (52.5 x 43 cm)
Private collection

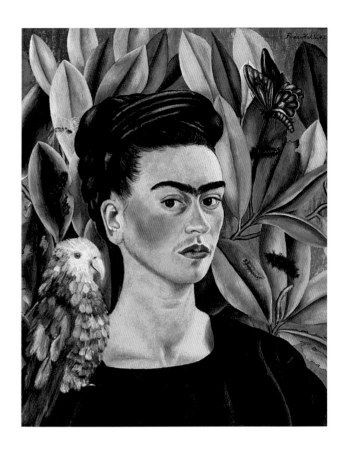

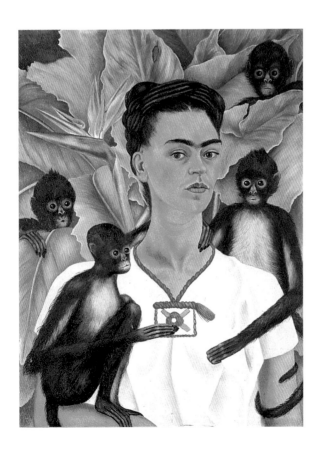

92
FRIDA KAHLO
Autorretrato con monos
[*Self-Portrait with Monkeys*]
1943
Oil on canvas, 32⅛ x 24⅞" (81.5 x 63 cm)
Jacques and Natasha Gelman Collection

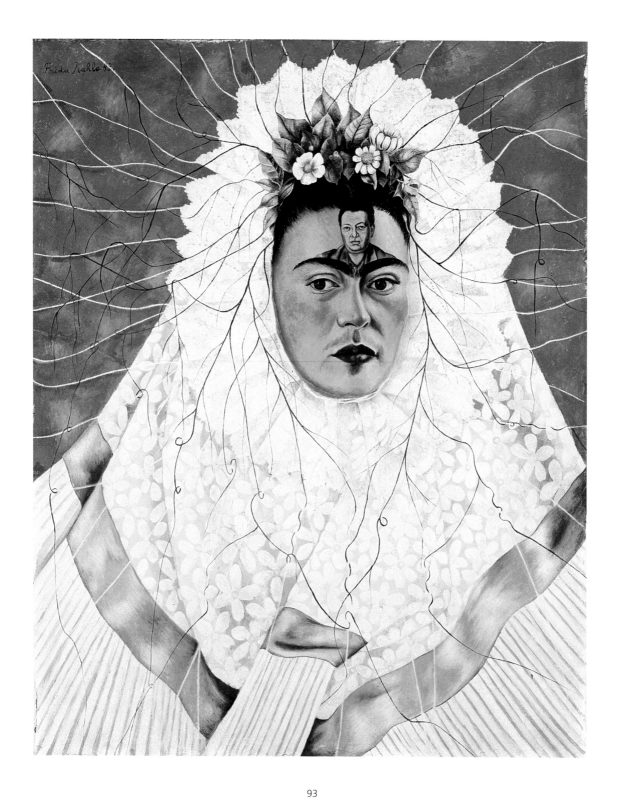

93

FRIDA KAHLO

Autorretrato con Diego en mi pensamiento
[*Self-Portrait with Diego on My Mind*]
1943
Oil on masonite, 30 x 24" (75 x 60 cm)
Jacques and Natasha Gelman Collection

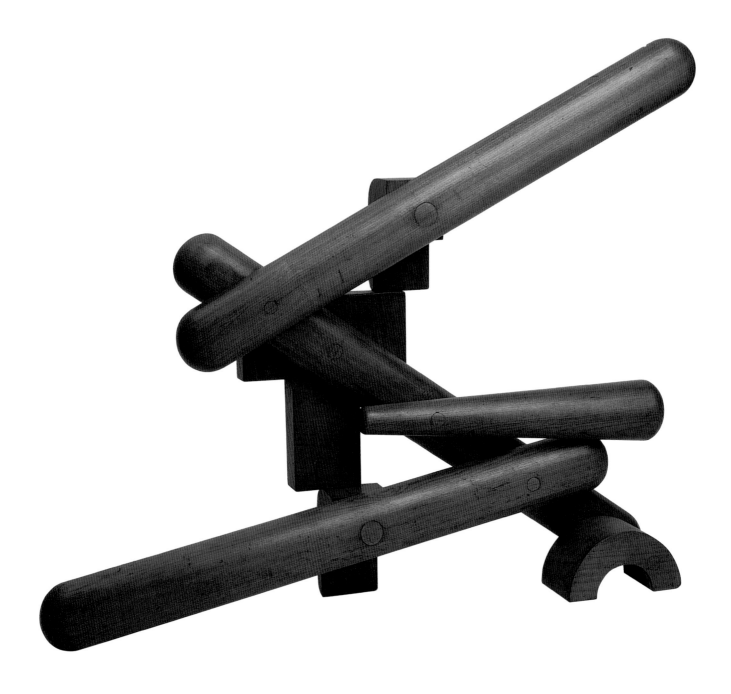

94
GYULA KOSICE
Röyi
1944
Wood, 39 x 31¹/₂ x 6" (99 x 80 x 15 cm)
Private collection

95
GYULA KOSICE
Sin título [Untitled]
1944
Bronze, 13⁵/₈ x 13¹/₂ x 8³/₄" (34.5 x 34.3 x 22 cm)
Private collection

96
FRANS KRAJCBERG
Cocar
1986
Wood, 60¹/₄ x 55¹/₈ x 31¹/₂" (153 x 140 x 80 cm)
Thomas Cohn–Arte Contemporânea,
Rio de Janeiro

97
FRANS KRAJCBERG
Sem título [Untitled]
1992
Burnt wood with natural pigment; nine elements mounted
in nine bases, overall: 11' 6" (334 cm) high, including bases
Collection the artist

98
GUILLERMO KUITCA
El mar dulce [*The Sweet Sea*]
1987
Synthetic polymer paint on canvas,
6' 6³/₄" x 9' 10¹/₈" (200 x 300 cm)
Collection Elisabeth Franck, Knokke-le-Zoute, Belgium

99
GUILLERMO KUITCA
Marienplatz
1991
Synthetic polymer paint on canvas,
6' 8" x 9' 4" (203.2 x 284.5 cm)
Annina Nosei Gallery, New York

100
GUILLERMO KUITCA
Corona de espinas [*Crown of Thorns*]
1990
Synthetic polymer paint and oil on canvas,
6' 6³/₄" x 59¹/₈" (200 x 150 cm)
Collection J. Lagerwey, The Netherlands

101
DIYI LAAÑ
Persistencia de un contorno Madí (Pintura Madí)
[*Persistence of a Madí Contour (Madí Painting)*]
1946
Enamel on wood, 17³/₄ x 33³/₄" (44 x 84.5 cm)
Private collection

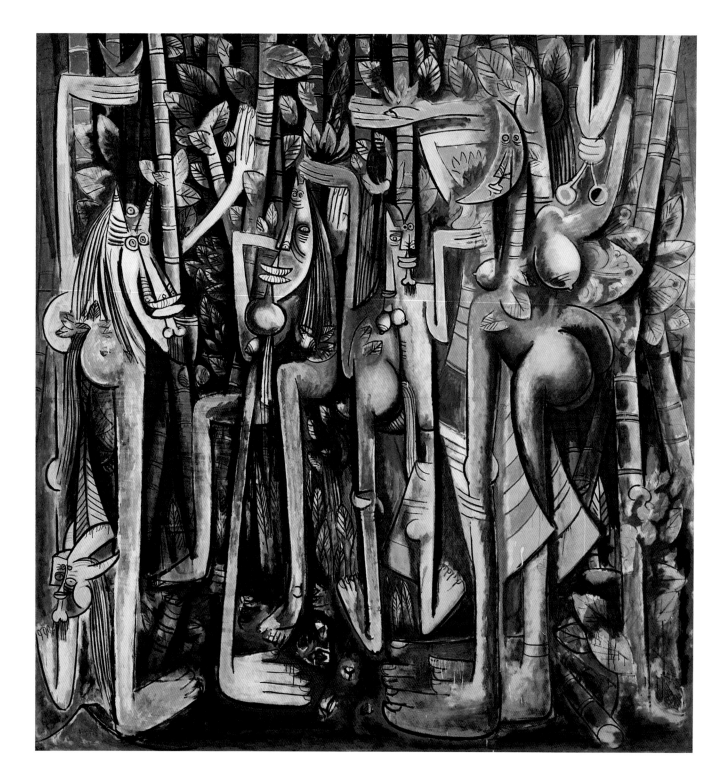

102
WIFREDO LAM
La Jungla [*The Jungle*]
1943
Gouache on paper mounted on canvas,
7' 10$\frac{1}{4}$" x 7' 6$\frac{1}{2}$" (239.4 x 229.9 cm)
The Museum of Modern Art, New York.
Inter-American Fund, 1945

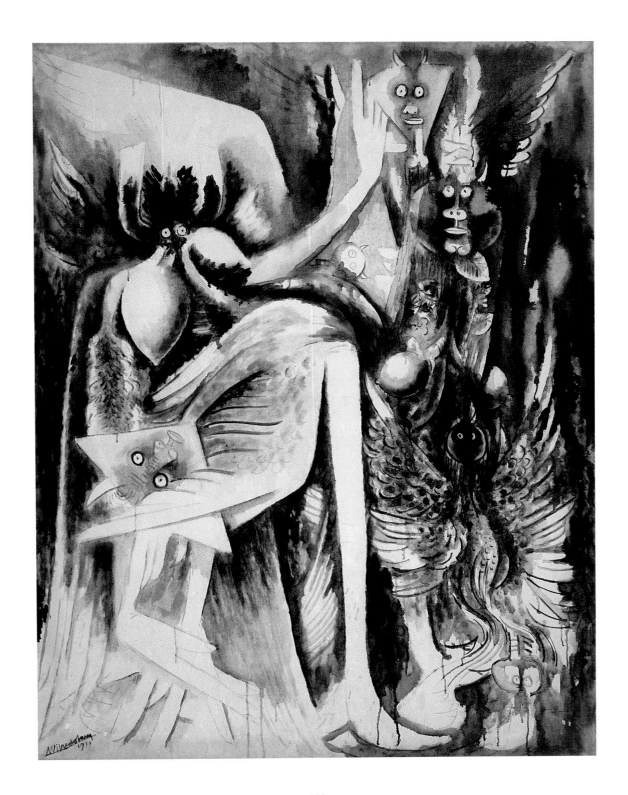

103
WIFREDO LAM
Idolo [*Idol*]
1944
Oil on canvas, 62$\frac{1}{4}$ x 50" (158 x 127 cm)
Private collection, Caracas

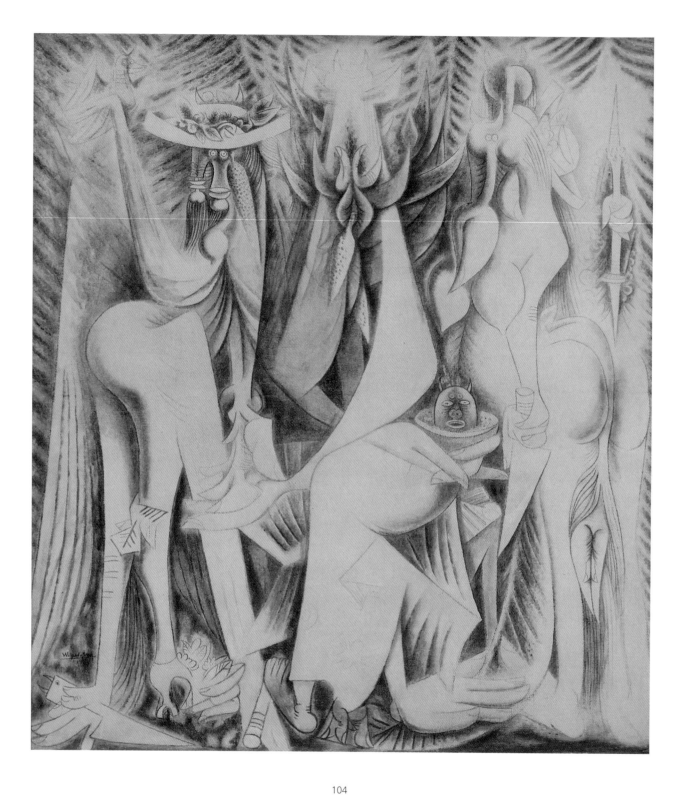

104
WIFREDO LAM
La présente éternelle (Hommage à Alejandro García Caturla)
[*The Eternal Present (Homage to Alejandro García Caturla)*]
1944
Oil on canvas, 7' 1" x 6' 5$^{1}/_{2}$" (215.9 x 196.8 cm)
Museum of Art, Rhode Island School of Design, Providence.
Nancy Sayles Day Collection of Latin American Art

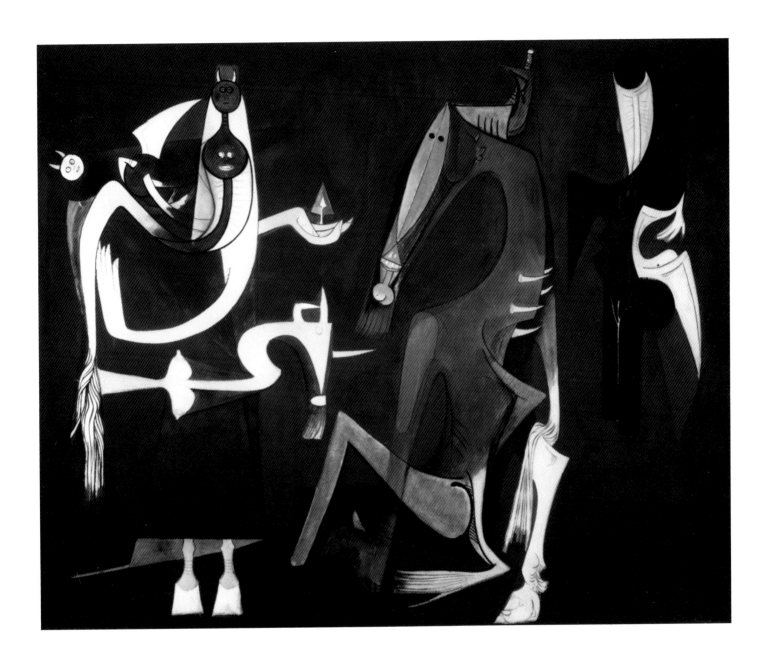

105
WIFREDO LAM
Luz de arcilla [*Light of Clay*]
1950
Oil on canvas, 69⅝" x 7' 1" (177 x 216 cm)
Fundación Museo de Bellas Artes, Caracas

106
JAC LEIRNER
To and From (Walker)
1991
Paper envelopes, polyurethane cord, and
plexiglass; dimensions variable, overall:
4" x 15' 6$^1/_2$" x 9$^5/_8$" (10 x 467 x 24 cm)
Walker Art Center, Minneapolis.
Butler Family Fund, 1992

107
JAC LEIRNER
Os cem (Roda) [*The One Hundreds (Wheel)*]
1986
Paper money on stainless steel,
2$^7/_8$ x 32" (7 x 81.3 cm)
Collection Marcantonio Vilaça, São Paulo

108
Jac Leirner
Pulmão [Lung]
1987
Twelve hundred Marlboro cigarette packages strung on a
polyurethane cord; dimensions variable: length ranges from
14' 5¹/₄" (440 cm) to 15' 9" (480 cm)
The Museum of Modern Art, New York.
David Rockefeller Fund for Latin-American Art
and Brazil Fund, 1991

109
JULIO LE PARC
Seis círculos en contorsión [*Six Circles in Contortion*]
1967
Wood, metal, electric motors, and lamps,
40$\frac{1}{8}$" x 8' x 8" (102 x 245 x 20 cm)
Collection the artist

110
JULIO LE PARC
Mural de luz continua: Formas en contorsión
[*Mural of Continuous Light: Forms in Contortion*]
1966
Wood, metal, electric motors, and lamps,
8' 2¹/₂" x 16' 5" x 8" (250 x 500 x 20 cm)
Fundación Museo de Bellas Artes, Caracas

111
RAÚL LOZZA
Estructura analítica [*Analytical Structure*]
1946
Oil and ribbon on wood, 20$^1/_2$ x 11$^7/_8$" (52.1 x 32.5 cm)
Galerie von Bartha, Basel

112
ROCÍO MALDONADO
Sin título (*La Victoria*) [Untitled (*The Victory*)]
1987
Synthetic polymer paint and collage on canvas,
57 x 66³/₈" (145 x 170 cm)
The Rivendell Collection, Annandale-on-Hudson, New York

113
ROCÍO MALDONADO
Extasis de Santa Teresa II [*Ecstasy of Saint Theresa, II*]
1989
Oil on canvas,
30³/₈ x 38¹/₄ x 6" (77 x 97 x 15 cm)
Private collection, Mexico

114
TOMÁS MALDONADO
Sin título [Untitled]
n.d.
Tempera on wood, mounted on board,
31 x 24" (79 x 60 cm)
Private collection

115
TOMÁS MALDONADO
Construcción de 2 elementos [*Construction with 2 Elements*]
1953
Oil on canvas, 40 x 28" (100 x 70 cm)
Galerie von Bartha, Basel

116
MARISOL

LBJ
1967
Synthetic polymer paint and pencil on wood construction,
6' 8" x 27$^7/8$" x 24$^5/8$" (203.2 x 70.9 x 62.4 cm)
The Museum of Modern Art, New York.
Gift of Mr. and Mrs. Lester Avnet, 1968

117
MATTA
Ecoutez vivre [*Listen to Living*]
1941
Oil on canvas, 29¹/₂ x 37³/₈" (74.9 x 94.9 cm)
The Museum of Modern Art, New York.
Inter-American Fund, 1942

118
MATTA
Le vertige d'éros [*The Vertigo of Eros*]
1944
Oil on canvas, 6' 5" x 8' 3" (195.6 x 251.5 cm)
The Museum of Modern Art, New York.
Given anonymously, 1944

119
MATTA
The Spherical Roof Around Our Tribe (Revolvers)
1952
Tempera on canvas,
6' 6⅝" x 9' 7⅞" (199.7 x 249.5 cm)
The Museum of Modern Art, New York.
Gift of D. and J. de Menil, 1954

120
CILDO MEIRELES

Inserções em circuitos ideológicos:
1. Projeto Coca-Cola
[*Insertions into Ideological Circuits:*
1. Coca-Cola Project]
1970
Printed stickers on Coca-Cola bottles;
dimensions variable
Collection the artist

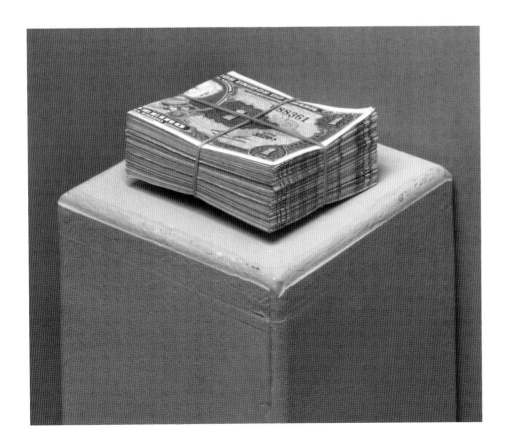

121
CILDO MEIRELES

Arvore do dinheiro [*Tree of Money*]
1969
Roll of 100 one-cruzeiro notes, bound with
rubber bands; dimensions variable
Collection the artist

122
CILDO MEIRELES
Missão-Missões (How to Build Cathedrals)
1987
6,000 coins, 1,000 communion wafers, and 2,000 bones,
19' 6³/₄" x 19' 6³/₄" (600 x 600 cm)
Private collection
Installation view, Parque Laje, Rio de Janeiro

123

JUAN MELÉ

Planos concretos no. 35 [*Concrete Planes, No. 35*]
1948
Mixed mediums; relief: 26 x 18" (65 x 45 cm)
Galerie von Bartha, Basel

124
ANA MENDIETA

Untitled, from the Silueta series
1980
Black-and-white photograph of site sculpture
(carved clay bed executed at Montaña de
San Felipe, La Ventosa, Oaxaca, Mexico),
53$^{1}/_{2}$ x 39$^{1}/_{4}$" (135.9 x 99.7 cm)
Estate of Ana Mendieta
and Galerie Lelong, New York

125
ANA MENDIETA

Untitled, from the Silueta series
1980
Black-and-white photograph of site sculpture
(carved clay bed executed at Montaña de
San Felipe, La Ventosa, Oaxaca, Mexico),
39$^{1}/_{4}$ x 53$^{1}/_{2}$" (99.7 x 135.9 cm)
Estate of Ana Mendieta
and Galerie Lelong, New York

126
A N A M E N D I E T A
Nacida del Nilo [*Nile Born*]
1984
Sand and binder on wood,
2³/4 x 19¹/4 x 61¹/2" (7 x 48.9 x 156.2 cm)
The Museum of Modern Art, New York.
Gift of an anonymous donor, 1992

127
CARLOS MÉRIDA

Plastic Invention on the Theme of Love
1939
Casein and watercolor on paper,
29^3/$_8$ x 21^7/$_8$" (74.7 x 55.3 cm)
The Art Institute of Chicago.
Gift of Katharine Kuh, 1955

128
CARLOS MÉRIDA

*Variations on the Theme of Love
(Variation 2, Ecstasy of a Virgin)*
1939
Gouache and pencil on paper,
18^1/$_2$ x 22^1/$_2$" (47 x 57.2 cm)
Quintana Fine Art USA, Ltd.

129
FLORENCIO MOLINA CAMPOS
Calentando el horno [*Heating the Oven*]
1929
Gouache and tempera on paper, mounted on
cardboard, 12⅝ x 19⅜" (32 x 48 cm)
Private collection, Buenos Aires

130
FLORENCIO MOLINA CAMPOS
Pisando . . . pa locro [*Grinding . . . the Corn*]
1930
Gouache, tempera, and collage on paper,
mounted on colored cardboard,
12⅞ x 19⅜" (32.2 x 48.5 cm)
Private collection, Buenos Aires

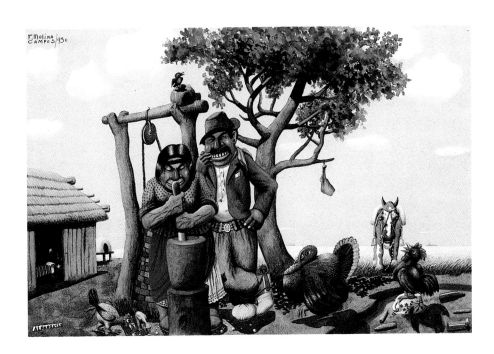

131
EDGAR NEGRET
Aparato mágico [*Magic Apparatus*]
1957
Wood and painted aluminum,
6' 4³/₈" x 36" x 20" (194 x 90 x 50 cm)
Collection the artist

132
EDGAR NEGRET

Navegador III [*Navigator III*]
1971
Painted stainless steel, 58 x 37 x 33" (147.3 x 94 x 83.8 cm)
Solomon R. Guggenheim Museum, New York.
Gift of Ira S. Agress, 1973

133
EDGAR NEGRET
Escalera [*Staircase*]
1972
Painted aluminum,
6' 4³/₄" x 6' 2³/₄" x 41" (195 x 190 x 104 cm)
Collection Hanoj Pérez, Bogotá

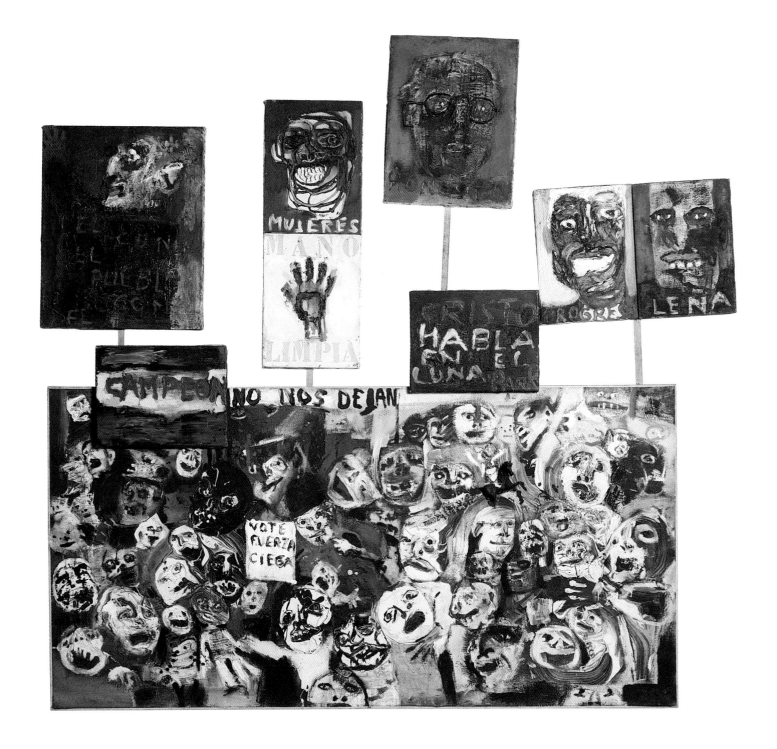

134

LUIS FELIPE NOÉ

Introducción a la esperanza [*Introduction to Hope*]
1963
Oil on canvas; nine panels, overall approximately:
6' 8³/4" x 7' ⁵/8" (205 x 215 cm)
Museo Nacional de Bellas Artes, Buenos Aires

135
HÉLIO OITICICA
Untitled (*Neo-Concrete Relief*)
1959
Oil on wood, 45^{1}/$_{4}$ x 45^{1}/$_{4}$" (115 x 115 cm)
Projeto Hélio Oiticica, Rio de Janeiro

136
HÉLIO OITICICA
Untitled (*Neo-Concrete Relief*)
1959
Oil on wood, 45^{1}/$_{4}$ x 45^{1}/$_{4}$" (115 x 115 cm)
Projeto Hélio Oiticica, Rio de Janeiro

137
HÉLIO OITICICA
Relevo espacial [*Spatial Relief*]
1959
Synthetic polymer paint on wood,
38⅝ x 47¼ x 7⅞" (98 x 120 x 20 cm)
Projeto Hélio Oiticica, Rio de Janeiro

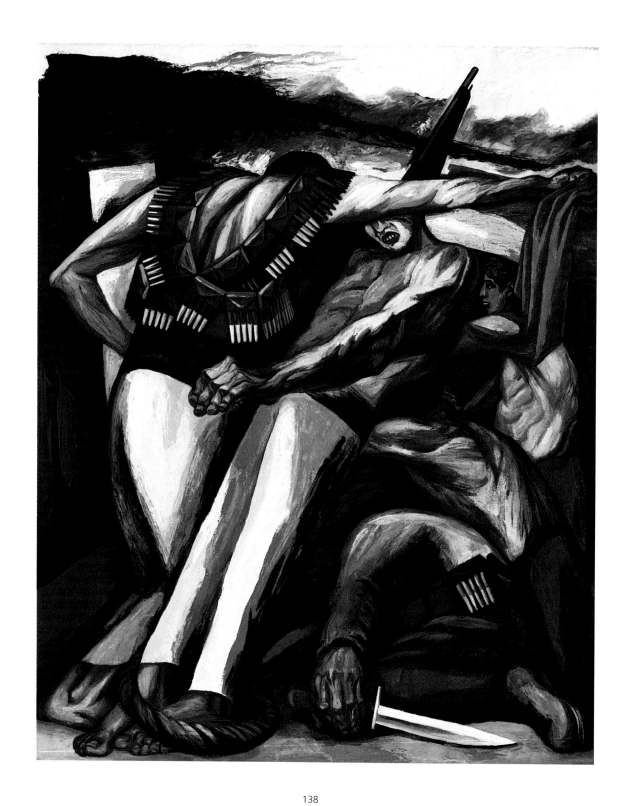

138
JOSÉ CLEMENTE OROZCO
Barricada [*Barricade*]
1931
Oil on canvas, 55 x 45" (139.7 x 114.3 cm)
The Museum of Modern Art, New York.
Given anonymously, 1937

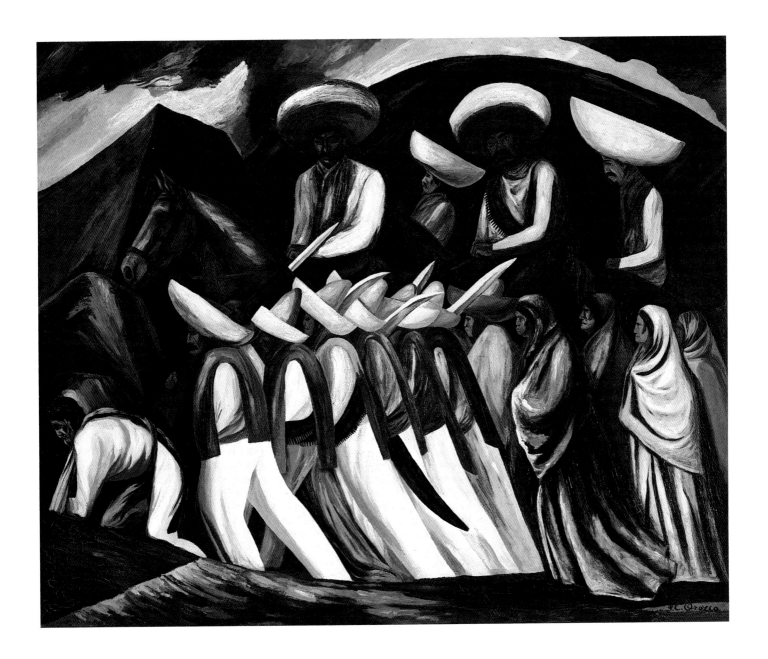

139
JOSÉ CLEMENTE OROZCO
Zapatistas
1931
Oil on canvas, 45 x 55" (114.3 x 139.7 cm)
The Museum of Modern Art, New York.
Given anonymously, 1937

140
JOSÉ CLEMENTE OROZCO
Dive Bomber and Tank
1940
Fresco; six panels, overall: 9 x 18' (275 x 550 cm);
each: 9 x 3' (275 x 91.4 cm)
The Museum of Modern Art, New York.
Commissioned through the Abby Aldrich Rockefeller Fund, 1940

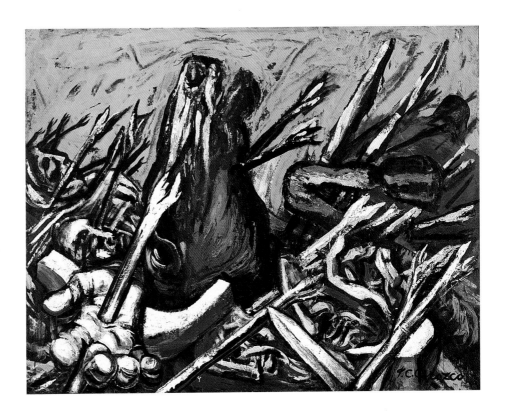

141

JOSÉ CLEMENTE OROZCO

Los teules IV [*The White Gods, IV*]
1947
Piroxilyn on masonite,
46 x 62⅝" (121.7 x 159 cm)
CNCA-INBA, Museo de Arte Alvar y Carmen T.
de Carrillo Gil, Mexico City

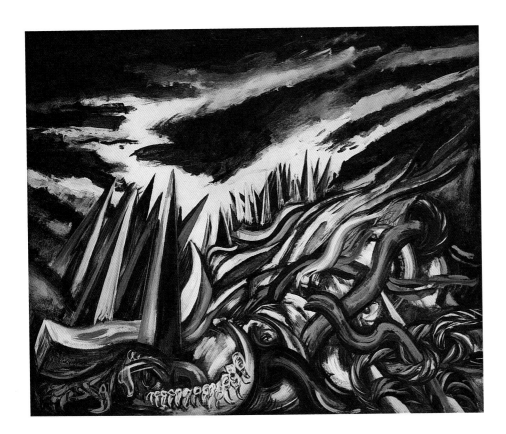

142

JOSÉ CLEMENTE OROZCO

Paisaje de picos [*Landscape with Peaks*]
1948
Oil and tempera on masonite,
40 x 48" (100 x 122 cm)
CNCA-INBA, Museo de Arte Alvar y Carmen T.
de Carrillo Gil, Mexico City

143
RAFAEL MONTAÑEZ ORTIZ
Archeological Find, 3
1961
Burnt mattress,
6' 2⁷/₈" x 41¹/₄" x 9³/₈" (190 x 104.5 x 23.7 cm)
The Museum of Modern Art, New York.
Gift of Constance Kane, 1963

144
RAFAEL MONTAÑEZ ORTIZ
Children of Treblinka
1962
Paper, earth, burnt shoes, and black paint on
wood backing, 17 x 14 x 6" (43 x 33.5 x 15 cm)
El Museo del Barrio, New York.
Gift of Dr. Robert Shaw

145
ALEJANDRO OTERO
Líneas coloreadas sobre fondo blanco
[*Colored Lines on White Ground*]
1951
Oil on canvas, 25¹/₈ x 21¹/₄" (64 x 54 cm)
Collection Oscar Ascanio, Caracas

146
ALEJANDRO OTERO
Líneas coloreadas sobre fondo blanco
[*Colored Lines on White Ground*]
1951
Oil on canvas, 32 x 31⁷/₈" (81.3 x 80.8 cm)
Collection Patricia Phelps de Cisneros, Caracas

147
A L E J A N D R O O T E R O
Colorritmo I [Color-Rhythm, I]
1955
Enamel on plywood,
6' 6³/4" x 19" (200.1 x 48.2 cm)
The Museum of Modern Art, New York.
Inter-American Fund, 1956

148
A L E J A N D R O O T E R O
Colorritmo 39 [Color-Rhythm, 39]
1959
Enamel on wood, 6' 6³/4" x 20⁷/8" (200.1 x 53 cm)
Collection Patricia Phelps de Cisneros, Caracas

149
CÉSAR PATERNOSTO
Trilce II
1980
Synthetic polymer paint on canvas,
66 x 66 x 4" (167.6 x 167.6 x 10.4 cm)
Huntington Art Gallery, University of Texas at Austin.
Barbara Duncan Fund, 1982

150
LILIANA PORTER
Triptych
1986
Synthetic polymer paint, oil, silkscreen,
and assemblage on canvas; overall:
6' 8" x 17' 2" (203.2 x 523.3 cm)
Collection Jorge and Marion Helft, Argentina

151
LILIANA PORTER
The Simulacrum
1991
Synthetic polymer paint, silkscreen, and collage
on paper, 40 x 60" (100 x 152.4 cm)
Collection the artist

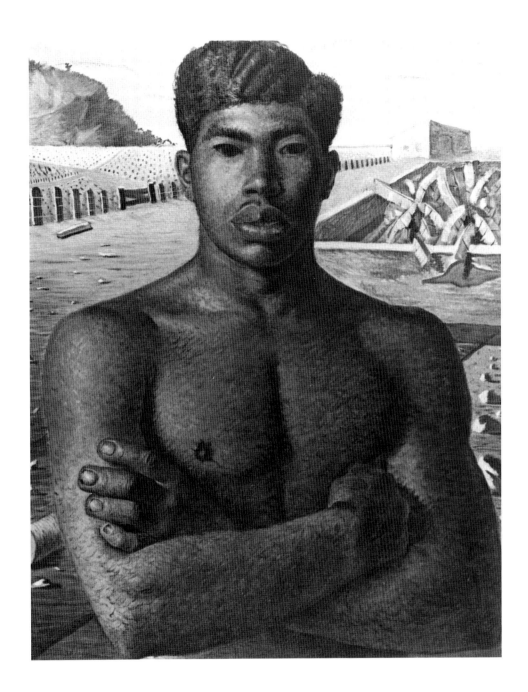

152
CÂNDIDO PORTINARI
O Mestiço [*The Mestizo*]
1934
Oil on canvas, 32 x 26" (81.3 x 65 cm)
Pinacoteca do Estado da Secretaria de Estado da
Cultura de São Paulo

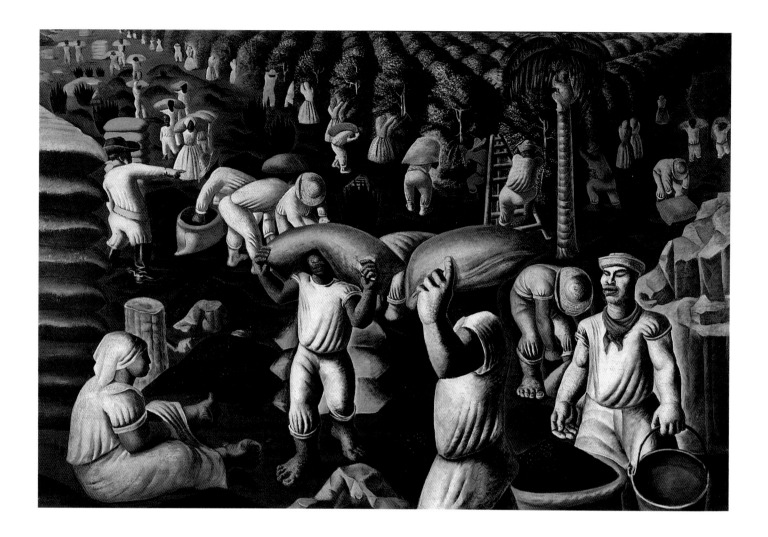

153

CÂNDIDO PORTINARI

Café [Coffee]
1935
Oil on canvas, 51" x 6' 5" (130 x 195.5 cm)
Museu Nacional de Belas Artes, Rio de Janeiro

154
LIDY PRATI
Sin título [Untitled]
1945
Oil on wood, 24³/₈ x 18⁷/₈" (62 x 48 cm)
Private collection

155
LIDY PRATI
Concreta no. 2-B [*Concrete Painting, No. 2-B*]
1948
Oil on composition board, 24 x 24" (60 x 60 cm)
Private collection, Zurich

156
EDUARDO RAMÍREZ VILLAMIZAR
Templo [*Temple*]
1987
Oxidized steel, 30³/₄ x 47¹/₄ x 25¹/₄" (78 x 120 x 64 cm)
Collection the artist

157
EDUARDO RAMÍREZ VILLAMIZAR
Torre Machu Picchu [*Machu Picchu Tower*]
1986
Oxidized steel, 9' 10^1/$_8$" x 53" x 41" (300 x 160 x 104 cm)
Collection Patricia Phelps de Cisneros, Caracas

158
NUNO RAMOS
Sem título [Untitled]
1991
Mixed mediums on wood; two panels, overall:
7' 10^1/$_2$" x 12' 1^3/$_4$" (240 x 340 cm)
Collection João Carlos de Figueiredo Ferraz, São Paulo

159
VICENTE DO REGO MONTEIRO
Adoração dos Reis Magos [*Adoration of the Magi*]
1925
Oil on canvas, 31⅞ x 39¾" (81 x 101 cm)
Collection Gilberto Chateaubriand, Rio de Janeiro

160
JOSÉ RESENDE
Installation view, left to right:

Sem tîtulo [Untitled]
1980
Iron and copper,
6' 6³/4" x 59¹/₁₆" x 59¹/₁₆" (200 x 150 x 150 cm)
Collection the artist

Sem tîtulo [Untitled]
1980
Rubber and copper,
13' 1¹/₂" (400 cm) high, 2" (5 cm) diameter
Collection M. A. Amaral Rezende, São Paulo

Sem tîtulo [Untitled]
1980
Iron, copper, and leather,
6' 10³/4" x 20" x 2" (210 x 50 x 5 cm)
Collection Luisa Strina, São Paulo

161
J OSÉ R ESENDE
Sem título [Untitled]
1980
Copper, aluminum, and stone,
9' 10$\frac{1}{8}$" x 24" x 6' 6$\frac{3}{4}$" (300 x 60 x 200 cm)
Thomas Cohn–Arte Contemporânea, Rio de Janeiro

162
ARMANDO REVERÓN
Luz tras mi enramada [*Light Through My Arbor*]
1926
Oil on canvas, 18$^7/_8$ x 25$^1/_8$" (48 x 64 cm)
Collection Jorge Yebaile, Caracas

163
ARMANDO REVERÓN
Paisaje en azul [*Landscape in Blue*]
1929
Oil on canvas, 25$^1/_8$ x 31$^1/_2$" (64 x 80 cm)
Fundación Galería de Arte Nacional, Caracas

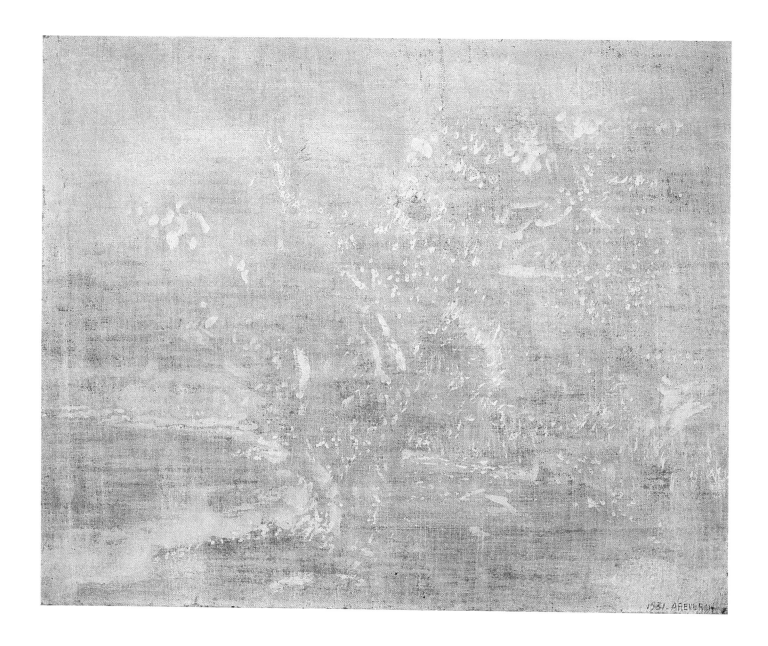

164

ARMANDO REVERÓN

El Arbol [*The Tree*]
1931
Oil on canvas, 25$^{1}/_{8}$ x 31$^{1}/_{2}$" (64 x 80 cm)
Collection Alfredo Boulton, Caracas

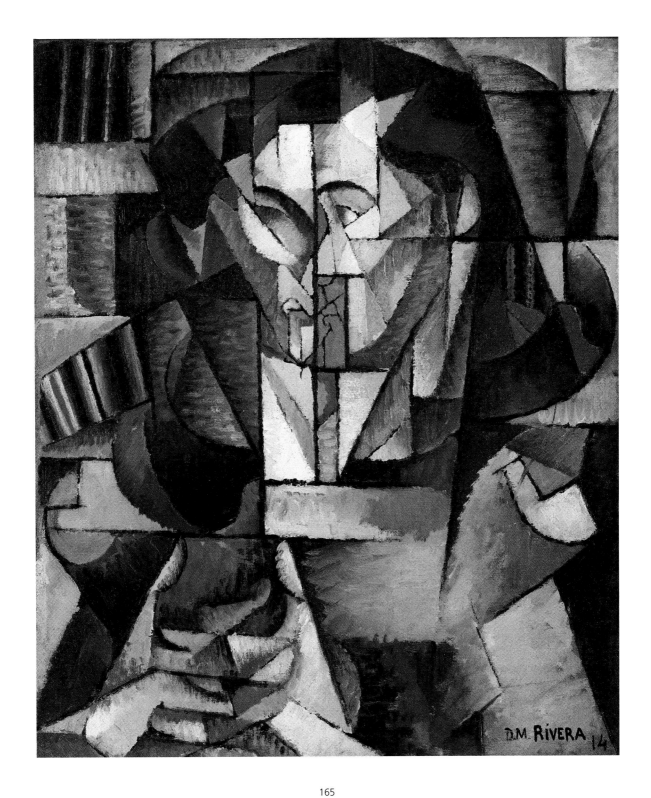

165

DIEGO RIVERA

Jacques Lipchitz (Retrato de un joven)
[*Jacques Lipchitz (Portrait of a Young Man)*]
1914
Oil on canvas, 25⅝ x 21⅝" (65.1 x 54.9 cm)
The Museum of Modern Art, New York.
Gift of T. Catesby Jones, 1941

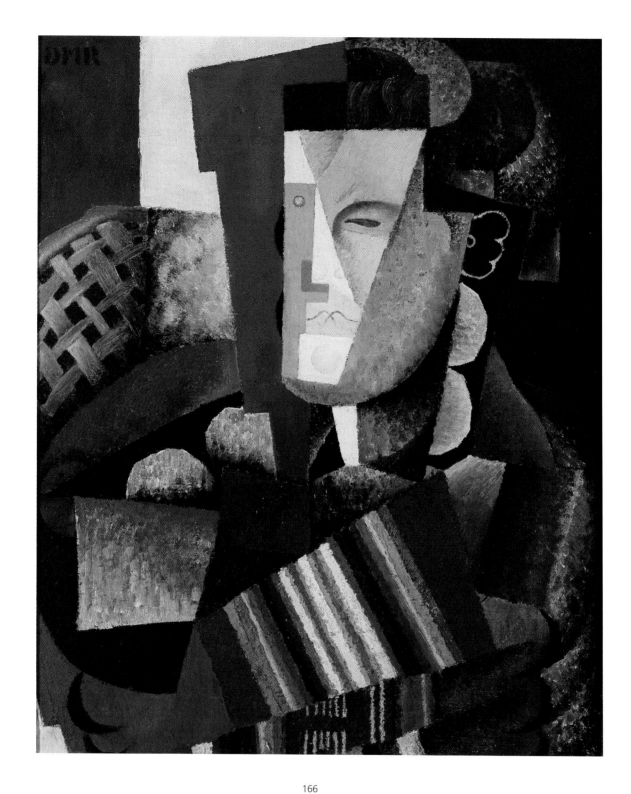

166
Diego Rivera
Retrato de Martín Luis Guzmán
[Portrait of Martín Luis Guzmán]
1915
Oil on canvas, 29 x 23³/₄" (72.3 x 59.3 cm)
Fundación Cultural Televisa, Mexico City

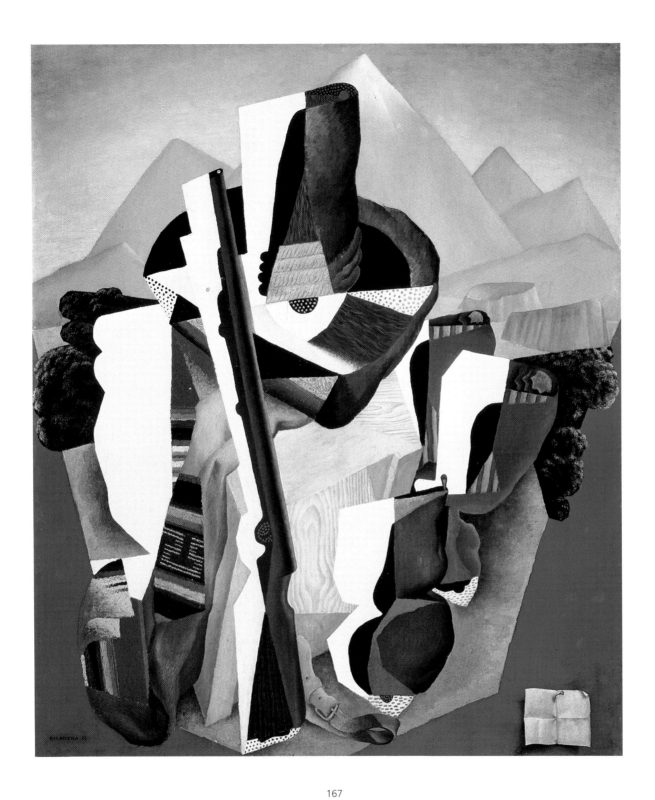

167
DIEGO RIVERA
Paisaje zapatista—El guerrillero
[*Zapatista Landscape—The Guerrilla*]
1915
Oil on canvas, 56³/₈ x 48³/₈" (144 x 123 cm)
CNCA-INBA, Museo Nacional de Arte, Mexico City

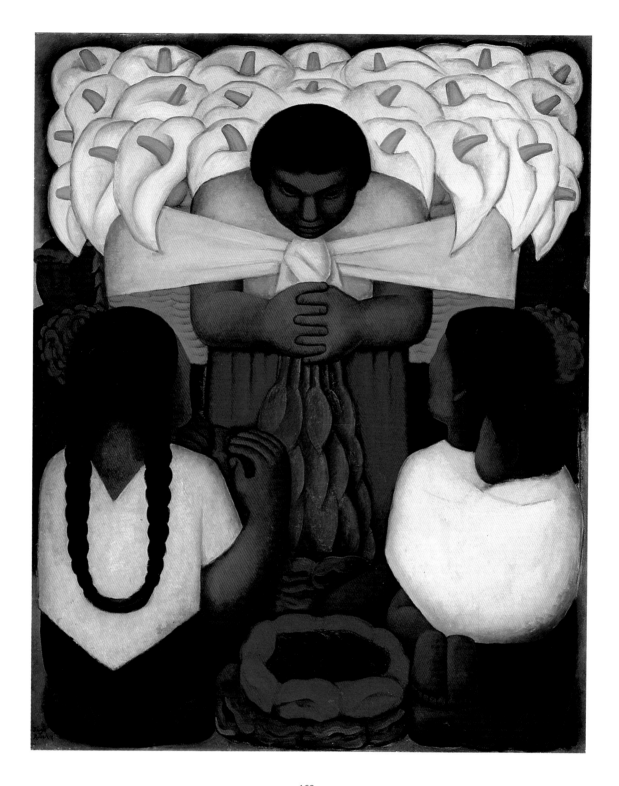

168
DIEGO RIVERA
Día de flores [*Flower Day*]
1925
Encaustic on canvas,
58 x 47¹/₂" (147.4 x 120.6 cm)
Los Angeles County Museum of Art.
Los Angeles County Fund

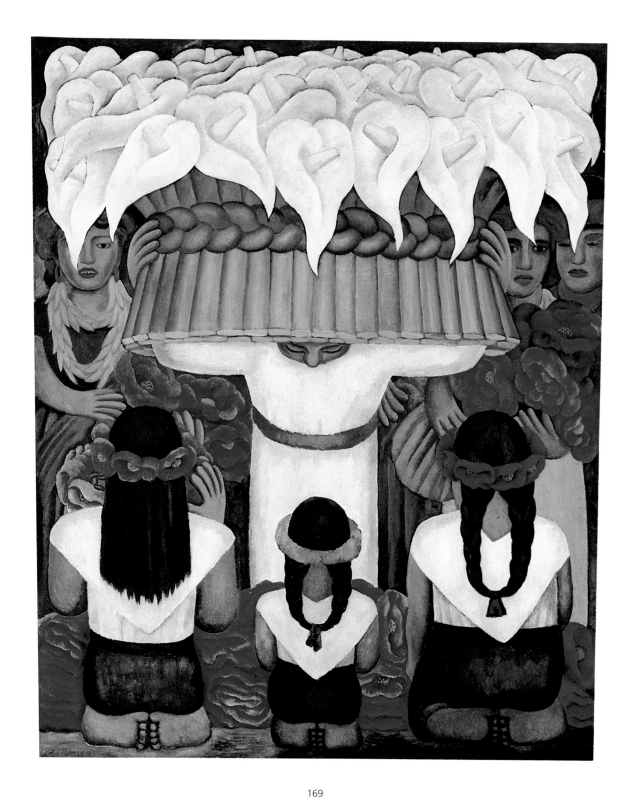

169
DIEGO RIVERA
Fiesta de flores, día de Santa Anita
[*Flower Festival: Feast of Santa Anita*]
1931
Encaustic on canvas,
6' 6¹/₂" x 64" (199.4 x 162.5 cm)
The Museum of Modern Art, New York.
Gift of Abby Aldrich Rockefeller, 1936

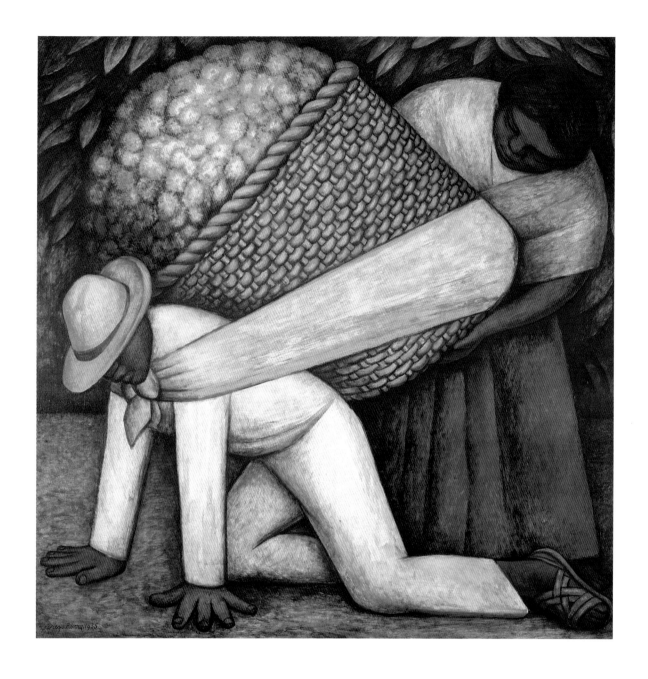

170
DIEGO RIVERA
The Flower Carrier
1935
Oil and tempera on masonite,
48 x 47⁷/₈" (122 x 121.3 cm)
San Francisco Museum of Modern Art,
Albert M. Bender Collection. Gift of Albert M.
Bender in memory of Caroline Walter

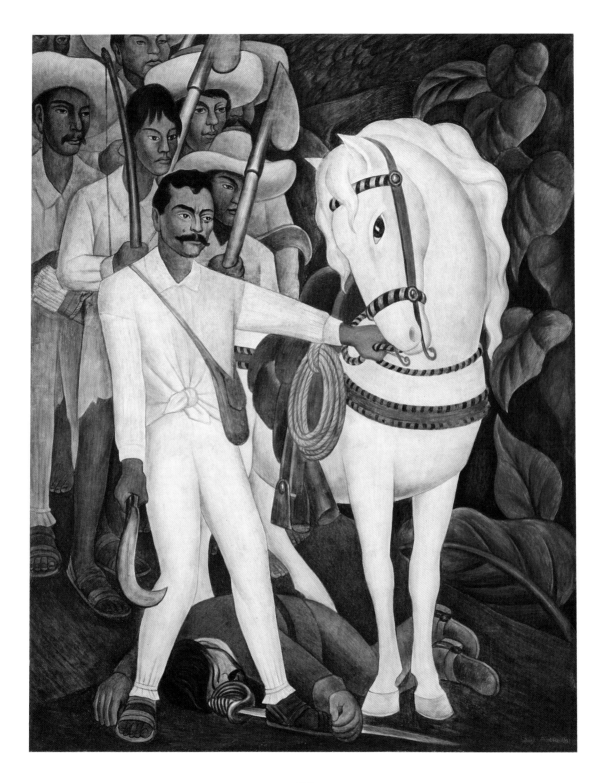

171
DIEGO RIVERA

El agrarista Zapata [*Agrarian Leader Zapata*]
1931
Fresco, 7' 9³/₄" x 6' 2" (238.1 x 188 cm)
The Museum of Modern Art, New York.
Abby Aldrich Rockefeller Fund, 1940

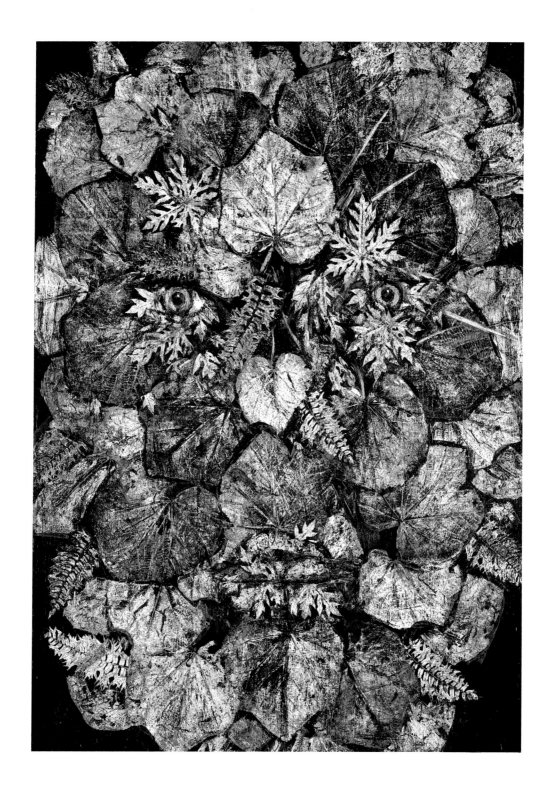

172

ARNALDO ROCHE RABELL

You Know I Am Aware
1990
Oil on canvas,
6' 11³/₄" x 59³/₄" (212.7 x 151.8 cm)
The Metropolitan Museum of Art, New York.
Edith C. Blum Fund, 1990

173
CARLOS ROJAS
Sin título, de la serie América
[Untitled, from the series America]
1989
Mixed mediums on canvas,
67 x 67" (170 x 170 cm)
Collection the artist

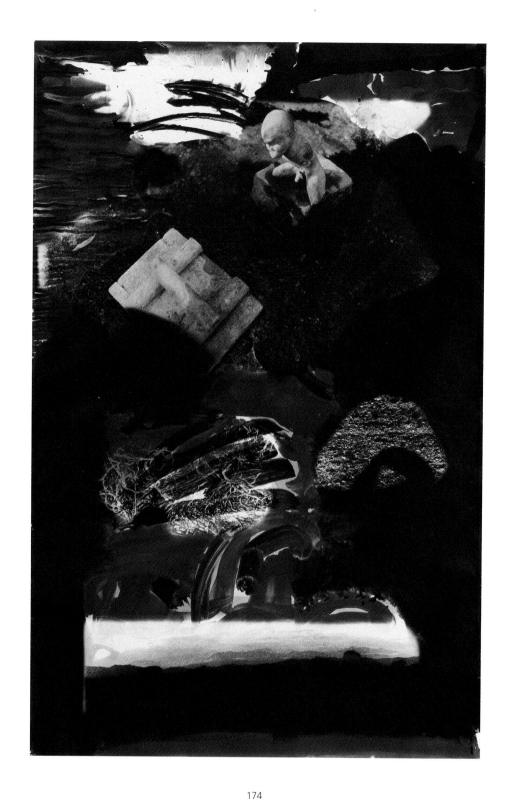

174
MIGUEL ANGEL ROJAS

Caño limón [Lemon Spring]
1992
Photograph, partially developed,
6' 7³/4" x 51³/4" (203 x 131.5 cm)
Collection the artist

175
RHOD ROTHFUSS
Superestructura Madí [*Madí Superstructure*]
1946
Oil on board on wood mount,
29³/₈ x 22⁷/₈" (74.5 x 58 cm)
Private collection

176
R H O D R O T H F U S S
Escultura con movimientos rotativos
[*Sculpture with Rotary Movements*]
1947
Painted wood,
39^{1}/$_{4}$ x 28^{3}/$_{4}$ x 7^{3}/$_{4}$" (99.5 x 73 x 19.6 cm)
Private collection

177
BERNARDO SALCEDO
Los Fusilados [*The Executed*]
1986
Bullet casings on photograph, with frame,
18$^1/_2$ x 40 x 1$^1/_4$" (47 x 100 x 3 cm)
Collection Alberto Sierra, Medellín

178
BERNARDO SALCEDO

Idea de mi abuelo [*My Grandfather's Idea*]
1981
Light-bulb socket and filament on photograph,
8$^1/_4$ x 7$^1/_4$ x 1$^5/_8$" (21 x 18.2 x 4 cm)
Collection Dr. Hernando Santos Castillo, Bogotá

179
BERNARDO SALCEDO

Señales particulares 23 [*Personal Signs 23*]
1981
Vacuum-cleaner attachment on photograph,
20$^1/_4$ x 15 x 3$^1/_8$" (50.5 x 38 x 8 cm)
M. Gutierrez Fine Arts, Key Biscayne, Florida

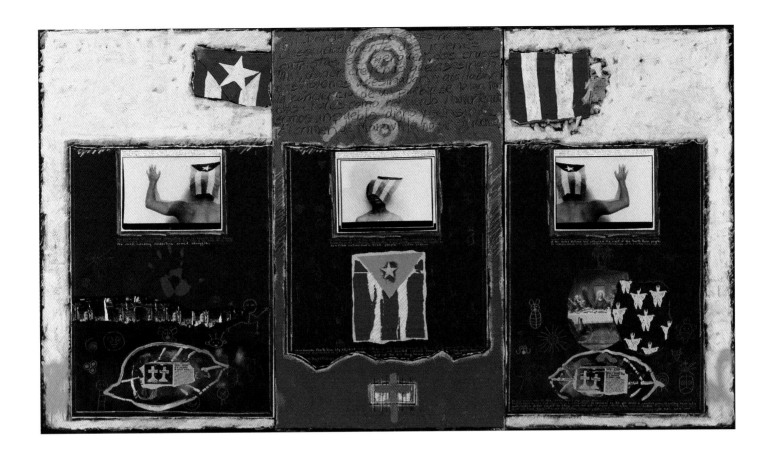

180
JUAN SÁNCHEZ

Mixed Statement
1984
Oil, photocollage, and mixed mediums on
canvas; triptych, overall: 54" x 8' (137.2 x 244 cm)
Collection Guariquen Inc.,
Puerto Rico and New York

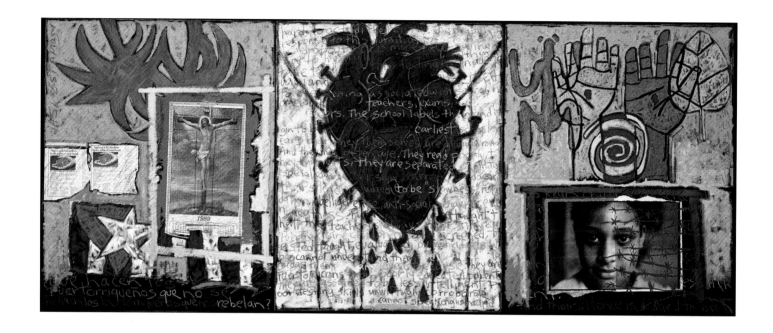

181

JUAN SÁNCHEZ

Bleeding Reality: Así Estamos
1988
Oil and mixed mediums on canvas; triptych,
overall: 44$\frac{1}{2}$" x 9' $\frac{3}{4}$" (112.5 x 273.7 cm)
El Museo del Barrio, New York. Purchase Fund

182
MIRA SCHENDEL

Sem título [Untitled]
1965
Monotype: oil on rice paper,
18^1/$_2$ x 9^1/$_{16}$" (47 x 23 cm)
Collection Ada Clara Dub Schendel Bento,
São Paulo

183
MIRA SCHENDEL

Sem título [Untitled]
1965
Monotype: oil on rice paper,
18^1/$_2$ x 9^1/$_{16}$" (47 x 23 cm)
Collection Ada Clara Dub Schendel Bento,
São Paulo

184
MIRA SCHENDEL

Droguinhas
c. 1966
Knotted Japanese paper,
15^3/$_4$ x 8 x 8" (40 x 20 x 20 cm)
Collection Ada Clara Dub Schendel Bento,
São Paulo

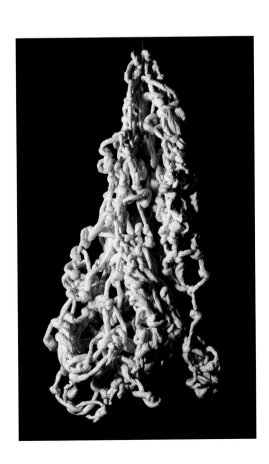

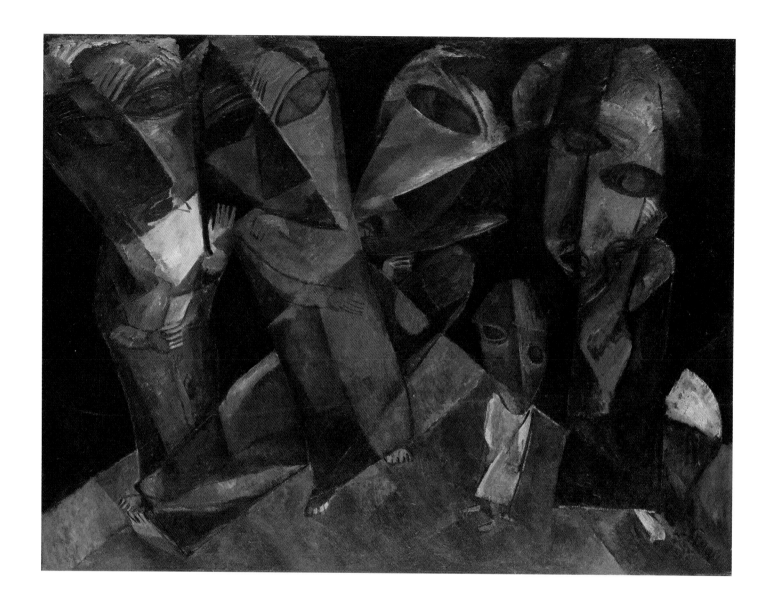

185
LASAR SEGALL
Os eternos caminhantes [*The Eternal Wanderers*]
1919
Oil on canvas, 54³/₈" x 6' ¹/₂" (138 x 184 cm)
Museu Lasar Segall, São Paulo

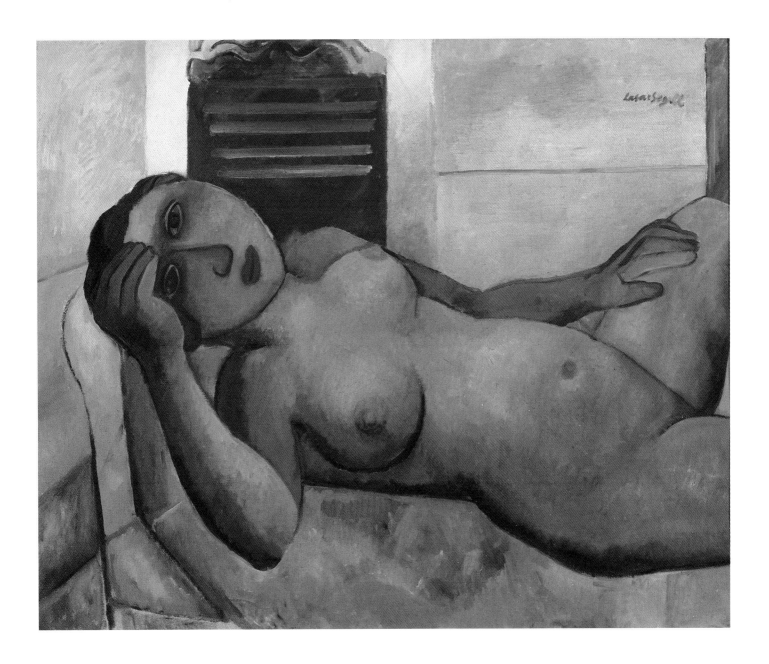

186
LASAR SEGALL
Figura feminina reclinada [*Reclining Woman*]
1930
Oil on canvas, 31⁷/₈ x 40" (81 x 100 cm)
Private collection, São Paulo

187
LASAR SEGALL

Rua do Mangue [*Street of Mangue*]
1928
Drypoint and etching on paper,
15^{1}/$_{8}$ x 21^{5}/$_{8}$" (37.7 x 54 cm)
Museu Lasar Segall, São Paulo

188
LASAR SEGALL

Favela [*Shantytown*]
1930
Drypoint on paper, 14^{5}/$_{8}$ x 20^{7}/$_{8}$" (36.5 x 52 cm)
Museu Lasar Segall, São Paulo

189
LASAR SEGALL

Primeira classe [*First Class*]
c. 1929
Drypoint and etching on paper,
20⁷/₈ x 14⁵/₈" (52 x 36.5 cm)
Museu Lasar Segall, São Paulo

190
LASAR SEGALL

Emigrantes [*Emigrants*]
1929
Drypoint on paper, 15³/₈ x 22³/₈" (38.5 x 56 cm)
Museu Lasar Segall, São Paulo

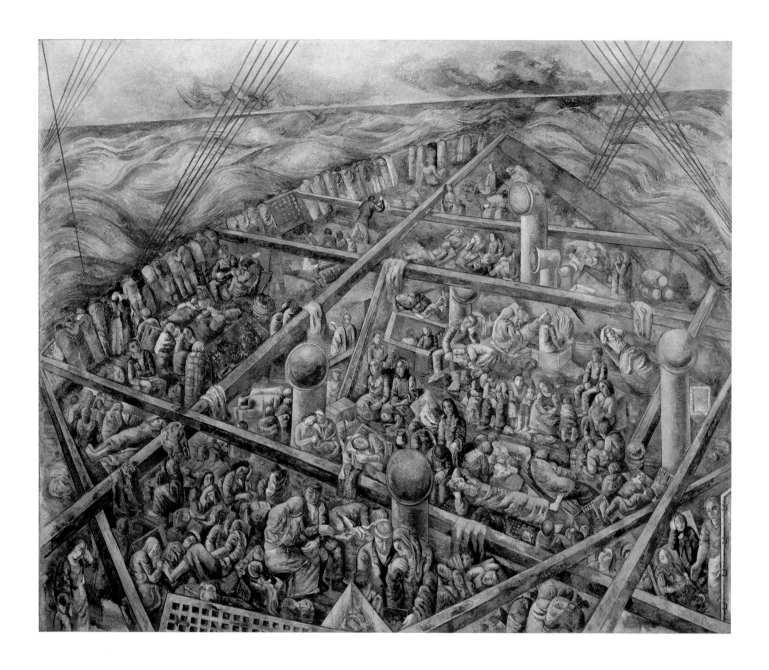

191
LASAR SEGALL

Navio de emigrantes [*Ship of Emigrants*]
1939–41
Oil with sand on canvas,
7' 6⅝" x 9' ¼" (230 x 275 cm)
Museu Lasar Segall, São Paulo

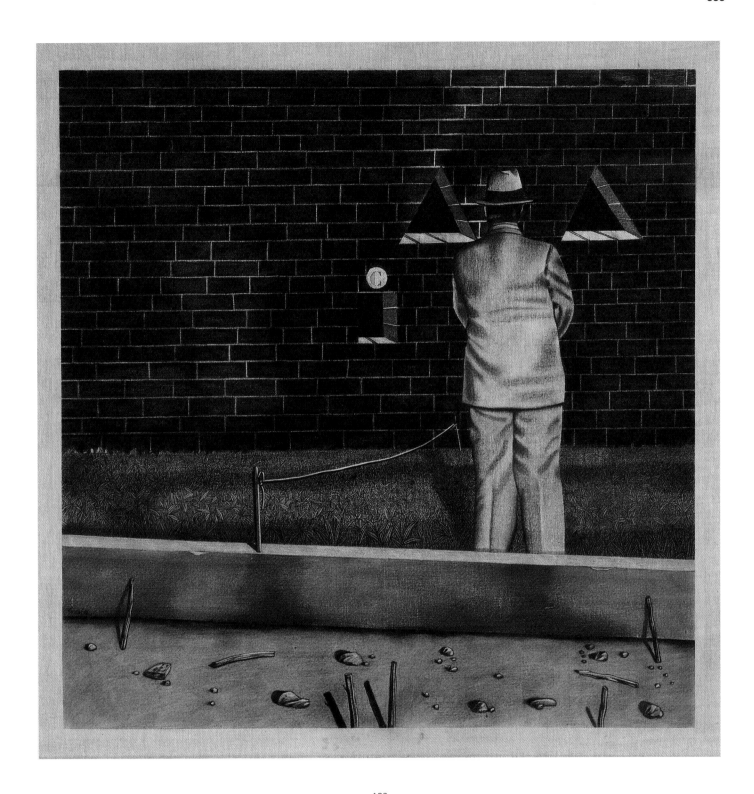

192
ANTONIO SEGUÍ
Contra el muro [*Against the Wall*]
1976
Charcoal and pastel on canvas, 59 x 59" (150 x 150 cm)
Fundación Museo de Bellas Artes, Caracas

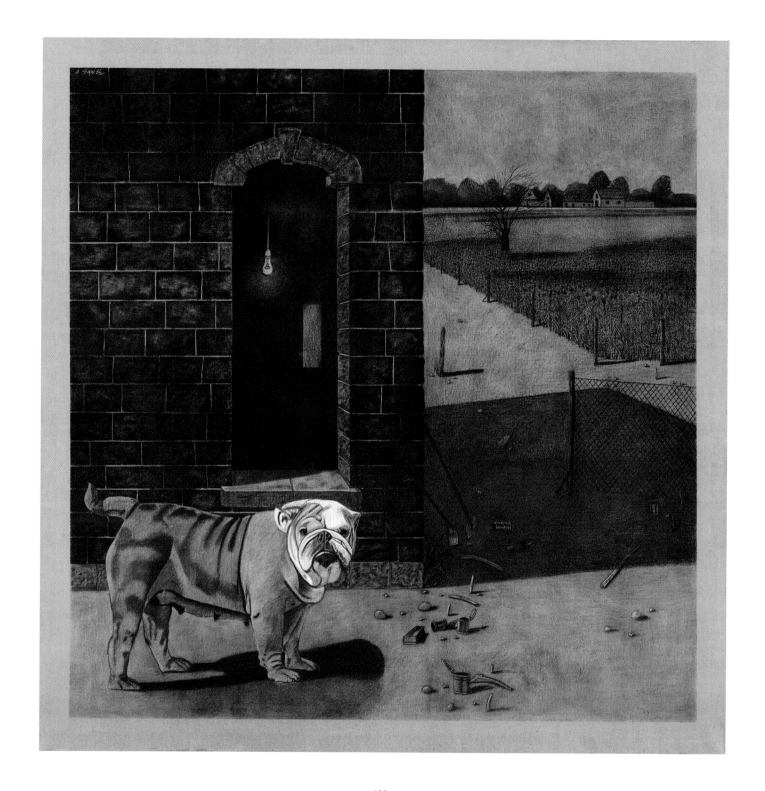

193
ANTONIO SEGUÍ
La distancia de la mirada
[*The Distance of the Gaze*]
1976
Charcoal and pastel on canvas,
6' 6" x 6' 6$^{1}/_{4}$" (195 x 195.4 cm)
Private collection, Buenos Aires

194
DANIEL SENISE
Sem título (*Sino*) [Untitled (*Bell*)]
1989
Mixed mediums on canvas, 8' 6" x 7' 4" (255 x 220 cm)
Private collection, Mexico

195

DANIEL SENISE

Sem título (*Sudario*) [Untitled (*Shroud*)]
1989
Mixed mediums on canvas, 7' x 42" (213.4 x 106.7 cm)
Collection Betty Levinson, Chicago

196
DAVID ALFARO SIQUEIROS
Víctima proletaria [*Proletarian Victim*]
1933
Enamel on burlap, 6' 9" x 47^1/$_2$" (205.8 x 120.6 cm)
The Museum of Modern Art, New York.
Gift of the Estate of George Gershwin, 1938

197
DAVID ALFARO SIQUEIROS
Suicidio colectivo [*Collective Suicide*]
1936
Enamel on wood with applied sections,
49" x 6' (124.5 x 182.9 cm)
The Museum of Modern Art, New York.
Gift of Dr. Gregory Zilboorg, 1937

198
DAVID ALFARO SIQUEIROS
Eco de un grito [*Echo of a Scream*]
1937
Enamel on wood, 48 x 36" (121.9 x 91.4 cm)
The Museum of Modern Art, New York.
Gift of Edward M. M. Warburg, 1939

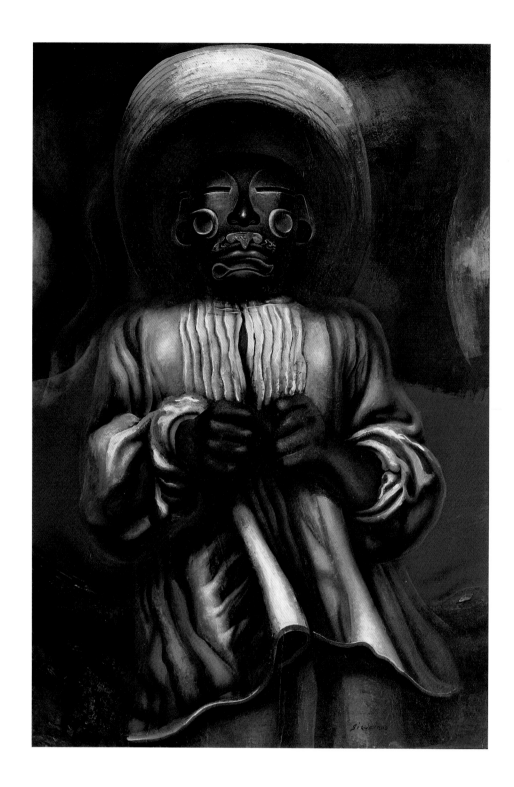

199
DAVID ALFARO SIQUEIROS
Etnografía [*Ethnography*]
1939
Enamel on composition board,
48$\frac{1}{8}$ x 32$\frac{3}{8}$" (122.2 x 82.2 cm)
The Museum of Modern Art, New York.
Abby Aldrich Rockefeller Fund, 1940

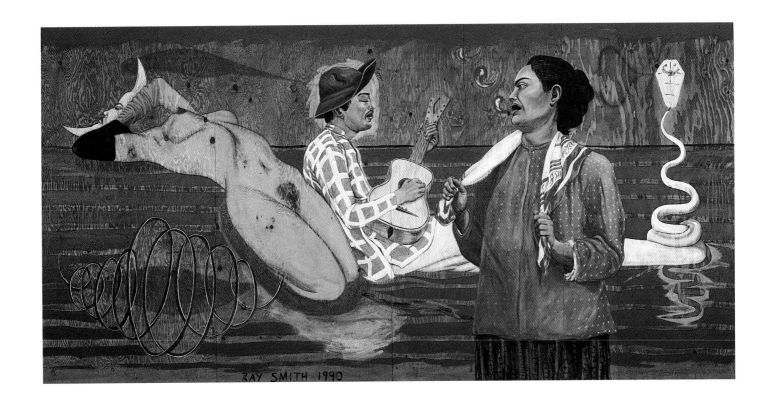

200
RAY SMITH

Maricruz Veracruz
1990
Oil on wood; four panels, overall:
8 x 16' (244 x 488 cm)
Private collection

201
JESÚS RAFAEL SOTO

Desplazamiento de un objeto luminoso
[*Displacement of a Luminous Element*]
1954
Paint and collage on plexiglass, and wood,
20 x 31¹/₂ x 1" (50 x 80 x 2.5 cm)
Collection Patricia Phelps de Cisneros, Caracas

202
JESÚS RAFAEL SOTO
Vibración [*Vibration*]
1965
Metal and oil on wood,
62³/₈ x 42¹/₄ x 5³/₄" (158.4 x 107.3 x 14.6 cm)
Solomon R. Guggenheim Museum, New York.
Gift of Eve Clendenin, 1967

203
JESÚS RAFAEL SOTO
Oliva y negro [*Olive and Black*]
1966
Flexible mobile: metal strips suspended in front of
two plywood panels painted with synthetic polymer paint
and mounted on composition board,
61$\frac{1}{2}$ x 42$\frac{1}{4}$ x 12$\frac{1}{2}$" (156 x 107.1 x 31.7 cm)
The Museum of Modern Art, New York.
Inter-American Fund, 1967

204
JESÚS RAFAEL SOTO
Escritura global [*Global Writing*]
c. 1970
Metal and painted wood,
41¹/₄ x 69¹/₄ x 7¹/₈" (103 x 173 x 17.8 cm)
Collection Patricia Phelps de Cisneros, Caracas

205
RUFINO TAMAYO
Animales [*Animals*]
1941
Oil on canvas, 30$\frac{1}{8}$ x 40" (76.5 x 101.6 cm)
The Museum of Modern Art, New York.
Inter-American Fund, 1942

206

RUFINO TAMAYO

Muchacha atacada por un extraño pájaro
[*Girl Attacked by a Strange Bird*]
1947
Oil on canvas, 70 x 50⅛" (177.8 x 127.3 cm)
The Museum of Modern Art, New York.
Gift of Mr. and Mrs. Charles Zadok, 1955

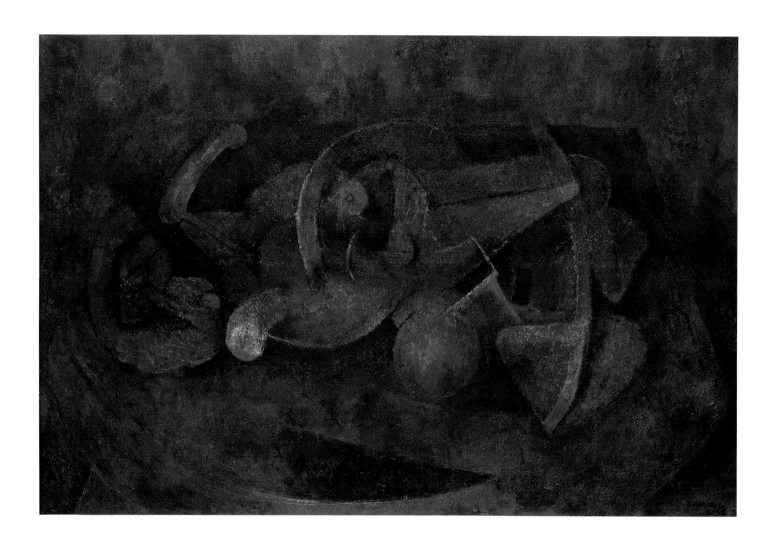

207
RUFINO TAMAYO
Insomnio [*Insomnia*]
1958
Oil on canvas, 38¹/₂ x 57" (97.8 x 145 cm)
Collection Francisco Osio

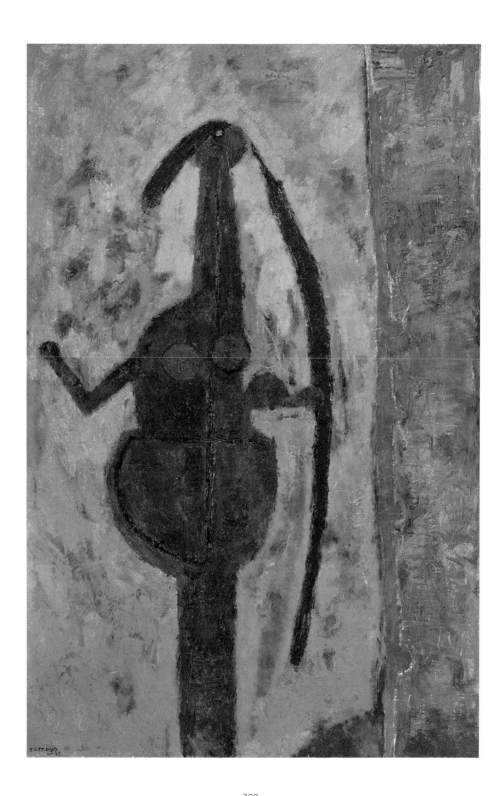

208
RUFINO TAMAYO
Mujer en gris [*Woman in Grey*]
1959
Oil on canvas, 6' 4³/₄" x 51" (195 x 129.5 cm)
Solomon R. Guggenheim Museum, New York

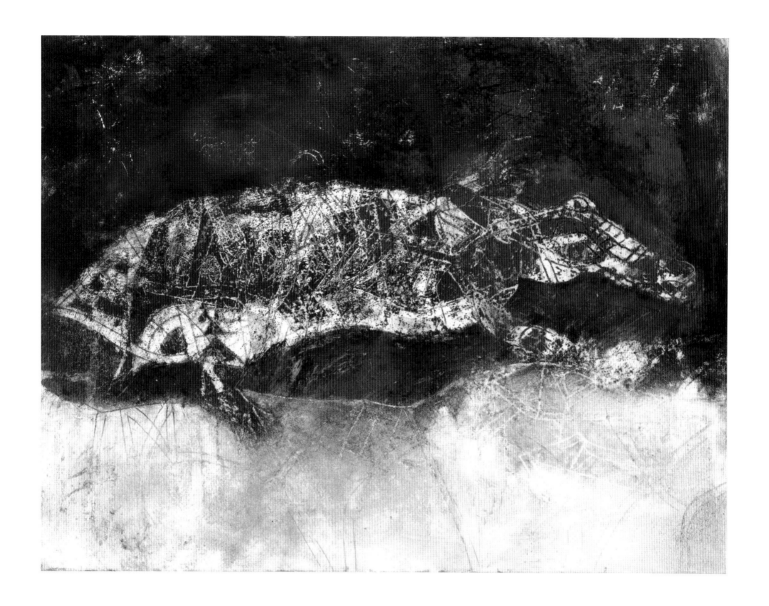

209
FRANCISCO TOLEDO
La función del mago [*The Magician's Performance*]
1972
Oil on canvas, 47$^{1}/_{4}$ x 62$^{1}/_{4}$" (120 x 158 cm)
CNCA-INBA, Museo de Arte Moderno, Mexico City

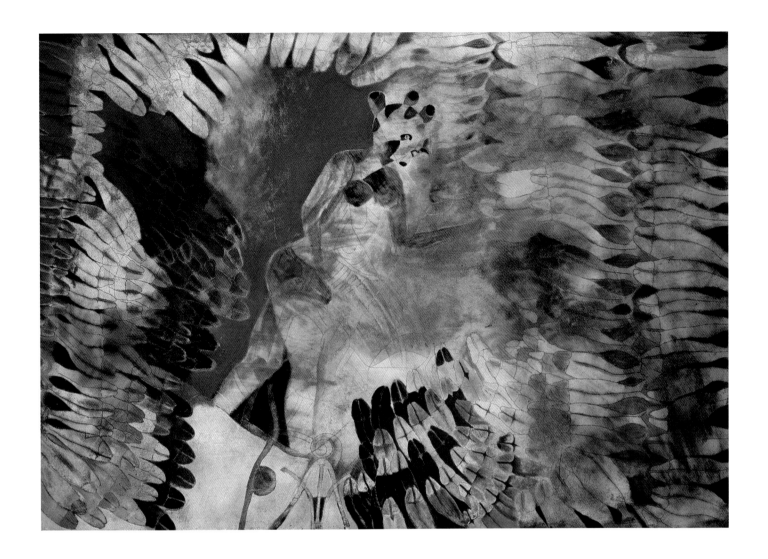

210
FRANCISCO TOLEDO
Mujer atacada por peces [*Woman Attacked by Fish*]
1972
Oil on canvas, 55$^1/_8$" x 6' 6$^3/_4$" (140 x 200 cm)
CNCA-INBA, Museo de Arte Contemporáneo
Internacional Rufino Tamayo, Mexico City

211
JOAQUÍN TORRES-GARCÍA
Pintura constructiva (El sótano)
[*Constructive Painting (The Cellar)*]
1929
Oil on wood, 31^1/$_2$ x 40" (80 x 100 cm)
Museo Nacional de Artes Visuales, Montevideo

212
JOAQUÍN TORRES-GARCÍA
Escena callejera [*Street Scene*]
1930
Oil on cardboard, 22 x 30^1/$_2$" (55 x 77.5 cm)
Collection Mr. Eduardo F. Costantini and
Mrs. María Teresa de Costantini, Buenos Aires

213
JOAQUÍN TORRES-GARCÍA
Objet plastique [*Plastic Object*]
1931
Paint and wood,
30^{1}/$_{2}$ x 7^{5}/$_{8}$ x 2^{1}/$_{4}$" (76.3 x 19.3 x 5.7 cm)
Hirshhorn Museum and Sculpture Garden,
Smithsonian Institution, Washington, D.C.
Gift of Joseph H. Hirshhorn, 1966

214
JOAQUÍN TORRES-GARCÍA
Composición con formas primitivas
[*Composition with Primitive Forms*]
1932
Oil on canvas, 50 x 34⅝" (127 x 88 cm)
Collection Mrs. Elizabeth Kaplan Fonseca, New York

215
JOAQUÍN TORRES-GARCÍA
Constructivo de la elíptica [*Elliptical Constructive Painting*]
1932
Oil on canvas, 36¹/₂ x 28⁷/₈" (92.5 x 73.2 cm)
Private collection

216
JOAQUÍN TORRES-GARCÍA
Constructivo con formas curvas
[*Constructive Painting with Curved Forms*]
1931
Paint and nails on wood,
19^{1}/$_{4}$ x 16^{1}/$_{4}$" (48.3 x 40.6 cm)
Galerie Dr. István Schlégl, Mrs. Nicole Schlégl,
Zurich

217
JOAQUÍN TORRES-GARCÍA
Objet plastique/composición
[*Plastic Object/Composition*]
1931
Paint and wood, 20^{1}/$_{2}$ x 16^{1}/$_{2}$" (52.1 x 41.9 cm)
IVAM Centre Julio González,
Generalitat Valenciana

218
JOAQUÍN TORRES-GARCÍA
Estructura constructiva con línea blanca
[*Constructive Structure with White Line*]
1933
Tempera, pastel, and crayon on board,
41 x 21⅛" (104.1 x 73.9 cm)
Private collection

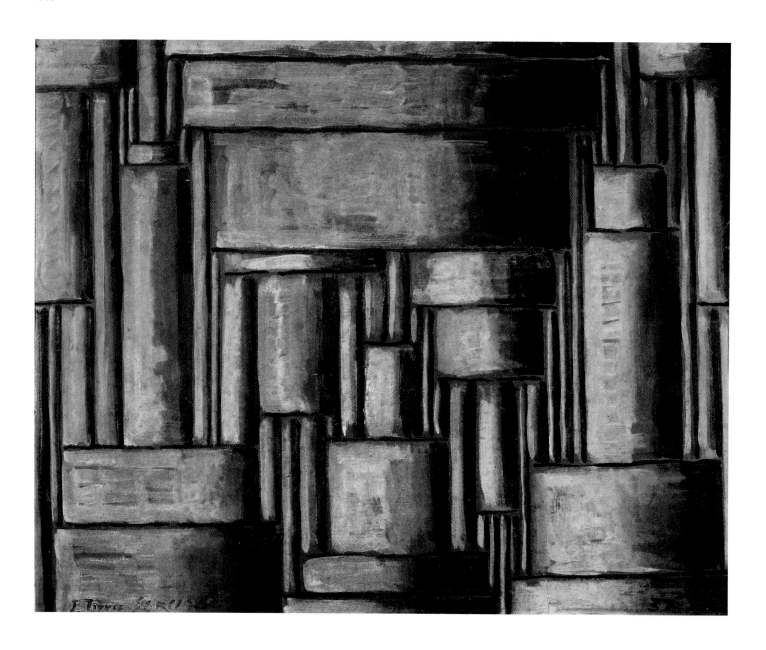

219

JOAQUÍN TORRES-GARCÍA

Estructura, forma abstracta tubular
[*Structure, Abstract Tubular Form*]
1937
Tempera, pastel, and crayon on board,
30^3/$_8$ x 38^1/$_4$" (77 x 97 cm)
Private collection

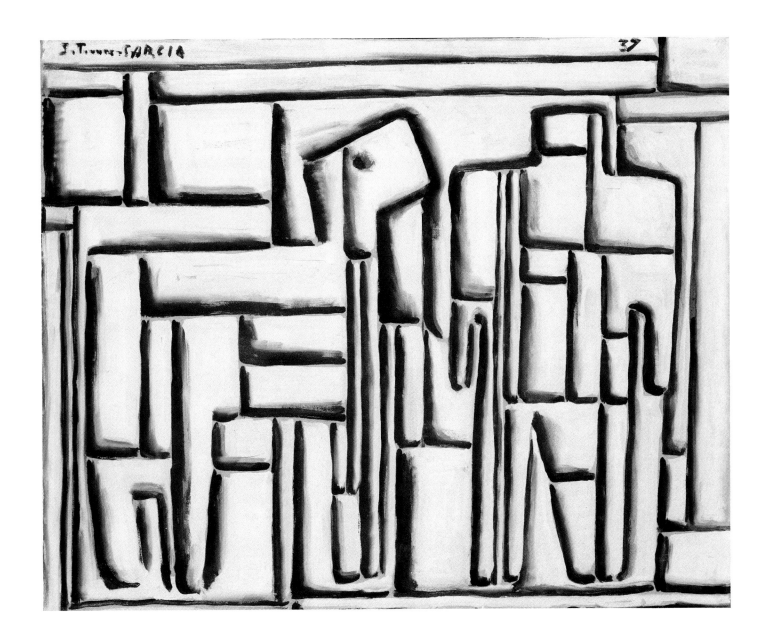

220
JOAQUÍN TORRES-GARCÍA
Hombre y perro [*Man and Dog*]
1937
Tempera on board, 30³/₄ x 38³/₄" (78 x 98.2 cm)
Private collection

221
T U N G A

Palindromo incesto [*Palindrome Incest*]
1992
Magnets, copper, steel, iron, and thermometers;
installation variable, overall approximately:
28' x 16' 6" (850 x 500 cm)
Collection the artist
Installation view, Galerie Nationale du Jeu de Paume, Paris

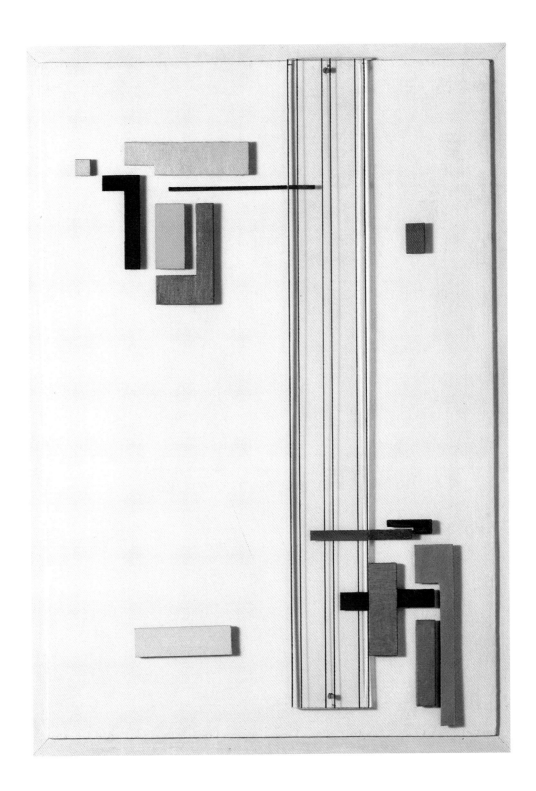

222
GREGORIO VARDÁNEGA
Relieve [*Relief*]
1949
Enameled wood and glass,
28¹/₄ x 19¹/₄" (70.5 x 48 cm)
Galerie von Bartha, Basel

223
Alfredo Volpi
Composição [*Composition*]
n.d.
Tempera on canvas, 43 x 28³/₄" (109 x 73 cm)
Collection Luiz Diederichsen Villares, São Paulo

224
ALFREDO VOLPI
Bandeirinhas geométricas [*Little Geometric Flags*]
c. 1960s
Tempera on canvas, 28³/₄ x 42¹/₂" (73 x 108 cm)
Collection Eugênia Volpi, São Paulo

225
XUL SOLAR

Homme das serpents [*Snake Charmer*]
1923
China ink and watercolor on paper,
10 x 12¼" (25 x 31 cm)
Private collection

226
XUL SOLAR

Pareja [*Couple*]
1923
Watercolor on paper,
10⅝ x 12⅞" (27 x 32.7 cm)
Collection Mr. Eduardo F. Costantini and
Mrs. María Teresa de Costantini, Buenos Aires

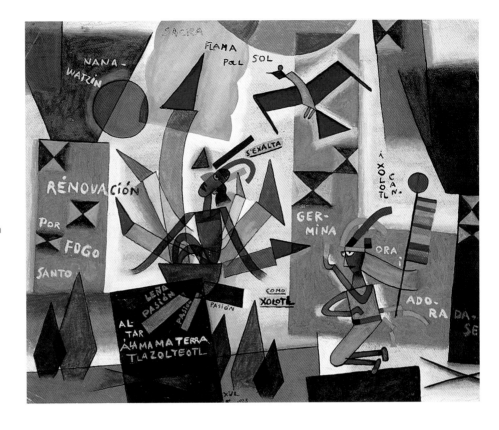

227
XUL SOLAR
Nana-Watzin
1923
China ink and watercolor on paper, mounted on
cardboard, 10^1/$_8$ x 12^3/$_8$" (25.5 x 31.5 cm)
Galería Vermeer, Buenos Aires

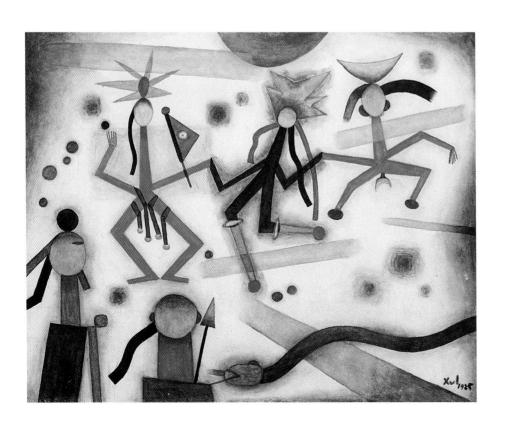

228
XUL SOLAR
San danza [*Holy Dance*]
1925
Watercolor on paper, mounted on cardboard,
11 x 14^1/$_2$" (28 x 37 cm)
Collection Jorge and Marion Helft, Argentina

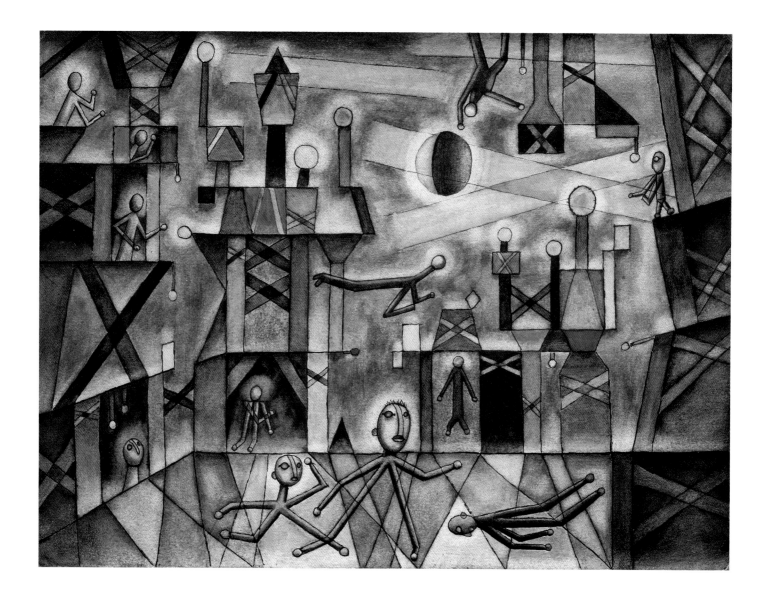

229
XUL SOLAR
Teatro [*Theater*]
1924
Watercolor on paper,
10⁷/₈ x 14³/₄" (27.5 x 37.5 cm)
Gradowczyk Collection, Buenos Aires

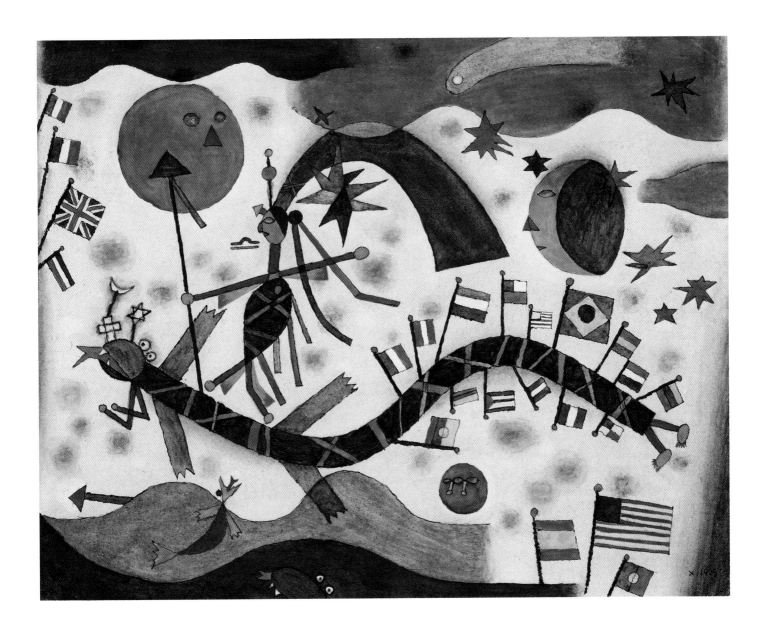

230

X U L S O L A R

Mundo [*World*]
1925
Watercolor, tempera, and pencil on paper,
10¹/₈ x 12⁵/₈" (25.5 x 32 cm)
Rachel Adler Gallery, New York

231
XUL SOLAR

Por su cruz jura [*He Swears by the Cross*]
1923
China ink and watercolor on paper,
10 x 12¹/₄" (25 x 31.1 cm)
Collection Mr. Eduardo F. Costantini and
Mrs. María Teresa de Costantini, Buenos Aires

232

XUL SOLAR

Bri, país y gente [*Bri, Country and People*]
1933
Watercolor on cardboard,
15³/4 x 22" (40 x 55 cm)
Collection Jorge and Marion Helft, Argentina

233

CARLOS ZERPA

Mi mamá me mima y yo en Capanaparo
[*My Mother Takes Care of Me in Capanaparo*]
1984
Wood, plexiglass, and mixed mediums
(photograph, shoes, knives, glass, marbles,
shovel, bamboo, and beehive); triptych, overall:
7' 7⁵/₈" x 8' 10" x 6" (232 x 270 x 15 cm)
Fundación Galería de Arte Nacional, Caracas

Biographies of the Artists

—

Compiled by Beverly Adams, Elaine Barella, Fatima Bercht, Linda Briscoe, Tadeu Chiarelli, John Alan Farmer, Elizabeth Ferrer, Lisa Leavitt, Rosemary O'Neill, Lisa Titus, and Joseph R. Wolin

Carlos Almaraz
Mexican-American, 1941–1989

Born in Mexico City, Carlos Almaraz moved with his parents to the United States, where he was raised in Chicago and the Mexican-American community of East Los Angeles. He attended the University of California at Los Angeles in 1964, and, after moving to New York in 1965, took courses at the Art Students League and the New School for Social Research. He returned to Los Angeles in 1971 and received an M.F.A. three years later from the Otis Art Institute. During the early 1970s Almaraz became involved with the Chicano movement, which was concerned with the farm workers' struggle, civil rights, education, and the socioeconomic condition of Mexican-Americans. Almaraz worked for Cesar Chávez and the United Farm Workers from 1973 to 1976. Like other Chicano artists in this period, he created public murals, in Mexican-American neighborhoods, that reflected social issues. In 1971 Almaraz became Mural Coordinator for the Department of Parks and Recreation in Los Angeles. In 1973 he founded the art collective Los Four with Roberto de la Rocha, Gilbert Luján, and Frank Romero and was a founder of two Chicano magazines, *Concilio de arte popular* and *Chisme-arte*. Aiming to raise Mexican-Americans' awareness of their history and culture, Los Four portrayed such subjects as pre-Columbian deities, the Virgin of Guadalupe, the leaders of the Mexican Revolution, and recent heroes such as Che Guevara. In 1974 Los Four was the subject of one of the first museum exhibitions of Chicano art in the United States, at the Los Angeles County Museum of Art. The group remained active until 1980. Almaraz's pastel-and-oil paintings of the early 1980s treat subjects such as automobile accidents as allegories of urban life. He also painted poetic landscapes with animals and imaginary beings that vibrate with strong color. His final, more muted works are concerned with themes of sin and redemption. Almaraz died in Los Angeles of complications arising from AIDS. His one-person exhibitions include *Moonlight Theater: Prints and Related Works by Carlos Almaraz*, The Grunwald Center for the Graphic Arts, University of California, Los Angeles, 1991. His work was represented in *Hispanic Art in the United States: Thirty Contemporary Painters and Sculptors*, The Museum of Fine Arts, Houston, 1987; *Chicano Art: Resistance and Affirmation, 1965–1985*, Wight Art Gallery, University of California, Los Angeles, 1990; and *Mito y magia en América: Los ochenta*, Museo de Arte Contemporáneo, Monterrey, Mexico, 1991.—L.L.

Tarsila do Amaral
Brazilian, 1886–1973

Tarsila do Amaral was born on a farm in Capivari, a small town in the interior of São Paulo state. Her father was a member of Brazil's wealthy rural elite. Amaral traveled to Europe several times with her family during her childhood. She began studying art in 1916 in São Paulo with the academic realist painters Pedro Alexandrino and J. Fischer Elpons, a German immigrant, and in 1920 she studied in Paris at the Académie Julian. She returned to Brazil in 1922 just after the *Semana de arte moderna*, an exhibition and series of cultural events designed to bring European modernism to Brazil, and she quickly immersed herself in the intellectual activity that followed. Through her friend Anita Malfatti, an influential modernist painter, she met the writer Oswald de Andrade, who became her companion. Together with him, Mário de Andrade, Malfatti, and Paulo Menotti del Picchia, she formed the short-lived Grupo dos Cinco. Amaral returned to Paris late in 1922 and studied with Fernand Léger, Albert Gleizes, and André Lhote. She and Oswald de Andrade met Pablo Picasso, Giorgio de Chirico, Constantin Brancusi, and the poet Blaise Cendrars. Her home in Paris was known for gatherings that brought artists and intellectuals of the Brazilian avant-garde together with other modernists living in Paris. Amaral returned to Brazil in December 1923, followed by Andrade and Cendrars, to explore the artistic heritage of her country; she traveled to Rio de Janeiro and the baroque towns of Minas Gerais state in 1924. Andrade began using "Pau-Brasil," a term for an indigenous dye-wood that was important for Brazil's colonial development, to describe a specifically Brazilian modernist aesthetic. Amaral's Pau-Brasil paintings of 1924 to 1927 employed Léger-inspired geometricism to depict national, rural, and urban industrial subjects in intense colors. Though based in Brazil, Amaral and Andrade returned to Paris several times in the 1920s. Her first important exhibition of Pau-Brasil paintings was held at the Galerie Percier in Paris in 1926. In 1928 she created a key painting whose title, *Abaporú*, comes from a Tupi-Guarani word. This painting was used by Andrade and Amaral as a symbol for the Antropofagia movement, which advocated replacing colonial culture by a new Brazilian tropical aesthetic that was primitive and earthy, without Pau-Brasil's emphasis on progress and industrialization. An exhibition of her Antropofagia works was presented in Paris in 1928. In 1929 Amaral broke with Andrade. In 1931 she visited Russia, where she exhibited at the Museum of Modern Western Art in Moscow. As a result of this trip, she produced a series of works, in the 1930s and 1940s, reflecting the influence of Soviet social realism. In subsequent decades Amaral reexamined and reworked early themes. Her one-person exhibitions include ones at the Museu de Arte Moderna, São Paulo, 1950; the 1963 São Paulo Bienal; and the Museu de Arte Moderna, Rio de Janeiro, 1969. Amaral's work appeared in *Art of Latin America since Independence*, Yale University Art Gallery, New Haven, 1966; *Art of the Fantastic: Latin America, 1920–1987*, Indianapolis Museum of Art, 1987; *Modernidade: Art brésilien du 20e siècle*, Musée d'Art Moderne de la Ville de Paris, 1987; *Art in Latin America: The Modern Era, 1820–1980*, Hayward Gallery, London, 1989; and

Bilderwelt Brasilien: Die europaïsche Erkundung eines "irdischen Paradieses" und die Kunst der brasilianischen Moderne, Kunsthaus Zürich, 1992. —E.B.

Carmelo Arden Quin
Uruguayan, born 1913

Carmelo Arden Quin was born in Rivera, Uruguay. From 1919 to 1930 he was educated in Marist institutions in Brazil; while a student, he became interested in Marxism. In 1930 he traveled in Argentina and Brazil. While a law student, he began to study painting in 1932 with the Catalan artist Emilio Sans. He returned to Uruguay in 1935. A meeting with Joaquín Torres-García in Montevideo the following year proved decisive to his artistic career. Moving to Buenos Aires in 1938, Arden Quin studied philosophy and literature and became active in that city's avant-garde. He contributed to the cultural review *Sinesis* and, in 1939, with the poet Edgar Bayley and others, he attempted to found a magazine, *Arturo*. At that time he became interested in "primitive" art and also developed aesthetic theories based on the concept of dialectical materialism. In 1941, while still a student, Arden Quin was a founder of the cultural and political review *El Universitario,* and he continued to be politically active, opposing Nazism. He traveled in 1941 to Paraguay; in 1942 to Brazil, where he met members of Rio de Janeiro's avant-garde; and in 1943 to Uruguay, where he again met with Torres-García. Upon his return to Buenos Aires, Arden Quin revived the review *Arturo* with a new group of artists, publishing a single issue in 1944. He participated in the two Arte Concreto-Invención exhibitions in 1945. A year later he helped found the Grupo Madí and was influential in developing its artistic philosophy. During this period Arden Quin created abstract wood wall reliefs featuring geometric forms and, in some instances, movable parts, recalling Torres-García's wood toys, which he had seen in 1939. He also produced irregularly shaped geometric paintings with areas of flat color bounded by heavy black lines; by 1947 the compositions became more complex and mechanistic. Although he broke with the Grupo Madí that year, he continued to participate in their exhibitions and promote their theories. Living in Europe from 1948 to 1952, he met Michel Seuphor, Jean (Hans) Arp, Auguste Herbin, Francis Picabia, and Nicolas de Staël; and from 1948 to 1956 he exhibited at the Salons des Réalités Nouvelles in Paris. Arden Quin traveled to Brazil in 1953 and organized in São Paulo a conference on the Madí movement. In Buenos Aires in 1954 he helped found the group Asociación Arte Nuevo. In the late 1950s and 1960s he continued to exhibit in Paris and contribute to periodicals such as *Ailleurs*, which he directed from 1962 to 1966. His one-person exhibitions include shows at the Galerie de la Salle, Saint-Paul de Vence, 1978, and the Espace Latino-Américain, Paris, 1983. His work has been included in *Vanguardias de la década del 40*, Mu-

seo de Artes Plásticas Eduardo Sívori, Buenos Aires, 1980, and *Art in Latin America: The Modern Era, 1820–1980*, Hayward Gallery, London, 1989. Arden Quin lives in Savigny-sur-Orge, near Paris.—E.F.

Luis Cruz Azaceta
Cuban-American, born 1942

Luis Salvador de Jesús Cruz Azaceta was born in Havana and moved to New York in 1960, a year after the Cuban Revolution succeeded. He started to draw and paint on his own in 1963. In 1969 he graduated from the School of Visual Arts in New York, where he had studied with Leon Golub. Azaceta began painting in a hard-edge abstract style, but abandoned this mode after traveling to Europe in 1969 and viewing the work of such artists as Hieronymus Bosch, Francisco Goya, and Francis Bacon. In New York in the early 1970s he began to paint in a figurative, expressionistic, and more visceral style. His subjects in this period included monstrous figures, automobile accidents, skeletal images, and scenes of urban violence. In the early and mid-1980s Azaceta emphasized the anxiety of urban life through harsh colors, energetic forms, and grotesque, anguished figures, often self-portraits. His recent work has concentrated on social issues; for example, he has expressed his concern with the AIDS crisis through images of figures in coffins set before fields of numbers representing body counts. Azaceta has also explored the sense of social, cultural, and psychological fragmentation he has experienced as a Cuban exile in the United States. His awards include National Endowment for the Arts Visual Arts Fellowships in 1980 and 1985, and a John Simon Guggenheim Memorial Foundation Fellowship in 1985. A one-person exhibition was held at the Queens Museum of Art, New York, 1991. His work has been included in *Hispanic Art in the United States: Thirty Contemporary Painters and Sculptors*, The Museum of Fine Arts, Houston, 1987; *Latin American Artists in New York since 1970*, Archer M. Huntington Art Gallery, University of Texas, Austin, 1987; *Art of the Fantastic: Latin America, 1920–1987*, Indianapolis Museum of Art, 1987; *Committed to Print: Social and Political Themes in Recent American Printed Art*, The Museum of Modern Art, New York, 1988; *The Decade Show: Frameworks of Identity in the 1980s*, Museum of Contemporary Hispanic Art, The New Museum of Contemporary Art, and The Studio Museum in Harlem, New York, 1990; and *Mito y magia en América: Los ochenta*, Museo de Arte Contemporáneo, Monterrey, 1991. Azaceta lives in New Orleans.—L.L.

Frida Baranek
Brazilian, born 1961

Frida Baranek was born in Rio de Janeiro. In 1983 she received a B.A. in architecture from the Universidade Santa Ursula, Rio de Janeiro. From 1982 to 1984 she studied sculpture with João Carlos

Goldberg and Tunga at the Escola do Museu de Arte Moderna and the Escola de Artes Visuais do Parque Lage, both in Rio de Janeiro. In 1984 and 1985 she attended the Parsons School of Design in New York. In her work Baranek combines references to Brazilian sculpture's Constructivist and Conceptual art traditions with a lively awareness of international developments. Her "air-drawings" are large-scale sculptural installations created through the expressive, gestural use of industrial materials such as rusted wire, steel, and stone; these works often seem to depict the aftermath of explosions. Baranek has had several one-person exhibitions at commercial galleries in Brazil. Her work has been included in *Panorama de escultura*, Museu de Arte Moderna, São Paulo, 1988; the 1989 São Paulo Bienal; the 1990 Venice Biennale; *Brasil: La nueva generación*, Fundación Museo de Bellas Artes, Caracas, 1991; and *Metropolis*, Martin-Gropius-Bau, Berlin, 1991. Baranek lives in Paris. —E.B.

Rafael Pérez Barradas
Uruguayan, 1890–1929

Rafael Pérez Barradas was born in Montevideo to Spanish immigrant parents; his father, Antonio, was a painter. As a teenager Barradas sketched in cafés and published caricatures in newspapers and magazines in Montevideo. The first exhibition of his paintings was held in 1910 at Casa Moretti, Catelli y Cía. Barradas helped found the satirical magazine *El Monigote* in 1913. He traveled to Italy, Switzerland, and France, meeting the Futurist Filippo Tommaso Marinetti in Milan, and in 1914 settled in Spain. Barradas was appointed art director of the weekly *Paraninfo* in Zaragoza the following year. He met Ignacio Zuloaga in 1915 and Joaquín Torres-García in Barcelona in 1916. He coined the term Vibracionismo (Vibrationism) for the style of his paintings of urban scenes, which synthesize elements of Futurism and Cubism; these paintings were first exhibited at the Galeries Dalmau in Barcelona in 1917. The artist moved in the following year to Madrid, where he illustrated children's books and drew comic strips. He began creating set and costume designs for the Teatro Eslava in 1920 and met the poet Federico García Lorca. In 1921 Barradas announced the inauguration of Clownismo, an ironic, farcical style from which he rapidly progressed to Fakirismo, then to Planismo, in which forms and figures are depicted in flat areas of color. He associated with the group of Ultraist writers and artists that included Norah and Jorge Luis Borges. In 1924 and 1925 Barradas contributed illustrations to the magazine *Revista de occidente*, edited by José Ortega y Gasset. He exhibited his theater designs at the 1925 *Exposition internationale des arts décoratifs et industriels modernes* in Paris. The next year he moved back to Catalonia, where, increasingly ill with tuberculosis, he painted views of the town of Hospitalet del Llobregat, mystical religious images, and Estampones, a series evoking the Montevideo of his youth. He

returned to Uruguay in 1928 and died within a few months. His one-person exhibitions include ones at the Galeries Dalmau, Barcelona, the Asociación Wagneriana, Buenos Aires, and the Ateneo de Montevideo, 1930; the Museo Nacional de Bellas Artes, Buenos Aires, 1960; and those at the Museo Nacional de Artes Visuales, Montevideo, and the Museo Nacional de Bellas Artes, Buenos Aires, 1972. Barradas's work was included in *The Latin-American Collection of The Museum of Modern Art*, The Museum of Modern Art, New York, 1943; the 1963 São Paulo Bienal; *Art of Latin America since Independence*, Yale University Art Gallery, New Haven, 1966; *Futurismo & futurismi*, Palazzo Grassi, Venice, 1986; and *Art in Latin America: The Modern Era, 1820–1980*, Hayward Gallery, London, 1989.—J.R.W.

Juan Bay
Argentine, 1892–1978

Juan Bay was born in Trenque Lauquen, Argentina. He moved to Italy in 1908 and studied painting and drawing in Milan until 1914. He first exhibited with the Italian Futurists in 1911 and remained actively involved with the group until 1920. Bay lived in Argentina from 1925 to 1929. In 1930 he became a member of Grupo del Milione in Milan and began writing art criticism for Argentine and European periodicals. He exhibited with the Futurists in the 1942 Venice Biennale and the 1943 Rome Cuadrienal. Bay returned to Argentina in 1949. Joining the Grupo Madí in 1954, he exhibited with them at the Galería Krayd in Buenos Aires. He rejected traditional conceptions of the frame and the convention of the rectangular field in his works of this period, which are highly abstract, brightly colored, wood reliefs featuring angular and curved shapes and cut-out spaces that expose the wall. These paintings frequently evoke movement, a typical Futurist concern. Bay's work was included in *La pintura y la cultura argentina de este siglo*, Museo Nacional de Bellas Artes, Buenos Aires, 1952; *Cincuenta años de pintura argentina*, Librería Viscontea, Buenos Aires, 1957; *Primera exposición internacional de arte moderno*, Museo de Arte Moderno, Buenos Aires, 1960; *Homenaje a la vanguardia argentina: Década del 40*, Galería Arte Nuevo de Buenos Aires, 1976; and *Art in Latin America: The Modern Era, 1820–1980*, Hayward Gallery, London, 1989.—E.F.

Jacques Bedel
Argentine, born 1947

Jacques Bedel, a sculptor, designer, and architect, was born in Buenos Aires. His father was a poet and art collector who transmitted his passion for literature and art to his son. Bedel attended the Facultad de Arquitectura y Urbanismo of the Universidad de Buenos Aires from 1965 to 1972. He received a fellowship from the French government in 1968 to travel to Paris, where he collaborated with the Groupe d'Art Constructif et Mouvement and made kinetic sculptures utilizing parabolic mirrors, perforated metals, and electricity. After abandoning kinetic art, Bedel created sculptures made of natural materials, such as stone and coal, and industrially processed ones like acrylic and stainless steel. He was a founder in 1971 of the Grupo CAYC (or Grupo de los Trece), originally an association of thirteen Argentine artists based at the Centro de Arte y Comunicación in Buenos Aires. Interested in producing socially committed art inspired by scientific, mathematical, and structuralist theories, Bedel and his colleagues played a critical role in the development of Systems art. They received the Prêmio Itamaraty, the Grand Prize of Honor, at the 1977 São Paulo Bienal. In 1974 Bedel was awarded a fellowship from the British Council to study new materials for sculpture. Since that time he has created sculptural books and scrolls made of polyester resin coated with iron and other metals; when opened, these sculptures reveal neither conventional texts nor illustrations but miniature three-dimensional pre-Columbian cities, archaeological ruins, and eroded landscapes. In 1980 Bedel received a Fulbright Fellowship to conduct research on a project titled *The Memory of Mankind* at the National Astronomy and Ionosphere Center, Cornell University, Ithaca, New York, and the National Aeronautics and Space Administration, Washington, D.C. The project, whose purpose was to produce indestructible books and scrolls inscribed in English and a universal mathematical language that would permit transmission of knowledge to future generations, was interrupted by the Falklands War. In addition to books and scrolls, Bedel has created spheres and missile-like obelisks that reflect an intellectualized approach to art yet are mythical, magical, and poetic. Bedel's one-person exhibitions include those organized by the Centro de Arte y Comunicación, Buenos Aires, 1977, and the Museo de Arte Americano, Maldonado, Uruguay, 1984. He participated in the 1979 São Paulo Bienal, the 1986 Venice Biennale, and the 1991 Havana Bienal. Bedel lives in Buenos Aires.—J.A.F.

José Bedia
Cuban, born 1959

Born and educated in Havana, José Bedia Valdés graduated in 1976 from the Escuela de Artes Plásticas San Alejandro, and in 1981 from the Instituto Superior de Arte, where he was trained primarily in the Western artistic tradition. Later that year he participated in *Volumen I*, a controversial seminal exhibition that signaled the emergence of a new artistic vanguard in Cuba. Since the early 1980s Bedia has created drawings, paintings, and installations that reflect an anticolonialist perspective and manifest his interest in the indigenous cultures of Africa and the Americas and the hybrid cultures of Cuba. In 1985 he was artist-in-residence at the State University of New York, College at Old Westbury. Later that year he lived on the Rosebud reservation of the Dakota Sioux, from whom he adopted his characteristic style of outline drawing. After returning to Cuba, José Bedia was increasingly influenced by Santería, an Afro-Cuban syncretic religion. His group exhibitions include the 1984, 1986, and 1989 Havana Bienales; the 1987 São Paulo Bienal; *Art of the Fantastic: Latin America, 1920–1987*, Indianapolis Museum of Art, 1987; *Magiciens de la terre*, Musée National d'Art Moderne, Centre Georges Pompidou, Paris, 1989; the 1990 Venice Biennale; *Mito y magia en América: Los ochenta*, Museo de Arte Contemporáneo, Monterrey, 1991; *El corazón sangrante/ The Bleeding Heart*, Institute of Contemporary Art, Boston, 1991; and *America: Bride of the Sun*, Koninklijk Museum voor Schone Kunsten, Antwerp, 1992. Bedia lives in Mexico City.—J.A.F.

Luis F. Benedit
Argentine, born 1937

Luis Fernando Benedit, born in Buenos Aires, received a degree in architecture from the Universidad Nacional de Buenos Aires in 1963. In the late 1950s and early 1960s, he made paintings of animals, fantasy personages, and other subjects. Having received a fellowship from the Italian government in 1966, Benedit traveled to Italy to study landscape architecture. Influenced in part by cybernetics and social anthropology, he exhibited in several art institutions, from 1967 to 1976, a series of habitats and labyrinths that resembled zoological and botanical experiments. The placement of fish, insects, small mammals, and plants in controlled environments provided insight into the dynamics of social behavior. Benedit's best-known installation of this period was the *Biotrón*, a large plexiglass cage filled with 4,000 live bees given the option of feeding from a natural environment (a garden) or an artificial one (twenty-five "automatic" flowers). In 1971 Benedit became a founding member of the Grupo CAYC, also known as the Grupo de los Trece, an association of Argentine artists, based at the Centro de Arte y Comunicación in Buenos Aires, who played a crucial role in the development of Systems art. In the mid-1970s he created drawings and objects that explore the same issues as his installations, especially the relationship between the natural and the artificial. In the late 1970s Benedit playfully transformed drawings of King Kong and other subjects made by his son Tomás into sculptures and paintings. A decade later he created a series of watercolors, many of which incorporate objects inspired by Charles Darwin's voyage to South America. Benedit's one-person exhibitions include *Projects: Luis Fernando Benedit*, The Museum of Modern Art, New York, 1972; and those at the Whitechapel Art Gallery, London, 1975; the Museum of Contemporary Art, Los Angeles, 1981; the Center for Inter-American Relations, New York, 1981; and the Fundación San Telmo, Buenos Aires, 1988. His work has been included in several São Paulo Bienals; the 1970 and 1986 Venice Biennales; *U-ABC*, Stedelijk Museum, Amsterdam, 1989; and *Art in*

Latin America: The Modern Era, 1820–1980, Hayward Gallery, London, 1989. Benedit lives in Buenos Aires.—J.A.F.

Antonio Berni
Argentine, 1905–1981

Antonio Berni was born in Rosario, Argentina. His father was an Italian immigrant tailor, his mother was a native of Argentina's Santa Fe province. Berni first studied drawing in 1916 at the Centro Catalán in Rosario, while apprenticing in a stained-glass workshop. His first exhibition, in 1921, included paintings in a Post-Impressionist style. In 1925 Berni received a scholarship to study painting in Europe, which the government of Santa Fe renewed for a two-year period. After visiting Madrid he moved to Paris, where he studied with André Lhote and Othon Friesz. During this period he became interested in political causes and leftist ideology. In the late 1920s Berni created paintings, collages, and photomontages influenced by Surrealism; he also began to read Freud and Marx. He returned to Argentina in 1931, but his exhibition of Surrealist-inspired works in Buenos Aires a year later was coldly received by critics. Briefly a member of the Communist Party, Berni was a founder of the Nuevo Realismo group in 1932. He subsequently began to create easel paintings and murals in a social-realist style. In 1933 Berni collaborated with David Alfaro Siqueiros and others on Ejercicio plástico, a mural in the home of Natalio Botana near Buenos Aires. From about 1935 to 1945 he taught at the Escuela de Bellas Artes, Buenos Aires. With Lino Enea Spilimbergo, Berni painted murals for the Argentine Pavilion at the 1939 New York World's Fair. Invited by the Comisión Nacional de Cultura to study pre-Columbian art, he traveled along the Pacific coast of the Americas in 1941 and subsequently made a series of works inspired by Indian cultures. Although he abandoned social realism in the 1950s, Berni continued to produce figurative work that addresses social and political themes. In 1958 he began a narrative series of prints, collages, and assemblages based on the fictional character Juanito Laguna, a boy of the slums; he created a similar series around another character, the prostitute Ramona Montiel, in 1963. Utilizing urban refuse to evoke the impoverished environment of Buenos Aires's rapidly growing industrial districts, Berni worked on these series until his death. He achieved international recognition after winning the Grand Prize for Printmaking at the 1962 Venice Biennale. Among his one-person exhibitions were ones at the Musée d'Art Moderne de la Ville de Paris, 1972, and the Museo Nacional de Bellas Artes, Buenos Aires, 1984. His work was included in The Latin-American Collection of The Museum of Modern Art, The Museum of Modern Art, New York, 1943; Art of Latin America since Independence, Yale University Art Gallery, New Haven, 1966; The Latin American Spirit: Art and Artists in the United States, 1920–1970, The Bronx Museum of the Arts, New York, 1988; and Art in

Latin America: The Modern Era, 1820–1980, Hayward Gallery, London, 1989.—J.A.F.

Martín Blaszko
Argentine, born 1920

Martín Blaszko was born in Berlin. In 1933 his family emigrated to Poland, where he studied drawing with Henryk Barczynski. In 1938 he studied with Jankel Adler in Danzig and visited Paris, where he met Marc Chagall. Blaszko moved to Argentina in 1939 and studied drawing and painting there. He met Carmelo Arden Quin in 1945, joined him as a founding member of the Grupo Madí in 1946, and participated in the first Madí exhibitions. In 1947 he and Arden Quin broke with the group. During the 1940s Blaszko created and exhibited abstract geometric paintings, but after 1947 he concentrated on three-dimensional work, producing sculptures in the form of columns, towers, and other vertical and monolithic shapes. His wood sculptures, such as Madí Column, 1947, merge geometric and organic forms and, although basically abstract, also refer to the body. Blaszko developed a theory of bipolarity, and his art reflects the kinds of opposing forces that he found inherent in nature. His Monument to the Unknown Political Prisoner received an award from The Institute of Contemporary Arts, London, in 1952, and was exhibited at The Tate Gallery that year. Blaszko's abstract bronze sculptures of the later 1950s and the 1960s feature long, angular forms intersecting in space. Works in bronze and cement from the 1960s and 1970s contain dense, irregular forms evoking architecture and human figures. In the 1970s Blaszko published essays on the social responsibility of artists. He participated in the 1952 and 1988 São Paulo Bienals and the 1956 Venice Biennale, and in 1958 he exhibited in the Argentine pavilion at the International Exposition in Brussels. His work has been included in Vanguardias de la década del 40, Museo de Artes Plásticas Eduardo Sívori, Buenos Aires, 1980. Blaszko lives in Buenos Aires.—E.F.

Jacobo Borges
Venezuelan, born 1931

Jacobo Borges was born in Caracas into a poor family living in Catia, on the outskirts of the city. He took classes for children taught by César Enriquez and Alejandro Otero at the Escuela de Artes Plásticas and studied printmaking with Pedro Angel González. Borges attended the Escuela de Artes Plásticas y Aplicadas "Cristóbal Rojas" in Caracas from 1949 to 1951. At the same time he drew a comic strip and worked at McCann-Erickson Advertising, where he met Carlos Cruz-Diez. While a student, Borges visited the reclusive Venezuelan painter Armando Reverón in Macuto and met the exiled Cuban poet Alejo Carpentier. Expelled from school for leading a student strike, he worked briefly in the Taller Libre de Arte. He lived in Paris from 1952 to 1956, creating Cubist-

inspired paintings with flat patches of bright colors and a lively sense of pictorial movement. He associated with Tabla Redonda and El Techo de la Ballena, two literary and artistic groups active in Caracas in the early 1960s. During this time he depicted grotesque figures in thickly impastoed expressionistic canvases that have grim and often violent overtones. Borges stopped painting for five years, beginning in 1965. He created set designs for a production of Carlos Muñiz's El Tintero, and from 1966 to 1968 he collaborated with filmmakers and other artists on an audiovisual production, Imagen de Caracas. The artist received a John Simon Guggenheim Memorial Foundation Fellowship in 1985 and spent a year in New York. His one-person exhibitions include ones at the Fundación Museo de Bellas Artes, Caracas, 1956; the Museo de Arte Moderno, Mexico City, and the Galería de Arte Nacional, Caracas, 1976; the Galería de Arte Nacional, Caracas, 1981; and the Museo de Monterrey, Mexico, and the Museo de Arte Contemporáneo, Caracas, 1987. His work has been represented in the Salon des Jeunes Artistes at the Musée d'Art Moderne de la Ville de Paris, 1952; the 1957 São Paulo Bienal; the 1958 and 1988 Venice Biennales; The Emergent Decade: Latin American Painters and Painting in the 1960s, Cornell University, Ithaca, New York, and the Solomon R. Guggenheim Museum, New York, 1965; Art of the Fantastic: Latin America, 1920–1987, Indianapolis Museum of Art, 1987; The Latin American Spirit: Art and Artists in the United States, 1920–1970, The Bronx Museum of the Arts, New York, 1988; and Art in Latin America: The Modern Era, 1820–1980, Hayward Gallery, London, 1989. Borges lives in Caracas.—J.R.W.

Fernando Botero
Colombian, born 1932

Fernando Botero was born in Medellín, Colombia. When he was twelve his uncle enrolled him in bullfighting school, where he sketched the animals and the arena. He began working as an illustrator for the Medellín newspaper El Colombiano in 1948. He was expelled from his Jesuit secondary school as a result of his published article on nonconformity in the art of Picasso. Botero's expressionistic watercolors of the late 1940s display the influence of José Clemente Orozco and other Mexican muralists. The artist moved to Bogotá in 1951. In 1952 he traveled to Europe, studying at the Real Academia de Bellas Artes de San Fernando in Madrid and at the Accademia San Marco in Florence; he also attended Roberto Longhi's lectures on Renaissance art at the Universitá degli Studi di Firenze. Botero returned to Bogotá in 1955; his new work, exhibited at the Biblioteca Nacional de Colombia, was poorly received. He moved to Mexico City the next year and met Rufino Tamayo and José Luis Cuevas. His work of this time shows the influence of the School of Paris, especially Georges Braque; by the late 1950s it employs the gestural

effects of Abstract Expressionism. Botero taught at the Escuela de Bellas Artes at the Universidad Nacional in Bogotá from 1958 to 1960, when he moved to New York, where he met Willem de Kooning, Franz Kline, Mark Rothko, and Red Grooms. By the mid-1960s Botero had developed a distinctive style in which figures, objects, and even landscapes appear balloonlike and inflated. His paintings reflect small-town Colombian life and satirize politicians, clerics, military men, and their families. His techniques and compositions recall the old masters and religious painting. Botero moved to Paris in 1973 and began to produce bronze, marble, and cast-resin sculptures portraying rotund and swollen figures, animals, and still lifes. Botero's one-person exhibitions include ones at the Pan American Union, Washington, D.C., 1957; the Staatliche Kunsthalle, Baden-Baden, and the Milwaukee Art Museum, 1966; the Center for Inter-American Relations, New York, 1969; the Staatliche Kunsthalle, Baden-Baden, 1970; the Museum Boymans–van Beuningen, Rotterdam, 1975; the Museo de Arte de Medellín, 1976; the Museo de Arte Contemporáneo, Caracas, 1977; the Hirshhorn Museum and Sculpture Garden, Smithsonian Institution, Washington, D.C., 1979; the Museo Nacional Centro de Arte Reina Sofía, Madrid, 1987; the Museo de Arte Contemporáneo, Caracas, and the Museo Rufino Tamayo, Mexico City, 1989; and the Galerie Didier Imbert and the City of Paris, 1992. His work was included in the 1959 São Paulo Bienal; *The Emergent Decade: Latin American Painters and Painting in the 1960s*, Cornell University, Ithaca, New York, and the Solomon R. Guggenheim Museum, New York, 1965; *Art of Latin America since Independence*, Yale University Art Gallery, New Haven, 1966; *Art of the Fantastic: Latin America, 1920–1987*, Indianapolis Museum of Art, 1987; *The Latin American Spirit: Art and Artists in the United States, 1920–1970*, The Bronx Museum of the Arts, New York, 1988; and *Art in Latin America: The Modern Era, 1820–1980*, Hayward Gallery, London, 1989. Botero lives in Paris, New York, Bogotá, and Pietrasanta, Italy.—J.R.W.

Waltercio Caldas
Brazilian, born 1946

Waltercio Caldas was born in Rio de Janeiro, where he studied in 1964 and 1965 with Ivan Serpa at the Escola do Museu de Arte Moderna. In 1968 he became interested in printmaking and, despite his focus on sculpture, has continued to work in that medium. His early work, influenced by the Pop and Conceptual art movements, questioned the nature and form of art and language. In 1975, with José Resende, Cildo Meireles, and other young artists, Caldas founded the alternative art journal *Malasartes*. In 1980 he edited another journal, *A parte do fogo*, with a group that included many of the same artists. From 1975 to 1981 Caldas created several series of Minimalist-Conceptual sculptures, including *Devices*, 1979, and *Zero and One*, 1980. From 1985 to 1989 he produced a series of small, machinelike objects. Caldas's most recent Minimalist sculptures emphasize the poetic richness of materials by stressing such contrasting qualities as light and shadow, form and absence. A founder of the Brazilian Association of Professional Visual Artists, Caldas teaches at the Instituto Villa-Lobos, Rio de Janeiro. His one-person exhibitions of his work include those at the Museu de Arte Moderna, Rio de Janeiro, 1973 and 1976, and the Museu de Arte de São Paulo, 1975. His work has been included in the 1983 São Paulo Bienal; *Abstract Attitudes: Caldas/Katz/Salcedo*, Museum of Art, Rhode Island School of Design, Providence, and Center for Inter-American Relations, New York, 1984; *Modernidade: Art brésilien du 20ᵉ siècle*, Musée d'Art Moderne de la Ville de Paris, 1987; *America: Bride of the Sun*, Koninklijk Museum voor Schone Kunsten, Antwerp, 1992; and Documenta 9, Kassel, 1992. Caldas lives in Rio de Janeiro.—E.B.

Sérgio Camargo
Brazilian, 1930–1990

Sérgio Camargo was born in Rio de Janeiro to a Brazilian father and an Argentine mother. In 1946 he entered the Academia Altamira in Buenos Aires, where he studied with Emilio Pettoruti and Lucio Fontana. While in Buenos Aires, Camargo became especially interested in Argentine Constructivism. From 1948 to 1953 he studied philosophy at the Sorbonne and traveled throughout Europe. He was particularly impressed by the works of Constantin Brancusi, Georges Vantongerloo, Jean (Hans) Arp, and Henri Laurens. Camargo lived in Brazil from 1953 until 1960, when he returned to Paris. Although he was familiar with the Brazilian Constructivists, particularly those associated with the neo-Concrete movement, he did not adhere to any specific group. Inspired by Laurens, his figurative work of the 1950s demonstrates a strong interest in the formal development of volume and space. In the 1960s he abandoned figuration and began to explore plane-volume relationships in a series of geometric wood reliefs. While Camargo never considered himself a kinetic artist, his work of this period shared aesthetic concerns with that of Latin-American kinetic artists then living in Paris, including Carlos Cruz-Diez and Jesús Rafael Soto. In 1965 Camargo began work on a sculptural wall for Oscar Niemeyer's Foreign Ministry building in Brasília. In 1974 he moved back to Rio de Janeiro. His late work comprises three-dimensional volume studies in white and black marble that reflect the influence of Arp, Laurens, and Brancusi. His one-person exhibitions include ones at the Museo de Arte Moderno, Mexico City, 1974; the Museu de Arte Moderna, Rio de Janeiro, 1975; and the Museu de Arte, São Paulo, 1980. Camargo's sculpture was represented in the 1955 and 1957 São Paulo Bienals; the 1963 Paris Biennale (International Sculpture Award); the 1965 São Paulo Bienal (Best National Sculptor Award); *The Emergent Decade: Latin American Painters and Paint-ing in the 1960s*, Cornell University, Ithaca, New York, and the Solomon R. Guggenheim Museum, New York, 1965; *Lumière et mouvement*, Musée d'Art Moderne de la Ville de Paris, 1967; Documenta 4, Kassel, 1968; the 1982 Venice Biennale; *Modernidade: Art brésilien du 20ᵉ siècle*, Musée d'Art Moderne de la Ville de Paris, 1987; *Art in Latin America: The Modern Era, 1820–1980*, Hayward Gallery, London, 1989; and *Bilderwelt Brasilien: Die europäische Erkundung eines "irdischen Paradieses" und die Kunst der brasilianischen Moderne*, Kunsthaus Zürich, 1992.—T.C.

Luis Camnitzer
Uruguayan, born 1937

Luis Camnitzer was born in Lübeck, Germany, into a Jewish family that fled to Uruguay in 1939. A student of art and architecture at the Universidad de Uruguay in Montevideo from 1953 to 1957 and from 1959 to 1962, Camnitzer received in 1957 a fellowship to study art for a year at the Akademie der Bildenden Künste, Munich. Awarded a John Simon Guggenheim Memorial Foundation Fellowship to study printmaking, he worked in New York in 1962. He went to Uruguay in 1963 but returned to the United States a year later. In 1965, with Liliana Porter and José Guillermo Castillo, Camnitzer founded the New York Graphic Workshop and developed the concept of FANDSO (Free Assemblage, Nonfunctional, Disposable, Serial Object). In the late 1960s he produced his first textual works, which included a series of mail-art pieces, adhesive labels, and etchings, and became a leading figure in the Conceptual art movement. In 1969 and 1970 he created installations on the theme of repression in Latin America. Camnitzer began to create work of a more general political character in the early 1970s. Utilizing texts, images, and occasionally objects, these works questioned traditional conceptions of the artist by encouraging the spectator to assume an active role in the production of meaning. Since the early 1980s when he resumed addressing specific issues, Camnitzer has produced several series of prints and installations about such subjects as colonialism, torture, and environmental destruction. A professor of art at the State University of New York, College at Old Westbury, where he has taught since 1969, Camnitzer has written prolifically on contemporary art. He received another John Simon Guggenheim Memorial Foundation Fellowship in 1982. His one-person exhibitions include ones organized by the Museo de Arte Moderno, Bogotá, 1977; the Museo Nacional de Artes Visuales, Montevideo, 1986; and the Lehman College Art Gallery, Bronx, New York, 1991. Camnitzer has participated in numerous biennials, including the 1984, 1986, and 1991 Havana Bienales and the 1988 Venice Biennale. His work was included in *Information*, The Museum of Modern Art, New York, 1970; *Latin American Artists in New York since 1970*, Archer M. Huntington Art Gallery, The University of Texas, Austin, 1987; *The Latin American Spirit: Art and Artists in the United*

States, 1920–1970, The Bronx Museum of the Arts, New York, 1988; *Committed to Print: Social and Political Themes in Recent American Printed Art*, The Museum of Modern Art, New York, 1988; *Encounters/Displacements: Luis Camnitzer, Alfredo Jaar, Cildo Meireles*, Archer M. Huntington Art Gallery, The University of Texas, Austin, 1992; and *America: Bride of the Sun*, Koninklijk Museum voor Schone Kunsten, Antwerp, 1992. Camnitzer lives in Great Neck, New York.—J.A.F.

Agustín Cárdenas
Cuban, born 1927

Agustín Cárdenas was born into an Afro-Cuban family in Matanzas, Cuba. They moved to Havana in 1933, and as a teenager Cárdenas worked in his father's tailor shop and attended art classes at night. From 1943 to 1949 he studied at the Academia Nacional de Bellas Artes San Alejandro in Havana under Juan José Sicre (a former student of Emile-Antoine Bourdelle), who introduced Cárdenas to the work of Jean (Hans) Arp, Constantin Brancusi, and Henry Moore. The modeled academic figures that Cárdenas made while a student were succeeded by curvilinear abstractions created by direct cutting in wood and stone. In 1951 he helped found the Grupo de los Once, an association in favor of modernist art. Working as Sicre's assistant in the early 1950s, he began creating vertical and angular totems inspired by the forms and spiritual content of African art, especially Dogon sculpture. In 1955 he was given a one-person exhibition at the Palacio de Bellas Artes, Havana, to which he donated much of his work before moving to Paris. There he associated with André Breton and the Surrealists and exhibited with the Réalités Nouvelles group from the late 1950s to the mid-1960s. Cárdenas created large carved stone sculptures in Saint Margarethen, Austria, in 1961 and in Mitzee Roman, Israel, the next year. He began to spend summers in Carrara, Italy, in 1963. In the mid-1960s the artist produced a series of black-and-white painted-wood sculptures. He visited Cuba in 1967 and a year later moved to Meudon, outside Paris. One-person exhibitions of his work have been presented by the Musée Galliera, Paris, 1972; the Fondation Nationale des Arts Graphiques et Plastiques, Paris, 1981; and the Fundación Museo de Bellas Artes, Caracas, 1982. Cárdenas lives in Meudon, France.—J.R.W.

Santiago Cárdenas
Colombian, born 1937

Santiago Cárdenas Arroyo was born in Bogotá. Raised in the United States, he studied painting with Robert Hamilton and Gordon Peers at the Rhode Island School of Design in Providence, earning a B.F.A. in 1960. Cárdenas traveled in Europe from 1960 to 1962 while serving with the United States armed forces. He then studied with Al Held, Alex Katz, and Jack Tworkov at the Yale University School of Art and Architecture, New Haven, from

which he received an M.F.A. in painting in 1965. The "flat" style of his paintings of the mid-1960s, which depict scenes of everyday life and common objects, reflects the influence of Katz. Cárdenas returned to Bogotá in 1965 and began teaching painting at the Universidad de los Andes, the Universidad Jorge Tadeo Lozano, and the Escuela de Bellas Artes, Universidad Nacional de Colombia; he served as the director of the latter school from 1972 to 1974. Cárdenas's highly realistic later work concentrates on the portrayal of such common things as coat hangers, electrical cords, Venetian blinds, and blackboards. Although his fascination with the mundane and his realistic mode of painting have led many critics to align him with the Pop art movement, he stresses the physicality of the objects he depicts rather than the social or cultural references they may evoke. He has had one-person exhibitions at the Center for Inter-American Relations, New York, 1973; the 1977 São Paulo Bienal; the Museo de Arte Moderno, La Tertulia, Cali, 1982; and the Frances Wolfson Art Gallery, Miami-Dade Community College, Wolfson Campus, Miami, 1983. Cárdenas's work has been included in *Realism and Latin American Painting: The 70s*, Center for Inter-American Relations, New York, 1980; the 1981 Medellín Bienal; *The Latin American Spirit: Art and Artists in the United States, 1920–1970*, The Bronx Museum of the Arts, New York, 1988; *Art in Latin America: The Modern Era, 1820–1980*, Hayward Gallery, London, 1989; and the 1990 Venice Biennale. Cárdenas lives in Bogotá.—L.B.

Leda Catunda
Brazilian, born 1961

Leda Catunda was born in São Paulo and studied at the Fundaçao Armando Alvares Penteado there from 1980 to 1985. She has created work that breaks with Brazil's neo-Concrete and Conceptual traditions through the use of kitsch, humor, and irony. Catunda is currently making work assembled from textile scraps and such common found objects or materials as shower curtains, tablecloths, and velour, which are used as supports for the application of collage elements and paint. The subjects of these works reflect a comic, intentionally unsophisticated, and personal iconography. The Museu de Arte, Pôrto Alegre, organized a one-person exhibition of her work, *Espaço Investigação*, in 1986. Catunda's work has been included in the 1983 and 1985 São Paulo Bienals; the 1984 Havana Bienal; *Today's Art of Brazil*, Hara Museum of Contemporary Art, Tokyo, 1985; *Modernidade: Art brésilien du 20ᵉ siècle*, Musée d'Art Moderne de la Ville de Paris, 1987; *U-ABC*, Stedelijk Museum, Amsterdam, 1989; and *Mito y magia en América: Los ochenta*, Museo de Arte Contemporáneo, Monterrey, 1991. Catunda lives in São Paulo.—E.B.

Emiliano di Cavalcanti
Brazilian, 1897–1976

Emiliano Augusto di Cavalcanti de Albuquerque e Melo was born in Rio de Janeiro. Di Cavalcanti, who studied law before devoting himself to art, began his artistic career as an illustrator for various periodicals. In 1917 he held a one-person exhibition of his caricatures at the offices of the magazine *A Cigarra*. He was a key organizer of the 1922 *Semana de arte moderna*, an influential series of cultural events that introduced European modernism to Brazil. While living in Paris from 1923 to 1925, he became interested in Cubism and met Pablo Picasso, Jean Cocteau, and Fernand Léger. He also traveled to Italy and Germany and was impressed by *Neue Sachlichkeit* painting. After his return to São Paulo he concentrated on developing a specifically Brazilian form of modernism. In 1928 he joined the Communist Party. He participated in the exhibition of Brazilian art at the Roerich Museum International Art Center, New York, in 1930. In 1932 he founded the Clube dos Artistas Modernos along with Flávio de Carvalho and other avant-garde artists and intellectuals in São Paulo. During this period he used caricatured figures and lively colors to create often humorous narratives of everyday Brazilian life. His paintings also reflect political concerns: the series A Realidade Brasileira of 1933 satirized the military. He went to Europe in 1935 and lived principally in France and Spain from 1937 to 1940. Returning to Brazil, he continued to employ in his work Brazilian themes. In 1948, at the Museu de Arte de São Paulo, he lectured on the importance of a nationalist art and criticized abstract movements. During the 1950s his style was heavily influenced by Picasso, in contrast to the predominantly nonobjective styles followed by his contemporaries. In 1955 he published his autobiography, *Viagem da minha vida: Testamento da alvorada* (My Life's Journey: Dawn Testament), and in 1964 he published *Reminiscências líricas de um perfeito carioca* (Lyric Reminiscences of a Perfect Carioca), which was also autobiographical. His one-person exhibitions include ones at the Museu de Arte Moderna, Rio de Janeiro, 1954; the Museu de Arte Contemporânea da Universidade de São Paulo, 1964, 1976, and 1985; and the Museu de Arte Moderna, São Paulo, 1971. Di Cavalcanti's work was represented in the 1951, 1953, 1963, and 1969 São Paulo Bienals; *Art of Latin America since Independence*, Yale University Art Gallery, New Haven, 1966; *Tradição e ruptura*, Bienal Foundation, São Paulo, 1984; *Modernidade: Art brésilien de 20ᵉ siècle*, Musée d'Art Moderne de la Ville de Paris, 1987; *Art in Latin America: The Modern Era, 1820–1980*, Hayward Gallery, London, 1989; and *Bilderwelt Brasilien: Die europäische Erkundung eines "irdischen Paradieses" und die Kunst der brasilianischen Moderne*, Kunsthaus Zürich, 1992.—T.C.

Lygia Clark
Brazilian, 1920–1988

Lygia Clark was born in Belo Horizonte, Minas Gerais, Brazil. She began studying landscape architecture with Roberto Burle Marx in Rio de Janeiro at age twenty-seven. From 1950 to 1952 she lived in Paris and studied with Arpad Szènes and Fernand Léger. In 1954 Clark joined the Grupo Frente, which instigated the neo-Concrete movement in Rio de Janeiro. Her home became one of the centers for Grupo Frente meetings, which were attended by artists and critics such as Hélio Oiticica, Lygia Pape, Ivan Serpa, and Mário Pedrosa. Between 1954 and 1958 Clark made a series of Constructivist-influenced paintings that highlight the differences between real and pictorial space and give special attention to the relationship of the picture plane to the frame. In 1959, together with Oiticica and other Constructivists in Rio de Janeiro, Clark signed the "Neo-Concrete Manifesto." From 1960 to 1963 she produced a series of objects titled Bichos (Animals) that could be manipulated by the spectator, reflecting her desire to bring art into life. In the mid-1960s Clark created a series of events and performances that physically engaged the audience through tactile experiences. She taught at the Sorbonne, Université de Paris, from 1970 to 1975. In the 1970s she became increasingly interested in the therapeutic possibilities of art; her interactive work, although incorporating some features of Happenings and performances, was an attempt to meld art and psychotherapy. Clark's later work is characterized by its anti-mechanical, biological character. After 1978 Clark dedicated herself solely to her psychoanalytic practice. Her first important exhibition of abstract paintings was at the Ministério da Educação e Cultura, Rio de Janeiro, 1952; other one-person exhibitions include those at the Paço Imperial do Rio de Janeiro, with Hélio Oiticica, 1986, and the Museu de Arte Contemporânea da Universidade de São Paulo, 1987. Her work was included in the 1953, 1955, 1957, 1959, 1961, 1963, and 1967 São Paulo Bienals; the *I exposição nacional de arte concreta*, Rio de Janeiro, 1957; *Konkrete Kunst: Fünfzig Jahre Entwicklung*, Helmhaus, Zurich, 1960; the 1960, 1962, and 1968 (individual gallery) Venice Biennales; *Art of Latin America since Independence*, Yale University Art Gallery, New Haven, 1966; *Modernidade: Art brésilien du 20ᵉ siècle*, Musée d'Art Moderne de la Ville de Paris, 1987; and *Art in Latin America: The Modern Era, 1820–1980*, Hayward Gallery, London, 1989. —T.C.

Carlos Cruz-Diez
Venezuelan, born 1923

Carlos Eduardo Cruz-Diez was born in Caracas. He began to draw and paint while recuperating from a childhood skating accident. His classmates at the Escuela de Artes Plásticas, Caracas, where he studied from 1940 to 1945, included Jesús Rafael Soto and Alejandro Otero. Cruz-Diez worked as a graphic designer for the Creole Petroleum Corporation from 1944 to 1955 and as a creative director for McCann-Erickson Advertising from 1946 to 1951; he traveled to New York to study advertising techniques in 1947. From 1953 to 1955 he taught at the Escuela de Artes Plásticas and worked as an illustrator for the newspaper *El Nacional*. In 1955 the artist moved to Barcelona. Impressed by Soto's work, seen on a brief trip to Paris, Cruz-Diez began to study the physical properties of color. He returned to Caracas in 1957 and opened a graphic art and industrial design studio, Estudio de Artes Visuales. He was appointed assistant director of the Escuela de Artes Plásticas the next year. In 1959 he began his series Fisicromías, panels transversed by narrow strips that modulate the color of the paintings, depending on the movement of the viewer and the quality of the ambient light. He moved to Paris in 1960. Cruz-Diez presented his theories about color in *Reflexión sobre el color*, published in 1989. His numerous public architectural projects in Venezuela include Ambientaciones Cromáticas at the José Antonio Páez power plant, Santo Domingo, completed 1973; the Simón Bolívar International Airport, Caracas, 1974–78; and Guri Dam, 1977–86. Outdoor double-sided Fisicromías were installed in the Place du Venezuela, Paris, 1975–78; in the Olympic Sculpture Park, Seoul, South Korea, 1988; and in the Parque Olivar de la Hinojosa, Madrid, 1991. His one-person exhibitions include ones at the Museo de Arte Moderno, Bogotá, 1975 and 1985; the Museo de Arte Moderno, Mexico City, 1976; and the Museo de Arte Contemporáneo, Caracas, 1981. His work has been included in *The Responsive Eye*, The Museum of Modern Art, New York, 1965; the 1967 São Paulo Bienal; the 1970 and 1986 Venice Biennales; *The Latin American Spirit: Art and Artists in the United States, 1920–1970*, The Bronx Museum of the Arts, New York, 1988; and *Art in Latin America: The Modern Era, 1920–1980*, Hayward Gallery, London, 1989. Cruz-Diez lives in Paris and Caracas.—J.R.W.

José Luis Cuevas
Mexican, born 1934

José Luis Cuevas was born in Mexico City. Raised in an apartment above his grandfather's paper factory, he began to draw on scraps of paper at the age of five. Cuevas is essentially self-taught. By the age of fourteen, he had illustrated numerous periodicals and books and had had his first exhibition in Mexico City. His works, predominantly in pen and ink, were influenced by the graphic art of Francisco Goya, Pablo Picasso, and José Clemente Orozco. Cuevas populated his drawings with grotesque and destitute characters and emphasized bodily distortion and mental anguish. In 1953 Cuevas published "La cortina del nopal" ("The Cactus Curtain"), an article condemning the propagandistic nature of the Mexican Mural Movement and advocating greater artistic freedom. This philosophy inspired the founding in 1960 of the group Nueva Presencia, which he joined for a brief time. It promoted individual expression and figurative art reflecting the contemporary human condition. Cuevas published numerous illustrated books and graphic series on personal, social, and historical themes; he also designed costumes and sets for the theater. Cuevas was awarded the National Prize for Fine Arts in Mexico in 1981. In 1992 the Museo José Luis Cuevas was inaugurated in Mexico City. His one-person exhibitions include ones at the Pan American Union, Washington, D.C., 1954 and 1963; the Fort Worth Art Center, 1960; the Museo de Arte Moderno, Mexico City, 1972, 1976, 1979, and 1985; the Musée d'Art Moderne de la Ville de Paris, 1976; the Musée de Beaux-Arts, Chartres, 1977; the Museum Ludwig, Cologne, 1978; and the Museo de Monterrey, Mexico, 1980. Cuevas's work has been included in the 1955, 1959, and 1975 São Paulo Bienals; *The Emergent Decade: Latin American Painters and Painting in the 1960s*, Cornell University, Ithaca, New York, and the Solomon R. Guggenheim Museum, New York, 1965; the 1982 Venice Biennale; *Imagen de Mexico: Der Beitrag Mexikos zur Kunst des 20. Jahrhunderts*, Schirn Kunsthalle Frankfurt, 1987; *The Latin American Spirit: Art and Artists in the United States, 1920–1970*, The Bronx Museum of the Arts, New York, 1988; and *Ruptura: 1952–1965*, Museo de Arte Alvar y Carmen T. de Carrillo Gil, Mexico City, 1988. Cuevas lives in New York, Paris, and Mexico City.—R.O.

José Cúneo
Uruguayan, 1887–1977

José Cúneo Perinetti, born in Montevideo, began to study art with Angel Luis Cattáneo in 1905, and the next year enrolled at the Círculo de Bellas Artes and studied under Carlos María Herrera and Felipe Menini. Cúneo traveled to Europe in 1907. He settled in Milan and frequented the studios of the sculptor Leonardo Bistolfi and the painter Anton Mucci. After visiting Paris in 1909, he returned to Montevideo, where he exhibited a series of paintings of Italian and European locations in a Post-Impressionist style. He traveled to Europe again in 1911. In Italy he became aware of Futurism and studied in Paris at the Académie Vitti with Hermen Anglada-Camarasa and Kees van Dongen. Returning to Uruguay in 1914, Cúneo devised an approach to landscape painting that features impasto and broad planes of strong color; he concentrated on local landscapes as subjects for his paintings. In the 1920s Cúneo was influenced by the expressive deformations and perspective in the work of Chaim Soutine. He exhibited a series of landscapes, completed at Cagnes in southern France, at the Galeria Zak, Paris, in 1930. Expressionistic landscapes of the Ranchos series of the late 1920s and the 1930s feature unusually high or low horizon lines, leaning buildings, a dark palette, and impasto. Works from the Luna series of the 1930s to the 1950s portray unnaturally large, brilliant

moons hovering over eerie nocturnal landscapes. In the 1950s Cúneo turned to a more abstract consideration of landscape in his series Lago de Iseo. A stay in Amsterdam, from 1954 to 1956, exposed him to abstract art, *art informel*, and the CoBrA group, impelling him to paint nonrepresentational pictures with evocative biomorphic forms. A one-person exhibition of his work was held in 1966 at the Salón del Subte, Intendencia Municipal, Montevideo. Cúneo's work was exhibited at the Panama-Pacific Exposition, San Francisco, 1915; the Exposición Ibero-Americana de Sevilla, 1930; the *Exposition internationale: Arts et techniques dans la vie moderne*, Paris, 1937; the 1954 and 1972 Venice Biennales; the Bienal Hispano-americana, Barcelona, 1955; and *Art of Latin America since Independence*, Yale University Art Gallery, New Haven, 1966.—R.O.

Jorge de la Vega
Argentine, 1930–1971

Jorge de la Vega was born in Buenos Aires. A self-taught painter, he studied architecture at the Universidad de Buenos Aires from about 1948 to 1952. During the 1950s he created both representational and abstract geometric paintings. Between 1961 and 1965 de la Vega worked and exhibited with Ernesto Deira, Rómulo Macció, and Luis Felipe Noé. Collectively known as the Nueva Figuración or Otra Figuración group, they produced intensely expressionistic figurative paintings that recall the works of Jean Dubuffet and the CoBrA artists and express an existentialist mood. In 1961 he traveled to Europe with the other Nueva Figuración artists, visiting several countries but spending most of the year in Paris. De la Vega began his Bestiario series in 1963 and his Conflicto Anamórfico series a year later; he often affixed objects covered with plastic resin onto these canvases. In 1965 de la Vega received a Fulbright Fellowship and traveled to the United States to teach painting at Cornell University; he returned to Buenos Aires in 1967. During the late 1960s he depicted satirically scenes of contemporary life in a series of black-and-white drawings and paintings; he also composed songs and performed in musical spectacles. De la Vega's work was the subject of an exhibition at the Museo Nacional de Bellas Artes, Buenos Aires, 1976. His work was included in *Neo-Figurative Painting in Latin America*, Pan American Union, Washington, D.C., 1962; *New Art of Argentina*, Walker Art Center, Minneapolis, 1964; *The Emergent Decade: Latin American Painters and Painting in the 1960s*, Cornell University, Ithaca, New York, and the Solomon R. Guggenheim Museum, New York, 1965; *Art of Latin America since Independence*, Yale University Art Gallery, New Haven, 1966; *Art of the Fantastic: Latin America, 1920–1987*, Indianapolis Museum of Art, 1987; and *The Latin American Spirit: Art and Artists in the United States, 1920–1970*, The Bronx Museum of the Arts, New York, 1988.—J.A.F.

Antonio Dias
Brazilian, born 1944

Antonio Dias was born in Campina Grande, Paraíba, Brazil. He left school at age fourteen to begin work as an architectural draftsman and graphic artist in Rio de Janeiro; there he studied with Oswald Goeldi at the Atelier Livre de Gravura da Escola Nacional de Belas Artes. In 1965 he was awarded a painting prize at the Paris Biennale. After receiving a scholarship from the French government, he moved to Paris in 1965 and a year later to Milan. His works of the 1960s include numerous mixed-medium reliefs that contain references to urban violence, sexuality, torture, and death, conveyed in a bold, cartoonish language akin to that of Pop art. In 1972 Dias received a John Simon Guggenheim Memorial Foundation Fellowship and spent a year in New York. During the 1970s he created conceptually based paintings and multi-medium works incorporating painting, film, video, sound, and photography. His 1972–76 series The Illustration of Art questioned the position of art and aesthetics in an ironic, Minimalist-Conceptualist fashion. In 1977 Dias traveled to India and Nepal, spending several months working with Sherpa artisans on the Tibetan border. As a result, his work since that time has incorporated handmade vegetable-fiber paper (Lokhti paper) and organic pigments. Residing in Brazil from 1978 to 1981, Dias founded the fine-arts school Núcleo de Arte Contemporânea at the Universidade Federal da Paraíba, João Pessoa. His current abstract work combines sensual tactile elements with signs and symbols. One-person exhibitions of his work have been organized by the Museu de Arte Moderna, Rio de Janeiro, 1974; the Städtische Galerie im Lenbachhaus, Munich, 1984; the Staatliche Kunsthalle, Berlin, 1988; and the Städtisches Museen, Mülheim an der Ruhr, 1989. His work has been included in the *Guggenheim International Exhibition, 1971*, the Solomon R. Guggenheim Museum, New York; the 1980 Venice Biennale; the 1980 São Paulo Bienal; *An International Survey of Painting and Sculpture*, The Museum of Modern Art, New York, 1984; *Modernidade: Art brésilien du 20ᵉ siècle*, Musée d'Art Moderne de la Ville de Paris, 1987; *Brazil Projects*, Institute for Contemporary Art, P.S. 1 Museum, Long Island City, New York, 1987; and *Bilderwelt Brasilien: Die europäische Erkundung eines "irdischen Paradieses" und die Kunst der brasilianischen Moderne*, Kunsthaus Zürich, 1992. Dias lives in Milan, Cologne, and Rio de Janeiro.—E.B.

Cícero Dias
Brazilian, born 1907

Cícero Dias was born in Recife, Pernambuco, Brazil. In 1926 he entered the Escola Nacional de Belas Artes in Rio de Janeiro to study architecture. Becoming fascinated with painting, he abandoned his architectural studies and returned to Recife. He is largely self-taught as a painter. Dias's first works

were inspired by the daily life of Brazil's northeast region and reflect a Surrealist influence. In 1930 he organized the Congresso Afro-Brasileiro do Recife with the sociologist Gilberto Freyre in an attempt to define and celebrate "true" contemporary Brazilian culture, as opposed to the European modernism imported in 1922 to São Paulo by the organizers of the *Semana de arte moderna*. In 1931 Dias participated in the Salão Nacional de Belas Artes in Rio de Janeiro, which was called the "Salão Revolucionário" that year. Dias visited Paris in 1937 and, overwhelmed by the cultural life of the city, remained there. He met Pablo Picasso and many Surrealist artists and writers, including the poet Paul Eluard. He lived in Lisbon during World War II and was awarded the first prize at the Lisbon Salão de Arte Moderna in 1943. Returning to Paris in 1945, he exhibited there his first abstract works and also had one-person exhibitions in London, Paris, and Amsterdam. Dias visited Brazil in 1948 and completed an abstract mural in Recife, which is considered the first of its kind in South America. An exhibition of his work was presented at the 1965 São Paulo Bienal and during the 1970s Dias had a number of other one-person exhibitions in Brazil. His work was included in *Art Mural*, Avignon, 1949; the 1950 Venice Biennale; *Electra*, Musée d'Art Moderne de la Ville de Paris, 1984; *Vertente surrealista*, Museu de Arte Moderna, Rio de Janeiro, 1986; *Modernidade: Art brésilien du 20ᵉ siècle*, Musée d'Art Moderne de la Ville de Paris, 1987; and *Bilderwelt Brasilien: Die europäische Erkundung eines "irdischen Paradieses" und die Kunst der brasilianischen Moderne*, Kunsthaus Zürich, 1992. Dias lives in Recife and Paris.—E.B.

Gonzalo Díaz
Chilean, born 1947

Gonzalo Díaz was born in Santiago. He was afflicted with polio at age five, an experience that contributed, he says, to the gravity apparent in his art. Díaz studied at the Escuela de Bellas Artes, Universidad de Chile, Santiago, from 1965 to 1969 and began teaching there in 1969. Díaz also taught at the Universidad Católica in 1974 and at the Instituto de Arte Contemporáneo from 1977 to 1986. Although he began creating installations in the late 1970s, he has never abandoned painting. In fact, he has been more interested in the practice and history of this medium than most of the other artists associated with the Avanzada, a loosely organized group of politically engaged Chilean artists who emerged in the late 1970s. Like many Avanzada artists, Díaz was strongly influenced by the death of the Chilean president Salvador Allende, a family friend, and the institution of Augusto Pinochet's military dictatorship in 1973. While he rarely addresses specific political issues in his art, he has consistently questioned the popular myths of Chile through an often labyrinthine artistic language. After receiving a grant from the Italian government in 1980, Díaz spent a

year in Italy; in 1987 he received a John Simon Guggenheim Memorial Foundation Fellowship. Díaz's one-person exhibitions include *El kilómetro 104*, Galería Sur, Santiago, 1985; *Marco/Banco de pruebas*, Galería Arte Actual, Santiago, 1988; and *Lonquén diez años*, Galería Ojo de Buey, Santiago, 1989. His work has been included in *Cuatro artistas chilenos: Díaz, Dittborn, Jaar, Leppe*, Centro de Arte y Comunicación, Buenos Aires, 1985; *Cirugía plástica: Konzepte zeitgenössischer Kunst Chile, 1980–1989*, Neue Gesellschaft für Bildenden Kunst, Berlin, 1989; and *Contemporary Art from Chile*, Americas Society, New York, 1991. Díaz lives in Santiago.—J.A.F.

Eugenio Dittborn
Chilean, born 1943

Born in Santiago, Eugenio Dittborn studied painting and printmaking there at the Escuela de Bellas Artes, Universidad de Chile, from 1962 to 1965. He also studied graphic arts at the Escuela de Fotomecánica, Madrid, in 1966; lithography at the Hochschule für Bildenden Künste, Berlin, in 1967 and 1969; and painting and lithography at the Ecole des Beaux-Arts, Paris, in 1968. Though inspired by the Conceptual art movement of the late 1960s, Dittborn was more influenced during the ensuing decade by similar aesthetic practices that were emerging independently in Chile, especially those displayed in the journal *Manuscritos*. Seeking alternatives to traditional painting and printmaking, Dittborn at this time began to incorporate photographic images and processes into mixed-medium works. Although many of these are responses to the experience of living under the military dictatorship of Augusto Pinochet, the works transcend the specific political context in which they were produced by addressing more universal themes. In the late 1970s Dittborn became a leading member of the so-called Avanzada, a loosely organized group of Chilean artists that emerged in Santiago. Since 1983 he has produced his Airmail Paintings, a series of large works originally done on wrapping paper and since 1988 on synthetic nonwoven fabric. Mailed by air to their destinations around the world, and exhibited with the envelopes in which they are sent, these works combine drawing, photo-silkscreen, texts, and objects such as feathers, buttons, and wool. They utilize photographs of anonymous people found in old magazines, newspapers, and books, to address contemporary political issues such as the tragedy of the *desaparecidos* ("disappeared ones"). Dittborn has also made several videotapes that deal with such themes. His one-person exhibitions include *From Another Periphery*, Artspace, Sydney, 1984; an installation at the Adelaide Festival, Adelaide, Australia, 1986; and *Eight Airmail Paintings Coming Back from Cuenca, London, Sydney, and Berlin*, an experimental ten-hour exhibition at the Kinok Film Shooting Stage, Santiago, 1990. His work has been included in *A Marginal Body: The Photographic Image in Latin America*,

Australian Centre for Photography, Sydney, 1987; *Transcontinental: Nine Latin American Artists*, Ikon Gallery, Birmingham, and Cornerhouse, Manchester, 1990; *The Interrupted Life*, The New Museum of Contemporary Art, New York, 1991; *America: Bride of the Sun*, Koninklijk Museum voor Schone Kunsten, Antwerp, 1992; and Documenta 9, Kassel, 1992. Dittborn lives in Santiago.—J.A.F.

Pedro Figari
Uruguayan, 1861–1938

Pedro Figari, a leading figure in law, education, journalism, and civic life, was born in Montevideo. After receiving his law degree, he was appointed public defender in Montevideo in 1886. In 1893 he founded the newspaper *El Deber*. Figari began painting on a part-time basis in the 1890s; his early paintings recall the work of his teacher, the Italian academic painter Godofredo Sommavilla. Figari was elected president of the Ateneo, a cultural association, in 1901, and in 1912 published *Arte: Estética, ideal*, his most important book. Figari traveled to France the following year. Appointed director of the Escuela de Artes y Oficios, Montevideo, in 1915, he resigned his post two years later because of opposition to his radical reforms. The stylistic influence of the French Post-Impressionists, especially Pierre Bonnard and Edouard Vuillard, whom he knew, became evident in his paintings of the late 1910s. After moving to Buenos Aires with his son and artistic collaborator, Juan Carlos, in 1921, Figari devoted himself to painting. In 1924 he was a founder of the Sociedad de Amigos del Arte, an organization in Buenos Aires that championed modern art. In 1925 he moved to Paris, where he lived for nine years; he was devastated by his son's death in 1927. Figari returned to Montevideo and was appointed artistic advisor to the Ministerio de Instrucción Pública in 1933. Throughout his career he depicted from memory the traditional life and customs of the people of the Río de la Plata, including the gauchos of the pampas, participants in the *candombe* rituals, and members of the bourgeoisie in their fashionable salons. One-person exhibitions of his work were organized by the Sociedad de Amigos del Arte, Buenos Aires, 1938; the Musée d'Art Moderne de la Ville de Paris, 1960; the Museo Nacional de Bellas Artes, Buenos Aires, 1961; the Instituto Torcuato Di Tella, Museo de Artes Visuales, Buenos Aires, 1967; the Center for Inter-American Relations, New York, 1986; and the Pavillon des Arts, Paris, 1992. Figari's work was included in *The Latin-American Collection of The Museum of Modern Art*, The Museum of Modern Art, New York, 1943; *Art of Latin America since Independence*, Yale University Art Gallery, New Haven, 1966; *Figari, Reverón, Santa María*, Biblioteca Luis Angel Arango, Bogotá, 1985; *The Latin American Spirit: Art and Artists in the United States, 1920–1970*, The Bronx Museum of the Arts, New York, 1988; and *Art in Latin America: The Modern Era, 1820–1980*, Hayward Gallery, London, 1989.—J.A.F.

Gonzalo Fonseca
Uruguayan, born 1922

Gonzalo Fonseca was born in Montevideo. He traveled to Europe at age eleven and was impressed by visits to Rome, Paris, and other cities. He studied architecture at the Universidad de la República Oriental del Uruguay from 1939 to 1941. Throughout most of the 1940s he studied under Joaquín Torres-García. Active in Torres-García's Montevideo workshop as a painter and muralist, Fonseca assimilated the master's concepts of Constructive Universalism. He shared Torres-García's interest in indigenous art forms and in the perceived universality of themes expressed in ancient art. Visiting Bolivia and Peru in 1945, Fonseca saw pre-Columbian archaeological sites. In 1950 he traveled to Egypt, Greece, Spain, and Turkey, then lived in Paris until 1952. The artist moved to the United States in 1958 when he received a John Simon Guggenheim Memorial Foundation Fellowship. Fonseca has executed several public sculpture commissions in the United States, including one for a glass mosaic mural at the New School for Social Research, New York, made under the auspices of the Taller Torres-García from 1959 to 1962. In 1968 Fonseca created a large cast-concrete sculpture in Mexico City for the International Olympic Committee. Since the 1970s he has produced stone sculptures that evoke archaeological ruins or fantastic architecture; their niches, inscriptions, doorways, staircases, and secret chambers help to impart a sense of the mysterious and the wonderful. One-person exhibitions of Fonseca's work have been held at the Portland Art Museum, Oregon, 1962; the Jewish Museum, New York, 1970; and the 1990 Venice Biennale. His work was included in *The Latin American Spirit: Art and Artists in the United States, 1920–1970*, The Bronx Museum of the Arts, New York, 1988; and *La escuela del sur: El Taller Torres-García y su legado/El Taller Torres-García: The School of the South and Its Legacy*, Museo Nacional Centro de Arte Reina Sofía, Madrid, 1991, Archer M. Huntington Art Gallery, The University of Texas, Austin, 1991, Museo de Monterrey, Mexico, 1992, The Bronx Museum of the Arts, New York, 1992–93, and the Museo Rufino Tamayo, Mexico City, 1993. Fonseca lives in New York and Pietrasanta, Italy.—E.F.

Julio Galán
Mexican, born 1958

Born in Múzquiz, Mexico, Julio Galán moved in 1970 with his family to Monterrey. After studying architecture there from 1978 to 1982, he began to pursue an artistic career. Traveling to New York in 1984, Galán met Andy Warhol, who greatly influenced him; he subsequently spent part of each year in New York. Although he has produced ceramic sculptures and pastels, Galán's primary body of work consists of figurative paintings with often inscrutable narratives. Frequently puncturing or adding collage and objects to these works, he

draws upon a wide variety of sources, both high and low, including Surrealist painting, the cinema, Mexican *retablo* imagery, and various forms of kitsch. While his repeated portrayal of his own, often feminized, image recalls the self-portraits of contemporary artists such as Francesco Clemente, it is perhaps more related to Frida Kahlo's depiction of herself in varied guises and costumes. Like the artists associated with the so-called neo-Mexicanismo movement, Galán often ironically questions traditional Mexican culture and social mores in his work; the homoerotic content of many of his paintings similarly calls into question conventional conceptions of gender and sexuality. Galán has had one-person exhibitions at the Museo de Monterrey, 1987; Witte de With, Center for Contemporary Art, Rotterdam, 1990; and the Stedelijk Museum, Amsterdam, 1992. His work has been included in *Magiciens de la terre*, Musée National d'Art Moderne, Centre Georges Pompidou, Paris, 1989; *Aspects of Contemporary Mexican Painting*, Americas Society, New York, 1990; *Through the Path of Echoes: Contemporary Art in Mexico*, Independent Curators Incorporated, New York, 1990; and *Mito y magia en América: Los ochenta*, Museo de Arte Contemporáneo, Monterrey, 1991. Galán lives in Monterrey and New York.—J.A.F.

Gego
Venezuelan, born 1912

Gertrude Goldschmidt, known as Gego, was born in Hamburg and graduated from Stuttgart University in 1938 with a degree in architecture. She worked for a short periods of time in a painting studio, a carpenter's shop, and architectural offices before leaving for Venezuela in 1939. During World War II she manufactured lamps and furniture in a workshop in Caracas, and from 1943 to 1948 she was a free-lance architectural designer. She became a Venezuelan citizen in 1952 and moved to the small town of Tarma. There she created watercolors, drawings, and monotypes in an expressionist style. Returning to Caracas in 1956, she began exploring three-dimensional work, at first with exercises on paper, investigating the conversion of planes, formed of parallel lines, into curved, sculptural volumes. Gego showed her early works at the Galería de la Librería Cruz del Sur, Caracas, in 1958. She taught sculpture at the Escuela de Artes Plásticas y Aplicadas "Cristóbal Rojas," in 1958 and 1959, and composition at the Facultad de Arquitectura y Urbanismo of the Universidad Central de Venezuela from 1958 to 1967. Gego visited the United States in 1959 and made sculptures and prints. Her first architectural sculpture, consisting of interlocking planes of parallel lengths of aluminum tubes, was installed in the Banco Industrial de Venezuela, Caracas, in 1962. From 1964 until 1977 she taught at the Instituto de Diseño, Fundación Neuman, Instituto Nacional de Cooperación Educativa (INCE). In 1966 she received a fellowship at the Tamarind Lithography Workshop in Los Angeles. Gego collaborated with her husband Gerd Leufert on the façades of the Sede del INCE, Caracas, in 1969; patterns of aluminum plates or tubes are backed by glass mosaics. Also that year, she exhibited her first Reticuláreas, room-sized, netlike environments of suspended wire segments, hooked and joined at the ends. She installed her sculpture *Cuerdas*, of nylon cord and metal, in the Parque Central in Caracas in 1972. One-person exhibitions of her work have been presented by the Fundación Museo de Bellas Artes, Caracas, 1961, 1964, 1968 (lithographs); 1969; and 1984 (steel wire sculptures, called Dibujos sin Papel); the Museo de Arte Contemporáneo, Caracas, 1977; and the Galería de Arte Nacional, Caracas, 1982 (watercolors). Gego's work was included in *The Responsive Eye*, The Museum of Modern Art, New York, 1965; *Art of Latin America since Independence*, Yale University Art Gallery, New Haven, 1966; *Latin America: New Paintings and Sculpture*, Center for Inter-American Relations, New York, 1969; and *The Latin American Spirit: Art and Artists in the United States, 1920–1970*, The Bronx Museum of the Arts, New York, 1988. Gego lives in Caracas. —J.R.W.

Víctor Grippo
Argentine, born 1936

Víctor Grippo was born in Junín, Argentina. He studied chemistry at the Universidad Nacional de La Plata and attended Héctor Carter's seminars in the visual arts at the Escuela Superior de Bellas Artes, Buenos Aires, where he later studied design. In the early 1970s Grippo became a leading member of the Grupo de los Trece (Grupo CAYC), originally an association of thirteen Argentine artists affiliated with the Centro de Arte y Comunicación, Buenos Aires. Since that time he has explored the relationships between science, art, and everyday life in a variety of mixed-medium works that incorporate texts. Drawing on the social, cultural, political, and economic significance of the mundane objects he utilizes, which have included foodstuffs, tools, and tables, these works are reminiscent of but not necessarily influenced by the contemporaneous Italian Arte Povera movement. Grippo's best-known works incorporate potatoes, which are indigenous to South America, vegetables whose process of transforming matter into energy he considers analogous to the processes underlying human consciousness. He often subjects them to transformations evocative of alchemy. One-person exhibitions of his work have been organized by the Centro de Arte y Comunicación, Buenos Aires, 1977, and the Fundación San Telmo, Buenos Aires, 1988. Grippo's work has been included in the 1972, 1977, and 1991 São Paulo Bienals; the 1986 Venice Biennale; *Transcontinental: Nine Latin American Artists*, Ikon Gallery, Birmingham, and Cornerhouse, Manchester, 1990; the 1991 Havana Bienal; and *America: Bride of the Sun*, Koninklijk Museum voor Schone Kunsten, Antwerp, 1992. Grippo lives in Buenos Aires.—J.A.F.

Alberto da Veiga Guignard
Brazilian, 1896–1962

Alberto da Veiga Guignard was born in Nova Friburgo in the state of Rio de Janeiro. As the result of a cleft palate, he had a permanent speech defect that made talking difficult for him. He first traveled to Europe in 1907, when he visited Switzerland with his family. He attended the Akademie der Bildenden Künste in Munich from 1917 to 1920, then studied painting in Florence from 1920 to 1923. While in Paris in the late 1920s, he became interested in the work of Raoul Dufy and Henri Matisse. Guignard returned to Brazil, settling initially in Rio de Janeiro, and produced landscapes and figure studies. In the early 1930s he met Cícero Dias and Ismael Nery and was somewhat influenced by their styles. He formed the Grupo Guignard in 1943, along with other artists of his generation including Iberê Camargo. In 1944, at the invitation of the mayor of Belo Horizonte, Juscelino Kubitschek, he founded the Escolinha do Parque, also known as the Escolinha Guignard, where he taught painting and design until his death. During these years he dedicated himself principally to landscape painting and depicted scenes of the colonial gold-mining cities of Minas Gerais state: Ouro Preto, Sabará, and São João del Rei. His work shows the influence of the painters of the early Italian Renaissance, as well as Dufy, Matisse, Paul Cézanne, and Vincent van Gogh. One-person exhibitions of his work were held at the Museu de Arte da Prefeitura de Belo Horizonte, 1974, and the Grande Galería do Palácio das Artes, Belo Horizonte, 1982. His work was included in the 1927 and 1928 Salons d'Automne, Paris; the 1928 Venice Biennale; the 1929 Salon des Indépendants, Paris; *Brazilian Exhibition*, Roerich Museum International Art Center, New York, 1930; *The Latin-American Collection of The Museum of Modern Art*, The Museum of Modern Art, New York, 1943; *Modernidade: Art brésilien du 20ᵉ siècle*, Musée d'Art Moderne de la Ville de Paris, 1987; and *Bilderwelt Brasilien: Die europäische Erkundung eines "irdischen Paradieses" und die Kunst der brasilianischen Moderne*, Kunsthaus Zürich, 1992.—T.C.

Alberto Heredia
Argentine, born 1924

Alberto Heredia was born in Buenos Aires. He studied there at the Escuela Nacional de Cerámica and the Escuela Nacional de Bellas Artes "Manuel Belgrano." He also studied with the sculptor Horacio Juárez in 1947. During the 1950s Heredia created sculptures that reflect the influence of Concrete art. Residing in Europe from 1960 to 1963, he exhibited the Cajas de Camembert (Camembert Boxes), a series of boxes filled with rubbish, which marked the emergence of his dis-

tinctive style. Since that time Heredia has produced assemblages and anthropomorphic sculptures, from scrap material and a variety of discarded objects including dolls, utensils, and furniture, which suggest the influence of Expressionism and Surrealism. Critically examining modern capitalist society, these works address themes such as alienation and violence, often from a darkly humorous perspective. His numerous fellowships include a Pollock-Krasner Foundation Grant, 1991. Heredia had a one-person exhibition at the Fundación San Telmo, Buenos Aires, in 1989. His work was included in *The Latin-American Collection of The Museum of Modern Art*, The Museum of Modern Art, New York, 1943; the 1957 São Paulo Bienal; *Surrealismo en la Argentina*, Instituto Torcuato Di Tella, Museo de Artes Visuales, Buenos Aires, 1967; *La post-figuración*, Centro de Arte y Comunicación, Buenos Aires, 1979; *Del pop art a la nueva imagen*, Museo Nacional de Artes Visuales, Montevideo, 1986; and *La conquista: 500 años por cuarenta artistas*, Centro Cultural Recoleta, Buenos Aires, 1991. Heredia lives in Buenos Aires.—R.O.

Alfredo Hlito
Argentine, 1923–1993

Alfredo Hlito was born in Buenos Aires and studied at the Escuela Nacional de Bellas Artes there from 1938 to 1942. His first abstract paintings of 1945 recall the tonalities and gridded structures of Joaquín Torres-García. Hlito joined the Asociación Arte Concreto-Invención, participated in their first exhibitions in 1946, and signed the "Manifiesto Invencionista." In 1948 he exhibited with the Asociación in the Salon des Réalités Nouvelles, Paris. By the late 1940s Hlito had developed a mature style in square abstract paintings called Ritmos Cromáticos; these works explore relations of pattern, movement, and space through a rectilinear system of colored lines and bars set against white backgrounds. His paintings of the 1950s, diamond-shaped or rectangular, utilize black lines of varying widths and colored trapezoidal or irregular forms, generally set at dynamic oblique diagonals. Hlito traveled to Europe in 1953, visiting France, Holland, and Italy, and meeting Max Bill and František Kupka. By the late 1950s he was creating abstract paintings of scrolled forms that inflect brightly colored and subtly atmospheric spaces. From 1964 to 1973 the artist lived in Mexico, where he directed the department of graphic design at the Editorial Universidad Nacional Autónoma de México. One-person exhibitions of his work have been organized by the Palacio de Bellas Artes, Mexico City, 1963, and the Museo Nacional de Bellas Artes, Buenos Aires, 1987. His work was included in *La pintura y la cultura argentina de este siglo*, Museo Nacional de Bellas Artes, Buenos Aires, 1952; the 1954 São Paulo Bienal; the 1956 Venice Biennale; *Konkrete Kunst: Fünfzig Jahre Entwicklung*, Helmhaus, Zurich, 1960; *Art of Latin America since Independence*, Yale University Art Gallery, New Haven, 1966; *Homenaje a la vanguardia argentina: Década del 40*, Galería Arte Nuevo, Buenos Aires, 1976; and *Vanguardias de la década del 40*, Museo de Artes Plásticas Eduardo Sívori, Buenos Aires, 1980.—E.F.

Enio Iommi
Argentine, born 1926

Enio Iommi was born Enio Girola in Rosario, Argentina. He first studied art in the studio of his Italian-born father, who was a sculptor, and with the Italian sculptor Enrico Forni. Iommi moved to Buenos Aires in 1939. His first abstract sculptures, made in the mid-1940s, are generally rectilinear arrangements of metal bars and planar elements in wood and plastic. In 1946 Iommi helped found the Asociación Arte Concreto-Invención. In the late 1940s he worked in at least two distinct modes, exploring relationships of form and space: one group of abstract metal sculptures features thin tubular lengths of metal curving and twisting dynamically through space, while another group is more geometric and planar. All of these works reflect the influence of Max Bill and Georges Vantongerloo. In 1954 the artist began work on a sculpture for a house being built by Le Corbusier in La Plata. Iommi received a gold medal at the International Exposition in Brussels in 1958. In the 1960s and 1970s Iommi's planar aluminum sculpture became more twisted and irregular. He was named a member of the Argentine Academia Nacional de Bellas Artes in 1975. By the late 1970s he was producing marble sculptures that emphasize contrasts between highly finished geometric forms and more roughly chiseled, irregularly shaped segments. His one-person exhibitions include those at the Museu de Arte Moderna, Rio de Janeiro, 1962; the Museo Nacional de Bellas Artes, Buenos Aires, 1963; the Museo de Artes Plásticas Eduardo Sívori, Buenos Aires, 1980; and the Hakone Open-Air Museum, Japan, 1981. His work has been included in the *Primera exposición internacional de arte moderno*, Museo de Arte Moderno, Buenos Aires, 1960; *Konkrete Kunst: Fünfzig Jahre Entwicklung*, Helmhaus, Zurich, 1960; the 1964 Venice Biennale; *Homenaje a la vanguardia argentina: Década del 40*, Galería Arte Nuevo de Buenos Aires, 1976; *Vanguardias de la década del 40*, Museo de Artes Plásticas Eduardo Sívori, Buenos Aires, 1980; *Abstracción en el siglo XX*, Museo de Arte Moderno, Buenos Aires, 1985; and *Art in Latin America: The Modern Era, 1820–1980*, Hayward Gallery, London, 1989. Iommi lives in Buenos Aires.—E.F.

María Izquierdo
Mexican, 1902–1955

María Cenobia Izquierdo was born in San Juan de los Lagos, Jalisco, Mexico, and raised in that town and Torreón. She entered into an arranged marriage at the age of fourteen and moved with her husband to Mexico City in 1923. When they separated a few years later, Izquierdo began painting. In 1928 she enrolled in the Escuela de Artes Plásticas (Academia de San Carlos), where she studied with Germán Gedovius. Her student works gained her the attention of Diego Rivera. She also met Rufino Tamayo, who was an instructor at the school that year. Izquierdo abandoned formal studies in 1929, and from then until 1933 she lived and shared a studio with Tamayo. During this period Izquierdo painted chiefly portraits, still lifes, and townscapes using simple bold forms, intense earthy colors, and a naive approach to modeling and perspective. She traveled to New York in 1930 and had a one-person exhibition at The Art Center; she also participated in the *Mexican Arts* exhibition at The Metropolitan Museum of Art. After returning to Mexico, she exhibited her work frequently. In 1932 she started teaching in the Departamento de Bellas Artes de la Secretaría de Educación. She began to depict the theme of the circus, which was to preoccupy her through the 1930s, and also initiated a series of small-scale allegorical compositions, typically featuring nude figures in cosmic settings or among classical ruins. In 1935 she organized a traveling exhibition of revolutionary posters by women, *Carteles revolucionarios de las pintoras del sector femenino de la Sección de Bellas Artes Plásticas*. Izquierdo met the French playwright and poet Antonin Artaud, who had come to Mexico in 1936. He published laudatory articles about her in French and Mexican periodicals and arranged for an exhibition of her work in Paris. She traveled to Chile in 1944 as a Mexican cultural ambassador, and exhibited in the Palacio de Bellas Artes, Santiago, and in other institutions. In 1945 she received a commission to create a mural for the Palacio del Departamento del Distrito Federal in Mexico City, but before she was able to begin work, the commission was canceled by a committee comprising Rivera and David Alfaro Siqueiros, on the ground that she lacked technical experience in the fresco medium. While still creating portraits and genre scenes in the 1940s, she was increasingly devoted to melancholic landscapes occupied by mysterious still-life arrangements. In 1950 she suffered an embolism that left her paralyzed for a time. One-person exhibitions of her work were held at the Galería de Arte Moderno, Mexico City, 1956; the Palacio de Bellas Artes, Mexico City, 1979; and the Centro Cultural/Arte Contemporáneo, Mexico City, 1988. Group exhibitions in which she was represented include *Twenty Centuries of Mexican Art*, The Museum of Modern Art, New York, and the Golden Gate International Exposition, San Francisco, 1940; *The Latin-American Collection of The Museum of Modern Art*, The Museum of Modern Art, New York, 1943; *Art Mexicain*, Musée d'Art Moderne de la Ville de Paris, 1951; *Imagen de Mexico: Der Beitrag Mexikos zur Kunst des 20. Jahrhunderts*, Schirn Kunsthalle Frankfurt, 1987; *Art in Latin America: The Modern Era, 1820–1980*, Hayward Gallery, London, 1989; and *Mexico: Splendors of Thirty Centuries*, The Metropolitan Museum of Art, New York, 1990.—E.F.

Alfredo Jaar
Chilean, born 1956

Born in Santiago, Chile, Alfredo Jaar resided in Martinique from the ages of six to sixteen. He received degrees in filmmaking, from the Instituto Chileno-Norteamericano de Cultura, Santiago, in 1979, and architecture, from the Universidad de Chile, Santiago, in 1981. Jaar moved to New York in 1982. Although he has produced work in a variety of mediums, he is best known for installations with photographic light boxes and mirrors. While the fact that these installations are site-specific and industrially produced reflects his architectural training, the use of illuminated images arranged in a manner reminiscent of cinematic montage attests to his background in film. Visually, the works recall Minimalist objects created by such artists as Robert Morris and Donald Judd. The use of photographic images, however, and a strategic arrangement of the light boxes on which they are displayed, allow the artist to address social and political issues neglected by the Minimalists. Investigating the political inequities between the so-called first and third worlds, Jaar has dealt with such topics as the plight of the gold miners of Brazil's Serra Pelada; the immigration of Latin Americans across the Rio Grande; the exportation of toxic waste by industrialized countries to Koko, Nigeria; and the detention of Vietnamese refugees in Hong Kong. A meticulous researcher, he usually travels to each site, where he takes the photographs he uses in his installations. Jaar has received fellowships from the John Simon Guggenheim Memorial Foundation (1985), the National Endowment for the Arts (1987), the Deutscher Akademischer Austauschdienst Berliner Kunstlerprogram (1989), and other institutions. His one-person exhibitions include *Frame of Mind*, Grey Art Gallery and Study Center, New York University, New York, 1987; *Alfredo Jaar*, La Jolla Museum of Contemporary Art, 1990, a version of which traveled to The New Museum of Contemporary Art, New York, 1992; *Alfredo Jaar: Geography=War*, Virginia Museum of Fine Arts and Anderson Gallery, School of the Arts, Virginia Commonwealth University, Richmond, 1991; *Alfredo Jaar: Two or Three Things I Imagine about Them*, Whitechapel Art Gallery, London, 1992; *Rafael, Manuel, y los otros*, Torre de la Santa Cruz, Cadiz, 1992; and *Das Pergamon-Projekt/Eine Ästhetik zum Widerstand*, Pergamonmuseum, Staatliche Museen zu Berlin, 1992–93. His work has been included in the 1986 Venice Biennale; the 1987 São Paulo Bienal; Documenta 8, Kassel, 1987; *Committed to Print: Social and Political Themes in Recent American Printed Art*, The Museum of Modern Art, New York, 1988; *Magiciens de la terre*, Musée National d'Art Moderne, Centre Georges Pompidou, Paris, 1989; *Encounters/ Displacements: Luis Camnitzer, Alfredo Jaar, Cildo Meireles*, Archer M. Huntington Art Gallery, The University of Texas, Austin, 1992; and *Arte amazonas*, Museu de Arte Moderna, Rio de Janeiro, 1992. Jaar lives in New York.—J.A.F.

Frida Kahlo
Mexican, 1907–1954

Magdalena Carmen Frida Kahlo y Calderón was born in Coyoacán, then a town on the outskirts of Mexico City. Her father, Guillermo Kahlo, a Hungarian Jewish immigrant from Germany, was a professional photographer; her mother, Matilde Calderón, was a religious Catholic mestiza from Oaxaca. In 1913 Kahlo contracted polio, her first bout with a lifelong series of illnesses, injuries, surgeries, and convalescences. She attended the Escuela Nacional Preparatoria in Mexico City from 1922 to 1925, taking classes in drawing and modeling in clay; she watched Diego Rivera paint murals in the school's auditorium. Kahlo briefly apprenticed with the engraver Fernando Fernández in 1925. A bus accident that year left her with permanent injuries, and she began to paint while bedridden in 1926. In 1928 she joined the Communist Party and, through the photographer Tina Modotti, met Rivera; he and Kahlo married the next year. She met the photographer Edward Weston in San Francisco in 1930, and she spent most of the following three years with Rivera in New York and Detroit. By the early 1930s she adopted the formal and hieratic style of Mexican votive paintings, or *retablos,* for her own works, combining the relentlessly observed with symbolic elements and the fantastic. Her paintings, preponderantly self-portraits, project an interior emotional life as well as a politically charged exploration of her Mexican heritage. In 1937 Leon Trotsky arrived in Mexico and stayed for two years at Kahlo's Coyoacán house. In 1938 André Breton claimed Kahlo's paintings as Surrealist in his essay for her first one-person exhibition at the Julien Levy Gallery in New York; the next year her work was shown at the Galerie Renou et Colle in Paris. Kahlo divorced Rivera in 1939 and remarried him the following year in San Francisco. She began teaching at the newly opened Escuela Nacional de Pintura, Escultura y Grabado, "La Esmeralda," Mexico City, in 1943, and despite worsening health she continued to paint during the 1940s. The artist died at her family home in Coyoacán, which in 1958 became the Museo Frida Kahlo. Exhibitions of her work were held at the Galería de Arte Contemporáneo, Mexico City, 1953; the Instituto Nacional de Bellas Artes, Mexico City, 1977; the Museum of Contemporary Art, Chicago, 1978; and, with the work of Modotti, at the Whitechapel Art Gallery, London, 1982. Her work was included in *The Latin-American Collection of The Museum of Modern Art*, The Museum of Modern Art, New York, 1943; *Art of the Fantastic: Latin America, 1920–1987*, Indianapolis Museum of Art, 1987; *Imagen de Mexico: Der Beitrag Mexikos zur Kunst des 20. Jahrhunderts*, Schirn Kunsthalle Frankfurt, 1987; *The Latin American Spirit: Art and Artists in the United States, 1920–1970*, The Bronx Museum of the Arts, New York, 1988; *Art in Latin America: The Modern Era, 1820–1980*, Hayward Gallery, London, 1989; and *Mexico: Splendors of Thirty Centuries*, The Metropolitan Museum of Art, New York, 1990.—J.R.W.

Gyula Kosice
Argentine, born 1924

Gyula Kosice was born in Kosice, Hungary, and four years later his family moved to Argentina. He studied drawing and sculpture at the Academias Libres in Buenos Aires. In the early 1940s he became interested in modernist movements abroad and wrote Surrealist-inspired poetry. In 1944 Kosice created *Röyi*, an abstract sculpture with movable parts that would be influential in the development of Concrete art in Argentina. The same year he and others attempted to found the cultural review *Arturo*; after disagreements with some of his collaborators, he published the magazine *Invención* and exhibited in the two Arte Concreto-Invención exhibitions in 1945. In 1946 Kosice was a founder of the Grupo Madí and wrote the "Manifiesto Madí." He exhibited with the group, participating in shows at the Altamira Escuela Libre de Artes Plásticas, Buenos Aires, in 1946, and at the Salon de Réalités Nouvelles, Paris, in 1948. He also directed the Madí magazine, *Arte Madí universal*, from 1947 to 1954. He held a one-person exhibition in 1947 at the Bohemian Club in Buenos Aires; the works shown reflected the artist's increasing use of industrial materials such as glass, neon, and fluorescent tubing. He moved to Paris in 1957 and began experimenting with light and water as components of large-scale acrylic sculptures. His book *La ciudad hidroespacial* (Hydrospatial City), published in Buenos Aires in 1972, proposed the possibility of urban environments suspended in space by hydraulic energy. Kosice's art of the 1970s evokes space capsules and utopian habitats. He represented Argentina with a work at the Olympic Sculpture Park in Seoul, South Korea, in 1988. His one-person exhibitions include ones at the 1964 Venice Biennale; the Instituto Torcuato Di Tella, Museo de Artes Visuales, Buenos Aires, 1968; the Museo de Arte Moderno, Buenos Aires, 1972; and the Museo Nacional de Bellas Artes, Buenos Aires, 1977 and 1991. Kosice's work was included in *Vanguardias de la década del 40*, Museo de Artes Plásticas Eduardo Sívori, Buenos Aires, 1980, and *Art in Latin America: The Modern Era, 1820–1980* Hayward Gallery, London, 1989. Kosice lives in Buenos Aires.—E.F.

Frans Krajcberg
Brazilian, born 1921

Born in Kozienice, Poland, Frans Krajcberg displayed artistic talent at an early age. He studied engineering in Leningrad in 1940 and 1941 but left school to fight with the Polish liberation army against Germany; his family perished in the Holocaust. From 1945 to 1947 Krajcberg attended the Academy of Fine Arts, Stuttgart, where he studied under Willi Baumeister. He moved to Brazil in 1948 and for ten years lived alternately in São Paulo and

Rio de Janeiro and in the subtropical forest in Paraná. In the 1957 São Paulo Bienal Krajcberg received first prize as best national painter. By then, he had abandoned his early figurative imagery and had developed an abstract, expressionistic vocabulary in which vegetal forms can be discerned. Soon afterward Krajcberg made nature the sole subject of his work and began to employ natural materials as artistic mediums. In the mid-1960s he created a series of works in Ibiza, Spain, for which agglutinated earth was applied thickly to the canvas. Subsequent works combine reliefs and natural objects, including stones, parts of plants and trees, and molds of such forms composed of gesso on handmade paper; the artist also made three-dimensional assemblages from the same materials. Exhibiting the myriad abstract patterns found in nature, these works metaphorically reveal the natural cycle of life and death through the process of artistic creation. Since 1958 Krajcberg has divided his time between Paris and Brazil, where he has lived and worked in isolation in Itabirito, Minas Gerais, and Nova Viçosa, Bahia—small, underdeveloped communities near lush tropical vegetation. While Krajcberg has created reliefs, prints, and photographs, his major works are large-scale sculptures. Displayed individually or in groups, these sculptures are powerfully expressive constructions made of tree trunks and aerial roots, some bearing the scars of burning, collected by the artist in the forests of northern Brazil. Since 1975 Krajcberg has addressed through his art and writings the need to protect Brazil's natural environment from destruction; in 1979, with the French critic Pierre Restany, he wrote the "Manifesto do Rio Negro," also known as the "Manifesto of Integral Naturalism," during a trip down the Amazon River. His one-person exhibitions include those at the Museu de Arte Moderna, Rio de Janeiro, 1965; the Israel Museum, Jerusalem, 1969; the Galerie de L'Espace Pierre Cardin, Paris, 1972; and the Musée National d'Art Moderne, Centre Georges Pompidou, Paris, 1975. His work has been included in the 1951, 1953, 1955, 1957, 1961, 1973, and 1977 São Paulo Bienals; the 1964 Venice Biennale; *Modernidade: Art brésilien du 20e siècle*, Musée d'Art Moderne de la Ville de Paris, 1987; and *Bilderwelt Brasilien: Die europäische Erkundung eines "irdischen Paradieses" und die Kunst der brasilianischen Moderne*, Kunsthaus Zürich, 1992. Krajcberg lives in Nova Viçosa and Paris.—F.B.

Guillermo Kuitca
Argentine, born 1961

Born in Buenos Aires, Guillermo Kuitca is the grandson of Russian Jews who emigrated to Argentina in the early twentieth century, a heritage that would influence his work. He studied painting with Ahuva Szlimowicz in Buenos Aires from 1970 to 1979 and also studied theater and cinema during secondary school. After receiving his first one-person exhibition at age thirteen at the Galería

Lirolay, Buenos Aires, Kuitca began to exhibit regularly. On a trip to Europe in 1980 he visited museums and galleries and met choreographer Pina Bausch in Wuppertal, West Germany. After returning to Buenos Aires in 1981, Kuitca designed and directed several theatrical productions. In the early 1980s he began to create figurative paintings in which he transformed themes and images borrowed from his own and other productions as well as from literature, film, and popular music; many of these works depict cavernous stage sets populated with minuscule figures engaged in mysterious, often violent scenes. In 1987 Kuitca began a series of paintings based on city maps and apartment floor-plans; most of these works are executed on canvas, but some are on mattresses. Kuitca's subjects reflect a consciousness of Argentine history, but he consistently addresses themes that reflect the general human condition. His one-person exhibitions include ones at Witte de With, Center for Contemporary Art, Rotterdam, 1990; the Kunsthalle Basel, 1990; The Museum of Modern Art, New York, 1991; and IVAM Centre del Carme, Valencia, 1993. His work has been included in *Art of the Fantastic: Latin America, 1920–1987*, Indianapolis Museum of Art, 1987; *New Image Painting: Argentina in the Eighties*, Americas Society, New York, 1989; *U-ABC*, Stedelijk Museum, Amsterdam, 1989; the 1989 São Paulo Bienal; *Metropolis*, Martin-Gropius-Bau, Berlin, 1991; *Mito y magia en América: Los ochenta*, Museo de Arte Contemporáneo, Monterrey, 1991; and Documenta 9, Kassel, 1992. Kuitca lives in Buenos Aires.—J.A.F.

Diyi Laañ
Argentine, born 1927

Diyi Laañ was born in Buenos Aires. She studied briefly at the Universidad de Buenos Aires, but was primarily self-taught as an artist. She abandoned her formal education to write short stories and poetry. In 1946 she signed the Grupo Madí manifesto, and she participated in the group's principal exhibitions in the 1940s and 1950s as well as the Salon des Réalités Nouvelles in Paris in 1948. Laañ contributed illustrations and poetry to the eight issues of the journal *Arte Madí universal*, edited by her husband, Gyula Kosice. Like other artists of the group, Laañ broke with the static and rectilinear conventions of abstract painting in her work of the 1940s; besides creating irregularly-shaped painted frames that eliminated the canvas entirely, she made articulated paintings with movable parts that did away with the concept of frame or border. Her work was included in *Homenaje a la vanguardia argentina: Década del 40*, Galería Arte Nuevo de Buenos Aires, 1976; *Vanguardias de la década del 40*, Museo de Artes Plásticas Eduardo Sívori, Buenos Aires, 1980; and *Art in Latin America: The Modern Era, 1820–1980*, Hayward Gallery, London, 1989. Laañ lives in Buenos Aires.—E.F.

Wifredo Lam
Cuban, 1902–1982

Wifredo Oscar de la Concepción Lam y Castilla was born in Sagua la Grande, Cuba. His father was a Chinese immigrant to Cuba, and his mother was of Afro-Cuban origin. He attended the Escuela de Bellas Artes, Havana, and left in 1923 for Madrid, where he studied with the painter Fernández Alvarez de Sotomayor and at the Academia Libre in the Pasaje de la Alhambra. Lam fought with the Republican forces in defense of Madrid in 1937. In Paris in 1938 he met Pablo Picasso, who introduced him to a wide circle of artists and writers. Lam joined the Surrealist group the next year and studied African art with Michel Leiris. He fled Europe with André Breton, André Masson, Claude Lévi-Strauss, and others in 1941; while detained in Martinique, Lam met the poet Aimé Césaire; and finally returned to Havana in 1942. In the early 1940s he began producing paintings that synthesized the dreamlike qualities of Surrealism with a pictorial space indebted to Cubism. In these works apparitional figures of humans, animals, and plants are seen in shallow jungle settings. The subjects and meanings of these paintings derive in large part from the myths and rituals of Santería, a popular Afro-Cuban religion that combines Catholicism with traditional African beliefs. Lam visited Haiti with Breton in 1945. He resettled in Paris in 1952 but continued to travel widely; he visited Cuba frequently before and after the Revolution. In the 1950s Lam's complex volumetric figures became flatter and more schematic, and the lush foliage gave way to vaporous stained fields. One-person exhibitions of Lam's work were held at the Fundación Museo de Bellas Artes, Caracas, 1955; the Kunsthalle Basel, 1966; the Hannover Gesellschaft, 1966; the Stedelijk Museum, Amsterdam, 1967; the Moderna Museet, Stockholm, 1967; the Palais des Beaux Arts, Brussels, 1967; the Musée d'Art Moderne de la Ville de Paris, 1968 and 1983; the 1972 Venice Biennale; the Museo Nacional de Bellas Artes, Havana, 1977; the Museo de Arte Moderno, Mexico City, 1978; the Museo Nacional de Arte Contemporáneo, Madrid, 1982; the Museo Nacional de Bellas Artes, Buenos Aires, and the Fundación Museo de Bellas Artes, Caracas, 1986; the Kunstsammlung Nordrhein-Westfalen, Düsseldorf, 1988; and the Americas Society, New York, 1992. Lam's work was included in *The Latin-American Collection of The Museum of Modern Art*, The Museum of Modern Art, New York, 1943; the *Guggenheim International Award Exhibition, 1964*, the Solomon R. Guggenheim Museum, New York; *Art of Latin America since Independence*, Yale University Art Gallery, New Haven, 1966; *Art of the Fantastic: Latin America, 1920–1987*, Indianapolis Museum of Art, 1987; *The Latin American Spirit: Art and Artists in the United States, 1920–1970*, The Bronx Museum of the Arts, New York, 1988; *Art in Latin America: The Modern Era, 1820–1980*, Hayward Gallery, London, 1989; *Crosscurrents of Modernism: Four Latin American*

Pioneers: Diego Rivera, Joaquín Torres-García, Wifredo Lam, Matta, Hirshhorn Museum and Sculpture Garden, Smithsonian Institution, Washington, D.C., 1992; and *Wifredo Lam and His Contemporaries, 1938–1952*, The Studio Museum in Harlem, New York, 1992.—J.R.W.

Jac Leirner
Brazilian, born 1961

Jacqueline Leirner was born in São Paulo. Her parents, Fulvia and Adolfo Leirner, are collectors of modern and contemporary art. From 1979 to 1984 Leirner studied at the Fundaçao Armando Alvares Penteado, São Paulo, and taught there from 1987 to 1989. Since the early 1980s she has produced sculptures and installations made of bank notes, cigarette packages, shopping bags, envelopes, stainless-steel ashtrays, and airplane tickets. Reflecting the influence of Minimalism and Arte Povera, these works reveal her interest in compiling, organizing, and finding a new place for ordinary objects, thereby endowing them with new meanings. The artist has expressed her admiration for the "subversive geniality" of Marcel Duchamp, Joseph Beuys, and Yves Klein. In 1986 Leirner created a series of sculptures titled The One Hundreds, composed of seventy thousand worthless Brazilian cruzeiros. In a series of the following year, titled Lung, each work is fabricated from parts of the packages that once contained the cigarettes she had smoked over a three-year period. In 1992 Leirner created two site-specific sculptures titled *To and From (Walker)*, which incorporated the envelopes containing the correspondence sent to the Walker Art Center in Minneapolis during a ten-month period. She created similar pieces for the Museum of Modern Art, Oxford. Leirner has had one-person exhibitions at the Museum of Modern Art, Oxford, and the Institute of Contemporary Art, Boston, 1991; the Walker Art Center, Minneapolis, 1992; and the Hirshhorn Museum and Sculpture Garden, Smithsonian Institution, Washington, D.C., 1992. Her work has been included in the 1983 and 1989 São Paulo Bienals; the 1990 Venice Biennale; *Transcontinental: Nine Latin American Artists*, Ikon Gallery, Birmingham, and Cornerhouse, Manchester, 1990; *Viva Brasil viva*, Liljevalch Konsthall, Kulturhuset, Stockholm, 1991; *Brasil: La nueva generación*, Fundación Museo de Bellas Artes, Caracas, 1992; and Documenta 9, Kassel, 1992. Leirner lives in São Paulo.—J.A.F.

Julio Le Parc
Argentine, born 1928

Born in Mendoza, Argentina, Julio Le Parc moved with his family to Buenos Aires in 1940. While working at a variety of day jobs, he began part-time art studies in 1942 at the Escuela Nacional de Bellas Artes, "Prilidiano Pueyrredón," Buenos Aires. After abandoning his formal studies in 1947, Le Parc became interested in the work of Argentina's avant-garde artists, particularly those affili-

ated with the Concrete art movement. Quitting his day jobs and breaking with his family, he chose to live a somewhat marginal existence, associating with anarchists and Marxists. In 1954 he began working with an experimental theater company in Buenos Aires; the next year he returned to the Escuela Nacional de Bellas Artes. In his early paintings, influenced by the work of the Asociación Arte Concreto-Invención, Le Parc investigated the optical properties of progressions of color and simple geometrical forms. After receiving a study grant from the Spanish government in 1958, Le Parc moved permanently to Paris, where he met Victor Vasarely. In 1960, with Francisco Sobrino, he founded the Groupe de Recherche d'Art Visual, which was dedicated to creating audience-interactive optical and kinetic objects and environments; he remained a leading figure in this group until it disbanded in 1968. In 1966 Le Parc won the Grand Prize for International Painting at the Venice Biennale. A year later France's Minister of Culture, André Malraux, decorated him with the Chevalier de l'Ordre des Arts et des Lettres. Exhibitions of his work have been organized by the Sala del Ministerio de la Cultura, Madrid, 1977; the Fundación Museo de Bellas Artes, Caracas, 1981; and the Salas Nacionales, Buenos Aires, 1988. Le Parc's work has been included in *The Responsive Eye*, The Museum of Modern Art, New York, 1965; *The 1960s: Painting and Sculpture from the Museum Collection*, The Museum of Modern Art, New York, 1967; the 1984 and 1986 Havana Bienales; the 1986 Venice Biennale; and *The Latin American Spirit: Art and Artists in the United States, 1920–1970*, The Bronx Museum of the Arts, New York, 1988. Le Parc lives in Cachan, France.—B.A.

Raúl Lozza
Argentine, born 1911

Born in Buenos Aires, Raúl Lozza had his first exhibition in 1928. In 1939 he created his first artworks with irregular frames and shapes. Four years later Lozza became a leading member of Contrapunto, an intellectual group in Buenos Aires that edited a literary magazine of the same name. During this period he also worked as a book illustrator and exhibited with the Asociación Arte Concreto-Invención, founded by Tomás Maldonado. In 1947, with Abraham Haber, Lozza developed a type of Concrete art he termed Perceptismo, which espoused multiplanar paintings, the separation of form from color, and perception of such paintings as objects. Lozza exhibited "perceptist" works at the Van Riel Galería de Arte, Buenos Aires, in 1949. In the late 1940s he developed theories related to geometric abstraction and from 1950 to 1953 published his writings on art in his magazine *Perceptismo*. Lozza was elected president of the Sociedad Argentina de Artistas Plásticos in 1962. One-person exhibitions of his work have been organized by the Museo de Santa Fé, Argentina, 1961; the Museu de Arte Moderna, Rio de Janeiro, 1963; and the Fundación San Telmo, Buenos Aires,

1985. His work has been included in *Vanguardias de la década del 40*, Museo de Artes Plásticas Eduardo Sívori, Buenos Aires, 1980, and *Art in Latin America: The Modern Era, 1820–1980*, Hayward Gallery, London, 1989. Lozza lives in Buenos Aires.—E.F.

Rocío Maldonado
Mexican, born 1951

Born in Tepic, Nayarit, Mexico, Rocío Maldonado studied drawing as a child. From 1977 to 1980 she attended La Escuela Nacional de Pintura, Escultura y Grabado, "La Esmeralda," Mexico City, where she studied printmaking with Octavio Bajonero. In 1981 she entered the workshops of Luis Nishizawa and Gilberto Aceves Navarro at the Escuela de Artes Plásticas, Universidad Nacional Autónoma de México, Mexico City. Maldonado is considered a leading member of the so-called neo-Mexicanismo movement, a loosely organized group of figurative artists who emerged in the 1980s and are linked by their critical employment of subjects drawn from Mexican history, art history, and popular culture. Since the early 1980s she has created expressionistically rendered drawings and paintings that question conventional representations of women. Many of these works depict female figures surrounded by allusive, floating images, such as eyes, hands, torsos, and cosmological symbols. In 1984 Maldonado began a series of paintings depicting cloth-and-china and cloth-and-wax dolls of a type popular in rural Mexico; she occasionally affixed the limbs of the latter type to the supports. In the late 1980s Maldonado began a series of paintings and drawings of female religious figures, including Saint Theresa, Saint Monica, and the Virgin of Guadalupe. Maldonado's work has been included in *17 artistas de hoy en México*, Museo Rufino Tamayo, Mexico City, 1985; *Art of the Fantastic: Latin America, 1920–1987*, Indianapolis Museum of Art, 1987; *Aspects of Contemporary Mexican Painting*, Americas Society, New York, 1990; *Through the Path of Echoes: Contemporary Art in Mexico*, Independent Curators Incorporated, New York, 1990; and *Mito y magia en América: Los ochenta*, Museo de Arte Contemporáneo, Monterrey, 1991. Maldonado lives outside Mexico City.—J.A.F.

Tomás Maldonado
Argentine, born 1922

Born in Buenos Aires, Tomás Maldonado graduated from the Academia de Bellas Artes, Buenos Aires, in 1938. He met Carmelo Arden Quin in 1943 and was a founder of the literary and arts review *Arturo* a year later with Arden Quin and others; he also created the abstract and expressionistic drawing for the cover of the first and only issue. In 1945 Maldonado contributed writings on art to the review *Contrapunto*. After ideological disagreements with the artists who showed in the Arte Concreto-Invención exhibitions of 1945, he

formed the Asociación Arte Concreto-Invención and directed its publication with others in the group. The group held its first exhibitions in Buenos Aires in 1946. Maldonado's work of this period is characterized by various modes of hard-edge abstraction; his paintings frequently contain series of lines, angles, or bands of color set against white backgrounds. In 1948 the artist traveled to Europe, where he met Max Bill and Georges Van-tongerloo. He participated in the exhibition *Arte concreto* at the Instituto de Arte Moderno in Buenos Aires in 1950. Interested in the fields of industrial design and architecture in the 1950s, Maldonado continued to paint, creating abstract works with elliptical and circular forms. He returned to Europe in 1956, when he was invited by Bill to teach at the Hochschule für Gestaltung in Ulm, West Germany, remaining until 1967. In 1965 Maldonado was the Lethaby Lecturer at the Royal College of Art in London. A year later he was named a fellow of the Council of Humanities at Princeton University. The artist moved to Italy in 1967. In 1968 he received the Design Medal from the Society of Industrial Artists and Designers. The following year he was invited by the Soviet Union's Institute of Technical Design to give lectures in Moscow, Leningrad, and Vilna. In 1971 he was named Professor of Environmental Planning at the Universitaria di Bologna. In addition to creating art, Maldonado has written numerous books, including *Avanguardia e razionalità: Articoli, saggi, pamphlets, 1946–1974*, published in 1974. His work has been included in *Art of Latin America since Independence*, Yale University Art Gallery, New Haven, 1966; *Homenaje a la vanguardia argentina: Década del 40*, Galería Arte Nuevo, Buenos Aires, 1976; and *Vanguardias de la década del 40*, Museo de Artes Plásticas Eduardo Sívori, Buenos Aires, 1980. Maldonado lives in Italy.—E.F.

Marisol
Venezuelan, born 1930

Born in Paris to affluent Venezuelan parents, Marisol Escobar was raised in Caracas. She traveled extensively in Europe and the United States as a child. From 1946 to 1949 she attended the Jepson School in Los Angeles, and she studied at the Ecole des Beaux-Arts and the Académie Julian in Paris in 1949 and 1950. After settling in New York in 1950, Marisol studied briefly under Yasuo Kuniyoshi at the Art Students League; from 1951 to 1954 she took classes at the New School for Social Research and at Hans Hofmann's school. She met the painters Willem de Kooning and Alex Katz and the sculptor William King. Frustrated by the limits of easel painting, Marisol turned in the mid-1950s to the construction of whimsical figurative sculptures made of found objects and roughly hewn or finely carved wood; painting self-portraits on them, she merged fantasy with an exploration of identity and social stereotypes. Her first one-person exhibition was at the Leo Castelli Gallery in New York in 1957. In the early 1960s

Marisol met Andy Warhol and appeared in his films *Kiss* and *The Thirteen Most Beautiful Women*. In 1967 she exhibited a series of sculptures, *Figures of State*, that caricature world leaders. In the late 1960s and 1970s she concentrated on producing prints and drawings, creating personal and erotic imagery by tracing parts of her own body directly onto paper. Marisol produced a series of portrait sculptures of artists in the early 1980s, and in 1991 she completed The American Merchant Mariners Memorial on the Hudson River in New York. One-person exhibitions of her work include those at the 1968 Venice Biennale; the Contemporary Arts Museum, Houston, 1977; and The National Portrait Gallery, Smithsonian Institution, Washington, D.C., 1991. Her work has been included in two exhibitions at The Museum of Modern Art, New York: *The Art of Assemblage, 1961,* and *Americans 1963*; Documenta 4, Kassel, 1968; *Art of Latin America since Independence*, Yale University Art Gallery, New Haven, 1966; and *The Latin American Spirit: Art and Artists in the United States, 1920–1970*, The Bronx Museum of the Arts, New York, 1988. Marisol lives in New York.—J.R.W.

Matta
Chilean, born 1911

Roberto Sebastián Antonio Matta Echaurren was born in Santiago, Chile, and grew up speaking French at home and at school. He studied architecture at the Universidad Católica in Santiago, and, after going to Europe in 1933, worked for a time in Le Corbusier's Paris office. Matta met Federico García Lorca in Spain in 1934. Two years later he met Salvador Dalí, who introduced him to André Breton; impressed by Matta's drawings, Breton invited him to join the Surrealist group in 1937. Matta began to paint the following year with the encouragement of Gordon Onslow Ford. He met Marcel Duchamp and was influenced by that artist's explorations of movement and process. After the outbreak of war in 1939, Matta, like many European artists and writers, fled to New York. Here he became a conduit for ideas and information between the exiled Surrealists and the nascent New York School. Matta's work and example, especially his use of automatist techniques, exerted a great influence on the American painters. His first one-person exhibition was held in 1940 at the Julien Levy Gallery in New York. Matta traveled to Mexico with Robert Motherwell in 1941 and the next year was included in the New York exhibitions *Artists in Exile* at the Pierre Matisse Gallery and *The First Papers of Surrealism* at the Whitelaw-Reid Mansion. His early abstractions gave way in the mid-1940s to scenes of anthropomorphic insectoids, replete with overtones of eroticism and violence. After Arshile Gorky's suicide in 1948, Matta returned to Europe and broke with the Surrealists; he associated with Asger Jorn and the Situationists, settling in Paris in 1954. Matta's work and activities in the 1960s and 1970s increasingly reflected his political sentiments, and he

traveled to Cuba, South America, Egypt, and Africa during this time. His paintings depicting abstracted beings—who commit ritualized and warlike acts—often assume monumental proportions. His one-person exhibitions include ones at The Museum of Modern Art, New York, 1957; the Nationalgalerie, West Berlin, 1970; the Kestner-Gesellschaft, Hanover, 1974; the Hayward Gallery, London, 1977; and the Musée National d'Art Moderne, Centre Georges Pompidou, Paris, 1985. His work has been included in *The Latin-American Collection of The Museum of Modern Art*, The Museum of Modern Art, New York, 1943; *The Emergent Decade: Latin American Painters and Painting in the 1960s*, Cornell University, Ithaca, New York, and the Solomon R. Guggenheim Museum, New York, 1965; *Art of Latin America since Independence*, Yale University Art Gallery, New Haven, 1966; *Art of the Fantastic: Latin America, 1920–1987*, Indianapolis Museum of Art, 1987; *The Latin American Spirit: Art and Artists in the United States, 1920–1970*, The Bronx Museum of the Arts, New York, 1988; *Art in Latin America: The Modern Era, 1820–1980*, Hayward Gallery, London, 1989; and *Crosscurrents of Modernism: Four Latin American Pioneers: Diego Rivera, Joaquín Torres-García, Wifredo Lam, Matta*, Hirshhorn Museum and Sculpture Garden, Smithsonian Institution, Washington, D.C., 1992. Matta lives in Paris.—J.R.W.

Cildo Meireles
Brazilian, born 1948

Cildo Meireles was born in Rio de Janeiro and studied there at the Escola Nacional de Belas Artes and the Escola do Museu de Arte Moderna. Since the late 1960s he has created objects and installations that address political, social, and aesthetic themes in an often poetic visual language. His work evokes that of Hélio Oiticica and other Brazilian artists who have invested the formal strategies of European modernism and postmodernism with a specifically Brazilian content. Employing the Duchampian Readymade, Meireles created his series Insertions into Ideological Circuits from 1970 to 1975. In these works he printed messages critical of his country's military regime onto circulating Coca-Cola bottles and bank notes. With other Brazilian artists of his generation, Meireles was a founder of the alternative journals *Malasartes* in 1975 and *A parte do fogo* in 1980. In 1975 he created *Blindhotland*, an installation that underscored the limitations of vision as a mode of access to truth by incorporating an assortment of seemingly identical balls of vastly different weights. In 1986 he reflected upon the "ashes" of painting in the installation *Gray*: two structures lined respectively with charcoaled and chalked canvas gradually became gray as spectators walked between them. In 1989 and 1990 Meireles exhibited *Missão-Missões (How to Build Cathedrals)* and *Oblivion*, installations that addressed the deleterious effects of colonization upon the indigenous peoples of Brazil.

He has also collaborated on independent films, including *Desvio para o vermelho* (*Red Shift*), directed by Tuca Moraes, and *Le faux monnaieur*, directed by Frederic Lafont, both in 1984. Meireles's installations have been exhibited at the Museu de Arte Moderna, Rio de Janeiro, 1984; the Museo de Arte Contemporânea, São Paulo, 1986; The Museum of Modern Art, New York, 1990; and The Institute of Contemporary Arts, London, 1990. His work has been included in the 1976 Venice Biennale; the 1977 Paris Biennale; the 1981 and 1989 São Paulo Bienals; *Modernidade: Art brésilien du 20ᵉ siècle*, Musée d'Art Moderne de la Ville de Paris, 1987; *The Latin American Spirit: Art and Artists in the United States, 1920–1970*, The Bronx Museum of the Arts, New York, 1988; *Brazil Projects*, Institute for Contemporary Art, P.S. 1 Museum, Long Island City, New York, 1988; *Magiciens de la terre*, Musée National d'Art Moderne, Centre Georges Pompidou, Paris, 1989; *Transcontinental: Nine Latin American Artists*, Ikon Gallery, Birmingham, and Cornerhouse, Manchester, 1990; *America: Bride of the Sun*, Koninklijk Museum voor Schone Kunsten, Antwerp, 1992; *Encounters/Displacements: Luis Camnitzer, Alfredo Jaar, Cildo Meireles*, Archer M. Huntington Art Gallery, The University of Texas, Austin, 1992; and Documenta 9, Kassel, 1992. Meireles lives in Rio de Janeiro.—E.B.

Juan Melé
Argentine, born 1923

Born in Buenos Aires, Juan N. Melé began studying drawing in 1934 and he attended the Escuela Nacional de Bellas Artes in that city from 1938 to 1945. In 1946 he became a member of the Asociación Arte Concreto-Invención. Like other Argentine Concrete artists in the mid-1940s, Melé rejected the idea of the frame as well as the rectangular format for paintings. Although basically trapezoidal in shape, his hard-edge paintings—which typically feature small, jutting, geometrical foms—resemble large cutouts. By the late 1940s Melé had developed compositions derived from Suprematism that consist of simple colored geometric forms on white backgrounds. Concurrently he created works with geometrical shapes mounted in relief on white surfaces. Melé lived in Paris in 1948 and 1949 on a French government grant. He attended L'Ecole du Louvre, studied with Georges Vantongerloo and Sonia Delaunay, and met Max Bill, Michel Seuphor, and other intellectuals. He exhibited his work in the Salon des Réalités Nouvelles, Paris, in 1948 and at the Maison de L'Amérique Latine in 1949. From 1950 to 1961, he lived in Buenos Aires, where he exhibited frequently and served as professor of art history at the Escuela Nacional de Bellas Artes. In the mid-1950s Melé created hard-edge paintings featuring brightly colored geometric shapes, which he exhibited in the 1953 São Paulo Bienal. Two years later he founded the artists' group Arte Nuevo. Melé lived in New York intermittently between 1961 and 1980. His one-person exhibitions include

retrospectives at the Museo de Artes Plásticas Eduardo Sívori, Buenos Aires, 1981, and at the Museo de Arte Moderno, Buenos Aires, about 1987. His work has been included in *Vanguardias de la década del 40*, Museo de Artes Plásticas Eduardo Sívori, Buenos Aires, 1980, and *Art in Latin America: The Modern Era, 1820–1980*, Hayward Gallery, London, 1989. Melé lives in Buenos Aires.—E.F.

Ana Mendieta
Cuban, 1948–1985

Ana Mendieta was born in Havana. Unable to emigrate from Cuba themselves, her parents sent Ana and her sister Raquel in 1961 to the United States, where the two were raised in orphanages until their mother joined them in the mid-1960s. Mendieta received a B.A. in 1969 and an M.A. in painting in 1972 from the University of Iowa, Iowa City. She subsequently enrolled in the University's Multimedia and Video Art Program and abandoned painting. Becoming strongly influenced by third-world feminism and Santería, an Afro-Cuban syncretic religion, Mendieta began to explore relationships between the body, spirituality, and the earth in ephemeral works and performances documented in photographs and films. She traveled to Oaxaca, Mexico, in 1973, 1974, 1976, and 1978; during this period she began her Silueta series of outdoor "earth-body sculptures," in which she traced her body's outline into earth, vegetation, and tree trunks. Mendieta moved to New York in 1978. Demonstrating her growing involvement in feminist and anticolonialist politics, she helped organize *Dialectics of Resistance: An Exhibition of Third World Women Artists in the United States*, A.I.R. Gallery, New York, in 1980. That year and in 1981, Mendieta visited Cuba, where she executed her Esculturas Rupestres (Rupestrian Sculptures), a series of simple figurative and symbolic images carved into rock and cave walls. Receiving a fellowship from the American Academy in Rome in 1983, she moved to that city, where she made her first indoor sculptures—floor works of molded earth and sand. Mendieta married the artist Carl Andre in 1985 and died tragically later that year, when she fell from a window of their thirty-fourth-floor New York apartment. An exhibition of her work was organized by The New Museum of Contemporary Art, New York, in 1987, and her work was included in *Women of the Americas: Emerging Perspectives*, Center for Inter-American Relations, New York, 1982; *The Decade Show: Frameworks of Identity in the 1980s*, Museum of Contemporary Hispanic Art, The New Museum of Contemporary Art, and The Studio Museum in Harlem, New York, 1990; and *America: Bride of the Sun*, Koninklijk Museum voor Schone Kunsten, Antwerp, 1992.—J.A.F.

Carlos Mérida
Guatemalan, 1891–1984

Carlos Mérida, born in Guatemala City, was of Maya-Quiché, Zapotec, and Spanish descent. In 1907 he moved to Quetzaltenango, Guatemala, where he studied painting and music. In 1910 he studied in Paris with Kees van Dongen, Hermen Anglada-Camarasa, and Amedeo Modigliani; he also met Piet Mondrian, Diego Rivera, Joaquín Torres-García, and Pablo Picasso. He returned to Guatemala in 1914 and, with the sculptor Yela Gunther, started an artistic and ethnographic pro-Indian movement. Mérida moved to New York in 1917 and to Mexico City in 1919. In works of this period he depicted Indian figures, rural scenes, and popular festivals in flat, brightly colored forms. In 1922 the artist assisted Rivera with murals in the Anfiteatro Bolívar of the Escuela Nacional Preparatoria; he joined the Mexican Mural Movement the next year, painting a mural in the Biblioteca Infantil of the Secretaría de Educación Pública in Mexico City. Also in 1922 he was a founder of the Sindicato Revolucionario de Obreros Técnicos y Plásticos. Mérida resided in Paris from 1927 to 1929, where he admired the art of his friends Joan Miró and Paul Klee and also that of Vasily Kandinsky. In 1929 he was named director of the Galería de Arte Moderno del Teatro Nacional in Mexico City; in 1931 he helped organize the Escuela de Danza for the Secretaría de Educación Pública, which he headed for three years. He explored abstract Surrealist pictorial methods in his works of the 1930s and 1940s. From the late 1930s through the 1940s, Mérida published books and articles on contemporary Mexican art, notably a 1937 series on the work of the muralists; he also produced editions of prints portraying the popular customs and regional dress of the people of Mexico and Guatemala. The artist taught fresco technique at North Texas State Teachers College, Denton, Texas, during 1941 and 1942. He traveled to Europe in 1950 and studied Venetian mosaic techniques. In the 1950s he developed a dynamic geometric style indebted to Synthetic Cubism. His commissioned works include exterior reliefs at the Multifamiliar Juárez housing project in Mexico City, 1952 (destroyed); a mosaic mural in the Palacio Municipal, Guatemala City, 1956; a stained-glass mural in the Museo Nacional de Antropología, Mexico City, 1964; and a mosaic mural in the Civic Center, San Antonio, Texas, 1968. One-person exhibitions of his work include those at the Palacio de Bellas Artes, Mexico City, 1937; the Dallas Museum of Art, 1943; the Museo de Arte Moderno, Mexico City, 1961, 1970, and 1977; and the Museo Nacional de Historia y Bellas Artes, 1971, and the Museo de Arte Moderno, 1985, both in Guatemala City. Mérida's graphic art was shown at the Palacio de Bellas Artes, Mexico City, and the Center for Inter-American Relations, New York, in 1981. His work also was included in *The Latin-American Collection of The Museum of Modern Art*, The Museum of Modern Art, New York, 1943;

the 1957 São Paulo Bienal; *Art of Latin America since Independence*, Yale University Art Gallery, New Haven, 1966; *Imagen de Mexico: Der Beitrag Mexikos zur Kunst des 20. Jahrhunderts*, Schirn Kunsthalle Frankfurt, 1987; *The Latin American Spirit: Art and Artists in the United States, 1920–1970*, The Bronx Museum of the Arts, New York, 1988; *Art in Latin America: The Modern Era, 1820–1980*, Hayward Gallery, London, 1989; and *Modernidad y modernización en el arte mexicano, 1920–1960*, Museo Nacional de Arte, Mexico City, 1991.—J.R.W.

Florencio Molina Campos
Argentine, 1891–1959

Florencio de los Angeles Molina Campos was born in Buenos Aires. Although he had no formal artistic training, he began drawing at an early age, rendering the landscape and people of rural Argentina, which he observed during vacations at his family's farm in Tuyú and later in Chajarí, in the province of Entre Ríos. After his father's death Molina Campos was forced to take a series of bureaucratic jobs, and in 1921 he tried farming without success. Meanwhile, he continued to draw, paint, and write about country life. In 1926 he exhibited for the first time in the Sociedad Rural Argentina, Palermo. As a result of this exhibition's success, he was offered a position as a drawing teacher at the Colegio Nacional Nicolás Avellaneda, Buenos Aires, which he held sporadically until 1948. Other exhibitions followed in Argentina and Uruguay. Molina Campos received the first of numerous commercial commissions in 1931, when he illustrated the annual calendar of a shoe manufacturer. By the early 1940s Molina Campos had become a caricaturist internationally known for his satirical renditions of the inhabitants of the Argentine countryside, including the gauchos—the cowboys of the pampas. He typically shows his subjects involved in daily chores, in festive celebrations, and at leisure, their faces and poses distorted to the point of being grotesque, expressing an affectionate derision that could come only from an artist profoundly familiar with his culture. Molina Campos went to Los Angeles in 1938 to study animation, and during the next two decades he divided his time between Argentina and the United States. In this period one-person exhibitions of his work were organized by the Chouinard Art Institute, Los Angeles, 1941; the Museum of Modern Art, San Francisco, 1942; the University of California at Los Angeles, 1943; and Columbia University, New York, 1947. Numerous North American magazines published his illustrations in the 1940s, including *Esquire*, *Fortune*, *Life*, *National Geographic*, and *Time*.—F.B.

Edgar Negret
Colombian, born 1920

Born in Popayán, Colombia, Edgar Negret studied at the Escuela de Bellas Artes, Cali, in 1938 and 1939. His early work is representational and reflects his academic training. After returning to Popayán to establish a studio, Negret met the Spanish sculptor Jorge de Oteiza, who introduced him to the work of Henry Moore and other modern sculptors. He resided in New York from 1948 to 1950. By this time he was creating abstract sculptures with figurative and organic references. From 1951 to 1955 Negret lived in Europe. Returning to New York, he met the artists Robert Indiana, Ellsworth Kelly, and Louise Nevelson. During this period he created metal sculptures that are more definitively abstract; those works of the series Magic Apparatuses, 1955–65, evoke machines, clocks, and other mechanisms. Through such work Negret pioneered the use of sheet metal and other industrial materials. In 1958 he received a UNESCO scholarship to study the indigenous art of the Americas, and he also taught sculpture at the New School for Social Research, New York. After returning to Bogotá in 1963, Negret began teaching at the Universidad de los Andes. His work of the 1960s includes freestanding and relief sculptures in metal, in which angular and curving elements are juxtaposed. Negret's sculptures of the 1970s frequently feature sheet metal formed into cylinders and spirals; these works evoke such diverse references as space navigation, futuristic architecture, and organic growth. In the 1980s he introduced new shapes that more directly suggest natural forms. Although abstract, these sculptures invoke the pre-Columbian cultures of the Andes through their forms and titles. In 1975 Negret received a John Simon Guggenheim Memorial Foundation Fellowship. In 1983 the artist founded a museum housing his work in his native Popayán. In 1988 he created a monumental sculpture for the Olympic Park in Seoul, South Korea. His one-person exhibitions include those at the Museo de Arte Moderno, Bogotá, 1965, 1971, and 1975; the Fundación Museo de Bellas Artes, Caracas, 1973; the 1965 and 1975 São Paulo Bienals; the Fundació Joan Miró, Barcelona, 1981; the Museo de Arte Contemporáneo, Madrid, 1983; and the 1986 Havana Bienal. His work has been included in the 1956 and 1968 Venice Biennales (Grand Prize for Sculpture at the latter); the 1957 São Paulo Bienal; *L'art colombien à travers les siècles*, Musée du Petit Palais, Paris, 1975; *América Latina: Geometria sensível*, Museu de Arte Moderna, Rio de Janeiro, 1978; *Contrastes de formas: Abstracción geométrica, 1910–1980*, Museo Nacional de Bellas Artes, Buenos Aires, 1986, Museu de Arte de São Paulo Assis Chateaubriand, 1986, Museo de Arte Contemporáneo, Caracas, 1987, and Salas Pablo Picasso, Madrid, 1990; and *The Latin American Spirit: Art and Artists in the United States, 1920–1970*, The Bronx Museum of the Arts, New York, 1988. Negret lives in Bogotá.—E.F.

Luis Felipe Noé
Argentine, born 1933

Luis Felipe Noé was born in Buenos Aires. He studied painting in the workshop of Horacio Butler from 1950 to 1952 and law at the Universidad de Buenos Aires from 1951 to 1955. After abandoning his legal studies, Noé worked as a journalist for several newspapers in Buenos Aires. In 1961 he traveled to Paris on a French government grant. Between 1961 and 1965 he worked and exhibited with Ernesto Deira, Jorge de la Vega, and Rómulo Macció. Collectively known as the Nueva Figuración or Otra Figuración group, these artists created expressionistic paintings that evoke the work of Jean Dubuffet and the CoBrA artists. Depicting aggregates of heads, bodies, and objects in a deliberately crude manner, Noé utilized expressionistic figuration in paintings of this period to explore what he described as the essentially chaotic nature of contemporary society. In addition to addressing specific social and political themes, many of the works reflect the artist's interest in existentialist philosophy. In the mid-1960s Noé began to create assemblages and installations incorporating unframed canvases, cutout figures, damaged panels, and empty stretchers and frames. Noé received the Premio Nacional Instituto Torcuato Di Tella in 1963 and a John Simon Guggenheim Memorial Foundation Fellowship in 1965. In that year he published the book *Antiestética*, in which he explained his aesthetic philosophy. He also moved to New York in 1965 and stopped painting in 1966 to focus on writing and teaching. Noé returned to Buenos Aires in 1969. He published *Una sociedad colonial avanzada* in 1971 and *Recontrapoder* in 1974. He resumed painting in 1975 with the series La Naturaleza y los Mitos and Conquista y Destrucción de la Naturaleza, about the Spanish conquest of Latin America. Though his paintings of this decade are as expressionistic as those of the 1960s, their forms are typically realized in brighter colors and are arranged in a linear manner. Noé moved to Paris in 1976 but returned to Buenos Aires in 1987. His one-person exhibitions include a retrospective at the Museo de Artes Plásticas Eduardo Sívori, Buenos Aires, 1987, and numerous gallery shows in Argentina. His work has been included in *New Art of Argentina*, Walker Art Center, Minneapolis, 1964; *The Emergent Decade: Latin American Painters and Paintings in the 1960s*, Cornell University, Ithaca, New York, and the Solomon R. Guggenheim Museum, New York, 1965; *Otra figuración . . . veinte años despues*, Fundación San Telmo, Buenos Aires, 1981; *Art of the Fantastic: Latin America, 1920–1987*, Indianapolis Museum of Art, 1987; and *The Latin American Spirit: Art and Artists in the United States, 1920–1970*, The Bronx Museum of the Arts, New York, 1988. Noé lives in Buenos Aires.—J.A.F.

Hélio Oiticica
Brazilian, 1937–1980

Born in Rio de Janeiro, Hélio Oiticica was influenced during his childhood by the anarchist beliefs of his grandfather José. In 1954 he entered the Escola do Museu de Arte Moderna, Rio de Janeiro, where he studied with Ivan Serpa and was inspired by the work of Piet Mondrian, Kasimir Malevich, and the European Constructivists. In 1955, while attending the meetings and participating in the exhibitions of the Grupo Frente, Oiticica met the artist Lygia Clark. Subsequently joining the short-lived neo-Concrete movement, he was included in the *I exposição neoconcreta* at the Museu de Arte, Rio de Janeiro, in 1959. Oiticica's work of this period includes the Metaesquemas (begun in 1957)—compositions of squares and rectangles on white grounds—and the Spatial Reliefs and Nuclei series, which incorporate actual space as elements of the works. Emerging in the early 1960s as one of the foremost Brazilian artists of his generation, Oiticica became increasingly interested in incorporating the viewer into the work of art. In 1960 he created his first Penetrables—labyrinths the spectator could explore physically. In 1963 he made his first Bólides—glass vessels, boxes, and other containers filled with pigment and earth. A year later Oiticica began attending the Mangueira Samba School. This experience partly inspired his invention of the Parangolé, a word denoting a state of mind, which was usually materialized in the form of cloth objects, resembling banners, capes, and tents, displayed or worn by the spectator. In 1967 Oiticica exhibited the installation *Tropicália*, which he described as the "first conscious, objective attempt to impose an obviously Brazilian image upon the current context of the avant-garde." After receiving a John Simon Guggenheim Memorial Foundation Fellowship in 1970, Oiticica moved to New York. His New-yorkaises comprise the various proposals and projects he developed while living there. He returned to Rio de Janeiro in 1978, two years before his death. Throughout his career, he adapted the forms of European modernism to the social and cultural context of contemporary Brazil in order to question the autonomy of the art object, the relationship between art and life, and other critical isues. The Projeto Hélio Oiticica, established shortly after his death, has worked to preserve and promote his art and theoretical writings. His one-person exhibitions include *Hélio Oiticica*, Whitechapel Art Gallery, London, 1969, and those at the Universidade Estadual do Rio de Janeiro, 1990, and Witte de With, Center for Contemporary Art, Rotterdam, 1992. His work was included in *Information*, The Museum of Modern Art, New York, 1970; *Modernidade: Art brésilien du 20e siècle*, Musée d'Art Moderne de la Ville de Paris, 1987; *The Latin American Spirit: Art and Artists in the United States, 1920–1970*, The Bronx Museum of the Arts, New York, 1988; *Art in Latin America: The Modern Era, 1820–1980*, Hayward Gallery, London, 1989; *Experiência neoconcreta, Rio de Janeiro 59/60*, Museu de Arte Moderna, Rio de Janeiro, 1991; and *Bilderwelt Brasilien: Die europäische Erkundung eines "irdischen Paradieses" und die Kunst der brasilianischen Moderne*, Kunsthaus Zürich, 1992.—J.A.F.

José Clemente Orozco
Mexican, 1883–1949

Born in Zapotlán el Grande, Jalisco, José Clemente Orozco moved with his family to Mexico City in 1890. He initially studied agriculture before attending, from 1908 to 1914, the Academia Nacional de Artes Plásticas (Academia de San Carlos), where he met Dr. Atl (Gerardo Murillo). During the early years of the Mexican Revolution, Orozco worked as a cartoonist and illustrator for the politically radical newspapers *El Imparcial* and *El hijo del Ahiuzote*. In 1912 he also worked on a series of paintings and lithographs portraying the lives of the prostitutes who worked near his Mexico City studio. His first one-person exhibition was held at the Librería Biblos, Mexico City, in 1916. Traveling to the United States in 1917, Orozco lived in San Francisco and New York. He returned to Mexico in 1920 and in 1923 joined Diego Rivera, David Alfaro Siqueiros, and other artists in the government-sponsored mural-painting program. He became a member of the Sindicato Revolucionario de Obreros Técnicos y Plásticos in 1923 and contributed to its publication, *El Machete*. He also began his first mural at the Escuela Nacional Preparatoria in Mexico City. In 1927 Orozco returned to the United States, where he stayed until 1934. He created murals at Pomona College, Claremont, California, in 1930; the New School for Social Research, New York, in 1930; and the Baker Library of Dartmouth College, Hanover, New Hampshire, in 1932; these institutions also presented one-person exhibitions of his work. After traveling to Europe in 1932, Orozco came back to New York, where he attended the Congress of American Artists. In 1934 he returned to Mexico City and painted a mural at the Palacio de Bellas Artes. He also painted important cycles of murals in Guadalajara from 1936 to 1939, at the Universidad de Guadalajara, the Palacio de Gobierno, and the Hospicios de Cabañas, now the Instituto Cultural Cabañas. In 1940 he was commissioned by The Museum of Modern Art, New York, to paint a portable fresco on six panels, *Dive Bomber and Tank*. Becoming increasingly interested in drawing and easel painting, the artist created a series of portraits in 1941 and 1942; however, he continued to create murals until his death. Orozco aimed to portray the human condition in a universal manner rather than in one that stressed national values. In his characteristically expressionistic style, humanity asserts control over its destiny and freedom from the enslavement of history, religion, political tyranny, and technology. Exhibitions of Orozco's work were held at the Palacio de Bellas Artes, Mexico City, 1947; the Institute of Contemporary Art, Boston, 1953; the 1961 São Paulo Bienal; the Museum of Modern Art, Oxford, 1980; and the Orangerie, Schloss Charlottenberg, Berlin, 1981. Major group exhibitions in which he was represented include *The Latin-American Collection of The Museum of Modern Art*, The Museum of Modern Art, New York, 1943; *Art of Latin America since Independence*, Yale University Art Gallery, New Haven, 1966; *Imagen de Mexico: Der Beitrag Mexikos zur Kunst des 20. Jahrhunderts*, Schirn Kunsthalle Frankfurt, 1987; *The Latin American Spirit: Art and Artists in the United States, 1920–1970*, The Bronx Museum of the Arts, New York, 1988; *Art in Latin America: The Modern Era, 1820–1980*, Hayward Gallery, London, 1989; and *Mexico: Splendors of Thirty Centuries*, The Metropolitan Museum of Art, New York, 1990. Orozco is interred in the Rotonda de los Hombres Ilustres in Mexico City.—R.O.

Rafael Montañez Ortiz
American, born 1934

Rafael Montañez Ortiz was born in Brooklyn, New York. As a child he became interested in religion and ritual; as a teenager, he read Freudian psychology, existentialist philosophy, anthropology, sociology, and Marxist theory. Ortiz created Abstract Expressionist paintings in the late 1950s, but he began to explore destruction as a creative force in 1959, initially cutting, burning, and driving spokes into piles of objects. He produced his Archaeological Finds series from 1961 to 1967 by mutilating mattresses, chairs, and other objects and spraying the remains with plastic resin. During this period he also became interested in the work of Arman, Osório César, and other Nouveaux Réalistes. In "Destructivism: A Manifesto" of 1962, the first of his numerous polemical writings, Ortiz explained destruction as a means of knowing the unconscious, questioning hierarchies, confronting taboos, and exploring emotional, sexual, and social conflict. Ortiz received a B.S. in art education and an M.F.A. from Pratt Institute, Brooklyn, in 1964. Inspired by Greek and Etruscan ritual divinations and the sacrificial practices of Mesoamerican cultures, he created numerous performances in the late 1960s. In his Destruction Ritual Realization series, he destroyed objects and killed chickens; in his Piano Destruction events, he demolished pianos with an ax. Ortiz was the founding director of El Museo del Barrio, New York, in 1969. Far removed from the theme of destruction, his works of the ensuing decade reflect his studies in Eastern religions and nontraditional healing practices. In 1973 came his first Physio-Psycho-Alchemy performances, in which participants' dreams, inner visions, and emotions became the material of art. He received an Ed.D. from Teachers College of Columbia University, New York, in 1982. In the mid-1980s he manipulated appropriated film footage using computer and laser video technology to reveal the unconscious repression of violent emotions. El Museo del Barrio organized an exhibition of his work in 1988, and it has been in-

cluded in *The Art of Assemblage*, The Museum of Modern Art, New York, 1961; *The 1960s: Painting and Sculpture from the Museum Collection*, The Museum of Modern Art, New York, 1967; *Ancient Roots/New Visions*, Fondo del Sol Visual and Media Center, Washington, D.C., 1977; and *The Latin American Spirit: Art and Artists in the United States, 1920–1970*, The Bronx Museum of the Arts, New York, 1988. Ortiz lives in New York.—L.L.

Alejandro Otero
Venezuelan, 1921–1990

Alejandro Otero Rodríguez was born in El Manteco, Venezuela, and grew up in Upata and Ciudad Bolívar. Otero studied at the Escuela de Artes Plásticas in Caracas from 1939 to 1945; he began teaching painting courses there in 1943. The artist moved to Paris in 1945 and embarked upon a series of increasingly abstract domestic still lifes known as the Cafeteras. Shown at the Museo de Bellas Artes in Caracas in 1949, these paintings caused a critical uproar in culturally conservative Venezuela; in reaction Otero and other Venezuelan artists in Paris published five issues of the polemic magazine *Revista los disidentes*. In Europe Otero became familiar with the work of Piet Mondrian and met Ellsworth Kelly. He returned to Caracas in 1952 and taught at the Escuela de Artes Plásticas from 1954 to 1959. In 1955 he began his Color-ritmo series of airbrushed paintings of vertical bars superimposed on hard-edged areas of color; Otero also worked on many public and architectural projects in Venezuela in the mid-1950s, including mosaic murals for the Ciudad Universitaria in Caracas. After serving as the Coordinator at the Museo de Bellas Artes for a year, he returned to Paris in 1960 and created collages and constructions with found objects. Otero moved back to Venezuela in 1964. By the end of the decade he had begun producing large, outdoor kinetic sculptures. Otero received a John Simon Guggenheim Memorial Foundation Fellowship in 1971 and conducted research for sculpture at the Center for Advanced Visual Studies of the Massachusetts Institute of Technology, Cambridge. Otero's public sculptures in the late 1970s include *Solar Delta* at the National Air and Space Museum, Smithsonian Institution, Washington, D.C., and, in the 1980s, *Torre Solar* at Guri Dam in Venezuela. A major exhibition of his work was shown at the 1966 Venice Biennale and he represented Venezuela at the 1982 Venice Biennale as well. Retrospectives were held at the Michener Galleries, University of Texas, Austin, 1975, and the Museo de Arte Moderno, Mexico City, 1976. His work was included in the 1959 and 1975 São Paulo Bienals; *The Emergent Decade: Latin American Painters and Painting in the 1960s*, Cornell University, Ithaca, New York, and the Solomon R. Guggenheim Museum, New York, 1965; *Art of Latin America since Independence*, Yale University Art Gallery, New Haven, 1966; *The Latin American Spirit: Art and Artists in the United States, 1920–1970*, The Bronx Museum of the

Arts, New York, 1988; and *Art in Latin America: The Modern Era, 1820–1980*, Hayward Gallery, London, 1989.—J.R.W.

César Paternosto
Argentine, born 1931

César Paternosto was born in La Plata, Argentina. He studied art and philosophy at the Escuela de Bellas Artes and the Instituto de Filosofía, Universidad Nacional de La Plata, from 1957 to 1961; he received a law degree from the same university in 1958. In the early 1960s Paternosto became a member of a circle of abstract painters, Grupo SI; the Argentine critic Aldo Pellegrini dubbed his style of this period Lyric Geometry. Paternosto moved to New York in 1967 and continued painting in an abstract geometric mode, utilizing shaped canvases and serial formats. In the late 1960s he created a series of works with unpainted frontal surfaces and bands of color on the paintings' edges. After being awarded a John Simon Guggenheim Memorial Foundation Fellowship for painting in 1972, Paternosto traveled to Europe. In 1977 he took the first of many trips to northern Argentina, Bolivia, and Peru, where he researched geometric abstraction in pre-Columbian stone sculpture, architecture, ceramics, and textiles. In the early 1980s Paternosto began to incorporate geometric pre-Columbian symbols, structural motifs, and Andean color schemes into his painting. He also wrote and lectured on the links between contemporary and pre-Columbian art. In 1989 he published *Piedra abstracta, la escultura Inca: Una visión contemporánea*. One-person exhibitions of his work have been organized by the Center for Inter-American Relations, New York, 1981; the Fundación San Telmo, Buenos Aires, 1987; and Exit Art, New York, 1993. Paternosto's group exhibitions include *Latin American Art since Independence*, Yale University Art Gallery, New Haven, 1966; *The 1960s: Painting and Sculpture from the Museum Collection*, The Museum of Modern Art, New York, 1967; *Más allá de la geometría*, co-organized by the Center for Inter-American Relations, New York, and the Instituto Torcuato Di Tella, Buenos Aires, 1968; *Latin American Artists in New York since 1970*, Archer M. Huntington Art Gallery, The University of Texas, Austin, 1987; *The Latin American Spirit: Art and Artists in the United States, 1920–1970*, The Bronx Museum of the Arts, New York, 1988; and *La escuela del sur: El Taller Torres-García y su legado/El Taller-García: The School of the South and its Legacy*, Museo Nacional Centro de Arte Reina Sofía, Madrid, 1991, Archer M. Huntington Art Gallery, The University of Texas, Austin, 1991, Museo de Monterrey, 1992, The Bronx Museum of the Arts, New York, 1992–93, and the Museo Rufino Tamayo, Mexico City, 1993. Paternosto lives in New York. —B.A.

Liliana Porter
Argentine, born 1941

Liliana Porter, born in Buenos Aires, studied print-making at the Universidad Iberoamericana, Mexico City, in 1960 and graduated from the Escuela Nacional de Bellas Artes, Buenos Aires, in 1963. After moving to New York in 1964, Porter continued to experiment with printmaking at the Pratt Graphic Art Center; during this period she created technically innovative prints that employ Pop-art imagery to comment upon urban society. A founder of the New York Graphic Workshop with Luis Camnitzer and José Guillermo Castillo in 1965, Porter concurrently became associated with the Conceptual art movement. Inspired in part by the Argentine writer Jorge Luis Borges, she has investigated since the late 1960s the relationships between illusion, artistic representation, and reality in prints, paintings, and wall installations; she has consistently utilized print techniques such as photo-etching and photo-silkscreen in this work. In the mid-1970s Porter began a series of mixed-medium works on paper and canvas depicting objects of childhood, images from Lewis Carroll's *Through the Looking-glass*, and reproductions of paintings from the Western artistic tradition. Though still a prolific printmaker, Porter has worked increasingly on canvas since the early 1980s and typically incorporates painting, silkscreen, collage, and actual objects into these works. Her one-person exhibitions include *Projects: Liliana Porter*, The Museum of Modern Art, New York, 1973; the Fundación San Telmo, Buenos Aires, 1990; the Centro de Recepciones del Gobierno, San Juan, 1991; and The Bronx Museum of the Arts, New York, 1992. Her group exhibitions include *Information*, The Museum of Modern Art, New York, 1970; *Latin American Artists in New York since 1970*, Archer M. Huntington Art Gallery, The University of Texas, Austin, 1987; *The Latin American Spirit: Art and Artists in the United States, 1920–1970*, The Bronx Museum of the Arts, New York, 1988; and *The Decade Show: Frameworks of Identity in the 1980s*, Museum of Contemporary Hispanic Art, The New Museum of Contemporary Art, and The Studio Museum in Harlem, New York, 1990. Porter lives in New York.—J.A.F.

Cândido Portinari
Brazilian, 1903–1962

Cândido Torcuato Portinari, the son of Italian immigrant laborers, was born on a coffee plantation in Brodósqui, São Paulo. Influenced by taking part in the restoration of a local church, he decided to become a painter and at age fifteen traveled to Rio de Janeiro to seek training. He enrolled at the Escola Nacional de Belas Artes, where he excelled at portraiture. In 1928 Portinari was awarded a fellowship to travel through Europe. He visited museums in France, Italy, Spain, and England but painted infrequently until his return to Brazil in 1931. In the early 1930s he obtained recognition

for his portraiture. He painted his first mural in 1933 in his family home in Brodósqui. In 1935 his painting *Café* [*Coffee*] received Second Honorable Mention at the Carnegie International Exhibition of Paintings in Pittsburgh. After 1935 he began to gain renown for his murals, which reflect the influence of Mexican muralism but explore Brazilian themes. From 1936 to 1939 Portinari was a professor at the Universidade do Distrito Federal, Rio de Janeiro, where he participated in an innovative restructuring of the fine-arts program and experimented with the use of traditional glazed tiles for large-scale murals. In 1939 Portinari was invited by the Minister of Education, Gustavo Capanema, to join a group of modernists completing Le Corbusier's Ministry of Education and Health Building in Rio de Janeiro. He designed tile murals for buildings, collaborating with Roberto Burle Marx, Oscar Niemeyer, and others. From 1943 to 1945 he created the tile mural *Via crucis* for Niemeyer's church of São Francisco at Pampulha in Belo Horizonte province. His murals of the 1940s and 1950s specifically refer to Pablo Picasso's work of the late 1930s and 1940s. Portinari's other important mural commissions include those for the Brazilian Pavilion at the 1939 New York World's Fair; the Hispanic Foundation, Library of Congress, Washington, D.C., 1942; and the United Nations, New York, 1953. Portinari was an unsuccessful Communist Party candidate for senator in 1946 and for federal deputy in 1948. He then began a series of paintings focusing on major events in Brazilian history. He also made portraits and works on regional and religious themes. In the late 1940s and 1950s Portinari exhibited widely in Brazil, Europe, and the United States. The Museum of Modern Art, New York, presented an exhibition of his work in 1940. His work was represented in *The Latin-American Collection of The Museum of Modern Art*, The Museum of Modern Art, New York, 1943; the 1950 Venice Biennale; *Art of Latin America since Independence*, Yale University Art Gallery, New Haven, 1966; *Modernidade: Art brésilien du 20ᵉ siècle*, Musée d'Art Moderne de la Ville de Paris, 1987; *The Latin American Spirit: Art and Artists in the United States, 1920–1970*, The Bronx Museum of the Arts, New York, 1988; and *Art in Latin America: The Modern Era, 1820–1980*, Hayward Gallery, London, 1989.—E.B.

Lidy Prati
Argentine, born 1921

Lidy Prati was born in Resistencia, Argentina, and studied art in various private studios in Buenos Aires. She was married to the painter Tomás Maldonado. Prati had her first exhibition in 1942 at the Salón Peuser, Buenos Aires. In 1944 she contributed drawings to the review *Arturo* under the name Lidy Maldonado. She participated in the first exhibition of the Asociación Arte Concreto-Invención, held in Buenos Aires in 1946. In this period she worked as a painter and graphic designer. Although she created abstract works with irregularly shaped edges, Prati also developed serial compositions—minimalist geometric abstractions influenced by Russian Suprematism—that feature patterns of small black, red, and white rectangles and squares on white backgrounds. In 1950 she participated in the exhibition *Arte concreto* at the Instituto de Arte Moderno, Buenos Aires. In 1951 she collaborated on the cultural journal *Nueva visión*. Traveling to Europe in 1952, Prati visited several countries and met Max Bill, Georges Vantongerloo, Giacomo Balla, and other artists; she also exhibited in Florence, Venice, and Verona. She participated in the 1954 São Paulo Bienal. In 1963 her work was included in the exhibition *Veinte años de arte concreto*, Museo de Arte Moderno, Buenos Aires. Prati lives in Buenos Aires.—E.F.

Eduardo Ramírez Villamizar
Colombian, born 1923

Eduardo Ramírez Villamizar was born in the provincial colonial town of Pamplona, Colombia. As a youth he was impressed by the vernacular architecture and baroque altarpieces of his home town. Ramírez Villamizar studied architecture, art, and decoration at the Universidad Nacional de Colombia, Bogotá, from 1940 to 1945, at which time he began to exhibit regularly. From 1945 to 1958 Ramírez Villamizar created figurative expressionistic paintings. In 1947 he worked for seven months with the sculptor Edgar Negret. He lived in Paris from 1950 to 1952, traveling to Italy and Spain, and again from 1954 to 1956. In 1957 Ramírez Villamizar participated in the São Paulo Bienal and the following year he exhibited in the Venice Biennale and began his first murals. In this period he began producing monochromatic reliefs and hard-edge geometric paintings featuring flat planes and strong colors, reflecting the influence of European Concrete art and the work of Joaquín Torres-García. Having visited pre-Columbian sites in Mexico in 1959, he later drew on their architectural structures and decorative forms for his abstract sculptures. Ramírez Villamizar taught art at New York University in 1963 and 1964. In 1964 and 1965 he created several murals for buildings in Colombia. He resided in New York from 1967 to 1973. For his one-person exhibition at the 1969 São Paulo Bienal, Ramírez Villamizar produced his first monumental sculptures. His work of the 1970s often translated pre-Columbian architectural forms into a Minimalist, geometric and abstract idiom. Ramírez Villamizar built *Four Towers*, his first monumental public sculpture, of reinforced concrete at the University of Vermont, Burlington, in 1971. He created other outdoor monolithic groupings at Fort Tryon Park, New York, in 1972 and in Bogotá in 1974. Ramírez Villamizar returned permanently to Bogotá in 1974. He continues to construct abstract sculptures that explore the geometry inherent in nature and present in pre-Columbian architecture. One-person exhibitions of his work include those at the Museo de Arte Moderno de Bogotá, 1972; the Museo de Arte de la Universidad Nacional, Bogotá, 1985; the Biblioteca Luis Angel Arango, Bogotá, 1985; and the Museo de Arte Moderno, Bucaramanga, Colombia, 1989. He represented Colombia at the 1976 Venice Biennale. His work was included in *Art of Latin America since Independence*, Yale University Art Gallery, New Haven, 1966; *Latin American Art, 1931–1966*, The Museum of Modern Art, New York, 1967; *L'art colombien à travers les siècles*, Musée du Petit Palais, Paris, 1975; *The Latin American Spirit: Art and Artists in the United States, 1920–1970*, The Bronx Museum of the Arts, New York, 1988; and *Homenaje a los artífices precolombinos*, Museo Nacional, Bogotá, 1990. Ramírez Villamizar lives in Bogotá.—L.L.

Nuno Ramos
Brazilian, born 1960

Nuno Alvarez Pessõa de Almeida Ramos was born in São Paulo. He received a B.A. in philosophy from the Universidade de São Paulo in 1982. In 1984 he joined the artists' group Casa-7 and participated in their exhibitions at the Centro Cultural, São Paulo, 1984; the Museu de Arte Contemporânea da Universidade de São Paulo, 1985; and the Museu de Arte Moderna, Rio de Janeiro, 1985. Ramos has diverged from his country's Constructivist and Conceptual tradition toward a more painterly expressionism. He has recently embarked on a series of nonfigurative paintings composed of multiple layers of impasto combined with three-dimensional materials such as rolled metal, glass, and organic matter. One-person exhibitions of his work have been organized by the Museu de Arte Contemporânea da Universidade de São Paulo, 1988, and the Centro Cultural, São Paulo, 1990. His work has been included in the 1985 and 1989 São Paulo Bienals; the 1986 Havana Bienal; *Modernidade: Art brésilien du 20ᵉ siècle*, Musée d'Art Moderne de la Ville de Paris, 1987; *Brasil já*, Galerie Landergirokasse, Stuttgart, 1988; and *Brasil: La nueva generación*, Fundación Museo de Bellas Artes, Caracas, 1991. Ramos lives in São Paulo.—E.B.

Vicente do Rego Monteiro
Brazilian, 1899–1970

Vicente do Rego Monteiro was born to a middle-class family in Recife, Pernambuco, Brazil. His parents encouraged their children's artistic abilities, and in 1911 Rego Monteiro was sent to Paris to study at the Académie Julian. In 1913 he exhibited paintings and sculptures at the Salon des Indépendants and also helped create sets for Sergei Diaghilev's *Ballets Russes*. Returning home in 1914, he became interested in the music and dance of northeastern Brazil. From 1919 to 1921 he had several exhibitions of watercolors and drawings portraying indigenous themes. In 1919 Rego Monteiro met the modernists Anita Malfatti, Victor Brecheret, and Emiliano di Cavalcanti in São Paulo. In order to better understand Brazil's artistic roots

and colonial past, he traveled in 1920 through the baroque cities of Minas Gerais state. Before returning to live in Paris from 1922 to 1930, he left eight works for inclusion in São Paulo's *Semana de arte moderna* in 1922. In Paris during the 1920s he was active in literary and artistic circles, and in 1923 published *Légendes, croyances et talismans des Indiens de l'Amazon*, adapted to French by Louis Duchartre. Always interested in the theater, he designed a stage adaptation of *Légendes* produced in 1924 and 1925. In 1930 Rego Monteiro was included in an exhibition of Latin American artists organized by Joaquín Torres-García at the Galerie Zack, Paris. Together with the poet and art critic Géo-Charles, he worked on the literary review *Montparnasse*; also with Géo-Charles he brought to Brazil in 1930 the first international exhibition, *L'Ecole de Paris*. He returned to his native Recife in 1932 and made a documentary film about rural Pernambuco in 1934. Becoming increasingly religious, he began to introduce Christian subjects into his paintings. In 1937 he decorated the Brazilian Chapel for the Vatican Pavilion at the *Exposition internationale: Arts et techniques dans la vie moderne* in Paris. In 1939 he was a founder of the critical review *Renovação*, which he edited until 1946. Throughout the 1940s and 1950s he dedicated himself to poetry. He lived in Paris again from 1946 to 1957, pursuing poetry until his return to Brazil. Rego Monteiro there served as a professor at the Universidade Federal de Pernambuco in 1957 and at the Instituto Central de Artes de Brasília from 1965 to 1968. A retrospective of his work was held at the Museu de Arte Contemporânea da Universidade de São Paulo in 1971. Rego Monteiro's paintings were included in *Modernidade: Art brésilien du 20ᵉ siècle*, Musée d'Art Moderne de la Ville de Paris, 1987; *Art in Latin America: The Modern Era, 1820–1980*, Hayward Gallery, London, 1989; and *Bilderwelt Brasilien: Die europäische Erkundung eines "irdischen Paradieses" und die Kunst der brasilianischen Moderne*, Kunsthaus Zürich, 1992.—E.B.

José Resende
Brazilian, born 1945

José Resende was born and schooled in São Paulo. After studying with Wesley Duke Lee at the Fundação Armando Alvares Penteado from 1963 to 1965, he received a B.A. in architecture from the Universidade Mackenzie in 1967 and an M.A. in history from the Universidade de São Paulo in 1981. Influenced by Brazil's neo-Concrete movement, Resende's early sculpture contains ironic references to Pop art and Minimalism. To provide an alternative to traditional art schools, he founded the Escola Brasil with Carlos Fajardo, Frederico Nasser, and Luiz Paulo Baravelli in 1970, and until 1974 he helped direct it. In 1975 Resende began the alternative art journal *Malasartes* with Waltercio Caldas, Cildo Meireles, and others; in 1980 he edited *A parte do fogo* with many of the same artists. After receiving a John Simon Guggenheim Memo-

rial Foundation Fellowship, Resende spent 1984 and 1985 in New York. Since the mid-1980s he has explored the properties of such materials as lead, leather, copper, and paraffin in a series of process-oriented sculptures. Resende taught at the Universidade Mackenzie from 1973 to 1975; at the Fundação Armando Alvares Penteado from 1976 to 1979; at the Universidade de São Paulo from 1981 to 1987; and at the Pontifícia Universidade Católica, Campinas, from 1976 to 1986. One-person exhibitions of his work have been organized by the Museu de Arte Contemporânea da Universidade de São Paulo, 1970 and 1990; the Museu de Arte Moderna, Rio de Janeiro, 1970 and 1975; the Museu de Arte de São Paulo, 1974; FUNARTE, Rio de Janeiro, 1988; and the Joseloff Gallery, University of Hartford, Connecticut, 1991. His work has been included in the 1967, 1983, and 1989 São Paulo Bienals; the 1980 Paris Biennale; *Modernidade: Art brésilien du 20ᵉ siècle*, Musée d'Art Moderne de la Ville de Paris, 1987; the 1988 Venice Biennale; *Viva Brasil viva*, Liljevalch Konsthall, Kulturhuset, Stockholm, 1991; and Documenta 9, Kassel, 1992. Resende lives in São Paulo.—E.B.

Armando Reverón
Venezuelan, 1889–1954

Armando Julio Reverón Travieso was born in Caracas. Reverón attended the Academia de Bellas Artes, Caracas, from 1908 to 1911; he was briefly expelled in 1909, when he and other students organized a strike for curricular reforms. In 1911 Reverón received a grant from the city of Caracas to study art in Europe. He subsequently traveled to Spain and enrolled in the Escuela de Artes y Oficios, Barcelona; after a brief return to Venezuela, Reverón studied at the Academia de San Fernando, Madrid, in 1912 and 1913. He traveled to Paris in 1914, returned to Spain, and left for Venezuela in 1915. While Reverón created few paintings during his European sojourn, his later works reveal an interest in Impressionism, pointillism, and the black paintings of Francisco Goya. Back in Caracas, Reverón became associated with the short-lived Círculo de Bellas Artes, a group of progressive Venezuelan artists and writers interested in Impressionism. From about 1919 to 1924 he created the paintings of his so-called Blue period—nearly monochromatic landscapes realized in similar tones of Impressionistic brushwork, which reflect the influence of the Rumanian artist Samys Mützner, the Venezuelan Emilio Boggio, and especially the Russian Symbolist Nicolas Ferdinandov, who were then living in Venezuela. In 1920 Reverón moved to the coastal village of Macuto with his companion, Juanita Ríos, a woman he met in La Guaira during Carnival in 1918 and would eventually marry (in 1950). He subsequently began to build "El Castillete de Las Quince Letras," a thatched-roof hut where he resided until his death. Having become more withdrawn and meditative, and inspired in part by the spiritual traditions of his coun-

try's indigenous inhabitants, Reverón began to approach the act of painting in increasingly ritualistic terms. From about 1925 to 1936 he produced the almost monochromatic paintings of his White period. Created with quick brushstrokes of thinly applied paint, these works portray abstracted landscapes and seascapes in an ethereal light. Beginning in the 1930s Reverón made life-size dolls that he used as models. From about 1936 to 1949 he created the paintings of his Sepia period, which were influenced to a great degree by his depressed mental state. While his works of the late 1930s typically depict expressionistically rendered female nudes, Reverón returned to landscape painting in the early 1940s. In 1974 the Castillete–Museo Armando Reverón was established in Macuto; in 1979 the Venezuelan government proclaimed the "Año de Reverón." One-person exhibitions of his work were organized by the Fundación Museo de Bellas Artes, Caracas, 1955; the Institute of Contemporary Art, Boston, 1956; the Museo de Arte Contemporáneo de Caracas, 1979; and the Palacio de Velázquez, Madrid, 1991. The artist's work was included in such group exhibitions as *The Emergent Decade: Latin American Painters and Painting in the 1960s*, Cornell University, Ithaca, New York, and the Solomon R. Guggenheim Museum, New York, 1965; *Art of Latin America since Independence*, Yale University Art Gallery, New Haven, 1966; *Figari, Reverón, Santa María*, Biblioteca Luis Angel Arango, Bogotá, 1985; *Art of the Fantastic: Latin America, 1920–1987*, Indianapolis Museum of Art, 1987; and *Art in Latin America: The Modern Era, 1820–1980*, Hayward Gallery, London, 1989.—J.A.F.

Diego Rivera
Mexican, 1886–1957

Born in Guanajuato, Mexico, José Diego María Rivera began to draw at age three. Studying at the Academia de San Carlos in Mexico City from 1898 to 1905, he took courses with Félix Parra, José María Velasco, and Santiago Rebull that reflected the positivist ideals predominant in Mexico's educational system at the turn of the century. In 1906 Rivera exhibited with the promodernist group Savia Moderna and received a four-year scholarship to study in Europe. In 1907 he traveled to Spain, where he studied with the realist painter Eduardo Chicharro y Agüera; in 1909 he visited Paris, Bruges, and London. After returning to Mexico in 1910, Rivera had a successful exhibition of his work, the proceeds of which partly financed a second trip to Europe in 1911. By 1913 he was working in a Cubist style, which he developed until 1917. In this period he associated with members of the European avant-garde, as well as with Mexican artists living in Paris. In 1914 he met Juan Gris and Pablo Picasso. In 1920 Rivera visited Italy, where he studied Etruscan, Byzantine, and Renaissance art. Upon his return to Mexico in 1921, he was appointed to a variety of federally sponsored arts positions by the Minister of Education, José Vas-

concelos, who invited him to visit Mayan ruins in the Yucatán. Rivera's first mural commission was for the Anfiteatro Bolívar of the Escuela Nacional Preparatoria, Mexico City, in 1922. That year he organized with other artists the Sindicato Revolucionario de Obreros Técnicos y Plásticos, which rejected easel painting as aristocratic and promoted monumental public art with historic and indigenous themes as the principal means of national artistic expression. At the end of 1922 he joined the Mexican Communist Party and his active involvement in its affairs included a trip to the Soviet Union in 1927 to celebrate the tenth anniversary of the October Revolution. In 1929, he was expelled from the Communist Party for disobedience to its policies (he would be readmitted as a member in 1954). His murals of the 1920s include those painted at the Secretaría de Educación Pública from 1923 to 1928 and at the Escuela Nacional de Agricultura in Chapingo from 1924 to 1927. In 1929 Rivera was appointed director of the Academia Nacional de Artes Plásticas (Academia de San Carlos), Mexico City, where he instituted radical curricular reforms. He married Frida Kahlo that year, and he began a monumental cycle of murals for the Palacio Nacional, on which he would work intermittently through the 1940s. In 1930 he traveled to the United States, where he painted murals in San Francisco at the Pacific Stock Exchange, 1930–31; and the California School of Fine Arts, 1931; The Detroit Institute of Arts, 1932–33; and the RCA Building, Rockefeller Center, New York, 1933. The latter work was destroyed in 1934 because of its Communist subject matter, but Rivera reproduced it at the Palacio de Bellas Artes, Mexico City. Between 1937 and 1942 he concentrated on oils and sketches of genre scenes and portraits. Rivera interceded for the admittance of the exiled Soviet revolutionary Leon Trotsky to Mexico in 1937; Trotsky and his wife, Natalia Sedova, lived in Kahlo's house in Coyoacán until 1939. That year Rivera and André Breton signed Trotsky's "Manifesto: For a Free Revolutionary Art." In 1940 he participated in the *Exposición internacional del surrealismo* at the Galería de Arte Mexicano, Mexico City. In 1942 Rivera began construction of his "residence-tomb" Anahuacalli, which now houses his large pre-Columbian art collection. He was awarded the Premio Nacional de Artes Plásticas by the Mexican government in 1950. Diagnosed with cancer in 1955, he traveled to Moscow for medical treatment and visited Czechoslovakia, Poland, and East Germany. Rivera's one-person exhibitions include those at the California Palace of the Legion of Honor, San Francisco, 1930; The Museum of Modern Art, New York, 1931; the Palacio de Bellas Artes, Mexico City, 1949; The Museum of Fine Arts, Houston, 1951; the Phoenix Art Museum, 1984; and The Detroit Institute of Arts, 1986 (afterwards circulated to Philadelphia, Mexico City, Madrid, and West Berlin). His work was included in *The Latin-American Collection of The Museum of Modern Art*, The Museum of Modern Art, New York, 1943; *Art of Latin America since Independence*, Yale University Art Gallery, New Haven, 1966; *The Latin American Spirit: Art and Artists in the United States, 1920–1970*, The Bronx Museum of the Arts, New York, 1988; *Art in Latin America: The Modern Era, 1820–1980*, Hayward Gallery, London, 1989; *Mexico: Splendors of Thirty Centuries*, The Metropolitan Museum of Art, New York, 1990; and *Crosscurrents of Modernism: Four Latin American Pioneers: Diego Rivera, Joaquín Torres-García, Wifredo Lam, Matta*, Hirshhorn Museum and Sculpture Garden, Smithsonian Institution, Washington, D.C., 1992. Rivera is interred in Mexico City's Rotonda de los Hombres Ilustres.—R.O.

Arnaldo Roche Rabell
Puerto Rican, born 1955

Arnaldo Roche Rabell was born in Santurce, Puerto Rico. His family moved to Vega Alta, Puerto Rico, shortly after his birth. Interested in art as a child, he began formal artistic studies at the Escuela Superior Lucchetti, Santurce, in 1969. Upon graduation he enrolled in the Escuela de Arquitectura, Universidad de Puerto Rico, Río Piedras, where he studied architecture, design, and illustration from 1974 to 1978. He moved to Chicago in 1979 to pursue a career as a painter. Roche Rabell received a B.F.A. in 1982 and an M.F.A. in 1984 from the School of the Art Institute of Chicago, where he was influenced by the artists Ray Yoshida and Richard Keane and by the art historian Robert Loescher. Since the late 1970s he has created expressionistic paintings, prints, and pastels featuring the human figure. Utilizing a complex technique, he rubs paint on an unprepared canvas draped over a nude model or object, or, alternatively, scrapes paint from a similarly draped canvas. In addition to depicting anonymous male and female models, Roche Rabell has repeatedly portrayed his mother and himself in these works. His best-known self-portraits are large, close-up images of his face. One-person exhibitions of his work have been organized by the Museo de Ponce, Puerto Rico, 1984; the Museo de la Universidad de Puerto Rico, Río Piedras, 1986; the InterAmerican Art Gallery, Miami-Dade Community College, Miami, 1989; and the Museo de Arte Contemporáneo, Monterrey, 1993. Roche Rabell's work has been included in the 1987 São Paulo Bienal; *Puerto Rican Painting: Between Past and Present*, Museum of Modern Art of Latin America, Organization of American States, Washington, D.C., 1987; *Art of the Fantastic: Latin America, 1920–1987*, Indianapolis Museum of Art, 1987; *Hispanic Art in the United States: Thirty Contemporary Painters and Sculptors*, The Museum of Fine Arts, Houston, 1987; and *Mito y magia en América: Los ochenta*, Museo de Arte Contemporáneo, Monterrey, 1991. Roche Rabell lives in Chicago and Puerto Rico.—J.A.F.

Carlos Rojas
Colombian, born 1933

Carlos Rojas was born in Facatativá, Colombia. He studied architecture at the Pontificia Universidad Javeriana and art at the Universidad Nacional, Bogotá, from 1953 to 1956. As a young artist he met the sculptors Edgar Negret and Eduardo Ramírez Villamizar. In 1958 he went to Rome, studying painting and sculpture at the School of Fine Arts and design at the Institute of Arts. On returning to Bogotá he taught drawing and design at the Universidad de los Andes, the Universidad Jorge Tadeo Lozano, the Colegio Mayor de Cundinamarca, and the Universidad Nacional. From this time until 1966, Rojas created paintings and collages that reflect the influence of Cubism; they contain intersecting fields of contrasting patterns or imitation surfaces such as wood grains and plaids, and solid colors. Frequently these works had unconventional shapes such as diamonds and ovals. The artist went to New York in the late 1960s, when his work was beginning to undergo radical change. His paintings of the series Ingeniería de la Visión, 1968–70, are Minimalist geometric abstractions that reflected his interest in physical science and perception. Concurrently he began creating abstract painted metal sculptures. His increasingly Minimalist sculptures of the 1970s were highly analytical; resembling large, geometric frameworks, they incorporated space into their structures. Rojas achieved his mature stage as a painter in the 1980s with square canvases that are completely abstract and frontal, typically featuring horizontal bands of color. His recent paintings explore illusionistic space through translucent layers of horizontal and vertical bands. The artist believes there is a natural inclination among Latin American artists toward geometric abstraction, which he regards as possessing an inherent spirituality. His one-person exhibitions include those at the Museo de Arte Moderno, Bogotá, 1965, 1974, 1977, and 1984; the Center for Inter-American Relations, New York, 1973; the Centro Colombo-Américano, Miami, 1982; and the Galería Casa Negret, Bogotá, 1988. Rojas's work has been included in *The Emergent Decade: Latin American Painters and Painting in the 1960s*, Cornell University, Ithaca, New York, and the Solomon R. Guggenheim Museum, New York, 1965; the 1975 São Paulo Bienal; *La plástica colombiana en el siglo XX*, Casa de las Américas, Havana, 1977; and *América Latina: Geometria sensível*, Museu de Arte Moderna, Rio de Janeiro, 1978. Rojas lives in Bogotá.—E.F.

Miguel Angel Rojas
Colombian, born 1946

Born in Bogotá, Miguel Angel Rojas moved with his family to Girardot, Colombia, in 1952. His education in Catholic schools influenced his later artistic development. Rojas studied architecture at the Pontificia Universidad Javeriana, Bogotá, from

1964 to 1966 and art at the Universidad Nacional, Bogotá, from 1968 to 1973. Since the late 1960s he has created paintings, photographs, prints, drawings, and installations that erode the boundaries between these mediums. Collectively, in spite of their stylistic differences, these works manifest the artist's continuing interest in exploring the nature of realism, eroticism, and personal identity. In the late 1960s and early 1970s Rojas produced abstract geometric paintings that reflect his architectural training. In 1972 he began to explore more personal themes in a series of photorealist prints and drawings of homoerotic subjects. Beginning in 1978 Rojas made a series of grainy photographs in the Teatro Faenza, an architecturally distinctive cinema in Bogotá patronized by homosexual men. In 1980 he created *Grano*, the first of many installations; in this work he completely covered the floor of a room with paper on which he drew highly realistic reproductions of the tiles found in his childhood home. In 1982 he produced *Vía Láctea*, a series of black-and-white photographs taken through a small hole in a public rest room. Absorbing the influence of the international avant-garde, Rojas began to create in the mid-1980s a series of expressionistic paintings and photographs, the latter produced using experimental darkroom techniques. Many of these works incorporate pre-Columbian imagery, a consequence of his growing interest in his ethnic roots. Rojas has taught at the Universidad Jorge Tadeo Lozano, the Universidad de los Andes, and the Universidad Nacional de Colombia. His one-person exhibitions include *Miguel Rojas*, Center for Inter-American Relations, New York, 1981, and a retrospective of photographs at the Museo de Arte de la Universidad Nacional, Bogotá, 1988. His work has been included in the 1981 São Paulo Bienal; *Works on Paper: Franco, González, Rojas*, Center for Inter-American Relations, New York, 1981; the 1985 Havana Bienal; *A Marginal Body: The Photographic Image in Latin America*, Australian Centre for Photography, Sydney, 1987; and *Mito y magia en América: Los ochenta*, Museo de Arte Contemporáneo, Monterrey, 1991. Rojas lives in Bogotá. —J.A.F.

Rhod Rothfuss
Uruguayan, 1920–1972

Rhod Rothfuss was born in Montevideo, and studied there at the Academia Nacional de Bellas Artes in the early 1940s. Living in Buenos Aires from 1942 to 1945, he met Gyula Kosice, Tomás Maldonado, and Carmelo Arden Quin, with whom he actively discussed issues related to modern art in Argentina. Rothfuss was a key theoretician for the development of the Concrete art movement in Argentina in the 1940s. In 1944 he contributed an important article to the single number of the cultural review *Arturo*, "El marco: Un problema de plástica actual" ("The Frame: A Problem in Contemporary Art"). In 1945 he participated in the two exhibitions titled *Arte Concreto-Invención*; the

following year he was a founder of the Grupo Madí. To emphasize the concrete aspect of his art, in this period, Rothfuss employed nontraditional formats for his paintings, such as diamonds or notched, irregular shapes. He also created abstract sculptures with movable parts from 1945 to 1950. His work was included in *Homenaje a la vanguardia argentina: Década del 40*, Galería Arte Nuevo, Buenos Aires, 1976; and *Vanguardias de la década del 40*, Museo de Artes Plásticas Eduardo Sívori, Buenos Aires, 1980.—E.F.

Bernardo Salcedo
Colombian, born 1939

Bernardo Salcedo was born in Bogotá and there studied architecture at the Universidad Nacional de Colombia, from 1959 to 1965, when he began teaching at the Universidad Nacional, the Pontificia Universidad Javeriana, and the Universidad Piloto, all in Bogotá. In the 1960s and 1970s he made box constructions with fragmented and juxtaposed objects, such as enigmatic bits of machinery and disembodied doll parts, that were indebted to Dada and Surrealism. He lived in Budapest for three years in the late 1970s. In the early 1980s Salcedo created the Señales Particulares, pictorial constructions that feature photographs and found objects. At the Venice Biennale in 1984 the artist showed wooden boxes filled with saw blades that he called Cajas del Agua. His monumental sculpture *Atrapa Rayos* was installed at the Aeropuerto José María Córdoba in Medellín that same year. The Museo de Arte Moderno in Bogotá held one-person exhibitions of his work in 1966, 1967, and 1969; in 1972 the Museo de Arte Moderno in Buenos Aires was the site of a Salcedo exhibition. His work has been included in the 1971 and 1983 São Paulo Bienals; the *Primer encuentro internacional de arte para la destrucción*, Pamplona, 1973; *Kunstsystemen in Latijns-Amerika*, Palais des Beaux-Arts, Brussels, 1974; *Abstract Attitudes: Caldas/Katz/Salcedo*, Museum of Art, Rhode Island School of Design, Providence, and Center for Inter-American Relations, New York, 1984; and *Fotografía: Zona experimental*, Centro Colombo Americano de Medellín, 1985. Salcedo lives in Bogotá.—J.R.W.

Juan Sánchez
American, born 1954

Born to parents of Afro–Puerto Rican descent in Brooklyn, Juan Sánchez was raised in predominantly Puerto Rican neighborhoods. While in high school he attended meetings of the Young Lords, a radical Puerto Rican political organization similar to the Black Panthers. He was inspired by the work of En Foco, originally a group of photographers who documented life in the Puerto Rican diaspora, after seeing the exhibition *Dos Mundos* at the City Gallery, New York, in 1972. In 1973 Sánchez met the artist Jorge Soto at the Taller Boricua, a collective of Puerto Rican painters, printmakers, and

sculptors who expressed their cultural roots in their work. In 1977 Sánchez received a B.F.A. from The Cooper Union for the Advancement of Science and Art, New York, where he studied with Hans Haacke, Charles Seide, and Eugene Tulchin. In 1980 he received an M.F.A. from Rutgers University, New Brunswick, New Jersey, where he studied with Leon Golub and Melvin Edwards. Since that time Sánchez has created mixed-medium paintings and prints he calls "Rican/Structions," a term borrowed from the Salsa musician Ray Barretto. These works reflect the artist's commitment to producing images that reconstruct Puerto Rican histories and identities from an activist perspective. Borrowing from varied sources, including Taino petroglyphs, Puerto Rican popular art forms, and mainstream American and European painting, they consist of layers of drawn and painted images, graffitilike texts, and photographs. In addition to participating in artists' collectives such as Group Material and Political Art Documentation/Distribution, Sánchez has written numerous articles and organized art exhibitions. His awards include fellowships from the National Endowment for the Arts, 1983; the New York State Council on the Arts, 1985; the John Simon Guggenheim Memorial Foundation, 1988; and the New York Foundation for the Arts, 1988 and 1992. Sánchez has had one-person exhibitions at Exit Art, New York, 1989, and the University Art Museum, State University of New York at Binghamton, 1991. His work has been included in *Committed to Print: Social and Political Themes in Recent American Printed Art*, The Museum of Modern Art, New York, 1988; and *The Decade Show: Frameworks of Identity in the 1980s*, the Museum of Contemporary Hispanic Art, The New Museum of Contemporary Art, and The Studio Museum in Harlem, New York, 1990. Sánchez lives in New York.—J.A.F.

Mira Schendel
Brazilian, 1919–1988

Mira Hargesheimer Schendel was born in Zurich. As a student in Milan, where her family had moved when she was a child, she studied philosophy. She had always enjoyed drawing, and she began to concentrate seriously on art after moving to Pôrto Alegre, Brazil, in 1949. In 1952 she moved to São Paulo. Though she is sometimes included among the Brazilian Constructivists, the artist holds a distinctive position within the context of Brazilian modernism. Schendel employed letters, words, and other graphic symbols as formal elements, and at the same time she imbued them with mystical characteristics. In the 1980s she worked on a series of visual interpretations of the *I Ching*, combining explorations of its graphic forms with modernist concerns. Schendel's first one-person exhibition was held in 1950, at the auditorium of the newspaper *Correio do povo* in Pôrto Alegre; others include those at the Museu de Arte Moderna, São Paulo, 1954; the Museu de Arte Moderna, Rio de Janeiro, 1968; and the Museu de Arte Contem-

porânea da Universidade de São Paulo, 1990. Group exhibitions in which her work was shown include the 1951, 1953, 1963, 1965, 1967, and 1981 São Paulo Bienals; the 1968 Venice Biennale; the *Concrete Poetry Show*, Lisson Gallery, London, 1968; *Modernidade: Art brésilien du 20ᵉ siècle*, Musée d'Art Moderne de la Ville de Paris, 1987; *The Image of Thinking in Visual Poetry*, the Solomon R. Guggenheim Museum, New York, 1989; and *Art in Latin America: The Modern Era, 1820–1980*, Hayward Gallery, London, 1989.—T.C.

Lasar Segall
Lithuanian, 1891–1957

Lasar Segall, son of a Torah scribe, was born in Vilna, Lithuania, and was raised in its ghetto. He received a religious education, which is reflected in the Jewish themes prevalent in his painting. Segall studied in Berlin at the Akademie der Bildenden Künste from 1907 to 1909. That year he exhibited as part of the Freie Sezession group. He moved in 1910 to Dresden, where he was affiliated with the academy as a Meisterschüler. There he met Otto Dix and George Grosz and joined the Expressionist movement. In 1912 Segall made his first trip to Brazil, where he had one-person exhibitions in São Paulo and Campinas in 1913 before returning to Dresden. For part of World War I he was confined as a Russian citizen. In 1917 and 1918 he resided in Vilna. In 1919 he founded the Gruppe 1919 der Dresdner Sezession with Dix, Otto Lange, and other artists. Segall emigrated to Brazil in 1923, and he exhibited works on Brazilian themes in Germany in 1926. He experimented with sculpture in Paris from 1928 to 1932, when he returned permanently to Brazil and founded the Sociedade Pró-Arte Moderna in São Paulo with Tarsila do Amaral, Anita Malfatti, Gregori Warchavchik, and others. During the 1920s and 1930s Segall became interested in stage and spectacle design. He designed the Sociedade's carnival balls in 1933 and 1934 and Yiddish theater productions. From the mid-1930s into the 1940s, he pursued themes of contemporary human suffering, concentrating especially on Jewish tragedies such as those of the concentration camps and pogroms. In the 1950s he began his last cycle of paintings, which focus on Brazilian society. In 1970 the artist's home opened as the Museu Lasar Segall, São Paulo. Segall had his first one-person exhibition at the Gurlitt Galerie, Dresden, in 1910. Several individual exhibitions of Segall's Expressionist work were held, including those at the Folkwang Museum, Hagen, 1920, and the Kunsthalle Leipzig, 1923. He had one-person exhibitions in São Paulo in 1924 and 1928. His exhibitions of the late 1940s include those at the Association of American Artists, New York, and the Pan American Union, Washington, D.C., 1948. He was given an exhibition at the Museu de Arte de São Paulo, 1951; he was the guest of honor at the 1951 and 1955 São Paulo Bienals; memorial exhibitions of his work were held

at the 1957 and 1959 São Paulo Bienals; and retrospectives took place in Venice, Paris, Barcelona, Amsterdam, and Nuremberg. Segall's work was included in *The Latin-American Collection of The Museum of Modern Art*, The Museum of Modern Art, New York, 1943; *Modernidade: Art brésilien du 20ᵉ siècle*, Musée d'Art Moderne de la Ville de Paris, 1987; *The Latin American Spirit: Art and Artists in the United States, 1920–1970*, The Bronx Museum of the Arts, New York, 1988; *Art in Latin America: The Modern Era, 1820–1980*, Hayward Gallery, London, 1989; *Degenerate Art: The Fate of the Avant-Garde in Nazi Germany*, Los Angeles County Museum of Art, 1991; and *Bilderwelt Brasilien: Die europäische Erkundung eines "irdischen Paradieses" und die Kunst der brasilianischen Moderne*, Kunsthaus Zürich, 1992.—E.B.

Antonio Seguí
Argentine, born 1934

Antonio Hugo Seguí was born in Córdoba, Argentina. He traveled in Europe in 1951 and 1952, studying painting and sculpture in Madrid and Paris. In his early work, influenced by the work of George Grosz and Otto Dix, among others, expressionistically rendered writhing bodies are depicted with overtones of social satire. In 1958 Seguí traveled across South and Central America and settled for a time in Mexico, where he continued to study art, visited pre-Columbian sites, and began collecting ancient art. He lived in Buenos Aires in the early 1960s and painted on photographic enlargements; his graphic work of this time was closely related to cartoons. In 1963 he moved to Arcueil, a suburb of Paris. In the late 1960s he made a number of painted-wood constructions. In the early 1970s he produced a series of parodic boating scenes and family portraits in the styles of Edouard Manet, Edgar Degas, and Henri Matisse. After a short trip to Africa he drew a series of elephants and Argentine landscapes in charcoal on large canvases. He executed a group of paintings after Rembrandt's *Anatomy Lesson of Doctor Tulp* in the late 1970s. An exhibition of his paintings of darkly comic nocturnal park scenes was held at the Musée d'Art Moderne de la Ville de Paris in 1979. In the 1980s Seguí made use of a recurrent character, a man in a suit and hat who traverses urban settings; in one series the little man visits the monuments of Paris, while in a later one he moves enmeshed in an overall patterning of figures, buildings, animals, trees, and other objects. His one-person exhibitions include those at the Galería Paideia and the Dirección de Cultura, Córdoba, Argentina, 1957; the Museo Municipal de Arte, Guatemala City, and the Museo de Arte Colonial, Quito, 1958; the Kunsthalle, Darmstadt, and the Instituto de Arte Contemporáneo, Lima, 1969; the Museo de Arte Moderno, Buenos Aires, 1972 and 1991; the Fundación Museo de Bellas Artes, Caracas, 1978; and the Présence Contemporaine at the Cloître Saint Louis, Aix-en-Provence, 1985. He represented Argentina in the Venice Bi-

ennales of 1964 and 1984, and his work has been included in *The Emergent Decade: Latin American Painters and Painting in the 1960s*, Cornell University, Ithaca, New York, and the Solomon R. Guggenheim Museum, New York, 1965; and *The Latin American Spirit: Art and Artists in the United States, 1920–1970*, The Bronx Museum of the Arts, New York, 1988. Seguí lives in Arcueil, Buenos Aires, and Córdoba.—J.R.W.

Daniel Senise
Brazilian, born 1955

Daniel Senise Portela was born in Rio de Janeiro and completed his education there. He studied civil engineering in 1980 at the Universidade Federal and painting from 1980 to 1984 at the Escola de Artes Visuais do Parque Lage, where he now teaches. Senise has created paintings that deviate from his country's Constructivist tradition, displaying a more lyrical mode of abstraction. He rubs, stains, and batters his canvases, which feature both recognizable and invented forms, religious references, and evocative anthropomorphic shapes. His work has been included in the 1985 and 1989 São Paulo Bienals; the 1986 Havana Bienal; *Modernidade: Art brésilien du 20ᵉ siècle*, Musée d'Art Moderne de la Ville de Paris, 1987; *U-ABC*, Stedelijk Museum, Amsterdam, 1989; the 1990 Venice Biennale; *Mito y magia en América: Los ochenta*, Museo de Arte Contemporáneo, Monterrey, 1991; *Viva Brasil viva*, Liljevalch Konsthall, Kulthurhuset, Stockholm, 1991; and *Brasil: La nueva generación*, Fundación Museo de Bellas Artes, Caracas, 1991. Senise lives in Rio de Janeiro.—E.B.

David Alfaro Siqueiros
Mexican, 1896–1974

David Alfaro Siqueiros was born in Chihuahua, Mexico. He studied in Mexico City from 1911 to 1913 at the Escuela de Artes Plásticas (Academia de San Carlos) and the Escuela al Aire Libre Barbizon. During the Mexican Revolution he contributed to the *carranzista* newspaper *La Vanguardia*; he joined the Constitutionalist army in 1914. Traveling to Europe as a military attaché in 1919, he met Diego Rivera in Paris. He edited the Barcelona review *Vida americana* in 1921. In its only issue was his first manifesto, "Tres llamamientos de orientación actual a los pintores y escultores de la nueva generación americana" ("Three Appeals for a Modern Direction to the New Generation of American Painters and Sculptors"), which advocated monumental public art, the value of indigenous culture, and the need to integrate universal themes with new forms and modern materials. After returning to Mexico City in 1922, Siqueiros painted murals at the Escuela Nacional Preparatoria, Mexico City. He also organized the Sindicato Revolucionario de Obreros Técnicos y Plásticos with Rivera and others and edited *El Machete*, the Union's publication. Siqueiros was imprisoned in

Taxco for his role in the May Day demonstrations held in Mexico City in 1930. It was in that year that he met the Soviet filmmaker Sergei Eisenstein and that he was exiled from Mexico for illegal political activity. Siqueiros began fresco commissions in Los Angeles at the Chouinard School of Art and the Plaza Art Center in 1932. For the latter, *La América tropical*, he employed the technique of airbrush on cement. Deported from the United States in 1932, Siqueiros traveled to Uruguay and Argentina, where he collaborated with Antonio Berni and Lino Enea Spilimbergo on an experimental mural for the home of the newspaper publisher Natalio Botana. He was deported from Uruguay in 1933 for political activity. In 1936 Siqueiros went to New York, where he established the experimental workshop A Laboratory of Modern Techniques in Art to explore the viability of modern industrial tools and paints, photography, and "accidental methods" in the fine arts. His students, including Jackson Pollock, created posters, floats, and murals that synthesized a realistic artistic style with leftist political content. Siqueiros served as an officer in the army of the Spanish Republic from 1937 to 1939. He returned to Mexico the next year and was implicated in the assassination plot against Leon Trotsky, who had been living in exile there. Siqueiros himself was exiled from Mexico in 1940. He completed murals in Chillán, Chile, in 1942, and Havana, in 1943. From 1952 to 1958 Siqueiros painted murals in Mexico City, including those at the Ciudad Universitaria and at the Museo Nacional de Historia. He was imprisoned by President López Mateos for "social dissolution" in 1960 but was pardoned in 1964. He then began work on his largest mural, *The March of Humanity in Latin America*, which he later modified for the Polyforum Cultural Siqueiros in Mexico City. The artist received the National Prize from the Mexican government in 1966 and the Lenin Peace Prize from the Soviet Union in 1967. One-person exhibitions of his work were held at the Casino Español, Mexico City, 1932; the Palacio de Bellas Artes, Mexico City, 1947; the Museo Universitario de Ciencias y Arte, Ciudad Universitaria, Mexico City, 1967; and the Museum of Modern Art, Kobe, Japan, 1972. Group exhibitions in which his work was represented include *The Latin-American Collection of The Museum of Modern Art*, The Museum of Modern Art, New York, 1943; *Art of Latin America since Independence*, Yale University Art Gallery, New Haven, 1966; *Imagen de Mexico: Der Beitrag Mexikos zur Kunst des 20. Jahrhunderts*, Schirn Kunsthalle Frankfurt, 1987; *The Latin American Spirit: Art and Artists in the United States, 1920–1970*, The Bronx Museum of the Arts, New York, 1988; *Art in Latin America: The Modern Era, 1820–1980*, Hayward Gallery, London, 1989; and *Mexico: Splendors of Thirty Centuries*, The Metropolitan Museum of Art, New York, 1990. Siqueiros is interred in the Rotonda de los Hombres Ilustres in Mexico City.—R.O.

Ray Smith
Mexican-American, born 1959

Born in Brownsville, Texas, Ray Smith Yturria was raised in Mexico City, where he attended a preparatory school with ample studio space and an extensive library. During this period he painted every day, acquired a knowledge of art history, and decided to become an artist. After his family's home was destroyed during the Mexico City earthquake of 1985, Smith went to New York, intending to stay only temporarily. While this move made him more conscious of his roots in the United States, it also reinforced his sense of himself as a Mexican. The artist's bicultural heritage is reflected in the paintings, prints, and sculptures he has produced since the late 1970s. Drawing from European and Mexican artistic traditions, Smith's major works are brightly colored figurative paintings on wood panels, which feature animals and animal-human hybrids arrayed against a variety of backgrounds, including decorative patterns, geometric designs, fields of letters and numbers, and landscapes. While the large scale and broadly political character of these works reflect the influence of the Mexican muralists, their style derives primarily from such artists as Pablo Picasso, Francis Picabia, and Fernand Léger. Smith has stated that the training in fresco painting he obtained from Mexican craftsmen during his youth led him to prefer wood to canvas as a support. Wood also reminds him of Mexican *retablos*. One-person exhibitions of his work have been organized by the Institute of Contemporary Art, Boston, 1989, and the Bonnefantenmuseum, Maastricht, The Netherlands, 1992. Group exhibitions in which he has participated include the 1989 Whitney Biennial; *With the Grain: Contemporary Panel Painting*, Whitney Museum of American Art at Champion, Stamford, Connecticut, 1990; *Through the Path of Echoes: Contemporary Art in Mexico*, Independent Curators Incorporated, New York, 1990; and *Mito y magia en América: Los ochenta*, Museo de Arte Contemporáneo, Monterrey, 1991. Smith lives in Cuernavaca and New York.—J.A.F.

Jesús Rafael Soto
Venezuelan, born 1923

Jesús Rafael Soto was born in Ciudad Bolívar, Venezuela. In his teens he worked as a commercial artist, painting posters for local movie theaters. He later entered the Escuela de Artes Plásticas in Caracas, where he met Carlos Cruz-Diez and Alejandro Otero. Upon seeing a Cubist painting by Georges Braque, he became interested in reductive and geometric modes of expression. Soto directed the Escuela de Artes Plásticas in Maracaibo from 1947 to 1950, when he left for Paris and began associating with Yaacov Agam, Jean Tinguely, Victor Vasarely, and other artists connected with the Salon des Réalités Nouvelles and the Galerie Denise René. In the mid-1950s Soto strove to create optical movement in his paintings and constructions; by the end of the decade he had developed an idiom in which squares, twisted wires, or other items are placed in front of a background of thin parallel lines, causing the objects to vibrate visually with the movement of the viewer. In 1969, for his retrospective at the Musée d'Art Moderne de la Ville de Paris, the artist constructed the first of his large Penetrables, environments of hanging plastic or metal tubes that could be entered and displaced by the spectator. He completed many public commissions, including murals for the UNESCO building in Paris in 1970. Soto was instrumental in establishing the Museo de Arte Moderno Jesús Soto in Ciudad Bolívar in 1973. The monumental *Esfera Virtual*, for the Olympic Sculpture Park in Seoul, South Korea, was installed in 1988. One-person exhibitions of his work have been held at the Stedelijk Museum, Amsterdam, 1968; the Fundación Museo de Bellas Artes, Caracas, 1971; the Museo de Arte Moderno, Bogotá, 1972; the Solomon R. Guggenheim Museum, New York, 1974; the Palacio de Velázquez, Madrid, 1982; the Museo de Arte Contemporáneo de Caracas, 1983; the Center for the Fine Arts, Miami, 1985; and the Museum of Modern Art, Kamakura, Japan, 1990. Soto's work has been included in the 1963 São Paulo Bienal; the 1964 and 1966 Venice Biennales; *The Emergent Decade: Latin American Painters and Painting in the 1960s*, Cornell University, Ithaca, New York, and the Solomon R. Guggenheim Museum, New York, 1965; *Art of Latin America since Independence*, Yale University Art Gallery, New Haven, 1966; *The Latin American Spirit: Art and Artists in the United States, 1920–1970*, The Bronx Museum of the Arts, New York, 1988; and *Art in Latin America: The Modern Era, 1820–1980*, Hayward Gallery, London, 1989. Soto lives in Paris and Caracas.—J.R.W.

Rufino Tamayo
Mexican, 1899–1991

Rufino Tamayo was born in Oaxaca, Mexico. He was of Zapotec Indian descent. Orphaned, he moved to Mexico City in 1911 to live with an aunt who owned a wholesale fruit business. He began taking drawing lessons in 1915 and attended the Escuela de Artes Plásticas (Academia de San Carlos) from 1917 to 1921. That year he was appointed head of the Departamento de Dibujo Etnográfico at the Museo Nacional de Arqueología in Mexico City; his work was influenced thereafter by pre-Columbian and Mexican folk art. Tamayo lived in New York from 1926 to 1928 and saw modern art from Europe in museums and galleries; he met Stuart Davis and viewed the Henri Matisse exhibition at The Brooklyn Museum in 1928. Back in Mexico City, he taught painting at the Escuela de Artes Plásticas (Academia de San Carlos) in 1928 and 1929. Like María Izquierdo, with whom he shared a studio from 1929 to 1933, Tamayo painted allusive figural compositions and still lifes, often with tropical fruits, in a high-keyed chromatic range. He met with disapproval from the prevailing

muralists because of his modernist sensibility, non-utilitarian aesthetic, political neutrality, and internationalism. He was named head of the Departamento de Artes Plásticas de la Secretaría de Educación in 1932 and painted a mural in the Escuela Nacional de Música the following year. As a delegate of the Liga de Escritores y Artistas Revolucionarios to the American Artists Congress, Tamayo returned to New York in 1936; he stayed for twelve years, teaching at the Dalton School from 1938 to 1947. He was commissioned to paint a mural in the Museo Nacional de Antropología in Mexico City in 1938. A series of pictures of violent animals from the early 1940s was based on forms from Mexican popular art but seemed to reflect wartime concerns. The artist painted a mural at Smith College in Northampton, Massachusetts, in 1943. He formed the Tamayo Workshop at the Art School of The Brooklyn Museum in 1946. His 1948 exhibition at the Palacio de Bellas Artes in Mexico City was attacked in the press by David Alfaro Siqueiros for its abstraction. Tamayo painted a series of pictures of human figures confronting the infinite celestial spaces of the universe in the late 1940s and early 1950s. He moved to Paris in 1949. Tamayo painted a mural in the Palacio de Bellas Artes, Mexico City, in 1952. He created a mural in the UNESCO building in Paris in 1958. In the 1950s his figures became flatter and more schematic, and his colors often tended toward intense harmonies of a single hue. He returned to Mexico in 1964 and painted a mural in the new Museo Nacional de Antropología, Mexico City. The next year he donated his collection of pre-Columbian art to Oaxaca to form the Museo de Arte Prehispánico de México Rufino Tamayo. The Museo de Arte Contemporáneo Internacional Rufino Tamayo opened in Mexico City in 1981. Tamayo's one-person shows include those at the Galería de Arte Moderno del Teatro Nacional, Mexico City, 1929; the Instituto de Arte Moderno, Buenos Aires, 1951; the Palacio de Bellas Artes, Mexico City, 1967 and 1987; the Phoenix Art Museum and the National Museum of Art, Belgrade, 1968; the Musée d'Art Moderne de la Ville de Paris, 1974; the Museo de Arte Moderno, Mexico City, and the Museum of Modern Art, Tokyo, 1976; the Fundación Museo de Bellas Artes, Caracas, 1977; the Phillips Collection, Washington, D.C., 1978; the Solomon R. Guggenheim Museum, New York, 1979; the Museo de Arte Contemporáneo Internacional Rufino Tamayo, 1987; and the Museo Nacional Centro de Arte Reina Sofía, Madrid, 1988. His work was included in *The Latin-American Collection of The Museum of Modern Art*, The Museum of Modern Art, New York, 1943; the 1949 and 1968 Venice Biennales; the 1953 and 1977 São Paulo Bienals; *The Emergent Decade: Latin American Painters and Painting in the 1960s*, Cornell University, Ithaca, New York, and the Solomon R. Guggenheim Museum, New York, 1965; *Art of Latin America since Independence*, Yale University Art Gallery, New Haven, 1966; *Art of the Fantastic: Latin America, 1920–1987*, Indianapolis Museum

of Art, 1987; *The Latin American Spirit: Art and Artists in the United States, 1920–1970*, The Bronx Museum of the Arts, New York, 1988; *Art in Latin America: The Modern Era, 1820–1980*, Hayward Gallery, London, 1989; and *Mexico: Splendors of Thirty Centuries*, The Metropolitan Museum of Art, New York, 1990. —J.R.W.

Francisco Toledo
Mexican, born 1940

Francisco Toledo was born in the town of Juchitán, Oaxaca, of Zapotec Indian heritage. In 1951 he moved to the city of Oaxaca, where, in 1956, he produced linoleum-block prints at a workshop led by Arturo García Bustos, a former student of Frida Kahlo. In 1957 Toledo began to study in the Taller Libre de Grabado de la Escuela de Diseño y Artesanías, part of the Instituto Nacional de Bellas Artes, Mexico City. He moved to Europe in 1960 and studied printmaking with Stanley William Hayter in Paris. Toledo met Rufino Tamayo and the writers Octavio Paz and Carlos Fuentes; he also admired the work of Marc Chagall, Paul Klee, and Jean Dubuffet. He returned to Mexico in 1965. The imagery of Toledo's paintings, drawings, and prints, which includes cartoonlike human figures, anthropomorphic animals, and animist landscapes, often with sexual overtones, is inspired by Oaxacan folklore as well as by pre-Columbian mythology and colonial-era legends. Toledo has also designed tapestries, made ceramics, and illustrated books. The artist lived in New York in 1966. An exhibition of a series of works inspired by the writings of Jorge Luis Borges traveled internationally in the late 1980s and early 1990s. Toledo donated a collection of graphic art to found the Instituto de Artes Gráficas de Oaxaca in 1989. His one-person exhibitions include those at the Galería Antonio Souza, Mexico City, and the Fort Worth Art Center, Texas, 1959; the Museo de Arte Moderno de Bogotá, 1976; in Mexico City, the Museo de Arte Moderno, 1980, and the Museo del Palacio de Bellas Artes, 1984; and The Mexican Fine Arts Center Museum, Chicago, 1988. Toledo's work has been featured in *Art of the Fantastic: Latin America, 1920–1987*, Indianapolis Museum of Art, 1987, and *Imagen de Mexico: Der Beitrag Mexikos zur Kunst des 20. Jahrhunderts*, Schirn Kunsthalle Frankfurt, 1987. Toledo lives in Oaxaca and Mexico City. —J.R.W.

Joaquín Torres-García
Uruguayan, 1874–1949

Joaquín Torres-García was born in Montevideo. His father was a Catalan merchant, and his mother was a native Uruguayan who taught her son at home. The family moved to Spain in 1891, settling first in Mataró, then in Barcelona. Torres-García enrolled at the Escuela Oficial de Bellas Artes de Barcelona (the "Llotja") and at the Academia Baixas as well; he also joined the Cercle Artístic Sant Lluc, a Catholic artists' association. By the end

of the decade he had become, along with Pablo Picasso and Julio González, part of the bohemian milieu of the café Els Quatre Gats. He exhibited and published drawings and illustrations in a style derived from those of Théophile-Alexandre Steinlen and Henri de Toulouse-Lautrec. Torres-García assisted Antoni Gaudí with stained-glass windows for the cathedral of Palma de Mallorca in 1903, and later with the windows for the Sagrada Familia in Barcelona. The artist's commissions of this time included murals for the Church of San Agustín in Barcelona, 1908; for the Uruguayan pavilion at the Exposition Universelle in Brussels in 1910; and for the seat of the Catalan government, the Palau de la Generalitat in Barcelona, where he worked from 1912 to 1918. He developed at this time a style of pastoral and monumental classicism derived from that of Pierre Puvis de Chavannes. Torres-García published the first book of his aesthetic theories, *Notes sobre art*, in 1913. He moved to New York in 1920 with the intention of manufacturing wood toys he had designed; there he met Marcel Duchamp, Katherine Dreier, Joseph Stella, and Gertrude Vanderbilt Whitney. He exhibited with Stuart Davis at the Whitney Studio Club in 1921; his works of this time are flat, graphic drawings and paintings of geometricized and fragmented cityscapes. He moved to Italy in 1922, then to Villefranche-sur-Mer, near Nice, in 1924. In 1926, Torres-García shared a studio in Paris with Jean Hélion. He became interested in prehistoric and primitive art, including pre-Columbian objects; his son Augusto worked making drawings of Nazca pottery for the inventory files of the Musée du Trocadéro. Torres-García met Theo van Doesburg in 1928 and Piet Mondrian the next year. He founded the group Cercle et Carré with Michel Seuphor in 1930. The style of Constructive Universalism he developed at this time retained the gridded structure of Neo-Plasticism but invested each compartmentalized rectangle with a schematic motif, emblematic of autobiographical, mathematical, spiritual, or metaphysical concerns. His compositions, which he often based on the proportions of the Golden Section, were in primary colors or were nearly monochromatic. He left Paris for Spain in 1932, returned to Montevideo in 1934, and in the following year founded the Asociación de Arte Constructivo (AAC) and published his book *Estructura*. Through teaching, writing, and lecturing, he promoted his aesthetic theory and the idea of a uniquely South American art. The AAC published the journal *Círculo y cuadrado* from 1936 until 1943. Torres-García's *Cosmic Monument*, a stone wall inscribed with symbols, was erected in the Parque José Enrique Rodó in Montevideo in 1938. The following year he wrote his autobiography. In 1943 he founded the Taller Torres-García in Montevideo, an arts-and-crafts workshop devoted to pedagogy and collective work, and published the theoretical book *Universalismo constructivo: Contribución a la unificación del arte y la cultura de América*. The Taller executed a mural cycle for Montevideo's Colonia Saint

Bois hospital in 1944 and began issuing the periodical *Removedor*. A fire during a show at the Museu de Arte Moderna, Rio de Janeiro, in 1978 destroyed many works. Torres-García's one-person shows include those at the Museo de Arte Moderno, Madrid, 1933; the Instituto de Arte Moderno, Buenos Aires, 1951; the Musée d'Art Moderne de la Ville de Paris, 1955; the Stedelijk Museum, Amsterdam, 1961; and the Comisión Nacional de Bellas Artes, Montevideo, 1962. Exhibitions were also presented at the National Gallery of Canada, Ottawa, the Solomon R. Guggenheim Museum, New York, and the Museum of Art, Rhode Island School of Design, Providence, 1971–72; and the Hayward Gallery, London, 1985. The exhibition *La escuela del sur: El Taller Torres-García y su legado/El Taller Torres-García: The School of the South and Its Legacy* was presented between 1991 and 1993 at the Museo Nacional Centro de Arte Reina Sofía, Madrid; the Archer M. Huntington Art Gallery, The University of Texas, Austin; the Museo de Monterrey, Mexico; The Bronx Museum of the Arts, New York; and the Museo Rufino Tamayo, Mexico City. His work was represented in *The Latin-American Collection of The Museum of Modern Art*, The Museum of Modern Art, New York, 1943; *The Emergent Decade: Latin American Painters and Painting in the 1960s*, Cornell University, Ithaca, New York, and the Solomon R. Guggenheim Museum, New York, 1965; *Art of Latin America since Independence*, Yale University Art Gallery, New Haven, 1966; *Art of the Fantastic: Latin America, 1920–1987*, Indianapolis Museum of Art, 1987; *The Latin American Spirit: Art and Artists in the United States, 1920–1970*, The Bronx Museum of the Arts, New York, 1988; *Art in Latin America: The Modern Era, 1820–1980*, Hayward Gallery, London, 1989; and *Crosscurrents of Modernism: Four Latin American Pioneers: Diego Rivera, Joaquín Torres-García, Wifredo Lam, Matta*, Hirshhorn Museum and Sculpture Garden, Smithsonian Institution, Washington, D.C., 1992.—J.R.W.

Tunga
Brazilian, born 1952

Antonio José de Barros Carvalho e Mello Mourão, known as Tunga, was born in Palmares, Pernambuco, Brazil. In 1974 he received a B.A. in architecture from the Universidade Santa Ursula, Rio de Janeiro. With José Resende, Waltercio Caldas, and others he founded the alternative art journals *Malasartes* in 1975 and *A parte do fogo* in 1980. During the 1980s Tunga made large-scale steel sculptures that reflect the influence of both the Brazilian neo-Concrete movement and Surrealism. He has also created monumental installations that incorporate surrealistic figures, images, and objects in what appear to be violent industrial landscapes. One-person exhibitions of his work have been organized by the Museu de Arte Moderna, Rio de Janeiro, 1974 and 1975; the Whitechapel Art Gallery, London, 1989; the Museum of Con-

temporary Art, Chicago, 1989; and the Galerie Nationale du Jeu de Paume, Paris, 1992. Tunga's work has been included in the 1981 and 1987 Venice Biennales; *Contemporary Art from Brazil*, Hara Museum of Art, Tokyo, 1985; the 1987 São Paulo Bienal; *Modernidade: Art brésilien du 20ᵉ siècle*, Musée d'Art Moderne de la Ville de Paris, 1987; *Tunga: "Lezarts"/Cildo Meireles: "Through,"* Kunststichting Kanaal, Kortrijk, Belgium, 1989; *U-ABC*, Stedelijk Museum, Amsterdam, 1989; *Transcontinental: Nine Latin American Artists*, Ikon Gallery, Birmingham, and Cornerhouse, Manchester, 1990; and *Viva Brasil viva*, Liljevalch Konsthall, Kulthurhuset, Stockholm, 1991. Tunga lives in Rio de Janeiro.—E.B.

Gregorio Vardánega
Argentine, born 1923

Gregorio Vardánega was born in Venice. His family emigrated to Argentina in 1926, and he studied art in Buenos Aires from 1939 to 1946. He joined the Asociación Arte Concreto-Invención that year, shortly after its founding, and he participated in exhibitions of Concrete art in Buenos Aires throughout the late 1940s. Vardánega produced geometric reliefs of glass and wood mounted on flat, white supports and created paintings, of small, colored, finely painted squares and rectangles on white canvases, that recall Suprematist works. In 1948 he traveled to Paris with Carmelo Arden Quin, exhibiting there the next year. The two artists helped found the Asociación de Arte Nuevo in 1954. By the time Vardánega moved to Paris in 1959, he was making abstract, biomorphic sculpture in metal, plastic, and wood. His work has been included in *Lumière et mouvement*, Musée d'Art Moderne de la Ville de Paris, 1967; *Les Gémaux*, Centre Culturel, Sceaux, France, 1976; *Grands et jeunes d'aujourd'hui*, Grand Palais, Paris, 1978; and *Vanguardias de la década del 40*, Museo de Artes Plásticas Eduardo Sívori, Buenos Aires, 1980. Vardánega lives in Paris.—E.F.

Alfredo Volpi
Brazilian, 1896–1988

Born in Lucca, Italy, Alfredo Volpi emigrated to São Paulo with his family when he was less than two years old. After 1910 he began to work as a decorative painter and stencil designer for homes, churches, and public spaces. Becoming interested in art by visiting exhibitions in São Paulo, Volpi painted his first landscapes in a Post-Impressionist style in 1914. Because of his working-class background, he never associated with the Brazilian modernists who were his contemporaries. In the early 1930s, together with other working-class artists, Volpi organized the Grupo Santa Helena, which was devoted to artistic study and production. After 1940 he began to move from a relatively traditional style influenced by Impressionism and Expressionism toward Constructivist abstraction. In the 1960s, under the influence of Brazilian

Constructivism, Volpi began an abstract phase that continued to the mid-1970s, employing traditional building façades and popular ornamental decoration as the strategic elements for geometric compositions. In his late series Vaults, fixed formal elements are the structure for compositions based on color permutations, which create rhythms and optical tension. Volpi's one-person exhibitions include those at the Museu de Arte Moderna, Rio de Janeiro, 1957 and 1972; the Museu de Arte Moderna, São Paulo, 1975 and 1986; and the Museu de Arte Contemporânea, Campinas, 1976. His work was included in the 1951, 1953 (Best National Painter Award), and 1961 São Paulo Bienals; the 1953, 1955, and 1964 Venice Biennales; *Modernidade: Art brésilien du 20ᵉ siècle*, Musée d'Art Moderne de la Ville de Paris, 1987; and *Bilderwelt Brasilien: Die europäische Erkundung eines "irdischen Paradieses" und die Kunst der brasilianischen Moderne*, Kunsthaus Zürich, 1992.—T.C.

Xul Solar
Argentine, 1887–1963

Oscar Agustín Alejandro Schulz Solari was born in San Fernando, Argentina. His father, from Riga, Latvia, was of German descent; his mother was from Zoagli, Italy. Xul Solar attended the Colegio Nacional in Buenos Aires from 1901 to 1905, then studied architecture at the Facultad de Ingeniería in 1906 and 1907. Leaving Argentina in 1912 on a ship bound for Hong Kong, he disembarked in London and traveled through England, France, and Italy. In 1914 he began painting. He met the Argentine modernist painter Emilio Pettoruti in Milan in 1916; at this time he began to sign works "Xul Solar." In Europe he practiced meditation and studied the occult and Asian religions; by 1919 he was creating works that picture his metaphysical ruminations in a modernist style of flatly applied, bright colors, schematic figures, geometricized forms and symbols, and, frequently, written words. He made contact with the Futurists in Italy and lived intermittently in Munich from 1921 to 1923. He returned to Buenos Aires in 1924 and joined the group Martín Fierro; its members, which included Pettoruti and Jorge Luis Borges, opposed the academicism and cultural conservatism of their country. Xul Solar's watercolors of the 1920s appropriated stylistic conventions of the European avant-garde but delineated a unique world with intimations of pre-Columbian cultures. In the 1930s and 1940s he depicted fantastic landscapes and architecture reflective of his interests in mysticism, theosophy, and astrology. The artist invented new languages he called *neocreol*, or *neocriollo*, and *panlengua* and attempted to give them visual form in his art of the late 1950s. Exhibitions of Xul Solar's work were held at the Museo Nacional de Bellas Artes, Buenos Aires, 1963; the Museo Municipal de Bellas Artes, La Plata, Argentina, 1968; and the Musée d'Art Moderne de la Ville de Paris, 1977. The artist's work was featured in *Art of the Fantastic: Latin America, 1920–1987*, Indianapolis

Museum of Art, 1987; and *Art in Latin America: The Modern Era, 1820–1980*, Hayward Gallery, London, 1989.—J.R.W.

Carlos Zerpa
Venezuelan, born 1950

Carlos Zerpa was born in Valencia, Venezuela, into a family of department-store owners. He moved to Milan in 1973 to study printmaking and photography at the Scuola Cova, and later he studied design with Bruno Munari at the Istituto Politécnico. Largely self-taught as a painter, he was by 1974 creating installations and performance pieces. In 1980 he returned to Valencia and began making regular trips to New York, where he lived from 1982 to 1984. Returning to Venezuela in 1984, he ceased performing to focus on making objects. Autobiographical in nature, his work recalls department-store display cases, which serve as the settings for his homages to the past. During his childhood in the 1950s, Zerpa was influenced by American popular culture, including comic strips and television. These images appear with bolero lyrics, found objects and emblems, and Christian imagery. His display cases are like altars for reconstructed memories and idolized objects. In 1992 he moved to New York. His one-person exhibitions include *Caliente, Caliente*, Museo de Arte Moderno, Mexico City, 1982; *Héroes y villanos*, La Sala Mendoza, Caracas, 1989; and *Two Rooms, Two Installations*, Museo de Arte Alvar y Carmen T. de Carrillo Gil, Mexico City, 1993. Zerpa's work has been included in the 1981 Medellín Bienal; the 1981 São Paulo Bienal; *Sacred Artifacts & Devotion Objects*, Alternative Museum, New York, 1982; *Contemporary Latin American Art*, The Chrysler Museum, Norfolk, Virginia, 1983; *Three Venezuelans in Two Dimensions: Miguel von Dangel, Ernesto León, Carlos Zerpa,* Americas Society, New York, 1988; *Mito y magia en América: Los ochenta*, Museo de Arte Contemporáneo, Monterrey, Mexico, 1991; *Latin America Drawing Today*, San Diego Museum of Art, 1991; and *Uncommon Ground: 23 Latin American Artists*, College Art Gallery, State University of New York, New Paltz, 1992. Zerpa lives in New York.—L.T.

Selected Bibliography

—

Compiled by Miriam M. Basilio

The following entries are divided into three main groupings: I. General Works; II. Individual Artists; and III. Bibliographies. The first group consists of general works on Latin American modern art in two categories: Books and Exhibition Catalogues, and Articles and Essays. The second group includes writings by, and monographs and articles on, the artists represented in the present book. The third group consists of published bibliographies on Latin American art.

I. GENERAL WORKS

Books and Exhibition Catalogues

Acha, Juan. *Arte y sociedad en América Latina: El producto artístico y su estructura*. Mexico City: Fondo de Cultura Económica, 1974.

Ades, Dawn, ed. *Art in Latin America: The Modern Era, 1820–1980*. New Haven: Yale University Press; London: Hayward Gallery, 1989.

Alegría, Ricardo, et al. *The Art Heritage of Puerto Rico: Pre-Columbian to Present*. New York: Metropolitan Museum of Art and Museo del Barrio, 1974.

Alloway, Lawrence. *Realism and Latin American Painting: The 70s*. New York: Center for Inter-American Relations, 1980.

Alvarez, Griselda, et al. *Los surrealistas en México*. Mexico City: Museo Nacional de Arte, 1986.

Amaral, Aracy. *Arts in the Week of '22*. Rev. ed. São Paulo: Câmara Brasileira do Livro, 1992. [Trans. by Elsa Oliveira Marques from *Artes plásticas na semana de 22*. São Paulo: Editora Perspectiva, 1970.]

———. *Arte para quê? A preocupação social na arte brasileira 1930–1970*. São Paulo: Nobel, 1984.

———. *Modernidade: Art brésilién du 20ᵉ siècle*. Paris: Musée d'Art Moderne de la Ville de Paris, 1987.

———. *Brasil: La nueva generación*. Caracas: Fundación Museo de Bellas Artes, 1991.

———, ed. *Projeto construtivo brasileiro na arte (1950–1962)*. São Paulo: Pinacoteca do Estado; Rio de Janeiro: Museu de Arte Moderna, 1977.

———, et al. *BR80: Pintura Brasil década 80*. São Paulo: Instituto Cultural Itaú, 1991.

Amaral, Aracy, and Paulo Herkenhoff. *Ultra Modern: The Art of Contemporary Brazil*. Washington, D.C.: The National Museum of Women in the Arts, 1993.

America: Bride of the Sun. Trans. by Arte Belas et al. Antwerp: Koninklijk Museum voor Schone Kunsten, 1992.

Andrade, Mário de. *Aspectos das artes plásticas no Brasil*. São Paulo: Livraria Martins Editora, 1965.

Argul, J. P. *Proceso de las artes plásticas del Uruguay: Désde la epoca indígena al momento contemporáneo*. 3d ed., rev. Montevideo: Barreiro y Ramos, 1975.

Arte Argentina dalla independenza ad oggi, 1810–1987. Rome: Istituto Italo–Latino Americano, 1987.

Arte argentino contemporáneo: Donación Fundación Antorchas. Buenos Aires: Museo Nacional de Bellas Artes, 1991.

Arze, Silvia, et al. *Pintura boliviana del siglo XX*. La Paz: Ediciones "Inbo," 1989.

Baddeley, Oriana, and Valerie Fraser. *Drawing the Line: Art and Cultural Identity in Contemporary Latin America*. London and New York: Verso, 1989.

Baker, Sally, ed. *Art of the Americas: The Argentine Project/Arte de las Américas: El proyecto argentino*. Hudson, N.Y.: Baker & Co., 1992.

Barnitz, Jacqueline, Florencia Bazzano Nelson, and Janis Bergman Carton. *Latin American Artists in New York since 1970*. Austin: Archer M. Huntington Art Gallery, University of Texas, 1987.

Batista, Marta Rosetti, et al. *Brasil: I tempo modernista, 1917–29: Documentação*. São Paulo: Istituto de Estudos Brasileiros, 1972.

Bayón, Damián. *Aventura plástica de Hispanoamérica: Pintura, cinetismo, artes de la acción (1940–1972)*. Mexico City: Fondo de Cultura Económica, 1974.

———. *Artistas contemporáneos de América Latina*. Paris: UNESCO; Barcelona: Ediciones del Serbal, 1981.

———. *Historia del arte hispanoamericano. Siglos XIX y XX*. Vol. 3. Madrid: Alhambra, 1988.

———, ed. *América Latina en sus artes*. Paris: UNESCO, 1974.

Beardsley, John, and Jane Livingston. *Hispanic Art in the United States: Thirty Contemporary Painters and Sculptors*. Houston: The Museum of Fine Arts; New York: Abbeville, 1987.

Belluzzo, Ana Maria de Moraes, ed. *Modernidade: Vanguardas artísticas na América Latina*. São Paulo: Memorial, UNESP, 1990.

Bercht, Fatima, ed. *Contemporary Art from Chile/Arte contemporáneo desde Chile*. New York: Americas Society, 1991.

Bierbaum, Thomas, Gunther Blank, and Matthias Reicher, eds. *Cirugía plástica: Konzepte zeitgenössischer Kunst in Chile, 1980–1989*. Berlin: Staatliche Kunsthalle, 1989.

Brasilien: Entdeckung und Selbstentdeckung. Zurich: Junifestwochen; Bern: Benteli Verlag, 1992.

Billeter, Erika, ed. *Images of Mexico: The Contribution of Mexico to 20th-Century Art*. Dallas: Dallas Museum of Art, 1987. [Trans. by Jack Rutland, Ann Fleming, and R. V. Rozelle from *Imagen de Mexico: Der Beitrag Mexikos zur Kunst des 20. Jahrhunderts*. Frankfurt: Schirn Kunsthalle, 1987.]

Blanc, Giulio V. *Into the Mainstream: Ten Latin American Artists Working in New York*. Jersey City, N.J.: Jersey City Museum, 1986.

Boulton, Alfredo. *Historia de la pintura en Venezuela*. Caracas: Editorial Arte, 1968.

———, et al. *Arte de Venezuela*. Caracas: Consejo Municipal del Distrito Federal, 1977.

Bousso, Vitória Daniela. *Nacional X internacional na arte brasileira*. São Paulo: Paço das Artes, 1991.

Brest, Jorge Romero. *New Art of Argentina*. Minneapolis: Walker Art Center, 1964.

Brett, Guy. *Transcontinental: Nine Latin American Artists*. London and New York: Verso, 1990.

Brito, Mario da Silva. *História do modernismo brasileiro*. 4th ed. Rio de Janeiro: Editora Civilização Brasileira, 1974.

Brito, Ronaldo. *Neoconcretismo: Vértice e ruptura do projeto construtivo brasileiro*. Rio de Janeiro: Edição FUNARTE, 1985.

Buchloh, Benjamin, Luis Camnitzer, and Gerardo Mosquera. *New Art from Cuba: José Bedia, Flavio Garciandia, Ricardo Rodríguez Brey*. Old Westbury: Amelie Wallace Gallery, State University of New York, 1985.

Calzadilla, Juan. *Obras singulares del arte en Venezuela*. Caracas: Euzko Americana de Ediciones; Bilbao: Editorial "La Gran Enciclopedia Vasca," 1979.

Cancel, Luis, et al. *The Latin American Spirit: Art and Artists in the United States, 1920–1970*. New York: Bronx Museum of the Arts and Harry N. Abrams, 1988.

Cardoza y Aragón, Luís. *La nube y el reloj: Pintura mexicana contemporánea*. Mexico City: Universidad Nacional Autónoma de México, 1940.

———. *Pintura contemporánea de México*. Mexico City: Ediciones Era, 1974.

———. *Ruptura, 1952–1965*. Mexico City: Museo de Arte Alvar y Carmen T. Carrillo Gil and Museo Biblioteca Pape, 1988.

Caso, Alfonso, et al. *Twenty Centuries of Mexican Art*. New York: The Museum of Modern Art, 1940.

Castleman, Riva. *Latin American Prints from The Museum of Modern Art*. New York: Center for Inter-American Relations, 1974.

Catlin, Stanton, and Terence Grieder. *Art of Latin America since Independence*. New Haven: Yale University Press, 1966.

Cervantes, Miguel, et al. *Míto y magia en América: Los ochenta*. Monterrey: Museo de Arte Contemporáneo, 1991.

Charlot, Jean. *Mexican Art and the Academy of San Carlos, 1785–1915*. Austin: University of Texas Press, 1962.

———. *The Mexican Mural Renaissance, 1920–1925*. New Haven and London: Yale University Press, 1963.

Chase, Gilbert. *Contemporary Art in Latin America*. New York: Free Press; London: Collier-Macmillan, 1970.

Chile vive. Madrid: Círculo de Bellas Artes, 1987.

Cocchiarale, Fernando, and Ana Bella Geiger. *Abstracionismo geométrico e informal: A vanguarda brasileira nos annos 50*. Rio de Janeiro: Edição FUNARTE, 1987.

del Conde, Teresa. *Siete pintores, la otra cara de la escuela mexicana*. Mexico City: Museo del Palacio de Bellas Artes, 1984.

———. *Mexican Painting 1950–1980*. Mexico City: IBM de México, 1990.

———, et al. *Rooted Visions: Mexican Art Today*. New York: Museum of Contemporary Hispanic Art, 1988.

Contemporary Art from Havana. London: Riverside Studios, 1989.

Córdova, Iturburu C. *80 años de pintura argentina: Del pre-impresionísmo a la novisima figuración*. Buenos Aires: Ediciones Librería la Ciudad, 1978.

Day, Holliday T., and Hollister Sturges, eds. *Art of the Fantastic: Latin America, 1920–1987*. Indianapolis: Indianapolis Museum of Art, 1987.

Debroise, Olivier. *Figuras en el trópico: Plástica mexicana, 1920–1940*. 2d ed. Barcelona: Océano, 1984 [1983].

Debroise, Olivier, and Graciela de Reyes Retana. *Modernidad y modernización en el arte mexicano, 1920–1960*. Mexico City: Museo Nacional de Arte, 1991.

Debroise, Olivier, Elizabeth Sussman, and Matthew Teitelbaum, eds. *El corazón sangrante/The Bleeding Heart*. Boston: Institute of Contemporary Art; Seattle: University of Washington Press, 1991.

Diccionario de las artes visuales en Venezuela. 2 vols. Caracas: Monte Avila Editores, 1982.

Duncan, Barbara. *Latin American Paintings and Drawings from the Collection of John and Barbara Duncan*. New York: Center for Inter-American Relations, 1970.

Edwards, Emily. *Painted Walls of Mexico: From Prehistoric Times until Today*. Austin: University of Texas Press, 1966.

Emerich, Luis Carlos. *Figuraciones y desfiguros de los 80s: Pintura mexicana joven*. Mexico City: Editorial Diana, 1989.

Exposición internacional del surrealismo. Mexico City: Galería de Arte Mexicano, 1940.

Expressionismo no Brasil: Heranças e afinidades. São Paulo: Imprensa Oficial do Estado, 1985.

Fabre, Gladys. *Paris: Arte abstracto, arte concreto—Cercle et Carré, 1930*. Valencia: IVAM Centro Julio González, 1990.

Fachereau, Serge. *Les Peintres révolutionnaires mexicains*. [Paris]: Editions Messidor, 1985.

Fernández, Justino. *A Guide to Mexican Art: From Its Beginnings to the Present*. Chicago and London: University of Chicago Press, 1969. [Trans. by Joshua C. Taylor from *Arte mexicano de sus orígenes a nuestros días*. 2d ed. Mexico: Porrúa, 1961.]

Ferreira Gullar. *Etapas da arte contemporânea—do cubismo ao neoconcretismo*. São Paulo: Editora Nobel, 1985.

Ferrer, Elizabeth, and Alberto Ruy Sánchez. *Through the Path of Echoes: Contemporary Art in Mexico/Por el camino de ecos: Arte contemporáneo en México*. New York: Independent Curators, 1990.

Fletcher, Valerie. *Crosscurrents of Modernism: Four Latin American Pioneers: Diego Rivera, Joaquín Torres-García, Wifredo Lam, Matta*. Washington, D.C.: Hirshhorn Museum and Sculpture Garden, Smithsonian Institution, 1992.

Franco, Jean. *The Modern Culture of Latin America: Society and the Artist*. Rev. ed. Harmondsworth, England: Penguin, 1970.

Frérot, Christine. *El mercado del arte en México: 1950–1976*. Mexico City: Instituto Nacional de Bellas Artes, 1990.

Fusco, Coco. *Signs of Transition: 80s Art from Cuba*. New York: Museum of Contemporary Hispanic Art, 1988.

Galasz, Gaspar, and Milan Ivelic. *La pintura en Chile: Desde la colonia hasta 1981*. Valparaiso: Universidad Católica de Valparaíso, 1981.

———. *Chile: Arte actual*. Valparaiso: Ediciones Universitarias de Valparaíso and Universidad Católica de Valparaíso, 1988.

Gesualdo, Vicente, ed. *Enciclopedia del arte en Argentina*. 5 vols. Buenos Aires: Editorial Bibliográfica Argentina, 1964.

Gil Tovar, Francisco. *Arte colombiano*. Bogotá: Editorial Santo Domingo, 1964.

Glusberg, Jorge. *Arte de sistemas/Systems Art*. Buenos Aires: Centro de Arte y Comunicación and Museo de Arte Moderno de Buenos Aires, 1971.

———. *Del pop-art a la nueva imagen*. Buenos Aires: Ediciones de Arte Gaglianone, 1985.

———. *Conversaciones sobre las artes visuales: Respuestas a Horacio de Dios*. Buenos Aires: Emecé Editores, 1992.

———. *Del constructivismo a la geometría sensible*. Buenos Aires: Centro de Arte y Comunicación, 1992.

Goldman, Shifra M. *Contemporary Mexican Painting in a Time of Change*. 3d ed. Austin and London: University of Texas Press, 1981.

Gradowczyk, Mario H. *Argentina: Arte concreto-invención, 1945/Grupo Madí, 1946*. New York: Rachel Adler Gallery, 1990.

Griswold del Castillo, Richard, Teresa McKenna, and Yvonne Yarbro Bejarano, eds. *Chicano Art: Resistance and Affirmation, 1965–1985*. Los Angeles: Wight Art Gallery, University of California, 1990.

Haber, Alicia. *Vernacular Culture in Uruguayan Art: An Analysis of the Documentary Functions of the Works of Pedro Figari, Carlos González, and Luis Solari*. Miami: Latin American and Caribbean Center, 1982.

Hechizo de Oaxaca. Monterrey: Museo de Arte Contemporáneo, 1991.

Helm, MacKinley. *Modern Mexican Painters*. New York: Dover, 1974 [1941].

Herzberg, Julia P., Sharon F. Patton, and Laura Trippi. *The Decade Show: Frameworks of Identity in the 1980s*. New York: Museum of Contemporary Hispanic Art, New Museum of Contemporary Art, and Studio Museum in Harlem, 1990.

Hulten, Pontus. *Futurismo & futurismi*. Venice: Bompiani, 1986.

Hurlburt, Laurance P. *The Mexican Muralists in the United States*. Albuquerque: University of New Mexico Press, 1989.

Ideas and Images from Argentina. New York: Bronx Museum of the Arts, 1989.

Jaguer, Eduard, et al. *Presencia viva de Wolfgang Paalen (con la colaboración del Movimiento Phases y de artistas mexicanos)*. Mexico City: Museo de Arte Alvar y Carmen T. Carrillo Gil, 1979.

Kalenberg, Angel. *Arte contemporáneo en el Uruguay*. Montevideo: Museo Nacional de Artes Visuales, 1982.

———. *Arte uruguayo y otros*. Montevideo: Edición Galería Latina, 1990.

King, John. *El Di Tella y el desarrollo cultural argentino en la década del sesenta*. Buenos Aires: Ediciones de Arte Gaglianone, Colección Ensayo, 1985.

Kirstein, Lincoln. *The Latin-American Collection of The Museum of Modern Art*. New York: Museum of Modern Art, 1943.

Kosice, Gyula. *Arte Madí*. Buenos Aires: Ediciones de Arte Gaglianone, 1983.

Lemos, Carlos, José Roberto Teixera Leite, and Pedro Manuel Gismonti. *The Art of Brazil*. Trans. Jennifer Clay. New York: Harper & Row, 1983 [1979].

Levinas, Gabriel, ed. *Arte argentino contemporáneo*. Madrid: Ameris, 1979.

Lourenço, Maria Cecília França. *Pinacoteca do Estado: Catálogo geral de obras*. São Paulo: Imprensa Oficial do Estado, 1988.

Manrique, Jorge Alberto, and Teresa del Conde. *Una mujer en el arte mexicano: Memorias de Inés Amor*. Mexico City: Instituto de Investigaciones Estéticas, Universidad Nacional Autónoma de México, 1987.

Marchán Fiz, Simón. *Del arte objetual al arte de concepto*. 3d ed. Madrid: Ediciones Akal, 1988 [1972].

Markman, Roberta H., and Peter T. Markman. *Masks of the Spirit: Image and Metaphor in Mesoamerica*. Berkeley, Los Angeles, and London: University of California Press, 1989.

Martin, Jean-Hubert, et al., eds. *Magiciens de la terre*. Paris: Musée National d'Art Moderne, Centre Georges Pompidou, 1989.

Melcherts, Enrique. *Introducción a la escultura chilena*. Valparaiso: Ferrand e Hijos, 1982.

Menocal, Nina, Iván de la Nuez, and Osvaldo Sánchez. *15 artistas cubanos*. Mexico City: NINART, Centro de Cultura, 1991.

Merewether, Charles. *Made in Havana: Contemporary Art from Cuba*. Sydney: Art Gallery of New South Wales, 1988.

———. *Mexico: Out of the Profane*. Adelaide: Contemporary Art Centre of South Australia, 1990.

Mérida, Carlos. *Modern Mexican Artists*. Mexico City: Frances Toor Studios, 1937.

Merlino, Adrian. *Diccionario de artistas plásticos de la Argentina: Síglos XVIII–XX*. Buenos Aires, 1954.

Mesquita, Ivo, et al. *O desejo na academia, 1847–1916*. São Paulo: Pinacoteca do Estado, 1991.

Messer, Thomas, and Cornell Capa. *The Emergent Decade: Latin American Painters and Painting in the 1960s*. Ithaca: Cornell University Press, 1966.

Mexico: Splendors of Thirty Centuries. New York: Metropolitan Museum of Art, 1990.

Montero Castro, Roberto. *De Venezuela, treinta años de arte contemporáneo/From Venezuela, Thirty Years of Contemporary Art (1960–1990)*. Seville: Pabellón de las Artes; Madrid: Ministerio de Relaciones Exteriores, Consejo Nacional de la Cultura; Caracas: Fundación Galería de Arte Nacional, 1992.

Morais, Frederico. *Artes plásticas na América Latina: Do transe ao transitório*. Rio de Janeiro: Civilização Brasileira, 1979.

Mosquera, Gerardo. *Exploraciones en la plástica cubana*. Havana: Editorial Letras Cubanas, 1983.

———. *The Nearest Edge of the World: Art and Cuba Now*. Brookline, Mass.: Polarities and New England Foundation for the Arts, 1990.

La mujer en México/Women in Mexico. Mexico City: Centro Cultural/Arte Contemporáneo, Fundación Cultural Televisa, 1990.

Museo de Arte Contemporáneo Sofía Imber: Obras de su colección/Works from Its Collection. Caracas: Museo de Arte Contemporáneo Sofía Imber, 1992.

Nova figuração: Rio/Buenos Aires. Rio de Janeiro: Museu de Arte Moderna/Instituto Cultural Brasil-Argentina, 1987.

One Hundred Years of Uruguayan Painting. Washington, D.C.: Corcoran Gallery of Art, 1967.

Ortega Ricàurte, Carmen. *Diccionario de artistas en Colombia*. 2d ed., rev. Bogotá: Plaza y Janés, Editores Colombia, 1979.

Ortiz Monasterio, Patricia Riestra, and Jaime Riestra, eds. *New Moments in Mexican Art/Nuevos momentos en el arte mexicano*. New York: Parallel Project; Madrid: Turner Libros, 1990.

Otra figuración . . . veinte años después. Buenos Aires: Fundación San Telmo, 1981.

Paz, Octavio. *La pintura mural de la revolución mexicana, 1921–1960*. Mexico City: Fondo Editorial de la Plástica Mexicana, 1960.

———. *Los privilegios de la vista: Arte de México*. Vol. 2, *Arte del siglo XX*. 2d ed. Mexico City: Fondo de Cultura Económica, 1989.

———. *Los privilegios de la vista*. Mexico City: Centro Cultural/Arte Contemporáneo, Fundación Cultural Televisa, 1990.

Pellegrini, Aldo. *Panorama de la pintura argentina contemporánea*. Buenos Aires: Editorial Paidós, 1967.

Perazzo, Nelly. *El arte concreto en la Argentina en la década del 40*. Buenos Aires: Ediciones de Arte Gaglianone, 1983.

Pontual, Roberto. *Dicionário das artes plásticas no Brasil*. Rio de Janeiro: Civilização Brasileira, 1969.

———. *Entre dois séculos: Arte brasileira do século XX, Coleção Gilberto Chateaubriand*. Rio de Janeiro: Editora JB, 1987.

Quirarte, Jacinto. *A History and Appreciation of Chicano Art*. San Antonio: Research Center for the Arts and Humanities, 1984.

Ramírez, Mari Carmen. *Puerto Rican Painting: Between Past and Present*. Princeton: Squibb Gallery, 1987.

Ramírez, Mari Carmen, ed. *El Taller Torres-Garcia: The School of the South and Its Legacy*. Austin: University of Texas, 1992.

Ramírez, Mari Carmen, and Beverly Adams. *Encounters/Displacements: Luis Camnitzer, Alfredo Jaar, Cildo Meireles*. Austin: Archer M. Huntington Art Gallery, University of Texas, 1992.

Reed, Alma. *The Mexican Muralists*. New York: Crown, 1960.

Rigol, Jorge. *Apuntes sobre la pintura y el grabado en Cuba: De los orígenes a 1927*. Havana: Editorial Letras Cubanas, 1982.

Rivera, Jorge B. *Madí y la vanguardia argentina*. Buenos Aires: Editorial Paidós, 1976.

Rodríguez, Antonio. *A History of Mexican Mural Painting*. London: Thames and Hudson, 1969.

Rodríguez, Bélgica. *La pintura abstracta en Venezuela: 1945–1965*. Caracas: Gerencia de Relaciones Públicas de Maraven, 1980.

Rodríguez Prampolini, Ida. *El surrealismo y el arte fantástico de México*. Mexico City: Universidad Nacional Autónoma de México, 1969.

Romero Brest, Jorge. *El arte en la Argentina: Ultimas décadas*. Buenos Aires: Editorial Paidós, 1969.

Romero Keith, Delmari. *Historia y testimonios: Galería de Arte Mexicano*. Mexico City: Galería de Arte Mexicano, 1985.

Rubiano Caballero, Germán. *Escultura colombiana del siglo XX*. Bogotá: Fondo Cultural Cafetero, 1983.

———. *La escultura en América Latina, siglo XX*. Bogotá: Universidad Nacional de Colombia, 1986.

Rubiano Caballero, Germán, Dicken Castro, and Germán Téllez. *Historia del arte colombiano*. Vol. 11, *Arte de la segunda mitad del siglo XX*, and Vol. 12, *El arte de nuestro días*. Barcelona and Bogotá: Salvat, 1983.

Salzstein-Goldberg, Sônia, and Ivo Mesquita. *Imaginários singulares*. São Paulo: Fundação Bienal de São Paulo, 1987.

Schávelson, Daniel, ed. *La polémica del arte nacional en México, 1850–1910*. Mexico City: Fondo de Cultura Económica, 1988.

Seis maestros de la pintura uruguaya. Buenos Aires: Museo Nacional de Bellas Artes, 1987.

Serrano, Eduardo. *Cien años de arte colombiano, 1886–1986*. Bogotá: Museo de Arte Moderno de Bogotá, 1985.

Staber, Margit Weinberg, Nelly Perazzo, and Tomás Maldonado. *Arte concreto-invención/Arte Madí*. Basel: Edition Galerie Von Bartha, 1991.

Stellweg, Carla. *Uncommon Ground: 23 Latin American Artists*. New Paltz: State University of New York, 1992.

Stofflet, Mary, et al. *Latin American Drawing Today*. San Diego: San Diego Museum of Art; Seattle: University of Washington Press, 1991.

Sturges, Hollister. *New Art from Puerto Rico*. Springfield, Mass.: Museum of Fine Arts, 1990.

Suárez, Orlando S. *Inventario del muralismo mexicano*. Mexico City: Universidad Nacional Autónoma de México, 1972.

Sullivan, Edward J. *Pintura mexicana de hoy: Tradición e innovación*. Monterrey: Centro Cultural Alfa/Galería Arte Actual Mexicano, 1989.

———. *Aspects of Contemporary Mexican Painting*. New York: Americas Society, 1990.

Tibol, Raquel. *Historia general de arte mexicano*. 2 vols. Mexico City: Editorial Hermes, 1966.

Traba, Marta. *Propuesta polémica sobre el arte puertorriqueño*. San Juan: Ediciones Librería Internacional, 1971.

———. *Dos décadas vulnerables en las artes plásticas latinoamericanas 1950–1970*. Mexico City: Siglo XXI Editores, 1973.

———. *Historia abierta del arte colombiano*. Cali: Museo de Arte Moderno, La Tertulia, 1974.

———. *Marta Traba*. Bogotá: Museo de Arte Moderno de Bogotá and Planeta Colombiana, 1984.

———. *Museum of Modern Art of Latin America: Selections from the Permanent Collection*. Washington, D.C.: General Secretariat, Organization of American States, 1985.

U-ABC: Painting, Sculpture and Photography from Uruguay, Argentina, Brazil and Chile. Amsterdam: Stedelijk Museum, 1989.

Vanguardias de la década del 40. Buenos Aires: Museo de Artes Plásticas Eduardo Sívori, 1980.

Vera, Luis Roberto. *17 artistas de hoy en México*. Mexico City: Museo Rufino Tamayo, 1985.

Weiss, Rachel, ed. *Being America: Essays on Art, Literature and Identity from Latin America*. New York: White Pine Press, 1991.

Wye, Deborah. *Committed to Print: Social and Political Themes in Recent American Printed Art*. New York: Museum of Modern Art, 1988.

Zanini, Walter, ed. *História geral da arte no Brasil*. 2 vols. São Paulo: Instituto Walther Moreira Salles, 1983.

Zuver, Marc, et al. *Cuba-USA: The First Generation*. Washington, D.C.: Fondo del Sol Visual Arts Center, 1991.

Articles and Essays

Baranik, Rudolf, et al. "Report from Havana: Cuba Conversation." *Art in America* 75, no. 3 (March 1987). Pp. 21–29.

Chiarelli, Domingos Tadeu. "The 'Jeca' Versus Picasso and Cia: Nationalism and Modernity in Monteiro Lobato's Art Criticism." *Brazilian Art Research Yearbook* (São Paulo), no. 1 (1992). Pp. 11–16.

Christ, Ronald. "Modern Art in Latin America: Art and Nation through Individual Discovery." *Arts Canada* 36, nos. 232/233 (December 1979/January 1980). Pp. 47–55.

Cuevas, José Luis. "The Cactus Curtain." *Evergreen Review*, no. 7 (Winter 1959). Pp. 111–20.

Damian, Carol. "Cuba-USA: La primera generación." *Art Nexus* (Bogotá), no. 3 (January 1992). Pp. 92–96.

Goldman, Shifra M. "How Latin American Artists in the U.S. View Art, Politics, and Ethnicity in a Supposedly Multicultural World." *Third Text* (London), nos. 16/17 (Autumn/Winter 1991). Pp. 189–92.

Grieder, Terence. "Argentina's New Figurative Art." *Art Journal* 24, no. 1 (Fall 1964). Pp. 2–6.

Iriarte, María Elvira. "Primeras etapas de la abstracción en Colombia." *Arte en Colombia* (Bogotá), no. 23 (1984). Pp. 30–35; no. 24 (1984). Pp. 44–50.

Ivelic, Milan. "El arte en Chile: Tres lustros de aislamiento." *Arte en Colombia* (Bogotá), no. 43 (February 1990). Pp. 44–47.

Lippard, Lucy. "Made in the U.S.A.: Art from Cuba." *Art in America* 74, no. 4 (April 1986). Pp. 27–35.

Medina, Alvaro. "Política y arte: Colombia en los años treinta y cuarenta." *Arte en Colombia* (Bogotá), no. 41 (September 1989). Pp. 88–91.

Merewether, Charles. "The Phantasm of Origins: New York and the Art of Latin America." *Art and Text* (Melbourne), no. 30 (September–November 1988). Pp. 52–67.

———. "El arte de la violencia: Un asunto de representación en el arte contemporáneo." Parts 1, 2. *Art Nexus* (Bogotá) 2 (October 1991). Pp. 92–96; 3 (January 1992). Pp. 132–35.

Mosquera, Gerardo. "Africa dentro de la plástica caribeña." Parts 1, 2. *Arte en Colombia* (Bogotá), no. 45 (October 1990). Pp. 42–49; no. 46 (January 1991). Pp. 72–77.

Pacheco, Marcelo. "An Approach to Social Realism in Argentine Art, 1875–1945." *Journal of Decorative and Propaganda Arts*, no. 18 (1992). Pp. 123–54.

Richard, Nelly. "Margins and Institutions: Art in Chile since 1973." *Art and Text* (Melbourne), no. 21 (May/June 1986), special issue.

Sullivan, Edward J. "Mito y realidad en el arte latinoamericano." *Arte en Colombia* (Bogotá), no. 41 (September 1989). Pp. 60–66.

Torruella Leval, Susana, and Shifra M. Goldman. "Latin American Art and the Search for Identity." *Latin American Art* (Scottsdale) 1, no. 1 (Spring 1989). Pp. 41–42.

Zilio, Carlos. "Da antropofagia a tropicália." In Carlos Zilio, João Luiz Lafetá, and Lígia Chiappinim Leite, *Artes plásticas e literatura*. São Paulo: Editora Brasiliense, 1982. Pp. 11–56.

II. INDIVIDUAL ARTISTS

Carlos Almaraz

Carlos Almaraz: Selected Works: 1970–1984/Paintings and Pastel Drawings. Los Angeles: Municipal Art Gallery, 1984.

Chicanarte. Los Angeles: Municipal Art Gallery, 1975.

Wortz, Melinda. "Carlos Almaraz." *Artnews* 82, no. 1 (January 1983). Pp. 117–18.

Tarsila do Amaral

Amaral, Aracy. *Desenhos de Tarsila*. São Paulo: Editora Cultrix, 1971.

———. *Tarsila: Sua obra e seu tempo*. 2 vols. São Paulo: Editora Perspectiva, 1975. [abridged ed., 1986.]

Andrade, Mário de, et al. *Revista acadêmica: Homenagem a Tarsila*. Rio de Janeiro: 1940.

Gotlib, Nádia Batella. *Tarsila do Amaral: A musa radiante*. São Paulo: Editora Brasiliense, 1983.

Marcondes, Marcos A. *Tarsila*. São Paulo: Arte Editora/Círculo do Livro, 1986.

Milliet, Sérgio. *Tarsila*. São Paulo: Coleção Artistas Brasileiros Contemporâneos, Museu de Arte Moderna, 1953.

Tarsila: Obras 1920/1930. São Paulo: IBM do Brasil, 1982.

Zilio, Carlos. *A querela do Brasil: A questão da identidade da arte brasileira: A obra de Tarsila, di Cavalcanti e Portinari, 1922–1945*. Rio de Janeiro: Edição FUNARTE, 1982.

Carmelo Arden Quin

Madí maintenant/Madí adesso. Saint Paul de Vence: Galerie de la Salle, 1984. [brochure]

Les quatre quarts de la peinture: La partie de ping-pong. Paris: Galerie Alain Oudin, 1989. [brochure]

de la Salle, Alexandre. *Arden Quin*. Paris: Espace Latino-Américain, 1983.

Luis Cruz Azaceta

Ferrer, Elizabeth. *Luis Cruz Azaceta: Pintado el mundo al revés*. Monterrey: Galería Ramis F. Barquet, 1992.

Goodrow, Gerard A. *Luis Cruz Azaceta*. New York: Frumkin/Adams Gallery, 1988.

Luis Cruz Azaceta. New York: Allan Frumkin Gallery, 1984.

Luis Cruz Azaceta. Cologne: Kunst-Station Sankt Peter, 1988.

Luis Cruz Azaceta: Tough Ride around the City. New York: Museum of Contemporary Hispanic Art, 1986.

Martin, J. "Luis Cruz Azaceta." *Arts Magazine* 56, no. 6 (February 1982). P. 19.

Torruella Leval, Susana. "Luis Cruz Azaceta: Arte y conciencia." *Arte en Colombia* (Bogotá), no. 43 (February 1990). Pp. 40–43.

Torruella Leval, Susana, Philip Yenawine, and Ileen Sheppard. *Luis Cruz Azaceta. The AIDS Epidemic Series*. New York: The Queens Museum of Art, 1991.

Frida Baranek

Herkenhoff, Paulo. "Frida Baranek." In Marcantonio Vilaça, ed., *Nuno Ramos/Hilton Berredo/Ester Grinspun/Fábio Miguez/Frida Baranek*. São Paulo: Jaú S/A Construtora e Incorporadora, 1989.

Mammi, Lorenzo, and Paulo Venâncio Filho. *Frida Baranek*. Rio de Janeiro: Galeria Sérgio Milliet, 1988.

Oliva, Achille Bonito. *Frida Baranek, Ivens Machado, Milton Machado, Daniel Senise, Angelo Venosa*. Rome: Sala I, 1990.

Rafael Pérez Barradas

Casal, Julio J. *Rafael Barradas*. Buenos Aires: Editorial Losada, 1949.

García Esteban, Fernando. *Rafael Barradas*. Montevideo: Museo Nacional de Artes Visuales, 1972.

Ignacio, Antonio de. *Historial Barradas*. Montevideo: Imprenta Letras, 1953.

Lubar, Robert, Juan Manuel Bonet, and Guillermo de Osma. *Barradas/Torres-García*. Madrid: Galería Guillermo de Osma, 1991.

Pereda, Raquel. *Barradas*. Montevideo: Edición Galería Latina, 1989.

Pereda, Raquel, María Jesús García Puig, and Rafael Santos Torroella. *Rafael Barradas*. Madrid: Galería Jorge Mara, 1992.

Rafael Barradas. Buenos Aires: Museo Nacional de Bellas Artes, 1974.

Romero Brest, Jorge. *Rafael Barradas*. Buenos Aires: Editorial Argos, 1951.

Juan Bay

"Juan Bay." In Margit Weinberg Staber, Nelly Perazzo, and Tomás Maldonado, *Arte concreto-invención/Arte Madí*. Basel: Edition Galerie Von Bartha, 1991.

Jacques Bedel

Chiérico, Osiris. "Jacques Bedel." *Confirmado* (Buenos Aires), September 5, 1968.

Glusberg, Jorge. "Jacques Bedel." In Jorge Glusberg, *Art in Argentina*. Milan: Giancarlo Politi Editore, 1986. Pp. 33–35.

Jacques Bedel: Esculturas. Buenos Aires: Galería Ruth Benzacar, 1979.

Tager, Alisa. "Jacques Bedel." In Sally Baker, ed., *Art of the Americas: The Argentine Project*. Hudson, N.Y.: Baker & Co., 1992. Pp. 117–31.

José Bedia

Ahlander, Leslie Judd. "José Bedia: Maestro de cuchillos y meteoros." *Arte en Colombia* (Bogotá), no. 46 (January 1991). Pp. 46–51.

Mosquera, Gerardo. *Crónicas americanas III: José Bedia Valdés*. Havana: Galería del Centro Wifredo Lam, 1986.

———. "Bedia, Tercer Mundo, y cultura occidental." *Viva el arte* (Guadalajara), no. 5 (Winter 1989). Pp. 90–91.

Sánchez, Osvaldo. "José Bedia: La restauración de nuestra alteridad/Restoring Our Otherness." *Third Text* (London), no. 13 (Winter 1991). Pp. 63–72.

Sullivan, Edward J. *José Bedia*. Mexico City: NINART, Centro de Cultura and Galería Ramis F. Barquet, 1991.

Thompson, Robert Farris. *José Bedia: Sueño circular*. Mexico City: NINART, Centro de Cultura and Galería Ramis F. Barquet, n.d.

Luis F. Benedit

Benedit: 1965–1975. Buenos Aires: Fundación San Telmo, 1988.

Espartaco, Carlos. *Introducción a Benedit*. Buenos Aires: Ediciones Ruth Benzacar, 1978.

Glusberg, Jorge. *Benedit-Fitotrón*. New York: The Museum of Modern Art, 1972.

———. *Luis Benedit*. Los Angeles: Los Angeles Institute of Contemporary Art, 1980.

———. *Luis Benedit: Pinturas y objetos*. Buenos Aires: Galería Ruth Benzacar, 1984.

Liliana Porter/Luis Benedit. Madrid: Galería Ruth Benzacar, 1988.

Stringer, John. *Luis Benedit*. New York: Center for Inter-American Relations, 1981. [brochure]

Sulic, Susana. *Benedit*. Buenos Aires: Centro Editor de América Latina, 1981.

Antonio Berni

Antonio Berni. Buenos Aires: Museo de Arte Moderno de la Ciudad Buenos Aires and Teatro Municipal San Martín, 1963.

Antonio Berni. Rio de Janeiro: Museu de Arte Moderna, 1968.

Antonio Berni: Obra pictórica. Buenos Aires: Museo Nacional de Bellas Artes, 1984.

The Art of Antonio Berni: Paintings, Prints, Constructions. Trenton: New Jersey State Museum, 1966.

Berni, Antonio. *Gráfica Antonio Berni, 1962–1978*. Buenos Aires: Fundación San Telmo, 1980.

Bessega, Martín. *Antonio Berni*. Caracas: Museo de Bellas Artes, 1977.

Troche, Michel, and G. Gassiot-Talabot. *Berni*. Paris: Musée d'Art Moderne de la Ville de Paris and Editions Georges Fall, 1972.

Viñals, José. *Berni: Palabra e imagen*. Buenos Aires: Imagen Galería de Arte, 1976.

Martín Blaszko

Blaszko, Martín. "Monumental Sculpture and Society." In *Ninth National and International Sculpture Conference: New Orleans, March 1976*. Lawrence: University of Kansas, 1976. Pp. 133–37.

———. "El entorno público y un mecenazgo ausente/The Public Environment and the Absence of Patronage." *Arte al día* (Buenos Aires), no. 51 (November 1991).

———. "Sculpture and the Principle of Bipolarity." *Leonardo 1* (1968). Pp. 223–32.

Harari, Paulina, and Ethel Martínez Sobrado. *Blaszko*. Buenos Aires: Centro Editor de América Latina, 1981.

Monzón, Hugo. "Arte integrado al espacio público." *Confirmado* (Buenos Aires) 12, no. 474 (February 1, 1979). P. 43.

Negri, Tomás Alva. "Una obra monumental de Martín Blazko [*sic*]." *Proa de la plástica* (Buenos Aires), October–November 1988. Pp. 91–93.

Jacobo Borges

Anzola Guerra, Luis, Manuel Hernández Serrano, and María Elena Ramos. *La Comunión: Jacobo Borges*. Caracas: Galería de Arte Nacional, 1981.

Arte actual de hispanoamérica: Jacobo Borges. Madrid: Instituto de Cultura Hispánica en el Centro Cultural de la Villa, 1977.

Ashton, Dore. *Jacobo Borges*. Caracas: Armitano, 1985.

Borges, Jacobo. *La montaña y su tiempo*. Caracas: Ediciones Petróleos de Venezuela, 1979.

Calzadilla, Juan, et al. *Jacobo Borges*. Caracas: Galería de Arte Nacional, 1974.

Guevara, Roberto. *Jacobo Borges*. Mexico City: Museo de Arte Moderno, 1976.

Jacobo Borges. 2d ed. Berlin: Staatliche Kunsthalle, 1988 [1987].

Sesenta obras de Jacobo Borges/60 Paintings by Jacobo Borges. Monterrey: Museo de Monterrey, 1987.

Fernando Botero

Botero: Aquarelles, dessins, sculptures. Basel: Galerie Beyeler, 1980.

Consalvi, Simón Alberto, and Ariel Jiménez. *Botero: Dibujos, 1980–1985*. Caracas: Museo de Arte Contemporáneo, 1986.

Fernando Botero: Recent Painting. London: Marlborough Fine Art, 1983.

Gallwitz, Klaus. *Fernando Botero*. New York: Center for Inter-American Relations, 1969.

McCabe, Cynthia Jaffee. *Fernando Botero*. Washington, D.C.: Smithsonian Institution Press, 1979.

Paquet, Marcel. *Fernando Botero—La Corrida: The Bullfight Paintings*. New York: Marlborough Gallery, 1985.

Ratcliff, Carter. *Botero*. New York: Abbeville, 1980.

Rivero, Mario. *Botero*. Bogotá: Plaza y Janés, 1973.

Rosenblum, Robert. *Fernando Botero: Recent Sculpture*. New York: Marlborough Gallery, 1982.

Spies, Werner. *Fernando Botero*. Munich: Prestel-Verlag, 1986.

Sullivan, Edward J. *Botero Sculpture*. New York: Abbeville, 1986.

Waltercio Caldas

Brito, Ronaldo. *"A natureza dos jogos" Waltercio Caldas Junior*. São Paulo: Museu de Arte Assis Chateaubriand, 1975.

———. "Os limites da arte e arte dos limites." In *Waltercio Caldas: Aparelhos*. Rio de Janeiro: GBM Editorial de Arte, 1979.

Salzstein-Goldberg, Sônia. *Waltercio Caldas*. Rio de Janeiro: Galeria Sérgio Milliet, 1988.

Venâncio Filho, Paulo. *Waltercio Caldas*. New York: Center for Inter-American Relations, 1984.

Sérgio Camargo

Bardi, P. M., Ronaldo Brito, and Casimiro Xavier de Medonça. *Sérgio Camargo*. Rio de Janeiro: Museu de Arte Moderna, 1981.

Brito, Ronaldo. "A Logic of Chance," trans. Florence Eleanor Irvin. In *Sérgio Camargo: Marble Sculptures*. Brasília: Ministry of Foreign Affairs and Ministry of Education and Culture, 1982.

———. *Camargo*. São Paulo: Ediçoes Akagawa, [1990].

Camargo. London: Gimpel Fils Gallery, 1974. [brochure]

Duarte, Paulo Sérgio. *Camargo: Morfoses*. São Paulo: Gabinete de Arte Raquel Arnaud Babenco, 1983.

Sérgio Camargo. Rio de Janeiro: Museu de Arte Moderna, 1975.

Sérgio Camargo. São Paulo: Gabinete de Artes Gráficas, 1977.

Luis Camnitzer

Camnitzer, Luis, Gerardo Mosquera, and Mari Carmen Ramírez. *Luis Camnitzer: Retrospective Exhi-*

bition, 1966–1990. New York: Lehman College Art Gallery, 1991.

Haber, Alicia. *Luis Camnitzer: Análisis, lirismo, compromiso*. Puerto Rico: Plástica, 1988.

Kalenberg, Angel. *Luis Camnitzer: Uruguay, Biennale di Venezia*. Montevideo: Museo Nacional de Artes Visuales, 1988.

Kalenberg, Angel, and Luis Camnitzer. *Luis Camnitzer*. Buenos Aires: Fundación San Telmo, 1987.

Luis Camnitzer. Montevideo: Museo Nacional de Artes Visuales, 1988.

Luis Camnitzer: Uruguayan Torture. New York: Alternative Museum, 1984.

Peluffo Linari, Gabriel. "La Transmigración de las ideas." In *Camnitzer/Sagradini*. Montevideo: Museo Juan Manuel Blanes, 1991.

Agustín Cárdenas

Agustín Cárdenas: Esculturas 1957–1981. Caracas: Museo de Bellas Artes, 1982.

Breton, André, and Edouard Glissant. *Cárdenas*. Chicago: Richard Feigen Gallery [1961].

Luis, Carlos. "Agustín Cárdenas." *Latin American Art* (Scottsdale) 1, no. 1 (Spring 1989). Pp. 26–28.

Pierre, José. *La sculpture de Cárdenas*. Brussels: La Connaissance, 1971.

———. *Cárdenas, sculptures récentes, 1972–73*. Paris: Le Point Cardinal, 1973.

Troche, Michel, and André Breton. *Cárdenas: Sculpteur*. Paris: Fondation Nationale des Arts Graphiques et Plastiques, 1981.

Santiago Cárdenas

Angel, Félix. "Colombian Figurative." In James D. Wright, ed., *Colombian Figurative*. San Francisco: Moss Gallery, 1990.

Pierre, José. *Cárdenas: Mostra personale*. Milan: Galleria Schwarz, 1962.

Carlos Rojas/Santiago Cárdenas. New York: Center for Inter-American Relations, 1973.

Santiago Cárdenas. Bogotá: Galería Garcés Velásquez [1991].

Santiago Cárdenas Arroyo. Bogotá: Museo de Arte Moderno, 1966.

Serrano, Eduardo. *Santiago Cárdenas*. Bogotá: Museo de Arte Moderno, 1976.

———. *The Art of Santiago Cárdenas*. Miami: Frances Wolfson Art Gallery, Miami-Dade County Community College, 1983.

Serrano, Eduardo, and Carlos García Osuna. *Santiago Cárdenas*. Madrid: Galería Cambio, 1978.

Leda Catunda

Costa, Oswaldo Corrêa da. *Leda Catunda*. Rio de Janeiro: Thomas Cohn–Arte Contemporânea, 1988.

Leda Catunda. São Paulo: Galeria de Arte São Paulo, 1990.

Emiliano di Cavalcanti

Amaral, Aracy. *Emiliano di Cavalcanti, 1897–1976: Works on Paper*. New York: Americas Society, 1987.

di Cavalcanti, Emiliano. *Viagem da minha vida: Testamento da alvorada*. Rio de Janeiro: Editora Civilização Brasileira, 1955.

———. *Reminiscências liricas de um perfeito carioca*. Rio de Janeiro: Civilização Brasileira, 1964.

Martins, Luis, and Paulo Mendes de Almeida. *Emiliano di Cavalcanti: 50 annos de pintura, 1922–1971*. São Paulo: Gráficos Brunner, 1971.

Retrospectiva di Cavalcanti. São Paulo: Museu de Arte Moderna [1971].

Zilio, Carlos. *A querela do Brasil: A questão da identidade da arte brasileira: A obra de Tarsila, di Cavalcanti e Portinari, 1922–1945*. Rio de Janeiro: Edição FUNARTE, 1982.

Lygia Clark

Brett, Guy. "Lygia Clark: The Borderline between Art and Life." *Third Text* (London), no. 1 (Autumn 1987). Pp. 65–94.

Clark, Lygia. "Un mythe moderne: La mise en évidence de l'instant comme nostalgia du cosmos." *Robho* (Paris), no. 4 (1965). P. 18.

———. "L'homme, structure vivante d'une architecture biologique et cellulaire." *Robho* (Paris), nos. 5/6 (1969). P. 12.

———. "Le corps est la maison—Sexualité: Envahissement du 'territoire' individuel." *Robho* (Paris), no. 8 (Fall 1971). Pp. 12–13.

———. "L'art, c'est le corps." *Preuves* (Paris) (1975). P. 138.

———. "The Relational Object." *Flue* (New York) 3, no. 2 (Spring 1983). Pp. 26–27.

Ferreira Gullar, Mário Pedrosa, and Lygia Clark. *Lygia Clark*. Rio de Janeiro: Edição FUNARTE, 1980.

Lygia Clark: First London Exhibition of Abstract Reliefs and Articulated Sculpture. London: Signals Gallery, 1965.

Lygia Clark e Hélio Oiticica. Rio de Janeiro and São Paulo: FUNARTE, Instituto Nacional de Artes Plásticas, 1986.

29 Esculturas de Lygia Clark. Rio de Janeiro: Galeria Bonino, 1960.

Carlos Cruz-Diez

Boulton, Alfredo. *Cruz-Diez*. Caracas: Armitano, 1975.

———. *Art in Gurí*. [Caracas]: Electrificación del Caroní [1988].

———. *La cromoestructura radial homenaje al sol de Carlos Cruz-Diez*. Caracas: Macanao Ediciones, 1989.

Clay, Jean. *Cruz-Diez et les trois étapes de la couleur moderne*. Paris: Editions Denise René, 1969.

Cruz-Diez, Carlos. *Reflexión sobre el color*. Caracas: FabriArt, 1989.

Cruz-Diez. Caracas: Museo de Arte Contemporáneo, 1981.

Dorante, Carlos. *Carlos Cruz-Diez*. Caracas: Instituto Nacional de Cultura y Bellas Artes, 1967.

José Luis Cuevas

Cuevas, José Luis. *Cuevas por Cuevas*. Mexico City: Ediciones Era, 1965.

———, et al. *Les obsessions noires de José Luis Cuevas*. Paris: Editions Galilée, 1982.

Cuevas, José Luis, and Jorge Ruiz Dueñas. *Marzo, més de José Luis Cuevas: Presencia del artista en México y en el extranjero*. Mexico City: Grupo Editorial Miguel Porrúa, 1982.

Exposición homenaje a José Luis Cuevas: Dibujos, acuarelas, litografías, grabados, serigrafías, collages y tapíces. Mexico City: Galería Metropolitana, Universidad Autónoma Metropolitana, 1984.

Gómez Sicre, José. *José Luis Cuevas*. Washington, D.C.: Museum of Modern Art of Latin America, Organization of American States, 1978.

José Luis Cuevas: Self-Portrait with Model. New York: Rizzoli, 1983.

Kartofel, Graciela. *José Luis Cuevas: Su concepto del espacio*. Mexico City: Universidad Nacional Autónoma de México, 1986.

Sanesi, Roberto. *José Luis Cuevas: Ipotesi per una lettura*. Milan: Centro Arte/Zarathustra, 1978.

Traba, Marta. *José Luis Cuevas*. Bogotá: Biblioteca Luis Angel Arango del Banco de la República, 1964.

Ulacia, Manuel, and Víctor Manuel Mendiola. *Retratos y parejas: José Luis Cuevas*. Mexico City: Secretaría de Hacienda y Crédito Público, 1991.

Xirau, R., et al. *Intolerance: José Luis Cuevas: Drawings, 1983*. Fort Dodge, Iowa: Blanden Memorial Art Museum, 1985. [Trans. by J. M. Tasende and Peter Selz from *Intolerancia: José Luis Cuevas: Dibujos, 1983*. Mexico City: Museo de Arte Moderno, 1985.]

José Cúneo

Argul, José P. *El pintor José Cúneo paisajista del Uruguay*. Montevideo: Editorial San Felipe and Santiago de Montevideo, 1949.

Haber, Alicia. *Cúneo Perinetti*. Montevideo: Galería Latina, 1990.

Pereda, Raquel. *José Cúneo: Retrato de un artista*. Montevideo: Edición Galería Latina, 1988.

Jorge de la Vega

Brest, Jorge Romero. *Jorge de la Vega*. Buenos Aires: Centro de Artes Visuales de Instituto Torcuato di Tella, 1967.

Casanegra, Mercedes. *Jorge de la Vega*. [Buenos Aires]: S. A. Alba, 1990.

Homenaje a Jorge de la Vega. Buenos Aires: Galería Carmen Waugh, 1971.

Jorge de la Vega. Caracas: Galería Conkright, 1973.

Jorge de la Vega: 1930–1971. Buenos Aires: Museo Nacional de Bellas Artes, 1976.

Magrassi, Guillermo E. *De la Vega*. Buenos Aires: Centro Editor de América Latina, 1981.

Antonio Dias

Conduru, Roberto. "'O país inventado' de Antonio Dias." *Gávea* (Rio de Janeiro), no. 8 (December 1990). Pp. 44–59.

Dias, Antonio. *Some Artists Do, Some Not*. Brescia: Edizioni Nuovi Strumenti, 1974.

Duarte, Paulo Sérgio. *Antonio Dias*. Rio de Janeiro: Edição FUNARTE, 1979.

Friedel, Helmut. *Antonio Dias: The Invented Country/Erfundenes Land*. Munich: Städtische Galerie im Lenbachhaus, 1984.

———. *Antonio Dias*. Milan: Studio Marconi, 1987.

Friedel, Helmut, and Ronaldo Brito. *Antonio Dias: Arbeiten auf Papier/Trabalhos sobre papel, 1977–1987*. Berlin: Staatliche Kunsthalle, 1988.

Millet, Catherine. *Antonio Dias*. Brussels: Galeries A. Baronian; Brescia: Pietro Cavellini, 1983.

Oliva, Achille Bonito. "Antonio Dias." *Flash Art International* (Milan), no. 145 (1988). Pp. 78–79.

Trini, Tommaso. "Produzione: Un caso di baratto." *Data* (Milan), no. 27 (July–September 1977). Pp. 22–25.

Cícero Dias

Cícero Dias. São Paulo: Galeria Ranulpho, 1984.

Cícero Dias: O sol e o sonho. São Paulo: Galeria Ranulpho, 1982.

Gonzalo Díaz

Dittborn, Eugenio, and G. Muñoz. "Acerca de la historia sentimental de la pintura chilena de Gonzalo Díaz." *La Separata* (Santiago), no. 2 (1982).

Mellado, Justo Pastor. *Banco/Marco de pruebas*. Santiago: Galería Arte Actual, 1988.

———. *Sueños privados, ritos públicos*. Santiago: Ediciones de la Cortina de Humo, 1989.

———. *Gonzalo Díaz: La declinación de los planos, instalación*. Santiago: Ediciones de la Cortina de Humo, 1991.

Valdés, Adriana. "Gonzalo Díaz." In Fatima Bercht, ed., *Contemporary Art from Chile/Arte contemporáneo desde Chile*. New York: Americas Society, 1991. Pp. 10–21.

Eugenio Dittborn

Brett, Guy. "Eugenio Dittborn." In Guy Brett, *Transcontinental: Nine Latin American Artists*, London and New York: Verso, 1990. Pp. 78–79.

Brett, Guy, and Sean Cubitt. *Camino Way: The Airmail Paintings of Eugenio Dittborn*. Santiago: Eugenio Dittborn, 1991.

Cubitt, Sean. "Retrato Hablado: The Airmail Paintings of Eugenio Dittborn." *Third Text* (London), no. 13 (Winter 1991). Pp. 17–24.

Dittborn, Eugenio. *Estrategias y proyecciones de la plástica nacional sobre la década de los ochenta*. Santiago: Grupo Camara, n.d.

E. Dittborn. Buenos Aires: Centro de Arte y Comunicación, 1979.

Final de pista: 11 pinturas y 13 graficaciones—E. Dittborn. Santiago: Galería Epoca, 1977.

Mellado, Justo Pastor. *El fantasma de la sequía, a propósito de las pinturas aeropostales de Eugenio Dittborn*. Santiago: Francisco Zegers Editor, 1988.

Richard, Nelly, and Ronald Kay. *V.I.S.U.A.L. Dittborn: Dibujos*. Santiago: Galería Epoca, 1976.

Valdés, Adriana. *Eugenio Dittborn*. Melbourne: George Paton Gallery, 1985.

Pedro Figari

Argul, José Pedro. *Pedro Figari*. Buenos Aires: Pinacoteca de los Genios, Codex, 1964.

Borges, Jorge Luis. *Figari*. Buenos Aires: Editorial Alfa, 1930.

Camnitzer, Luis. "Pedro Figari." *Third Text* (London), nos. 16/17 (Autumn/Winter 1991). Pp. 83–100.

Corradini, Juan. *Radiografía y macroscopía del grafismo de Pedro Figari*. Buenos Aires: Museo Nacional de Bellas Artes, 1978.

Figari, Pedro. *Arte: Estética, ideal*. 3 vols. 2d ed. Colección de clásicos uruguayos. Montevideo: Biblioteca Artigas, 1960 [1912].

———. *Educación y arte*. Colección de clásicos uruguayos. Montevideo: Biblioteca Artigas, 1965.

Figari, Pedro, Manuel Mujica Lainez, and Córdova Iturburu. *Pedro Figari, 1861–1938: Sus dibujos*. Buenos Aires: Editor R. Arzt, 1971.

Herrera MacLean, Carlos A. *Pedro Figari, 1861–1938*. Montevideo: Salón Nacional de Bellas Artes, 1945.

Manley, Marianne. *Intimate Recollections of the Río de la Plata: Paintings by Pedro Figari*. New York: Center for Inter-American Relations, 1986.

Oliver, Samuel. *Pedro Figari*. Buenos Aires: Ediciones de Arte Gaglianone, 1984.

Pedro Figari (1861–1938). New York: William Beadleston Gallery and Coe Kerr Gallery, 1987.

Gonzalo Fonseca

Gonzalo Fonseca: Recent Works. New York: The Jewish Museum, 1970.

Gonzalo Fonseca: XLIV Biennale di Venezia. Montevideo: Museo Nacional de Artes Visuales, 1990.

Manley, Marianne V. "Gonzalo Fonseca." *Latin American Art* (Scottsdale) 2, no. 2 (Spring 1990). Pp. 24–28.

Montealegre, Samuel. "Gonzalo Fonseca: Por el dédalo de mithos y logos." *Arte en Colombia* (Bogotá), no. 37 (September 1988). Pp. 48–51.

Julio Galán

Cameron, Dan. *Julio Galán*. New York: Annina Nosei Gallery, 1992.

Driben, Lelia. *Julio Galán*. New York: Annina Nosei Gallery, 1990.

Julio Galán. Seville: Pabellón Mudéjar, Parque de Maria Luisa, 1992.

Julio Galán: Dark Music. Pittsburgh: Pittsburgh Center for the Arts, 1993.

Pellizzi, Francesco. *Julio Galán*. New York: Annina Nosei Gallery, 1989.

Sims, Lowery S. *Julio Galán*. Monterrey: Museo de Monterrey, 1987.

Sullivan, Edward J. "Sacred and Profane: The Art of Julio Galán." *Arts Magazine* 64, no. 10 (Summer 1990). Pp. 51–55.

Gego

Acuarelas de Gego. Caracas: Galería de Arte Nacional, 1982.

Chocrón, Isaac. *Catálogo esculturas Gego*. Bogotá: Biblioteca Luis Angel Arango del Banco de la República, 1967.

Ossot, Hanni. *Gego*. Caracas: Museo de Arte Contemporáneo, 1977.

Palacios, María Fernanda. "Conversación con Gego." *Revista Ideas* (Caracas), no. 3 (May 1972).

Traba, Marta. "Gego: Caracas 3.000." In Marta Traba, *Mirar en Caracas: Crítica de arte*. Caracas: Monte Avila Editores, 1974.

———. *Gego*. Caracas: Museo de Arte Contemporáneo, 1977.

Víctor Grippo

Brett, Guy. "Víctor Grippo." In Guy Brett, *Transcontinental: Nine Latin American Artists*. London and New York: Verso, 1990. Pp. 86–87.

Glusberg, Jorge. *Víctor Grippo*. Buenos Aires: Centro de Arte y Comunicación, 1980.

———. "Ideología y regionalismo." In *Víctor Grippo: Obras de 1965 a 1987*. Buenos Aires: Fundación San Telmo, 1988. N.p.

Martín-Crosa, Ricardo. "Víctor Grippo." In Sally Baker, ed. *Art of the Americas: The Argentine Project*. Hudson, N.Y.: Baker & Co., 1992. Pp. 59–73.

di Paola, Jorge. "Víctor Grippo: Cambiar los hábitos, modificar la conciencia." *El Porteño* (Buenos Aires), no. 4 (1982).

Alberto da Veiga Guignard

Bax, Petrônio. *Exposição em memória do pintor Guignard*. Belo Horizonte: Galeria Kardinal, 1966.

Bento, Antônio, et al. *Guignard (1896–1962): Pinturas e desenhos*. Rio de Janeiro: Galeria de Arte BANERJ, 1982.

A modernidade em Guignard. Rio de Janeiro: Pontifícia Universidade Católica do Rio de Janeiro and Empresas Petróleo Ipiranga [1982].

Morais, Frederico. *Alberto da Veiga Guignard*. 2d ed., rev. Rio de Janeiro: Monteiro Soares Editores e Livreiros, 1978 [1974].

Moura, Antônio de Paiva. *A projeção da escola Guignard*. Belo Horizonte: Fundação Escola Guignard, 1979.

Viera, I. L. *A escola Guignard na cultura modernista de Minas: 1944–1962*. Brazil: Companhia Empreendimento Sabará, 1988.

Alberto Heredia

López Anaya, Jorge. *Alberto Heredia: Esculturas y dibujos, 1970/1984*. Buenos Aires: Fundación San Telmo, 1984.

Santana, Raúl. "Alberto Heredia." In Gabriel Levinas, ed., *Arte argentino contemporáneo*. Madrid: Editorial Ameris, 1979.

Alfredo Hlito

Alfredo Hlito. Buenos Aires: Galería Rubbers, 1981.

Alfredo Hlito: Retrospectiva. Buenos Aires: Museo Nacional de Bellas Artes, 1987.

Ambrosini, Silvia. *Alfredo Hlito*. Madrid: Editorial Ameris, 1979.

Brill, Rosa M. "Alfredo Hlito: Pintor y pensador." *Competencia* (Buenos Aires), no. 189 [1980]. Pp. 186–89.

———. *Hlito*. Buenos Aires: Centro Editor de América Latina, 1981.

Hlito, Alfredo. "Espacio artístico y sociedad." *Nueva visión* (Buenos Aires), no. 4 (1953). Pp. 29–34.

———. "Significado y arte concreto." *Nueva visión* (Buenos Aires), nos. 2/3 (1953). P. 27.

———. "Situación del arte concreto." *Nueva visión* (Buenos Aires), no. 6 (1955). Pp. 25–29.

Pinturas de Alfredo Hlito. Buenos Aires: Sala Van Riel, 1952.

Enio Iommi

Enio Iommi. Buenos Aires: Galería Carmen Waugh [1972].

Enio Iommi: Exposición retrospectiva. Buenos Aires: Museo de Artes Plásticas Eduardo Sívori, 1980.

Monzón, Hugo. *No perder la memoria: Enio Iommi esculturas, 1979–1992*. Buenos Aires: Fundación Banco Patricios, 1992.

Pellegrini, Aldo. *Enio Iommi*. Buenos Aires: Galería Bonino, 1966.

María Izquierdo

Andrade, Lourdes, et al. *María Izquierdo*. Mexico City: Centro Cultural/Arte Contemporáneo, 1988.

Artaud, Antonin. "La pintura de María Izquierdo." *Revista de revistas* (Mexico City), August 23, 1936.

María Izquierdo. Monterrey: Museo de Monterrey [1977].

Michelena, Margarita, et al. *María Izquierdo*. Guadalajara: Departamento de Bellas Artes, Gobierno de Jalisco, 1985.

Monsiváis, Carlos, et al. *María Izquierdo*. Mexico City: Casa de Bolsa Cremi, 1986.

Tibol, Raquel. *María Izquierdo y su obra*. Mexico City: Museo de Arte Moderno, 1971.

———. "María Izquierdo." *Latin American Art* (Scottsdale) 1, no. 1 (Spring 1989). Pp. 23–25.

Alfredo Jaar

Alfredo Jaar 1+1+1. New York: Alfredo Jaar, 1987.

Ashton, Dore, and Patricia C. Phillips. *Alfredo Jaar: Gold in the Morning*. New York: Alfredo Jaar, 1986.

Drake, W. Avon, et al. *Alfredo Jaar: Geography=War*. Richmond: Virginia Museum of Fine Arts and Anderson Gallery, Virginia Commonwealth University, 1991.

Grynsztein, Madeleine. *Alfredo Jaar*. La Jolla: La Jolla Museum of Contemporary Art, 1990.

Jaar, Alfredo. "La géographie ça sert, d'abord, à faire la guerre (Geography=War)." *Contemporánea* 2, no. 4 (June 1989). Pp. 1–5.

———. "L'artiste et le Lézard." In Michel Nuridsany, ed., *Effets de miroir*. Ivry-sur-Seine: Information Arts Plastiques Ile-de-France, 1989. P. 175.

Jiménez, Carlos. "Alfredo Jaar: Image and Reality." *Lapiz* (Madrid), March 1989. Pp. 62–66.

Phillips, Patricia C. *Alfredo Jaar: Two or Three Things I Imagine about Them*. London: Whitechapel Art Gallery, 1992.

Staniszewski, Mary Anne. "Alfredo Jaar/Interview." *Flash Art International* (Milan), no. 143 (November–December 1988). Pp. 116–17.

Valdés, Adriana. "Alfredo Jaar: Imágenes entre culturas." *Arte en Colombia* (Bogotá), no. 42 (December 1989). Pp. 46–53.

Frida Kahlo

Borsa, Joan. "Frida Kahlo: Marginalization and the Critical Female Subject." *Third Text* (London), no. 12 (Autumn 1990). Pp. 21–40.

Breton, André. "Frida Kahlo de Rivera." In *Frida Kahlo (Frida Rivera)*. New York: Julien Levy Gallery, 1938.

Drucker, Malka. *Frida Kahlo: Torment and Triumph in Her Life and Art*. New York: Bantam, 1991.

García, Rupert. *Frida Kahlo: A Bibliography*. Berkeley: Chicano Studies Library Publications Unit, University of California, 1983.

Gómez Arias, Alejandro, et al. *Frida Kahlo: Exposición homenaje*. Mexico City: Sala Nacional, Palacio de Bellas Artes, 1977.

Grimberg, Salomon. *Frida Kahlo*. Dallas: Meadows Museum, Southern Methodist University, 1989.

Herrera, Hayden. *Frida: A Biography of Frida Kahlo*. New York: Harper and Row, 1983.

———. *Frida Kahlo: The Paintings*. New York: HarperCollins, 1991.

Lowe, Sarah M. *Frida Kahlo*. New York: Universe, 1991.

Merewether, Charles, and Teresa del Conde. *The Art of Frida Kahlo*. Adelaide: Art Gallery of South Australia and the Adelaide Festival of the Arts, 1990.

Mulvey, Laura, and Peter Wollen. *Frida Kahlo and Tina Modotti*. London: Whitechapel Art Gallery, 1983. [Reprinted in Laura Mulvey, *Visual and Other Pleasures*. Bloomington and Indianapolis: Indiana University Press, 1989. Pp. 81–107.]

Prignitz-Poda, Helga, et al. *Frida Kahlo: Das Gesamtwerk*. Frankfurt: Neue Kritik, 1988.

Tibol, Raquel. *Frida Kahlo: Crónica, testimonios, y aproximaciones*. Mexico City: Ediciones de Cultura Popular, 1977.

———. *Frida Kahlo: Una vida abierta*. Mexico City: Editorial Oasis, 1983.

Zamora, Marta. *Frida Kahlo: El pincel de la angustia*. Mexico City: 1987. Abbreviated English edition: *Frida Kahlo: The Brush of Anguish*. Trans. and ed. by Marilyn Sode-Smith. San Francisco: Chronicle, 1990.

Gyula Kosice

Chiérico, Osiris. *Kosice: Reportaje a una anticipación*. Buenos Aires: Ediciones Taller Libre, 1979.

Exposición fotográfica de 32 escultura y poemas de Gyula Kosice. Buenos Aires: Bohemian Club, Galerías Pacifico, 1947.

Habasque, Guy. *Kosice*. Paris: Collection Prisme, 1965.

Kosice, Gyula. *Arte hidrocinético: Movimiento, luz, agua*. Buenos Aires: Editorial Paidós, 1968.

———. *La ciudad hidroespacial*. Buenos Aires: 1972.

———. *Arte y arquitectura del agua*. Caracas: Monte Avila Editores, 1984.

Squirru, Rafael. *Kosice*. Buenos Aires: Ediciones de Arte Gaglianone, 1990.

Squirru, Rafael, Gyula Kosice, and Jorge López Anaya. *Kosice: Obras 1944/1990*. Buenos Aires: Museo Nacional de Bellas Artes, 1991.

Frans Krajcberg

Courthion, Pierre. *Krajcberg*. Paris: Galerie XXe Siècle, 1962. [brochure]

Frans Krajcberg: Imagens do fogo. Rio de Janeiro: Museu de Arte Moderna; Salvador: Museu de Arte Moderna da Bahia, 1992.

Krajcberg: Obras recentes. Vitória, Brazil: Usina Praia do Canto, 1988.

Mendonça, Casimiro Xavier de, and Pierre Restany. *Frans Krajcberg*. Curitiba, Brazil: Sala Miguel Bakun, 1981.

Montoia, Paulo. "Frans Krajcberg, a os 63 annos: A energia de um jovem artista." *Skultura* (São Paulo), Autumn 1984. Pp. 11–13.

Restany, Pierre. *Krajcberg*. Paris: Galerie "J," 1966. [brochure]

———. *Frans Krajcberg*. Jerusalem: Israel Museum and Galerie Goldmann Schwarz, 1969.

———. *Frans Krajcberg*. Paris: Centre National d'Art et de Culture Georges Pompidou, 1975.

Zanini, Walter. *Krajcberg*. Buenos Aires: Galería Bonino, 1960.

Guillermo Kuitca

Becce, Sonia. *Guillermo David Kuitca: Obras, 1982–1988*. Buenos Aires: Julia Lublin Editions, 1989.

Beeren, Wim, and Edward Lucie-Smith. *Guillermo Kuitca*. Amsterdam: Galerie Barbara Farber, 1990.

Carvajal, Rina. *Guillermo Kuitca*. Rotterdam: Witte de With, Center for Contemporary Art, 1990.

Driben, Lelia. *Kuitca*. São Paulo: XX Bienal Internacional, 1989.

Glusberg, Jorge, and Louis Grachos. *New Image Painting: Argentina in the Eighties: Rafael Bueno, Guillermo Kuitca, Alfredo Prior*. New York: Americas Society, 1989.

Merewether, Charles. *Guillermo Kuitca*. Rome: Gian Enzo Sperone; New York: Annina Nosei Gallery, 1990.

Oliva, Achille Bonito. *Guillermo Kuitca*. New York: Annina Nosei Gallery, 1991.

Zelevansky, Lynn. *Guillermo Kuitca/Projects 30*. New York: Museum of Modern Art, 1991. [brochure]

———. *Guillermo Kuitca*. Newport Harbor, California: Newport Harbor Art Museum, 1992.

Diyi Laañ

Homenaje a la vanguardia argentina: Década del 40. Buenos Aires: Galería Arte Nuevo, 1976.

Wifredo Lam

Ayllón, José, and Lou Laurin Lam. *Exposición antológica, "Homenaje a Wifredo Lam," 1902–1982*. Madrid: Museo Nacional de Arte Contemporáneo, Ministerio de Cultura, 1982.

Blanc, Giulio V., Julia P. Herzberg, and Lowery Stokes Sims. *Wifredo Lam and His Contemporaries*. New York: The Studio Museum in Harlem, 1992.

Breton, André. *Lam*. Port-au-Prince: Centre d'Art, 1946.

Fouchet, Max-Pol. *Wifredo Lam*. Paris: Albin Michel; Barcelona: Polígrafa, 1984.

Gaudibert, Pierre, et al. *Wifredo Lam*. Düsseldorf: Kunstsammlung Nordrhein-Westfalen, 1988.

Herzberg, Julia P. "Wifredo Lam." *Latin American Art* (Scottsdale) 2, no. 3 (Summer 1990). Pp. 18–24.

Leiris, Michel. *Wifredo Lam*. Milan: Fratelli Fabbri; New York: Harry N. Abrams, 1970.

Merewether, Charles, et al. *Wifredo Lam: A Retrospective of Works on Paper*. New York: Americas Society, 1992.

Nuñez Jiménez, Antonio. *Wifredo Lam*. Havana: Editorial Letras Cubanas, 1982.

Ortíz, Fernando. *Wifredo Lam*. Havana: Publicaciones del Ministerio de Educación, 1950.

Sims, Lowery S. "Wifredo Lam: Transpositions of the Surrealist Proposition in the Post–World War II Era." *Arts Magazine* 60, no. 4 (December 1985). Pp. 21–25.

———. "In Search of Wifredo Lam." *Arts Magazine* 63, no. 4 (December 1988). Pp. 50–55.

Soupault, Philippe. *Wifredo Lam: Dessins*. Paris: Editions Galilée-Dutrou, 1975.

Taillardier, Ivonne. *Wifredo Lam*. Paris: Editions Denoël, 1970.

Xuriguéra, Gérard. *Wifredo Lam*. Paris: Filipacchi, 1974.

Yau, John. "Please Wait by the Coatroom: Wifredo Lam in The Museum of Modern Art." *Arts Magazine* 63, no. 4 (December 1988). Pp. 56–59.

Jac Leirner

Brett, Guy. "A Bill of Wrongs." In *Parallel/Bienale*. São Paulo: Galerie Millan, 1989.

———. "Jac Leirner." In Guy Brett, *Transcontinental: Nine Latin American Artists*. London and New York: Verso, 1990. Pp. 62–63.

Corris, Michael. "Não Exótico." *Artforum* 30, no. 4 (December 1991). Pp. 89–92.

Elliott, David. *Jac Leirner*. Oxford: Museum of Modern Art; Glasgow: Third Eye Centre, 1991.

Ferguson, Bruce W. *Viewpoints: Jac Leirner*. Minneapolis: Walker Art Center, 1991. [brochure]

Jac Leirner. Venice: XLIV Biennale, 1990.

Plaza, Julio. *Jac Leirner and Ação Barros*. São Paulo: Galeria Tenda, 1982.

Julio Le Parc

Elia, Alberto, ed. *Julio Le Parc: Experiencias 30 años 1958–1988*. Buenos Aires: Secretaría de Cultura de la Nación and Ministerio de Relaciones Exteriores y Cultor, 1988.

Le Parc. Munich: Galerie Buchholz, 1968. [brochure]

Le Parc: Couleur 1959. Paris: Galerie Denise René, 1970. [brochure]

Le Parc: Pinturas recientes. Bogotá: Museo de Arte Moderno, 1976.

Popper, Frank, and Jean Clay. *Le Parc*. Caracas: Museo de Bellas Artes, 1967.

Raúl Lozza

Chiérico, Osiris. *Raúl Lozza: "Pintura concreta."* Buenos Aires: Galería de Arte Van Eyck, 1989.

Haber, Abraham. *Raúl Lozza y el perceptismo: La evolución de la pintura concreta*. Buenos Aires: Diálogo, 1948.

Raúl Lozza, cuarenta años en el arte concreto (sesenta con la pintura). Buenos Aires: Fundación San Telmo, 1985.

Rocío Maldonado

Ferrer, Elizabeth. *Rocío Maldonado*. Mexico City: Galería OMR, 1993.

Sullivan, Edward J. "Rocío Maldonado." In Patricia Riestra Ortiz Monasterio and Jaime Riestra, eds., *New Moments in Mexican Art/Nuevos momentos en el arte mexicano*. New York: Parallel Project; Madrid: Turner Libros, 1990. Pp. 57–60.

———. *Rocío Maldonado*. Mexico City: Galería OMR, 1990.

Tomás Maldonado

Maldonado, Tomás. *Design, Nature and Revolution: Toward a Critical Ecology*. New York: Harper and Row, 1972. [Trans. by Mario Domandi from *La speranza progettuale*. Turin: Giulio Einaudi, 1970.]

———. *Avanguardia e razionalità: Articoli, saggi, pamphlets, 1946–1974*. Turin: Giulio Einaudi Editore, 1974. [Trans. by Francesc Serra i Cantarell from *Vanguardia y racionalidad: Artículos, ensayos y otros escritos, 1946–1974*. Rev. ed. Barcelona: Gustavo Gilli, 1977.]

———. *Il futuro della modernità*. Milan: Giancomo Feltrinelli, 1987.

Marisol

Barnitz, Jacqueline. "The Marisol Mask." *Artes Hispánicas* (Bloomington, Ind.) 1, no. 2 (Autumn 1967). P. 45.

Creeley, Robert. *Presences: A Text for Marisol*. New York: Scribner's and Sons, 1976.

Diament Sujo, Clara. *Marisol*. Rotterdam: Museum Boymans–Van Beuningen, 1968.

Grove, Nancy. *Magical Mixtures: Marisol Portrait Sculpture*. Washington, D.C.: National Portrait Gallery, Smithsonian Institution, 1991.

Marisol. New York: Sidney Janis Gallery, 1984.

Medina, José Ramón. *Marisol*. Caracas: Armitano, 1968.

Schulman, Leon. *Marisol*. Worcester, Mass.: Worcester Art Museum, 1971.

Matta

Breton, André. *Préliminaires sur Matta*. Paris: René Drouin [1947].

Carrasco, Eduardo. *Matta conversaciones*. Santiago: Ediciones Chile y América, 1987.

De Francia, Peter, and André Breton. *Matta: Coïgitum*. London: Hayward Gallery, 1977.

Ferrari, Germana. *Matta: Indice dell' opera grafica dal 1969 al 1980*. Viterbo: Amministrazione Provinciale di Viterbo, 1980.

Ferrari, Germana, ed. *Entretiens morphologiques: Notebook no. 1, 1936–1944*. London: Sistan, 1987.

Matta. Granada: Diputación Provincial de Granada, Area de Cultura, 1991.

Matta: Catalogue raisonné de l'oeuvre gravé (1943–1974). Stockholm: Sonet; Paris: Georges Visat, 1975.

Matta: The First Decade. Waltham, Mass.: Rose Art Museum, Brandeis University, 1982.

Rubin, William. *Matta*. New York: Museum of Modern Art, 1957.

Sawin, Martica. *Matta: The Early Years*. New York: Maxwell Davidson Gallery, 1988.

Sayag, Alain. *Matta: Dessins, 1936–1989*. Paris: Galerie de France, 1990.

Sayag, Alain, et al. *Matta*. Paris: Musée National d'Art Moderne, Centre Georges Pompidou, 1985.

Sebastian Matta: Mostra antologica in Bologna. Bologna: Museo Civico, 1963. [Special issue of *Bologna: Revista del Comune*, no. 2 (May 1963).]

Stringer, John. *Printed Matta: Highlights from Four Decades of Printmaking by Roberto Matta*. New York: Center for Inter-American Relations, 1983.

Webster, Douglas. *Matta Now: Recent Paintings*. Scottsdale: Yares Gallery, 1985.

Cildo Meireles

Brett, Guy. "Cildo Meireles." *Review: Latin American Literature and Arts*, no. 42 (January–June 1990). Pp. 26–30.

———. "Cildo Meireles." In Guy Brett, *Transcontinental: Nine Latin American Artists*. London and New York: Verso, 1990. Pp. 46–47.

Brito, Ronaldo, and Eudoro A. Macieira de Sousa. *Cildo Meireles*. Rio de Janeiro: Edição FUNARTE, 1981.

Gomes, Federico. "O território sem fronteiras da arte." *Módulo*, July–August 1981. Pp. 26–35.

Leffingwell, Edward. "Report from Brazil: Tropical Bazaar." *Art in America* 78, no. 6 (June 1990). Pp. 87–95.

Meireles, Cildo. "Inserções em circuitos ideológicos." *Malasartes*, no. 1 (September–November 1975). P. 15.

Tunga "Lezarts"/Cildo Meireles "Through." Kortrijk, Belgium: Kunststichting Kanaal, 1989.

Weschler, Lawrence. "Studio—Cildo Meireles: Cries from the Wilderness." *Artnews* 89, no. 6 (Summer 1990). Pp. 95–98.

Juan Melé

Caride, Vicente P., and Juan Melé. *Arte Invención: Retrospectiva Juan N. Melé: Oleos y acrílicos 1945–1973*. Buenos Aires: Centro Cultural General San Martín, 1973.

Juan N. Melé: Invenciones: New York–Buenos Aires: Pinturas, esculturas. Buenos Aires: Museo de Arte Moderno, 1987.

Juan Melé: Retrospectiva. Buenos Aires: Museo de Artes Plásticas Eduardo Sívori, 1981.

Ana Mendieta

Barreras del Río, Petra, and John Perreault. *Ana Mendieta: A Retrospective*. New York: New Museum of Contemporary Art, 1987.

Camnitzer, Luis. "Ana Mendieta." *Arte en Colombia* (Bogotá), no. 38 (December 1988). Pp. 44–49.

———. "Ana Mendieta." *Third Text* (London), no. 7 (Summer 1989). Pp. 47–52.

Jacob, Mary Jane. *Ana Mendieta: The "Silueta" Series, 1973–1980*. New York: Galerie Lelong, 1991.

Katz, Robert. *Naked by the Window: The Fatal Marriage of Carl Andre and Ana Mendieta*. New York: The Atlantic Monthly Press, 1990.

Lippard, Lucy. "The Pains and Pleasures of Rebirth: Women's Body Art." *Art in America* 64, no. 3 (May–June 1976). Pp. 73–81.

Mendieta, Ana. "La Venus Negra, Based on a Cuban Legend." *Heresies* 4, no. 1 (1981). P. 22.

Mendieta Harrington, Raquel. "Ana Mendieta: Self Portrait of a Goddess." *Review: Latin American Literature and Arts*, no. 39 (January–June 1988). Pp. 38–39.

Carlos Mérida

Cardoza y Aragón, Luis. *Carlos Mérida*. Madrid: Ediciones de la Gaceta Literaria, 1927.

Carlos Mérida: Graphic Work, 1915–1981. New York: Center for Inter-American Relations, 1981.

Carlos Mérida: Pintor, muralista, grabador, investigador, escenógrafo, diseñador. Mexico City: Museo de Arte Moderno, 1970.

Goeritz, Mathías, Alfonso Soto Soria, and Carlos Mérida. *El diseño, la composición y la integración plástica de Carlos Mérida*. Mexico City: Universidad Nacional Autónoma de México, Museo de Ciencias y Arte, 1963.

Guzmán, Xavier, et al., eds. *Escritos de Carlos Mérida sobre arte: El muralismo*. Mexico City: Instituto Nacional de Bellas Artes, 1987.

Homenaje a Carlos Mérida. Mexico City: Galería de Arte Mexicano, 1971.

Koeninger, Patty. *A Salute to Carlos Mérida*. Austin: University Art Museum, University of Texas, 1976.

Luján Muñoz, Luis. *Carlos Mérida: Precursor del arte contemporáneo latinoamericano*. Guatemala City: Cuadernos de la Tradición Guatemalteca, 1985.

Nelken, Margarita. *Carlos Mérida*. Mexico City: Universidad Nacional Autónoma de México, 1961.

de la Torre, Mario, ed. *Carlos Mérida en sus 90 años*. Mexico City: Cartón y Papel de México, 1981.

Westheim, Paul. *Carlos Mérida 70 Aniversario: Exposición retrospectiva*. Mexico City: Museo Nacional de Arte Moderno, 1961.

Florencio Molina Campos

Bonomini, Angel, and Enrique Molina. *Florencio Molina Campos*. Buenos Aires: Asociación Amigos de las Artes Tradicionales, 1989.

Edgar Negret

Aguilar, José Hernán. "Negret y la cultura del aislamiento." *Arte* (Bogotá), no. 2 (1987). Pp. 40–53.

Berkowitz, Marc, et al. *Edgar Negret*. San Juan: Museo de Bellas Artes, Instituto de Cultura Puertorriqueña, 1974.

Carbonell, Galaor. *Edgar Negret: A Retrospective*. New York: Center for Inter-American Relations, 1976.

———. *Negret: Las etapas creativas*. Medellín: Fondo Cultural Cafetero, 1976.

Castillo, Carlos. *Negret: Retrospectiva, 1945–1978*. Bogotá: Galería Garcés Velásquez, 1978.

Edgar Negret. Amsterdam: Stedelijk Museum, 1970.

Martínez-Novillo, Alvaro, et al. *Edgar Negret*. Madrid: Museo Español de Arte Contemporáneo, 1983.

Montaña, Antonio. *Edgar Negret: Obras recientes*. Bogotá: Galería Luis Perez, 1990.

Panessa, Fausto. "En México: Un museo para Negret." *Diners* (Colombia) 27, no. 264 (March 1992). Pp. 56–59.

Salvador, José María. *Edgar Negret: De la máquina al mito/1957–1991*. Monterrey: Museo de Monterrey; Mexico City: Museo Rufino Tamayo, 1991.

Serrano, Eduardo. *Negret: Cincuenta años/Cientocincuenta obras*. Bogotá: Museo de Arte Moderno, 1987.

Luis Felipe Noé

Casanegra, Mercedes. *El color y las artes plásticas: Luis Felipe Noé*. Buenos Aires: S.A. Alba, 1988.

Glusberg, Jorge. *La nueva figuración: Deira–de la Vega–Macció–Noé*. Buenos Aires: Ruth Benzacar Galería de Arte, 1986.

Luis Felipe Noé: Paintings. New York: Galeria Bonino, 1966.

Noé, Luis Felipe. *Antiestética*. 1965. Reprint. Buenos Aires: Ediciones de la Flor, 1988.

———. *Una sociedad colonial avanzada*. Buenos Aires: Ediciones de la Flor, 1971.

———. *El arte de América Latina es la revolución*. Santiago: Editorial Andrés Bello, 1973.

———. *Recontrapoder*. Buenos Aires: Ediciones de la Flor, 1974.

———. *Noé: Porqué pinté lo que pinté, dejé de pintar lo que no pinté, y pinto ahora lo que pinto*. Buenos Aires: Galería Carmen Waugh, 1975.

Rivera, Rosa María. *Luis Felipe Noé: Pinturas 1988–1989*. Buenos Aires: Galería Ruth Benzacar, 1989.

Rojas-Mix, Miguel. "Noé y la transvanguardia o tras la vanguardia de Noé." *Arte en Colombia* (Bogotá) 38 (December 1988). Pp. 64–68.

Sánchez, Marta A. *Noé*. Buenos Aires: Centro Editor de América Latina, 1981.

Hélio Oiticica

Brett, Guy. "Hélio Oiticica: Reverie and Revolt." *Art in America* 77, no. 1 (January 1989). Pp. 110–20, 163–65.

Figueiredo, Luciano, Lygia Pape, and Waly Salomão, eds. *Aspiro ao grande labirinto: Textos de Hélio Oiticica*. Rio de Janeiro: Rocco, 1986.

Hélio Oiticica. London: Whitechapel Art Gallery, 1969.

Hélio Oiticica. Rotterdam: Witte de With, Center for Contemporary Art, 1992.

Lygia Clark e Hélio Oiticica. Rio de Janeiro and São Paulo: FUNARTE, Instituto Nacional de Artes Plásticas, 1986.

Os projetos de Hélio Oiticica. Rio de Janeiro: Museu de Arte Moderna, 1961.

Salomão, Waly. *Hélio Mangueira Oiticica*. Rio de Janeiro: Galeria UERJ, 1990.

José Clemente Orozco

Cardoza y Aragón, Luis. *Orozco*. Mexico City: Instituto de Rocco, 1986.

Cardoza y Aragón, Luis, et al. *José Clemente Orozco*. Paris: Musée d'Art Moderne de la Ville de Paris, 1979.

del Conde, Teresa, ed. *José Clemente Orozco: Antología crítica*. Mexico City: Universidad Nacional Autónoma de México, 1983.

Elliott, David, ed. *Orozco!* Oxford: Museum of Modern Art, 1980.

Exposición nacional de homenaje a José Clemente Orozco con motivo del XXX aniversario de su fallecimiento. Mexico City: Palacio de Bellas Artes, 1979.

Exposición nacional de José Clemente Orozco. Mexico City: Secretaría de Educación Pública, 1947.

Fernández, Justino. *Obras de José Clemente Orozco en la colección Carrillo Gil*. Mexico City: 1949.

———. *José Clemente Orozco: Forma e idea*. 2d ed., rev. Mexico City: Editorial Porrúa, 1956.

Helm, MacKinley. *Man of Fire: José Clemente Orozco*. Boston: Institute of Contemporary Art; New York: Harcourt Brace, 1953.

Hopkins, Jon H. *Orozco: A Catalogue of His Graphic Work*. Flagstaff: Northern Arizona University Publications, 1967.

J. C. Orozco Memorial Exhibition. Boston: Institute of Contemporary Art, 1952.

Johnson, Alvin. *Notes on the New School Murals*. New York: New School for Social Research, n.d.

Marrozini, Luigi. *Catálogo completo de la obra gráfica de Orozco*. San Juan: Instituto de Cultura Puertoriqueña, 1970.

Monsiváis, Carlos. *"Sainete, drama y barbarie"— J. C. Orozco: Caricaturas, grotescos*. Mexico City: Museo Nacional de Arte [1983].

Orozco, José Clemente. *An Autobiography*. Austin: University of Texas Press, 1962. [Trans. by Robert Stephenson from *Autobiografía*. Rev. ed. Mexico City: Ediciones Era, 1970 (1945).]

———. *Textos de Orozco: Con un estudio y un apéndice por Justino Fernández*. Mexico City: Imprenta Universitaría, 1955.

———. *El artista en Nueva York (cartas a Jean Charlot, 1925–1929, y tres textos inéditos)*. Mexico City: Siglo XXI, 1971.

Reed, Alma. *Orozco*. New York: Oxford University Press, 1956. [Trans. from *Orozco*. Mexico City: Fondo de Cultura Económica, 1955.]

Reed, Alma, and Margarita Valladares de Orozco. *Orozco*. Dresden: VDB Verlag der Kunst, 1979.

Rafael Montañez Ortiz

GAAG: The Guerrilla Art Action Group, 1969–1976: A Selection. New York: Printed Matter, 1978.

Ortiz, Ralph. "Culture and the People." *Art in America* 59, no. 3 (May–June 1971). P. 27.

Rafael Montañez Ortíz: Years of the Warrior, Years of the Psyche, 1960–1988. New York: Museo del Barrio, 1988.

Alejandro Otero

Alejandro Otero. Caracas: Museo de Arte Contemporáneo, 1985.

Alejandro Otero: Ensamblajes y encolados. Caracas: Sala de Exposiciones Fundación Eugenio Mendoza, 1964.

Balza, José. *Alejandro Otero*. [Milan]: Olivetti, 1977.

Boulton, Alfredo. *Alejandro Otero*. Caracas: Oficina Central de Información, Colección Venezolanos, 1966.

———. *Art in Gurí*. Caracas: Electrificación del Caroní [1988].

Davill, Jerry M., et al. *Alejandro Otero: A Retrospective Exhibition*. Austin: Michener Galleries, University of Texas, 1975.

Las estructuras de Alejandro Otero. Caracas: Museo Nacional de Bellas Artes, 1991.

Otero Rodríguez, Alejandro, and Miguel Otero Silva. *Polémica sobre arte abstracto*. Caracas: Letras Venezolanas, 1957.

Palacios, Inocente. *Alejandro Otero*. Caracas: Instituto Nacional de Cultura y Bellas Artes, 1967.

Ramos, María Elena. "Alejandro Otero: Las estructuras de la realidad." *Art Nexus* (Bogotá), no. 2 (October 1991). Pp. 97–99.

César Paternosto

Fèvre, Fermín. *Paternosto*. Buenos Aires: Centro Editor de América Latina, 1981.

———, et al. *César Paternosto: Obras 1961/1987*. Buenos Aires: Fundación San Telmo, 1987.

Hunter, Sam. *César Paternosto and the Return of the Enchantment*. New York: Mary-Anne Martin/Fine Art, 1984.

Lippard, Lucy, and Ricardo Martín-Crosa. *César Paternosto: Paintings 1969–1980*. New York: Center for Inter-American Relations, 1981.

Minemura, Toshiaki. *César Paternosto*. Tokyo: Fuji Television Gallery, 1982.

Paternosto, César. *Piedra abstracta, la escultura Inca: Una visión contemporánea*. Buenos Aires and Mexico City: Fondo de Cultura Económica, 1989. [English version, translated by Esther Allen, University of Texas Press, forthcoming.]

Liliana Porter

Cuperman, Pedro. *Liliana Porter*. Buenos Aires: Arte Nueva Galería de Arte, 1980.

———. *About Metaphors: The Art of Liliana Porter*. New York: World Gallery, Syracuse University, 1990.

González, Miguel. *Liliana Porter*. Cali: Museo de Arte Moderno, La Tertulia, 1983.

Kalenberg, Angel. *Liliana Porter: Selección de Obras, 1968–1990*. Buenos Aires: Fundación San Telmo, 1990.

Liliana Porter. Bogotá: Museo de Arte Moderno, 1974.

Liliana Porter/Luis Benedit. Madrid: Ruth Benzacar Galería de Arte, 1988.

Ramírez, Mari Carmen, and Charles Merewether. *Liliana Porter: Fragments of the Journey*. New York: Bronx Museum of the Arts, 1992.

Stringer, John. *Liliana Porter*. New York: Center for Inter-American Relations, 1980.

Cândido Portinari

Aquino, F. *Cândido Portinari*. Buenos Aires: Codex, 1965.

Bardi, Pietro Maria. *Cem obras primas de Portinari*. São Paulo: Museu de Arte Assis Chateaubriand, 1970.

Bento, Antonio. *Portinari*. Rio de Janeiro: Editorial Leo Christiano, 1982.

Camargo, Ralph. *Portinari: Desenhista*. Rio de Janeiro: Museu Nacional de Belas Artes, 1977.

Fabris, Annateresa. *Portinari: Pintor social*. São Paulo: Universidade de São Paulo, 1990.

Lemmon, Sarah. "Cândido Portinari: The Protest Period." *Latin American Art* (Scottsdale) 3, no. 1 (Winter 1991). Pp. 31–34.

Portinari: His Life and Art. Chicago: The University of Chicago Press, 1940.

Portinari: O menino de Brodósqui. Rio de Janeiro: Livro-arte Editôra, 1979.

Valladares, Clarivaldo Prado. *Análise iconográfica da pintura monumental de Portinari nos Estados Unidos*. Rio de Janeiro: Museu Nacional de Belas Artes [1975].

Zilio, Carlos. *A querela do Brasil: A questão da identidade da arte brasileira: A obra de Tarsila, di Cavalcanti e Portinari, 1922–1945*. Rio de Janeiro: Edição FUNARTE, 1982.

Lidy Prati

Arte concreto. Buenos Aires: Instituto de Arte Moderno, 1950.

Eduardo Ramírez Villamizar

Carbonell, Galaor. *Eduardo Ramírez Villamizar*. Bogotá: Museo de Arte Moderno, 1975.

Catlin, Stanton L., et al. *Eduardo Ramírez: Sculptor*. New York: Center for Inter-American Relations, 1968.

Eduardo Ramírez Villamizar: Esculturas. Caracas: Museo de Bellas Artes, 1978.

Escallón, Ana María, et al. *El espacio en forma: Eduardo Ramírez Villamizar. Exposición retrospectiva, 1945–1985*. Bogotá: Biblioteca Luis Angel Arango, 1986.

Morais, Frederico. *Ramírez Villamizar*. Bogotá: Museo de Arte Moderno, 1984.

Ramírez Villamizar. Colombia: XXXVII Bienal de Venecia, 1976.

Traba, Marta. *Ramírez Villamizar*. Bogotá: Galería Garces Velásquez, 1979.

Nuno Ramos

Mammi, Lorenzo. "Nuno Ramos." In Marcantonio Vilaça, ed., *Nuno Ramos/Hilton Berredo/Ester Grinspun/Fábio Miguez/Frida Baranek*. São Paulo: Jaú S/A Construtora e Incorporadora, 1989.

Nuno Ramos. São Paulo: Gabinete de Arte, 1991.

Vicente do Rego Monteiro

Simon, Michel, et al. *Vicente do Rego Monteiro: 42 reproduções em fotogravura*. Recife: Secretaría do Interior, Pernambuco, 1944.

Zanini, Walter. *Vicente do Rego Monteiro (1899–1970)*. São Paulo: Museu de Arte Contemporânea da Universidade de São Paulo, 1971.

———. "Rego Monteiro e a Escola de Paris." *Revista galeria* (São Paulo), no. 15 (1989). Pp. 116–19.

José Resende

Barella, Elaine. *José Resende: New Sculpture from Brazil.* Hartford: Joseloff Gallery, University of Hartford, 1991.

Brito, Ronaldo. *José Resende.* Rio de Janeiro: Espaço Arte Brasileira Contemporânea, 1980.

José Resende. São Paulo: Museu de Arte Moderna de São Paulo, 1974.

Resende, José. "Ausência da escultura." *Malasartes*, no. 3 (April–June 1976). Pp. 4–8.

Armando Reverón

Armando Reverón. Caracas: Armitano, 1979.

Arroyo, Miguel G., et al. *Armando Reverón (1889–1954): Exposición antológica.* Madrid: Ediciones Museo Nacional Centro de Arte Reina Sofía, 1992.

Boulton, Alfredo. *Exposición retrospectiva de Armando Reverón.* Caracas: Museo de Bellas Artes, 1975.

———. *Reverón.* Caracas: Ediciones Macanao, 1979.

———. *Reverón en cien años de pintura en Venezuela.* Caracas: Museo de Arte Contemporáneo, 1989.

———. *Mirar a Reverón.* Caracas: Ediciones Macanao, 1990.

———, et al. *Armando Reverón.* Boston: Institute of Contemporary Art, 1956.

Calzadilla, Juan. *Armando Reverón, 1889–1954: Colección de la Galería de Arte Nacional de Caracas.* Caracas: Consejo Nacional de la Cultura, 1979.

Calzadilla, Juan, and Wuilly Aranguren, eds. *Reverón: 18 testimonios.* [Caracas]: Lagoven, S.A. Filial de Petróleos de Venezuela and Galería de Arte Nacional, 1979.

Manthorne, Katherine E. "Armando Reverón." *Latin American Art* (Scottsdale) 4, no. 1 (Spring 1992). Pp. 33–35.

Pérez Oramas, Luis. *Armando Reverón: De los prodigios de la luz a los trabajos del arte.* Caracas: Museo de Arte Contemporáneo Sofía Imber, 1989.

Presencia y luz de Armando Reverón: Exposición iconográfica documental en el centenario de su nacimiento. Caracas: Ediciones Galería de Arte Nacional, 1989.

Diego Rivera

Azuela, Alicia. *Diego Rivera en Detroit.* Mexico City: Universidad Nacional Autónoma de México, 1985.

Debroise, Olivier. *Diego de Montparnasse.* Mexico City: Fondo de Cultura Económica, 1979.

Diego Rivera: A Retrospective. New York: W. W. Norton; Detroit: Detroit Institute of Arts, 1986.

Diego Rivera: Catálogo general de obra de caballete. Mexico City: Instituto Nacional de Bellas Artes, 1989.

Eder, Rita, et al. *Diego Rivera: Exposición nacional de homenaje.* Mexico City: Palacio de Bellas Artes, 1977.

Favela, Ramón. *Diego Rivera: The Cubist Years.* Phoenix: Phoenix Art Museum, 1984.

———. *Diego Rivera: El joven e inquieto Diego María Rivera (1907–1910).* Mexico City: Editorial Secuencia, 1991.

Herner de Larrea, Irene. *Diego Rivera: Paradise Lost at Rockefeller Center.* Mexico City: Edicupes, 1987.

López Rangel, Raquel. *Diego Rivera y la arquitectura mexicana.* Mexico City: Dirección General de Publicaciones y Medios, 1986.

McMeekin, Dorothy. *Diego Rivera: Science and Creativity in the Detroit Murals.* East Lansing: Michigan University Press, 1985.

O'Gorman, Juan. *La técnica de Diego Rivera en la pintura mural.* Mexico City: Frente Nacional de Artes Plásticas, 1954.

Reyero, Manuel. *Diego Rivera.* Mexico City: Fundación Cultural Televisa, 1983.

Rivera, Diego, with Gladys March. *My Art, My Life.* New York: Citadel Press, 1960. [Reprint, New York: Dover, 1990.]

Rochfort, Desmond. *The Murals of Diego Rivera.* London: South Bank Centre, 1987.

Taracena, Berta. *Diego Rivera: Su obra mural en la ciudad de México.* Mexico City: Galería de Arte Misrachi, 1981.

Tibol, Raquel, ed. *Arte y política: Diego Rivera.* Mexico City: Editorial Grijalbo, 1979.

Wolfe, Bertram. *The Fabulous Life of Diego Rivera.* New York: Stein and Day, 1969.

Arnaldo Roche Rabell

"Espíritus": Works by Arnaldo Roche-Rabell. San Juan: Galería Botello, 1991.

García Gutiérrez, Enrique. "Arnaldo Roche Rabell: New Expressionism." *Latin American Art* (Scottsdale) 2, no. 1 (Winter 1990). Pp. 40–44.

García Gutiérrez, Enrique, and Michael Bonesteel. *Arnaldo Roche Rabell: Eventos, milagros, y visiones.* San Juan: Museo de la Universidad de Puerto Rico, 1986.

García Gutiérrez, Enrique, and Gregory G. Knight. *Arnaldo Roche Rabell: Actos compulsivos.* Ponce: Museo de Arte de Ponce, 1984.

Merewether, Charles, and Enrique García Gutiérrez. *Roche: The First Ten Years.* Monterrey: Museo de Arte Contemporáneo, 1993.

Carlos Rojas

Aguilar, José Hernán, et al. *Carlos Rojas: Una constante creativa.* Bogotá: Museo de Arte Moderno, 1990.

Carlos Rojas. Miami: Centro Colombo-Americano [1982].

Carlos Rojas: Esculturas. Bogotá: Biblioteca Luis Angel Arango, 1966.

Serrano, Eduardo. *Carlos Rojas.* Bogotá: Museo de Arte Moderno, 1984.

de Urdinola, Maritza Uribe. *Carlos Rojas.* Cali: Museo de Arte, La Tertulia, 1974.

Miguel Angel Rojas

Aguilar, José Hernán. "Miguel Angel Rojas, espacios simbólicos." *Revista diva*, no. 2 (March 1990). Pp. 22–23.

González, Miguel. "Miguel Angel Rojas: La realidad como reflexión." *Arte en Colombia* (Bogotá), no. 21 (May 1983). Pp. 36–39.

Pini, Ivonne. "Conversación con Miguel Angel Rojas." *Arte en Colombia* (Bogotá), no. 40 (May 1989). Pp. 71–75.

Serrano, Eduardo. "*Grano* y otras obras de Miguel Angel Rojas." *Revista del arte y arquitectura en América Latina* (Medellín) 2, no. 6 (1981). Pp. 42–47.

Stringer, John. *Miguel Angel Rojas: "Grano."* Bogotá: Sala de Proyectos, Museo de Arte Moderno, 1980.

Rhod Rothfuss

Rothfuss, Rhod. "El marco: Un problema de plástica actual." *Arturo* (Buenos Aires), no. 1 (Summer 1944).

Bernardo Salcedo

Bayón, Damián. "Salcedo: Historia d'O antes o después?" *Arte en Colombia* (Bogotá), no. 1 (July 1976). Pp. 34–35.

Bernardo Salcedo: "La extrema Izquierda." Bogotá: Museo de Arte Moderno, 1966.

Serrano, Eduardo. *Bernardo Salcedo.* New York: Center for Inter-American Relations, 1984.

Juan Sánchez

Fusco, Coco. "Rican/Structions." *Art in America* 78, no. 2 (February 1990). Pp. 156–61, 187.

Gonchar, Nancy, and Gladys Jiménez-Muñoz. *Rican/structed Realities: Confronted Evidence/Realidades Riqueñas/estructuradas: Evidencia confrontada.* Binghamton: University Art Museum, State University of New York, 1991.

Herzberg, Julia P. "Juan Sánchez." *Latin American Art* (Scottsdale) 3, no. 4 (December 1991). Pp. 62–64.

Ingberman, Jeanette, et al. *Juan Sánchez, Rican/Structed Convictions.* New York: Exit Art, 1989.

Juan Sánchez: Paintings and Prints. Jersey City, N.J.: Jersey City Art Museum, 1989.

Sánchez, Juan. *Huellas: Avanzada estética para la liberación nacional.* New York: Charas, La Galería en el Bohio, 1988.

Sullivan, Edward J. "Juan Sánchez." *Arts Magazine* 64, no. 3 (November 1989). P. 93.

Mira Schendel

Mira Schendel. São Paulo: Museu de Arte Contemporânea da Universidade de São Paulo, 1990.

Mira Schendel. São Paulo: Paulo Figueiredo Galeria de Arte, 1982.

Naves, Rodrigo. *Mira Schendel: Pinturas recentes*. São Paulo: Paulo Figueiredo Galeria de Arte, 1985.

Lasar Segall

Bardi, P. M. *Lasar Segall*. 2d ed., rev. São Paulo: Museu de Arte Moderna; Milan: Edizioni del Milione, 1959 [1952].

Frommhold, Erhard. *Lasar Segall and Dresden Expressionism*. Milan: Galleria del Levante, 1976.

Horn, Gabriele, and Vera d'Horta Beccari. *Lasar Segall, 1891–1957: Malerei, Zeichnungen, Druckgrafik, Skulptur*. Berlin: Staatliche Kunsthalle, 1990.

d'Horta, Vera, and Marcelo Mattos Araújo. *A gravura de Lasar Segall*. São Paulo: Museu Lasar Segall, 1988.

Lasar Segall: Antologia de textos nacionais sobre a obra e o artista. Rio de Janeiro: Edição FUNARTE, 1982.

Lasar Segall: Textos depoimentos, exposições. São Paulo: Museu Lasar Segall, 1985.

Levi, Liseta. *Os temas judáicos de Lasar Segall*. São Paulo: B'nai Brith, 1970.

Morais, Frederico, and Anibal M. Machado. *Lasar Segall e o Rio de Janeiro*. Rio de Janeiro: Museu de Arte Moderna, 1991.

Naves, Rodrigo, and Marcelo Mattos Araújo. *O desenho de Lasar Segall*. São Paulo: Museu Lasar Segall, 1991.

Antonio Seguí

Antonio Seguí: Exposición retrospectiva, 1958–1990. Buenos Aires: Museo Nacional de Bellas Artes [1991].

Antonio Seguí: "Personnes." Paris: Galerie Nina Dausset, 1979.

Antonio Seguí: Pinturas. Caracas: Museo de Bellas Artes, 1978.

Cairol, Julian. *Antonio Seguí*. New York: Claude Bernard Gallery, 1988.

Mandriargues, André Pierre. *Antonio Seguí: Litografías*. San Juan: Galería Colibrí, 1969.

Nanni, Martha. *Antonio Seguí: Peinture à responsabilité limitée*. Paris: Galerie Claude Bernard and Galerie Jeanne Bucher, 1964.

Oldenburg, Bengt. *Seguí*. Buenos Aires: Centro Editor de América Latina, 1980.

Schwartz, Ellen. *Paris as Seen by Antonio Seguí*. New York: Lefebre Gallery, 1983.

Seguí. Utrecht: Hedendaage Kunst, 1971.

Segui: Parques nocturnes. Paris: Musée d'Art Moderne de la Ville de Paris, 1979.

Daniel Senise

Cocchiarale, Fernando. *Daniel Senise: 20a Bienal Internacional de São Paulo*. São Paulo: XX Bienal Internacional, 1989.

Daniel Senise. Recife: Pasárgada Arte Contemporânea, 1990.

Daniel Senise: Peintures récentes. Paris: Galerie Michel Vidal, 1991. [brochure]

Guenther, Bruce. *Daniel Senise: Surface Dialogue*. Chicago: Museum of Contemporary Art, 1991.

Oliva, Achille Bonito. *Frida Baranek, Ivens Machado, Milton Machado, Daniel Senise, Angelo Venosa*. Rome: Sala I, 1990.

Schneider, Dietmar. "Kunst-Abenteuer Brasilien." *Kunst-Köln* (April 1988). Pp. 31–35.

David Alfaro Siqueiros

Arenal de Siqueiros, Angélica Solís, and Ruth Solís. *Vida y obra de David Alfaro Siqueiros: Juicios críticos*. Mexico City: Fondo de Cultura Económica, 1975.

Folgarait, Leonard. *So Far from Heaven: David Alfaro Siqueiros' "The March of Humanity" and Mexican Revolutionary Politics*. Cambridge: Cambridge University Press, 1987.

Micheli, Mario de. *Siqueiros*. New York: Harry N. Abrams, 1968. [Trans. by Ruth Solis from *Siqueiros*. Rev. ed. Mexico City: Secretaría de Educación Pública, 1985.]

———. *Siqueiros e il muralismo messicano*. Florence: Palazzo Vecchio, 1976.

Rodríguez, Antonio. *Siqueiros*. Mexico City: Fondo de Cultura Económica, 1974.

Siqueiros, David Alfaro. *Esculto-pintura: Cuarta etapa del muralismo en México*. Mexico City: Galería de Arte Misrachi; New York: Tudor Publishing, 1968.

———. *Art and Revolution*. London: Lawrence and Wishart, 1975.

———. *Me llamaban el Coronelazo (Memorias)*. Mexico City: Editorial Grijalbo, 1977.

Tibol, Raquel. *Siqueiros: Introductor de realidades*. Mexico City: Universidad Nacional Autónoma de México, 1961.

———, ed. *Textos de David Alfaro Siqueiros*. Mexico City: Fondo de Cultura Económica, 1974.

Ray Smith

Merewether, Charles. *The Burning Plains*. Rome: Galerie Gian Enzo Sperone, 1990.

Monsiváis, Carlos. *Ray Smith: Pintura y escultura*. Mexico City: Galería de Arte Contemporáneo, 1989.

Pellizzi, Francesco. *Ray Smith*. Maastricht: Bonnefantenmuseum, 1992.

Santamaría, Guillermo. *Ray Smith*. Mexico City: Galería OMR, 1991.

Sullivan, Edward J. *Ray Smith*. New York: Sperone Westwater Gallery, 1989.

Jesús Rafael Soto

Boulton, Alfredo. *Soto*. Caracas: Ernesto Armitano, 1973.

Boulton, Alfredo, Gloria Moure, and José María Iglesias. *Soto*. Madrid: Palacio de Velázquez, Parque del Retiro, 1982.

Boulton, Alfredo, and Masayoshi Homma. *Jesús Rafael Soto*. Kamakura, Japan: Museum of Modern Art, 1990.

Brett, Guy. *Soto*. New York: Marlborough Gallery, 1969.

Clay, Jean. *Soto*. Paris: Musée d'Art Moderne de la Ville de Paris, 1969.

d'Elme, Patrick. "La logique de Soto/Soto's Logic." *Cimaise* 17, no. 97 (May–August 1970). Pp. 12–23.

Jesús-Rafael Soto. Helsinki: Helsingin Kaupungin Taidekokoelmat, 1979.

Joray, Marcel, and Jesús Rafael Soto. *Soto*. Neuchâtel, Switzerland: Editions du Griffon, 1984.

Leenhardt, Jacques. *Soto*. Knokke-le-Zoute, Belgium: Elisabeth Franck Gallery, 1988.

Renard, Claude-Louis. *Soto: A Retrospective Exhibition*. New York: Solomon R. Guggenheim Museum, 1974.

———. *Soto: Oeuvres actuelles*. Paris: Musée National d'Art Moderne, Centre Georges Pompidou, 1979.

Somaini, Luisa. *Soto: Opere recenti*. Milan: Arnoldo Mondatori Arte, 1991.

Soto: Cuarenta años de creación, 1943–1983. Caracas: Museo de Arte Contemporáneo, 1983.

Soto, Jesús Rafael. "Le role des concepts scientifiques dans l'art." In *Colloquium: La dimensione scientifica dello sviluppo culturale*. Rome: Academia Nazionale dei Lincei, 1990.

———. *Textos*. Madrid: Theospacio, 1990.

Xuriguéra, Gérard. *Soto: Oeuvres récentes*. Nice: Galerie Sapone, 1990.

Rufino Tamayo

Cardoza y Aragón, Luis, et al. *Rufino Tamayo: Pinturas*. Madrid: Centro de Arte Reina Sofía, Ministerio de Cultura, 1988.

del Conde, Teresa, et al. *Rufino Tamayo: 70 años de creación*. Mexico City: Museo de Arte Contemporáneo Internacional Rufino Tamayo, Instituto Nacional de Bellas Artes, 1987.

Corredor-Matheos, J. *Tamayo*. Barcelona: Ediciones Polígrafa, 1982.

Genauer, Emily. *Rufino Tamayo*. New York: Harry N. Abrams, 1975.

Goldwater, Robert. *Rufino Tamayo*. New York: Quadrangle Press, 1947.

Paz, Octavio. *Tamayo en la pintura mexicana*. Mexico City: Universidad Nacional Autónoma de México, 1959.

———. *Rufino Tamayo: Peintures, 1960–1974*. Paris: Musée d'Art Moderne de la Ville de Paris, 1974.

Paz, Octavio, and Jacques Lassaigne. *Rufino Tamayo*. Trans. Kenneth Lyons. New York: Rizzoli, 1983 [1982].

Rufino Tamayo: Antología crítica. Mexico City: Terra Nova, 1987.

Rufino Tamayo: Exposición homenaje: 50 años de labor artística. Mexico City: Palacio de Bellas Artes, 1967.

Rufino Tamayo: Fifty Years of His Painting. Washington, D.C.: Phillips Collection, 1978.

Rufino Tamayo: Myth and Magic. New York: Solomon R. Guggenheim Museum, 1979.

Sullivan, Edward J. *Sculptures and Mixographs by Rufino Tamayo*. Chicago: Mexican Fine Arts Center, 1991.

Tibol, Raquel, ed. *Textos de Rufino Tamayo*. Mexico City: Universidad Nacional Autónoma de México, 1987.

Francisco Toledo

Acha, Juan, et al. *Francisco Toledo*. Mexico City: Museo de Arte Moderno, 1980.

Ashton, Dore. *Francisco Toledo*. Beverly Hills: Latin American Masters, 1991.

Cardoza y Aragón, Luis. *Toledo: Pintura y cerámica*. Mexico City: Ediciones Era, 1987.

del Conde, Teresa. *Francisco Toledo*. Mexico City: Secretaría de Educación Pública, 1981.

———. *Francisco Toledo: A Retrospective of His Graphic Works*. Chicago: Mexican Fine Arts Center, 1988.

Monsiváis, Carlos. *Toledo: Lo que el viento a Juárez*. Mexico City: Ediciones Era, 1986.

Sullivan, Edward J. *Francisco Toledo*. New York: Nohra Haime Gallery, 1990.

Traba, Marta. *Los signos de la vida: José Luis Cuevas, Francisco Toledo*. Mexico City: Fondo de Cultura Económica, 1976.

Joaquín Torres-García

The Antagonistic Link: Joaquín Torres-García–Theo van Doesburg. Amsterdam: Institute of Contemporary Art, 1991.

Brandao, Leda. *Joaquín Torres-García*. Monterrey: Museo de Monterrey, 1981.

Buzio de Torres, Cecilia. *Torres-García and His Legacy*. New York: Kouros Gallery, 1986.

Buzio de Torres, Cecilia, et al. *Torres-García*. Valencia: IVAM, Centro Julio Gónzalez; Madrid: Museo Nacional Centro de Arte Reina Sofía, 1991.

———. *Torres-García: Grid-Pattern-Sign. Paris-Montevideo, 1924–1944*. London: Hayward Gallery, 1985.

Cassou, Jean. *Torres-García*. Paris: Fernand Hazan, 1955.

De Castro, Sergio, Mario Gradowczyk, and Marie Aline Prat. *Hommage à Torres-García: Oeuvres 1928 à 1948*. Paris: Galerie Marwan Hoss, 1990.

Duncan, Barbara. *Joaquín Torres-García, 1874–1949: Chronology and Catalogue of the Family Collection*. Austin: Archer M. Huntington Art Gallery, University of Texas, 1974.

Gradowczyk, Mario H. *Joaquín Torres García*. Buenos Aires: Ediciones de Arte Gaglianone, 1985.

Jardí, Enric. *Torres-García*. Trans. Kenneth Lyons. New York: New York Graphic Society, 1973.

———. *Joaquín Torres-García: Epoca Catalana (1908–1928)*. Montevideo: Museo Nacional de Artes Visuales, 1988.

Joaquín Torres-García: Paintings, 1931–1946/Oceanic Art. New York: Royal Marks Gallery, 1969.

Kalenberg, Angel, and Jacques Lassigne. *Torres-García: Construction et symboles*. Paris: Musée d'Art Moderne de la Ville de Paris, 1975.

Lubar, Robert, Juan Manuel Bonet, and Guillermo de Osma. *Barradas/Torres-García*. Madrid: Galería Guillermo de Osma, 1991.

Medina, Alvaro. "Torres-García y la escuela del sur." *Art Nexus* (Bogotá), no. 3 (January 1992). Pp. 52–61.

Pineda, Rafael. *Joaquín Torres-García: Epoca de Paris, 1926–1932*. Caracas: Galería Siete Siete, 1980.

Ramírez, Mari Carmen, ed. *El Taller Torres-García: The School of the South and Its Legacy*. Austin: University of Texas Press, 1992.

Robbins, Daniel. *Joaquín Torres-García, 1874–1949*. Providence: Museum of Art, Rhode Island School of Design, 1970.

Torres-García, Joaquín. *Historia de mi vida*. Barcelona: Paidós, 1990 [1939].

———. *Universalismo constructivo*. 2 vols. Buenos Aires: Editorial Poseidón, 1944. [Reprint, Madrid: Alianza Editorial, 1984.]

———. *Escritos*. Edited by Juan Fló. Montevideo: Arca, 1974.

Tunga

Brett, Guy. "Tunga." In Guy Brett, *Transcontinental: Nine Latin American Artists*. London and New York: Verso, 1990. Pp. 54–55.

Tunga "Lezarts"/Cildo Meireles, "Through." Kortrijk, Belgium: Kunststichting Kanaal, 1989.

Duarte, Paulo Sérgio. *Tunga*. Chicago: Museum of Contemporary Art, 1989.

Tunga. São Paulo: Gabinete de Arte Raquel Arnaud Babenco, 1983.

Tunga. Glasgow: Third Eye Centre, 1990.

Gregorio Vardánega

Ragon, Michel. *Gregorio Vardánega*. Paris: Galerie Denise René, 1969.

Alfredo Volpi

Alfredo Volpi: Pintura (1914–1972). Rio de Janeiro: Museu de Arte Moderna, 1971.

Araújo, Olivio Tavares de. *Dois estudos sobre Volpi*. São Paulo: FUNARTE, Coleção Contemporânea, 1986.

———. *A. Volpi*. São Paulo: Art Editora, Círculo do Livro, 1991.

Marcondes, Marcos A. *A. Volpi*. São Paulo: Círculo do Livro, 1991.

Mastrobuono, Marco Antônio. *Alfredo Volpi*. Brasília: Edição FUNARTE, 1980.

Retrospectiva Alfredo Volpi. São Paulo: Museu de Arte Moderna, 1975.

Volpi: 90 annos. São Paulo: Museu de Arte Moderna, 1986.

Xul Solar

Borges, Jorge Luis. "Recuerdos de mi amigo Xul Solar." *Comunicaciones* (Buenos Aires), no. 3 (November 1990).

Gradowczyk, Mario H. *Alejandro Xul Solar (1887–1963)*. Buenos Aires: Galería Kramer and Ediciones Anzilotti, 1988.

———. *Alejandro Xul Solar*. New York: Rachel Adler Gallery, 1991.

Nelson, Daniel E. "Alejandro Xul Solar." *Latin American Art* (Scottsdale) 3, no. 3 (Fall 1991). Pp. 28–30.

Svanascini, Osvaldo. *Xul Solar*. Buenos Aires: Ediciones Culturales Argentinas, 1962.

Taverna Irigoyen, J. M. *Xul Solar*. Buenos Aires: Centro Editor de América Latina, 1980.

Xul Solar: 1887–1963. Paris: Musée d'Art Moderne de la Ville de Paris, 1977.

Carlos Zerpa

Stein, Axel. *Three Venezuelans in Two Dimensions: Miguel von Dangel, Ernesto León, Carlos Zerpa*. New York: Americas Society, 1988.

III. BIBLIOGRAPHIES

Bailey, Joyce Waddell, ed. *Handbook of Latin American Art: A Bibliographic Compilation*. 3 vols. Santa Barbara, Denver, and Oxford: ABC-Clio Information Services, 1984.

Collazo, Alberto, and Jorge Glusberg. *Guía bibliográfica de las artes visuales en la Argentina: Siglo XX*. Buenos Aires: Centro de Arte y Comunicación [1983].

Findlay, James A. *Modern Latin American Art: A Bibliography*. Westport and London: Greenwood Press, 1983.

Kupfer, Monica E. *A Bibliography of Contemporary Art in Latin America: Books, Articles and Exhibition Catalogs in the Tulane University Library, 1950–1980*. New Orleans: Center for Latin American Studies and Howard Tilton Memorial Library, Tulane University, 1983.

Acknowledgments

The exhibition on which this book is based has required the support and counsel of museum professionals, art historians and critics, collectors, dealers, and government officials from Latin America, Europe, and the United States. On behalf of The Museum of Modern Art and its International Council, I wish to express the deepest gratitude to all those who have participated in the exhibition and its accompanying publications, educational programs, and special events.

The exhibition could not have been realized without the support of The International Council of the Museum, under whose auspices it was organized. Patricia Phelps de Cisneros, Chairman of the Honorary Advisory Committee for the exhibition, has been an advocate of the project from the outset, generously agreeing to lead sponsorship solicitation for the exhibition and its publications, and invaluable in her aid for the Venezuelan contribution to the exhibition. Her assistant, Rosa Amelia Sosa, has been most helpful, both in Caracas and in New York, with many details of organization. We are deeply grateful for the collaboration of the Galería Mendoza in organizing artists' representations from Venezuela, and especially to Mr. and Mrs. Eugenio Mendoza for their generous contribution to the New York showing. It was Alfredo Boulton, a former chairman of The International Council and a noted art historian, who first opened my eyes to the works of Armando Reverón and other Venezuelan masters nearly thirty years ago, and his guidance on the present selection is deeply appreciated. Gilberto Chateaubriand, whose contagious enthusiasm for Brazilian art is always an inspiration, has lent several works from his superb collection. Without the advocacy of Dr. José E. Mindlin, many key works by Brazilian artists could not have been included in the exhibition, and we are deeply grateful for his persuasive diplomatic skill on our behalf. Jorge Helft, one of the principal lenders, has played a similar role in Argentina, assisting in coordinating many complex details regarding the loan of works of art. His advice has been helpful not only in Buenos Aires but in Paris and New York as well. Our work in Colombia could not have been achieved without the assistance of Mr. and Mrs. Julio Mario Santo Domingo, for which they have our warmest thanks. Barbara D. Duncan, a scholar and an exhibition organizer in this field for many years, has contributed much useful advice, as well as moral support.

Mrs. Henry Ives Cobb and Mrs. Donald B. Straus served succeeding terms as president of The International Council, from 1957 to 1972, and their leadership was critical in developing its Latin American program. Their successor as president, Joanne M. Stern, has encouraged me to organize this exhibition for many years; without her friendship and loyalty it would never have been possible. Both Mrs. Gifford Phillips, president from 1984 to 1991, and Jeanne C. Thayer, the Council's current president, have shared my enthusiasm for this project and given it the Council's highest priority.

David Rockefeller, the chairman of the Board of Trustees of The Museum of Modern Art, has long been an advocate of Latin American art and has generously supported my efforts to secure major works of art for the exhibition. The Museum's president, Agnes Gund, has been warmly enthusiastic about plans for the New York showing, and especially for educational and community programs in conjunction with it. Plans for the exhibition would not have gone forward without the support of Richard E. Oldenburg, the Museum's director, and Kirk Varnedoe, chief curator of the Department of Painting and Sculpture. They both have our warmest thanks.

I wish to express special appreciation to Luis R. Cancel, Commissioner of Cultural Affairs for the City of New York, who, as a scholar of Latin American art history and former director of The Bronx Museum of the Arts, has brought an informed passion to this project. His counsel has been essential in our efforts to bring the exhibition to our city's Latino communities.

In making the selection of works for the exhibition, I have been aided by an invaluable group of ten advisors (listed at the beginning of this volume), representing diverse ideas within the scholarly and curatorial community, who also have given generous assistance in the organization of the exhibition. Many other colleagues as well have made important contributions to the selection of art and the organization of the exhibition. In Buenos Aires, Marcelo Pacheco gave invaluable assistance as coordinator for research and assembly of works from Argentina and Uruguay. Samuel Oliver, formerly director of the Museo Nacional de Bellas Artes, Buenos Aires, and a distinguished architect and critic, advised on the selection of works by Pedro Figari and contacted collectors on our behalf. Martha Nanni was extremely helpful in many areas, especially the selection of works by Xul Solar and Antonio Berni; she also collaborated on the installation of the exhibition in the version seen in Seville. Nelly Perazzo advised us on the selection of Argentine Concrete art, her area of specialization. The perspective of Jorge Glusberg, director of the Centro de Arte y Communicación in Buenos Aires, was deeply appreciated. In Brazil, Aida Cristina Cordeiro and Margareth de Moraes coordinated the sending of works from São Paulo and Rio de Janeiro, respectively, and their expertise as registrars greatly facilitated arrangements. Oswaldo Corrêa da Costa gave essential advice regarding Brazilian art and contacted several artists and critics on our behalf. In São Paulo, I was grateful to be able to discuss the selection of contemporary works for the exhibition with Ivo Mesquita who shared many perceptive insights. In Chile, I was happy to renew a friendship of some thirty years with Nemesio Antúnez, director of the Museo Nacional de Bellas Artes, Santiago, and to meet for the first time the critic Justino Mellado, whose comments on the work of Gonzalo Díaz and Eugenio Dittborn were most important. In Bogotá, Paulina de Córdoba gave generously

of her time in arranging my visits to artists and collectors. I am grateful to Carolina Ponce de Léon for discussing with me the Colombian selection. Lucy Villegas, Director, and Alejandro Alonso, Vice Director, Museo Nacional de Bellas Artes in Havana, supplied documentation on contemporary Cuban artists. In Mexico, my friendship with Helen Escobedo has brought many discoveries over the years, which were important for the selection of Mexican works. I was grateful to have suggestions from Olivier Debroise regarding contemporary work. Robert Littman, director of the Centro Cultural/Arte Contemporáneo, gave useful advice in many areas. Dr. Teresa del Conde and Agustín Arteaga have discussed important aspects of the selection with me and have been especially enlightening.

In arranging to borrow works from national collections in Latin America, we have benefited from the assistance of many important officials. We would like to express appreciation to the following individuals: in Argentina, Kive Staiff, General Director of Cultural Affairs; and Guido Di Tella, Chancellor, Ministry of Foreign Relations; in Colombia, Dr. Juan Manuel Ospina, Director, Instituto Colombiano de Cultura (Cocultura); in Mexico, Fernando Solana Morales, Secretary of Foreign Relations; Dr. Rosario Green, Assistant Secretary for Latin America, Cultural Affairs, and International Cooperation; Rafael Tovar y de Teresa, President, and Jaime García Amaral, Coordinator of Cultural Affairs, Consejo Nacional para la Cultura y las Artes; Dr. Gerardo Estrada Rodríguez, General Director, Miriam Kaiser, Director of International Exhibitions, Miriam Molina, National Coordinator of Fine Arts, and José Sol Rosales, Director, Centro Nacional de Conservación de Obras Artísticas, Instituto Nacional de Bellas Artes; Manuel M. Alonso Muñoz, Director General, Lotería Nacional; Gustavo Petricioli, Ambassador of Mexico to the United States; and Fausto Zapata, Consul General, and Mireya Teran, Mexican Cultural Institute, New York; in Spain, Delfin Colomé, General Director of Cultural and Scientific Relations; Rafael Pastor, Ambassador of Spain, and José Miguel Muro y Martínez, Cultural Counselor, Spanish Embassy in Argentina; in Uruguay, Dr. Adolfo Díaz Estapé, Ambassador of Uruguay to Argentina; and in Venezuela, Dr. José Antonio Abreu, President, Consejo Nacional de la Cultura.

Many of the works borrowed for the exhibition are national treasures in their countries of origin, and we are deeply grateful to private collectors and galleries, and to museums and other public institutions for making them available. A complete list of lenders to the New York exhibition appears on the following pages. We would like especially to acknowledge those who facilitated loans: Dr. Wim Beeren, former director, and Dr. Rini Dippel, Deputy Director, Stedelijk Museum, Amsterdam; Dr. Thomas F. Staley, Director, and Sue Murphy, Art Collection Curator, Harry Ransom Humanities Research Center, and Jessie Otto Hite, Acting Director, Archer M. Huntington Art Gallery, University of Texas at Austin; Leopoldo Rodes, President, Fundació Museu d'Art Contemporani, Barcelona; Gloria Zea, Director, Museo de Arte Moderno de Bogotá; Rafael Iglesia, Director, Museo Nacional de Bellas Artes, Buenos Aires; Marcos Curi, Director, Museo de Arte Contemporáneo, Buenos Aires; Douglas G. Schultz, Director, Albright-Knox Art Gallery, Buffalo; Luis Miguel La Corte, Director, and Rafael Romero, Executive Director, Fundación Galería de Arte Nacional, Caracas; María Elena Ramos, Director, and Federica Palomero, Curator, Fundación Museo de Bellas Artes, Caracas; Sofía Imber, Director, Museo de Arte Contemporáneo Sofía Imber, Caracas; Charles F. Stuckey, Curator, Twentieth Century Painting and Sculpture, and Suzanne Folds McCullagh, Curator of Earlier Prints and Drawings, The Art Institute of Chicago; Michael E. Shapiro, Director, and Maurice Tuchman, Senior Curator for Twentieth Century Drawings, Los Angeles County Museum of Art; Sylvia Pandolfi Elliman, Director, and Renato González Mello, Curator, Museo de Arte Alvar y Carmen T. de Carrillo Gil, Mexico City; Graciela de Reyes Retana, Director, Museo Nacional de Arte, Mexico City; Kathy Halbreich, Director, Walker Art Center, Minneapolis; Angel Kalenberg, Director, Museo Nacional de Artes Visuales, Montevideo; Thomas Krens, Director, and Diane Waldman, Deputy Director, Solomon R. Guggenheim Museum, New York; William S. Lieberman, Chairman, Twentieth Century Art, The Metropolitan Museum of Art, New York; François Barre, President, C.N.A.P., Fonds National d'Art Contemporain, Ministère de l'Education Nationale de la Culture, Paris; James K. Ballinger, Director, and Clayton Kirking, Associate Curator of Latin American Art, Phoenix Art Museum; Daniel Rosenfeld, Curator, Museum of Art, Rhode Island School of Design, Providence; Heloisa Lustosa, Director, Museu Nacional de Belas Artes, Rio de Janeiro; Professor W. H. Crowel, Director, Museum Boymans–van Beuningen, Rotterdam; John R. Lane, Director, San Francisco Museum of Modern Art; Harry S. Parker, Director, Fine Arts Museums of San Francisco; Ana Mae Tavares Bastos Barbosa, Director, Museu de Arte Contemporânea, Universidade de São Paulo; Fabio Magalhães, Director, Museu de Arte de São Paulo Assis Chateaubriand; Maria Alice Milliet de Oliveira, Director, Pinacoteca do Estado de São Paulo; Dr. Mauricio Segall, Director, and Marcelo Mattos Araujo, Museologue, Museu Lasar Segall, São Paulo; Jose Sebastian Witter, Director, Instituto de Estudos Brasileiros, Universidade de São Paulo; Carmen Alborch, Director, IVAM Centre Julio Gonzalez, Valencia; Dr. Bélgica Rodríguez, Director, Art Museum of the Americas, OAS, Washington, D.C.; James Demetrion, Director, and Valerie Fletcher, Curator, Hirshhorn Museum and Sculpture Garden, Smithsonian Institution, Washington, D.C.

Several art dealers and private galleries have been especially helpful. We would like to acknowledge special advice or assistance given by the following: Barbara Farber, Amsterdam; Miklos von Bartha, Basel; Galería Garcés Velázquez, Bogotá; Luis Pérez, Bogotá; Ruth Benzacar, Buenos Aires; Oscar Ascanio, Caracas; César Segnini, Galería Durban, Caracas; Armando Colina, Galería Arvil, Mexico City; Alejandro Días, Galería de Arte Contemporáneo, Mexico City; Alejandra R. de Yturbe and Mariana Perez Amor, Galería de Arte Mexicano, Mexico City; Nina Menocal, Ninart Centro de Cultura, Mexico City; Patricia Riestra Ortiz Monasterio and Jaime Riestra, Galería OMR, Mexico City; Ramón López Quiroga, Mexico City; Rachel Adler, New York; George Adams, Frumkin/Adams Gallery, New York; Mary Sabbatino, Galerie Lelong, New York; Annina Nosei, New York; Angela Westwater, New York; Mary-Anne Martin, New York; Clara Diament Sujo, New York; Sharon Schulz Simpson, New York; Thomas Cohn, Rio de Janeiro; Raquel Arnaud, São Paulo; and Luisa Strina, São Paulo.

Earlier versions of the exhibition were shown in Seville, Paris, and Cologne in 1992–93. The first of these showings was commissioned by the City of Seville as part of its Columbus quincentennial celebration. Our deepest gratitude is extended to Alejandro Rojas-Marcos y de la Viesca, Mayor of the City of Seville, and to the Comisaría de la Ciudad de Sevilla para 1992 for inviting the exhibition. Special thanks are due to Ignacio Montaño Jiménez and Fernando Fernández de Córdova, who headed the Comisaría, and the rest of its staff, including Juan Víctor Rodríguez Yagüe, María Rosa García Fernández, and Carmen Vázquez Prieto. Our warm appreciation goes to María de Corral López-Dóriga, Director of the Museo Nacional Centro de Arte Reina Sofía, for initiating the collaboration between Seville and The Museum of Modern Art. In Paris, the exhibition was shown in the Musée National d'Art Moderne, Centre Georges Pompidou, and in the Hôtel des Arts, Fondation National des Arts. This joint showing was arranged by the late Dominique Bozo, President of the Centre Georges Pompidou, whose recent death is deeply mourned by the international art community. We wish to express our appreciation to the following staff of the Musée National d'Art Moderne: its director, Germain Viatte; the commissioners of the exhibition, Alain Sayag and Claude Schweisguth, assisted by Claire Blanchon; registrars Annie Boucher and Jean-Claude Boulet; and Martine Silie, head of exhibition services. We are very grateful to Ramon Tio Bellido, artistic director of the Hôtel des Arts, for his splendid installation of work by contemporary artists, and to the following members of his staff: Jacques Goust, Lina Nahmias, and Claire Le Restif. In Cologne, the exhibition was presented in the Josef-Haubrich Kunsthalle under the auspices of the Museum Ludwig. Our thanks go to Marc Scheps, Director, Museum Ludwig, and to Dr. Gerhard Kolberg, curator of the exhibition, and his assistant Francesca Romana Onofri. Gérard A. Goodrow, assistant to the director, also has our warm appreciation for his efforts on behalf of the project. Mia M. Storch extended warm hospitality on behalf of the Kunsthalle.

For the New York presentation, Jerome Neuner, Director of Exhibition Production and Design, solved many installation problems with superb professionalism. He was ably seconded by Douglas Feick. Diane Farynyk, Registrar, and members of her staff, supervised the complex details of packing, shipping, and receiving of works. The insurance arrangements were in the capable hands of Richard L. Palmer, Coordinator of Exhibitions. Cora Rosevear, Associate Curator, administered loans from the Museum's Department of Painting and Sculpture.

Of special importance to this exhibition are the educational programs, which provide essential information for the public, and programs done in collaboration with community organizations. It has been a pleasure to work with the Department of Education, and we thank Carol Morgan, its acting director, and all the members of the department, especially Emily Kies Folpe, who prepared the exhibition brochure, Amelia Arenas, and Romy Phillips. Jerri Allyn served as consultant for symposia and special programs, and we are grateful for her efforts.

Jeanne Collins encouraged me to undertake this project early on, and as director of Public Information she made every effort to see that the exhibition received the widest coverage. As acting director, Jessica Schwartz has developed imaginative programs, assisted by Lucy O'Brien, writer/editor, and Helen Bennett, press representative. Aurora Flores, public-relations consultant for the exhibition, has been especially effective in developing press and community programs for New York's Latino audience. A grant from WXTV-Channel 41/Univision Television Group, Inc., has made it possible to produce radio and television announcements for which the distinguished actor Edward James Olmos generously contributed his services. The New York City Transit Authority provided free placement of posters throughout the subway system. We are also grateful to Daniel Vecchitto, Director of Development, and John L. Wielk, Manager of Exhibition and Project Funding, for coordinating sponsorship and fund-raising appeals.

Turning from the exhibition to its publications, I must first extend my profound thanks to the authors of the essays in this volume for their fine contributions to the growing body of scholarship on Latin American modern art: Aracy Amaral, distinguished art historian and critic, São Paulo; Dore Ashton, Professor of Art History, The Cooper Union for the Advancement of the Arts and Sciences, New York; Jacqueline Barnitz, Associate Professor, Department of Art History, University of Texas at Austin; Florencia Bazzano Nelson, Visiting Professor, Rochester Institute of Technology; Fatima Bercht, Director of Visual Arts, Americas Society, New York; Guy Brett, art historian and critic, London; Rina Carvajal, independent curator, Caracas; Paulo Herkenhoff, critic, Rio de Janeiro; Elizabeth Ferrer, curatorial consultant, Americas Society, New York; Max Kozloff, art historian, New York; Charles Merewether, critic, New York; Daniel

E. Nelson, Assistant Professor, SUNY Geneseo, New York; Mari Carmen Ramírez, Curator of Latin American Art, Archer M. Huntington Art Gallery, University of Texas at Austin; and Edward J. Sullivan, Chairman, Department of Fine Arts, New York University. I also wish to express my warm appreciation for the superb work of my co-editors, Fatima Bercht and Elizabeth Ferrer, and to the Americas Society for assisting The Museum of Modern Art in producing the book. As both scholars and exhibition organizers, they have the experience and professional contacts essential in organizing so extensive a publication, and I cannot adequately thank them for the devotion they have given to this task. They have been assisted in the preliminary editing of texts and preparation of artists' biographies by Joseph R. Wolin and John Alan Farmer. Mr. Wolin was also of inestimable aid to me in my introduction to this book and in preparing the smaller publication that accompanies the exhibition. Miriam Basilio is responsible for the bibliography.

In the Department of Publications, I am particularly grateful to Osa Brown, Director, and to her staff for giving the book such meticulous attention in the face of the complexities such an ambitious project entails. I thank Nancy Kranz, Manager of Promotion and Special Services, for her contribution. The final coordination of the project and editing of the texts have been the work of Harriet Schoenholz Bee, Managing Editor, who has coped with the problems of multiple authorship and pressing deadlines with scrupulous attention to detail and calm professionalism. She has been ably assisted by Christopher Lyon, who has worked tirelessly to bring the project to completion, and by Susan Weiley, Jessica Altholz, and Barbara Einzig. Vicki Drake was responsible for production of the book, quality control of illustrations, and supervision of the printing. Michael Hentges, Director of Graphics, has overseen the design of this book, which was created with skill and sensitivity by Phillip Unetic, and has been responsible for the design of the smaller publication, *Selections from the Exhibition*, as well as, with Thomas Stvan, graphics for the exhibition and coordinating printed matter related to it. Alexandra Bonfante-Warren edited texts for the smaller publications.

Rona Roob, Museum Archivist, and Rachel Wild, Archives Technician, supplied much useful information regarding the Museum's Latin American collection and its early history of exhibitions. We also owe thanks to the Museum's Department of Rights and Reproductions, especially its former director, Richard Tooke, and his successor, Mikki Carpenter. Bruce M. White photographed many works in Seville, and documented the exhibition's installation there.

At the Museum, I especially want to express my heartfelt gratitude to the staff of the International Program with whom I have worked most closely, during the past two-and-a-half years, on preparing the exhibition and managing its tour. Above all, special recognition must be given to

Marion Kocot, Senior Program Associate, who has coordinated all aspects of the exhibition from its initial research, through its European showings, to its presentation in New York. She has done a superb job of controlling the vast amount of correspondence, the constantly changing checklists, and the intricate arrangements for collecting, shipping, and installing the works of art. I have relied on her judgment and acute vision at every stage of this endeavor. She has been closely seconded by Gabriela Mizes, who has worked tirelessly and with incomparable accuracy on countless demanding details. Without them, the exhibition could never have been realized. Scott Johnson, Executive Secretary, has handled a vast amount of administrative and financial detail with skill and calm in the midst of constant deadlines; and Lisa Titus, Program Assistant, has taken charge of extensive loan correspondence and filing. Rose Kolmetz has translated quantities of correspondence and press clippings with her customary skill. Elizabeth Streibert, Associate Director, has made it possible for me to undertake the responsibility of this show by assuming, with grace and consummate professionalism, the burden of the major administrative responsibilities for the International Program during this long period. Carol Coffin, executive director of The International Council, has coordinated solicitation efforts, especially for contributions to the publications, and has served as a liaison with members of the Council. All of these colleagues have my deepest thanks for their patience, understanding, and good humor. In addition to the core staff, we were fortunate to work with several other colleagues who joined our exhibition team for the European tour. Marion Kahan served as registrar for the tour, and she also aided us in supervising the installation in Seville and Paris. Nestor Montilla, the Museum's assistant registrar, was responsible for works from United States collections and assisted with the Seville, Paris, and Cologne showings. Guillermo Alonso assisted with the installations in Seville and Paris. Caroline Baumann acquired photographs and provided editorial assistance, with special attention to the demands of the three European catalogues. In nearly forty years of working at the Museum I have never encountered a better team or a more congenial one.

And finally, on behalf of the trustees of The Museum of Modern Art, I would like to express a most important debt of gratitude, that owed to the artists whose works provide the heart of this exhibition and publication. I also heartily second the profound thanks expressed by the director of this Museum, Richard E. Oldenburg, to those individuals and organizations who have given so generously to the support of the exhibition, its publications, and related programs.

On a personal note, I wish to acknowledge the support and companionship of John Dowling, my daughter Lisa, and my son Mark David, and to thank them for their love and understanding, especially throughout the long process of preparing this exhibition. W. R.

Contributors to the Publication

Lenders to the Exhibition

Argentina
Museo Nacional de Bellas Artes, Buenos Aires
Luis F. Benedit
Elena Berni
Mr. and Mrs. Jorge Castillo, Buenos Aires
Mr. Eduardo F. Costantini and María Teresa de Costantini, Buenos Aires
Marta and Ramón de la Vega
Nelly and Guido Di Tella, Buenos Aires
Gradowczyk Collection
Víctor Grippo
Jorge and Marion Helft
Alberto Heredia
Mrs. María Marta Zavalía, Buenos Aires
Private collectors
Ruth Benzacar Galería de Arte, Buenos Aires
Galería Vermeer, Buenos Aires

Belgium
Elisabeth Franck, Knokke-le-Zoute

Brazil
Museu Nacional de Belas Artes, Rio de Janeiro
Projeto Hélio Oiticica, Rio de Janeiro
Instituto de Estudos Brasileiros da Universidade de São Paulo
Museu de Arte Contemporânea da Universidade de São Paulo
Museu de Arte de São Paulo Assis Chateaubriand
Museu Lasar Segall, São Paulo
Pinacoteca do Estado da Secretaria de Estado da Cultura de São Paulo
Ricard Takeshi Akagawa, São Paulo
M. A. Amaral Rezende, São Paulo
Jean Boghici, Rio de Janeiro
Waltercio Caldas
Maria Camargo
Gilberto Chateaubriand, Rio de Janeiro
João Carlos de Figueiredo Ferraz, São Paulo
Maria Anna and Raul de Souza Dantas Forbes, São Paulo
Frans Krajcberg
Adolpho Leirner, São Paulo
Cildo Meireles
Bruno Musatti, São Paulo
José Resende
Ada Clara Dub Schendel Bento, São Paulo
Tunga
Marcantonio Vilaça, São Paulo
Luiz Diederichsen Villares, São Paulo
Eugênia Volpi, São Paulo
Private collectors
Thomas Cohn–Arte Contemporânea, São Paulo
Galeria Luisa Strina, São Paulo

Chile
Gonzalo Díaz
Eugenio Dittborn

Colombia
Museo de Arte Moderno, Bogotá
Fernando Botero
Agustín Chávez, Bogotá
Hernán Maestre, Bogotá
Hanoj Pérez, Bogotá
Eduardo Ramírez Villamizar
Carlos Rojas
Miguel Angel Rojas
Rafael Santos Calderón, Bogotá
Dr. Hernando Santos Castillo, Bogotá
Alberto Sierra, Medellín
Galería Garcés Velázquez, Bogotá

France
Musée National d'Art Moderne, Centre Georges Pompidou, Paris
Frida Baranek
Amélie Glissant, Paris
Julio Le Parc
Alexandre de la Salle, Saint Paul
Galerie Franka Berndt, Paris

Germany
Antonio Dias

Great Britain
Guy Brett, London

Mexico
Consejo Nacional para la Cultura y las Artes– Instituto Nacional de Bellas Artes
CNCA-INBA, Museo de Arte Alvar y Carmen T. de Carrillo Gil, Mexico City
CNCA-INBA, Museo de Arte Moderno, Mexico City
CNCA-INBA, Museo Nacional de Arte, Mexico City
José Bedia
Andrés Blaisten, Mexico City
Club de Industriales, A.C.
Francisco Osio
Ma. Esthela E. de Santos, Monterrey
Private collectors
Fundación Cultural Televisa, Mexico City
Galería de Arte Méxicano, Mrs. Alejandra R. de Yturbe, Miss Mariana Pérez Amor
Ninart Centro de Cultura

The Netherlands
Stedelijk Museum, Amsterdam
Museum Boymans–van Beuningen, Rotterdam
J. Lagerwey

Spain
Fundació Museu d'Art Contemporani, Barcelona
IVAM Centre Julio González, Generalitat Valenciana

Switzerland
A. L'H., Geneva
M. von Bartha, Basel
Private collectors

Galerie von Bartha, Basel
Galerie Dr. István Schlégl, Mrs. Nicole Schlégl, Zurich

United States
The Rivendell Collection, Annandale-on-Hudson
Huntington Art Gallery, University of Texas at Austin
Harry Ransom Humanities Research Center, The University of Texas at Austin
Albright-Knox Art Gallery, Buffalo
The Art Institute of Chicago
Los Angeles County Museum of Art
Solomon R. Guggenheim Museum, New York
The Metropolitan Museum of Art, New York
El Museo del Barrio, New York
The Museum of Modern Art, New York
Phoenix Art Museum
Museum of Art, Rhode Island School of Design, Providence
San Francisco Museum of Modern Art
Art Museum of the Americas, OAS, Washington, D.C.
Hirshhorn Museum and Sculpture Garden, Smithsonian Institution, Washington, D.C.
Elsa Flores Almaraz and Maya Almaraz, South Pasadena
Luis Camnitzer
Bernard Chappard, New York
Rosa and Carlos de la Cruz
Gonzalo Fonseca
Guariquen Inc., Puerto Rico and New York
Alfredo Jaar
Alice M. Kaplan, New York
Mrs. Elizabeth Kaplan Fonseca, New York
Betty Levinson, Chicago
Estate of Ana Mendieta
Francesco Pellizzi
Liliana Porter
Private collectors
Rachel Adler Gallery, New York
Barry Friedman Ltd., New York
Frumkin/Adams Gallery, New York
John Good Gallery, New York
M. Gutierrez Fine Arts, Key Biscayne, Florida
Galerie Lelong, New York
Annina Nosei Gallery, New York
Quintana Fine Art USA, Ltd.

Uruguay
Museo Nacional de Artes Visuales, Montevideo

Venezuela
Fundación Galería de Arte Nacional, Caracas
Fundación Museo de Bellas Artes, Caracas
Museo de Arte Contemporáneo de Caracas Sofía Imber
Alfredo Boulton, Caracas
Angel Buenaño, Caracas
Patricia Phelps de Cisneros, Caracas
Carlos Cruz-Diez
Jorge Yebaile, Caracas
Private collectors

Photograph Credits

The photographers and sources of the illustrations reproduced in this volume are listed alphabetically below, followed by the number of the page on which each illustration appears. Unless otherwise indicated, a page number refers to all of the illustrations on that page. We gratefully acknowledge the cooperation of all those who have made photographs available for this volume.

Courtesy Acquavella Modern Art, Reno: 108

Courtesy Rachel Adler Gallery, New York: 50 center and bottom, 183 top, 367

Courtesy Ricard Takeshi Akagawa, São Paulo: 175

David Allison, for The Museum of Modern Art, New York: 290

Lourdes Almeida: 118 right, 121

Walter Amed: 43 top

Javier Andrada, Seville: 180, 245

Courtesy Archer M. Huntington Art Gallery, University of Texas at Austin: 123, 127, 160, 162, 296

Courtesy John Arnstein, São Paulo: 137 right

Courtesy The Art Institute of Chicago: 280 top

Courtesy Oscar Ascanio, Caracas: 294 top

© Dirk Bakker: 64 top

Courtesy Frida Baranek, Paris: 179

Courtesy Galerie von Bartha, Basel: 88

Courtesy Ruth Benzacar Galería de Arte, Buenos Aires: 154, 155, 217

Courtesy Andrés Blaisten, Mexico City: 243 bottom

Uwe Boek: 244

Courtesy Alfredo Boulton, Caracas: 310

Guy Brett, London: 101, 103 (courtesy Projeto Hélio Oiticica, Rio de Janeiro)

César Caldarella: 47 left, 48 top left and bottom right, 50 top, 181, 224 bottom, 281, 352 bottom, 364 bottom, 365, 368, 369

Courtesy Luis Camnitzer: 164

Claudio González Canda, Buenos Aires: 142

Cathy Carver, courtesy Museum of Art, Rhode Island School of Design, Providence: 216, 260

Estudio Casenave: 48 center right

Enrique Cervera: 184 bottom, 190, 191, 225, 250, 322

Bernard Chappard: 354

Courtesy Gilberto Chateaubriand, Rio de Janeiro: 32

Christie's, New York: 33, 35

Laura Cohen: 249, 312

Jorge Contreras: 107 (courtesy Fundacíon Cultural Televisa, Mexico City), 248 bottom

H. Febres Cordido, E. Vergara, and M. Fernandez: 42 bottom, 44 bottom

Pedro Oswaldo Cruz, Rio de Janeiro: 135, 159, 286

Courtesy José Luis Cuevas: 124, 125

Mauricio Cyrne, courtesy Projeto Hélio Oiticica, Rio de Janeiro: 287

D. James Dee, courtesy Torres-García family: 75, 77, 78

Michael Desjardins: 104

Hernán Díaz, courtesy Ida Rubin: 96

Courtesy Eugenio Dittborn: 157

Rafael Doniz, courtesy CNAC-INBA, Museo de Arte Contemporáneo Internacional Rufino Tamayo, Mexico City: 351

Courtesy Galería Durban/César Segnini: 227

Rita Eder, Mexico City: 97

Margot Fernández: 42 top, 44 top

Rômulo Fialdini: 54, 55, 56, 57, 89, 90, 91, 161 left, 172 bottom, 173, 209, 210, 235, 236, 300, 327 bottom, 363

Gabriel Figueroa Flores: 267

Courtesy Gonzalo Fonseca: 81

Pedro Franciosi: 92

Courtesy Frumkin/Adams Gallery, New York: 178, 186

Fundacíon Galería de Arte Nacional, Caracas: 194, 370

Fundación Museo de Bellas Artes, Caracas: 261, 333

Fundacíon Olga y Rufino Tamayo, A.C.: 118 left

Courtesy Galería de Arte Mexicano, Mexico City: 112, 119 left

Courtesy Galerie Schlégl, Zurich: 356 top

Courtesy Gallery B. Farber: 256

Paolo Gasparini: 94 right

Courtesy Gunther Gerzso, Mexico City: 114

Jose Ignacio González and Pablo Oseguera, courtesy Galería OMR: 149

Courtesy M. Gradowczyk: 358, 366

Courtesy Carlos Haime, New York: 130

David Heald, © Solomon R. Guggenheim Foundation, New York: 228 bottom, 283, 349

Courtesy Hirshhorn Museum and Sculpture Garden, Smithsonian Institution, Washington, D.C.: 353

Gilles Hutchinson, Paris: 360

J. Hyde, Paris: 253

Instituto Nacional de Bellas Artes, Mexico City: 22, 23, 26, 27, 29, 61, 62, 63, 64 bottom, 66, 67, 69, 71, 247, 291 top

IVAM, Centre Julio González, Generalitat Valenciana: 356 bottom

Kanaal Art Foundation, Kortrijk: 140, 163 right

Kate Keller, The Museum of Modern Art, New York: 109 left, 232, 263, 273 (with Mali Olatunji), 311, 315, 338

Kleinfenn, Paris, courtesy Hôtel des Arts, Paris: 185

Courtesy Kunsthaus, Zurich: 220 top, 305

Courtesy Lou Laurin Lam, Paris: 110

Courtesy Julio Le Parc, Paris: 264

Lepkowski, Berlin: 219

© 1992 Museum Associates, Los Angeles County Museum of Art: 170, 314

Lutteroth & Sanchez Uribe, courtesy CNAC-INBA: 313

Courtesy Mary McCully, London: 73

Courtesy Ivens Machado: 138

Courtesy Marisol: 129

Christoph Markwalder, Basel: 177 bottom, 192, 193, 239, 240 top, 266, 270, 277, 301 bottom, 361

Robert E. Mates, © Solomon R. Guggenheim Foundation, New York: 343

James Mathews, The Museum of Modern Art, New York: 198, 271

Petre Maxim: 43 bottom

Petre Maxim and Mariano V. de Aldaca: 41

Vicente Mello, Rio de Janeiro: 139

© The Estate of Ana Mendieta: 146, 147 (courtesy Galerie Lelong, New York)

Courtesy The Metropolitan Museum of Art, New York: 318

© Oscar Monsalve, Bogotá: 131

Wilton Montenegro: 163 left, 276

Musée National d'Art Moderne, Paris: 212

Museo de Arte Moderno, Buenos Aires: 49

Courtesy El Museo del Barrio, New York: 326

Museo Nacional de Artes Visuales, Montevideo: 215, 352 top

Museu de Arte Contempôranea da Universidade de São Paulo: 30, 58

Courtesy Museu Lasar Segall, São Paulo: 330, 331, 332

Museum of Art, Rhode Island School of Design, Providence: 28

The Museum of Modern Art, New York: 109 right, 196, 205, 258, 274, 292, 339

Museum of Modern Art of Latin America, Organization of American States, Washington, D.C.: 21

Courtesy Edgar Negret: 95, 282

Courtesy Annina Nosei Gallery, New York: 230, 255

José Verde O.: 111(courtesy CNAC-INBA), 118 left (courtesy Fundacíon Olga y Rufino Tamayo, A.C.)

Claude Oiticica, courtesy Projeto Hélio Oiticica, Rio de Janeiro: 102

Mali Olatunji, The Museum of Modern Art, New York: 224 top, 246 top, 272, 279, 289, 295 left, 317, 340, 347

Marco Antonio Pacheco, courtesy Galería OMR: 268

Courtesy César Paternosto: 82, 83

Courtesy Francesco Pellizzi, New York: 229

Rolf Petersen, The Museum of Modern Art, New York: 344

Courtesy Patricia Phelps de Cisneros, Caracas: 294 bottom, 295 right, 342, 345

Courtesy Phoenix Art Museum: 246 bottom

Courtesy Pinacoteca do Estado da Secretaria de Estado da Cultura de São Paulo: 53, 299

Liliana Porter: 153

Courtesy José Resende: 306

Pedro Roth: 47 right

Adam Rzepka, Musée National d'Art Moderne, Paris: 204

Antonio Saggese: 137 left

Courtesy Alexandre de la Salle, Saint Paul (France): 176

Courtesy San Francisco Museum of Modern Art: 316

Courtesy Ma. Esthela E. de Santos, Monterrey: 120

Ken Showell, courtesy El Museo del Barrio, New York: 293

Bernard Silberstein, courtesy Carla Stellweg Gallery, New York: 113

Sotheby's, New York: 24

Courtesy J. R. Soto: 94 left

Courtesy Sperone Westwater, New York: 341

Stedelijk Museum, Amsterdam: 25

Soichi Sunami, The Museum of Modern Art, New York: 288, 337, 346

Gerardo Suter: 117, 119 right

Alfredo Testoni, Montevideo: 79, 80

Oystein Thorvaldsen, courtesy The Henie-Onstad Art Center, Hoevikodden: 151

Courtesy Cecilia de Torres: 87

Courtesy Villanueva Collection, Caracas: 259

Walker Art Center, Minneapolis: 262 top

Tom Warren: 161 right, 233 top

Bruce M. White, New York: 171, 172 top, 174, 182, 183 bottom, 184 top, 187, 188, 189, 195, 197 (courtesy Marlborough Gallery, New York), 199, 200, 201, 202, 203, 206, 207, 208, 211, 213, 214 (courtesy Art Museum of the Americas, OAS, Washington. D.C.), 218, 220 bottom, 221, 222, 223, 226, 233 bottom, 234 (courtesy Fawbush Gallery), 237, 238, 240 bottom, 241, 242, 243 top, 251, 252, 254, 262 bottom, 265, 275, 278, 280 bottom, 284, 285, 291 bottom (courtesy CNAC-INBA, Museo de Arte Alvar y Carmen T. de Carrillo Gil, Mexico City), 297, 298 (courtesy Bernice Steinbaum Gallery, New York), 301 top, 302, 303, 304, 307 , 308, 309, 319, 320, 321, 323, 324, 325, 327 top, 328, 334, 335 (courtesy Galería OMR), 336, 348 (courtesy Galería Arvil), 350, 355, 359, 362, 364 top

Sergio Zalis: 105

Index

Page numbers in italics refer to illustrations.